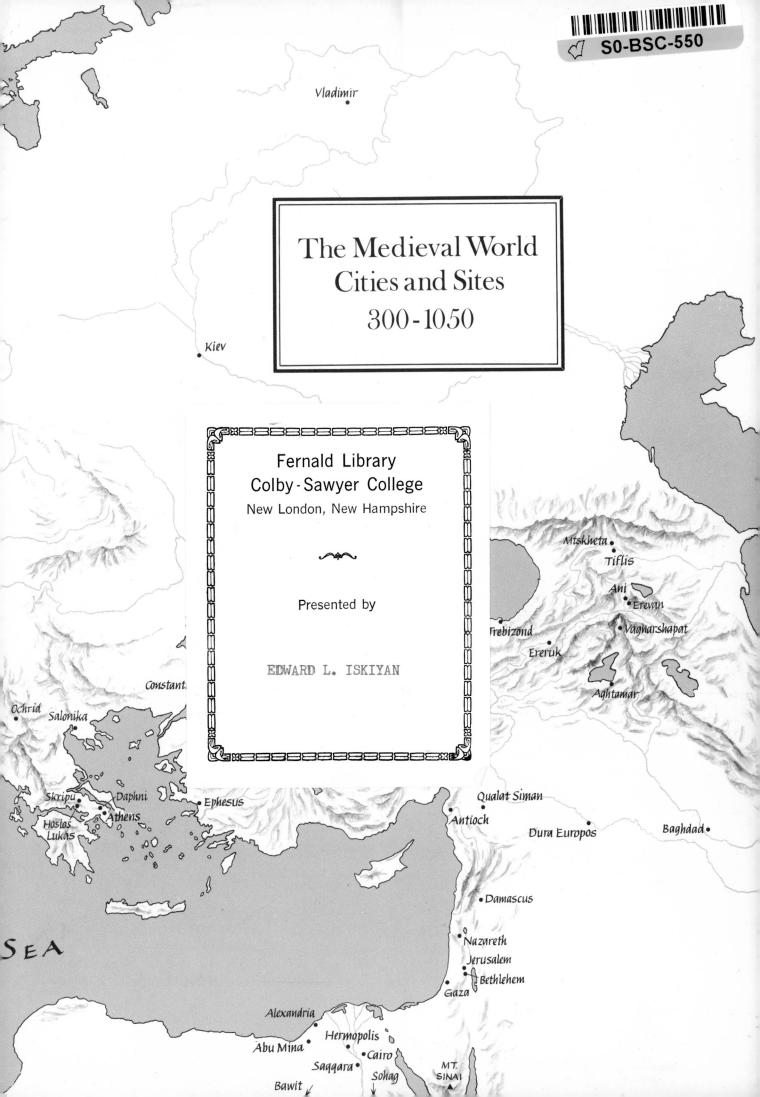

The Medieval World Cities and Sites

300-1050

Vladimir

Kiev

Mtskheta

Tiflis

Ani
Erevan

Trebizond
Vagharshapat

Ereruk

Aghtamar

Ochrid Salonika

Constant.

Skripu Daphni

Hosios Athens
Lukas

Ephesus

Qualat Siman

Antioch

Dura Europos Baghdad

Damascus

Nazareth
Jerusalem
Bethlehem
Gaza

SEA

Alexandria

Hermopolis

Abu Mina

Cairo

Saqqara Sohag

Bawit

MT.
SINAI

ART of the
MEDIEVAL WORLD

LIBRARY OF ART HISTORY

H. W. Janson, GENERAL EDITOR

George Zarnecki

ART
OF THE
MEDIEVAL
WORLD

ARCHITECTURE · SCULPTURE · PAINTING

THE SACRED ARTS

Harry N. Abrams, Inc., Publishers, New York

Nai Y. Chang, Vice-President, Design and Production
John L. Hochmann, Executive Editor
Margaret L. Kaplan, Managing Editor
Barbara Lyons, Director, Photo Department, Rights and Reproductions
Patricia Egan, Editor
Deirdre Silberstein, Picture Editor
Robin Fox, Designer

Maps, Chronological Chart, Glossary, and Index
prepared with the assistance of Nora Beeson,
Charles Little, and Grace Sowerwine

Library of Congress Cataloging in Publication Data
Zarnecki, George.
Art of the medieval world.
(Library of art history)
Bibliography: p.
Includes index.
1. Art, Medieval—History. I. Title.
N5970.Z37 1975b 709'.02 75-25576
ISBN 0-8109-0361-X.

Library of Congress Catalogue Card Number: 75-6531

Published by Harry N. Abrams, Incorporated, New York, 1975

Printed and bound in Japan

Editor's Preface

The present book is one of a series. *The Library of Art History* comprises a history of Western art in five volumes, devoted respectively to the Ancient World, the Middle Ages, the Renaissance, the Baroque and Rococo, and the Modern World. The set, it is hoped, will help to bridge a gap of long standing: that between one-volume histories of art and the large body of specialized literature written for professionals. One-volume histories of art, if they are to be books rather than collections of essays, must be—and usually are—the work of a single author. In view of the vast chronological and geographic span of the subject, no one, however conscientious and hard-working, can hope to write on every phase of it with equal assurance. The specialist, by contrast, as a rule deals only with his particular field of competence and addresses himself to other specialists. *The Library of Art History* fits in between these two extremes; written by leading scholars, it is designed for students, educated laymen, and scholars in other fields who do not need to be introduced to the history of art but are looking for an authoritative guide to the present state of knowledge in the major areas of the discipline.

In recent years, such readers have become a large and significant group. Their numbers reflect the extraordinary growth of the history of art in our system of higher education, a growth that began in the 1930s, was arrested by the Second World War and its aftermath, and has been gathering ever greater momentum since the 1950s. Among humanistic disciplines, the history of art is still something of a newcomer, especially in the English-speaking world. Its early development, from Vasari (whose famous *Lives* were first published in 1550) to Winckelmann and Wölfflin, took place on the Continent, and it became a formal subject of study at Continental universities long before it did in England and America. That this imbalance has now been righted—indeed, more than righted—is due in part to the "cultural migration" of scholars and research institutes from Germany, Austria, and Italy forty years ago. The chief reason, however, is the special appeal of the history of art for modern minds. No other field invites us to roam so widely through historic time and space, none conveys as strong a sense of continuity between past and present, or of kinship within the family of man. Moreover, compared to literature or music, painting and sculpture strike us as far more responsive vessels of individuality; every stroke, every touch records the uniqueness of the maker, no matter how strict the conventions he may have to observe. Style in the visual arts thus becomes an instrument of differentiation that has unmatched subtlety and precision. There is, finally, the problem of meaning in the visual arts, which challenges our sense of the ambiguous. A visual work of art cannot tell its own story unaided. It yields up its message only to persistent inquiry that draws upon all the resources of cultural history, from religion to economics. And this is no less true of the remote past than of the twentieth century—if we are to understand the origins of nonobjective art, for instance, we must be aware of Kandinsky's and Mondrian's profound interest in theosophy. The work of the art historian thus becomes a synthesis illuminating every aspect of human experience. Its wide appeal is hardly surprising in an age characterized by the ever greater specialization and fragmentation of knowledge. *The Library of Art History* was conceived in response to this growing demand.

H. W. Janson

To JOAN EVANS and KENNETH J. CONANT

whose friendship over the years
has been a very great privilege and pleasure

Author's Foreword

A book which covers more than a thousand years of art, both in the Christian West and East, is bound to be fairly general and selective. Nobody can honestly claim to be the master of such a vast body of material and it will be evident that the author had to rely frequently on the opinions of others. Also, with the best will in the world, no individual can examine all the works of art mentioned in this book, and so, in many cases, I have had to content myself with the testimony of others and with the study of photographs and reproductions. However, the aim of this book is not the discovery of new facts, but an assessment of the general lines of development in Christian art from the time of Constantine the Great to the fourteenth century, when new artistic ideas, evolved in Italy, were to revolutionize the traditions of the medieval world.

The brief chapters, arranged chronologically and often regionally, give only the barest outlines of the art of the period covered and the reader wishing to pursue the subject further will find a selection of books in the Bibliography, as a guide to further reading. While writing this book, the author had the advantage of having before him Creighton Gilbert's volume in this series, *History of Renaissance Art*, in which some of the artists and their works that fall within the scope of both this and his book have already been discussed. In trying to avoid repetition, I have dealt with the art of the fourteenth century in less detail than I originally planned. It is therefore essential for the reader who is particularly interested in this period to consult both books.

I wish to express my thanks to those friends who helped me in various ways in writing this book. Dr. Cecilia Meredith helped in planning the early chapters; she is not to blame for any shortcomings, however, these are my own responsibility. Miss Susan Catling typed the illegible manuscript with remarkable skill and patience. Miss Patricia Egan prepared the text for publication, making valuable suggestions for improvements. Finally the general editor, H. W. Janson, has my thanks for his patience and forbearance in his dealings with the author whose teaching and administrative duties made his work slow and erratic.

Contents

ART of the
MEDIEVAL WORLD

I

Early Places of Worship and Pre-Constantinian Art

The early Christians gathered together for worship in private houses, and their meals, which involved the blessing of bread and wine, took place in dining rooms. Therefore there was no need at that time for any special cult building, nor indeed would it have been safe to have one erected. But the situation changed gradually as the new religion grew in strength and spread all over the Roman Empire. By the early third century, the Christian dogmas, liturgy, and organization became more clearly defined, the Church acquired possessions, and the ordained clergy became professional officials. Except during periods of persecution, Christians worshiped openly and were tolerated by the State, as were so many smaller religions and sects. The early gatherings for meals and prayers developed into regular services in which the Eucharist was the focal point. Prayers, chanting, processions, baptism, and the administrative work of large

congregations could no longer be adequately performed in ordinary private houses, and thus a *domus ecclesiae,* or house church, was evolved, often by a radical rebuilding of a private house.

Such house churches are known to have existed from contemporary texts and a few fragmentary remains. A securely dated example of 231 (the date of its adaptation for Christian worship; fig. 1) partially survives in Dura-Europos in northern Mesopotamia. It consists of a central courtyard, on one side of which was the assembly room for about sixty people, who were presided over by a bishop seated on a raised platform. A small vestry was nearby. On the other side of the courtyard, adjoining the assembly room, was a smaller room for about thirty catechumens receiving instruction, who could hear the service without participating in it. Finally, on the third side were smaller rooms, including a baptistery with a font under a

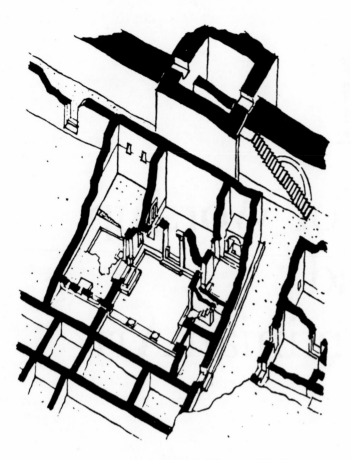

1. Plan of House Church (*domus ecclesiae*),
Dura-Europos. 231

canopy. A series of wall paintings, or rather their fragments, which originally decorated this baptistery are preserved in Yale University Art Gallery (colorplate 1). These paintings are not of high artistic quality and were obviously the work of a second-rate craftsman, trained in the tradition of late antique painting. What is remarkable, however, is the subject matter of the decoration, for here are found a number of Biblical scenes that were to become standard iconographic types. The painter of these scenes was not an innovator and he must have been following an already existing tradition, of which, alas, no other examples survive. The scenes on the long walls were arranged in two horizontal zones: the upper, painted in a sketchy manner, represents Christ's miracles, while below, in a more monumental style, are represented the

Three Marys at the Sepulcher. Of particular interest is the painting on the lunette of the canopy behind the font, showing the Good Shepherd, below whose feet are the small nude figures of Adam and Eve. This juxtaposition of the figures clearly refers to the doctrine of original sin and its redemption through Christ, and it alludes to the sacrament of baptism, through which original sin is washed away. Thus these paintings, however mediocre their execution, are invaluable evidence of the early decoration of houses of worship, in which some of the Christian dogmas found visual expression.

Architecturally, the most interesting of the Early Christian structures were the *martyria,* commemorative buildings over the tombs of martyrs. Persecutions had already started in about 35 A.D., when St. Stephen was stoned in Jerusalem; St. Peter was crucified, head downward, in Rome, probably during the persecution of Nero in 64 A.D., and St. Paul was beheaded there probably at the same time. The worst persecutions, those of the emperors Decius (250) and Diocletian ("Great Persecution," 303–5), resulted in the deaths of many thousands of Christians and their leaders. The cult of the martyrs developed early, and their burial grounds became places for commemorative services. Modest canopies built over the tombs gradually gave way to more ambitious and complex structures, often influenced in form by pagan mausolea. Some were two-storied structures with the altar over the tomb and a funeral banqueting room above.

Perhaps the best-known Early Christian structures are the catacombs. The Christians rejected the cremation of the dead, and most of their burial grounds were surface cemeteries. Underground burials were possible only in regions where soft rock was available, as in Rome, Naples, and Syracuse, and they were not exclusively Christian. The artistic importance of the catacombs lies chiefly in the paintings with which they were often adorned.

The *arcosolia,* or burial chambers of the cata-

combs, were owned by individuals or families, and it was due to private initiative that some were covered with painted decoration. They form the largest body of material on which we can base our knowledge of the earliest painting practiced by the Christians, or sponsored by them and executed by pagan artists. As far as the style of these paintings is concerned, it is exactly the same as that of any contemporary non-Christian work. In most cases the backgrounds are white or creamy, well suited to dark interiors, on which thin red or green lines provide geometric frames for figural or floral decoration (fig. 2). The forms, whether human, animal, or vegetable, are rendered by rapid, light, brush strokes. The lively figures are full of movement and elegance. The forms are small and stand out clearly against the light, neutral background, without any attempt at perspective. Not only are the technique and color scheme used in the cata-

combs similar to those in contemporary pagan paintings, but so are many of the motifs; the profusion of birds surrounded by decorative scrolls of foliage, the putti, and the seasons, among many others. Had it not been for the addition of Christian subjects, it would be hard to know that this was already Christian art. The subjects which occur most often are those of the Good Shepherd, figures with raised hands in an attitude of prayer, or *orants*, and scenes from the Old and, less frequently, the New Testament. These Biblical subjects often represent events which were particularly appropriate to Christians whose lives were in peril, subjects illustrating mortal danger and deliverance through prayer and divine intervention, such as the Three Hebrews in the Fiery Furnace (fig. 3), Jonah and the Whale, Daniel in the Lions' Den, and the Sacrifice of Isaac from the Old Testament, and the Raising of Lazarus and

2. *Good Shepherd*. Ceiling painting of burial chamber. 3rd century.
Catacomb of Priscilla, Rome

3. *Three Hebrews in the Fiery
Furnace.* Wall painting.
3rd century.
Catacomb of Priscilla,
Rome

4. *Virgin and Child.*
Wall painting. 3rd century.
Catacomb of Priscilla, Rome

other miracles performed by Christ from the New Testament. Many of these subjects occur in prayers for the salvation of the soul and are still mentioned today in the Mass for the Dead.

The earliest catacomb paintings date from the third century, but their exact chronology is very uncertain. Among the early examples, all in Rome, are paintings in the catacombs of S. Domitilla, of S. Callisto, and of Priscilla; in this last, there is a remarkable but unfortunately much damaged representation of the Virgin and Child (fig. 4). The tradition of painting burial chambers in the catacombs continued well into the fifth century, but with the recognition of Christianity as the official religion of the State and the consequent building of churches, the most important works of painting were henceforth to be made in these churches.

The martyria and the catacombs with their paintings testify to the great attention given by the early Christians to their dead, and especially to those who were martyrs. The earliest works of Christian sculpture are also connected with the dead. While the majority of burials were made in plain coffins, at times elaborately carved marble or stone sarcophagi were commissioned, follow-

5. Sarcophagus with the Good Shepherd, from Via Salaria.
Early 3rd century. Lateran Museum, Rome

6. Sarcophagus with Jonah and the Whale, from the Vatican cemetery.
Late 3rd century. Lateran Museum, Rome

ing the pagan Roman custom. Since sarcophagi seldom bear inscriptions, their dating is difficult and, in most cases, relies on stylistic assessments. Nevertheless, a fairly large number can safely be attributed to the third century. The best of these are preserved in Rome, though they were, of course, made in many other centers, for instance, in Provence.

As in the case of paintings, the sarcophagus reliefs are closely related to contemporary pagan works, and the only difference lies in their use of Christian iconography. Here, as in paintings, many subjects commonly employed in pagan sculptures continued to be carved on works for Christian use, especially pastoral scenes and portraits of the deceased. Other pagan motifs were adopted but were given a new, Christian meaning, such as the Good Shepherd, derived from the Greek statue type of Hermes Kriophoros (fig. 5). Christ referred to himself as the Good Shepherd (*"Ego sum pastor bonus"*; John 10:11, 14), so it was natural that

this traditional pagan theme was readily adopted by the Christians. Scenes of the story of Jonah and the Baptism of Christ frequently occur and obviously this is because they are symbolic of salvation.

Although there can be no doubt that much of the iconography of the early sarcophagi was deeply religious in intention, the sculptors, clearly with the patron's approval, delighted in including charming naturalistic details of birds, animals, insects, fishes, and plants. The story of Jonah on the sarcophagus from the Vatican cemetery (now in the Lateran Museum; fig. 6) incorporates many delightful motifs, not required by the narrative but nevertheless carved with visible delight and skill. The high relief was achieved with the help of the drill and the deep undercutting of forms, some completely detached from the background. Nothing can illustrate more tellingly the indebtedness of this earliest Christian art to the sensuous and naturalistic art of pagan antiquity.

II
Constantine the Great and the Art of the Fourth Century

The year 313 A.D. was momentous in the history of mankind. By the so-called Edict of Milan, Emperor Constantine the Great proclaimed religious toleration which meant, in practice, that from this date onward, Christianity assumed a privileged position in the Roman Empire. This religion, which at times had been persecuted and at best merely tolerated, now became the faith of vast territories which stretched from the Atlantic to Mesopotamia, and from the whole length of the North African coast to Britain. In Europe, the Rhine and the Danube rivers marked the limits of Roman power.

Another momentous step taken by Constantine in 330 was the removal of the capital of the Empire from Rome to the Greek city of Byzantium on the shores of the Bosphorus, where Europe joins Asia. This "New Rome" was to be known as Constantinople, after its founder. From its inauguration, it was a Christian city and its bishops or patriarchs were to compete for preeminence with the bishops of Rome, the popes. For a time, the eastern and western halves of the Roman Empire maintained a semblance of unity but in 395, on the death of Theodosius the Great, the separation became definite.

The removal of the capital to the eastern Mediterranean location was dictated by political necessity and foresight. The Empire, covering vast territories, was under increasing pressure from invading barbarians, and Rome was no longer suitable as the administrative and military center from which to rule and defend it. The future was to demonstrate how wise was the step taken by Constantine: the Eastern Empire survived until 1453, while the Western Empire fell in 476.

ARCHITECTURE

The years immediately following the Edict of Milan marked the beginning of truly monumental Christian architecture. Under the protection

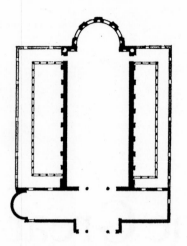

7. Plan of Constantinian Basilica (*aula regia*), Trier. Early 4th century

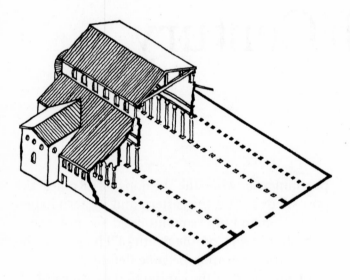

8. Isometic reconstruction of St. John Lateran, Rome. c. 320

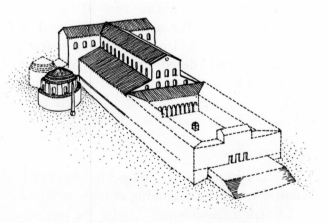

9. Isometric reconstruction of Old St. Peter's, Rome. c. 400

of the emperor, Christianity came triumphantly into the open. The religion of the poor now became the official creed of a mighty state, and in the process its character changed considerably. The clergy acquired new status and the liturgy was enriched to make it more worthy of the official religion of the Empire. The architectural requirements of the new, solemn liturgy could not be met by the modest *domus ecclesiae*, and thus large churches started to be built.

Constantine himself sponsored the erection of many churches in Rome, Constantinople, the Holy Land, and elsewhere, and these acquired a high prestige and were particularly influential for future developments. Church types of the Constantinian period are characterized by a great diversity of plans and forms. Lack of traditions of large-scale Christian building forced patrons and architects to turn for models to pagan structures, adapting these to the peculiar requirements of the Christian cult.

The most popular form of Constantinian church was a basilica. The name derives from pagan basilicas, or assembly halls, built for various purposes and in diverse forms all over the Roman Empire (fig. 7). Although every element of a Christian basilica can be found in late Roman architecture, there are no parallels for the whole structure and probably none existed, even if modest buildings for certain pagan sects present some similarities to it. The basic form of the church was a long rectangle, terminating in an apse. The main body was a nave, flanked by aisles, which were separated from it by rows of columns. The nave, higher than the aisles, was lit by clerestory windows; it had a wooden ceiling, which is surprising, since the Romans had by then perfected the method of covering large buildings with groined vaults or tunnel vaults. Evidently the Christians did not want the heavy aspect the vaulted Roman buildings possessed, and preferred lighter structures, exploiting the exposed timber constructions of the roofs for decorative purposes.

Within this general basilican type, the variations of detail were great. Local traditions and building materials, the shapes and sizes of the sites allocated for the buildings, and no doubt the funds which were available, as well as other factors, account for almost endless differences among individual basilicas. In the first place, an ordinary parish church would obviously differ from a cathedral, a church containing a *cathedra*, or bishop's throne. The cathedral church of Rome, St. John Lateran (fig. 8), was built at the initiative of the emperor Constantine, and it was located within the imperial palace. It is known from old drawings, and some remains are incorporated in the present structure. It was a five-aisled basilica with a western apse and two chambers projecting sideways from the west end of the outer aisles: they served as a vestry (*diaconicon*, or the area in the deacons' charge), and as a place for receiving offerings brought by the congregation, and as a *prothesis*, for the safekeeping of the Eucharist. Saint John's Cathedral was built soon after 313, and St. Peter's basilica, another of Constantine's foundations, about 330, though the work on this vast project was completed only long after the emperor's death in 337 (figs. 9–11). Saint Peter's, like St. John Lateran, was a five-aisled basilica, but it differed in one important respect: between the nave and the apse, across the whole width of the church and beyond, was a transept as high as the nave. This new feature was dictated by the peculiar character of the church. The growing cult of martyrs and saints, and the resulting popularity of pilgrimages to their tombs, created new conditions which were met by the erection of large martyria that were no longer canopies, but entire churches over the tombs of martyrs. Saint Peter's tomb was a center of veneration from early times, and it was not surprising that Constantine resolved to honor the apostle by providing a worthy church over his tomb. This Old St. Peter's, replaced by the present building in the sixteenth century but

10. *Old St. Peter's, Rome.* Drawing. Vatican Library (Barb. lat. 2733), Rome

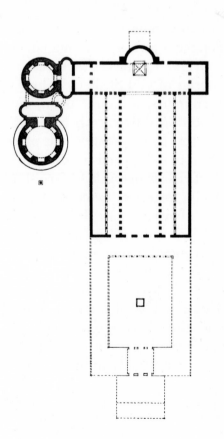

11. Plan of Old St. Peter's, Rome. c. 400

known to us from descriptions and visual sources, had to be exceptionally large to accommodate vast numbers of pilgrims. The transept, separated from the aisles by screens and from the nave by the chancel arch, was, together with the apse, the martyrium proper; the tomb of the apostle was deep underground, just in front of the apse, and surmounting the tomb was a baldachin that rested on twisted marble columns. According to the *Liber Pontificalis*, that invaluable source for the history of the popes and the churches of Rome, the six columns were brought from Greece. The nave and the aisles were intended for the burial of those wishing to rest in close proximity to the relics of the martyred apostle. It was there also that the funeral meals took place.

In front of the nave and aisles of St. Peter's was a vast arcaded atrium, an open courtyard, in the center of which was a fountain incorporating a giant Roman bronze pine cone, the *Pigna*, that is now in a courtyard of the Vatican. This work was later copied by Carolingian craftsmen for Charlemagne's residence at Aachen.

The exterior of Old St. Peter's, like all Early Christian churches, was quite plain, and in this lies an important difference between them and pagan temples. The decoration was placed *inside* the Christian buildings and consisted principally of the use of rich materials and furnishings. The marble walls, mosaics, frescoes, mosaic pavements, and, above all, the splendid columns and capitals, often spoils from Roman buildings, must have created a sumptuous impression. In St. Peter's the focus of attention was the shrine of the apostle;* above it stood the six twisted marble columns just mentioned, four of them supporting curved ribs set diagonally, from whose intersection hung a crown-shaped candelabrum, the gift of Constantine. Subsequent

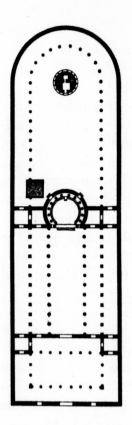

12. Plan of Church of the Holy Sepulcher, Jerusalem. c. 335

medieval crown-candelabra and twisted columns owed their inspiration to this famous shrine; even the celebrated bronze baldachin by Bernini in the rebuilt St. Peter's was inspired by this Constantinian model. Two other twisted columns stood in the corners of the apse and were joined to the baldachin by means of architraves, from which curtains were suspended. In St. John Lateran, the timbers of the open roof were adorned with gold sheets, the altar and the tables for offerings were of gold, and there were numerous chandeliers and candlesticks of precious metals. Gone was the early stress on simplicity and poverty; the Constantinian church exhibited an imperial splendor and lavishness.

Although the basilican church was adopted in every part of the Empire, its variations were endless. There were no directives specifying what form the building and decoration should take. The early cathedral of Aquileia, founded about 314, was, for instance, built on the complex plan of two parallel halls joined at their west

* An illustration of this is found on the ivory casket from Pola, reproduced in R. Krautheimer, *Early Christian and Byzantine Architecture* (Pelican History of Art), Harmondsworth, 1965, pl. 8A.

end by various rooms which included a baptistery. Similarly, the Constantinian cathedral at Trier consisted of two very large basilican churches built side by side with a baptistery between them. The cathedral at Orléansville in North Africa had five aisles, like the two Roman basilicas we have discussed, but its innovation was a crypt raised above floor level and surmounted by an apse concealed from the outside by a straight east wall.

The commemorative churches and martyria also presented a great variety of types. The church of the Nativity at Bethlehem, commissioned by Constantine, was a basilica but it ended in an octagonal structure containing the Grotto of the Nativity. The church of the Holy Sepulcher on Golgotha (fig. 12), in Jerusalem, another foundation of Constantine, was a five-aisled basilica to which was joined the martyrium proper, in the form of a courtyard with a colonnade, containing two precious relics: the Rock of Calvary, the witness of Christ's death,

and the Holy Sepulcher, the witness of His resurrection. The tomb was cut from the rock in a conical shape and was framed by twelve columns supporting a baldachin. This famous structure, rebuilt later on numerous occasions, was to be imitated throughout Christendom.

Nothing substantial survives of the Constantinian foundations in the new capital, Constantinople. The original Hagia Sophia and the church of the Holy Apostles were subsequently entirely rebuilt, but it is known that the former was a basilica and the latter a cross-shaped building with a dome over the crossing. This peculiar form is explained by the fact that the church of the Holy Apostles was originally intended as a mausoleum for Constantine; some years after his death, however, the relics of the apostles were acquired and placed there (hence its dedication), and the body of Constantine was transferred to an additional circular, domed mausoleum. Constantine's daughter, Constantina, was also buried in a round mausoleum, S.

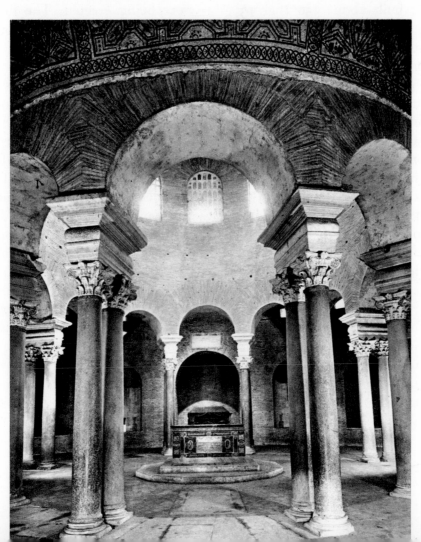

13. Interior of
S. Costanza,
Rome. c. 350

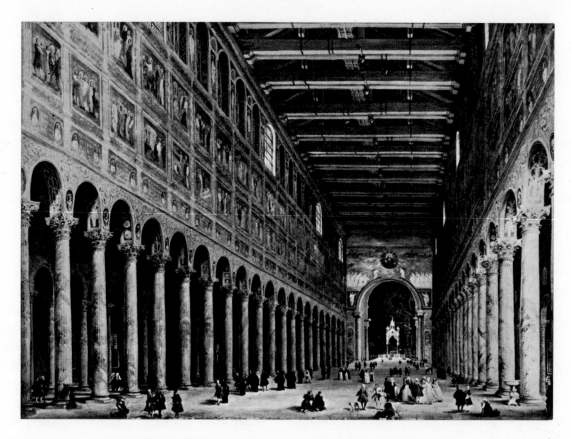

14. Giovanni Paolo Pannini. *The Interior of S. Paolo fuori le mura.*
Oil on canvas, c. 1750 (church begun 385). Private Collection

Costanza in Rome, built about 350 (fig. 13); the splendid mosaics of this building will be discussed later in this chapter (see page 26).

The almost feverish building activities from 313 until 337, when Constantine died, were not confined to the main centers, but took place throughout the Empire. In spite of its vastness, close contacts existed among all the imperial provinces, thanks to political unity and good communications, though the split between its eastern and western parts gained in strength and was eventually made official in 395 by its division under separate emperors. However the bishop of Rome, as the successor of St. Peter, to whom Christ gave the leadership of the Church ("Thou art Peter, and it is upon this rock that I will build my church"; Matthew 16:18), was recognized by all as the senior among the bishops. The oecumenical or general councils provided opportunities for large gatherings of the clergy and, though their aim was primarily theological, they must have promoted an exchange of artistic ideas and of information about buildings that

were being erected. The first council, held in 325 at Nicaea in Asia Minor, brought together some two hundred and fifty bishops, who condemned as heretical the doctrine of Arius concerning the different natures of the Son and the Father. The second council met at Constantinople in 381 to declare the divinity of the Holy Spirit, and to give the bishop (patriarch) of Constantinople second place after the bishop of Rome. The first eight councils met in the eastern provinces of the Empire, thus emphasizing the decisive importance of the East.

After the death of Constantine, the pace of church building slowed down considerably. The Church was troubled by the spread of Arianism, and later, under the emperor Julian the Apostate (361–63), it suffered renewed persecution. But the restoration of paganism was short-lived, though it lingered on for some time even after Theodosius the Great (378–95) closed the pagan temples and confiscated their properties. When Rome was sacked by the Goths in 410 the churches were spared but the temples were looted

and ruined. The Rome that arose once more from this calamity was entirely Christian. But with the political decline of the western part of the Empire under the pressure of barbarian invasions, Rome lost much of its artistic leadership.

During the great revival of artistic life in the Empire under Theodosius, the most important building erected in Rome was that of S. Paolo fuori le mura (fig. 14). Disastrously restored after the fire of 1823, the original church is known from numerous descriptions, drawings, and paintings. It was a conservative structure, largely based in scale and design on St. Peter's. What was important, however, is that many decorative details, especially the Composite and Corinthian capitals, were accomplished and correct copies of pagan classical originals. This attempt to give the Christian basilica as classical an appearance as possible was significant. Western Christians no longer feared that their cult buildings might resemble those of the pagan past; on the contrary, faced with the barbaric threat and the political supremacy of the East, they were now proud of their classical heritage.

In the second half of the fourth century, Rome's chief rival in Italy was Milan, for a time an imperial capital and an important religious center under the leadership of St. Ambrose. The churches built there display highly original forms, which were to have considerable influence in later centuries. Two of these churches stand out especially: S. Lorenzo, a domed quatrefoil, and the Holy Apostles (now S. Nazaro), built on the plan of a Latin cross, or cross having a stem longer than the transverse arms.

PAINTING AND MOSAIC

The Early Christian churches, with their great expanses of walls, were admirably suited to painted decoration. Unfortunately, no wall paintings survive in fourth-century churches, but some catacomb paintings clearly reflect the monumental wall decorations in the basili-

cas. In the catacomb of SS. Pietro e Marcellino in Rome, for instance, the composition of Christ enthroned between St. Peter and St. Paul, above the *Agnus Dei* adored by four saints (fig. 15), is, in all probability, an imitation of apse painting in contemporary Roman churches.

Catacombs, chiefly in Rome, are the main source of knowledge of fourth-century painting. In comparison with the earlier paintings, those of the fourth century are richer in their subject matter and they also differ slightly in style. The triumph of Christianity is reflected in such subjects as Christ enthroned triumphantly in the midst of the apostles. Although stylistically the fourth-century paintings are still much indebted to late antique, pagan works, they show, in comparison with the previous century, a certain change. The forms tend to be solid and more compact, with well-defined contours; the colors

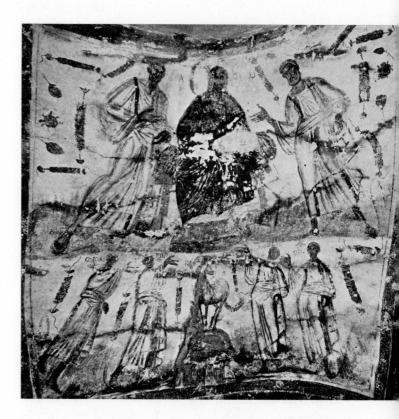

15. *Christ Enthroned Between St. Peter and St. Paul* (above); *Agnus Dei Adored by Four Saints* (below). Wall painting. 4th century. Catacomb of SS. Pietro e Marcellino, Rome

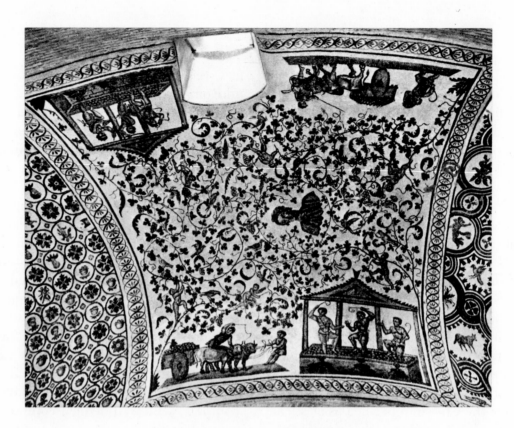

16. Portion of vault mosaics. c. 350.
Santa Costanza, Rome

are heavier and the facial types more indi-
vidualized, almost portrait-like.

The most sumptuous manner of decorating
churches was by mosaics applied to walls, domes,
and apses. Pavements were also frequently made
in this technique. Mosaics were adopted from
Roman art, and it is little wonder that in style
and subject matter they are deeply indebted to
late antique models. The large apse mosaics in
Constantinian churches have perished, but we
are fortunate in having the well-preserved vault
mosaics of S. Costanza in Rome (fig. 16). Divid-
ed by decorative frames into rectangular sec-
tions, they consist of small busts, cupids, birds,
animals, and pastoral scenes, enclosed by medal-
lions, or vine-scrolls, or branches bearing flowers
and fruit. There is nothing Christian in this de-
lightful work. Originally there were small
Biblical scenes on the walls but they have not
survived, though two much-restored mosaics in
wall niches do exist that show a typological pair
of subjects, one from the Old Testament pre-

figuring one from the New: Moses receiving the
tables of the Law, and St. Peter receiving the
keys from Christ.

On the basis of the surviving material, it is
impossible to assess the achievements of fourth-
century painters and mosaicists, but it is safe to
claim that it was thanks to them that the founda-
tions were laid for the future development and
blossoming of monumental painting both in the
West and the East.

SCULPTURE

Broadly speaking, there are three principal types
of sculpture: first of all, the free-standing statues
so favored by antique civilizations; secondly,
reliefs applied to architecture or to various ob-
jects, such as sarcophagi; finally, miniature
sculpture in ivory, metal, and other media.

Following the example of their pagan prede-
cessors, Christian emperors had statues of them-
selves erected in important places in Rome,
Constantinople, and elsewhere, but only a few

have survived. Parts of a colossal statue of Constantine the Great were found in the fifteenth century in the basilica of Maxentius in Rome (now in the Museo dei Conservatori; fig. 17). About seven times lifesize, this marble colossus represented the emperor enthroned, awe-inspiring and giving a tremendous impression of power. His facial features are treated realistically, following the traditions of pagan Roman portraiture. The bronze, over-lifesize statue of an emperor at Barletta, in Apulia, belongs to the same tradition of triumphal, imperial art the aim of which was to enhance the prestige of the ruler. In contrast to these western statues, those representing Arcadius (d. 408) which survive in Constantinople, albeit from the end of the century, are given a more idealized treatment, which seems to belong to the Greek heritage in Byzantium.

Another form of promoting imperial prestige was the triumphal arch commemorating military exploits. Constantine's famous arch in Rome was begun in 312 to celebrate the victory over Maxentius by which he achieved the purple (fig. 18). The inscription states that Constantine overcame the tyrant by divine inspiration, but this does not necessarily mean the God of the Christians. In any case, the triumphal program of the reliefs on the arch is pagan. Much of the sculpture of the arch is reused from older Roman monuments, suggesting a shortage of good contemporary sculptors. The Constantinian reliefs of the Victories in the larger spandrels, and the Sun and the Moon in the side roundels, are weak imitations of older models. The most significant sculptures, however, are the friezes depicting Constantine's victory, his entry into Rome, and the distribution of gifts (fig. 19). From the point of view of classical proportions and harmony, these reliefs mark a decline. Yet they have a powerful expressive quality and solemn majesty.

Imperial triumphal monuments were also erected in the new capital, Constantinople, but only fragments survive. The plinth of the Obelisk

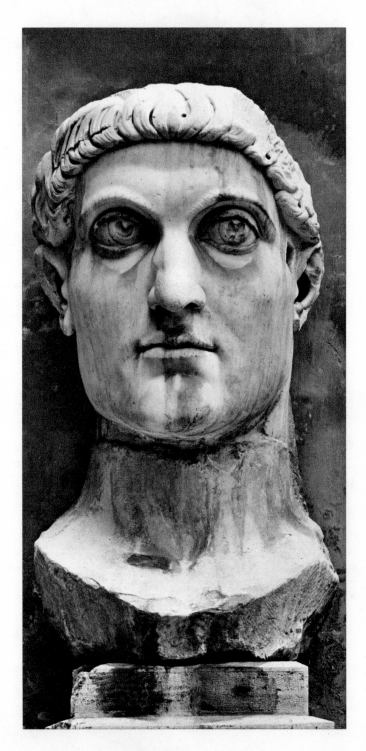

17. *Head of Constantine the Great.*
Marble, height of head 8′ 6″. 4th century.
Museo dei Conservatori, Rome

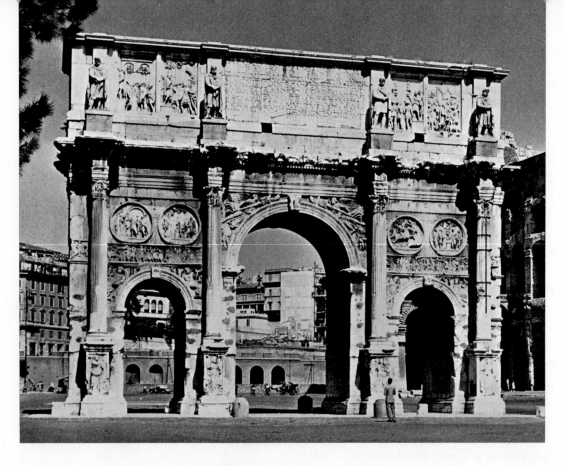

18. Arch of Constantine, Rome. Begun 312

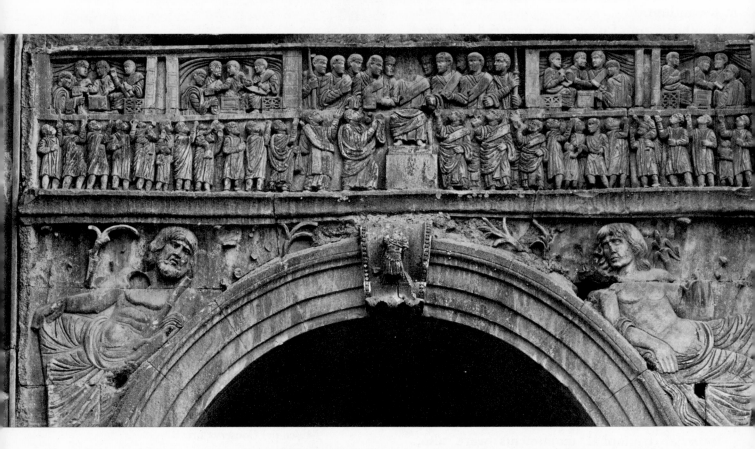

19. *Constantine Distributing Gifts*. 312–15. Arch of Constantine, Rome

of Theodosius in the Hippodrome, dating from about 390, is completely covered with reliefs showing the emperor and his court watching the racing chariots (fig. 20). Here, the departure from classical canons is even more extreme than on the Arch of Constantine. Not only are the frontality and stiff immobility very artificial when compared with the movement and variety of poses in classical works, but the sizes of the figures vary according to their importance and the "inverted" perspective heightens the air of unreality—the figures in front are smallest, as if the whole scene were viewed through the eyes of the emperor standing at the back.

Also in Constantinople, two colossal columns were erected by Theodosian emperors, imitating those of Trajan and Marcus Aurelius in Rome. Theodosius I erected the first, in 386; Arcadius the other, in 403. Only the lowest part of the latter column survives, but sixteenth-century drawings show that its spiral reliefs represented the campaign of the emperor against the Goths. The surviving base, divided into registers, displays a program similar to that on the Arch of Constantine, but the triumphal idea is more emphatically expressed and the cross on the highest zone implies that the emperor was victorious through Christ. Thus the triumphal imperial monument was given, if obliquely, a religious significance.

The most numerous works of fourth-century sculpture are sarcophagi. Mass-produced, many are of mediocre quality, but there are also some of high artistic merit, such as the so-called Sarcophagus of the Two Brothers, with their portrait busts in the center (Lateran Museum, Rome; fig. 21), and above all, that of Junius Bassus, prefect of Rome, who died in 359 (fig. 22). In both these works the classical traditions of round, soft modeling and natural, varied poses are maintained. The desire for richer Christian programs is achieved by arranging scenes in two registers; in the first case by a continuous friezelike arrangement, and in the second, by scenes framed

by columns and other architectural devices. The resulting effects are of great clarity and beauty. The range of subjects in comparison with earlier sarcophagi is greater, although scenes involving triumph over suffering still predominate, as before.

The classical tendencies found in these sarcophagi were also present in some of the ivories made in the fourth century. The celebrated casket in the Museo Cristiano in Brescia was made as a reliquary (fig. 23). The cult of the martyrs and their relics increased enormously during the fourth century, in spite of warnings pointing out the dangers of exaggerated worship. However, both St. Jerome and St. Augustine gave their full support to the practice. The Brescia casket looks like a miniature sarcophagus, with numerous scenes from the Old and New Testaments in continuous friezes, the most important subjects emphasized by their larger size and enclosing frames. The figure of Christ is that of a handsome youth, as if He were a hero of some classical myth.

No less strikingly classical is the ivory relief on a diptych from the end of the century in the Bargello in Florence, showing Adam in Paradise surrounded by animals (fig. 24), a subject inspired, no doubt, by some representation of Orpheus. It must be remembered that paganism was still very much alive in that century, and not only during the reactionary reign of Julian the Apostate; and it must be assumed that the same artists had to work for both heathen and Christian patrons. An ivory diptych now divided between Paris (Musée de Cluny) and London (Victoria and Albert Museum; fig. 25), and made toward the end of the century to celebrate a wedding uniting two Roman families, is still entirely classical in form and pagan in spirit, each leaf representing a priestess in front of an altar. No wonder so much Christian art of the fourth century is Christian only in subject matter and not different in any fundamental stylistic aspect from late classical works. But in

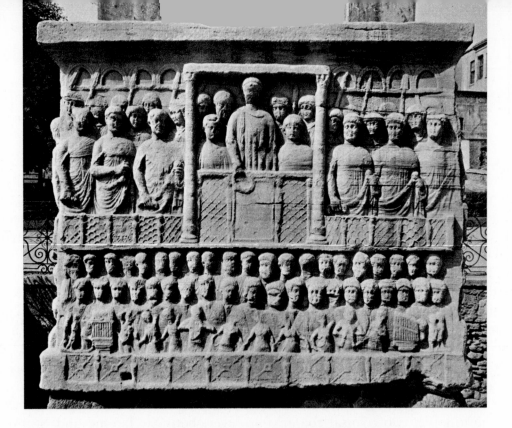

20. *Theodosius and Court Watching Chariot-race.*
Base of Obelisk of Theodosius. c. 390. Constantinople

21. Sarcophagus of the Two Brothers. 44 1/2 × 83 7/8″. 4th century.
Lateran Museum, Rome

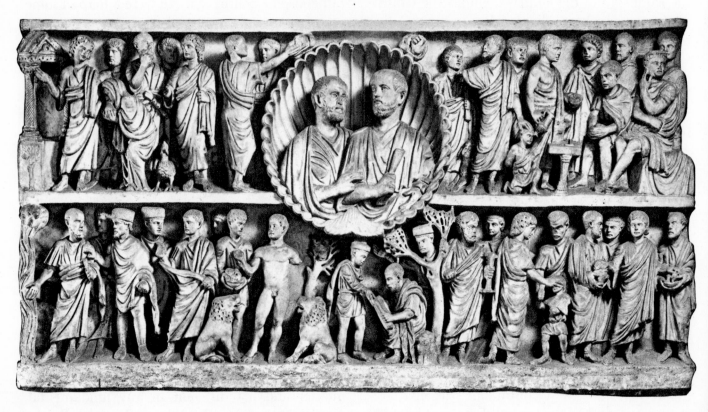

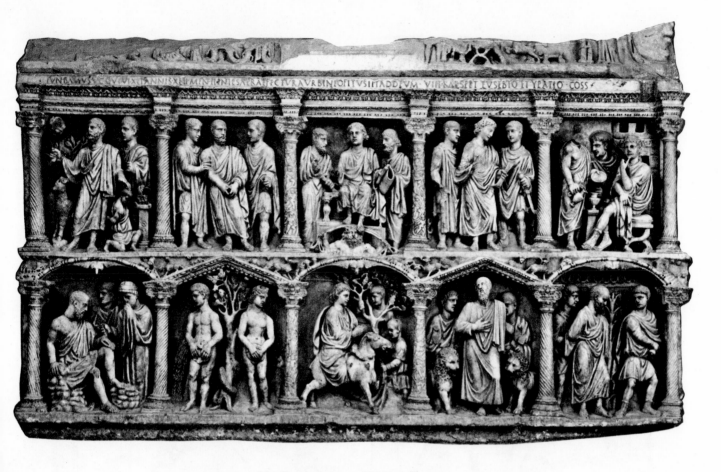

22. Sarcophagus of Junius Bassus.
Length 95 5/8″. After 359. Vatican, Grottoes of St. Peter's, Rome

23. Ivory Casket. Height 8 1/2″.
4th century.
Museo Cristiano, Brescia

many cases Christians had no hesitation at including thoroughly pagan subjects in their work. Mosaics, catacomb paintings, and the reliefs on sarcophagi are full of such subjects, though admittedly they play a secondary role. However, this was not always the case; the late fourth-century silver casket with embossed reliefs found in Rome (now in the British Museum; colorplate 2) demonstrates this admirably. On the front is represented the owner of the casket, Projecta, a bride assisted by her servants; on the back of the lid she is conducted to the house of her bridegroom, Secundus. The lid and sides are filled with nereids, sea monsters, and tritons, while the central figure is a half-nude Venus dressing her hair. Nothing here suggests Christian art. And yet we learn from its inscription that the bride and bridegroom were Christians: SECVNDE ET PROIECTA VIVATIS IN CHRISTO.

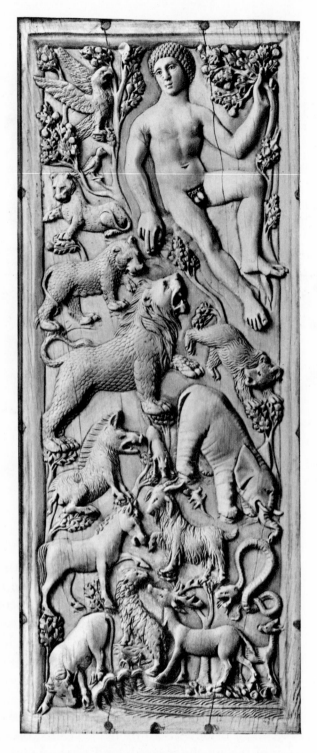

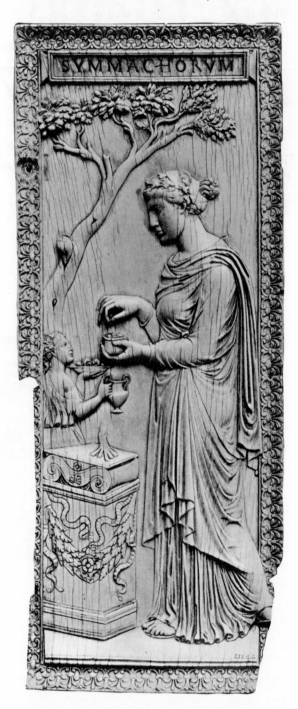

25. *Priestess of Bacchus Before Altar of Jupiter.*
Symmachorum Diptych, right leaf.
Ivory, 11 3/4 × 4 7/8″. Late 4th century.
Victoria and Albert Museum, London

24. *Adam in Paradise.* Ivory diptych, left leaf.
Late 4th century.
Museo Nazionale (Bargello), Florence

III

Art in the
East and West Until the
Eighth Century

The division of the Empire into halves by the emperor Theodosius in 395, to be ruled by his two sons, hastened the decline of the western half. The barbarian menace increased from year to year, and in the course of the fifth century all the provinces, from Africa to Britain, came under that rule. Italy, too, had her share of devastation and indignity.

In 404 Honorius established his capital in Ravenna, and six years later Alaric the Goth plundered Rome and left it in ruins, a feat repeated in 455 by the Vandals who had been preceded a few years earlier by Attila the Hun. By 476 the Western Roman Empire had ceased to exist and Italy was ruled by barbarian kings. Throughout this chaotic period the only stabilizing force was the Church, under the able leadership of such popes as Leo I the Great (440–61), whose jurisdiction was recognized in lands from which the imperial power had disappeared forever.

The Eastern or Byzantine Empire, in spite of barbarian pressure and the turbulence of the period, emerged stronger than ever, and in the time of Justinian (527–65) it reconquered, if only temporarily, parts of Africa, Spain, and Italy. But the Eastern Empire embraced vast lands with different traditions and ethnic backgrounds; in the past it had been kept together only through the prestige and strength of Roman rule, and now it was torn by religious disputes and heresies. Suppression and persecution were rife. The emperors considered that the control and protection of the Church was a part of their duty, and thus Emperor Justinian finally assumed the additional role of head of the Eastern Church.

ARCHITECTURE

In spite of wretched conditions and so much destruction in Italy in the fifth century, its artistic

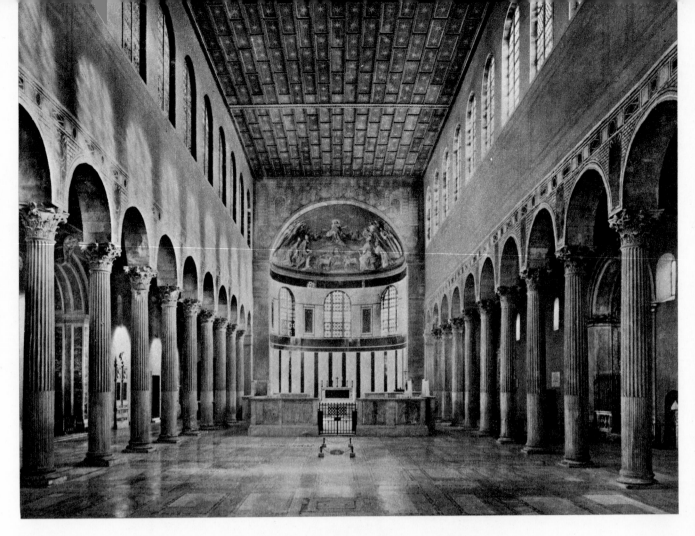

26. Interior of S. Sabina, Rome. 422–32

27. Interior of S. Maria Maggiore, Rome. 432–40

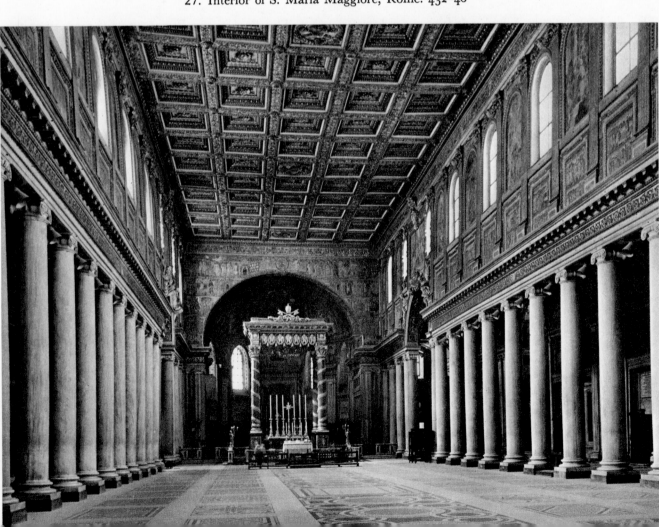

life was full of vitality. A surprising amount of building was carried out in Rome and other imperial cities, such as Milan and Ravenna. A number of large basilican churches were erected in Rome, including S. Sabina (fig. 26) and, above all, S. Maria Maggiore (432–40; fig. 27), which is very striking in its use of classical details. The monumental columns of the nave are crowned with Ionic capitals and carry not an arcade, as was the case with S. Paolo fuori le mura (see fig. 14), but an austere entablature. The walls above it are divided by fluted pilasters, and there are other classical decorative devices.

Of buildings designed on a central plan, two in Rome are outstanding. The Lateran Baptistery, first erected by Constantine, was rebuilt following the original octagonal plan (fig. 28), but columns separating the ambulatory from the central space were introduced to support a dome over the baptismal basin. This elegant baptis-

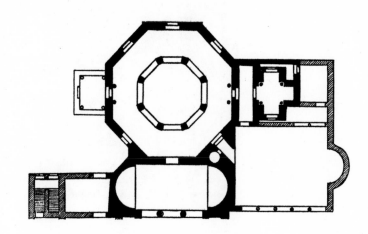

28. Plan of Baptistery,
St. John Lateran, Rome.
As rebuilt 432–40

29. Interior of S. Stefano Rotondo,
Rome. 468–83

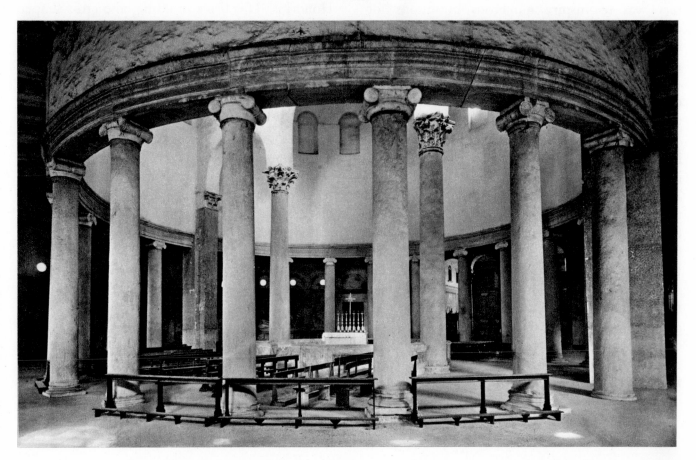

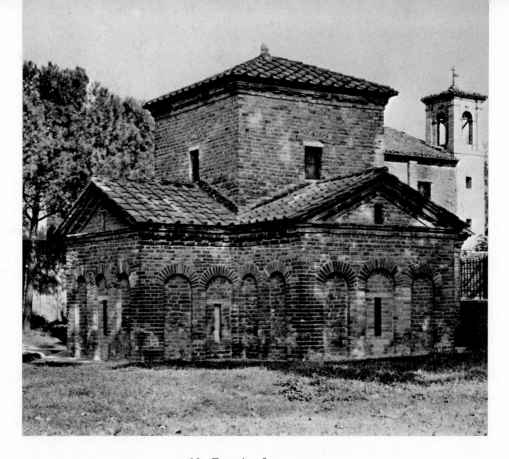

30. Exterior from west,
Mausoleum of Galla Placidia, Ravenna. 425–50

tery was to inspire numerous imitations for many centuries to come. More complex in form is S. Stefano Rotondo, built probably as a martyrium to house the relics of the first martyr (fig. 29). In spite of its name it is not merely a rotunda, but a fusion of a circular form with a Greek cross, a cross having arms of equal length.

Politically, the most important city of Italy in the fifth century was Ravenna, to which the imperial capital was transferred from Milan. Located on the Adriatic coast in proximity to the territories of the Eastern Empire, it emerged from comparative obscurity to become an artistic center of great brilliance. Having no great local traditions, the builders of its churches and palaces followed designs from many quarters. Under the patronage of Galla Placidia (425–50), the cross-shaped church of S. Croce (now largely destroyed) was built in imitation of fourth-century Milanese churches, and to the narthex adjoins a mausoleum (fig. 30) for the sarcophagi of her husband, herself, and her brother, Emperor Honorius. This brick building, also cross-shaped and covered over the crossing by a dome on pendentives, is very plain externally. But the marble paneling and mosaics of the interior are of great richness (see colorplate 5); they start the series of mosaics for which Ravenna is justly famous.

The church of S. Apollinare Nuovo (figs. 31, 32), founded in 490 by Theodoric, king of Ostrogothic Italy and by then established in Ravenna, represents what became a local type: a large brick basilica, with an apse that is round on the inside but polygonal outside, a peculiarity that was to have a long history. The exterior of the building is no longer quite plain, but enriched by flat buttresses and bands which frame the windows. Sant'Apollinare in Classe (consecrated 549; figs. 33, 34) continued this type, with some modifications, into the sixth century. During the time that Ravenna was under the rule of the Arian Ostrogoths, another mausoleum was built, this time for King Theodoric, who died in 526 (fig.

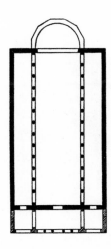

31. Plan of S. Apollinare Nuovo, Ravenna. 490

32. Interior toward east,
S. Apollinare Nuovo, Ravenna
(apse modern reconstruction). 490

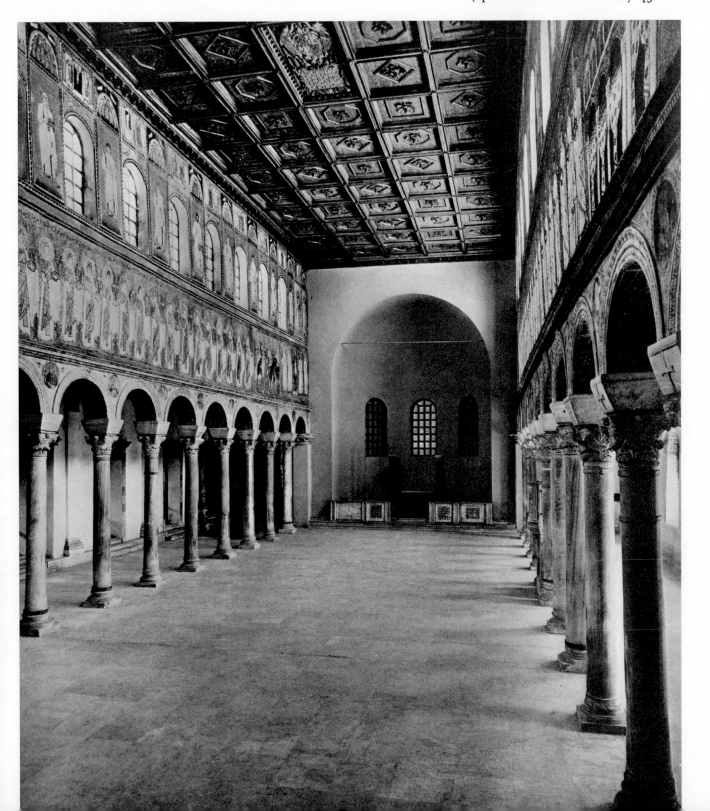

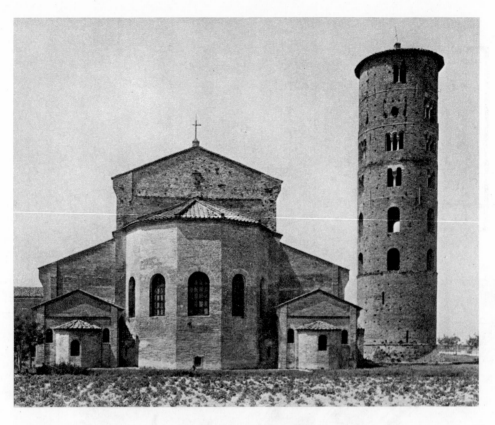

33. Exterior of east end,
S. Apollinare in Classe, near Ravenna. 549

34. Interior toward east,
S. Apollinare in Classe, near Ravenna. 549

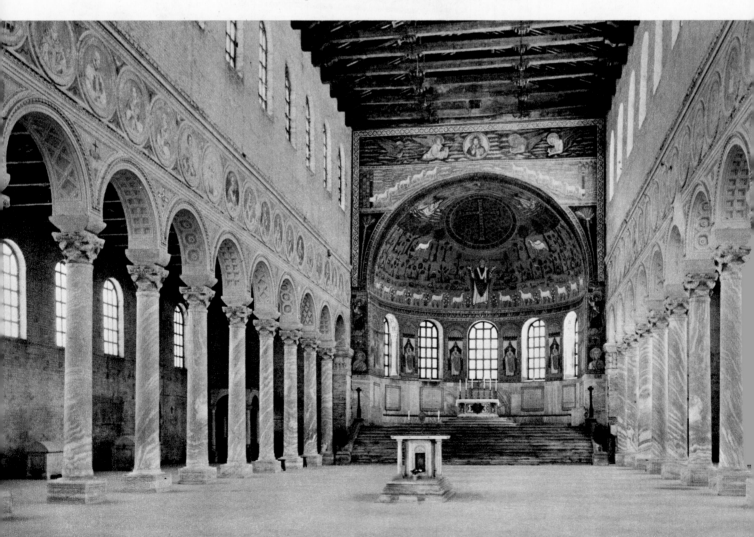

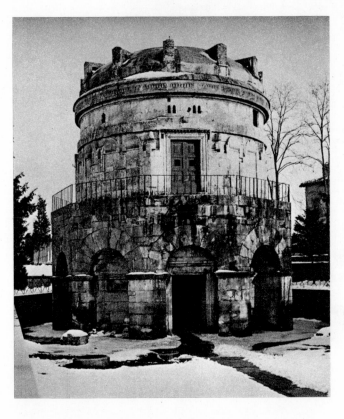

35. Mausoleum of Theodoric, Ravenna. After 526

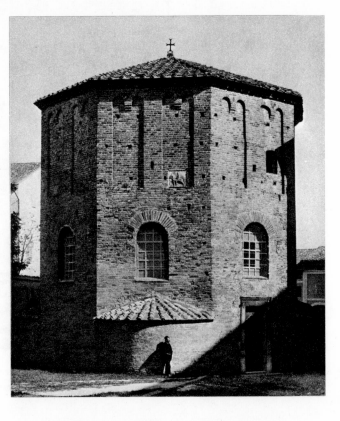

36. Baptistery of the Orthodox, Ravenna.
1st quarter 5th century (see colorplate 8)

35). Brought up in Constantinople as a hostage, Theodoric admired Roman culture and it is not surprising that his tomb is distantly modeled on double-storied Roman imperial tombs. Built of huge ashlar blocks and covered by a monolithic dome, it stands out among the brick buildings of Ravenna as a monument to a barbarian who looked nostalgically for inspiration to the Roman past. In religious buildings erected in Ravenna under his rule, the local building traditions were continued; the Arian Baptistery (c. 500) is derived from the nearby octagonal brick structure, the so-called Orthodox Baptistery (fig. 36), dating from the first quarter of the fifth century.

In comparison with this rather conservative type of building in Italy during the fifth and

early sixth centuries, the richness of the types that were in vogue in the East is truly astonishing and the modifications of the basilican plan very far-reaching. The brick church of the Acheiropoeitos in Salonika (c. 470; fig. 37) had a complex double narthex, incorporating low towers. The wide nave, allocated to the clergy by the Eastern liturgy, was separated from the aisles not only by the normal arcades, but also by barriers and hangings. Additional space was available for the congregation in the upper galleries over the aisles. The church is spacious and well lit, thanks to unusually large windows.

Comparatively little is known of Constantinopolitan churches of the fifth century. The ruined monastic church of St. John Studios (fig. 38), a basilica with galleries enclosing the nave

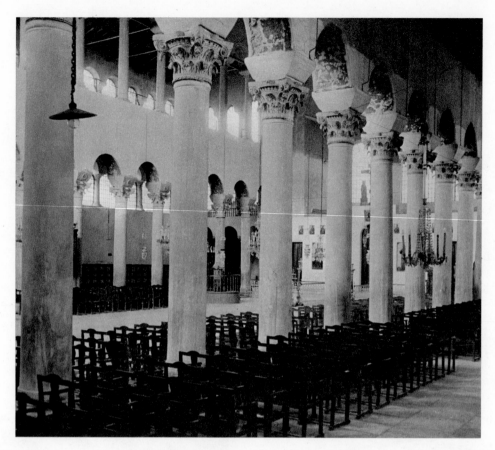

37. Interior of Church of the Acheiropoeitos,
Salonika. c. 470

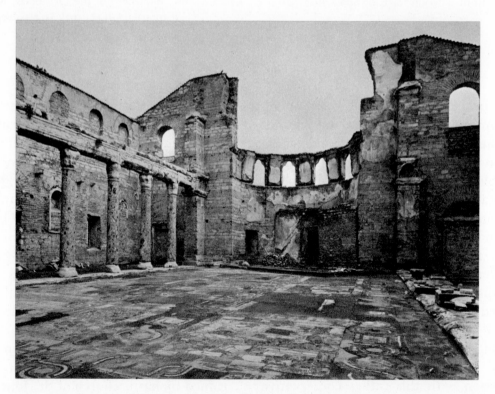

38. Interior of Church of St. John Studios, Constantinople. 5th century

on three sides, and externally a polygonal apse, must have been striking in its use of colored materials. Built of concrète faced with bricks and a few courses of white stone, it was enriched inside by marble slabs and colored columns, contrasting with white bases and capitals.

Of the two huge churches of the fifth century erected in Ephesus, the cathedral of St. Mary was a basilica but the church of St. John had four arms projecting from the central square building (fig. 39).

The Early Christian architecture of Syria evolved several original features. The earlier ashlar churches, rectangular and aisleless, had, by the fifth century, given way to complex, often very large buildings. The pilgrimage church at Qualat-Siman (fig. 40), one of the most striking, was built about 470 to enclose the pillar of St. Simeon Stylites, on which the anchorite spent

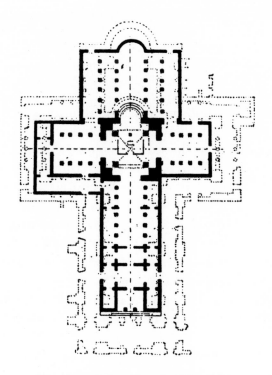

39. Plan of first Church of St. John, Ephesus. c. 450

40. View of pilgrimage church, Qualat-Siman (Syria). c. 470

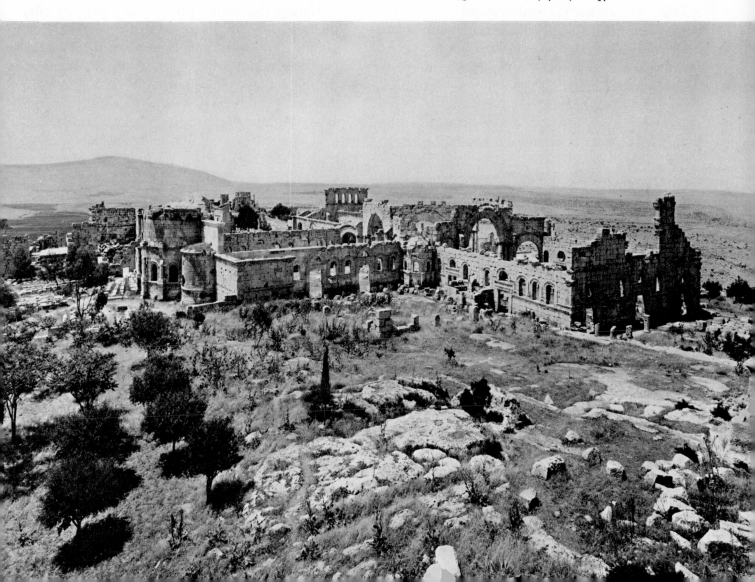

42

many years and on which he died in 459. Like St. John's at Ephesus, it consisted of the central martyrium (in this case octagonal) from which radiate four arms, each a large basilica, two with narthexes. Adjoining this vast church was a veritable town of monastic buildings. The huge blocks of masonry are cut with astonishing precision. There is a wealth of decorative detail, such as string-courses and moldings framing all the doors and windows, and richly carved arches and capitals. The eastern arm ends in three apses of which the central one is the largest, externally articulated by detached columns in two rows, one above the other, and crowned by an arcaded corbel table. These and other details will, as we shall see, reappear in Romanesque architecture.

Another striking feature of certain later Syrian churches was the façade flanked by low towers, between which were deep porches; occasionally there were also towers on either side of the apse. Like the masonry, which shows connections with the Roman practice, numerous details are also derived from classical prototypes, of which there were many in Syria, but there are also obvious links with contemporary architecture in the imperial capital. Nevertheless, Syrian architecture of the fifth and sixth centuries stands out as being most impressive and highly inventive.

Imperial patronage in distant centers facilitated the widespread use of church types that had evolved in the capital. At times the plan and even the materials were sent out, as in the case of the cross-shaped church at Gaza in the Holy Land, built in 401, or the pilgrimage church of St. Menas built a little later at Abu Mina in Egypt. The cult of St. Menas, a local martyr, enjoyed great popularity throughout the Christian world and pilgrimages to his martyrium were associated with miraculous cures by water. The huge church built of ashlar, now in ruins, is a T-shaped basilica with the narrow aisles of the nave continuing on all three sides of both arms of the transept. However, in a few later

basilican buildings in Egypt a highly original design for the east end was used, based on a trefoil form. At Hermopolis, the cathedral (second quarter of the fifth century) has transept arms of semicircular shape, the aisles continuing within them; together with the central apse, the basilica ends in a trilobe. The fortress-like White Monastery at Sohag has no transept, but the chancel, in addition to an eastern apse, has two adjoining ones, placed at right angles (fig. 41). Whether the idea of such a trefoil form was actually invented in Egypt is not certain.

In spite of the great variety in the types of buildings that were in use during the fifth century, from Asia Minor to Spain and from Egypt to Provence and the Balkans, it can be safely said that the prevalent form of church was a basilica (with all its unending variants), while martyria and baptisteries were, *mutatis mutandis*, centralized structures.

During the sixth century, and especially after the beginning of Justinian's rule (527–65), the architectural history of Byzantium parted company with that of the West. While the basilican church remained the normal type in the West throughout all subsequent periods until the end of the Middle Ages, Justinian's Byzantine architects created new church forms, which were to leave their mark on the whole future history of building in the Eastern Empire.

In the riots of 532 (notorious for the slaughter of 30,000 people herded into the Hippodrome by the imperial troops) the Constantinian church of Hagia Sophia was destroyed by fire. Its

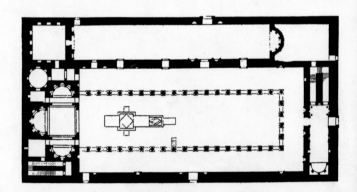

41. Plan of White Monastery (Deir-el-Abiad), Sohag (Egypt). Mid 5th century

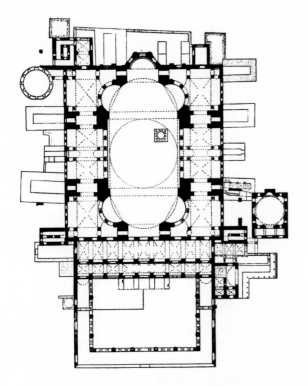

subsequent rebuilding, on an entirely new plan and enormous scale, was an event which, without exaggeration, can be termed a landmark in world architectural history. Justinian entrusted the work to two men, Anthemius of Tralles and Isidorus of Miletus; within five years they completed the structure, and it was dedicated after the Christmas of 537. As in many other cases where ambitious buildings were undertaken for which no precedents existed, technical troubles soon appeared. The first dome of Hagia Sophia crashed down within twenty-one years of its dedication, and was replaced by a higher one.

The novelty of the church lies in its plan and its spatial composition (colorplates 3, 4; figs. 42, 43). The central dome on pendentives rests on four enormous piers extending north and south, and these are pierced by aisles and galleries

42, 43. ANTHEMIUS OF TRALLES and ISIDORUS OF MILETUS.
Plan of Hagia Sophia, Constantinople, 537;
Interior toward apse (see colorplates 3, 4)

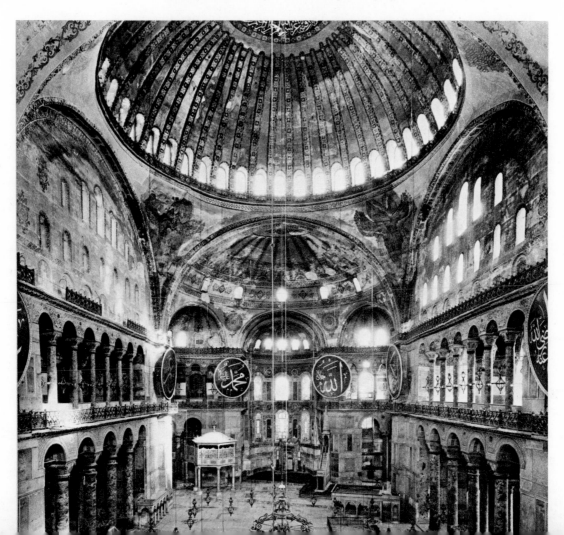

above them. The dome is abutted toward the east and west by lower semidomes, and these, in turn, are extended by still lower exedrae or niches. In the eastern semidome there are three niches, of which the central one acts as an apse; the western semidome has two side niches and in the center, opposite the apse, a rectangular extension toward the narthex and its upper gallery. All the niches, save the apse, are divided into two stories with arcaded colonnades opening toward the church. The south and north walls, below the main dome, are enclosed by enormous arches and have, likewise, two arcaded stories; on the ground floor they open toward the aisles, those on the second floor are galleries. The interior is lit by numerous windows at the base of the dome, as well as in the niches, the apse, the side walls, and the galleries. Thus, seen from inside, the building is a fusion of longitudinal and centralized space, dominated by the huge dome and harmoniously enclosed by curving surfaces of gradually smaller dimensions.

The numerous colonnades and windows extend the space in mysterious and ambiguous directions. The awe-inspiring effect is particularly strong when the church is viewed from the aisles; these were allocated to the congregation, while the central space was reserved for the clergy and the emperor.

The mosaics of the dome, the multi-colored columns, the marble slabs of the walls and pavement, the sculpture lavished on the capitals—all these added to the impression of luxuriant richness inside. Externally (fig. 44), the church appears as an overwhelming massive dome, resting on tower-like piers and descending downward and outward, toward east and west, by way of subsidiary semidomes. The whole complex was within a vast rectangle, the limits of which are now marked by four Turkish minarets. Technically, Hagia Sophia is daring, and aesthetically, highly original and beautiful.

Two buildings are in some ways related to it, one also in Constantinople, the other in Raven-

44. ANTHEMIUS OF TRALLES and ISIDORUS OF MILETUS.
Exterior from southwest, Hagia Sophia, Constantinople. 537

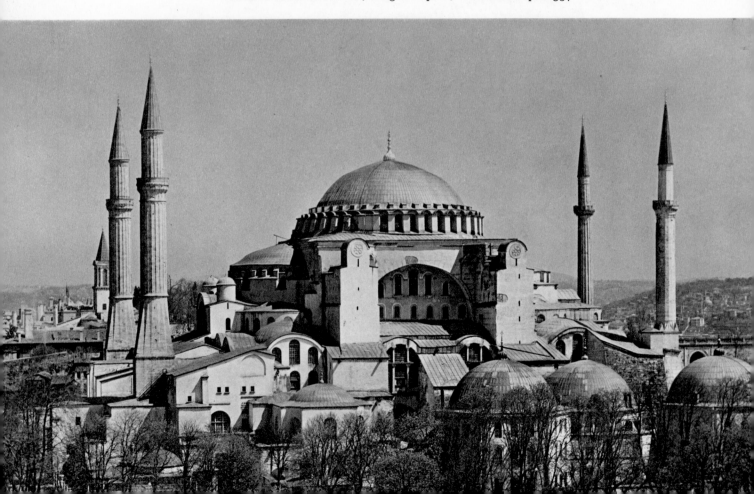

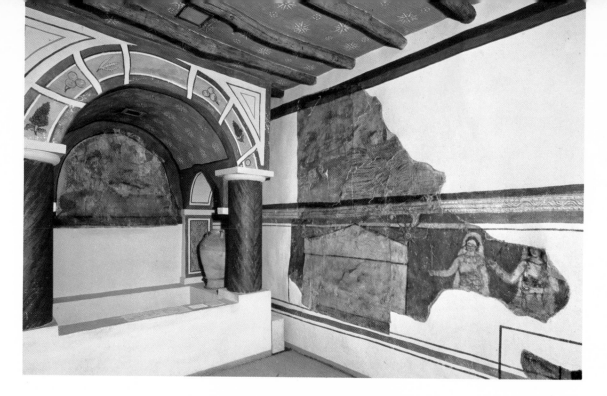

Colorplate 1. *Three Marys at the Sepulcher* (right); *Good Shepherd* (in lunette).
Wall painting from Baptistery, Dura-Europos. 231.
Yale University Art Gallery, New Haven

Colorplate 2. Casket of Secundus and Projecta.
Silver, partly gilded; height 11″. Late 4th century.
British Museum, London

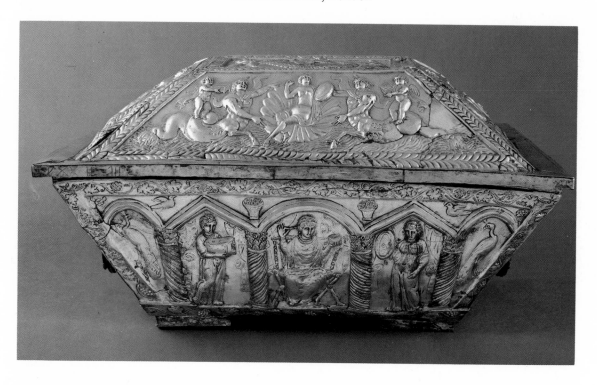

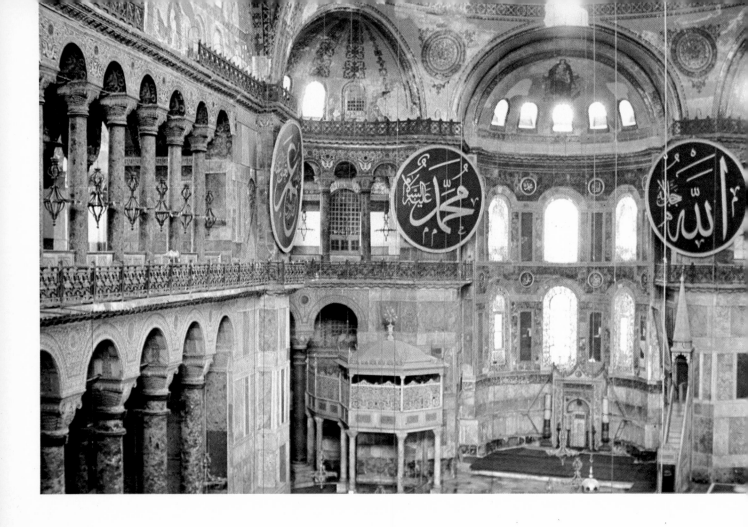

Colorplates 3, 4. ANTHEMIUS OF TRALLES and ISIDORUS OF MILETUS.
Two views of interior toward east, Hagia Sophia, Constantinople. 537

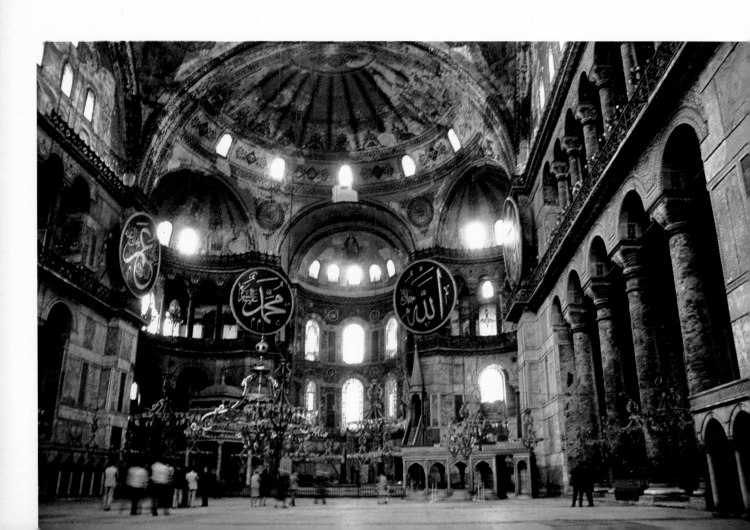

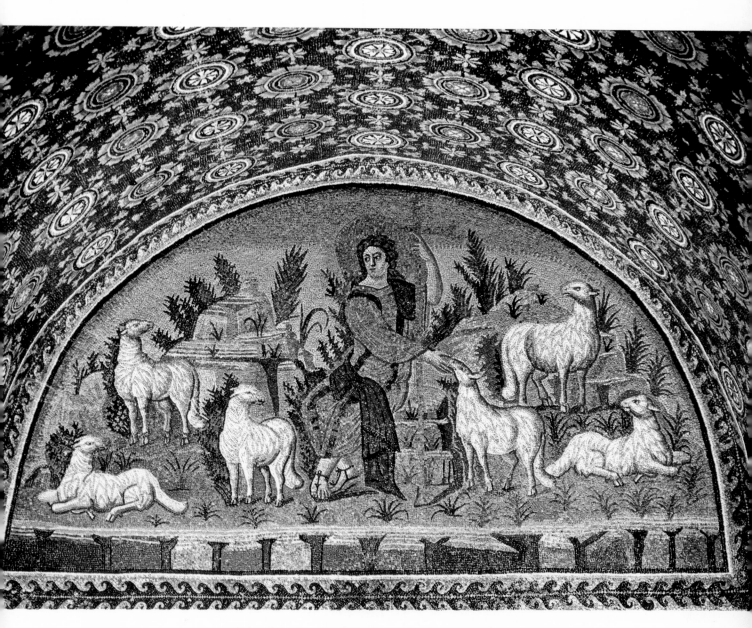

Colorplate 5. *Good Shepherd*. Mosaic. 425–50.
Mausoleum of Galla Placidia, Ravenna

Colorplate 6. ▶
Empress Theodora and Her Court (detail).
Mosaic in chancel. 548. San Vitale, Ravenna

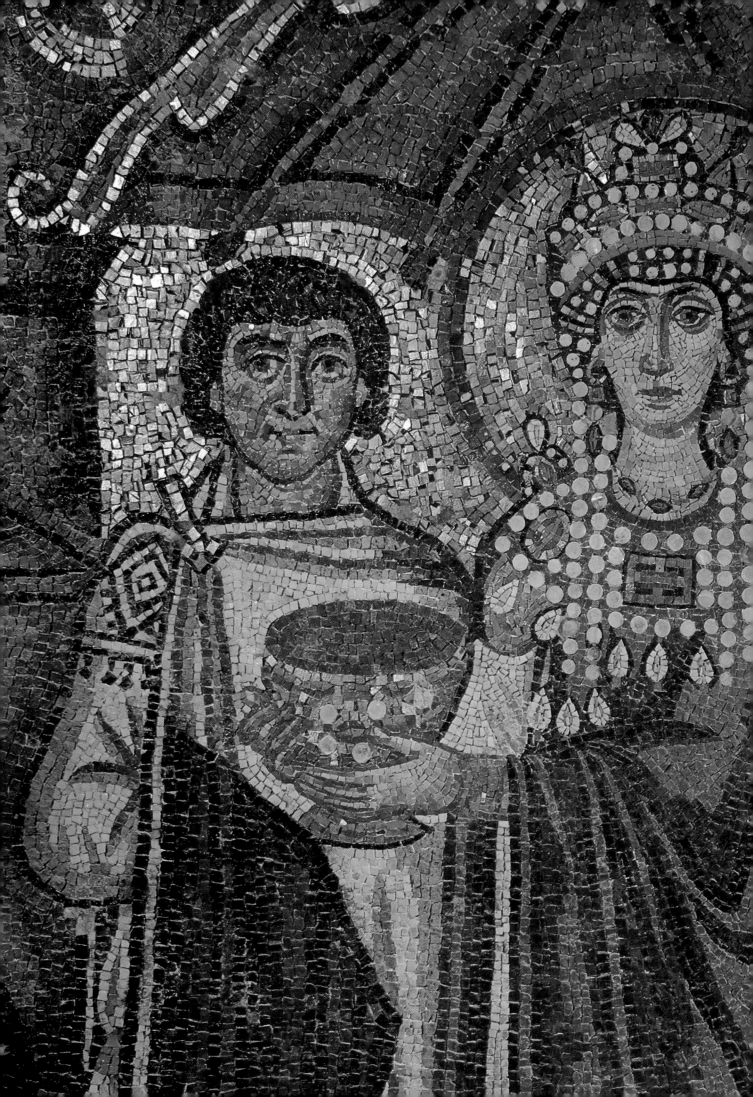

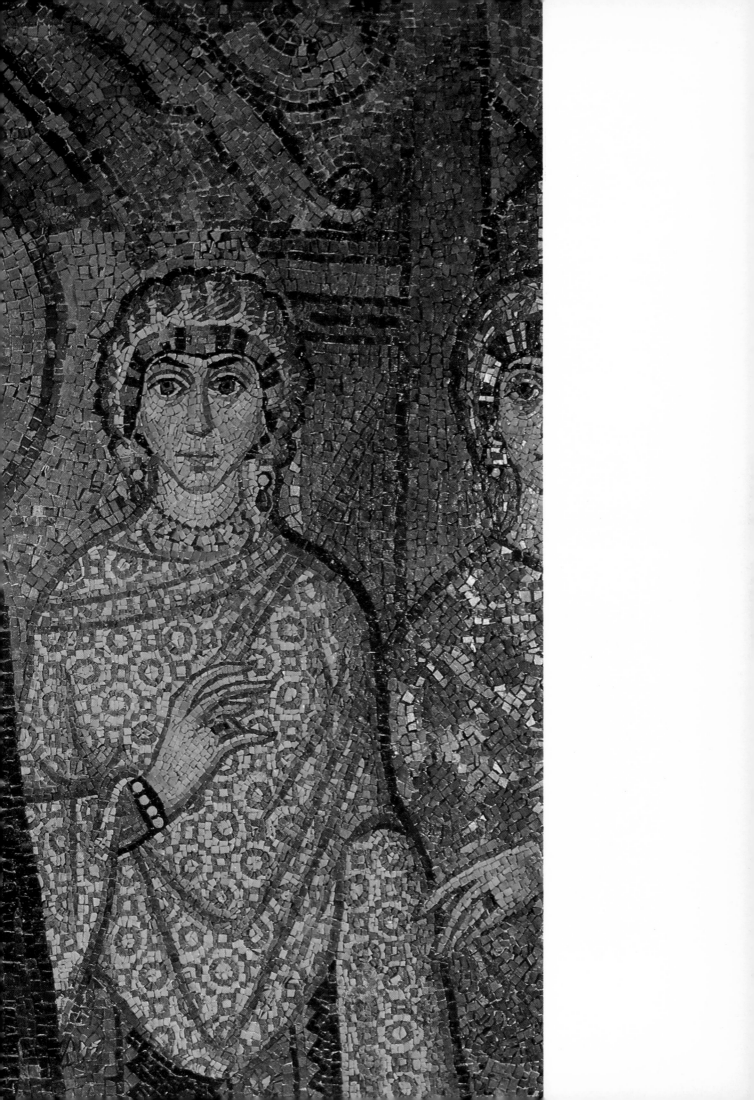

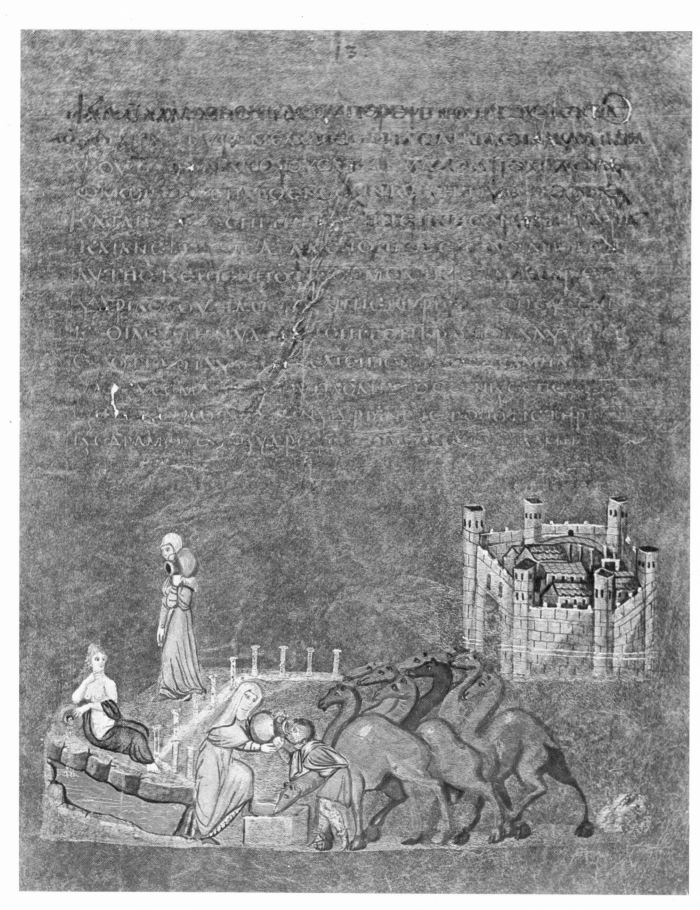

Colorplate 7. Page with *Rebecca and Eliezer at the Well*.
Vienna Genesis. 11 3/4 × 9 7/8″. 6th century.
National Library (Cod. theol. gr. 31, fol. 13), Vienna

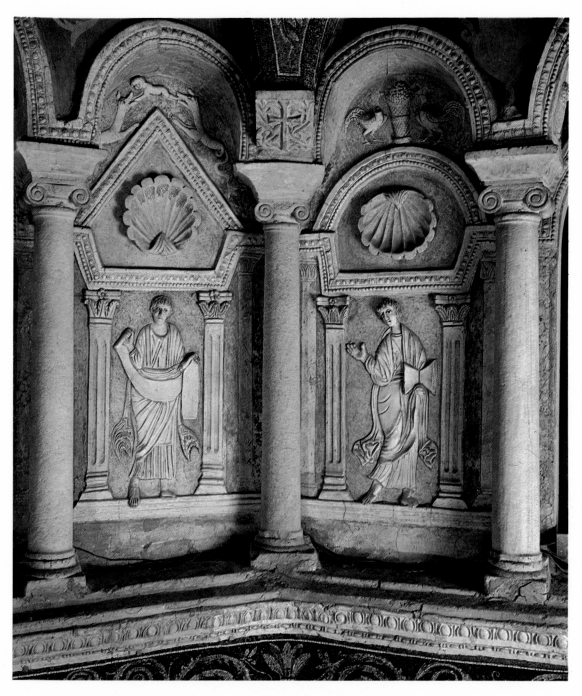

Colorplate 8. *Prophets*. Stucco, painted. 3rd quarter 5th century.
Baptistery of the Orthodox, Ravenna

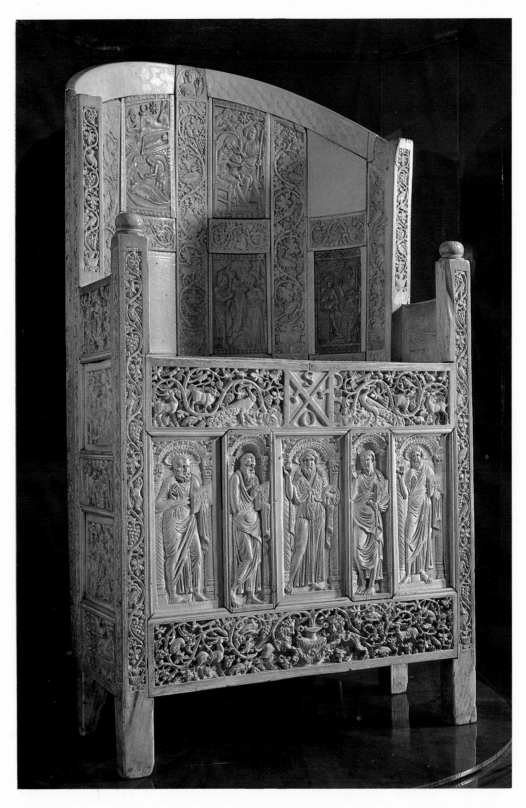

Colorplate 9. Throne of Maximian.
Ivory over wood; height 4' 11". 545-53.
Museo Arcivescovile, Ravenna

na. The Constantinopolitan church is that of Hagios Sergios and Bacchos, built by Justinian early in his reign and thus probably prior to Hagia Sophia. It is a miniature and simplified version of Hagia Sophia, built on an octagonal plan within a rectangle. The other is the church of S. Vitale at Ravenna (figs. 45–48), begun when the city was still the capital of the Ostrogothic kingdom and finished in 548, eight years after Ravenna was conquered by Justinian. The inspiration was doubtlessly Constantinopolitan, for the church has numerous similarities with that of Hagios Sergios and Bacchos, though the technique is western. It is a domed octagon with seven slender niches and a chancel ending in a polygonal apse. The dome rests on squinches. The niches have triple arcades, opening at ground level into an octagonal ambulatory and, at the second level, into galleries. The spatial composition is thus closely related to the near-contemporary imperial foundations at Constantinople, but there are also differences. The church is built entirely of brick, not of the brick, mortar, and ashlar of the other two. The dome on squinches at S. Vitale is constructed of terracotta tubes, while in Constantinople the domes were made of bricks. The exterior of S. Vitale is simple and clear; no molding of any kind is employed, just plain walls and buttresses. Its interior is lavishly decorated with marble, mosaics, and sculpture (see pages 57–61).

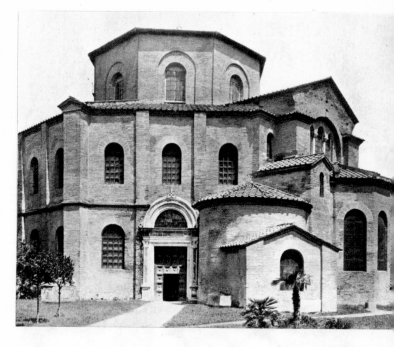

46. Exterior of S. Vitale, Ravenna. 548

47. Interior toward apse, S. Vitale, Ravenna. 548

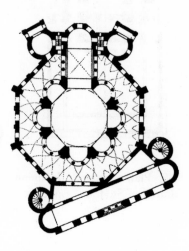

45. Plan of S. Vitale, Ravenna. 548

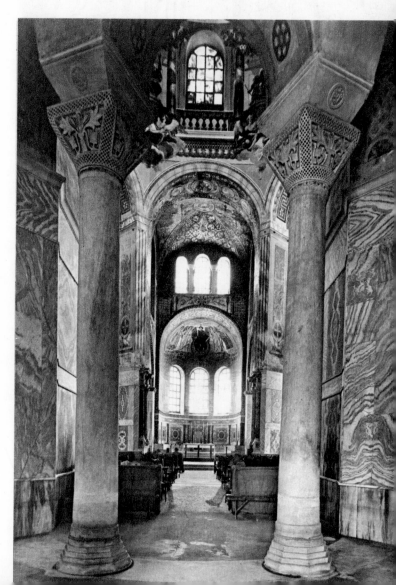

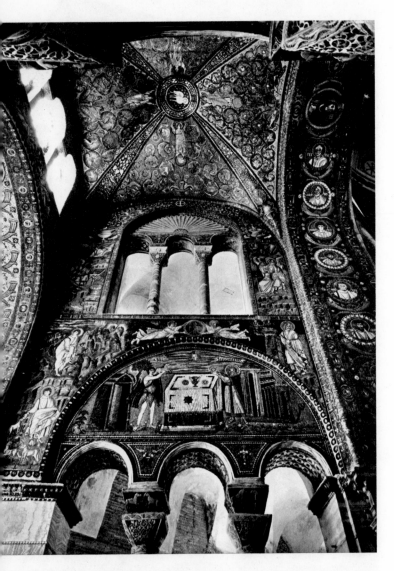

48. Chancel wall including mosaic lunette
of *Abel and Melchizedek*. 548.
San Vitale, Ravenna

However, Byzantine architecture in the future did not follow the example of these three remarkable churches, but settled for a more sober building style. Justinian himself caused two older churches to be rebuilt, one, the Constantinian Holy Apostles in the capital, the other, St. John at Ephesus (fig. 49; see fig. 39). The first is known from descriptions and from derivations of it such as St. Mark's in Venice; the other is a

ruin. Both were cruciform in shape, with domes over the crossing and over all the arms. The Holy Apostles was built on the Greek-cross plan and had five domes; the nave of St. John is longer than the transepts and chancel, and, in addition to four domes over the eastern part, it has two domes of elliptical shape over the nave. The domes rest on pendentives and in both churches, there are aisles and galleries. These so-called domed basilicas became almost the standard type throughout the Empire and lent themselves to endless variations.

Until the beginning of the fifth century the city of Constantinople was defended by the fortifications erected by Constantine. The town had increased in population and wealth, but was, at the same time, exposed to the danger of attack by the barbarians. The plunder of Rome

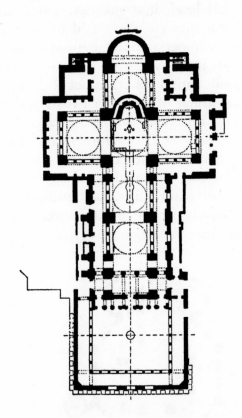

49. Plan of second (Justinian)
Church of St. John, Ephesus. 565

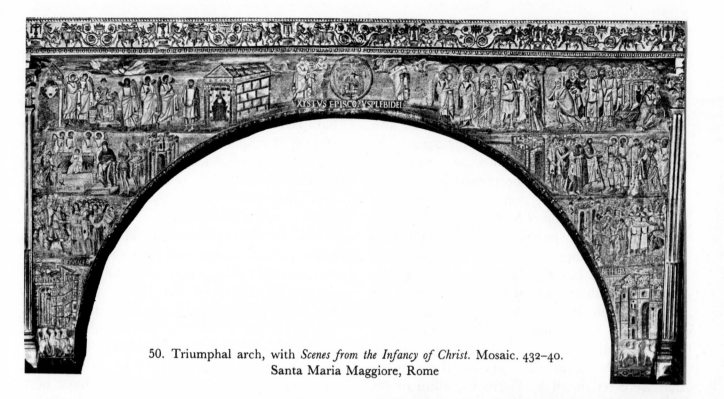

50. Triumphal arch, with *Scenes from the Infancy of Christ*. Mosaic. 432–40.
Santa Maria Maggiore, Rome

by the Goths in 410 must have influenced the
decision to attempt to avoid a similar fate over-
taking Constantinople. Accordingly, in 413,
during the minority of Theodosius II, the regent
Anthemius started the construction of new de-
fenses, some distance outside Constantine's
walls. The walls of Theodosius are four and one-
half miles long, starting from the Sea of Mar-
mara, incorporating the Golden Gate built by
Theodosius I, and ending at the Golden Horn.
The fortifications are thirty feet high and six-
teen feet thick; they are reinforced by ninety-six
towers, mainly square, but some polygonal; in
front was a moat sixty feet wide. The long coast-
line was also fortified by a wall having 188 tow-
ers, and finished in 439.

These colossal defenses, of which a great deal
still survives, proved impregnable for over a
thousand years, until 1453. They are one of the
most remarkable achievements of military archi-
tecture of all ages.

MOSAICS, WALL PAINTINGS, AND MANUSCRIPTS

The custom of decorating interiors of churches
with mosaics and paintings, initiated in the Con-

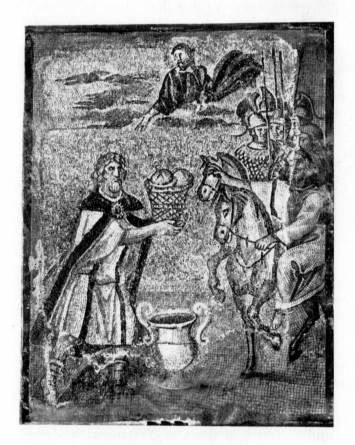

51. *Sacrifice of Melchizedek*.
Mosaic on nave wall. 432–40.
Santa Maria Maggiore, Rome

stantinian period, continued and expanded both in the West and the East during the fifth and sixth centuries. Rome retained for some time its leading position, though many important schemes, known to have been carried out, have been lost. Fortunately, something is known of the mosaic decoration of S. Paolo fuori le mura, made during the papacy of Leo I (440–61), thanks to paintings and watercolor copies from before the fire (see fig. 14). The mosaic of the triumphal arch has been restored, and shows the apocalyptic vision with the Twenty-four Elders (Rev. 4:10) worshiping Christ, and the saints who, according to copies, were represented in the apse. Down the nave were wall paintings, that were repainted by Pietro Cavallini in the thirteenth century; it is likely that he retained the original program of Old Testament scenes on the one side and scenes from the life of St. Paul, to whom the church was dedicated, on the other.

The most important decorative mosaic scheme still surviving in Rome is in S. Maria Maggiore, due to Pope Sixtus III (432–40; see fig. 27). It reflects the triumph of the Church and of the Virgin, who had only recently been proclaimed *Theotokos*, the Mother of God, at the Council of Ephesus (431). The original mosaic of the apse is lost, but those of the arch survive and represent events from the infancy of Christ as told in the apocryphal Gospel of Pseudo-Matthew (fig. 50). The decorative scheme, though religious, is based on imperial triumphal monuments, such as the base of the Column of Arcadius in Constantinople (see page 29), but the triumph of the emperor over the barbarians is replaced by the triumph of Christ over unbelievers and paganism. Triumphal themes are also found on the nave walls. There, the scenes narrate the life and victories of the Old Testament leaders— Abraham, Jacob, Moses, and Joshua—who were regarded as prefigurations of Christ, while some scenes also prefigure events of the New Testament. Thus, the scene nearest the altar shows

Melchizedek offering bread and wine to Abraham (Gen. 14; fig. 51), who is represented as a victorious emperor on horseback, thus continuing the triumphal idea of the arch. Moreover, the event is frequently referred to as a prefiguration of the Eucharist, as by St. Ambrose in his sermon on the sacraments.

Not every scene from the Old Testament was related to one in the New, but the whole series was regarded as a prefiguration. The typological association of the Old and New Testaments was frequently stressed by the early Fathers. In S. Maria Maggiore, the New Testament scenes are not included but they are alluded to by association. For instance, the scene of Moses Teaching, not recorded in the Bible, seems to have been specifically made up as an antetype of Christ Teaching in the Temple. The forty-four scenes on the nave walls were probably based on early Biblical illustrations in manuscripts, but our knowledge of these is very limited. Stylistically, the mosaics of S. Maria Maggiore show an interesting transition from the antique, as represented by paintings in the catacombs, to the medieval. The scenes are set in landscape or against architectural backgrounds, but the figures are unproportionally big for their setting. Moreover, the space is severely curtailed by the strip of gold which replaces the middle distance.

No paintings of a pre-Justinian date survive in Constantinople but, fortunately, some mosaics in Salonika give an idea of early painting in the Eastern Empire. The earliest are the mosaics in the dome of Hagios Georgios (a palace chapel converted from the mausoleum of Galerius), representing heaven, presided over by Christ who is surrounded by saints. The quality of these mosaics is very fine indeed, and the treatment of the figures combines simplicity of design with serene facial expressions. This style clearly has deep roots in the idealism of classical Greek art, and differs considerably from the expressive painting in Italy that reflects the realism of late Roman art.

Somewhat later (mid fifth century; fig. 52) is the mosaic in the apse of Hosios David, also in Salonika, showing a youthful Christ seated on a rainbow within a mandorla, the symbol of glory, surrounded by the symbols of the Evangelists and two prophets. The scene seems to represent the vision of the coming of Christ.

This mosaic is related to those which decorate the small mausoleum of Galla Placidia in Ravenna (colorplate 5; fig. 30), thus underlining the fact that despite the division of the Empire under Theodosius, the art in both halves had close and numerous contacts. The scene most resembling the *Christ in Glory* in Hosios David at Salonika is the *Good Shepherd* above the entrance to the mausoleum. In both cases the figures and landscapes are similar, but in Ravenna the setting is less atmospheric and the firmer lines make it appear more clear-cut.

The mosaics for which Ravenna is famous reflect to some extent the turbulent history of the city. The decoration of S. Apollinare Nuovo, built for Arian use by Theodoric and converted to the Orthodox cult in the middle of the sixth century, has mosaics which were commissioned by Theodoric but redesigned by Bishop Agnellus (556–65). The mosaics of the nave are arranged in three registers, and include processions of male and female saints proceeding from the palace of Ravenna on the one side, and from the port of Classe on the other, toward the Virgin and Christ who flank the apse (figs. 53, 54). Originally figures of Theodoric and his court were included, but they were removed by Agnellus. Placed against a green ground and a golden sky, isolated from each other by symbolic palms resembling arcades, the saints are motionless and stereotyped without individual features. Nevertheless, they produce a fine decorative, rhythmic effect.

The Christological scenes in the zone above the windows are divided between the two sides of the nave; one group illustrates the ministry, the other the Passion of Christ. The figures are stocky, with emphatic gestures, and are related to those in S. Maria Maggiore but they are flatter and more defined by outlines than by modeling. Moreover, the figures are represented on the first plane against a gold background and thus there is hardly any recession in depth.

As we have seen, the interior of the church of S. Vitale, consecrated in 547, was embellished with marble panels, and mosaics were restricted to the chancel (figs. 55, 56). In the apse, Christ is seated on a globe, between angels and saints. His function is twofold: first of all, He is there as the focal point of the church, receiving the homage and offerings of Justinian and his wife Theodora with their court, and including the archbishop of Ravenna, Maximian, who are represented on the walls of the chancel (colorplate 6; figs. 57, 58). In contrast to the parallel processions in S. Apollinare Nuovo, the design here is more vigorous and the figures have more vitality and individuality; in fact, the heads of Justinian and Maximian seem to be portraits.

The second function of the enthroned Christ is more symbolic. The two principal narrative scenes in the chancel are antetypes of the Eucharist. In one, Abel and Melchizedek are offering the lamb and the bread at the altar (fig. 59);

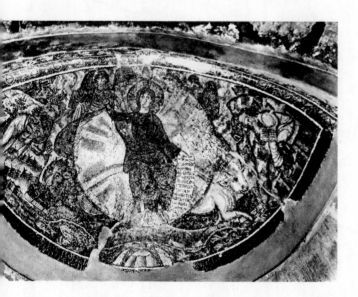

52. *Christ in Glory*. Apse mosaic.
Mid 5th century. Hosios David, Salonika

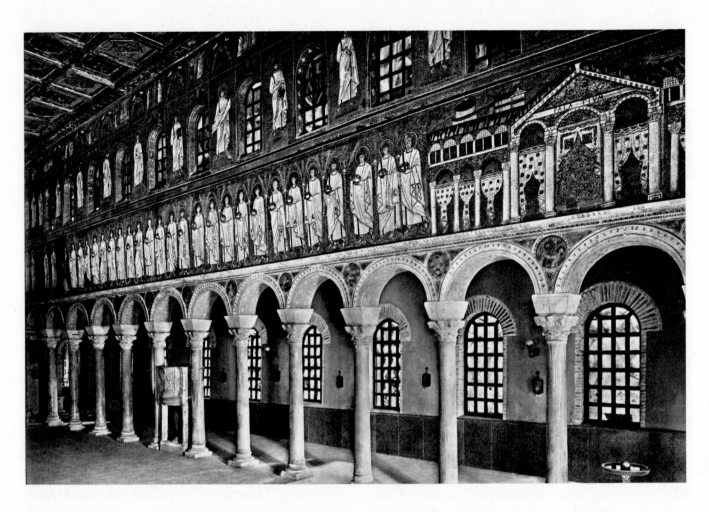

53, 54. Mosaic decoration on nave walls. 556–65.
Sant'Apollinare Nuovo, Ravenna.
Male saints on south wall (*above*);
female saints on north wall (*below*)

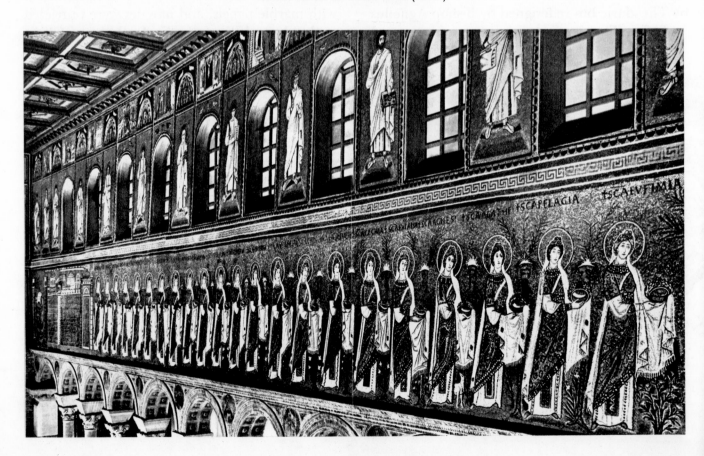

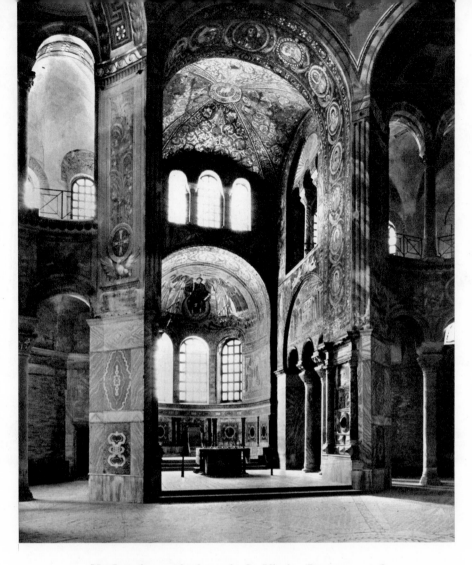

55. Interior and chancel, S. Vitale, Ravenna. 548

56. *Christ in Glory*. Apse mosaic. 548.
San Vitale, Ravenna

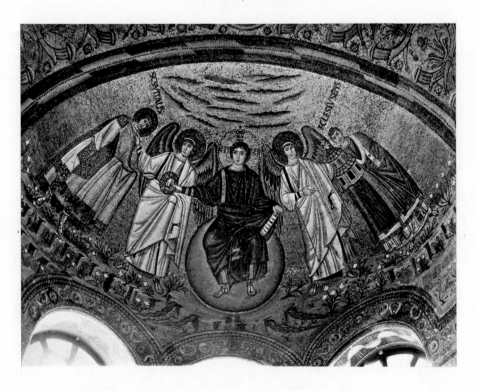

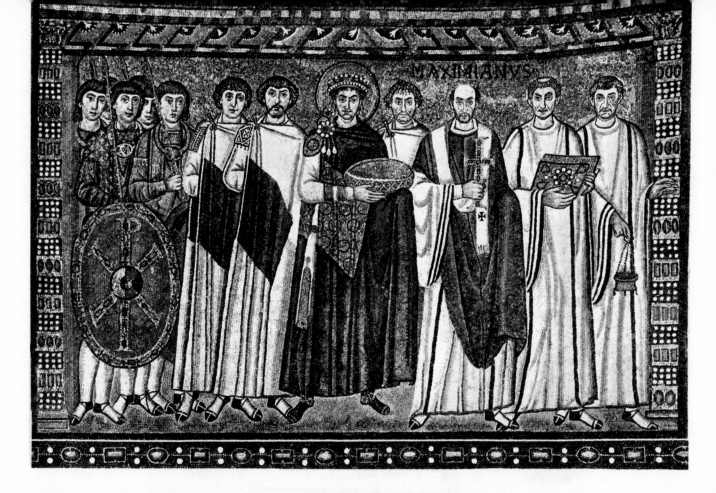

57. *Emperor Justinian and His Court.*
Mosaic in chancel. 548. San Vitale, Ravenna

58. *Empress Theodora and Her Court.*
Mosaic in chancel. 548. San Vitale, Ravenna
(see colorplate 6)

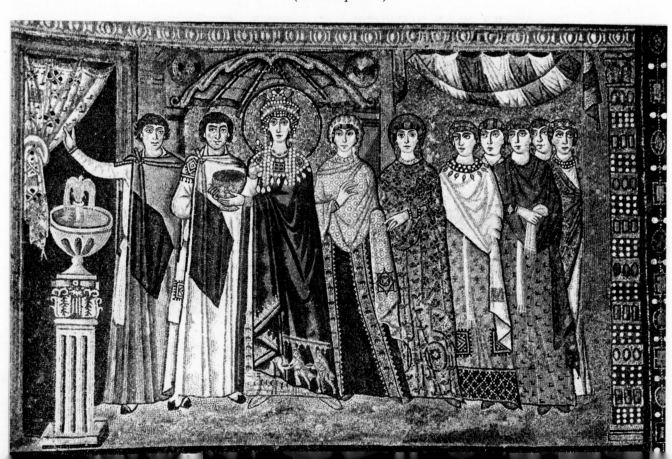

in the other, Abraham is offering a calf to three angels, and he is then shown about to sacrifice Isaac. Saint Ambrose, writing about the sacraments, said "We pray that by the hand of the angels thou wilt receive this offering upon thy heavenly altar as thou didst receive the gifts of thy servant Abel the Just, and the sacrifice of Abraham our father, and that which the high priest Melchizedek offered to thee." Christ in the apse of S. Vitale is, so to speak, receiving these gifts.

The extensive cycle of mosaics in S. Vitale has no contemporary parallels, but the apse mosaics of the basilica of St. Catherine on Mount Sinai suggest that there were other ambitious works at that time. These represent two scenes,

Moses before the burning bush and Moses receiving the tables of the Law, and they date from the time of Justinian. The fragmentary remains of Justinian's mosaic decoration of Hagia Sophia (the vault of the southwest ramp room) are of exquisite quality but are confined to purely ornamental devices. In the excavations on the site of the Great Palace in Constantinople extensive mosaic pavements came to light which date, in all probability, from the third quarter of the sixth century (fig. 6o). The Romans had excelled in this type of floor decoration and the palace pavements are directly descended from Roman work. They consist of secular scenes, such as work in the fields, games, hunting, fighting animals, and monsters, as well

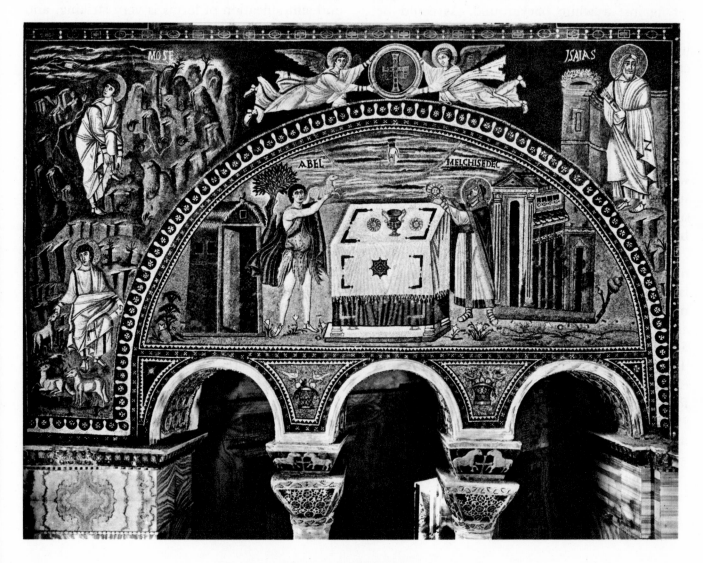

59. *Abel and Melchizedek.* Mosaic in chancel. 548.
San Vitale, Ravenna

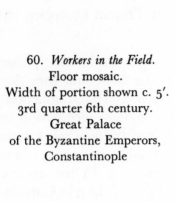

60. *Workers in the Field.*
Floor mosaic.
Width of portion shown c. 5'.
3rd quarter 6th century.
Great Palace
of the Byzantine Emperors,
Constantinople

as rich scrolls of vegetation, all in lively colors set against a white background. As could be expected, the quality of these mosaic pavements in the Great Palace was of the highest. Occasionally, in provincial centers, such pavements were made by lesser craftsmen and the resulting products border on folk-art quality. Very extensive discoveries in the field of floor mosaics were made in the Syrian capital of Antioch, where they were used in private dwellings as well as public buildings, and where the variety of styles and quality is very great. They include subjects from everyday life, street scenes, and buildings.

Since mosaics are infinitely more durable than frescoes or other techniques of wall painting, it is not surprising that our knowledge of monumental painting during the period is based principally on mosaics. But this does not mean that all the frescoes of this period have perished. There are still numerous fragments in Italy and elsewhere, and the most extensive series are found in Egypt, in monastic chapels at Bawit (fig. 61) and Saqqara. These Coptic paintings are pale reflections of the art of the big centers, and they are difficult to date. A large number are presumably of the sixth century, and some might be even later than the Arab conquest of Egypt

(640). In them the austere linear figure style and simplification of forms is very striking, and reflects, no doubt, the hostile attitude of the monks toward classical traditions.

This period also saw the development of panel painting for cult purposes, though very few examples survive. Such icons on wood adorned churches and were also suitable, because of their smaller size and low cost, for private worship. The most remarkable series of early icons survives in St. Catherine's Monastery on Mount Sinai. One panel is dated by Weitzmann to the sixth century and represents the Virgin between two military saints, Theodore and George;* another, with the half-figure of St. Peter, is attributed to the seventh century.

More numerous are the surviving examples of another technique of painting, namely, manuscript illuminations. Although an enormous amount of manuscripts must have perished, a fair number were preserved in church treasuries and in the seclusion of libraries.

By the time Christianity came into the open, there had occurred a dramatic change in the format of written texts; the earlier rolls of pa-

* K. Weitzmann and others, *A Treasury of Icons: Sixth to Seventeenth Centuries*, New York, 1967, p. x.

pyrus had been replaced by the more convenient and durable *codex* of parchment pages bound together between hard protective covers. Rolls continued to be made for special purposes (e.g., obituary rolls) throughout the Middle Ages, but they too were now made of strips of parchment stitched together. The book format naturally influenced the illustrations. The previous method of continuous narrative, suitable for rolls, did not disappear altogether, but single illustrations were more appropriate to the codex. In the early books, however, the two methods were often mixed.

The type of book that was produced most frequently was, of course, of a religious character, especially the Bible and the Gospels, but interest in classical authors and the scientific works of antiquity did not disappear overnight and, in fact, some of the earliest surviving books

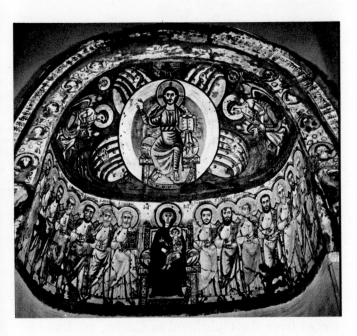

61. *Christ in Glory* (*above*);
Virgin and Child with Apostles (*below*).
Wall painting from chapel at Monastery of Apollo,
Bawit. 6th–7th century.
Coptic Museum, Cairo

of the Christian era are copies of non-Christian works. The famous Vatican Virgil (fig. 62), from the early fifth century, was probably copied in Rome and, in its style, is related to the mosaics in S. Maria Maggiore. As in these mosaics, the figures are on the front plane and the background is piled up behind them. The figures are solid and sometimes rather awkward and stiff, outlined by firm, broad contours.

The illustrations were copied, like the text, from earlier examples, but it must be assumed that, in the process, many modifications were made in the subject matter and in the original style. The page with the picture of Laocoön, for instance, shows within one frame three successive events in the story of this Trojan priest: on the left, he is about to sacrifice a bull in front of the temple of Apollo; above, two snakes are seen swimming toward the Trojan coast; on the right, he and his two sons are being strangled by the snakes. The striking difference in scale between the two representations of Laocoön suggests that they derive from different models; and since the last scene disagrees with Virgil's text, which says that the sons were killed first, it must be assumed that this group was inserted at some time into the original set of pictures. Similar insertions can be found in other miniatures, and thus it appears that the cycle was based on a nucleus of early scenes that had been continuously adapted and enlarged, with new details incorporated in accordance with the changing ideas of the times.

The Vatican Virgil still belongs to the tradition of classical book illustration; its importance for the development of medieval painting lies in the fact that such manuscripts were copied during the Middle Ages and in this way elements of classical artistic ideas were transmitted and adapted.

The other early fifth-century manuscript that survives from Rome is the fragment of a Bible, now in Berlin (State Lib. Ms. theol. lat. 485), known as the Quedlinburg Itala fragment.

CONIVCIANSIERIAMIIIAIITIEALOPHAICLISOUIIIVIOACIA
SINMANIBVSIVISTRISVISTAMASCINDISSITIINVRBIEM
VLTROMSIMAMAGNOIIIOIIAADMOIIMIABIIIO
VINTVRAMHINOSIAOSIAIAIAMAMIRIMIIIOIIS
TALIBVSIINSIDIISPIRIVRIIIIO ARIESINONIS
CREDITARESCAPIIO DOLISLACRIMISOMICONCIIS
OUOSNIOUIITI DIDIISNICCIARISIVSACHILIIS
NONANNII DOMVIRI DICIAINONMIIIIMICARINAI

62. *Laocoön*. Vatican Virgil. Early 5th century. Illumination 4 × 6 1/2″.
Vatican Library (Ms. lat. 3225, fol. 18v), Rome

This is the earliest known illustrated Bible, and probably had few precursors; consequently the artist relied on stock types, similar to those found in the Virgil. That he had no exact model on which he could base his pictures is proved by the instructions to guide him, written beneath the paint of the pictures; these instructions were covered by the opaque colors of the miniatures, and were revealed only because the paint flaked off.

The only illustrated manuscript of the New Testament in Latin to survive from this period is the copy of the Gospels in Corpus Christi College, Cambridge; it is known as the Gospels of St. Augustine, since it is likely that it was brought to England in 597 by St. Augustine, the first archbishop of Canterbury, a missionary from Pope Gregory the Great. Only two full-page miniatures survive: one shows a portrait of St. Luke with twelve scenes illustrating episodes from his Gospel (fig. 63); the other is divided into twelve compartments showing most of the story of Christ's Passion, from the Entry into Jerusalem to the Carrying of the Cross. The first page includes events not found in the Gospel of St. Luke, although it adjoins the preface to his Gospel. A surprising omission is the scenes from the childhood of Christ, for Luke is the only Evangelist to relate the birth of Christ in detail. Perhaps such scenes were placed at the beginning of the book, close to the portrait of Matthew, now missing.

The great problem for the illustrators of the New Testament was the repetition of events in all four books. The special arrangement in the Gospels of St. Augustine shows that there was

already the idea of organizing the illustrations independently of the text, and it seems likely that the order of the scenes was dictated by the liturgy. For instance, the strange order of the Passion scenes corresponds to the sequence of readings in the lectionary. The artistic quality of the Gospels of St. Augustine is not very high; perhaps it was not thought worth while to send an expensive book to a still largely heathen England. Its considerable importance lies rather in what it reveals about early picture cycles.

The illustrations of the earliest Greek manuscripts show similar problems to those found in Latin books. Classical texts were illustrated with composite cycles that were of early origin; it was the religious books that contained many new ideas. The Biblical cycles followed the text closely; the illustrations of the New Testament, however, were arranged according to liturgical requirements and the pictures did not follow each Gospel story.

A manuscript which can be located and dated very precisely is the copy of Dioscurides' *De materia medica,* now in Vienna, that was commissioned in Constantinople in 512 by Princess Juliana Anicia. The book contains not only the text of Dioscurides, but also additional matters by other authors, and it is illustrated by more than four hundred pictures of medicinal herbs, insects, and birds, as well as portraits of the authors. To these was added a frontispiece (fig. 64) showing the princess seated between allegories of Magnanimity and Prudence. She is giving coins to a putto, a reference to her generosity in founding a church in Honoratae, a suburb of Constantinople; another putto, bowing at her feet, represents the Gratitude of the Arts. The scene is framed by intersecting ropes that form small spandrels containing tiny scenes of various building activities. This miniature, which reveals so much about the exaggerated pomp of high society in the Byzantine capital, is skillfully adapted to the late classical style of the other miniatures, based on ancient prototypes and probably originating from Alexandria.

63. *St. Luke and Scenes from His Life.*
Gospels of St. Augustine of Canterbury. 6th century.
Corpus Christi College (Ms. 286, fol. 129v),
Cambridge, England

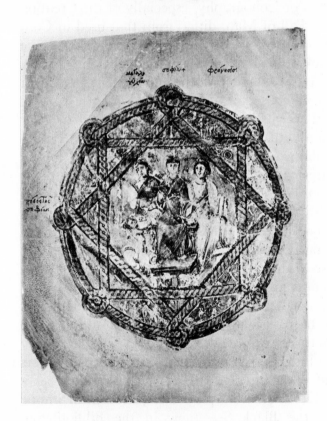

64. *Princess Juliana Anicia
Between Magnanimity and Prudence.*
Frontispiece of Dioscurides,
De materia medica. 15 1/4 × 13 1/4″. 512.
National Library (Cod. med. gr. 1r), Vienna

Also of Alexandrian or Constantinopolitan origin is the famous *Iliad* in the Ambrosian Library in Milan, dating to about 500 (fig. 65). It differs from other known manuscripts of the period by the tumultuous, agitated style of the battle scenes. The pictures were probably based on an illustrated roll, but they must have been considerably modified from their source.

Of the Greek Old Testament cycles of about the same date, one of the most important was the so-called Cotton Genesis. Originally it must have been a splendid book with perhaps over three hundred pictures, but alas, it was reduced to a few fragments by the fire in the library of Sir Robert Cotton in 1731; only these are now in the British Library. A very similar book served as a model for the thirteenth-century mosaics in the narthex of St. Mark's in Venice (see page 263), and with the help of the mosaics many scenes in the Cotton Genesis can be reconstructed. The iconography, especially of the Creation and Fall of Man, differs from that used in Constantinople, and it has been suggested that the book originated in Alexandria. This iconography had a profound influence on the art of the West throughout the Middle Ages.

Three luxury manuscripts of the sixth century stand out as a group, all painted on purple vellum, with script in gold or silver and miniatures of singular refinement. One of these is the Vienna Genesis (colorplate 7), a picture book with an abbreviated text. On each page the text occupies the upper half, the scenes below arranged in one or two registers. They illustrate the text faithfully, but sometimes picturesque details are inserted, such as the half-nude personification of the well in the episode depicting Rebecca giving Eliezer water to drink. The pictures are lively and light, without heavy outlines, and show to what extent Greek painters still looked to classical art for inspiration.

Of the other purple codices, one is from Sinope on the Black Sea (now in the Bibliothèque Nationale, Paris), the other preserved in the Diocesan Museum in the Calabrian town of Rossano (fig. 66). Unlike the Vienna Genesis, where the text and the pictures are closely related on each page, the pictures in the Rossano Gospels dominate the whole page and precede the text. Most of them show a scene from the life of Christ, and below are four prophets holding scrolls lettered with words from their writings that relate to the event above. This interest in relating events in the Old Testament to those in the New was one of the main preoccupations of early theologians, and it continued throughout the Middle Ages, especially in the West.

It has been argued that these luxury books were produced in Constantinople, for purple was an imperial color; although this cannot be proved, the classical elements in them suggest a center of great refinement, where classical traditions were still held in high esteem. The manuscripts which were made far away from the capital, such as the Rabbula Gospels (fig. 67), written in 586 (not in Greek but in Syriac) and probably also painted around that date in northern Mesopotamia, show greater austerity and harshness of form.

SCULPTURE

Although the finest surviving products of the plastic arts of this period are ivory carvings, sculpture was also made in numerous media—marble, stone, stucco, wood, bronze, and many others—but the works were often of coarser quality. The development away from classical ideals and toward shallow relief, well-defined outlines, and an ornamental quality is perhaps best seen in the new type of capital, having large imposts and covered with flat floral or abstract ornament, which developed in Byzantium and was introduced into Italy through Ravenna (see fig. 48). The cubic capitals of the Middle Ages are descended from this importation.

Stucco decoration was a comparatively cheap technique but so easily damaged, especially in damp conditions, that few examples survive.

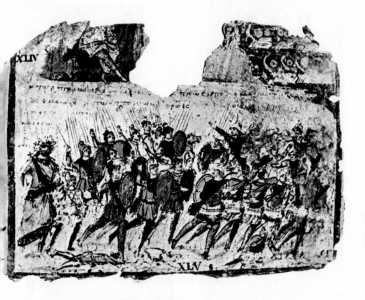

65. Ambrosian *Iliad* (fragment). c. 500.
Biblioteca Ambrosiana (Cod. F. 205. inf.), Milan

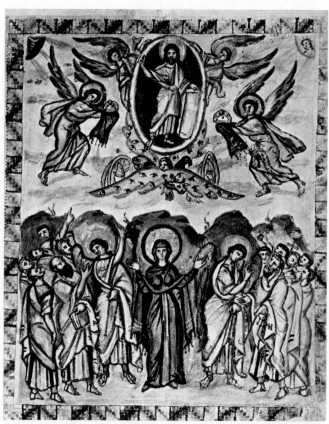

67. *Ascension of Christ*.
Rabbula Gospels. 586.
Biblioteca Laurenziana
(Cod. Plut. I, 56, fol. 13v), Florence

66. *Communion of the Apostles*.
Rossano Gospels. 12 1/2 × 10 1/4". 6th century.
Diocesan Museum
(Cod. pur. Rossanensis, fol. 3v), Rossano

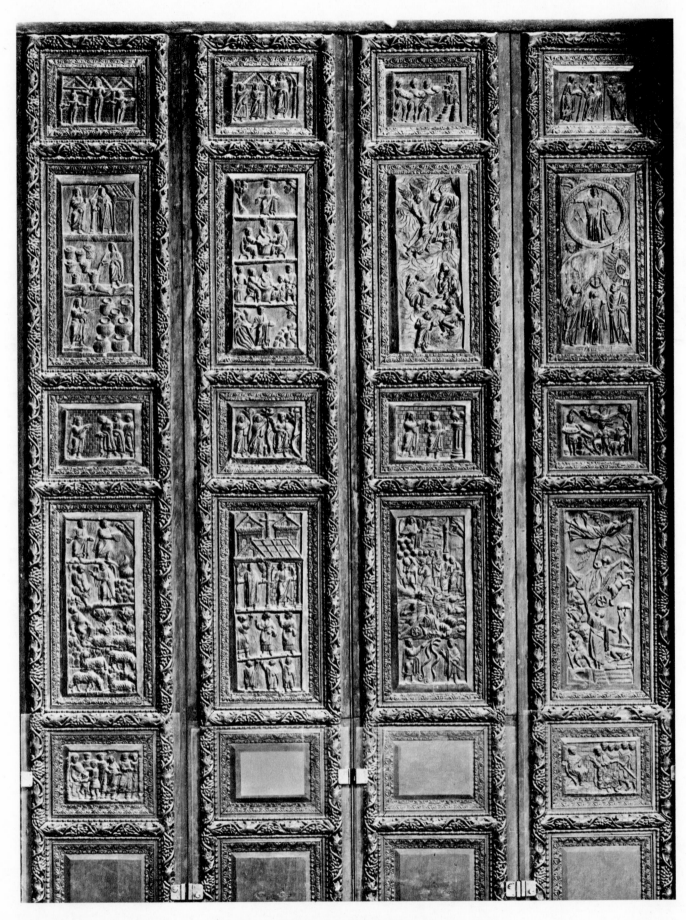

68. Doors of Main Portal. Wood, height c. 10'.
Mid 5th century. Santa Sabina, Rome

69. *Crucifixion,*
panel of Doors. 11 × 15 3/4″. Mid 5th century.
Santa Sabina, Rome

Best known are the sixteen reliefs of standing prophets in architectural frames on the walls of the Orthodox Baptistery at Ravenna (color-plate 8), which illustrate well the tendency away from the three-dimensional treatment of sculpture; they rely on flat forms, and the folds of the garments are used for obtaining a rich surface pattern. A large number of marble or stone sarcophagi follow, in a greater or less degree, the same development, whether made in Constantinople or Italy.

The most famous wood sculpture of the period that remains are the doors, composed of two large valves, of the church of S. Sabina in Rome, dating from the middle of the fifth century (figs. 68, 69). Such doors were probably made quite frequently, but the chances of their surviving intact were small: S. Ambrogio in Milan has some fragments of comparable doors. The S. Sabina doors originally consisted of fourteen panels on each valve but some were lost and have been replaced by imitations. The scenes are

70. *Nereids Dancing.*
Coptic. Stone. 6th century.
Museo Civico, Trieste

drawn from both the Old and New Testaments and, presumably, some relationship was intended between them, as in early illuminated manuscripts. Among the scenes represented, the *Crucifixion* is of particular interest, showing Christ in the center, His arms outstretched and hands nailed, but almost entirely concealing the cross. The two thieves flanking the composition are smaller than Christ, and they are shown nailed to crosses which are more distinctly visible behind their bodies. This reluctance to represent Christ on the cross was no doubt dictated by respect for Him, because memories of such executions in Rome, inflicted on slaves and the lower orders, were still fairly fresh in people's memories. There is a strange contrast in this scene between the naturalism of the modeling of the nude figures and their arbitrary sizes which have to do with their relative importance. The acanthus bordering the panels is no longer

the recognizable plant, but a flat, almost abstract ornament.

This and perhaps other, similar doors must have been well known to the artists of the Middle Ages, who followed their example in the same material (S. Maria im Kapitol, in Cologne), or in bronze (Hildesheim, and elsewhere).

Because of the dryness of the climate in Egypt, a large number of sculptures in wood survived there from this period, and among them are some carved wooden doors. Egyptian Christian sculpture, like the painting or textiles, forms a fairly distinctive stylistic group. Although Egypt shared with the rest of the Mediterranean lands the heritage of Hellenistic culture, a number of factors led to its isolation during the Early Christian period. The Alexandrian Church, because of its Monophysism, was declared heretic in 451 at the Council of Chalcedon, and from then on, Byzantine rule in Egypt was only nominal, depending on the strength of the Byzantine garrison. Christian monasticism was born in Egypt in the third century, and by the fourth it had become a powerful force, hostile to classical traditions. And yet the art produced in Coptic Egypt until and even after the Arab conquest in the mid-seventh century is a strange mixture of pagan and Christian elements, executed in a style at once rustic and vigorous. Wall paintings at Bawit and Saqqara have already been mentioned (see page 62). In sculpture, a considerable body of material still exists, chiefly funerary stelae but also numerous architectural enrichments, such as lintels, friezes, and even tympana. Carved in soft limestone, these works often possess a considerable charm and decorative quality (fig. 70). The forms of some of them can only be explained by influence from the court art of Constantinople, but the majority are provincial products, based on local artistic traditions. Many Levantine countries also, for instance Syria, show a similar process of combining Constantinopolitan fashions with art forms drawn from their own recent and distant past.

Ivory carving was highly valued in antiquity, for the material is ideal for a very minute representation of details, it is hard and therefore durable, and it can be highly polished. Elephant tusks came from Africa and Asia, but they were carved in urban centers—Constantinople, Rome, Alexandria, and many others. Ivory was used for making secular and sacred objects, such as reliquaries, of which the casket in Brescia has already been discussed (see fig. 23). But by far the largest number that survive from this period are diptychs. Consisting of two leaves joined by hinges, they originally served for writing on the wax that coated their hollowed inner surfaces. Diptychs, richly decorated on the outer surfaces, were sometimes made to commemorate family events, such as weddings, but their main function was to convey the news of the appointment of a new consul. With time it became the custom for a consul to send diptychs to the emperor and high officials, notifying them of his honor. Thus these objects can usually be dated very precisely.

By the fifth century many diptychs were reused for Church liturgy; on them were inscribed the names of saints, of the deceased, and even of the living for whom prayers were to be said during the Mass. These diptychs found their way into church treasuries, and thus had a better chance of surviving. One such diptych is that of Flavius Anastasius, consul of Constantinople in 517, now divided between the Victoria and Albert Museum in London (fig. 71) and the Antiquarium in Berlin; the whole was once in the cathedral at Liège, until the church was destroyed late in the eighteenth century. Both leaves of the diptych show, as was customary, the enthroned consul holding a scepter and the *mappa circensis* (signal cloth for starting circus games). On the Berlin leaf is the name of the consul and a circus scene. The London half is almost the same, but below are two servants leading horses and a group of slave-entertainers, one having a crab attached to his nose. Anasta-sius distributed several practically identical diptychs; a single leaf and another complete diptych also survive. The Liège diptych was clearly reused for Church liturgy, because each leaf is still inscribed on the inside with a list of saints. Although not a great work of art, it is a fairly representative example of competent work executed in Constantinople at the beginning of the sixth century, in which a hieratic pose and a decorative effect were the intention.

Only a little later is the celebrated leaf of a diptych, now in the British Museum, representing the archangel Michael (fig. 72). It has been argued that it was made to commemorate a meeting of Greek churchmen with the papal representatives in Constantinople in 519, aiming at restoring unity of the Church. Carved by an outstanding artist, this ivory is most instructive in showing to what extent classical traditions were still alive in the Empire. The wonderful modeling of the figure, the soft, rationally arranged draperies, and the architectural frame are still wholly classical. But on closer inspection some inconsistencies may be detected: the archangel stands on the steps *behind* the arcade, yet both his arms are *in front* of it. This unconcern for realistic detail was to increase with time.

Most elaborate were the multiple diptychs, each wing composed of five interlocking panels. Because of their large size and splendor, they were often reused in later times as book covers, and thus a number survived in the greater safety of monastic libraries and church treasuries.

One such large diptych, now in the Louvre, is thought to represent the emperor Justinian (fig. 73). He is on horseback, his foot supported by the personification of Earth symbolizing his extensive possessions, and he is approached by a general bearing a statuette of Victory. Below, barbarians led by a Victory bring their gifts, including an elephant tusk. Above, crowning the whole composition, is the bust of a youthful, beardless Christ in a medallion, supported by two flying angels.

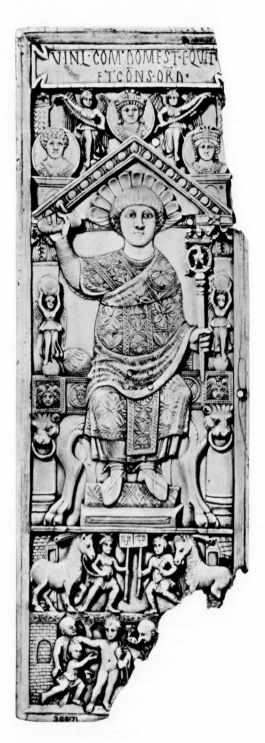

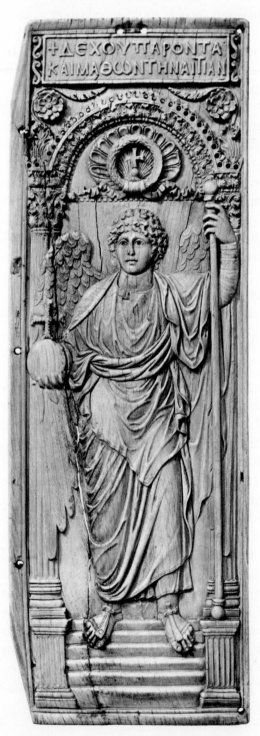

72. *Archangel Michael.* Ivory diptych,
right leaf; 17 × 5 1/2″. 519(?).
British Museum, London

71. Diptych of Flavius Anastasius,
left leaf. Ivory, 14 3/8 × 5 1/8″. 517.
Victoria and Albert Museum, London

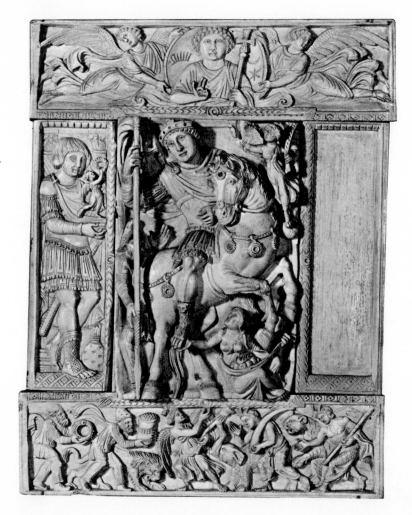

73. *Justinian*
(Barberini Ivory).
Multiple diptych,
one leaf; 13 1/2 × 10 1/2".
2nd quarter 6th century.
Louvre, Paris

74. Throne of Maximian,
front panels:
*St. John the Baptist,
and the Four Evangelists.*
Ivory over wood. 545–53.
Museo Arcivescovile,
Ravenna
(see colorplate 9)

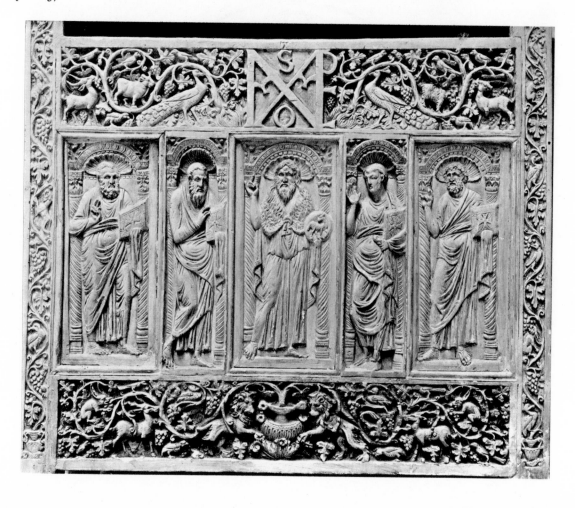

74

The Victorious Emperor on horseback is a motif found in Roman statues and on coins, and the whole program is derived from Roman triumphal sculpture. However, the inclusion of Christ blessing the emperor stresses the fact that the triumph is through God, whom the emperor represents on earth.

This diptych is stylistically related to the ivory throne which was made for Maximian, the archbishop of Ravenna (545–53) and Justinian's trusted viceroy (colorplate 9; fig. 74). His monogram is carved prominently on the front of the throne. The figures on both the throne and the diptych are too big for the panels they occupy, and seem squashed into their frames; on both they have big feet and hands, and round heads with heavy jaws.

The high-backed throne is made of wood that is entirely covered with ivory plaques, some of which are later replacements. The panels on the front represent St. John the Baptist in the center, holding a disk with the Lamb, the symbol of Redemption, and the four Evangelists. On the back are scenes from the life of Christ: on the inside, His infancy, and on the outside, His miracles. Down the sides are scenes from the life of Joseph, his suffering on one side and his triumph on the other. It has been argued that the iconography of the throne was devised to apply to Maximian, for in contemporary theological writings, Joseph was the model of the good bishop.

The panels are framed by strips of "inhabited scrolls," branches of vine with animals and birds. It is assumed that this masterpiece was a gift from Justinian, sent for the dedication ceremony of S. Vitale in 547. The work must have been made in an artistic center of the highest importance. In the past it was believed that this center was Alexandria or Antioch, but modern scholars favor Constantinople as the most likely. The

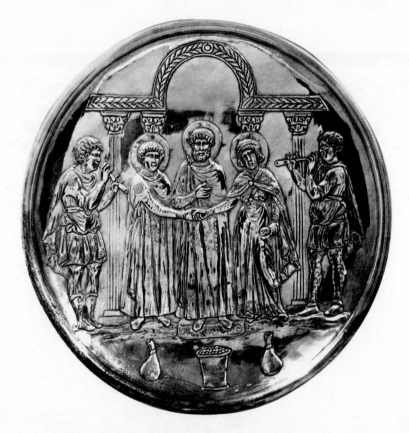

75. *Marriage of David.* Silver, diameter 10 5/8″. 610–29.
Museum of Antiquities, Nicosia (Cyprus)

style is not uniform, and it is clear that several artists collaborated in this undertaking. What these artists had in common was their admiration for late classical art, which they emulated both in the figure style and in the decorative motifs. Especially the Evangelists, clad in togas, bring to mind earlier representations of classical philosophers.

The marked classicism of ivory carving during the reign of Justinian continued for some time and embraced other media as well. In goldsmiths' work, even during the rule of Heraclius (610–41) in the following century, many outstanding works were produced: some are unashamedly pagan in style and subject matter, plates decorated with Silenus and a Maenad, for example, or with Venus and Adonis. A group apart are the nine silver dishes found on Cyprus, depicting the story of David derived from Psalter illustrations.* The scenes show David vanquishing man and beast and the ceremonies of the anointing, presentation, arming, and marriage of David (fig. 75). It seems that the series must have been specially made for imperial use, perhaps for Heraclius himself, who, like many Byzantine emperors, may have associated himself with King David and appeared under the guise of the Biblical hero. In Byzantine imperial art the borderline between the religious and the secular is often hardly perceptible.

To the reign of Heraclius belong some of the mosaics in Salonika, by then the second city of the Empire. In the church dedicated to St. Demetrius, the patron saint of the city (rebuilt after a devastating fire in 1917), all the mosaics are devoted to the saint, and include representations of the church benefactors as well (fig. 76). Linear, austere, and monumental, they are a rare survival from the iconoclastic destructions that were to take place in the near future.

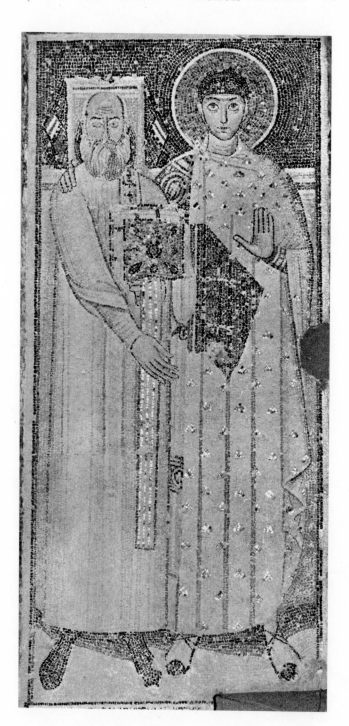

76. *St. Demetrius and Donor*. Wall mosaic. 610–41. Hagios Demetrios, Salonika

* This has been demonstrated by K. Weitzmann, "Prolegomena to a Study of the Cyprus Plates," *Metropolitan Museum Journal*, 3, 1970, pp. 97–111.

In the meantime the Empire was entering a period of peril and territorial losses. The Lombard invasion of Italy in 568 left only Ravenna and the southern region in Greek hands. The Persian conquests in the east, though short-lived, were soon followed by the permanent loss to Islam of North Africa, including Egypt, as well as Palestine, Syria, and Mesopotamia; even Constantinople was threatened and besieged. The Slavs were making inroads into Greece and establishing permanent settlements. In 680 the Bulgarians crossed into the northern Balkans and formed there a state that was hostile to the Empire. The Empire, thus reduced to Greek-speaking territories, was to enter into a turbulent period of civil strife, the central issue of which was the question of images. The Iconoclastic Controversy erupted in 726, with the edict of Emperor Leo III against icons. The superstitious worship of icons had reached, by then, such proportions that the emperor rallied enough support to order the destruction of all images of Christ and the saints. He also aimed at checking the growth of the monasteries, with their enormous wealth and their hold on the population. Under his son Constantine V the destruction of icons, mosaics, and other objects bearing figures of saints was ruthlessly carried out and action against the iconodules turned into cruel persecution. Monastic property was confiscated and many monks put to death. The cult of icons was restored in 787, if only temporarily, by the widow of Emperor Leo IV, Irene, who blinded and deposed her son and proclaimed herself empress. Iconoclasm returned between 815 and 843, after which another empress, Theodora, allowed icons to be used again. From the point of view of artistic life, this turbulent period was one of stagnation. But the greatest tragedy was the wholesale destruction of works of art and the stripping of churches of their decoration. It is for this reason that our knowledge of pre-Iconoclastic art in the capital and throughout the Byzantine Empire is so scanty.

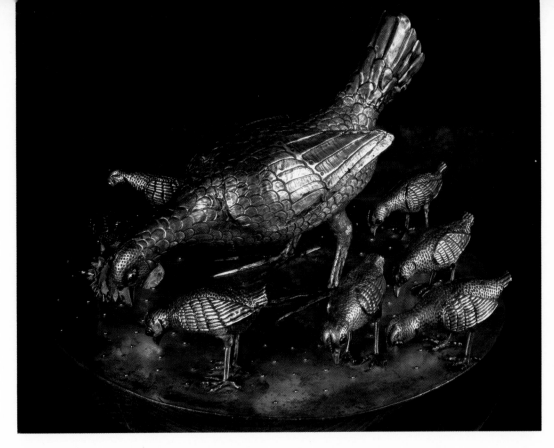

Colorplate 10. *Hen and Seven Chickens*. Silver, gilded, with garnets and sapphires; diameter 18″.
Cathedral Treasury, Monza

Colorplate 11. Votive Crown of King Recceswinth.
Gold with pearls and precious stones; diameter 8 1/2″. 653–72.
Museo Arqueologico, Madrid

Colorplates 12, 13. Sutton Hoo Ship-burial. c. 625–33.
British Museum, London.
(*above*) Hinged Buckle.
Gold with filigree, garnets, and millefiori enamels
(*below*) Purse Lid.
Gold frame with garnets and millefiori enamels
(ivory or bone background restored)

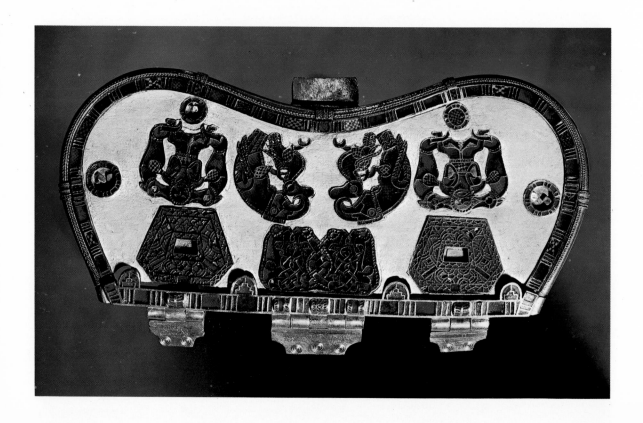

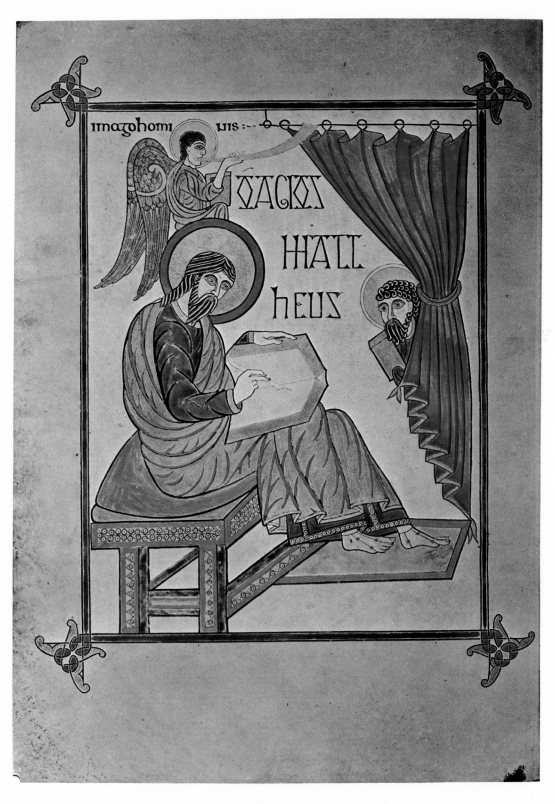

Colorplate 14. *Saint Matthew*. Lindisfarne Gospels. 13 1/2 × 9 3/4″. Before 698.
British Library (Ms. Cotton Nero D. iv, fol. 25v), London

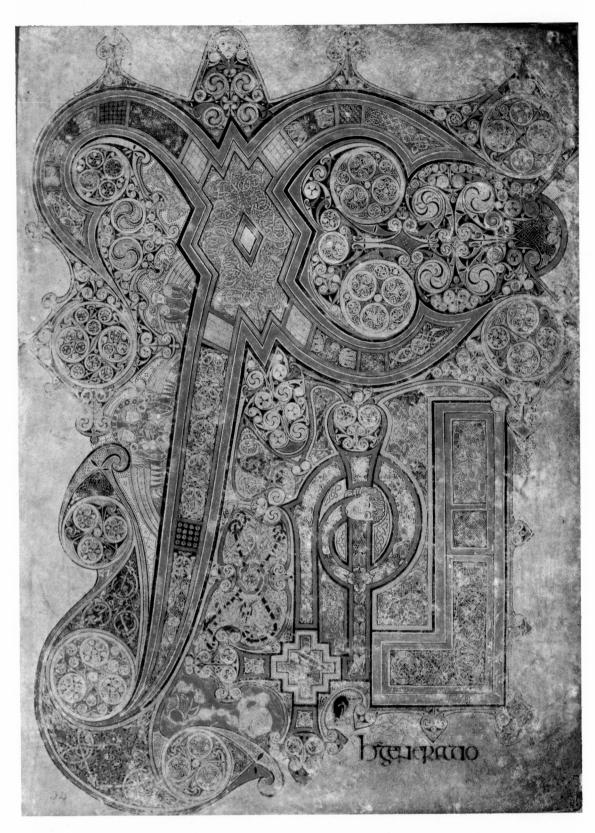

Colorplate 15. *Chi-Rho* monogram page. Book of Kells.
Page 13 × 9 1/2″. Late 8th century.
Trinity College Library (Ms. 58, A.I. 6, fol. 34r), Dublin
(courtesy the Board of Trinity College, Dublin)

IV

Art of the "Dark Ages"

A. Lombard and Pre-Carolingian Art in Italy

The new Germanic kingdoms which replaced the Western Empire were born in bloodshed, but they laid the foundations on which modern Europe was eventually built. Not all of these kingdoms survived for long. For instance, the Vandals, who crossed from Spain into the flourishing provinces of northern Africa in 429, managed to sustain their tyrannical rule there for only about a century, losing part of their territories to the Berbers and part to the Eastern Empire.

In Italy, the Ostrogothic kingdom established under Theodoric the Great (488–526) did not last even that long, for Ravenna fell in 540 and by 554 the whole of the peninsula was recovered by Justinian's army, but not before the country had been laid waste. Theodoric's brilliant patronage of the arts has already been mentioned (see page 39); it aspired to the continuity of the classical tradition of Rome, and as the art of that period in Italy was produced by local artists, there was nothing specifically Germanic about it.

The invasion of Italy by the Lombards in 568 led to a more lasting rule and an intermingling of races. Not all of Italy was taken by the Lombards; the Byzantine exarchate of Ravenna survived until 752 and the papal territories, including Rome, although threatened, were never taken. The Lombard kingdom established in the north, with its capital at Pavia, was thus separated from the semi-independent Lombard dukedoms of Spoleto and Benevento. The end of the northern kingdom came in 774 through the conquest of Charlemagne, while the southern dukedoms survived until the Norman conquest in the eleventh century.

Like most nomadic peoples the Lombards were skilled in various crafts, but because most of their objects were made from perishable ma-

77. Plaque from the Helmet of King Agilulf.
Gilded copper. Early 7th century.
Museo Nazionale (Bargello), Florence

terials, little has survived. Only metal objects—weapons and personal ornaments decorated with interlaces, geometric patterns, birds, and animals—are known in fair numbers. A few exceptional objects survive, such as a gilt-copper plaque from the helmet of King Agilulf (590–615; fig. 77), on which the king, flanked by winged Victories, is shown receiving tribute from his new subjects. This crude but nevertheless lively work must have been inspired by Byzantine art, possibly ivories such as the Justinian diptych (see fig. 73). Stranger still is the enigmatic silver-gilt disk on which stand a hen and seven chicks (colorplate 10). It is said to have belonged to Queen Theodelinda and is now in the treasury of Monza Cathedral.

At the time of their conquest of Italy, and for more than a century afterward, the Lombards practiced Arianism. With their conversion to Catholicism, the fusion of the two races and cultures, the victorious warriors and the subdued Romans, was accelerated. In church building, the seventh century in Italy was a period of decline and crudeness, with a gradual improvement in the next century. Under the last Lombard king, Desiderius (756–74; deposed by Charlemagne), a considerable revival took place. For instance, the convent of S. Salvatore in Brescia, the foundation of Desiderius and his wife, was an ambitious building which, in some ways, foreshadows the Carolingian renaissance.

Lombard art is best known by its prolific production of sculpture: capitals, ciboria, sarcophagi, and very numerous marble panels used in chancel screens. The earliest works date from the first half of the eighth century and many are signed with the names of the sculptors, who do not have Lombard names; it must be concluded that the works were produced by the subjected Romans. The motifs used most frequently are interlaces, simple scrolls, symmetrically placed animals and birds, and occasional human figures. Narrative scenes occur only exceptionally.

The most ambitious works of Lombard sculpture are in the capital of the kingdom, Pavia, and in Cividale, the seat of the dukedom of Friuli (north of Trieste). The altar commissioned by the pious Duke Ratchis (crowned in 744) for the church of St. John at Cividale, as a result of a donation by Duke Pemmo (deposed in 731; thus the work dates between 731 and 744), is particularly striking; on the side panels are narrative scenes, the *Visitation* and the *Adoration of the Magi,* while on the altar frontal is the elaborate *Christ in Majesty* (fig. 78), between two seraphim and four angels. The relief is in two

planes, the figures shown either frontally or in profile. The human anatomy is quite arbitrary: the hands of the angels are gigantic in comparison with their feet, and the length of their arms depends on the distance between their bodies and the mandorla they are supposed to support. The folds of the drapery are purely decorative. By classical standards, this is a truly barbaric work, and it foreshadows the attitude of mind so prevalent in medieval art, for which the requirements of symmetry and ornamental design overrule anatomical reality. It cannot be denied that the Ratchis *Majesty* is a highly successful decorative relief.

The Lombard conquest of Italy, and the Byzantine inability to eject the invaders, left the papacy to its own devices. The Iconoclastic Controversy, which began in 726, marks the

permanent parting of the ways between Rome and the Eastern Empire. Lombard attempts to unify their possessions at the expense of the papal territories led eventually to an alliance between the popes and the Franks; this brought about the end of the Lombard kingdom in 774, and marked the beginning of German involvement in Italy.

During these troubled centuries of barbaric invasions, Byzantine reconquest, and Lombard menace, no great building undertakings were initiated in Rome, though the restoration and rebuilding of churches went on sporadically. Surprisingly, new mosaics were made, but standards, as could be expected, were declining. The cheaper fresco technique was used more extensively than mosaics, and in the church of S. Maria Antiqua on the Palatine Hill survives a

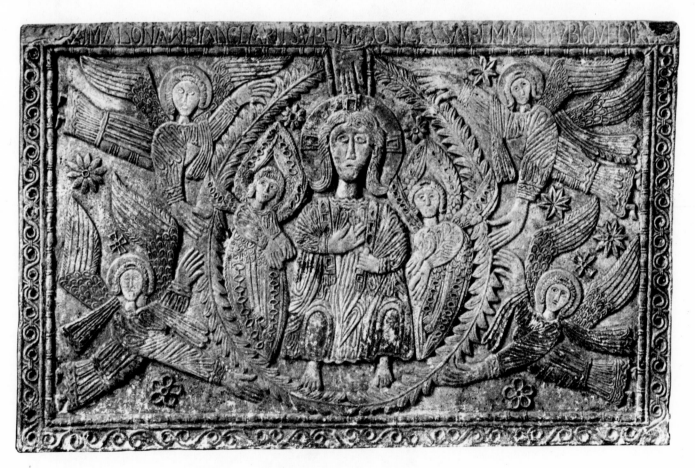

78. *Christ in Majesty*. Altar Frontal of King Ratchis. 731–44.
Museo del Duomo, Cividale

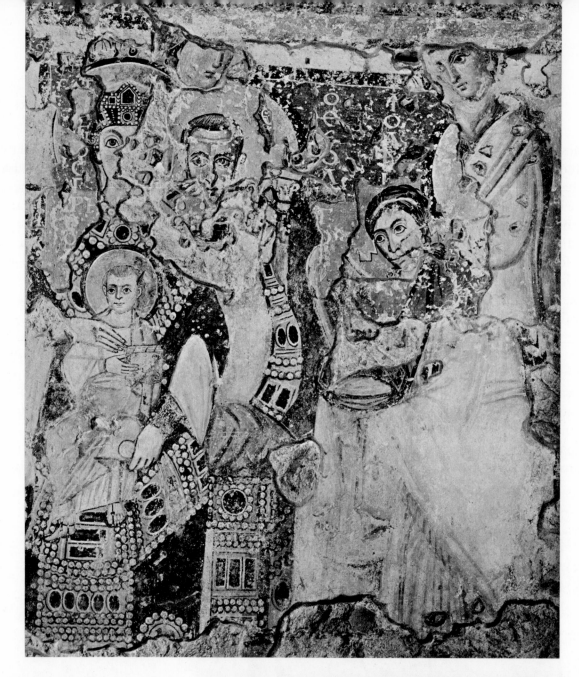

79. *Maria Regina* (*Virgin Enthroned*).
Wall painting. 1st half 6th century.
Santa Maria Antiqua, Rome

80. *Head of Archangel Gabriel*, from *Annunciation*.
Wall painting. Mid 7th century.
Santa Maria Antiqua, Rome

veritable museum of wall paintings of succeeding periods, albeit in a fragmentary condition. The earliest, dating from the first half of the sixth century, is the celebrated *Maria Regina*, Mary the Queen, with the imperial crown and a bejeweled robe, enthroned and holding the Child (fig. 79). This was the first of a long series of representations of the crowned Virgin, the series which culminated in the twelfth century with the Coronation of the Virgin.

By the middle of the seventh century, this layer of wall paintings was covered by another, a composition of the *Annunciation*, of which small fragments survive, including the heads of the Virgin and the archangel Gabriel (fig. 80). In contrast to the hieratic and linear style of *Maria Regina*, that of the *Annunciation* must have been lively, almost impressionistic, painted with quick and decisive brush strokes. This surprisingly classical style was surely inspired from Byzantium. More paintings were added at various times in the eighth century, and these too show strong connections with Byzantine art,

which is understandable since some of the popes of the period were of Greek birth.

This revival of the illusionistic style of late antiquity, transmitted through Byzantine channels, is also found far from Rome, notably in the frescoes of S. Maria at Castelseprio, near Milan. The rather rustic-looking church was built there in the seventh century, near the summer residence of the archbishops of Milan. It is not known when the frescoes, discovered in 1944, were painted, and the controversy about their date has not yet ended. It is most likely, however, that their date is not very distant from that of the *Annunciation* in S. Maria Antiqua, say about 700. The inscriptions suggest that the painter was a Greek, and the style confirms this. The surviving scenes are from the infancy of Christ, and one of the best preserved is the *Journey to Bethlehem* (fig. 81). All the scenes are set in landscapes or against architectural backgrounds, and there is a marvelous sense of perspective and receding space. The figures are depicted with great economy of form and with admirable

81. *Journey to Bethlehem.* Apse fresco. c. 700.
Santa Maria foris Portas, Castelseprio

understanding of movement and expression. Warm colors predominate and give the whole decoration a pleasing visual unity.

B. Visigothic Art in Spain

Having sacked Rome in 410, the Visigoths settled at first (418) in southern Gaul, centered on Toulouse, as *foederati*, the confederates of the Roman Empire. Later in the century they gained a footing in, and then control of, the Iberian Peninsula, which they were to rule until the Arab conquest of 711. However, they were never the real masters of the whole of Spain; the Basques of the north were not easy to subdue, nor were the Suevi, who settled in Galicia; the southern and eastern coastland was in Byzantine hands during the reign of Justinian. Like most Germanic barbarians in Western Europe, the Visigoths were Arians and their policies toward the local Catholic population were harsh until 589, when they adopted Catholicism themselves. From then on they readily assimilated, but turned their religious intolerance to the persecution and forcible conversion of the large Jewish population. In 629, the Byzantines lost their last possessions in Spain.

The achievements in Visigothic architec-

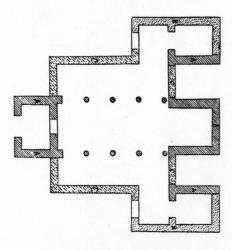

82. Plan of S. Juan de Baños de Cerrato (Palencia province). Consecrated 661

ture are impressive, not so much for the size of the churches, which are rather modest, but for the high quality of workmanship and the variety of types of buildings. Unfortunately scarcely anything survives in Toledo, the capital of the kingdom, and the only well-preserved churches are in remote parts of the country, where their isolation gave them a better chance of being left intact. Such is the case of S. Juan de Baños (Palencia; fig. 82), finished in 661, as testified by an inscription. It is an aisled structure with three separate rectangular compartments at the east end. The feature of all Visigothic churches was the angularity of the plans and the almost total absence of round apses. Santa Comba de Bande (Orense), built on the Greek-cross plan, is vaulted throughout, with barrel vaults in the arms of the cross and the groin at the crossing. The church celebrated for its lavish sculptural decoration is S. Pedro de la Nave (Zamora), moved from the valley in 1934 to its new site, El Campillo (figs. 83–85). It dates from the very end of the seventh century. The complex plan consists of an aisled nave, a transept surmounted by a square tower, and a long chancel. The arms of the transept have chapels at each end that project beyond the body of the church, and the chancel is flanked by chapels that are linked with it by small openings. Also remarkable for its sculptural decoration is the partially preserved church of S. Maria de Quintanilla de las Viñas (Burgos).

All of these structures are built of large ashlar, beautifully dressed, that testifies to the great technical skill of the masons; this is in striking contrast to contemporary Lombard buildings in Italy. Another feature these churches have in common is the use of the horseshoe arch for arcades, chancel arches, and sometimes even doorways. The abundance of sculpture on the capitals and bases, as well as on internal and external friezes and around arches, on pillars, and on other architectural members, is unparalleled elsewhere during this period. This

83. Plan of S. Pedro de la Nave (Zamora province)

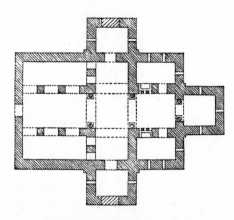

84. Exterior from southwest,
S. Pedro de la Nave (Zamora province).
End of 7th century

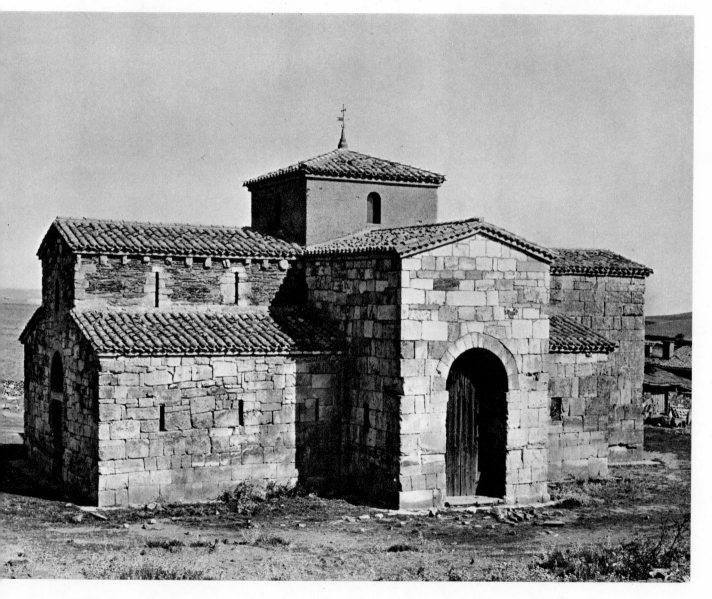

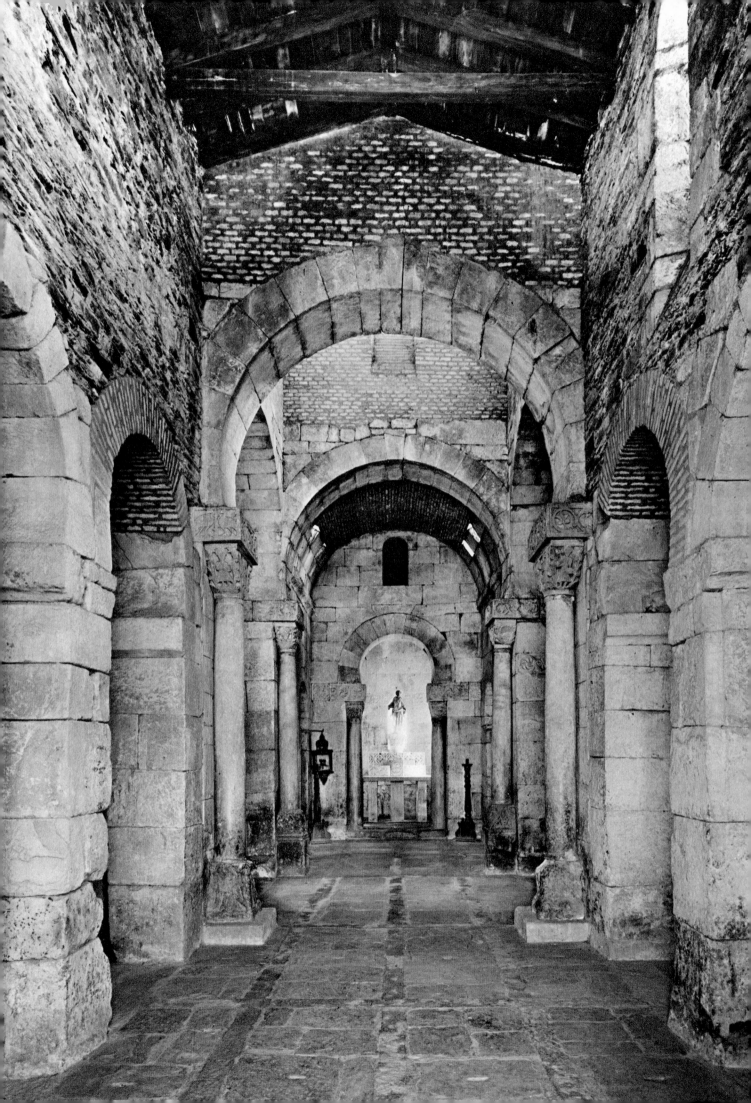

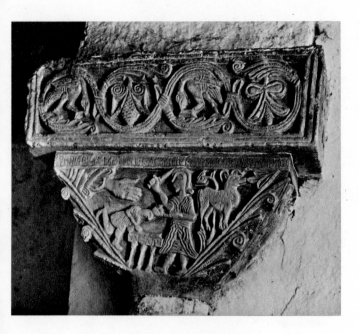

85, 86. San Pedro de la Nave (Zamora province).
End of 7th century. Interior (*left*);
Capital with Sacrifice of Isaac (*above*)

numerous works in metal, such as bronze buckles, brooches with inlaid garnets, and, above all, votive crowns, have survived. These last, some bearing the names of Visigothic kings (colorplate 11), must have been hurriedly buried when, in 711, the Arab invasion brought the Visigothic kingdom to an end, and they remained undisturbed until their discovery in the last century.

C. Merovingian Art

In contrast to the spectacular marches across Europe and rapid conquests by the Vandals, the Visigoths, and the Lombards, the westward expansion of the Franks from across the Rhine was slow, and achieved by gradual settlement as much as by conquest. Clovis, of the Merovingian dynasty, defeated the last Roman ruler of Gaul in 486, and took control of most of the area, settling his Franks among the Gallo-Roman population; in 496 he and his troops were baptized at Rheims. Before he died, in 511, Clovis had pushed the frontiers of his kingdom south to the Pyrenees and had united most of the Germanic tribes east of the Rhine under his rule, making Paris his capital. In spite of its subsequent division into German-speaking Austrasia, Neustria (which stretched from the Channel to the Loire River), Aquitaine, and Burgundy (which included Provence), the kingdom of the Franks or *Francia* survived as an entity even though power passed from the kings to the *mayors,* or governing ministers, of the palace. In a decisive battle near Poitiers in 732, Charles Martel, *mayor* of Austrasia, defeated the invading Muslims and saved the rest of Europe from the fate of Visigothic Spain.

sculpture, like that of the Lombards, is very flat, executed on two planes without any modeling. But it is highly decorative, and occasional traces of colors testify that it was even richer when new. The sources of this sculptural decoration must have been similar to those which inspired the Lombard sculpture, but the variety of its motifs and the wide use of sculpture for architectural decoration place Visigothic sculpture in the forefront of this artistic activity during this period in the whole of Western Europe. Historiated capitals, that is, capitals carved with narrative subjects, are generally thought of as the invention of Romanesque artists, but the *Sacrifice of Isaac* (fig. 86) and the *Daniel in the Lions' Den* at S. Pedro de la Nave testify that the idea was already in use in seventh-century Spain.

No works of painting survive in Visigothic churches, and the manuscript known as the Ashburnham Pentateuch, which used to be considered Visigothic, is now thought more likely to have been produced in Italy. But

At the time of the first Frankish settlements in Gaul, Early Christian art and architecture were firmly rooted there and the newcomers added nothing to this artistic life except in the field of metalwork. They provided, needless to say, the patronage for building churches, out of piety or to increase their own prestige. The historian

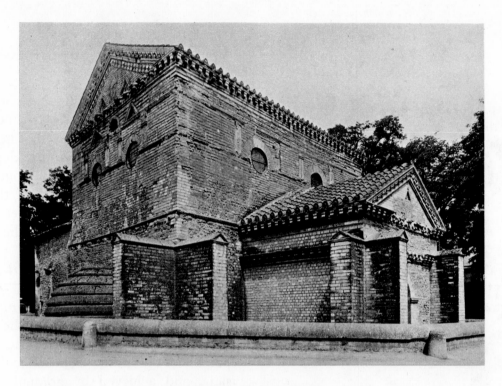

87. Exterior from northeast,
Baptistery of St. John, Poitiers. 7th century

and bishop St. Gregory of Tours (d. 594) left a description of the church of St-Martin of Tours. Though of modest size, it had one hundred and twenty columns, eight doors, and, even more interesting, a belfry and a lantern tower. All Merovingian buildings reflect, in a simplified form, the earlier styles—the late antique and the Early Christian. One of the few surviving seventh-century buildings in Merovingian Aquitaine is the baptistery of St. John at Poitiers (fig. 87), built of stone and reused Roman bricks, with stone pilasters, capitals, and pediments, all rather crude and only faintly echoing classical prototypes. The walls are further decorated with geometric forms made of terracotta inlays. There is something barbaric in trying to make a building look like a large piece of jewelry, studded with colored stones.

However, in spite of the general decline in civilized life during the centuries of constant internal struggle for power and for territories, building activities continued on a modest scale. The Church and expanding monasticism provided the main hope of a regeneration of moral standards, and of intellectual and artistic life on a somewhat higher level. Monasticism had existed in Gaul since the fourth century, and it expanded rapidly under the Merovingian rulers. A further impetus to the development of monasteries came with the Irish missions led by St. Columbanus, who left Ireland in 590 and founded a string of monasteries in Gaul, before settling at Bobbio in Italy.

One of the monasteries founded by Columbanus was for women, at Jouarre in the Marne Valley, east of Paris. Connected with the monastery were three churches, of which one was built in the cemetery and had a burial crypt; it still survives, albeit in altered form (fig. 88). This vestige of a late seventh-century structure shows that Merovingian standards of building and sculpture could be very high. The monastery is formed of stones shaped as octagons, cubes, and lozenges, fitted together very skillfully and providing a highly decorative effect. This technique was clearly imitated from the Roman *opus reticulatum*.

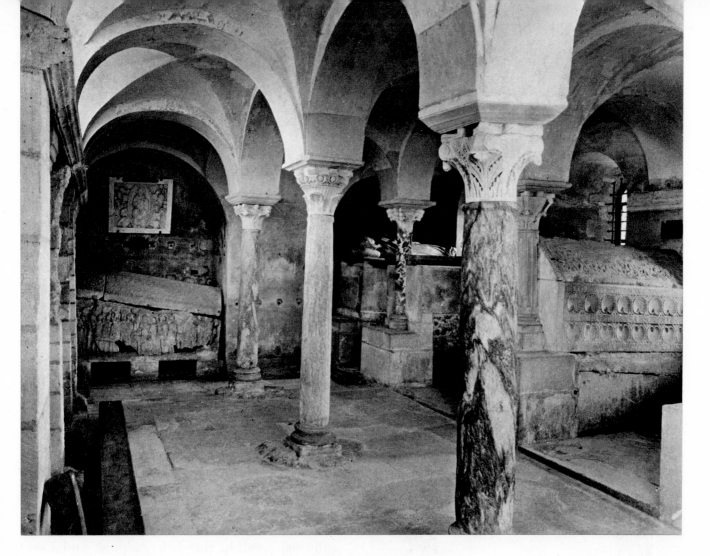

88. Crypt, Chapel of St. Paul, Jouarre.
Late 7th century

89. *Last Judgment* (?). Sarcophagus of Agilbert,
long side. Late 7th century.
Crypt of Chapel of St. Paul, Jouarre

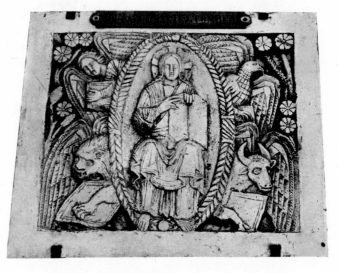

90. *Christ in Majesty* (?). Sarcophagus of Agilbert,
plaster cast of end relief. Late 7th century.
Crypt of Chapel of St. Paul, Jouarre

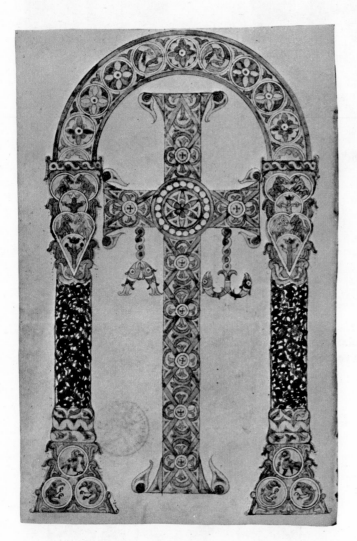

91. Cross Page.
Sacramentary of Gelasius.
10 1/4 × 6 7/8″. Mid 8th century.
Vatican Library
(Cod. Regin. lat. 316, fol. 131v),
Rome

The crypt is furnished with a row of Roman marble columns having seventh-century capitals of remarkably high quality. They are made of marble quarried in the Pyrenees, and it is assumed that they were brought to Jouarre readymade. But the crypt at Jouarre is celebrated for the series of three sarcophagi it contains. One, decorated with two rows of stylized sea shells executed with great subtlety and precision, was made for the first abbess, Theodechilde, who died soon after 662. The second, for an unknown burial, is entirely covered with geometric patterns and simple palmettes in lozenge frames. The third sarcophagus, however, is the most splendid (figs. 89, 90). It is traditionally given to Agilbert, bishop of Paris, who died at Jouarre soon after retiring there in 685; he had studied for some years in Ireland, and was subsequently bishop of Dorchester before returning to his native Gaul. The sarcophagus is carved on one long and one short side with ambitious figural subjects, possibly the *Last Judgment* and *Christ in Majesty*. It has been pointed out that the iconography of the latter is unusual in that the symbols of the Evangelists are half-hidden by the mandorla, and that they do not turn toward Christ, as is customary, but outward, as in Coptic wall paintings and in the mosaic of Hosios David at Salonika (see fig. 52). From this it has been concluded* that the Jouarre sculptor was a Copt who fled to Europe when Egypt was overrun by the Arabs. On the other hand, Agilbert's stay in England may have resulted in an artistic contact from there, for certainly some of the motifs on the anonymous sarcophagus at Jouarre were very common in Anglo-Saxon sculpture. Whatever the sources of the Jouarre sarcophagi, they are incomparably more sophisticated than anything else that survives in Gaul from the seventh century.

The Merovingian style of illumination, rep-

* J. Hubert, J. Porcher, and W. F. Volbach, *Europe of the Invasions,* New York, 1969, p. 77.

resented by a fairly large number of manuscripts (fig. 91), reflects the taste for small ornamental forms; this brings to mind Germanic jewelry studded with precious and semiprecious stones. The human figures are invariably clumsy but the animals, birds, and fishes, which are often contorted to fit into the available space or to form a required letter, are lively and full of character. The close connection between this type of decorative painting and metalwork is further emphasized by the frequent use of the motif of a cross from which hang the letters Alpha and Omega in imitation of actual metal crosses. It is often claimed that the chief source for Merovingian painting was Coptic textiles, but in most cases it is Lombard art and barbarian metalwork that account for the majority of its features.

Continental art of the eighth century was affected by the Irish missionaries in Gaul and the missions from England to the heathen German tribes. These activities left their mark either by the books, reliquaries, and other objects the monks brought or imported, or by the example of Anglo-Saxon artists and craftsmen working on the Continent. This influence of Anglo-Saxon art was felt even more strongly during the succeeding Carolingian period.

D. Early Irish and Anglo-Saxon Art

The Celts inhabiting the British Isles were already Christian in the fifth century, when the Anglo-Saxons invaded and conquered gradually all of England. The invaders were heathen, and under their ruthless pressure disappeared any vestiges of Latin culture which still existed before their coming. Celtic Christianity survived only in mountainous Wales and in Ireland.

The Anglo-Saxons brought with them the usual artistic skills of the Germanic tribes, especially great excellence in the field of metalwork. The famous Sutton Hoo ship-burial, dis-

92. Purse Lid (detail). Sutton Hoo Ship-burial.
Gold frame with garnets and millefiore enamels.
c. 625–33. British Museum, London
(see colorplate 13)

covered in 1939 in Suffolk, supplies the richest collection of objects so far; they are chiefly of metal, illustrating the artistic achievements and taste of the Anglo-Saxons on the eve of their conversion to Christianity, toward the middle of the seventh century.

The rich ornaments of the objects include stylized and interlocked animals, garnet incrustations, jewels, filigree, and many other motifs and techniques (colorplates 12, 13; fig. 92). There are also figure subjects, such as the purse lid decorated not only with abstract, geometric patterns and interlacing animals, but also with a man between two beasts and a bird of prey attacking a duck, both twice repeated. These subjects seem to have been inspired by oriental textiles which, through trade, must have been known to the Anglo-Saxons. In fact the Sutton Hoo treasure included several Mediterranean silver objects, among them a Constantinopolitan salver of about 500. The minute chequerboard patterns on the edge of the purse lid are of particular significance, since they are made in *millefiori* enamel, a technique unknown to earlier Germanic metalworkers and one which they must have adopted in England from their Celtic subjects. This fusion of Germanic and Celtic art

forms was to characterize much of Anglo-Saxon art after the conversion.

Christianity was reintroduced into England from two directions in the course of the seventh century. The Roman mission of St. Augustine (see page 64), sent by Pope Gregory the Great in 597, established a bishopric (later raised to archbishopric) at Canterbury, and slowly converted the southern part of the country.

St. Augustine of Canterbury and his companions were all Benedictine monks. Benedictine monasticism, based on a strict but sensible Rule, was the creation of St. Benedict, who established, about 529, a monastery at Montecassino (see page 252), halfway between Rome and Naples; his sister St. Scholastica founded nearby a convent for women. About 581 Montecassino was completely destroyed by the Lombards, but by then a few other monasteries based on the Benedictine Rule had come into existence elsewhere in Italy. Pope Gregory the Great had much admiration for the Rule and himself founded a Benedictine monastery in Rome, where he became a monk, and later the abbot, before his election to the papacy. By sending Benedictine monks as missionaries to England, he transplanted this form of monasticism far beyond Italy and assured its unique place in the future development of medieval religion and the intellectual life of Europe.

At the time of St. Augustine's landing in Kent the Irish missions, from their monastery on the island of Iona, were already converting Scotland; by the early seventh century they had established themselves on the island of Lindisfarne, off the eastern coast of Northumbria. From there they converted the northern half of the country and the Midlands, but by the decision of the Synod of Whitby of 664, the ancient Celtic observances, which had developed in the absence of contact with Rome, were abandoned in favor of Roman customs. Thus the whole of England was brought into the orbit of influences from the Continent, with important consequences for its future artistic development.

The Celtic Church, both in Wales and in Ireland, was largely monastic, based on Rules which appeared in Western Europe from the fourth century on. The Irish monks, fired by missionary zeal, turned their attention not only to heathen Scotland and England, but also, through the missions of St. Columbanus (see page 90), to Merovingian Gaul and even Italy, where they established numerous monasteries in the seventh century which were renowned for both their piety and their learning. By the ninth century Celtic monasticism on the Continent had been replaced entirely by the Benedictine Rule, but it left a legacy that was of the utmost importance, namely, the love of study, the collecting of books, and the copying of ancient texts. These pursuits were followed earlier by the Benedictine monks in England than by any of their Continental brethren.

For some time to come, England was divided into several kingdoms that were usually at war with each other, but the Church provided a unifying and a civilizing force. Building in stone was reintroduced, and by the end of the seventh century there were some fifty stone churches, a few of which still survive. Those in the south, connected with the activities of St. Augustine and his successors—among whom one, Theodore, was a Greek—were simple aisleless structures with an apsidal chancel, chapels, and burial annexes, called *porticus*, adjoining the nave. In the north, masons and other craftsmen were brought from Gaul to help in building the earliest churches, while the ecclesiastics, both in the south and north, acquired books on their frequent journeys to Rome and Gaul and established libraries at home. In the monastic scriptoria books were copied and illuminated for use in England and for missionary activities on the Continent. The English monks had by now joined the Irish in their missionary spirit, and the conversion of those German tribes that were still heathen was due to them.

One of the books brought to England for the missionary work of St. Augustine was the Italian

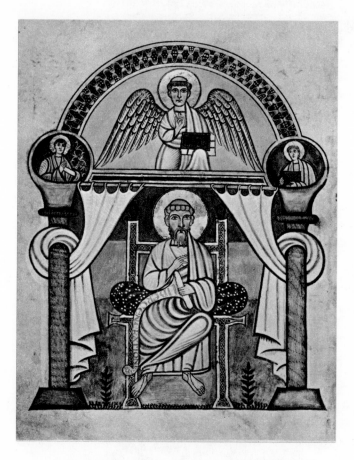

93. *St. Matthew*. Codex Aureus of Canterbury.
15 1/2 × 12 1/2″. Mid 8th century. Royal Library
(Ms. A. 135, fol. 9v), Stockholm

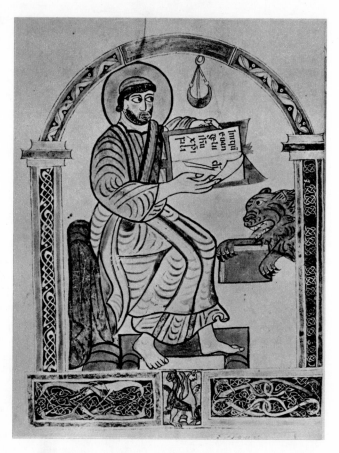

94. *St. Mark*. Cutbercht Gospels. 12 1/2 × 9 3/8″.
Late 8th century. National Library
(Cod. 1224, fol. 71v), Vienna

Gospel Book to which reference has already been made (see fig. 63). Many others are known from documentary sources, including the books from the famous library of Cassiodorus at Vivarium, in Calabria. Copies made in England from such books were seldom exact, though the Codex Amiatinus, now in Florence, which is based on the Codex Grandior from Vivarium, faithfully reflects the late antique style of the original. In most cases the Mediterranean model was modified by additions of Anglo-Saxon or Celtic ornament. Several manuscripts from Canterbury show this fusion of diverse elements into what is usually termed the Hiberno-Saxon style.

The large Codex Aureus now in Stockholm (fig. 93) includes a full-page illumination of

St. Matthew enthroned that is clearly based on an Early Christian prototype, but the interlacing ornament on his throne and on the narrow lintel above him is a Hiberno-Saxon interpolation. Even more clearly Hiberno-Saxon is the Gospel Book written by Cutbercht in the later eighth century (fig. 94), either in southern England or on the Continent (the book was in Salzburg in the ninth century). The intertwining animals below the representation of St. Mark are closely related to the decoration on the Sutton Hoo purse lid, thus demonstrating the continuity of taste for the patterns first devised to decorate pagan jewelry.

There can be no doubt of the Irish contribution to the creation of the highly individual Hiberno-

95. *Symbol of St. Matthew.* Book of Durrow. 9 5/8 × 6 1/8″. c. 675.
Trinity College Library (Ms. 57, A.IV.5, fol. 245v), Dublin

96. Cross Page. Lindisfarne Gospels. 13 1/2 × 9 3/4″. Before 698.
British Library (Ms. Cotton Nero D. iv, fol. 210v), London

Saxon style that is found in the early Northumbrian manuscripts, but the predominant elements of decoration in them are nevertheless Anglo-Saxon. This applies to the Gospel Book known as the Book of Durrow, of about 675, which was formerly in the monastery of Durrow, near Tullamore, in Ireland, but was produced in Northumbria (fig. 95). It applies also to the Lindisfarne Gospels, written by Eadfrith shortly before 698 (colorplate 14; fig. 96); its figure subjects are based on the Codex Grandior of Cassiodorus, but the style of the original figures is rejected in favor of a flat and almost ornamental treatment.

In both these manuscripts there are pages entirely covered by decoration, the "carpet pages," with the motif of the cross in the center. Celtic spirals and trumpets mix freely with

97. *Cats and Mice,* detail of *Chi-Rho* monogram page. Book of Kells.
Late 8th century. Trinity College Library (Ms. 58, A.1.6, fol. 34r), Dublin
(courtesy the Board of Trinity College, Dublin;
see colorplate 15)

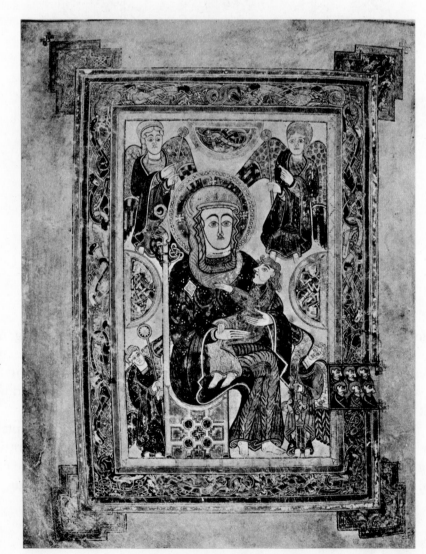

98. *Virgin and Child.*
Book of Kells.
Page 13 × 9 1/2".
Late 8th century.
Trinity College Library
(Ms. 58, A.1.6, fol. 7v),
Dublin
(courtesy the Board of
Trinity College,
Dublin)

Anglo-Saxon animals and birds intertwining with each other, and the technical mastery of the drawing is matched by the subtle colors. In such pages the artist's imagination appears to run riot, and yet, on closer examination, it is apparent that it is controlled by a learned system of symmetry and by balancing the forms and colors.

In the Book of Kells, an Irish manuscript produced on Iona at the end of the eighth century and later taken to the monastery of Kells (County Meath, Ireland; colorplate 15; figs. 97, 98), what was initiated in the seventh century was now carried even further. The exuberance of the ornament, the variety of motifs, and their intricacy seem boundless. But as if to relieve the incredible complications of line and color, the artist inserted some figure subjects, head-terminals, and even an amusing group of cats and rats. Some pages illustrate subjects not usually found in Hiberno-Saxon manuscripts, such as the Temptation of Christ and the Virgin and Child, and it is assumed that for these the monks of Iona had an Eastern, possibly Coptic, manuscript as a model. But whatever the model, the treatment of the figures is flat and decorative, and the forms, whether faces or draperies, are made into strange geometric units. A similar simplification of forms is found in Irish stone carving and metalwork.

The artistic activities in Northumbria during the seventh and eighth centuries, frequently referred to as the Northumbrian Renaissance, included not only painting but monumental sculpture, metalwork, and ivory carving. One of the peculiarities found on the British Isles are the high crosses, of which the Ruthwell Cross in southern Scotland (fig. 99) and the Bewcastle Cross in Cumberland are the most famous. The figure subjects on them, in contrast to those in manuscripts, have a monumental quality and nobility that are clearly of Mediterranean inspiration, and this is further confirmed by the use, on numerous crosses, of the vine-scroll

99. *Christ Worshiped by Desert Beasts.*
Ruthwell Cross (main panel of shaft, north face).
Red sandstone, height c. 3 1/2'. 2nd half 7th century.
Ruthwell (Dumfriesshire), Scotland

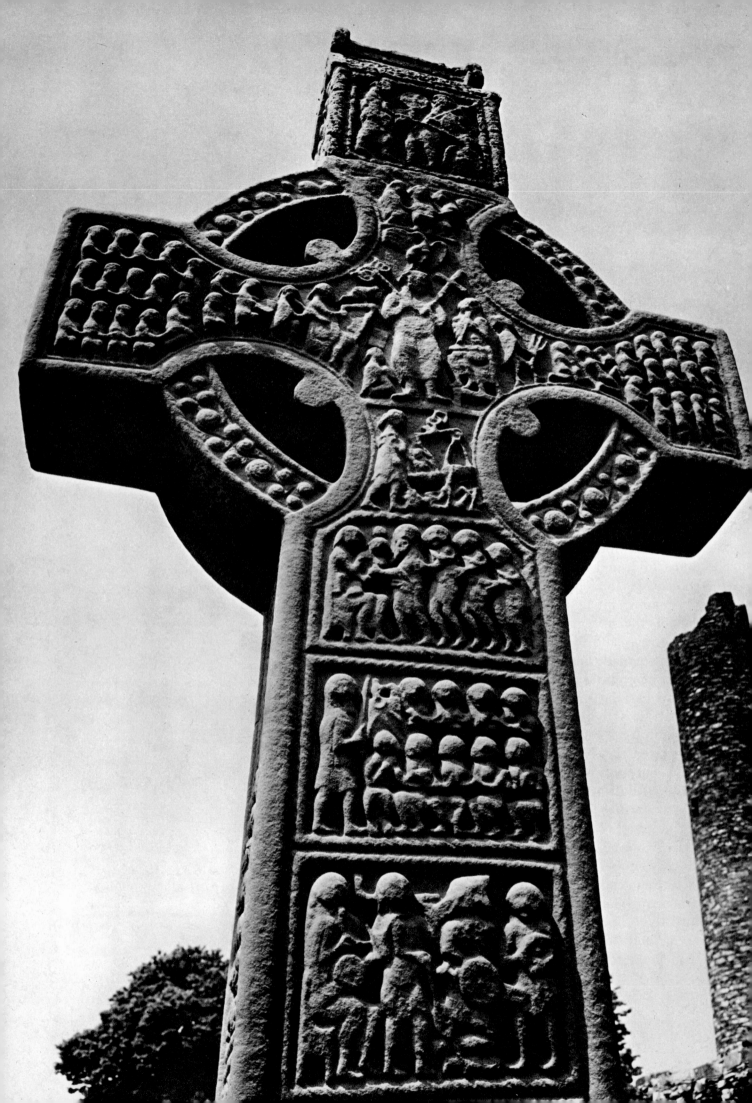

101. *Angel.* Height c. 3'. 8th century (?).
Church, Breedon-on-the-Hill (Leicestershire)

motif, with naturalistic birds and animals. The popularity of crosses in England and Ireland was prodigious, and many thousand examples are still to be seen from various periods of the early Middle Ages (fig. 100). Stone sculpture was also used to decorate churches and their furniture. Decorative friezes, not unlike those in Visigothic Spain, were applied to walls at Breedon-on-the-Hill (Leicestershire); some eighty feet of frieze survive, though not in their original position. Also at Breedon there are several reliefs of high quality (fig. 101), usually dated to the eighth century, which are probably inspired by Byzantine ivories made in the sixth century.

The artistic achievements of Ireland and Anglo-Saxon England were of considerable importance for future developments, not only in the British Isles, but also in Europe as a whole; for the Carolingian revival was, in part, due to the contribution of scholars and artists from across the English Channel.

100. *Last Judgment.* Cross of Muiredach, east face.
Total height c. 18'. 10th century.
Monasterboice (County Louth), Ireland

V

The Carolingian Renaissance

The emergence of Western Europe as a strong and unified force, from the chaotic conditions of the "Dark Ages," was due to collaboration between the papacy and the Frankish rulers Pepin (751–68) and his son Charlemagne (768–814). For the first time since the days of the pagan Roman Empire, large areas of Europe north of the Alps were united under a single ruler whose main objective was not to extort the maximum benefit possible for himself and his relatives, but to achieve stable conditions of life for all. Successive popes, threatened by Lombard ambitions, gave support to Pepin and Charlemagne in exchange for their military help. The crowning of Pepin as king by Pope Stephen II at St-Denis in 754, and of Charlemagne as emperor by Pope Leo III in Rome in 800, gave the Carolingian dynasty the recognition it needed from the Church for prestige at home and abroad. In return, their defeat of the Lombards freed Rome from that menace, and brought the Franks into close contact with Italy. The German involvement in papal and Italian affairs was to last for many centuries and had important political and artistic consequences.

Charlemagne's ambitious plan was the revival of imperial Roman power in the West under his rule. For obvious reasons, the theocratic state he created tried to emulate not pagan Rome, but that of the first Christian emperor, Constantine the Great, and the great Byzantine ruler Justinian. The Carolingian revival embraced many fields of activity necessary for the efficient administration of the State and the Church, but it is remembered best for the renaissance of learning, based on newly formed schools, and for the arts, promoted by the imperial court and by the episcopal and monastic centers. At a time when the Byzantine East was torn by the Iconoclastic Controversy, a splendid blossoming

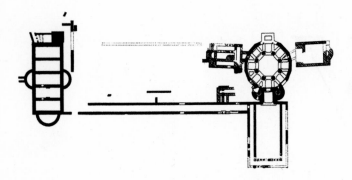

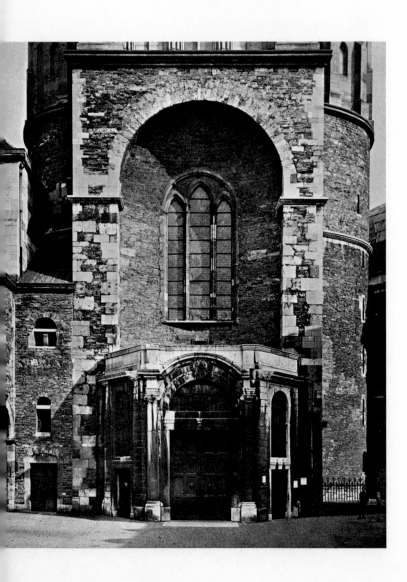

102, 103. (*above*) Plan of Royal Hall
(left) and Palace Chapel
(right), Aachen.
(*below*) Exterior from west,
Palace Chapel, Aachen.
Late 8th century

of the arts was taking place in the West. This development, initiated by Charlemagne, was continued under his successors Louis the Pious (814–40) and Charles the Bald (840–77), but a rapid decline set in toward the end of the ninth century, as a result of the political division of the Empire and the disastrous invasions of the barbarians.

ARCHITECTURE

The buildings of the Carolingian period, whether secular or ecclesiastical, are known very imperfectly, for few survive above ground. However, excavations have revealed a certain amount, so at least something is known about the plans and size of the structures. There are also descriptions and drawings of some of the buildings, now vanished.

The new prosperity and security affected town planning, for in many cases old Roman defensive walls were taken down to allow for the expansion of urban building. But as the new town dwellings were built of timber, they sooner or later fell victim to fire or to rebuilding in later centuries. There is greater evidence, however, about the more ambitious buildings, such as palaces and churches.

The imperial palaces at Aachen and Ingelheim were erected toward the end of the eighth century; during the earlier part of his reign Charlemagne and his court had no permanent residence, but moved from place to place as business of state required.

The principal palace at Aachen was intended to be an imitation of the papal palace, the Lateran, in Rome and of the palace of the Byzantine emperors in Constantinople. It consisted of a complex of buildings grouped around a large courtyard, with the royal hall (*aula regia*) marking its northern limit and the palace chapel (*capella palatina*) the southern (fig. 102). The first of these was an imitation of the Constantinian Basilica at Trier (see fig. 7), the other of the

104. Interior toward east, Palace Chapel, Aachen. ▶
Late 8th century

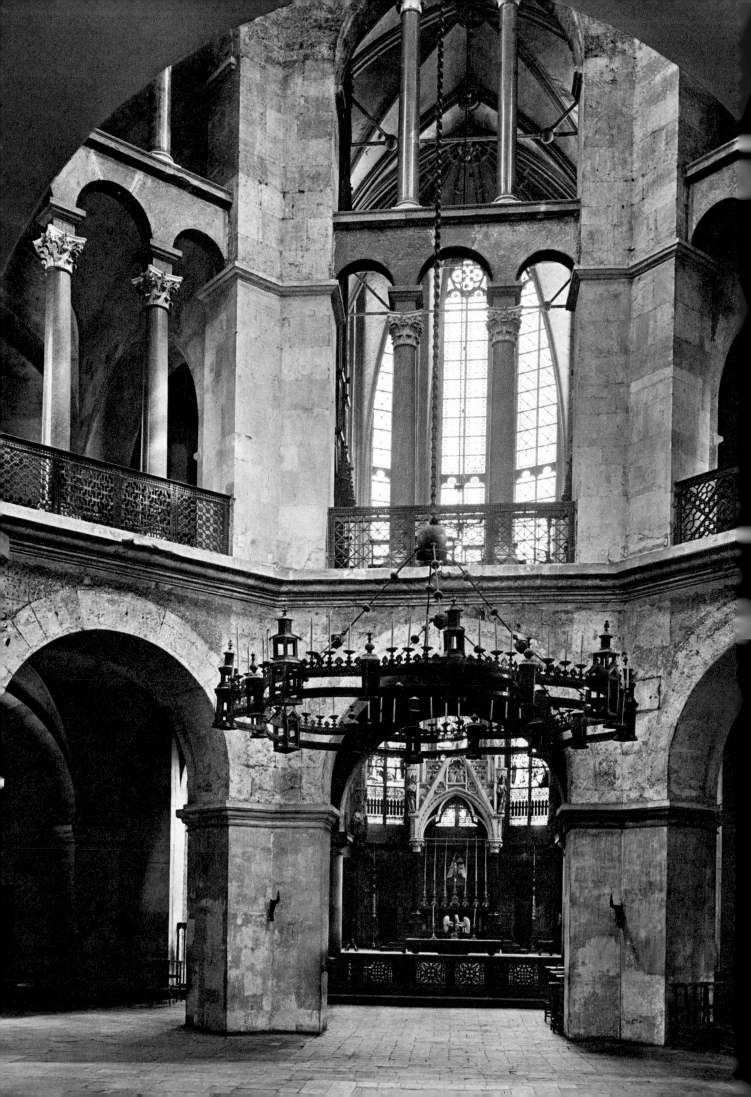

central-plan palace chapels of Byzantium, al-
though the immediate model was Justinian's
church of S. Vitale in Ravenna (see figs. 45,
47), which Charlemagne knew well from his
visit to the city. The chapel (figs. 103, 104),
which survives practically intact, has a central
octagon formed by arcades resting on massive
piers, and enclosed by an ambulatory. Surmount-
ing the vaults of the ambulatory and opening to-
ward the octagon is a gallery of gigantic arcades
filled with pairs of columns in two tiers. A
dome crowns the central space. The columns and
most of the capitals were brought from ruined
classical buildings in Rome and Ravenna. The
walls are dressed with marble slabs, and mosaics

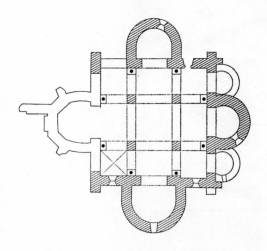

105, 106. Plan and Interior toward northeast,
Oratory of Theodulf, Germigny-des-Prés.
Consecrated 806

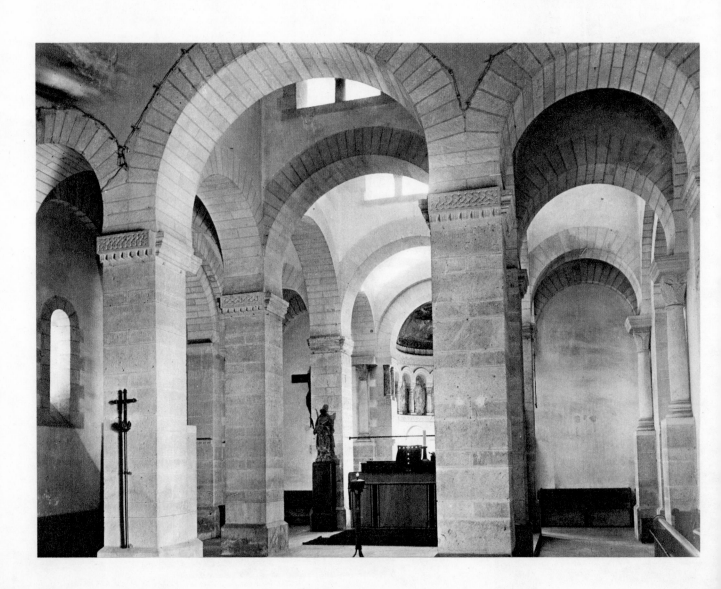

decorated the dome and the groin vaults of the ambulatory. In comparison with S. Vitale, the chapel is more massive, heavy, and angular. Under the influence of Aachen the fashion for centrally planned (but not necessarily octagonal) palace chapels spread through the West and endured for many centuries.

A building which, in a sense, falls into a similar category as the palace chapel at Aachen, though architecturally it is different and in size more modest, is the oratory at Germigny-des-Prés (figs. 105, 106), a short distance from the famous abbey at Fleury (St-Benoît-sur-Loire, of which more later). It was built by a member of the intellectual elite of the court, Theodulf, bishop of Orléans and abbot of Fleury, and was consecrated in 806. Adjoining Theodulf's country villa, it was a private church and this may account for its centralized plan, consisting originally of an inscribed Greek cross with three apses on the east, one on the north, and one on the south. The apses are horseshoe-shaped in plan and their arches are also of this shape, a feature generally attributed to the Visigothic origin of the founder, who was born in the border region of the Spanish March. The arms of the cross are barrel-vaulted; the raised central bay is covered by a dome.

The majority of churches were, however, basilican. Such was the abbey of St-Denis near Paris (fig. 107), rebuilt by Pepin and finished in 775 by Charlemagne. This church had already acquired the status of a royal abbey; it had special links with the royal house under the Merovingian dynasty, and the close relationship continued under the Carolingians. It was here that Pepin was crowned and buried. St-Denis was the earliest Carolingian church, and its T-shaped plan was a revival of the type found in some of the most important Early Christian churches in Rome, such as Old St. Peter's. This type had gone out of use about 400, and its reappearance in the eighth and ninth centuries must be viewed as a deliberate return to the form used in the

golden age of the early Church, patronized by Constantine the Great and his successors.

Although in essence derived from Roman basilicas, St-Denis had some unusual features. One of these was a second apse, in the west wall of the church; such an apse was even more pronounced in the monastic church at Fulda, consecrated in 819. The apse and transept of Old St. Peter's in Rome faced west but it had since become the rule that the main altar in a church was in the eastern projection. In order to preserve the arrangement of St. Peter's, the church at Fulda was provided with two apses, at opposite ends, and a western transept.

Both St-Denis and Fulda were monastic churches and both were influential in the future development of monastic architecture. Because of Irish and Anglo-Saxon influences on the monastic life of Western Europe at the time of Charlemagne's accession to the throne, there was a variety of monastic observances in the West. As in so many other fields, Charlemagne aimed at a greater uniformity and discipline,

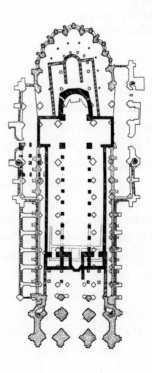

107. Plan of Abbey Church, St-Denis. 8th to 13th century (darkest areas designate Carolingian basilica; after K. J. Conant)

108. *Plan of Ideal Monastery.*
Red ink on parchment; 44 1/8 × 30 1/4". c. 820.
Stiftsbibliothek, St. Gall (Switzerland)

quarters, the workshops, the guesthouse, stables, etc. It is a sensible layout of a wide range of buildings, a veritable monastic town. Many future monasteries followed this model in all essentials.

No less instructive than this plan is the engraving showing the abbey, which is now destroyed, of Centula, or St-Riquier, in Picardy (fig. 109). This monastery was completed in 799 by Abbot Angilbert, who was one of the outstanding members of the court circle before he became a monk. Charlemagne was the principal benefactor of the monastery, and thus it must be assumed that the form of the church met with

109. View of Centula Abbey (St-Riquier),
near Abbeville. Consecrated 799 (engraving by Petau, 1612,
after an 11th-century manuscript illumination)

and in this case, he gave his support to the Benedictine Rule and the Roman liturgy. But the greatest activity in monastic reform took place under Louis the Pious, directed by St. Benedict of Aniane (d. 822) with the full support of the deeply religious emperor. Louis built, as a model to be imitated, the monastery of Cornelimünster near Aachen, to which selected monks from all over the Empire were sent for training. It is presumably in the circle of Benedict of Aniane, about 820, that the celebrated plan of St. Gall originated. This parchment plan (fig. 108), still preserved in the library of St. Gall, includes not only the basilican church with an apse at either end, but also the cloister, the monks'

imperial approval. Many elements of Northern Romanesque are hinted at here.

The church was elaborate in plan and elevation; there was equal emphasis on both the east and west ends, two crossing towers (probably of wood), a chancel flanked by circular stair-turrets, and a complex west façade, also with a pair of stair-turrets, and an atrium in front of it. The western block had externally the appearance of a second transept; it was in two stories, the upper one containing an altar and opened by arcades toward the nave. This so-called westwork was to be repeated with modifications in a number of Carolingian churches —Rheims Cathedral, Corbie, and Corvey (fig. 110)—and passed from there into Ottonian and Romanesque architecture. The westwork eventually led to a great change in church design, namely, an emphasis on the façade of a church; it is this, combined with large towers, that makes the appearance of a medieval church so fundamentally different from that of an Early Christian basilica.

The complex treatment of the east end of a medieval church also has its roots in the Carolingian period; the most interesting developments were in connection with the veneration of relics and pilgrimages. In order to facilitate the free access of worshipers to the tomb of a saint, usually in a crypt below the main altar, experiments were made in building special passages around crypts and the addition of chapels leading out of these passages, for further relics. At St-Philbert-de-Grand-Lieu (before 847) this resulted in the steplike arrangement (*en échelon*) of chapels, a method which was to be developed to the full in later centuries.

The building which, in many ways, best expresses the spirit of the Carolingian *renovatio*, is the gatehouse, or *Torhalle*, built about 800 in front of the monastic church at Lorsch (fig. 111). The structure survives in perfect condition, with three through arcades in its ground story and a hall or chapel above. It was always a free-stand-

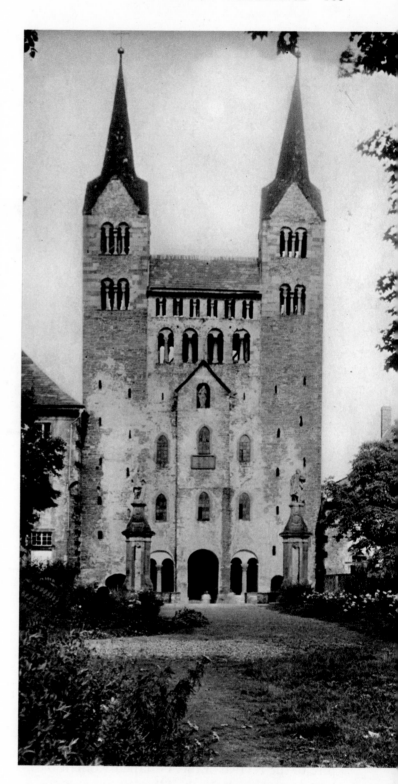

110. Exterior of Corvey Abbey, showing Westwork. 875–85

110

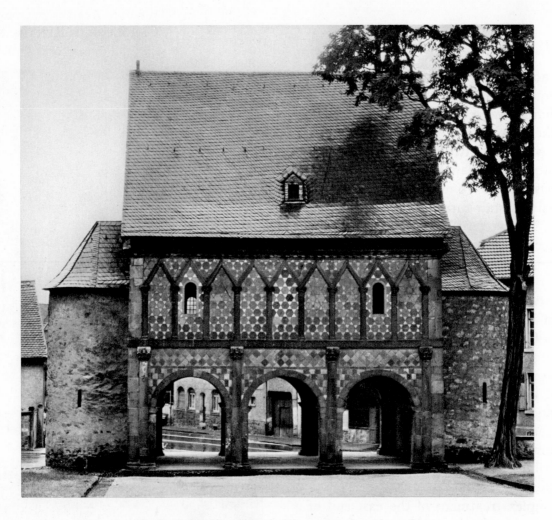

111. Torhalle (Gatehouse), Monastery, Lorsch. c. 800.

ing building and, as has been convincingly argued, it was inspired by the triumphal arch of Constantine the Great in Rome (see fig. 18). However, the Lorsch gatehouse only remotely resembles its model. Not only is it small by comparison, but, more important, it is not a highly articulated arch enriched with sculpture in high relief but very flat, its divisions being linear rather than plastic, and great stress is laid on an abstract color effect. In spite of fluted pilasters and classical capitals, it is a thoroughly medieval work. The trend which led in the Frankish Empire to the revival of the T-shaped Roman basilica also affected the building of contemporary churches in Rome, the two outstanding examples of this revival being S. Stefano degli Abissini and S. Prassede (fig. 112), though several others were built or rebuilt in the ninth century.

Outside the territories ruled by the Carolingian dynasty, the "renaissance" tendencies are less marked. The Christian kingdom of the Asturias in northern Spain, with Oviedo as the capital, was in touch both with Rome and the Carolingian Empire, but in artistic matters national traditions were dominant. The art of the Visigoths, submerged by conquering Islam, was the obvious inspiration, so much so that some buildings of uncertain date are considered by some scholars to be Visigothic, by others as Asturian.

Among the structures securely dated by documents is S. Maria de Naranco, near Oviedo, built by King Ramiro I and dedicated in 848 (fig. 113). It is a two-storied rectangular building, once part of a larger palace complex. One of the three low chambers of the ground story

contained baths, while the whole of the upper story, covered with a tunnel vault with transverse arches, was at once the audience hall and a chapel. In the middle of one long wall was a projecting staircase, while the corresponding projection on the opposite side of the building (now destroyed) was probably intended for the altar. The short walls of this hall are linked by open arches with loggias. This building seems to have combined the roles of the *aula regia* and the *capella palatina* of Charlemagne's palace complex at Aachen (see page 104).

The churches of the Asturian kingdom were usually three-aisled basilicas that terminated in three rectangular barrel-vaulted apses. In two cases (S. Maria de Bendones, near Oviedo, and S. Julian de los Prados, Oviedo) deep transepts are incorporated, with flat timber ceilings; these dominate the entire building in size and height. Some of the Asturian churches are decorated with rich sculpture for which there are no parallels in the Carolingian Empire; and at S. Miguel de Liño (fig. 114), a short walk from Naranco,

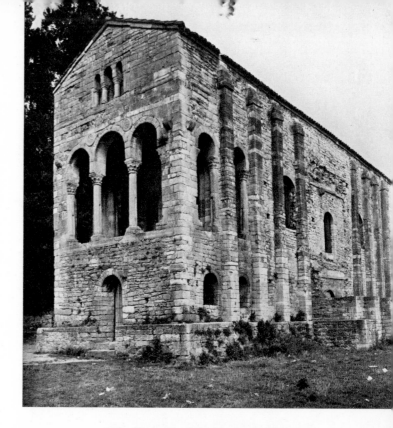

113. Exterior of S. Maria de Naranco (near Oviedo). Dedicated 848

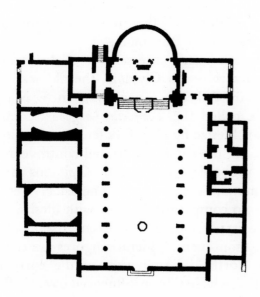

112. Plan of S. Prassede, Rome. c. 817–24

114. Exterior from southwest, S. Miguel de Liño, Mt. Naranco (near Oviedo). Founded 857

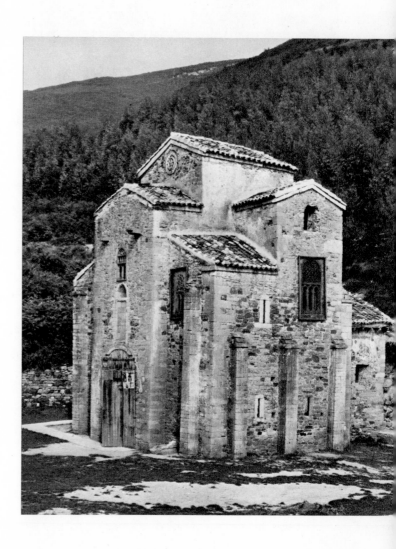

the rose windows foreshadow developments which took place in the twelfth century.

Examples of ninth-century architecture still in existence in England are singularly scanty, chiefly because the major churches were destroyed by the Vikings, whose raids began in 835 and increased in ferocity until they had conquered part of the country and settled there.

SCULPTURE

Documentary evidence suggests that sculpture played some part in the decoration of Carolingian buildings, but very few vestiges of such dec-

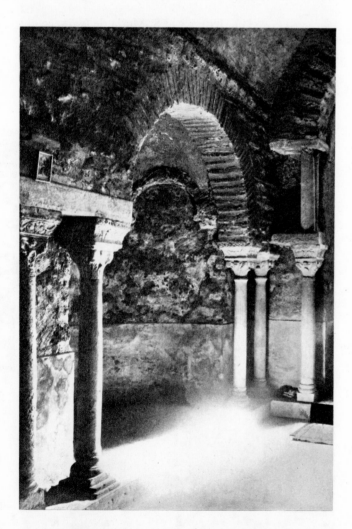

115. Chapel (now crypt), Church of St-Laurent, Grenoble. c. 800

orative schemes survive. Friezes, somewhat similar to those on Visigothic churches, were employed; some were made of terracotta plaques. Texts mention reliefs also on the gables of churches. However, architectural sculpture was most frequently applied to capitals. Some of these, as at Aachen, were reused Roman capitals brought from Italy, but good imitations of Corinthian and Ionic capitals were frequently made locally. Stucco decoration became widely used, as at Centula, where numerous narrative reliefs in this technique were placed at various points in the church. The entire interior of Theodulf's church at Germigny-des-Prés was covered with ornamental stucco patterns, and the same material served for decoration of the chapel of St-Laurent at Grenoble (c. 800; fig. 115). The stone capitals in the chapel have high abaci, as high as the capitals themselves, and are carved with birds and beasts adoring a cross or merely facing each other. The closest parallels for such abaci are found in somewhat earlier churches in or near Verona. There is ample evidence to suggest that the high abaci found on so many Carolingian capitals originated in northern Italy, and that ultimately their models were the Byzantine capitals of Ravenna.

The most elaborate scheme of decoration in stucco survives in Cividale, the old seat of the Lombard dukes (see page 82). In S. Maria in Valle, called the *Tempietto Longobardo*, founded in 761, lifesize figures of six female saints in high relief are the subject of heated controversy over their probable date (fig. 116). Opinions vary and the matter has not been conclusively resolved, since no comparable stuccos with lifesize figures still exist; but there is a strong likelihood that these monumental, hieratic figures are the work of a North Italian master of the early ninth century, who had been influenced by early Byzantine art.

The chapel belonged to a convent, and the two innermost figures represent saintly nuns, the other four being saintly queens in regal robes and

116. *Six Female Saints*. Stucco, lifesize. c. 761.
Tempietto Longobardo, S. Maria in Valle, Cividale del Friuli

crowns. The stucco decoration around the window and the doorway below consists of stylized patterns and naturalistic vine-scrolls; these were painted and embellished with colored glass globes, all now broken. Carolingian stuccos studded with glass are also found at S. Salvatore in Brescia, and among the stuccos already mentioned at Germigny-des-Prés. There were other extensive stucco decorations, dating from the ninth century, in monastic churches of the Alpine region—at Disentis (Switzerland) and Malles Venosta (Italian Tyrol)—of which fragments survive. In all these cases the stuccos were painted; it is likely that the work was carried out by teams of artists who used both techniques with equal ease, and that the stylistic interconnections between sculpture and painting were the result of their common authorship. If this view is correct the Cividale stuccos are less isolated, for a somewhat similar figure style is found in Italian wall paintings and even in manuscript illumination.

Marble reliefs for chancel screens in the "Lombard" style, which originated in the eighth century, continued to be produced in Italy, and during the ninth century some such reliefs were exported beyond the Alps or were imitated there. Other church furnishings were made in the "Lombard" style, such as pulpits and ciboria. These carvings had nothing "renaissance" in them; on the contrary, they were essentially "barbaric" and old-fashioned. No wonder Charlemagne did not employ their sculptors.

In his attempt to re-create the splendor of Rome in his capital, Charlemagne reused other works brought from Italy in addition to capitals and columns. The equestrian bronze statue of Emperor Zeno from Ravenna, at that time believed to represent Theodoric, was set up in the courtyard of the Aachen Palace, in emulation of the equestrian statue of Marcus Aurelius (believed at that time to represent Constantine the Great) which stood in front of the Lateran Palace. A Gallo-Roman she-bear in bronze was placed in the porch of the palace chapel, in imitation of the Roman she-wolf. Also, the bronze pine cone was made in resemblance of the *Pigna*, which at that time still crowned the fountain in the atrium of Old St. Peter's in Rome (see page 22). Also significant was Charlemagne's wish to

be buried in an ancient Roman sarcophagus which, in fact, still survives at Aachen. The tomb of his successor, Louis the Pious, was also a reused Roman sarcophagus, of which a few fragments are preserved at Metz.

This accumulation of splendid Roman objects, many in bronze, at the court of Aachen and, no doubt, at the other imperial residences, inspired local imitations. No large-scale bronze-casting had been done in Western Europe since the fall of the Roman Empire, and it is almost a miracle that the Carolingian craftsmen were able to master that technique, used in the intervening centuries only to produce small portable objects. The four doors for the palace chapel at Aachen are simple, decorated with border moldings and having doorknockers in the form of lions' heads (fig. 117). Yet they are impressive

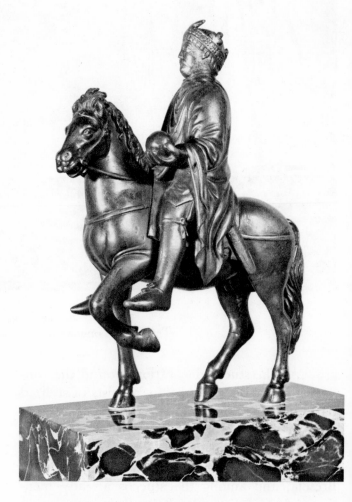

118. *Equestrian Charles the Bald (Charlemagne?).* Bronze, height 9 1/2″. 9th century. Louvre, Paris

117. Bronze Doors of main portal. Height 13′. c. 800. Palace Chapel, Aachen

for their size and the perfection of their casting. Even more beautiful are the eight sections of the balustrade inside, covered with acanthus leaves and fluting, on the second floor of the octagon of the chapel, still in the position they occupied about 800. A small bronze equestrian statuette, believed to represent Charlemagne but more likely Charles the Bald (now in the Louvre, but previously in the treasury of Metz Cathedral; fig. 118), is probably based on the equestrian statue of "Theodoric." It was cast in the round in two pieces, testimony not only of the technical skill of the craftsmen, but also of their artistic ability in combining movement and dignity.

These works of the court craftsmen amply justify the term "Carolingian renaissance" in their conscious attempt to re-create the Roman past. But not all works of art of the period have the same classical character. Away from the imperial court, the influence of Hiberno-Saxon art was strong enough to inspire such works as the great chalice given by Count Tassilo (d. 788) to the abbey of Kremsmünster, or the first or lower book cover of the Lindau Gospels (c. 800; colorplate 16). This last combines niello inlay and cloisonné enamel, and imitates the "carpet pages" of Northumbrian and Irish manuscripts. The cover was made on the Continent, as is suggested by the cloisonné enamel, inspired by Byzantine and Italian models and unknown at that time in Britain. But the style of the intertwining animals is Hiberno-Saxon.

Also quite unclassical are the ninth-century works of sculpture found in Asturian buildings. As it was in the Visigothic period, the profusion of Asturian sculpture is again quite remarkable, especially in the two buildings already mentioned: S. Maria de Naranco and S. Miguel de Liño, both near Oviedo. At Naranco the capitals in the upper hall are block-shaped, but triangular "niches" alternate upward and downward on the side faces, each containing a small figure, while on the main faces animals with double contours are within four arcades (fig. 119). There is a striking connection between these bizarre capitals and the painted capitals in Merovingian manuscripts, and no doubt these last served as models for the Asturian sculptors (see fig. 91). Another source they used were the Byzantine consular diptychs, for the reliefs on the doorjambs at S. Miguel are copies of the circus scenes from such diptychs.

PAINTING: FRESCO AND MOSAIC

In Rome, building activities were directed toward restoring old churches rather than erecting new ones. Some churches received new mosaics and fresco decorations. In the Triclinium, the

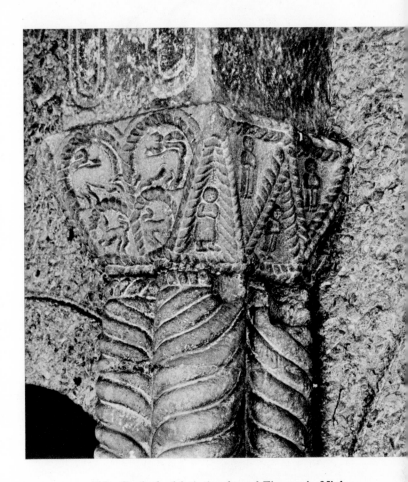

119. Capital with Animals and Figures in Niches. Dedicated 848. Upper Hall, S. Maria de Naranco (near Oviedo)

banqueting hall of the old Lateran Palace, Pope Leo III made, in 799, a mosaic which well symbolized the alliance of the papacy with the Franks, as well as the aspirations of the papacy to leadership of the West. The mosaic was drastically restored in the seventeenth century, but watercolor drawings remain of the original work (fig. 120). Two subjects formed the focus: St. Peter giving the pallium to Pope Leo and a banner to Charles, still described as "king" [of the Franks]; and Christ giving keys to Pope Sylvester and a victory banner to Constantine the Great. The second of these representations was inspired by the *Constantinian Donation*, the famous forgery claiming that Pope Sylvester I had

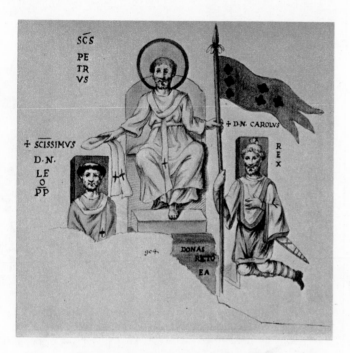

120. *St. Peter Presenting the Papal Pallium
to Pope Leo III and the Banner
to Charlemagne.* Watercolor copy
(18th century) of mosaic in Leonine
Triclinium, St. John Lateran, Rome
(original 799). Royal Library, Windsor
(by the gracious permission of Her Majesty
Queen Elizabeth II)

112). The entrance to the chapel incorporates
two antique porphyry columns surmounted by
marble imitations of Ionic capitals, a truly
splendid revival of classical details. Mosaics are
lavished on this small structure, and the vaulting
is crowned by a composition of four angels sup-
porting a medallion with the bust of Christ, in
clear imitation of the sixth-century mosaic on the
vault of the chapel in the archbishops' palace at
Ravenna. But, in comparison with their proto-
types, all these mosaics are stiffer, more rigid and
linear. There can be no doubt that, in compari-
son with classical and Early Christian illusion-
ism, these are already truly medieval works; they
rely on strong contour and on drapery that is a
pattern rather than a means of modeling the
body it covers, and the emphasis is not on action
and movement, but on the expressiveness of the
highly spiritual faces.

Mosaics north of the Alps from this period
must have been carried out by artists who came
from Italy. The dome of the palace chapel at
Aachen had a representation of Christ between
the Twenty-four Elders of the Apocalypse, and
the apse at Germigny-des-Prés still has, though
much restored, the *Ark of the Covenant* with two
golden cherubim above it, blessed by the hand
of God and flanked by two adoring angels (fig.
123). This last subject is unusual, but to persons
like Theodulf, the founder of the church, it must
have had a deep significance. The problem pre-
occupying the minds of the Carolingian clergy
was image worship, since the matter that shook
the Eastern Empire to its foundations could not
have been ignored in the West. The Iconoclastic
Controversy, which led to the prohibition of
religious figurative art in Byzantium (see page
76), took a new turn when the Council of Nicaea,
in 787, decreed the restitution of image worship.
The decision was officially opposed by Charle-
magne and his theologians in the celebrated
Libri Carolini, read at the Frankfurt Synod of 794.
Byzantine image worship was condemned be-
cause it attributed to images supernatural pow-

miraculously cured Emperor Constantine of
leprosy and then baptized him; in gratitude,
Constantine decreed that St. Peter and his Ro-
man successors should be the sole leaders of the
Church in Rome and Italy; then, having built
the Lateran and the basilicas of St. Peter and of
St. Paul, he left Italy to found a new capital in
Constantinople. The mosaic was propaganda as
much for the papacy as for the Carolingian
dynasty, and was made in preparation for the
crowning of Charlemagne as emperor, which
took place a year later.

The iconography of other mosaics in Rome
follows fairly closely the Early Christian ex-
amples, such as the apse mosaics in S. Prassede,
in S. Cecilia, and in S. Marco. The first two were
due to Pope Pascal I (817–24), who also em-
bellished with mosaics the chapel of S. Zeno in
the church of S. Prassede (figs. 121, 122; see fig.

121, 122. Chapel of S. Zeno, S. Prassede, Rome. 817–24.
(*above*) Entrance to Chapel.
(*below*) Dome mosaic, *Christ and Four Angels*

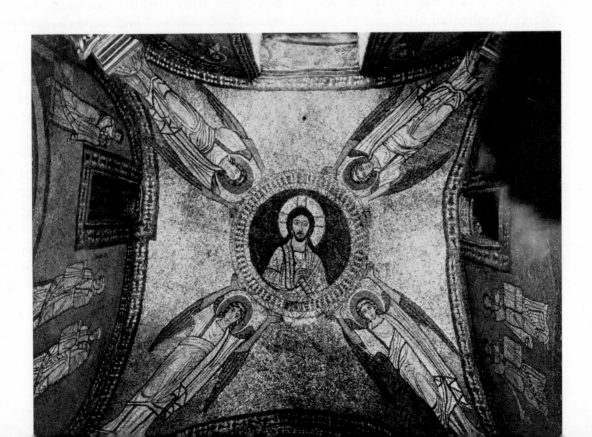

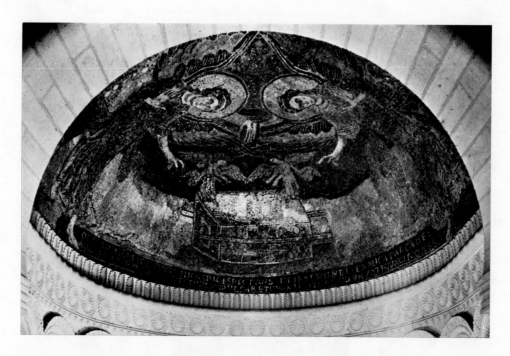

123. *Ark of the Covenant Adored by Angels.*
Dome mosaic. c. 806. Oratory of Theodulf, Germigny-des-Prés

ers, but images as works of art were not opposed, still less forbidden. Nevertheless, during the lifetime of Charlemagne there was a marked restraint in the choice of subjects, those recommended in the *Libri Carolini* being illustrations from the Bible and from the lives of the saints. The attitude to images was relaxed by the Paris Synod of 825, resulting in the much richer iconography of later Carolingian art.

One of the arguments of the Council of Nicaea was that the Biblical description of the Temple of Solomon, with the Ark of the Covenant surmounted by cherubim, was proof of God's approval of images. The *Libri Carolini* rejected this, claiming that these works in the Temple were God-inspired and could not be compared to ordinary works of art. It is believed that Theodulf was one of the principal authors of the *Libri Carolini* and yet, in the chapel built by him, it is not Christ in Majesty or some other more usual subject that is represented, but the Ark of the Covenant, as if Theodulf was trying to make his chapel an imitation of the Temple of Solomon.

Of the less durable technique of wall decoration, the fresco, very little has survived. In St-Germain at Auxerre, scenes of the martyrdom of St. Stephen are preserved in the crypt, painted about 850 in a style full of lively movement and convincing expressions. The crypt, which has some good capitals made in stucco, is further decorated with painted acanthus leaves and *trompe-l'oeil* columns and capitals that pretend to support the vaulting. Somewhat similar wall paintings, but without any narrative scenes and confined only to imitation columns with Ionic capitals that support an architrave, are found in the upper chamber of the gatehouse at Lorsch. From documents we learn that in the imperial palace at Ingelheim, near Mainz, Louis the Pious ordered the painting of scenes depicting the deeds of ancient rulers and, facing them, those of Christian heroes, including scenes from the recent Frankish past. In the church at the same place, Old and New Testament scenes were on separate walls of the nave. Great emphasis was placed on the exploits of David and Solomon, the favorite heroes of the Frankish

rulers and frequently compared to these by their Frankish contemporaries.

In the Alpine region, along the old pass from Switzerland to Italy, a few churches have preserved their ninth-century wall paintings; those at Müstair (in Switzerland) are the most extensive, but unfortunately overrestored. At Malles Venosta (nearby, but in the Italian Tyrol; colorplate 17), side by side with the stuccos already mentioned (see page 113), are frescoes of high quality that include portraits of the donors. The inspiration for these paintings came from northern Italy, where, toward the end of the existence of the Lombard kingdom, the arts flourished in a sudden outburst of activity under the patronage of the last king, Desiderius. The fragmentary paintings at Cividale and those at S. Salvatore at Brescia testify to the high standard of this art.

The only parallel to the Carolingian nonfigurative paintings is found in the Asturian church of S. Julian de Los Prados at Oviedo, built in the first quarter of the ninth century, where the subjects are exclusively ornamental and architectural motifs. Except for the four crosses, this decoration could easily be taken for non-Christian, and it seems certain that these paintings reflect a deliberately iconoclastic attitude.

Such extreme examples were probably rare; on the whole, Carolingian wall paintings had a didactic function, following the precept of St. Gregory the Great, who wrote that "painting is admissible in churches, in order that those who are unlettered may yet read by gazing at the walls what they cannot read in books."

MANUSCRIPTS AND ALLIED ARTS

However, Carolingian art expressed itself to the fullest, and is best known today, through manuscript painting. The main credit for this must go to Charlemagne. Einhard, his biographer, writes that, although the emperor could hardly write, he was fluent in Latin and could understand Greek and that he "most zealously cultivated the liberal arts." Einhard further writes that Alcuin,

"who was the greatest scholar of the day, was his [Charlemagne's] teacher." Charles' interest in learning led to great efforts to establish schools in monasteries and bishoprics. He surrounded himself with scholars and promoted them to high office. Alcuin, the renowned teacher at York, was induced by Charles to take charge of the palace school at Aachen in 782, and fourteen years later, when Alcuin became abbot of St-Martin at Tours, that monastic center soon became a celebrated seat of learning. Through Alcuin the achievements of the Northumbrian renaissance were made available on the Continent, and they stimulated the Carolingian revival. Einhard, who was the author of the *Vita Caroli Magni,* was brought up in the monastery of Fulda, founded in 743 by St. Boniface, the great Anglo-Saxon missionary; he joined the palace school at Aachen and became the secretary of Louis the Pious. An artist himself, Einhard had studied Vitruvius and had a genuine interest in classical art. He is credited with assembling at Aachen a collection of manuscripts and carvings which could serve as models for the court artists. Other scholars, poets, and theologians at the court, or in close contact with it, created and stimulated the demand for books imported from Italy and Byzantium, and commissioned copies of them. The variety of these models produced the differences between the various groups of Carolingian manuscripts.

The Ada Group At Aachen itself, two distinctive styles were in existence, the so-called Ada Group and the Palace School. The earliest manuscript of the Ada Group was commissioned by Charles and his queen in 781, and completed in a year and seven months by a scribe, Godescalc (fig. 124). It is a Gospel Lectionary with lavish paintings that use a great deal of gold and heavy colors, including much purple. The text is written in gold and silver. The ornamental motifs on the opening page of each Gospel rely heavily on interlaces of Hiberno-Saxon origin, but the portraits of the Evangelists and the *Christ in Majesty*

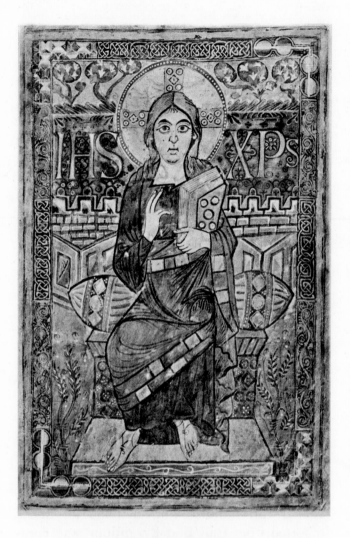

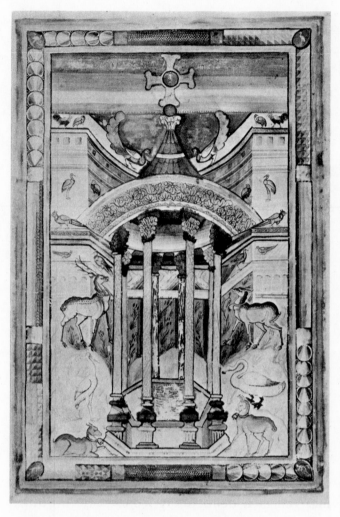

124. *Christ Blessing.*
Gospel Lectionary of Godescalc.
12 5/8 × 8 1/4″. 781–83. Bibliothèque Nationale
(Ms. nouv. acq. lat. 1203, fol. 3r), Paris

125. *Fountain of Life.*
Gospel Book of St-Médard de Soissons.
14 1/8 × 10 1/2″. Early 9th century. Bibliothéque Nationale
(Ms. lat. 8850, fol. 6v), Paris (see colorplate 18)

derive from Byzantine models, such as the mosaics of S. Vitale at Ravenna (see fig. 56). These miniatures are still hesitant, a clear sign of the artist's lack of experience, but in the later works from this school—the Ada Gospels, the Gospel Book of St-Médard of Soissons (commissioned by Charles and given to Soissons by Louis the Pious; colorplate 18), and others—the colors are more vivid, the drawing more assured and lively, the details more precise, and the impression of depth more convincing. The portraits

of the Evangelists are frequently surrounded by frames incorporating minute narrative scenes. Occasionally such small scenes are painted within the initials.

The Godescalc Gospels commemorated the baptism of Charles's son Pepin in Rome and, appropriately, it included a representation of a baptistery with a basin for immersion; the baptistery was given the form of a Fountain of Life flanked by birds and animals. This composition was repeated in other manuscripts, with

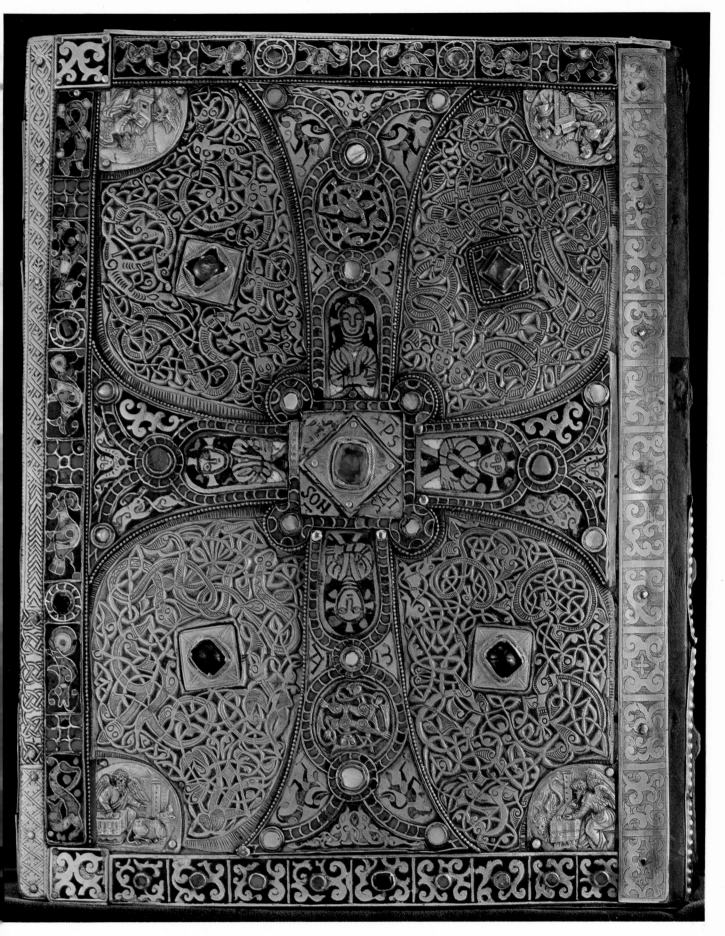

Colorplate 16. Book Cover (back). Lindau (Ashburnham) Gospels.
Silver gilt with enamel and precious stones; 13 3/8 × 10 3/8″. c. 800.
Pierpont Morgan Library (Ms. 1), New York

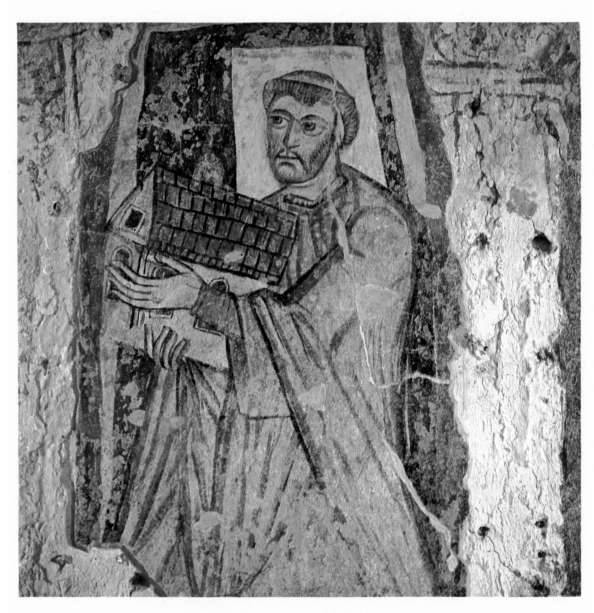

Colorplate 17. *Portrait of the Donor*. Fresco.
9th century. San Benedetto, Malles Venosta

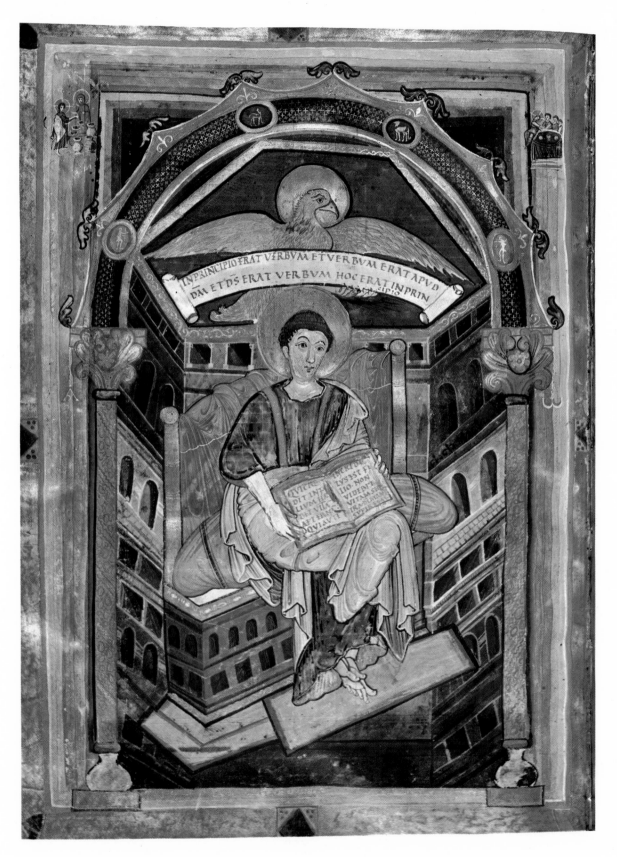

Colorplate 18. *St. John the Evangelist.* Gospel Book of St-Médard de Soissons.
14 1/8 × 10 1/2″. Early 9th century.
Bibliothèque Nationale (Ms. lat. 8850, fol. 180v), Paris

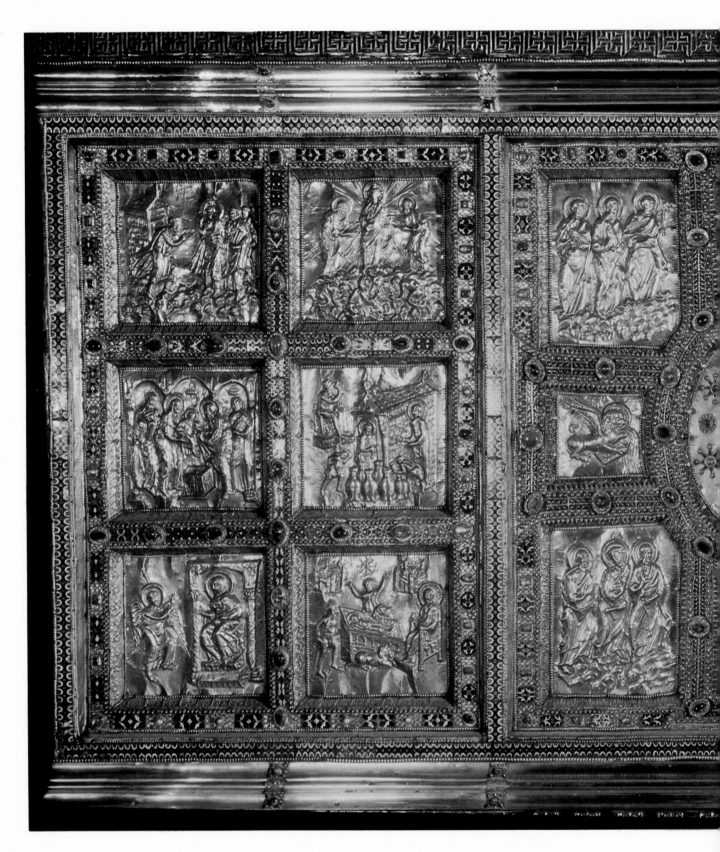

Colorplate 19. WOLVINIUS. Front of Altar of St. Ambrose (*Paliotto*).
Gold with enamel and precious stones; 2′ 9 1/2″ × 7′ 2 5/8″. 824–59.
Sant'Ambrogio, Milan

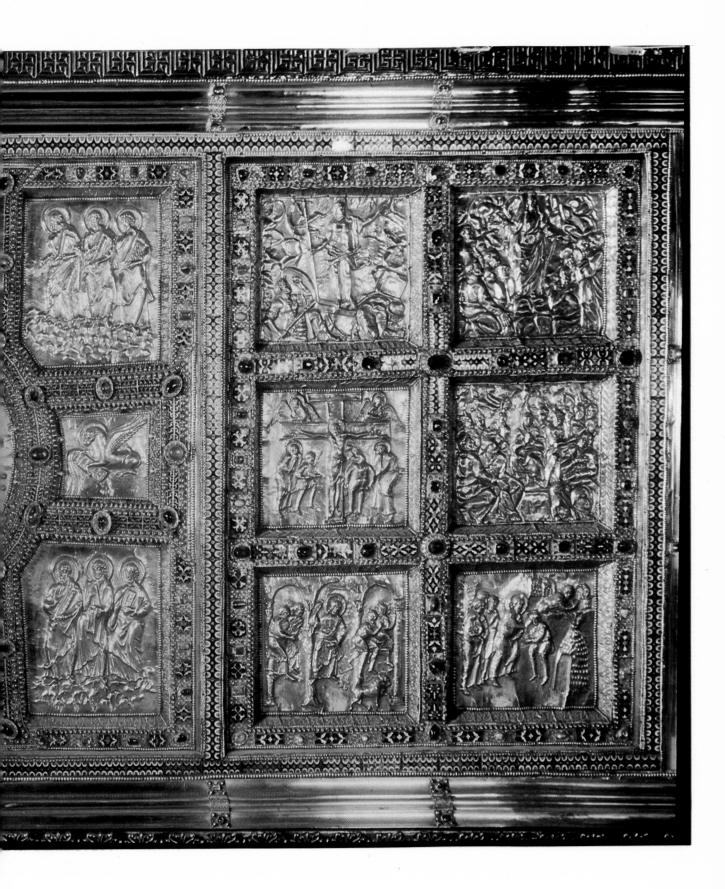

Colorplate 20. *St. Mark.* Gospel Book of Ebbo. 10 1/4 × 7 3/4″. 816–35.
Bibliothèque Municipale (Ms. 1, fol. 6ov), Epernay

Colorplate 21. *Presentation of the Bible to Charles the Bald.* Vivian Bible
(First Bible of Charles the Bald). 19 1/2 × 13 5/8″. c. 845.
Bibliothèque Nationale (Ms. lat. 1, fol. 423r), Paris

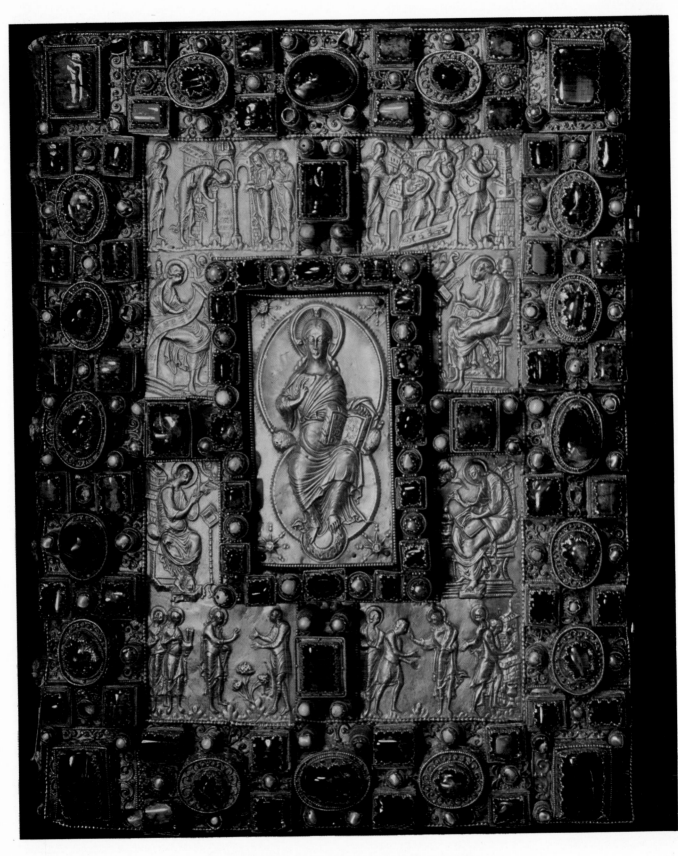

Colorplate 22. Book Cover with *Christ in Majesty*,
Four Evangelists, and Scenes of Christ's Miracles (front).
Codex Aureus of St. Emmeram.
Gold with pearls and precious stones; 16 1/2 × 13″. 870.
Bayerische Staatsbibliothek (Cod. lat. mon. 14000), Munich

much elaboration and the inclusion of classical details (fig. 125). To assess the importance of these earliest Carolingian manuscripts, it is sufficient to turn to the Merovingian works which preceded them. The contrast is between a naive and childlike art and one that strives to bridge the gap of centuries and return to the great traditions of Early Christian art.

Closely related in style, and perhaps even the work of the same artists, are a few ivory book covers of which those for the Lorsch Gospels (fig. 126; the back cover is in the Victoria and Albert Museum, the front in the Vatican) are the most outstanding. In their form both parts are based on five-part diptychs, but their stylis-

tic source is clearly Maximian's throne in Ravenna (see colorplate 9). This agrees well with the connections between the Ada Group style and Byzantine art of the sixth century, particularly the Ravenna mosaics. Other ivories which must have been made by the court painter-carvers confirm that the sources for their sculptured works were ivory diptychs of the fifth and sixth centuries. This certainly holds true for the book cover of the Dagulf Psalter in the Louvre and the book cover in Oxford (fig. 127), which is on a book attributed to Chelles, near Paris. This last, with the youthful Christ in the center trampling on a serpent and lion (Psalm 90:13: "Thou shalt walk upon the asp and the basilisk: and

126. Ivory Book Cover with Virgin,
Zacharias, and John the Baptist.
Lorsch Gospels (back). 14 7/8 × 10 3/4".
Early 9th century.
Victoria and Albert Museum, London

127. Ivory Book Cover with *Youthful Christ*
and Scenes from His Life.
8 1/4 × 5". Early 9th century.
Bodleian Library (Ms. Douce 176), Oxford

128. *The Four Evangelists.*
Aachen Gospels. 12 × 9 1/2". c. 810.
Cathedral Treasury (Evangeliar, fol. 14v), Aachen

thou shalt trample under foot the lion and the dragon"), is framed by small scenes, six being identifiable copies of fifth-century diptychs.

The Palace School The manuscripts of the Palace School are fewer in number, and are all datable to the last decade of the eighth and the first of the ninth centuries. They include the Vienna Treasury Gospels and the Aachen Gospels. Their striking feature is the portraits of the Evangelists, painted either one to a page (at Vienna), or all four together (at Aachen; fig. 128). These miniatures are generally agreed to be the work of Greeks, for it is inconceivable that northern or even Italian artists could have mastered the Hellenistic style in which these manuscripts are painted. The illusionistic treat-

ment of the landscape, the architectural backgrounds, and the figures spring from late antique art. The figures, clad in voluminous togas, provide a complete contrast to the more linear style of the Ada Group. There are no unnecessary and distracting details; they are painted rather than drawn. The modeling is achieved with the help of light and shade, and the source of light is rational throughout. There is a certain similarity between these paintings, beautiful in their simplicity, and those in the Lombard chapel at Castelseprio (see fig. 81), a circumstance that is often used for dating the latter to the Carolingian period.

The Palace School style has its roots in the art of classical antiquity, a Mediterranean style artificially transplanted to Aachen. But this style

initiated a development that was to last for some four hundred years and which was, in many ways ironically, to symbolize the northern element in medieval art. Only in its final states, toward the end of the twelfth and early in the thirteenth century, did this development lead to an astonishing return to classical traditions in the metalwork of Nicholas of Verdun and in the stone sculpture of the Master of the Antique Figures at Rheims (see page 372).

These two styles of painting at the court of Charlemagne had their influence in the immediate as well as in the more distant future.

The Rheims School The next step in the development of Carolingian art was due to the patronage or influence of Emperor Louis the Pious. Deeply religious and learned, he gave support to St. Benedict of Aniane in his work of monastic reform. The modified Benedictine Rule was imposed on all the monastic houses of the Empire. Physical work by the monks was no longer required, more stress was put on elaborate liturgy, and more monks were required to be priests. All of this meant a higher intellectual level in monastic life, and with it, more and more books. Louis himself was a bibliophile and a suggestion has been made that the so-called Rheims School of manuscript painting was, in fact, located at one of his residences, Aachen or Ingelheim.

The claim of Rheims as a center for book illumination rests on the evidence of dedicatory verses in a Gospel Book, the Ebbo Gospels (colorplate 20), still preserved at Epernay: the verses were written by Peter, abbot of Hautvillers (halfway between Rheims and Epernay), in praise of Ebbo, archbishop of Rheims from 816 to 835 and formerly the imperial librarian, who made a gift of this book to Hautvillers. The books known as the Rheims books have certain common characteristics and clearly came from one scriptorium. The painters of this so-called Rheims School were probably trained by the Greeks of the Palace School, for their style

springs from the illusionism of such books as the Aachen Gospels. Among the Rheims books are copies of illustrated classical texts, such as the plays of Terence and the *Physiologus,* proving that the scriptorium had access to a body of classical models. The most important manuscripts surviving from the scriptorium are the Ebbo Gospels at Épernay and the Psalter which, by about 1000, found its way to Canterbury (and ultimately to the University at Utrecht); it is generally known as the Utrecht Psalter. Both these books were made sometime during the rule of Ebbo.

The Utrecht Psalter (figs. 129, 130) is not painted, but drawn in brown bister; the drawings stretch without frames across the page, interrupting the three columns of the text. The small figures are drawn with great rapidity and with only a few strokes, and they are set in hilly landscapes indicated with a line or two. Everything is movement, gesture, and expression. The crowds swarm like ants, agitated, tense, in constant motion, their robes swirling as if blown by the wind. This dynamic, expressive style obviously depends on late antique models but, at the same time, it is very personal and the work of a great artist. No wonder this style caught the imagination of many later artists. As the style is novel, so is the iconography, which is a literal illustration of the text. A similarly ecstatic, nervous, and expressive style is found in the Ebbo Gospels, in which the portraits of the Evangelists are, however, painted, not drawn.

Inspired by the style and iconography of the Utrecht Psalter is a group of ivories known as the Liuthard group, which were made as book covers for manuscripts (some by a scribe named Liuthard) associated with Charles the Bald. The manuscripts date to between 850 and 860, but a case has recently been made for dating these ivories to the preceding reign of Louis the Pious.

The division of the Empire into three kingdoms by the Treaty of Verdun (843) marks the begin-

132

ETCIRCUMDABOALTA
RITUUMDNE
UTAUDIAUOCIMLAU
DIS ETINARREMUNI
UERSAMIRABILIATUA·
ONEDILEXIDECOREMDO
MUSTUAE ETLOCUMHA
BITATIONISGLORIAE
TUAE

NEPERDASCUMIMPIIS
ANIMAMMEAM ETCU
UIRISSANGUINUM
UITAMMEAM·
INQUORUMMANIBUS
INIQUITATESSUNT·
DEXTERAEORUMREPLE
TAESTMUNERIBUS·

EGOAUTEMININNOCEN
TIAMEAINGRESSUSSUM
RIDIMEMEETMISERERE
MEI·
PESMEUSSTETITINDIREC
TO INECCLESIISBENE
DICAMTEDNE·

XXVI DAUID PRIUSQUAMLINE RETUR

DNSINLUMINATIO
MEAETSALUSMEA·
QUEMTIMEBO·
DNSPROTECTORUITAE
MEAE AQUOTREPIDABO·
DUMADPROPIANTSUPER
MINOCENTES UTEDANT
CARNESMEAS·
QUITRIBULANTMEINI
MICIMEI IPSIINFIRMA

TISUNTETCECIDERUNT·
SICONSISTANTADUER
SUMMECASTRA NON
TIMEBITCORMEUM·
SIEXSURGATADUERSU
MEPROELIUM INHOC
EGOSPERABO·
UNAMPETIIADNOHANC
REQUIRAM UTINHA
BITEMINDOMODNI·

OMNIBUSDIEBUSUI
TAEMEAE
UTUIDEAMUOLUNTATE
DNI ETUISITEMTEMPLU
EIUS
QNMABSCONDITMEIN
TABERNACULOSUOIN
DIEMALORUM PRO
TEXITMEINABSCONDITO
TABERNACULISUI·

129. Page with text and illustration of Psalm 26.
Utrecht Psalter. 13 × 9 7/8″. 816–35.
University Library (Ms. Script. eccl. 484, fol. 15r), Utrecht

ning of the political division which separated France and Germany. Charles the Bald was to rule over the Romance-speaking West Franks, Louis the German over the German-speaking East Franks, while to Lothar I was allocated the narrow and long stretch of territories between the two, from Frisia (now the Netherlands) through Mid-Francia (including Aachen, Burgundy, and Provence) to Italy. This artificial creation disintegrated before long, and the lands then known as Lotharingia, from Burgundy to the North Sea, have remained a bone of contention between France and Germany.

The School of Metz Under Lothar's rule and during the bishopric of Drogo (bishop 823–44, archbishop 844–55), Metz became an artistic

DIUMLINGUASSUAS
INTENDERUNTARCUM
REMAMARAM·UTSA
CITTENTINOCCULTIS
INMACULATUM·
SUBITOSAGITTABUNTEU
ETNONTIMEBUNT·FIR
MAUERUNTSIBISERMO
NEMNEQUAM·
NARRAUERUNTUTABS·
CONDERENTLAQUEOS·

·DIXERUNTQUISUIDE
BITEOS·
SCRUTATISUNTINIQUITA
TES DEFECERUNTSCRU
TANTESSCRUTINIO·
ACCEDETHOMOETCORALTU
ETEXALTABITURDS·
SAGITTEPARUULORUFAC
TAESUNTPLAGEEORUM
ETINFIRMATAESUNT
CONTRAEOSLINGUAEEORU

CONTURBATISUNTOMNES
QUIUIDEBANTEOS·ETTI
MUITOMNISHOMO·
ETADNUNCIAUERUNT
OPERADI·ETFACTAEIUS
INTELLEXERUNT·
LAETABITURIUSTUSIN
DNO·ETSPERABITINEO·
ETLAUDABUNTUR·OM
NESRECTICORDE·

LXIII INFINEM
PSLODCANTICUMHIE
TEDECETHYM
NUSDSINSION·ETTIBI
REDDETURUOTUM
INHIERUSALEM·
·EXAUDIORATIONEMME
AM·ADTEOMNISCARO

REMIAETTACCEIDE
UERBOPERECRINA
UENIET·
UERBAINIQUORUMPRAE
UALUERUNTSUPERNOS·
ETIMPIETATIBUSNOS
TRISTUPROPICIABERIS·
BEATUSQUEMELEGISTI

TIONISQUANDOIN
CIPIEBANTPROFICISCI
ETADSUMSISTI·INHABI
TABITINATRIISTUIS·
REPLEBIMURINBONIS
DOMUSTUAE·SCMEST
TEMPLUMTUUMMIRABI
LEINAEQUITATE·

130. Page with text and illustration of Psalm 63.
Utrecht Psalter. 13 × 9 7/8″. 816–35.
University Library (Ms. Script. eccl. 484, fol. 36r), Utrecht

center producing important manuscripts and ivories which show some influence of the Rheims School style (fig. 131). There is sufficient similarity between the illuminations and the ivories to attribute them to the same artists. The best-known manuscript of the group is the Drogo Sacramentary of about 850 (fig. 132), decorated with historiated initials that illustrate episodes from the life of Christ and liturgical scenes. On the ivory cover of this manuscript there are also small scenes showing events from Christ's life as well as liturgical scenes, including various moments in the Mass.

It was also at Metz, during the reign of Lothar II (855–69), that one of the most beautiful works of Carolingian art was produced: the great rock crystal with eight episodes engraved upon it from the story of Susanna, falsely accused of

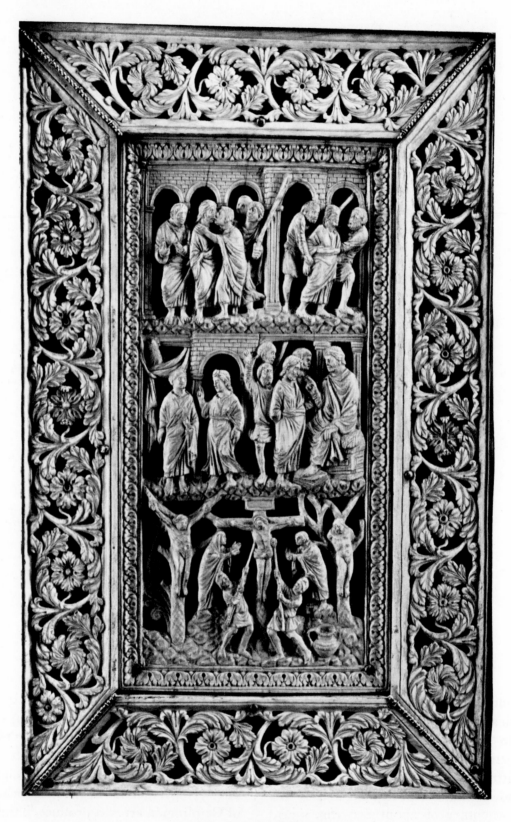

131. Ivory Book Cover
with Scenes from the Passion of Christ.
10 × 6 3/4". Mid 9th century.
Bibliothèque Nationale (Ms. lat. 9388), Paris

132. Initial C with *Ascension of Christ*.
Sacramentary of Drogo. 10 3/8 × 8 3/8".
c. 850. Bibliothèque Nationale (Ms. lat. 9428, fol. 71v), Paris

adultery (fig. 133). The inscription over the central scene states that the object was made for King Lothar; it has been convincingly argued that the date must have been 865, when, under papal pressure, the king took back his wife, whom he had previously accused of adultery. The gift of the crystal was probably a gesture of reconciliation. Although it is more orderly in composition than the Utrecht Psalter, the crystal brings

to mind some of those drawings but its closest connection is with the Metz ivories. Metz lost its importance as an artistic center after the division of Lotharingia, in 870, into the West and East Frankish kingdoms, but it was during this last phase of activity in Metz, between 870 and 875, that an important work of art was made there, namely, the coronation throne of Charles the Bald, known as the Cattedra di S. Pietro,

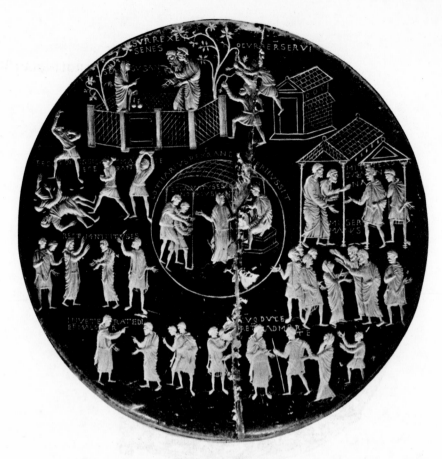

133. Crystal of Lothar.
Rock crystal, diameter 4 1/2". 865. British Museum, London

preserved in the main apse altar of St. Peter's in Rome. The throne became an object of veneration, and, enclosed by a Baroque cover, was practically forgotten until a recent restoration and publication made it known again.* The wooden structure of the throne is embellished by ivory plaques and strips. On the front of the throne are ivory plaques engraved with the exploits of Hercules, reused from an older, probably eighth-century object, taken, no doubt, from the imperial treasury. The strips are carved with acanthus scrolls "inhabited" by constellations, by Sol, Luna, Terra, and Oceanus, and by lively combat groups; below the gable is the coronation of Charles the Bald. The carving is executed with great skill and artistry, and it has been convincingly demonstrated that the principal stylistic source for these ivories was, once again, the Utrecht Psalter.

* *Atti della Pontificia Accademia Romana di Archeologia: Memorie*, series 3, vol. 10, Vatican, 1971.

The School of Tours Another center which for a brief period came to the fore in the production of manuscripts, was Tours. It was to the ancient abbey of St-Martin at Tours that Alcuin retired from the imperial court in 796, and spent the last eight years of his life on the revision of the Vulgate text of the Bible. The books illuminated during his abbacy were only modestly decorated with paintings, clearly inspired by Hiberno-Saxon models. It was not until later, during the abbacy of two lay abbots, Adalbard (834–43) and Vivian (843–51), that a very large number of books, chiefly Bibles, were illuminated at Tours. The library at St-Martin perished in the Viking raid of 853, so our knowledge of the

134. *Genesis Scenes*. Moûtier-Grandval (Alcuin) Bible.
20 1/8 × 14 3/4". c. 840.
British Library (Ms. Add. 10546, fol. 5r), London▶

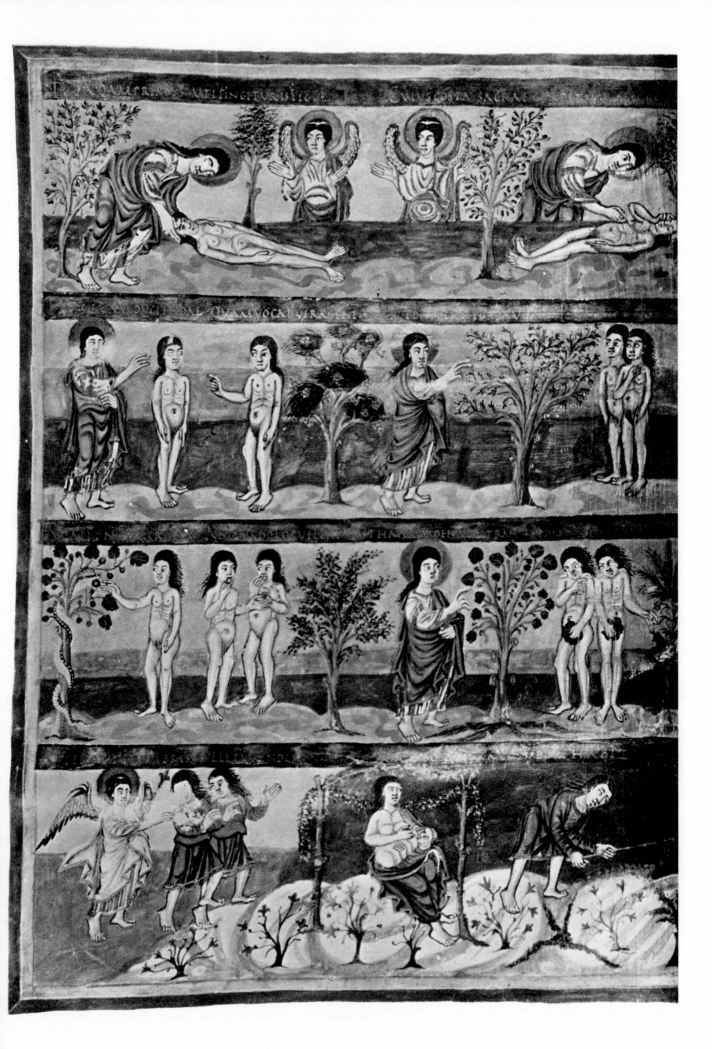

Tours School is based on books which were commissioned from outside or sent elsewhere as gifts. For his work on the Vulgate text Alcuin must have obtained several early Bibles, and these would have served as models for Carolingian painters. The great Moûtier-Grandval Bible has a page depicting the opening chapters of Genesis, from the *Creation of Adam* to *Adam's Labors* (fig. 134); here God is youthful and beardless, as He is often represented in Early Christian art. The scenes are in horizontal strips, two to each strip, and take place in a landscape in which receding space is suggested by bands of color, as in antique painting. Another famous Bible made at Tours and given to Charles the Bald, probably in 845, is known as the Vivian Bible or the First Bible of Charles the Bald (colorplate 21). One of the whole-page pictures shows the actual ceremony of the presentation of the book, a scene of considerable historical interest.

Other Centers There were, of course, numerous

135. MASTER OF ST. GILES. *St. Giles Saying Mass* (detail).
Entire panel 24 × 18″. 15th century.
National Gallery, London

other centers of book production, of lesser importance than those already mentioned or perhaps less well known through the accidental loss of their books. The rather eclectic manuscripts from the court of Charles the Bald are usually attributed to St-Denis Abbey. In the monastic centers of the north, especially at St-Amand, the influence of the Hiberno-Saxon style was sufficiently strong to inspire a purely decorative type of illumination with elegant interlaces, known as the Franco-Saxon style.

Charles the Bald was a considerable patron of the arts. He became lay abbot of St-Denis in 867, and he is credited with the creation of a Court style based at the abbey. Apart from the somewhat eclectic manuscripts, superb works in metal were produced in this Court School. One of these was the gold altar frontal given to the abbey by Charles. This altar frontal is known from a Franco-Flemish painting of about 1500 in the National Gallery, London (fig. 135), the original frontal having been destroyed during the French Revolution. Studded with precious stones, it had an embossed *Christ in Majesty* in the center. A similar subject, also in embossed gold, forms the center of the book cover made in 870 by the Court School (colorplate 22), a work that is still preserved in Munich. The symbols of the Evangelists and small scenes of Christ's miracles surround the *Majesty,* and numerous gems give the whole a sumptuous and colorful appearance. The style owes something to the Rheims and Tours schools. The elongated figures are graceful and elegant, the draperies cling tightly and flutter at the edges.

The only other center where metalwork of such a high quality was made at that time, or a little earlier, was Milan. The golden altar, or *Paliotto,* still in use in S. Ambrogio over the tomb of St. Ambrose, was due to the patronage of Angilbert II, archbishop from 824 to 859, and it was executed by a certain Wolvinius (colorplate 19; fig. 136). These facts are known from the inscriptions on the two lower roundels

136. WOLVINIUS. *St. Ambrose Crowning Master Wolvinius.*
Medallion on back of Altar of
St. Ambrose (*Paliotto*).
Silver with gold leaf, enamel,
and precious stones; dimensions of whole
2′ 9 1/2″ × 7′ 2 5/8″. 824–59.
Sant'Ambrogio, Milan (see colorplate 19)

at the back of the altar, one showing the archbishop presenting the altar to St. Ambrose, the other a rather extraordinary scene in which St. Ambrose places a crown on the head of the craftsman. Surely there were no artists of the Renaissance who could claim such rewards for their talents.

The altar's four sides are decorated with small scenes in embossed gold, silver, and silver-gilt, framed by filigree and enamels. The iconography of the scenes is unusual for Carolingian art

since it is concerned with the New Testament only. It is believed that the iconography is based on Early Christian and Byzantine sources. There are other works in metal from this period in Italy, but none can be compared in artistic merit to the *Paliotto*.

The breakup of the Empire, and murder and pillage, brought the artistic life of the West to a standstill by the end of the ninth century. The Vikings, as we have seen (page 112), turned their attention first to the British Isles, sacking the Northumbrian abbeys; ultimately they settled in parts of England, the Shetland and Orkney islands, and the coastal areas of Ireland. Toward the middle of the ninth century the Vikings turned to the Continent, pillaging Rouen, Paris, Tours, Trier, and many other cities. Their raids continued until finally, in 911, a treaty gave them the territories around the lower Seine for settlement. Thus the Duchy of Normandy came into being, and the Vikings, having accepted Christianity, became vassals of the French crown.

The second threat to the West came from the Muslims. Sicily, until then under the rule of Byzantium, was occupied by Arabs from Africa, who used the island as a base for raids and conquests, however temporary, in southern Italy. They even reached Rome in 846 and pillaged St. Peter's, and in 881 they burnt Montecassino. The harassment of the Italian coastland continued throughout the next century until Byzantium reasserted its power in the south and fleets were built by the trading cities, such as Venice, Pisa, and Genoa. In the meantime the Arabs from Spain, who established themselves in a stronghold in Provence, raided the Alpine regions for well over a century. It is ironic to think that the final defeat of the Sicilian Arabs came at the hands of the descendants of the Vikings from Normandy.

Italy suffered from yet other invasions, those of the Hungarians, who, having occupied land on the middle Danube, plundered Lombardy in 899 and repeated the feat at regular intervals, reaching at one time (947) as far as Apulia. But the most devastating Hungarian raids were on Germany and, on occasion, on France. Not until their disastrous defeat in 955 by Otto the Great was the menace removed; and by the end of the century the Hungarians had become a Christian kingdom.

VI

Middle Byzantine Art; Armenian and Georgian Art

The period between 843, the end of the Iconoclastic Controversy, and the occupation of Constantinople by the Latins in 1204 is often called the Macedonian Renaissance, from the dynasty which started with Basil I the Macedonian (867–86) and ended in 1056; it was followed by a series of rulers among whom the most important were the Comnenes (1081–1185). During that long period Byzantium retained, in spite of many setbacks, its role as a leading power and the heir of the Roman Empire. The loss, in 1071, of most of Asia Minor to the Seljuk Turks was a disaster, with serious consequences for the future, but Byzantine influences were extended in other directions by the conversion of the Balkans (Bulgaria in 864) and Russia (988).

One result of the Iconoclastic Controversy in church building was a reduction in the size of churches. The monasteries, which had previously consisted of communities of several hundred persons, became very small, chiefly because of taxation. The sanctuary, or *naos*, where the liturgy was performed, thus shrank in size, and with it, the rest of the church. Most plans were of the Greek-cross type or the octagon-dome type, or a combination of these. The Katholikon at Hosios Lukas in Greece (figs. 137–40), built in 1011, is a good example of a Greek-cross-octagon building, consisting of a large octagonal dome that rests on a square base with the help of corner squinches. The square is penetrated by the four arms of the Greek cross, the eastern arm ending in an apse and having an additional dome over the sanctuary. All this is contained in a rectangular structure. Between the arms of the cross are additional two-story bays, opening by arcades and galleries toward the central square and the cross arms. The interior is covered with marble incrustations and mosaics, lit by subdued light coming from all directions.

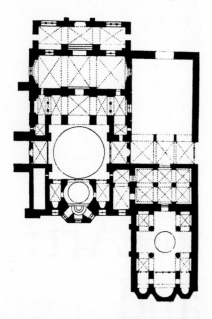

137, 138, 139, 140. Katholikon (1011) and
Panaghia (mid 19th century),
Monastery of Hosios Lukas (Greece)

(*left*) Plan of Katholikon (left)
and Panaghia (right)

(*below*) Interior toward east,
Katholikon

(*opposite, above*) Exterior from east,
Katholikon (left) and Panaghia (right)

(*opposite, below*) Exterior from south,
Katholikon

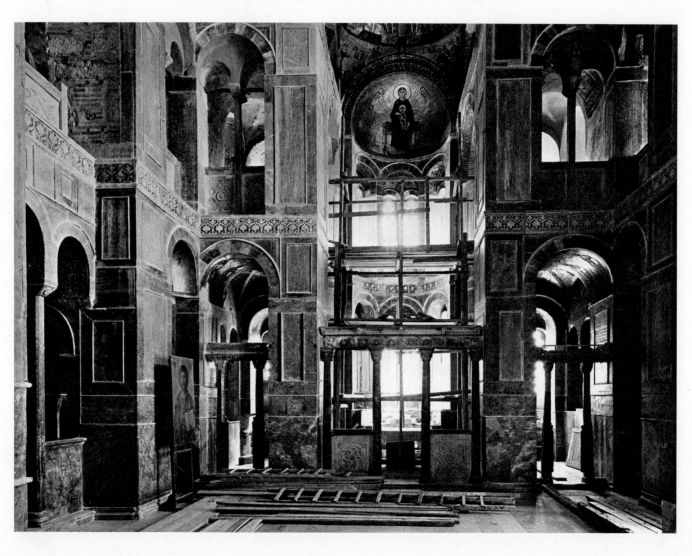

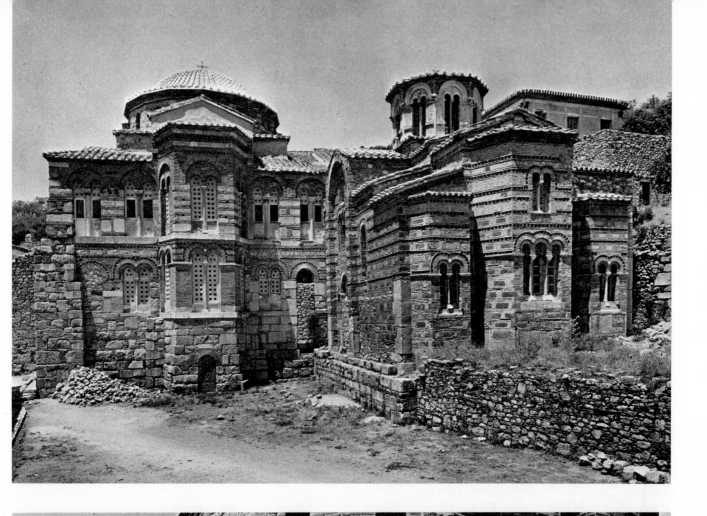

The general impression is of breath-taking beauty. The exterior is rich in color effects by the use of ashlar framed by courses of brick, and the rough texture of the ashlar is emphasized by the use of numerous smooth marble reliefs.

The part played by sculpture in the churches of this period is not well known because the Turks, when they subsequently converted the churches into mosques, destroyed the figural representations. But some rich nonfigurative decorations are still in existence, such as the capitals and pilasters of the Fenari Isa Čami church in Constantinople (tenth century), and the friezes of the Panaghia at Skripu in Greece (ninth century). Adjoining the eleventh-century Katholikon at Hosios Lukas is an older monastic church, the Panaghia, dating from soon after the middle of the tenth century. A recent restoration uncovered decorative exterior friezes of terracotta consisting of Kufic letters, carved tympana over the windows of the dome, gargoyles for the ejection of rainwater, marquetries (plaques of marble with grooved designs filled with colored paste or mastic), and other decorative features, all of them inspired by Islamic sources (fig. 139, right). Also Islamic in inspiration are the window grilles of the Katholikon. These clearly Islamic elements came to Greece* from Constantinople, where, in the second quarter of the ninth century, Emperor Theophilus built a palace on the Asiatic side of the Bosphorus in imitation of the Caliphs' Palace in Baghdad; he and some of his successors also made additions to the Great Palace at Constantinople (see page 51), furnished under strong Islamic influence. Hosios Lukas was a monastery of imperial foundation (Romanus II), and must have been in fairly close touch with the capital. Some of its mosaics were, it will be seen, by artists sent from Constantinople.

* A. Grabar, "La décoration architecturale de l'églises de la Vierge à Saint-Luc en Phocide et les débuts des influences islamiques," *Comptes rendues de l'Académie des inscriptions et belles-lettres,* Jan.–Mar., 1971.

141. *Lion and Tree.*
Silk, compound twill; 9 1/2 × 13 2/3″.
Late 10th–early 11th century.
Treasury of St. Servatius, Maastricht

In spite of frequent warfare, contact with Islam was close, especially through trade. Byzantine silks (fig. 141), woven in Constantinople throughout this period, show an obvious debt to Islamic textiles. Such silks supplied motifs which were copied in other media, not only in Byzantium but also in the West, where Eastern textiles were sought after and highly valued.

The greatest achievements of Middle Byzantine art were in the fields of painting and ivory carving, and the term Macedonian Renaissance refers principally to them. The stripping of the mosaics and paintings from churches during the period of Iconoclasm subsequently provided an opportunity for great decorative schemes to be put in hand. The church of Hagia Sophia was one of the first to be restored to its former glory by new apse mosaics, completed in 867, of which there still survive the central group of the Virgin and Child (fig. 142) and one of the two assisting archangels. The majestic figures demonstrate that the hiatus of artistic production for over a hundred years was bridged remarkably well, and that the artists recaptured the classical element, always the strength of Byzantine art,

in the modeling of the faces and the treatment of the draperies. The same can be said of the nearly contemporary miniatures of the Homilies of St. Gregory Nazianzen (fig. 143), made between 880 and 883 for Emperor Basil I.

Byzantine art rose to even greater heights during the reign of Constantine VII Porphyrogenitus (912–59), a scholar, author, and artist. Two masterpieces date from this period and must have been due to the influence of the court circle: the Joshua Rotulus, now in the Vatican, and the Paris Psalter. The Joshua manuscript is obviously based on an ancient model which was a roll, not a codex (fig. 144). The tenth-century artist captured extremely well the classical spirit of the original, introducing here and there modifications in keeping with Byzantine customs. For instance, in the scene of the Gibeonites before Joshua, the ambassadors are shown prostrate, their hands veiled as in the court ceremonial. Stylistically the manuscript is related to the Paris Psalter, though in this latter, a codex, the figures are large and they fill the pages more fully.

In both manuscripts there is a profusion of various personifications, as in the *Repentance of David* (fig. 145), where a pensive girl above the kneeling David is inscribed with the word "repentance." But the classicism of this art is best seen in the naturalism of the poses and gestures and in the modeling of all the forms. In spite of their being copies, both have the freshness and inventiveness of great works of art.

Although some mosaics from the tenth and eleventh centuries survive in Hagia Sophia and elsewhere, the most complete scheme of decoration from the period is in the Katholikon of Hosios Lukas (c. 1020). It is also the most illuminating, as an illustration of a complex iconographic system that was evolved during the Middle Byzantine period. The highest zone, that of the domes and the conch of the apse, symbolized heaven. The zone of squinches, pendentives, high vaults, and upper walls was devoted to the life of Christ. The lower walls and vaults were

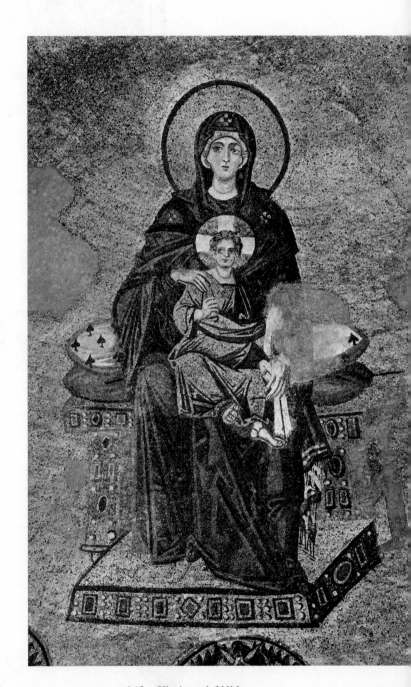

142. *Virgin and Child.*
Apse mosaic. 867.
Hagia Sophia, Constantinople

146

143.
Sacrifice of Isaac;
Jacob Wrestling
with the Angel,
and Dream of Jacob;
Anointing of David.
Homilies of
St. Gregory Nazianzen.
17 1/8 × 12″. 880–83.
Bibliothèque Nationale
(Ms. gr. 510, fol. 174v), Paris

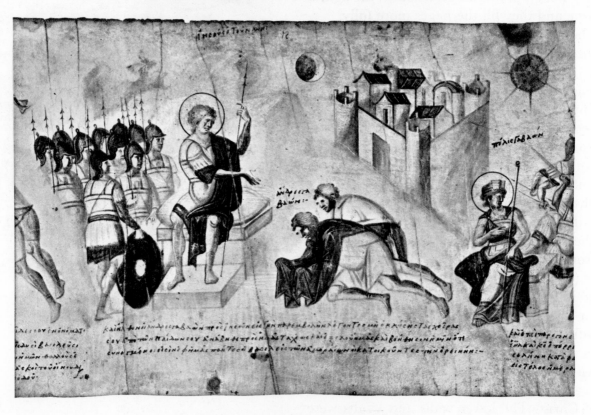

144. *Gibeonites Before Joshua.* Joshua Rotulus.
Height 12 3/8″; total length c. 33′. 10th century.
Vatican Library (Ms. pal. gr. 431), Rome

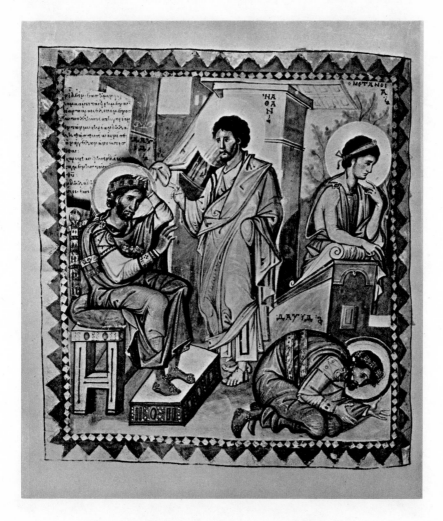

145. *Repentance of David*. Paris Psalter.
Page 14 1/8 × 10 1/4″. 10th century.
Bibliothèque Nationale (Ms. gr. 139, fol. 136v), Paris

designated to the terrestrial world. Only three subjects were used in domes during this period, the Ascension, the Pentecost, and the Pantocrator or All-Ruler. At Hosios Lukas two of these were represented, the Pantocrator with four archangels in the large dome (it was destroyed in an earthquake in 1593) and the Pentecost in the smaller one over the naos (fig. 146). Here, the center of the composition is occupied by the *Hetoimasia*, or prepared throne, upon which sits the dove of the Holy Ghost. From the throne, light radiates and descends like the spokes of a wheel on the circle of the seated apostles. The placing of this subject above the altar makes it clear that it was not intended as a narrative, historical event, but as "an allegory of the divine inspiration of the Church whose priests officiated below."*

The Virgin and Child are enthroned in the conch of the apse, thus completing the decoration of the "heavenly" zone. Among the scenes of the second zone, for instance, on the pendentives of the large dome, are the *Annunciation, Nativity, Presentation,* and *Baptism*; illustrations of the Passion and Resurrection are in the narthex (colorplate 23). Unlike such cycles in the West, which are arranged chronologically according to the life of Christ, in Byzantium the order of the scenes was dictated by the calendar of festivals.

* O. Demus, *Byzantine Mosaic Decoration: Aspects of Monumental Art in Byzantium*, Boston, 1950, p. 20.

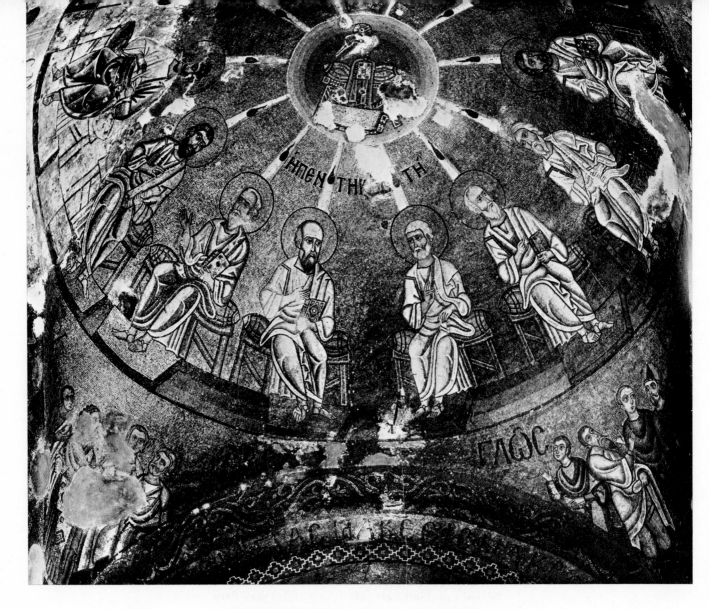

146. *Pentecost.* Dome mosaic in naos. c. 1020.
Katholikon, Monastery of Hosios Lukas (Greece)

On the walls of the whole church, in the third zone, are a host of saints, many of them monastic saints of local fame.

There is great stress on symmetry at Hosios Lukas, not only in the compositions but also in the correspondence of scenes on either wall of the church, along its east-west axis. It is for reasons of symmetry that some scenes are reversed, in comparison to their customary composition. The symmetry was also extended to embrace iconography and ideas, so that the scenes on either side of the building correspond in that respect as well.

This strict, even rigid iconographic system was not without influence on the style, which grew more austere and less dynamic. Even the narrative scenes became more hieratic, like icons, and the figures are as if frozen in movement. The lightness and freshness of the classicizing phase of the tenth century gave way to a more linear and "abstract" style.

Byzantine painting and mosaics are found during this period in new territories, recently brought under the Byzantine sphere of influence and rule. As a result of the conquest of Bulgaria (1018–1185) the cathedral of Hagia Sophia at Ochrid (now in Yugoslavia; fig. 147) was painted by artists who were presumably brought from Constantinople, about the middle of the eleventh century. Greek masons and painters were also

summoned to Kiev soon after the baptism of the Great Prince Vladimir (988) and his marriage to the daughter of Emperor Basil II, but nothing is left in Kiev from that early period. However, mosaics survive in the cathedral of Hagia Sophia in Kiev (colorplate 24), founded in 1037 by Prince Yaroslav, and these must have been executed by artists brought from Constantinople; but the frescoes, executed in 1045, depart in many respects from the iconography and style of Byzantine painting in Constantinople, and it is assumed that they were painted by local artists. There is documentary evidence that Greek mosaicists became monks in Kiev, and

trained local pupils. Although for many centuries Russia had been in close artistic contact with Constantinople, the eleventh century saw the birth of what was to become Russian art.

A great number of ivories produced in Constantinople during the tenth and eleventh centuries reached the West and thus survive to this day. Their popularity was well merited, for their execution is superb. Most of them are small portable altars, diptychs and triptychs (fig. 148). Frequently, the Crucifixion or the Virgin and Child is in the center, with a row of saints on the wings. The figures are frontal and stiff, placed against a flat background; even in narrative

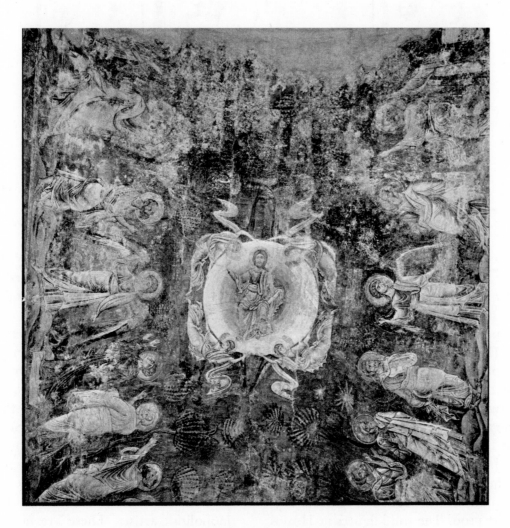

147. *Ascension of Christ*. Fresco on main vault.
Mid 10th century.
Hagia Sophia, Ochrid (Yugoslavia)

150

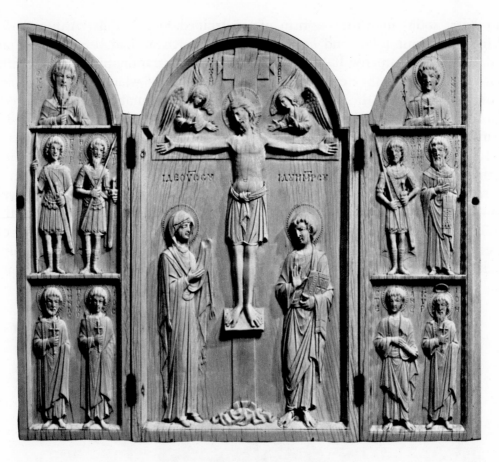

148. Triptych with *Crucifixion*, and Saints.
Ivory, height 10 7/8''. 10th century.
British Museum, London

scenes, such as the *Crucifixion,* they seem immo-
bile and have the character of devotional icons.
These ivories must have had the approval of
even such a discriminating patron as Constan-
tine VII Porphyrogenitus, for the earliest ivory
of this type (Palazzo Venezia, Rome; c. 945)
bears the name Constantine. They are equiv-
alent in style to the mosaics at Hosios Lukas.

With the twelfth century there was a marked
change in the style of Byzantine art. The austere
art of Hosios Lukas was now replaced by a style
more classical and more three-dimensional. This
is shown by the mosaics in the church of the Dor-
mition at Daphni, now a suburb of Athens, dat-
ing from about 1100. The solid figures at Hosios
Lukas have, as their equivalents here, figures

which are lighter and more lively. But although
they are very convincingly modeled their volume
is indicated first and foremost by lines, not only
by light and shade.

The development of twelfth-century painting
in Byzantium witnessed the increasing impor-
tance of line, and with it, great stress on dynamic
movement and violent emotions. This phase is
well illustrated by the frescoes in the Macedoni-
an (now Yugoslavian) church of St. Panteleimon
at Nerezi, dated by an inscription to 1164 (fig.
149). The church was founded by relatives of the
reigning emperor, which explains the high quali-
ty of the frescoes, clearly the work of Constan-
tinopolitan artists. These are no longer imper-
sonal icons or stiff, immobile figures. The scenes,

on the contrary, give the impression of great emotional tension, expressed not only by the faces, but also by the poses, the gestures, and the complicated multiple lines that add to the impression of motion.

To the patronage of those bitter enemies of Byzantium, the Norman kings of southern Italy and Sicily, are due the greatest Byzantine decorative schemes in mosaic that survive on Italian soil. Greek artists came in waves to work for Roger II and his two successors at Palermo, Cefalù, and Monreale, their work spanning roughly the period 1140–90 (see page 262). The last Byzantine work was in the newly built monastic church at Monreale, which William II planned as his mausoleum. Founded in 1174 and completed in 1183, and the mosaics made between 1180 and 1190, it was a colossal task, accomplished with Norman efficiency and, no doubt, unlimited money (fig. 150). The Byzantine artists were faced with the novel problem of decorating a basilican church, very different

from the contemporary form of churches in their own country. Instead of domes, pendentives, and other curved surfaces, they were confronted with vast expanses of flat walls. Only the apse and the vaulting of the sanctuary provided familiar fields for decoration, and here they used familiar subjects, a Pantocrator of colossal size (as at Cefalù) and below, the Virgin and Child, copying the miraculous icon, the *Virgin Panachrantos (Immaculate Virgin)* in Hagia Sophia in Constantinople. Below is a row of saints, including the newly canonized martyr (1174), St. Thomas of Canterbury. The walls of the huge church, with its transept and nave, are covered with scenes from the Old and New Testaments and endless saints. Finally, William II is shown twice, offering the church of Monreale to the Virgin and being crowned by Christ. Stylistically, especially in the Biblical scenes, the new dynamic linear forms dominate. It is tragic that the Norman kings, who obviously admired and exploited Byzantine art, devoted so much effort

149. *Lamentation of Christ.*
Portion of fresco on wall of north cross-arm. 1164.
Saint Panteleimon, Nerezi (Yugoslavia)

+to bringing about the downfall of the Byzantine Empire.

ARMENIAN AND GEORGIAN ART

Although in many ways connected with Byzantine art, the arts of the Armenians and the Georgians have a character all their own. The Armenians inhabited the plateau which is today in eastern Turkey and the southern part of the Caucasus; the Georgians lived, as they still do, further north in the Caucasus. Both states acted as buffers between the ancient Roman Empire and Persia, and were subject to those cultural influences. In the early fourth century Christianity became the state religion of each, developing along lines similar to Monophysism (the doctrine of the single, divine nature of Christ) and related in this respect to the Coptic and Syrian churches. The independent, national churches of Armenia and Georgia were each headed by a *katholikos*, or patriarch.

By 387 Armenia was divided between Byzantium and Persia; after the Arab conquest of Persia in 642, Arab domination over the eastern part of the country was firmly established. Although never completely free and independent, the Armenians were subsequently ruled by their feudal aristocracy, of whom the Bagratids became the most powerful. In 885–86 Ashot Bagratuni became king, recognized by the Arabs as well as the Byzantines. The tenth and early eleventh centuries witnessed a blossoming of artistic life, centered on the new capital, Ani. But soon, under strong Byzantine pressure, one western province after another fell to Constantinople —with disastrous results for both states, for the Seljuk Turks then appeared on Armenia's eastern borders and no adequate army or organization was available to oppose them. The in-

◀ 150. *Pantocrator;*
Virgin and Child with Angels; Saints.
Apse mosaic. 1180–90.
Cathedral, Monreale (Sicily)

151. Plan of Basilica, Ereruk (Armenia). Fifth century

vasion started in 1048, and with the calamitous defeat of the imperial army at Mantzikert in 1071 Armenia came under Turkish rule.

The early history of Georgia was just as turbulent, with the Byzantines, Persians, Arabs, and Seljuks all exercising their influence in turn and extending their rule over the country. But in the ninth century the Bagratids, the same house that was becoming predominant in Armenia, established a Georgian monarchy. The Georgians were luckier than the Armenians: they were never wholly conquered by the Byzantines or the Turks, and King David the Builder (1089–1125), benefiting from the hostilities between the Turks and the crusaders, recovered Tiflis (Tbilisi), which had long been in Muslim hands, and established it as the capital of Georgia. He also conquered large parts of Armenia from the Seljuks, though this acquisition was subsequently lost to the Mongols when they invaded Asia Minor in 1220. Meanwhile a new state, Little Armenia, came into being in Cilicia, the southeastern province of Asia Minor. Its population consisted of Armenian immigrants who settled there in the late tenth century and of the more recent refugees from Armenia, by then under Muslim rule. Little Armenia survived until 1375, when it was conquered by Egypt.

The earliest churches in Armenia and Georgia, as can be expected, show strong influences

152. Exterior from south, Church of the Holy Cross,
Agthamar (Armenia). 915–21

from northern Mesopotamia and, above all, Syria. Basilican plans, as at fifth-century Ereruk in Armenia (fig. 151), are sometimes combined with two-towered façades that project beyond the walls of the nave. The churches are vaulted throughout. Another type became particularly popular from the late sixth century onward: the centrally planned church with a dome supported by pendentives or squinches. The variety of forms was great. The now ruined church of Zvart'nots in Armenia, built between 644 and 652, consists, for instance, of a central quatrefoil made of one solid and three colonnaded niches between heavy tall piers that support a central dome. This structure is enclosed by a two-storied circular ambulatory connecting with the central space by open arcades at both levels. Even more complex is the church of St. Hrip'simē at Vagharshapat in Armenia, built in 618; it has four apses, one on each side of a square, and four narrow, tall corner niches. Four rectangular chambers are placed between the apses in such a way that, externally, the church appears to be a large cube surmounted by a dome. Tall triangular niches placed on either side of each apse provide the only external articulation.

The design of this church remained popular for several centuries; a variant of the type is the church of the Holy Cross at Aghtamar on Lake Van (fig. 152), built by King Gagig Artstruni between 915 and 921, which is renowned for its extensive wall paintings and external sculpture. The walls are literally covered by friezes, stringcourses, medallions, and large reliefs; these include Biblical scenes and grotesques, and on the west wall the founder is shown in ceremonial robes, offering to Christ a model of the church. Although influenced by Byzantine art and incorporating Sassanian and Islamic motifs, this sculpture is highly original, and in some respects it anticipates Romanesque decoration in the West.

Lavish sculpture was also characteristic of Georgian churches. The seventh-century church

of the Holy Cross (Jvari) near Mtskheta, a cruciform building with a dome over the crossing (fig. 153), is remarkable for its sculptural decoration; there are figures of the founder and his family, and a carved tympanum over the entrance that again anticipates by many centuries a favorite form of decoration in Romanesque art. Another Georgian church celebrated for the sculpture applied to its exterior (numerous reliefs) and interior (a hexagonal column carved with figural motifs) is the monastery built between 958 and 966 at Oshki (Osk Vank), in a remote part of northeastern Turkey.

In 961 Ani (now located on the Turkish-Soviet frontier) became the Armenian capital, and the peace and prosperity of this period was reflected in the erection of splendid buildings, secular and religious, surrounded by fortifications. Even today, ruined and abandoned, the site of Ani is impressive, with its walls, cathedral, and a few other churches still standing albeit open to the elements and gradually crumbling away. The cathedral was built by the architect

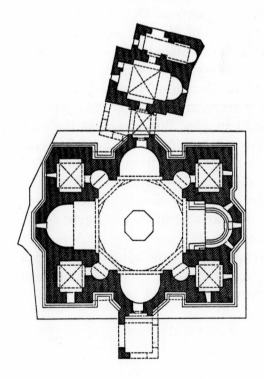

153. Plan of Church of the Holy Cross, Mtskheta (Georgia). 7th century

Trdat, whose fame must have been great for he was commissioned to repair the dome of Hagia Sophia in Constantinople after it was damaged by an earthquake in 989. The cathedral (989–1001) is built on a cross plan with a dome over the crossing, the whole incorporated within rectangular walls articulated on the exterior by triangular recesses and blind arches.

Armenian and Georgian architecture developed along similar lines because these countries were in close contact; in the ornamentation there were some differences, that in Armenia being frequently abstract, influenced by Islamic art.

Although some mosaics and quite a number of wall paintings survive in both countries, the most important field of painting was book illumination, particularly in Armenia and Little Armenia. The earliest liturgical books were written in Greek or Syrian; when national alphabets were invented, early in the fifth century, the task of translating sacred works began, which stimulated the development of book illumination. The early paintings were copies or modifications of Early Christian and Byzantine models, but, as in the other arts, an Oriental element was also present. One of the most venerable illuminated books is the Etchmiadzin Gospels in the Matenadaran Library at Erevan. Its ivory covers are provincial Byzantine five-part diptychs of the sixth century, and the main manuscript was illuminated in 989. But bound at the end of the volume are two leaves of about 600 containing four full-page scenes from the Gospels (fig. 154); these show the simplification of Byzantine models and a strongly hieratic style not unlike the contemporary art in Coptic Egypt (see fig. 61). Throughout its history religious Armenian painting remained in close contact with Byzantium, while freely drawing upon the nonfigurative art of Islam for decorative motifs.

After the Seljuk conquest new centers of manuscript painting arose in Little Armenia and attained great excellence, particularly during the thirteenth century. By then the country's close contact with the Crusading states and the frequent marriages between the Franks and the Armenians caused artistic influences to flow in both directions. Among the most celebrated painters of Little Armenia was a certain T'oros Roslin, active during the third quarter of the thirteenth century at Hromkla, the seat of the *katholikos*. This prolific artist combined Byzantine and Western elements very skillfully, as in the Gospel Book, signed and dated 1262, now in the Walters Art Gallery, Baltimore (colorplate 25).

During this period Little Armenia became a vassal of the Mongolian empire which stretched from China to Anatolia. Relations with the Mongols were friendly, and in 1253 the Armenian king Het'um I even made the long trip to Karakorum, in Outer Mongolia, to visit the Great Khan Mongke. Through this cooperation with the Mongols Chinese works of art must have reached Armenia, for undeniable Far Eastern elements are found in some Armenian works. In a manuscript dating from 1288 (Erevan, Ms. 979), for example, a bust of the youthful Christ in a medallion is flanked by two lions having manes like flames, a characteristic Chinese form.

The geographical position of Georgia and Armenia and their contacts with other races and faiths caused their art to develop many original traits, while remaining within the Western tradition. Some scholars claim that Armenian art had a profound influence on the Western European art of the Romanesque period, and undoubtedly some features of Western buildings, such as squinches, seem to have originated there; in sculpture, too, some Armenian influences can be detected (see page 268).

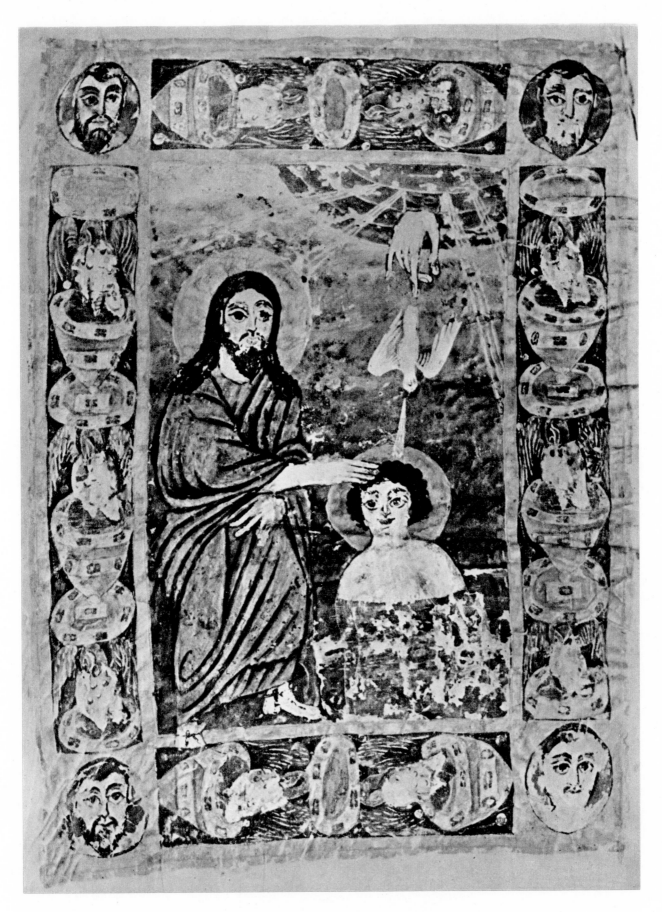

154. *Baptism of Christ*. Gospels of Etchmiadzin.
11 × 7 7/8″. c. 600. Matenadaran Libary (Ms. 2374), Erevan

VII

Ottonian Art

The victory of the German army under Otto the Great over the Hungarians, in 955, marked the beginning of the rebirth of Germany. Under the Saxon dynasty, Germany was the first Western country to regain strong centralized power, which enabled her to return to a more organized and civilized form of life. The reform of the Church, initiated by the Order of Cluny, spread to Italy and Germany and found fervent support in the Saxon dynasty. With the coronation of Otto as emperor by Pope John XII in Rome, in 962, the dream of the new dynasty was fulfilled: Germany was restored to a position comparable to that which the Frankish Empire had achieved under Charlemagne. But the Carolingian Empire had consisted of both Germany and France, as well as much of Italy. Now France, divided and weak, was a separate political entity and gradually became also separate culturally. The new Empire, the Holy Roman Empire as it was called, included the northern part of Italy and large new territories east of the Elbe River, conquered from the Slavs, an expansion which was vigorously opposed by the new Christian state of Poland (Christianized in 966). This expansion in the east gave rise to new centers of activity, and to the great Carolingian Rhineland cities were now added those further east, Hildesheim, Magdeburg, Quedlinburg, Gernrode, Merseburg, and others. The policy of revival of the Empire brought, as its inevitable result, an involvement in papal and Italian affairs; this proved catastrophic in the long run, draining the energies and resources so needed in Germany for keeping in check the unruly dukes. The Italian policy of the successive emperors, however, meant from the artistic point of view that a great many Germans traveled to Italy or lived there, and thus acquired an intimate knowledge of her artistic heritage, pagan as well as Christian.

The term "Ottonian" art, by which is under-

stood the art of the Empire of the tenth and the greater part of the eleventh centuries, is inaccurate, since it embraces the reigns not only of the Saxon or Ottonian dynasty—Henry I, the three Ottos, and Henry II—but also the two Salian rulers, Conrad II and Henry III.

The political aim of the Ottonian *renovatio,* the term used frequently during the rule of Otto the Great, was the revival of the Carolingian state in all its splendor. It is, therefore, not surprising that the chief source of Ottonian art was Carolingian. The term *renovatio* had yet another meaning, the revival of the Roman past to which the Holy Roman emperors felt themselves to be the heirs.

Carolingian art was centralized, depending largely on the imperial court and the intellectual elite connected with it. Ottonian art, on the other hand, developed in a number of ecclesiastical centers, reflecting the growing importance and wealth of those bishops and abbots whom the emperors favored with generous gifts of land, in return for their loyalty and support against the opposing dukes. There was no clearly defined Ottonian court style, but instead a great many regional centers.

ARCHITECTURE

It is not surprising that Henry I (919–36) devoted much energy to building castles and defensive walls for cities. He built a palace and a monastery at Quedlinburg, his favored city, where he and his wife were buried. Practically nothing survives from this period.

The great foundation of Otto the Great (936–73) was the cathedral of Magdeburg, begun in 955, of which some vestiges remain. Otto was clearly imitating Charlemagne when he had capitals and columns brought from Rome and Ravenna. The general arrangement of the church was based on that of the Carolingian abbey at Fulda, having two apses facing east and west. The bishopric of Magdeburg was raised to an

archbishopric in 968, and was to play an important role in central Europe. This most influential building of Otto's reign was destroyed by fire, and replaced by the present Gothic structure.

The best-preserved building from the tenth century in Germany is the church of St. Cyriakus at Gernrode, south of Magdeburg, near the Elbe River (figs. 155–57). Its founder was Margrave Gero, one of the military leaders who extended German rule over the Slav tribes between the Elbe and the Oder. Built between 960 and 965, it consists of a choir standing over a crypt, a transept, a nave covered by a timber ceiling, two aisles, and the westwork flanked by two round towers, to which a second apse was added in the twelfth century. Externally the building is enriched by arcades enclosing the nave windows, and blind arcades on the towers. On the north tower the pilasters carry not round arches but gables, an archaic feature, perhaps imitating the gatehouse at Lorsch (see fig. 111). Inside the piers and columns alternate, while the galleries above the aisles open toward the nave with arcades arranged in two groups of six.

This system of alternating supports was further elaborated at Hildesheim in the abbey church of St. Michael (figs. 158, 159), built between 1010 and 1033 by Bishop (later Saint) Bernward, of whom more will be said later (see

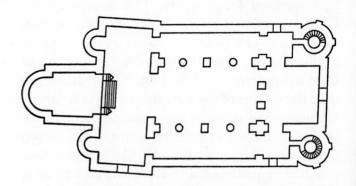

155, 156, 157. St. Cyriakus, Gernrode. 960–65.
(*above*) Plan (with reconstruction of
10th-century westwork; after E. Lehmann).
(*opposite, above*) Interior from southeast.
(*opposite, below*) Exterior from east

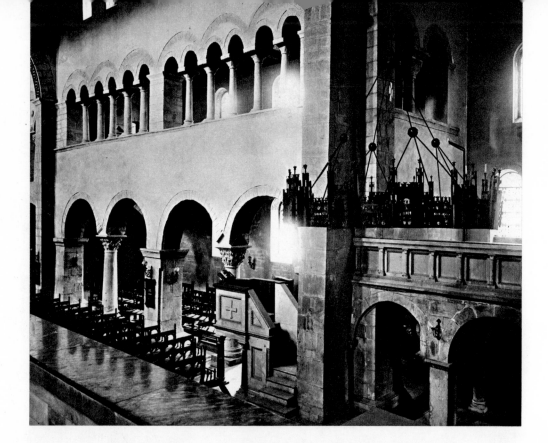

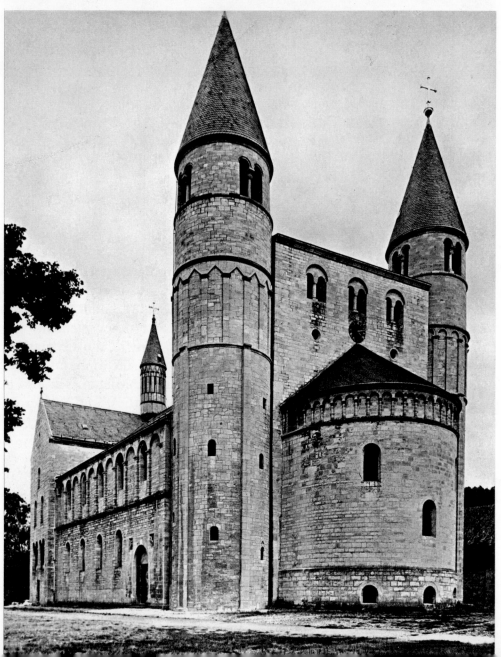

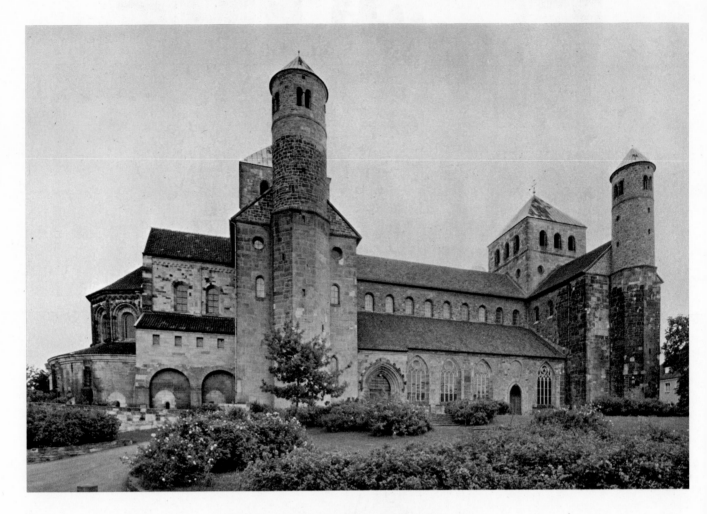

158, 159, 160. St. Michael, Hildesheim. 1010–33
(*above*) Exterior from south
(*opposite, above*) Interior toward west
(*opposite, below*) Interior from northeast transept

page 172). St. Michael's consists of an aisled nave divided into three square bays supported by piers, with a pair of columns between them. In comparison with Early Christian basilicas and their uninterrupted rows of columns, this later arrangement gave the interior a new and interesting rhythm. At either end of the nave there is a transept with a square crossing tower, and to each arm of the transepts are added turrets outside, polygonal in their lower half and round above. Thus the church is furnished with six towers, making its silhouette complex and exciting. There is an apsidal termination at each end; the one toward the west is raised above a large crypt and provided with an ambulatory passage. The elements so

boldly combined at Hildesheim had been used separately in Carolingian buildings: the two apses appear at Fulda, the crossing towers at Centula, and other elements in more recent structures, namely, the alternation of supports at Gernrode and the ambulatory at St-Martin at Tours. But St. Michael's is also novel in many respects (fig. 160), and it exerted considerable influence on Romanesque architecture in Germany, and even in Normandy. Its angularity and austerity is well matched by the heavy cubical (or cushion) capitals used throughout. It has already been suggested that such capitals originated from the Byzantine block capitals, such as those at S. Vitale at Ravenna (see fig.

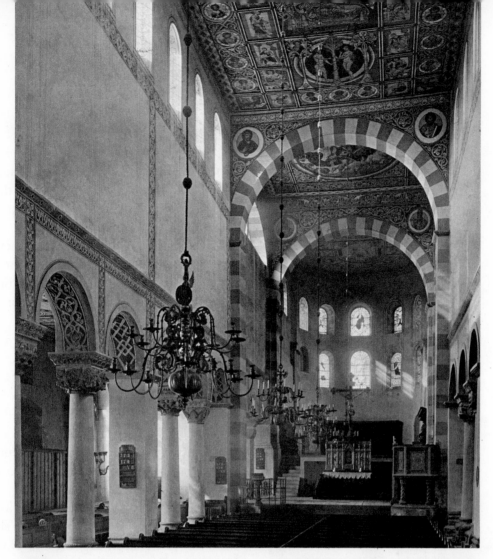

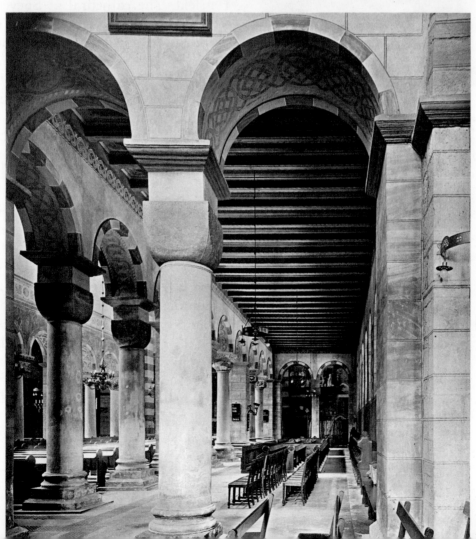

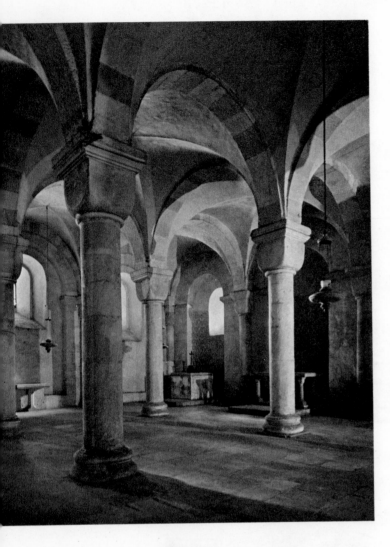

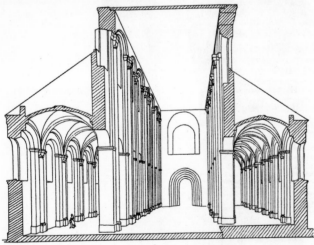

161, 162. Cathedral, Speyer.
(*top*) Crypt. Begun 1030.
(*above*) Reconstruction of 11th-century
interior, toward west

47). Cubic capitals became the most favored form in Germany, their popularity lasting for some two hundred years. About the middle of the eleventh century, the scallop capital was introduced (e.g., at St. Lucius at Werden); it was formed by the fusion of four cubic capitals into one, making the capital less heavy. This does not mean that the Corinthian and other forms of capitals were no longer in use; some extremely beautiful examples of noncubic capitals are found, for instance, in the chapel of St. Bartholomew at Paderborn, about 1017, the work of Greek craftsmen *(per Grecos operarios)*, or at Zyfflich, where there is a capital decorated with atlases, based on some classical model.

Building activities throughout Germany at this time of political expansion and prosperity were truly prodigious, but the most impressive undertakings were started during the reign of Conrad II (1024–39). Two of these are now ruins, though impressive in their sheer size, namely, the abbeys at Limburg on the Haardt and at Hersfeld. The cathedral at Speyer is well preserved, however, if overrestored (figs. 161–63). Started in 1030, work continued during the reign of Henry III, and was finished in 1061 under Henry IV. The east end had to be rebuilt toward the end of the century, due to the encroachment of the Rhine.

The building was to have been the mausoleum of the Salian dynasty, and, in consequence, it has a huge crypt extending under the chancel and the transept. The new feature at Speyer is the use in the nave arcade of square piers with engaged shafts. On the nave side the piers formed giant arches on the model of the Constantinian *aula regia* at Trier (see fig. 7), no doubt a conscious reference to classical imperial building; but on the aisle side they supported groin vaults. There are six towers: two pairs of square towers flank the chancel and the western doorway, and one of the two octagonal towers is placed over the crossing, the other over the westwork. The rebuilding of the east end in Lombard Roman-

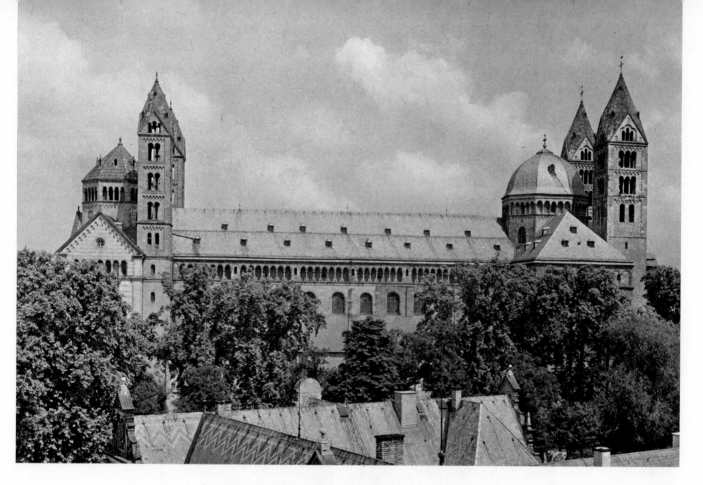

163. Exterior from south, Cathedral, Speyer.
Begun 1030

esque style set the fashion for the other Rhineland imperial cathedrals, those at Mainz and Worms. At the same time, the transept and the nave were covered with a groin vault. Speyer is a truly monumental building in its size and massiveness of form. It was started as an Ottonian structure, but already it incorporated such Romanesque features as the engaged shafts.

PAINTING

The great misfortune is that none of the great Ottonian churches preserves its original wall paintings. The fragmentary or overrestored remains that exist come from buildings at Fulda and Reichenau. The wall paintings in the church of S. Vincenzo at Galliano, in Lombardy, dating to the early years of the eleventh century, show a close connection with Ottonian illuminations, suggesting that, as during the Carolingian period, the Alps were no obstacle to the spread of artistic fashion.

Knowledge of Ottonian painting is based al-

most exclusively on manuscript painting, and this limitation must be borne in mind.

As could be expected, the earliest Ottonian manuscripts are little more than copies of those produced in the Carolingian court schools. Such is, for instance, the Gero Codex now in Darmstadt, a Gospel Lectionary based on the Lorsch Gospels and written during the third quarter of the tenth century.

Most of the Carolingian books were Bibles, their illuminations chiefly drawn from the Old Testament. Now, however, the majority of books illuminated were for church services, such as Sacramentaries (Canon of the Mass, and the Collects and other prayers used during the whole year) and Gospel Lectionaries (extracts, or pericopes, from the Gospels to be read on particular days). Consequently, their illuminations are of New Testament subjects. From the point of view of iconography, the greatest contribution of Ottonian painting is the introduction of narrative cycles of the life of Christ.

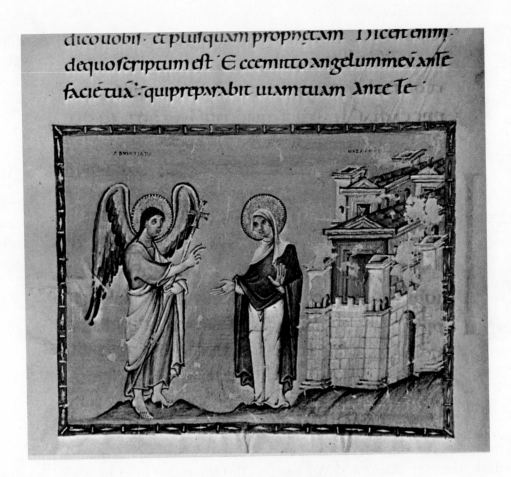

164. *Annunciation.* Codex Egberti.
Page 9 3/8 × 7 1/2″. 977–93.
Stadtbibliothek (Cod. 24, fol. 9r), Trier (see colorplate 26)

One of the most celebrated manuscripts of Ottonian painting is the Evangeliary known as the Codex Egberti, in Trier (colorplate 26; fig. 164); it contains a dedication picture, portraits of the Evangelists, and fifty scenes from the New Testament, as well as numerous initials. The dedication page represents the seated figure of Egbert, with two monks offering him the book. Egbert, a former monk in Flanders and the imperial chancellor to Otto II, became archbishop of Trier in 977 and died there in 993. He was a great patron of the arts. The splendid façade of Trier Cathedral—its western apse flanked by two majestic bays with doorways and galleries above them, and two round turrets at either end —is a work of the early eleventh century, but

may already have been designed during the time of Egbert. He commissioned superb goldsmiths' work, some of which still survives. But it is the manuscripts associated with him that are of the greatest importance.

The two monks on the dedication page of the Codex Egberti are identified by an inscription as from *Augia,* the Latin name of Reichenau, and for this reason the manuscript has traditionally been ascribed to that celebrated monastic center on Lake Constance. But forceful arguments have recently been advanced for Trier as the place where this and related manuscripts were made, although this view has not been unanimously accepted.

The scenes in the codex are framed to separate

them from the text. The figures are full of reminiscences of classical art in their poses and gestures; also classical are the atmospheric backgrounds of the scenes. Because of these antique elements, it is taken for granted that the painters responsible for this manuscript had for their model an Early Christian book from Italy. It can even be postulated that this model was related in style to the Vatican Virgil (see fig. 62), for there is a considerable similarity in the arrangement of the pictures and in the style of the Codex Egberti and the Virgil. However, the Ottonian painters introduced some modifications of the Early Christian iconography, for it has been demonstrated* that they borrowed some motifs from contemporary Middle Byzantine manuscripts which must have reached Germany during this period.

One of the painters of the Codex Egberti was an anonymous artist of extraordinary talent who is known to art historians as the Gregory Master, a name given to him because of his other work, the illuminated copy of the Letters of St. Gregory, now divided between Chantilly and Trier, commissioned by Archbishop Egbert presumably between 983 and 987 (colorplate 27). The same artist is credited with a group of ivories which exhibit an understanding of the articulation of the human figure similar to that found in his paintings.

A group of manuscripts known as the Liuthar group, ascribed with equal conviction to Trier or Reichenau, is so called because a monk named Liuthar is represented in one of the books, the Aachen Gospels of Otto III. The manuscripts of this group were produced at the turn of the tenth century, and show a considerable change of mood in comparison with the restrained paintings of the earlier period. The page with the figure of St. Luke in the Gospel Book of Otto III, in Munich, illustrates this eloquently (color-

plate 28). The Evangelist, his arms outstretched, his eyes glaring in an expression of ecstasy, is surmounted by the busts of prophets and of angels from whom descend rays of divine inspiration. The whole composition expresses dynamic spiritual force, and the energy is further emphasized by the striking, almost brutal colors. It is interesting to note that this book has a Byzantine ivory at the center of its cover.

Of the many centers of Ottonian painting, some stand out by their very individual local styles: Trier, Reichenau, Cologne, Hildesheim, Regensburg, Salzburg, Fulda, and Echternach. Among the works from this last, centered on the abbey founded in the eighth century by Anglo-Saxon missionaries, is a late Ottonian Gospel Book of unusual splendor (figs. 165, 166). It was commissioned by Emperor Henry III between 1045 and 1046, to be presented to the cathedral of Speyer. Like the architecture of the cathedral itself, the painting in this book, known as the Codex Aureus for its lavish use of gold, is on the borderline, difficult to define, between the Ottonian and Romanesque styles. Its forms are solid, well defined by their outlines, and the folds of the robes are frequently painted for no other reason than their decorative effect. All this is clearly Romanesque; but un-Romanesque is the treatment of the faces, modeled with highlights used in the antique manner.

On two pages of the Codex Aureus the faces of the central figure, Christ in one case, the Virgin Mary in the other, are even more "illusionistic," and there can be no doubt that a Byzantine painter was responsible for both of them. On one of the pages in question, Henry III (still a king) and his wife Agnes are presenting the book to the Virgin, to whom the cathedral of Speyer was dedicated; the building in the background is intended to represent the cathedral, though it is not a very accurate depiction of it. On the other page Henry's parents, Conrad II and Gisela, are shown venerating Christ. The participation of a Greek painter in the produc-

* H. Buchthal, "Byzantium and Reichenau," *Byzantine Art— An European Art*, Athens, 1964, p. 58.

168

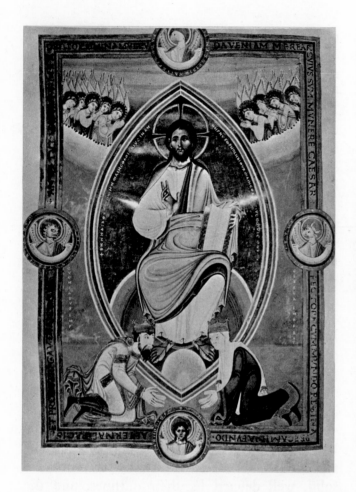 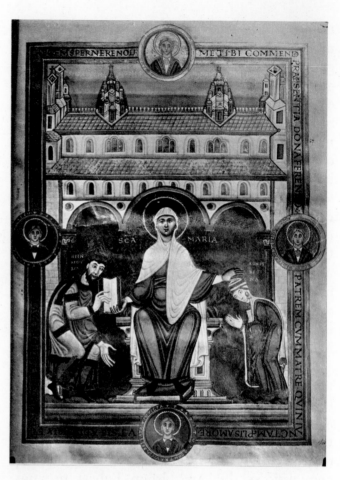

165, 166. Gospel Book (Codex Aureus) for Speyer Cathedral.
Page 19 5/8 × 13 3/4″. 1043-46. Library (Cod. Vitr. 17), Escorial.
(*left*) *Conrad II and Queen Gisela Venerating Christ* (fol. 2v).
(*right*) *Henry III and Queen Agnes Presenting
the Codex Aureus to the Virgin* (fol. 3r)

tion of this book, if only in a marginal way, shows to what extent the artistic connections with Byzantium, initiated during the reign of Otto II through his marriage to Theophano, daughter of Emperor Romanus II, continued throughout the Ottonian period. The fact that this painter was entrusted with painting the faces of the two most important figures proves in what high esteem Byzantine painting was held.

An ivory carving in the Musée de Cluny in Paris shows Otto II and Theophano in imperial

robes on either side of Christ and being crowned by Him (fig. 167). The work closely resembles tenth-century Constantinopolitan examples, such as *Christ Crowning Emperor Romanus II and Empress Eudokia* (945-49) in the Cabinet des Médailles in Paris, and it must have been made by a Greek. The presence of Greek artists and Greek works of art (such as the ivory on the cover of the Gospel Book of Otto III) acted as a constant stimulus to Ottonian artists. For instance, a group of exquisite ivories made in Milan during Otto II's reign (973-83; fig. 168) is

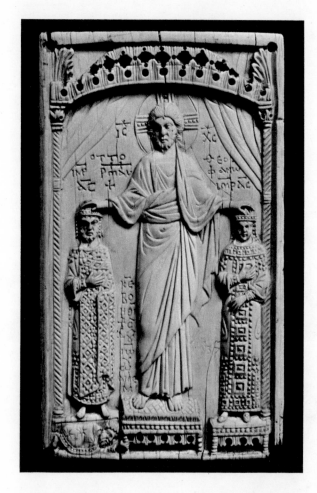

167. *Christ Crowning Emperor Otto II and Empress Theophano.* Ivory, 7 1/8 × 4″. 973–83. Musée de Cluny, Paris

manuscript painting was metalwork. Contemporary documents tell of wonderful and costly gifts made by emperors, dukes, bishops, abbots, and abbesses to churches, and some of these still survive; studded with precious stones, antique cameos, and enamels, and with embossed and engraved figures and ornaments, these objects were venerated for the relics they contained or because of their use on the altars or in the liturgy. The superb crosses, such as the Lothar Cross at Aachen (c. 990) or the three crosses in the abbey church, now cathedral, at Essen, gifts of Abbess Mathilde (973–82; colorplate 29), are works of extraordinary beauty, as well as wonders of technical skill. The artists who made them were masters of many techniques, who on occasion turned to large-scale sculpture; such work was often covered with sheets of gold or silver and it was, therefore, at the same time a carved sculpture and a work in metal. These large sculptures were, in most cases, reliquaries. Such was the celebrated Gero Cross, the gift of Archbishop

profoundly indebted in style to the same Middle Byzantine group of ivories, and this influence spread to other media, such as stucco. The huge ciborium above the altar in S. Ambrogio in Milan, dating from the early eleventh century (it was repaired in the twelfth; fig. 169), has, on its four gables, stucco figural compositions similar to those in Milanese ivories, and no doubt influenced by them.

SCULPTURE IN METAL

The medium next in importance to Ottonian

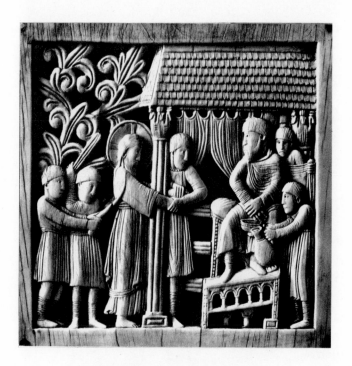

168. *Pilate Washing His Hands.*
Panel of Magdeburg Antependium.
Ivory, 4 1/8 × 3 7/8″. c. 973–83.
Bayerisches Nationalmuseum, Munich

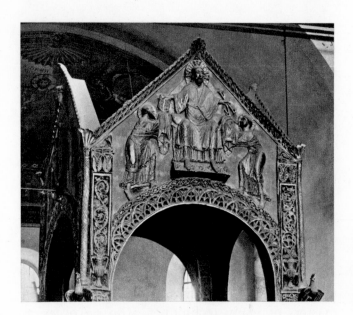

169. *Christ Between St. Peter and St. Paul.*
Ciborium, front face. Stucco, gilded and painted.
Early 11th century. Sant'Ambrogio, Milan

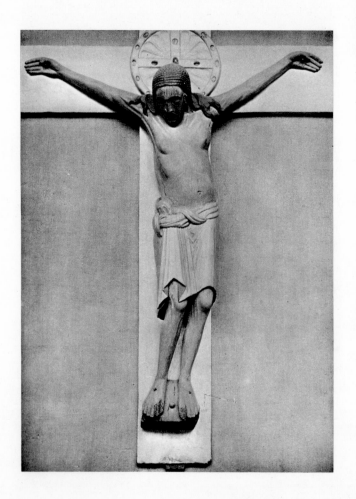

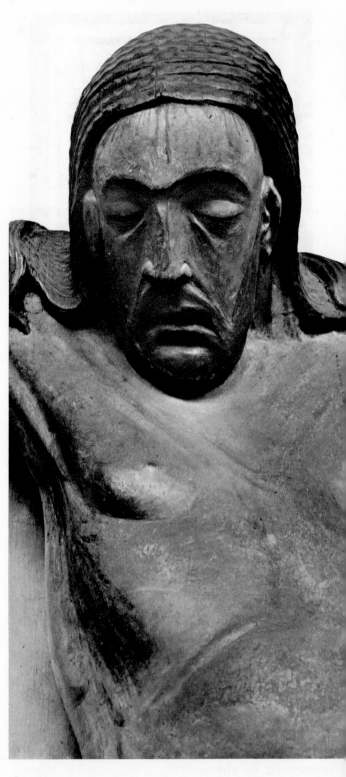

170, 171. Cross of Archbishop Gero, and detail.
Wood, painted; height of figure 6′ 2″. 969–76.
Cathedral, Cologne

Gero (969–76; figs. 170, 171), still in use in Co-
logne Cathedral. At the back of the head is con-
cealed a cavity for the consecrated host. Made of
wood, in this case the figure was covered with
gesso and painted. It is an expressive and pathet-
ic representation of the dead Christ; the sagging
skin and swollen stomach are extraordinary in
their realism, and contrast with the geometrical-
ly treated loincloth.

Another cult image which was also a reliquary
is the Golden Virgin, still an object of devotion
in Essen Cathedral, and probably also the gift
of Abbess Mathilde (fig. 172). Carved of wood,
it is fully enclosed by gold sheets and some details
are adorned with filigree and gems. The group
expresses, by simple means, the tenderness of
feeling between the mother and child, but the
stare of the round enamel eyes creates the im-
pression of remoteness and unreality. The con-
temporary golden cult image of St. Foy at
Conques (colorplate 30), whose face is a reused
Roman parade helmet, has a similar remote
gaze. Mathilde made yet another gift to her
church, namely, the giant seven-armed cande-
labrum cast in bronze, in imitation of the cande-
labrum from the Temple of Solomon that is
depicted on the Arch of Titus in Rome.

The emperor Henry II (1002–1024) was a
particularly pious ruler and a generous benefac-
tor of churches. Two gold altar frontals which are
associated with his name are still in existence;
one is at Aachen; the other, better preserved,
was given by Henry to Bâle (Basel) Cathedral
and is now in the Musée de Cluny (fig. 173).
The tiny figures of the emperor and his wife
Kunigunde are shown prostrated at Christ's
feet in the central arch; in the side arches are
three archangels and St. Benedict, and above,
in four small medallions, are personifications of
the Virtues, surrounded by delicate scrolls of
foliage. This work of serene beauty and elegance
must have been much admired even in the suc-
ceeding age, for its reflections are to be found in
some Romanesque stone sculptures.

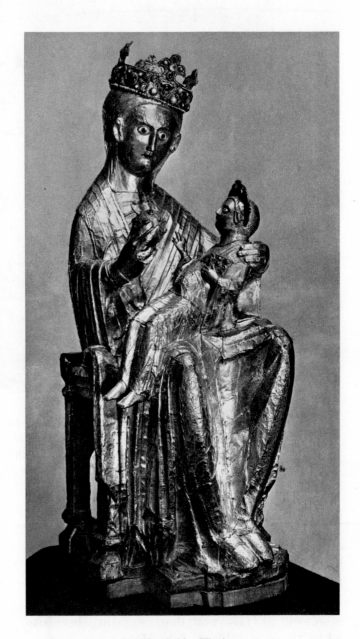

172. *Golden Virgin.*
Gold over wood;
enamel, filigree, and precious stones;
height 29 1/2". 973–82.
Cathedral Treasury, Essen

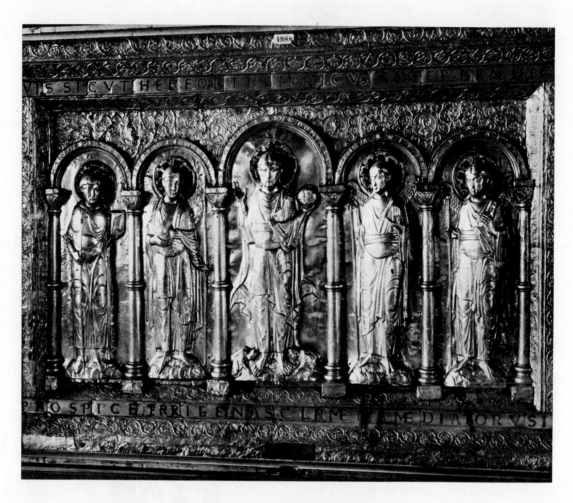

173. *Christ with Archangels Michael, Gabriel,
and Raphael, and St. Benedict.* Altar Frontal of Henry II (for Bâle Cathedral).
Silver with gilt and niello; 47 × 70". 1002–24.
Musée de Cluny, Paris

As Henry II was the greatest patron of the arts among the Ottonian rulers, so Bernward of Hildesheim was the greatest among the princely bishops. He was a tutor of Otto III, a friend of Empress Theophano, and a much-traveled man who went to Italy more than once and also visited St-Denis and Tours. Like Henry, he was canonized in the twelfth century. He was bishop of Hildesheim from 993 to 1022, and during this time Hildesheim became the center for manuscript painting and many other arts. It was he who built the abbey of St. Michael (see figs. 158–60). His fame as a patron rests, above all, on the metal objects commissioned by him—the silver crozier, a pair of silver candlesticks, a silver-gilt cross, the bronze doors, and the bronze

column which once supported a crucifix. All these were cast in the *cire-perdue* technique, the lost wax process that had been used for the casting of the bronze doors at Aachen two hundred years earlier (see fig. 117).

The doors and the column would be particularly impressive for their size alone, sixteen and one-half feet and fourteen feet in height, respectively. The doors were cast before 1015, the column soon afterward. The idea of making doors with figure subjects probably occurred to Bernward when, visiting Milan and Rome, he saw Early Christian wooden doors with Biblical scenes. Bronze doors were often made in Byzantium, but they were usually cast in small sections that were nailed to a wooden core; a door

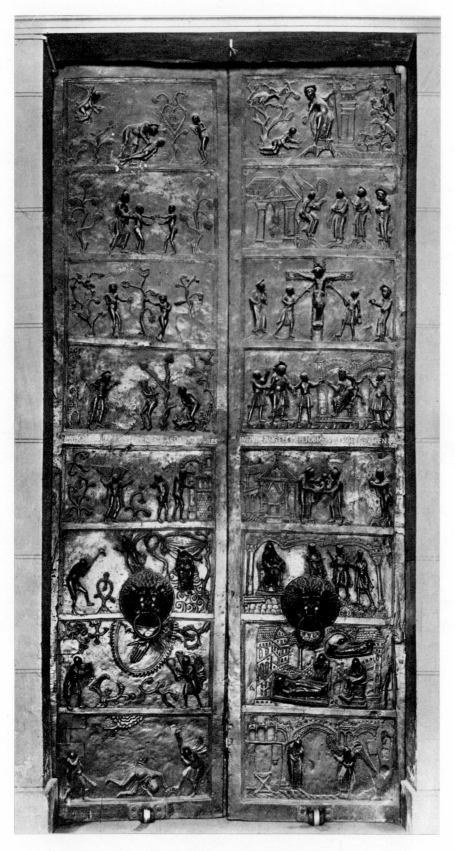

174. Bronze Doors of Bishop Bernward.
Height 16′ 6″. 1015.
Cathedral (originally for Abbey Church of St. Michael), Hildesheim

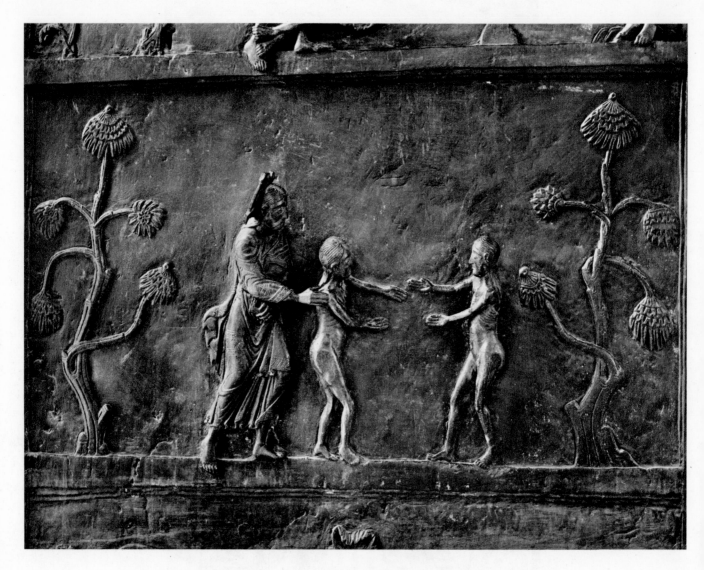

175, 176, 177. Bronze Doors of Bishop Bernward. 1015.
Cathedral, Hildesheim
(*above*) *The Meeting of Adam and Eve.* 22 × 42′
(*opposite, right*) *Eve Suckling Cain*
(*opposite, far right*) *Virgin and Child,*
detail of *Adoration of the Magi*

of this type was made early in the eleventh century at Augsburg. What Bernward wanted, however, was infinitely more difficult, namely, two wings cast as solid entities (figs. 174–77).

The left wing shows eight scenes from Genesis, the right has the same number taken from the New Testament. Some of the scenes adjacent on the two wings are related in a significant way: Original Sin is next to the Crucifixion; Eve suckling Cain is facing the Virgin and Child in the Adoration scene, thus contrasting mother-

hood arising from sin with that from immaculate conception. The general arrangement was inspired by the Carolingian Bibles of the School of Tours (see fig. 134), in which narrative strips are placed in the same way as on the doors.

The modeling of the figures increases in projection toward the heads of the figures, and through this ingenious method the sculptors achieved the illusion of the independence of the figures from their background. They are agitated and expressive, their gestures eloquent and full

178. *Miracle of Christ.*
Portion of Bronze Column of Bishop Bernward.
Column height 12′ 5 1/2″. 1015–22.
Cathedral (originally for Abbey Church of St. Michael), Hildesheim

of subtle meaning. Certain differences in the treatment of the draperies suggest that the wax model was prepared by two artists. The doors were set up in the abbey of St. Michael, but soon after Bernward's death they were moved to the cathedral. The influence of these majestic doors was profound and the echo of their style is found as far away as Spain.

While in Rome, Bernward must have admired the two surviving columns of Trajan and of Marcus Aurelius, with their depictions of the triumphs of these Roman emperors, and conceived the idea of making a column with reliefs illustrating the miracles and other episodes from Christ's life (fig. 178). The continuous narrative relief includes twenty-four scenes; it starts at the bottom, moves up in a spiral, and ended originally with a crucifix placed at the top of the column, symbolizing the final triumph and fulfillment of Christ's life on earth.

The influence of Ottonian art radiated in all directions, to Poland, Bohemia, Italy, France, Spain, and England. At no other time was the prestige of German art greater.

Colorplate 23. *Harrowing of Hell*. Mosaic in lunette of narthex. c. 1020.
Katholikon, Monastery of Hosios Lukas (Greece)

Colorplate 24. *Virgin Orans*. Apse mosaic. c. 1037.
Hagia Sophia, Kiev

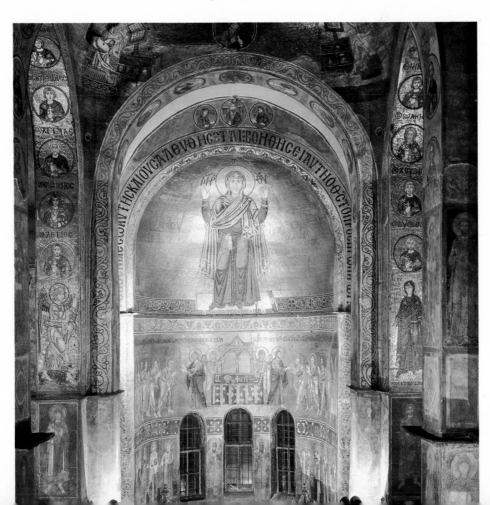

Colorplate 25. T'OROS ROSLIN. Canon Tables. Gospel Book.
8 1/2 × 11 3/4″. 1262 (signed and dated).
Walters Art Gallery (Ms. 10.539, fol. 5v), Baltimore

Colorplate 26. *Archbishop Egbert of Trier,*
Presented with the Codex Egberti by Two Monks.
Dedication page, Codex Egberti. Page 9 3/8 × 7 1/2″. 977–93.
Stadtbibliothek (Cod. 24, fol. 2v), Trier

Colorplate 27. THE GREGORY MASTER. *Pope Gregory the Great.*
Detached page of *Registrum Gregorii* (*Letters of St. Gregory*).
10 5/8 × 7 7/8″. 977–93. Stadtbibliothek, Trier

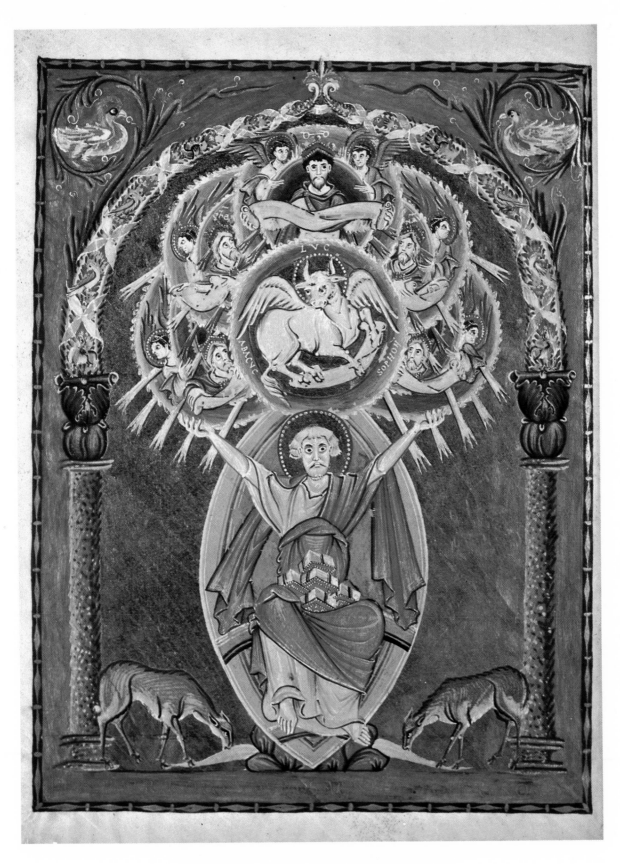

Colorplate 28. *St. Luke*. Gospel Book of Otto III.
13 1/8 × 11 1/8″. 983–1002. Bayerische Staatsbibliothek
(Cod. lat. mon. 4453, fol. 139v), Munich

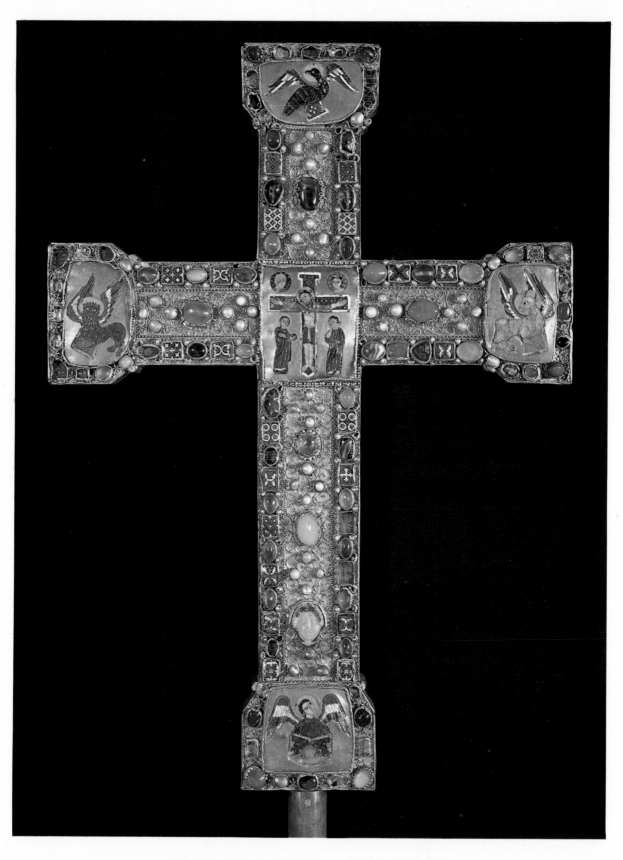

Colorplate 29. Enamel Cross of Abbess Mathilde.
Gold with enamel, filigree, and precious stones; height 18 1/2″. c. 985(?).
Cathedral Treasury, Essen

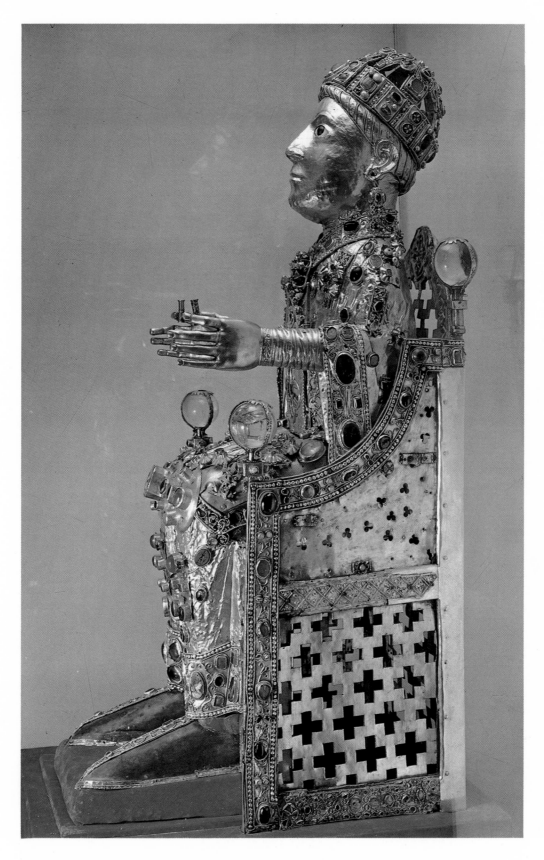

Colorplate 30. *Ste. Foy.*
Gold over wood; filigree and precious stones; height 33 1/2''.
Late 10th century. Cathedral Treasury, Conques

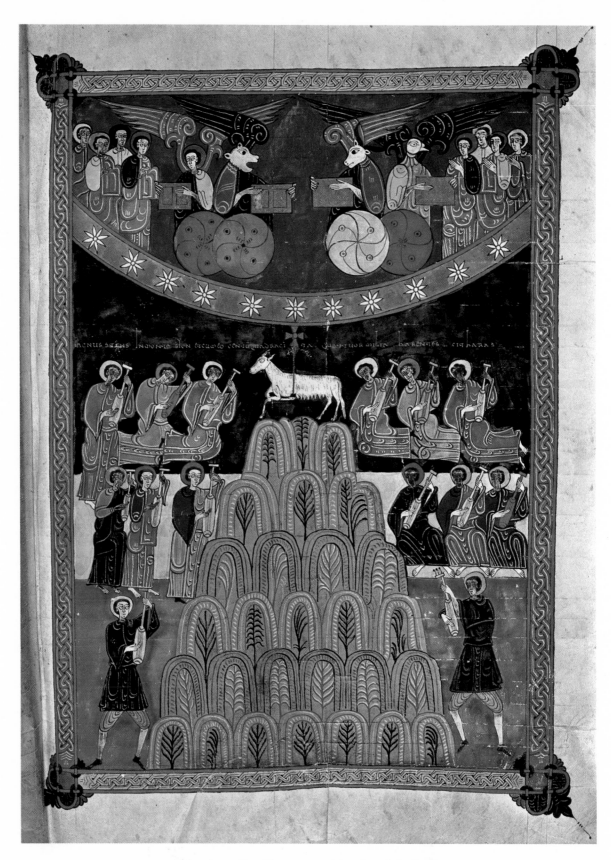

Colorplate 31. FACUNDUS. *Adoration of the Lamb.*
Beatus of Liébana, *Commentary on the Apocalypse.* 1047.
Biblioteca Nacional (Ms. B. 31, fol. 205r), Madrid

VIII

"First Romanesque" and Mozarabic Art

Political and economic conditions outside the Empire also improved during the tenth and eleventh centuries, but at a slower pace. However, the germs of a future revival were visible in the monastic reform initiated by the abbey of Cluny, founded in 910.

Reform was essential; the disintegration of the Carolingian Empire had led to a turbulent period, and as a result of the invasions and civil wars, religious life had declined and with it, morals. Church offices, secular and monastic, were at the mercy of unscrupulous rulers. With the plunder of churches by the barbarians, as well as by local rulers who were little more than brigands, the fugitive monks no longer observed the Rule.

The reform movement extended throughout France, Italy, Spain, and England, either with Cluny's help or under its direct or indirect influence. An independent reform movement originated in Flanders and Lotharingia and spread through the Empire; it was later reinforced by the Cluniac movement which was centered, in Germany, on the abbey of Hirsau.

The term "First Romanesque" is applied to the earliest experiments in art, chiefly in building, which eventually led to the Romanesque style. Based mainly on the Benedictine monasteries of northern Italy, these experiments spread along the Mediterranean coast to Catalonia, north along the Rhone Valley, and east as far as Dalmatia. The chief preoccupation of the builders was the vaulting of the churches, for timber ceilings made them vulnerable to fire. It will be remembered that Ottonian buildings were covered with flat timber ceilings, and vaults were used only in crypts (see page 162). Thus, First Romanesque churches were, in this respect, more "progressive." The vaulting of churches presented formidable technical difficulties and was not achieved overnight. The first steps were

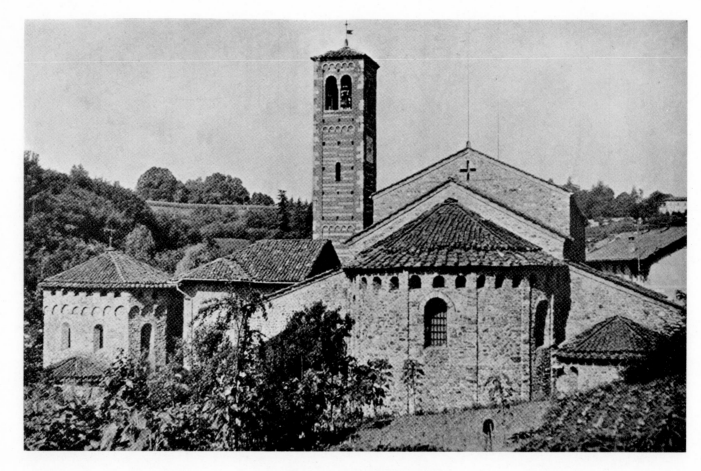

179. Exterior from east, S. Pietro,
Agliate (near Milan). c. 875

made in Lombardy, where only one bay, that between the apse and the nave, was vaulted. These Lombard churches were of the basilican type with three apses, and a distinctive external decoration consisting of pilasters carried up to the eaves and joined together by small blind arcades. These "Lombard arches" were derived from the brick architecture of Ravenna, but most First Romanesque churches were built of roughly dressed stone.

The beginnings of this type of building can be traced to the late ninth century, one of the earliest being S. Pietro at Agliate (c. 875; fig. 179). But it was in Catalonia that the next important step forward was taken, the vaulting of entire churches with barrel vaulting.

We have seen that the Christian kingdom of Asturias evolved a lively artistic life in the course of the ninth century, but this art declined and was eventually replaced by what is generally known as Mozarabic art. Mozarabs were the Christian heirs of the Visigoths, and, living under Arab domination, they absorbed many customs and tastes from their Islamic neighbors. As long as they remained politically loyal their religious practices and places of worship were respected. But with Christian revolts the persecution of the Mozarabs began, and there was mass migration north, to newly reconquered territories around León. The majority of the churches left behind in Arab-held lands was destroyed; a number of the buildings erected by the Moz-

arabs in their new settlements still survive, although many must have perished during the final Arab invasions of the Christian states by Al-Manzor (died 1002), which left Barcelona, León, and Santiago in ruins.

Mozarabic churches are characterized by the profuse use of the horseshoe arch, in ground plans (apses) and for arches, doorways, and other features. This Visigothic form had been widely adopted by the Arabs, and was now reintroduced into northern Spain: for instance, S. Miguel de Escalada (fig. 180), finished in 913, has three horseshoe apses, and all the arcades are of this shape. Many features of these buildings were derived from the brilliant Arab architecture in Andalusia, such as corbel tables, and segmented domes over the apses and over the square bays between apses and naves. Another feature of Mozarabic churches were the capitals of the Corinthian type decorated with chip-carved ornament.

Mozarabic art is also known for its original manuscript painting, confined chiefly to the Apocalypse and the commentary on it by Beatus of Liébana, a north Spanish monk of the eighth

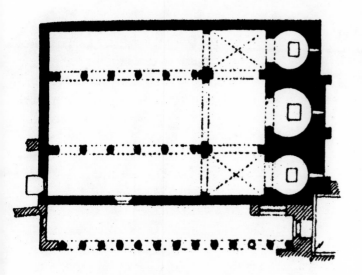

180. Plan of S. Miguel de Escalada (province of León). Finished 913

century, and to the Bible. The popularity of the Beatus text is shown by the great number of illustrated copies that still survive, the earliest being a copy made by a monk, Magius from Cordoba, who settled in S. Miguel de Escalada and died there in 968. Many of the early Spanish manuscripts bear the names of scribes and painters, and give the dates of their completion. The copy of Beatus now in Madrid, for instance (colorplate 31), was written and illuminated by a monk, Facundus, in 1047, for King Ferdinand I and his wife, Doña Sancha, in the monastery of S. Isidoro at León. Some copies were made in Gascony, and it is known that other monastic libraries outside Spain owned Beatus texts. It is generally agreed that these books had a considerable influence on the iconography of Romanesque art.

Mozarabic manuscripts are striking for their almost harsh colors and strange style, unrelated to anything in the West except perhaps early Hiberno-Saxon art. The forms are simplified or exaggerated, and there is no attempt to give a three-dimensional impression; on the contrary, everything is flat and geometric. It is an expressive art which is said to be derived from Visigothic painting, of which there are, alas, no survivals. Some features of this art are clearly of Islamic inspiration: the Twenty-four Elders of the Apocalypse adoring the Lamb, in the S. Isidoro copy, are based on court musicians in an Arab manuscript or ivory carving.

Side by side with this Mozarabic art in northern Spain, Lombard architecture appeared in Catalonia about the middle of the tenth century and showed rapid progress in vaulting techniques; before long, entire churches became covered with barrel vaults. By the early eleventh century a further advance was made by the introduction of transverse arches at each bay. The early First Romanesque churches in Catalonia were of the same three-aisled form as those in Lombardy, but gradually the arrangement became more ambitious, incorporating a transept,

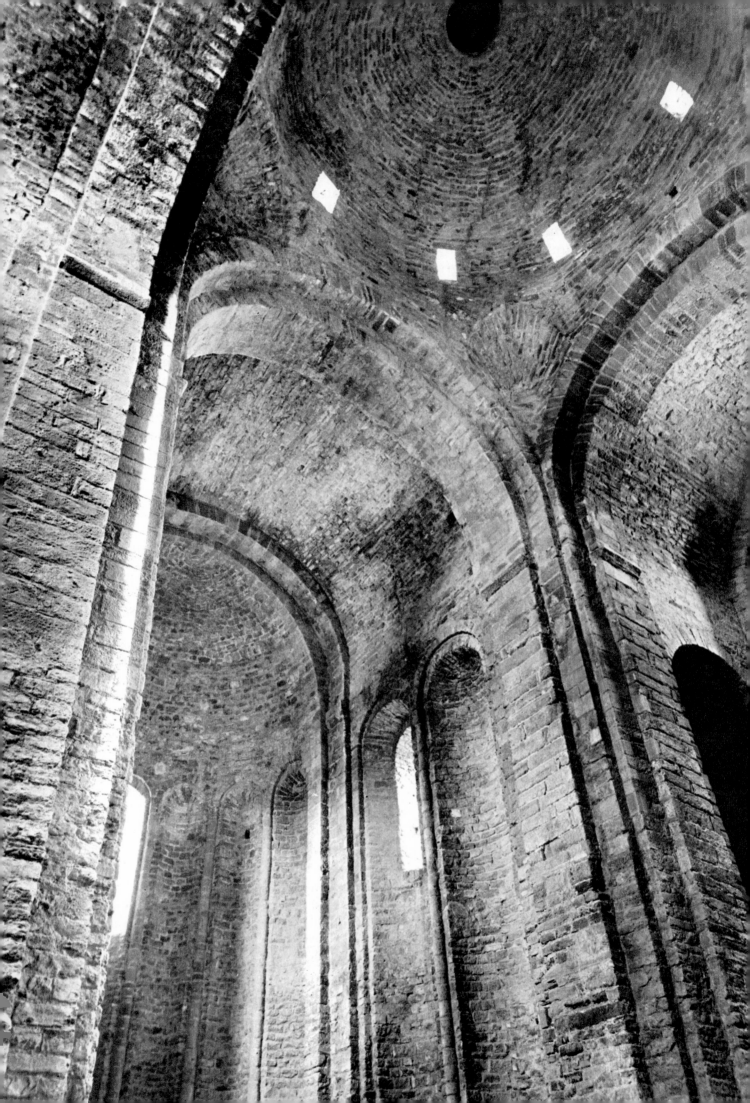

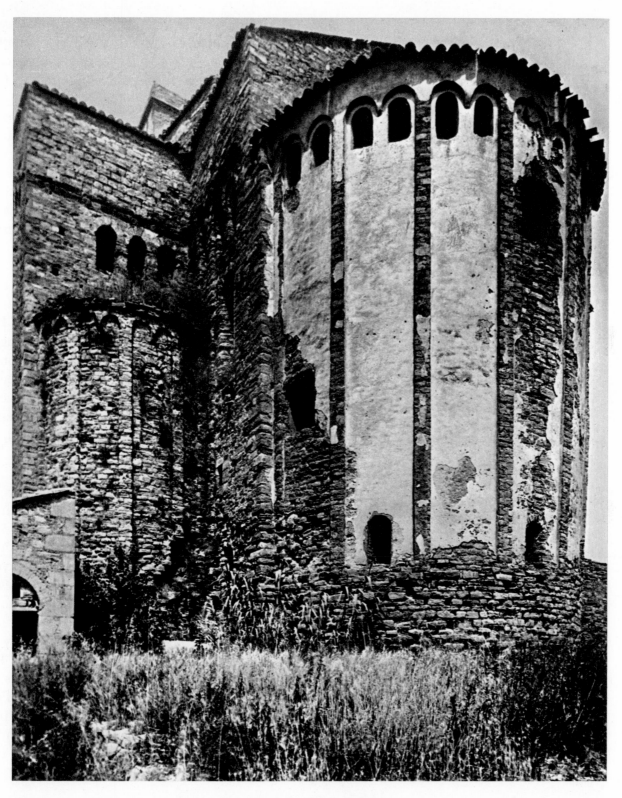

181, 182. S. Vicente de Castillo,
Cardona (Catalonia). 1029–40
(*left*) Interior toward apse
(*above*) Exterior of apse

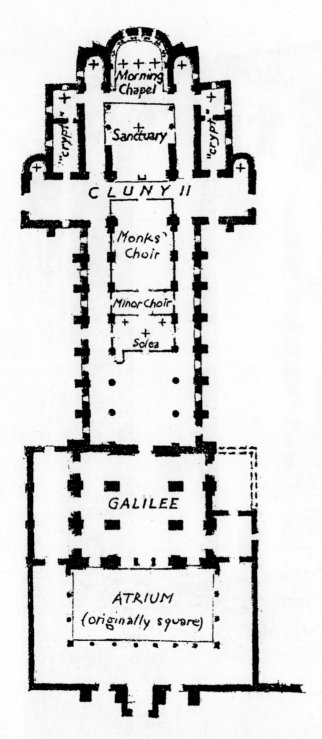

CLUNY II

Morning
Chapel

"crypt" Sanctuary "crypt"

Monks'
Choir

Minor Choir

Solea

GALILEE

ATRIUM
(originally square)

183. Plan of Abbey Church, Cluny II
(reconstruction by K. J. Conant). c. 955–81

and a dome over the crossing. The use of transverse arches or ribs led to the development of piers with projecting pilasters or shafts (compound piers). At S. Vicente de Castillo at Cardona (figs. 181, 182), built between 1029 and 1040, all the important innovations are combined—a dome, groin-vaulted aisles, a barrel-vaulted nave with arches, and clerestory windows in the high walls of the nave—while the exterior still has all the characteristic Lombard features. Some of the large abbeys on both sides of the Pyrenees retain many First Romanesque elements, yet go far beyond these in their ambitious and complex forms.

"First Romanesque" architecture spread from Lombardy to the kingdom of Burgundy (then part of the Empire), and to the duchy of Burgundy. The second of the successive buildings of Cluny (fig. 183), known from the excavations of Professor Kenneth Conant, was completed in 981, but rebuilt in the course of the eleventh century. It was essentially a First Romanesque church, but some features were northern, for instance, the westwork with two towers. The form of the original church of Cluny II was imitated in some dependent monasteries: Romainmôtier, Payerne (kingdom of Burgundy, now Switzerland), and many others.

The Cluniac abbey of St-Bénigne at Dijon, built by St. William of Volpiano in the first years of the eleventh century, was a First Romanesque building of eccentric form, with a rotunda to the east of its sanctuary in imitation of the church of the Holy Sepulcher in Jerusalem. Only the crypt of the rotunda survives. Of the large First Romanesque churches in Burgundy, one is still preserved in its entirety, the abbey of St-Philibert at Tournus, built between 950 and 1009, but with later additions (figs. 184–86). Its ambulatory with rectangular chapels is derived from

184. Interior of St-Philibert, ▶
Tournus. 950–1009

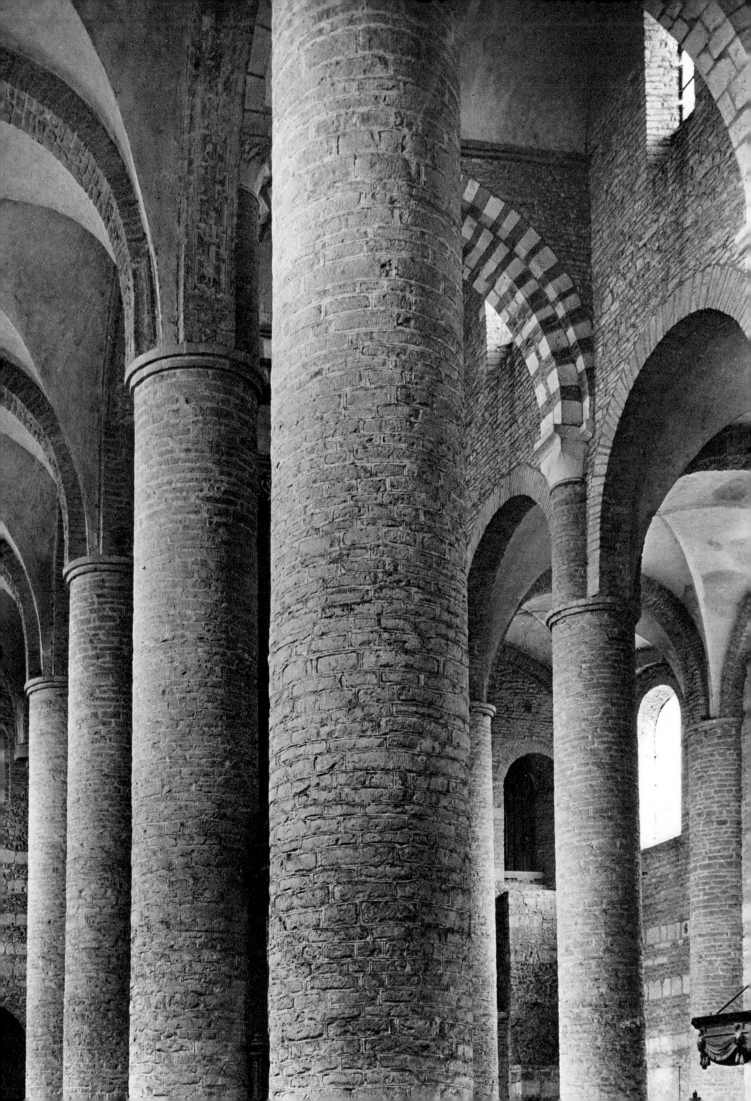

192

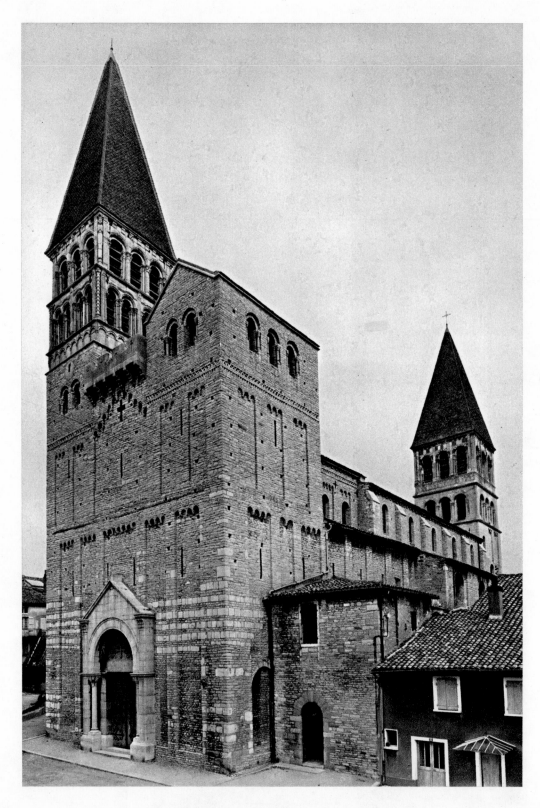

185. Exterior from southwest,
St-Philibert, Tournus. 950–1009

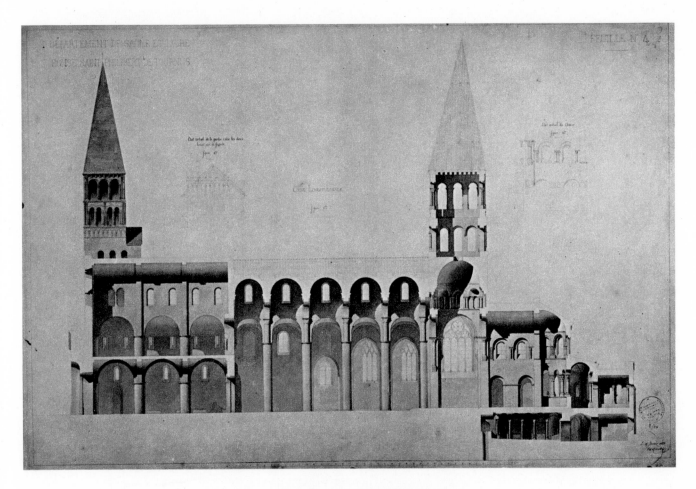

186. Longitudinal section of St-Philibert,
Tournus. 950–1009

St-Martin at Tours. No other church has, under one roof, so many forms of vaulting as Tournus. The three-aisled narthex and the chapel of St. Michael above it have groin vaults, barrel vaults with transverse ribs, interpenetrating barrel vaults and half barrel vaults; in the nave the barrel vaults (c. 1070) are placed not along the axis but across it. Externally, Lombard pilasters and arches are used extensively and there are numerous capitals, some carved with crudely executed figures, including one of a mason-sculptor holding an axe or hammer (fig. 187).

187. *Mason-Sculptor Holding Tool*.
Relief above Capital. 950–1009.
St-Philibert, Tournus

IX

Late Anglo-Saxon and Viking Art

The Viking invasions and settlements of England, which started in the ninth century, completely disrupted the artistic life there. Only after the middle of the tenth century were there signs of a revival, due to the growing political power of the southern kingdom of Wessex and, above all, to religious reform influenced by the abbeys at Fleury and at Flanders. But the Viking menace was not over; new raids began in the last decade of the tenth century and, before long, England was ruled by a Danish king, Knut (1016–35). He was a devout Christian and well earned the title, Knut the Great. In 1042 the crown went to Edward the Confessor—half-Saxon, half-Norman, and educated in Normandy—and during his reign the first signs of Romanesque art began to appear in England. His death, in 1066, gave the excuse for the Norman conquest of England, which greatly changed the life, as well as the art, of that country.

The religious reforms of the tenth century reintroduced the strict Benedictine Rule to over thirty monasteries for men, and six or more for women. Old ruined abbeys and churches were repaired, and many new structures were erected. But after the Conquest all the large monastic and cathedral churches were rebuilt in the Romanesque style; thus our knowledge of earlier tenth-century architecture is based on excavations and on the few rural examples which, because of their remoteness, were left alone. The recent excavations at Winchester revealed that the Old Cathedral incorporated a seventh-century church, to which was added an elaborate westwork before 980, and, before 994, an apsidal east end over the crypt and two additional apses that pointed south and north. The lofty eighth-century church built by St. Aldhelm at Bradford-on-Avon was restored at this time (fig. 188), and the handsome external

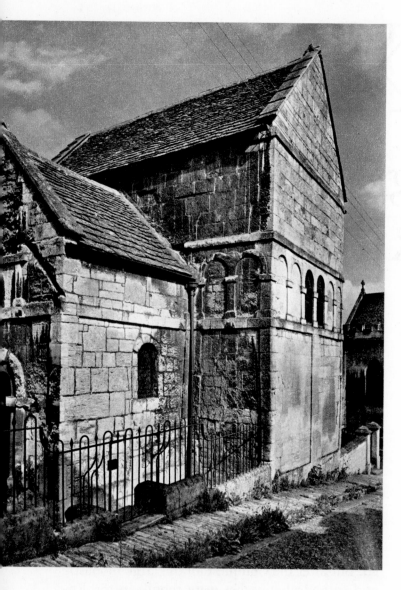

188. Exterior from northwest,
Church of St. Laurence, Bradford-on-Avon (Wiltshire).
10th century

of the *Crucifixion,* carved on the walls of porches or above the chancel arches. A large fragment of a relief with secular subjects was discovered at Winchester, from the early eleventh century, and a text describes elaborate reliefs with religious scenes on the tower of the New Cathedral at Winchester, built between 980 and 990.

However, the works of late Anglo-Saxon art which are best preserved, and must have been greatly admired in Europe at the time, were illuminated manuscripts, usually known by the misleading term of Winchester School. These manuscripts were produced in monastic scriptoria in the south of the country; Winchester, with three large monasteries, was undoubtedly one of the most important, but similar manuscripts came from Canterbury, Glastonbury, Ely, Abingdon, and other centers.

The Winchester School style came into being in the course of the tenth century, and during the episcopate of St. Ethelwold at Winchester (963–84) it had already produced some of its mature masterpieces, such as the Benedictional of St. Ethelwold (colorplate 32). Paintings of the Winchester School are characterized by rich colors among which gold was prominent; a dynamic figure style with linear drapery, often agitated as if blown by a tempestuous wind; and rich borders composed of unruly broad acanthus leaves which frequently overgrow the frames. It has been argued that the main source of this style is Carolingian, in particular the Ada School manuscripts, and that the Metz School exercised an influence on its initial stages—but, if so, the style that emerged in England is highly individual.

About the year 1000 the masterpiece of the Rheims School, the Utrecht Psalter, was brought to Canterbury and was copied there at least three times, about 1000, 1150, and 1200 respectively. The influence of the illusionistic style of this manuscript on the Winchester School was considerable, and it encouraged the practice of making illuminations by drawing with colored

arcading added. Also a number of highly original towers were built, decorated with pilaster strips, arcading, and gables, those at Earls Barton and Barton-on-Humber being the best preserved (fig. 189).

Many reliefs survive to suggest that sculpture played an important part in the decoration of these churches. Some were over-lifesize reliefs

189. Exterior from southwest, Church at Earls Barton (Northamptonshire).
10th century

66.

Noe ꝼꞃume. ꞃꝼa hinꞇ nꞇꞃuꞅꝥꞃo hehꞇ. hynꝺe þam hal
gan. hꞅꝥꝟon cynn. ongan. oꝛoyꞇ lice þ hoꝛ pynꞇan
micle miꝼꞇ ꞇliꝼꞇꞇ. magꞇm ꞃagꝺe. þ þaꞇ ꝟnꝼulꞇ þinꞇ.
þꞇꝺum ꞃꞇ ꝼꞇuꝺo. ꞅꞇꝺe piꞇꞇ. hꞇ nꞇꝟohꞇꝟon þaꞇ. ꞅꞇ
ꞃꝺꞇh. ꝟmb pꞇnꞇꞃꞇꝺ ꝟoꝟn. þaꞇ ꝼaꞃꞇ mꞇꞇoꝺ. ꞅꝼꞇꝟon
hꞇꝟ. maꞇꞇꞇ ꞅꞇꞇꝟo hluꝟꞇꞅꞇꝼan. mꞇꝟꞇn ꞃꞇuꞇan. ꞇonꝼan
hmꞇꞇ ꞅꞇꞅaꞃꞃmoꝺ þꞇꝼ ꝼloꝺe. þaꞃꞇnoꞇꞇ. þꝟ ꝟelꞇꞇꝟn
ꝼ ꞃꝟnꝺꞃꞇꞅ cynn. Symle biꝼ þꝟ hꞇꞇuꝺꞃa. þꞇhꞇꞇꝟnꝼꞇh
ꞇꞇꞇꝟ ꞃꝼꞇuꞇꞇꞇ ꝼꞇꞇ ꞃꝟꞅꞇꝟmaꞃ. ꝟꞃꝺꝟoꞇ bꞇꞇꞇꞃaꝺ.

190. *Noah's Ark. Caedmon's* Poems.
Illustration 9 × 7 3/4". 2nd quarter 11th century.
Bodleian Library (Ms. Jun. 11, p. 66), Oxford

of Caedmon's poems in Old English, copied in
the second quarter of the eleventh century (fig.
190); the prow of Noah's ark, for instance, has
the characteristic Scandinavian form. In the
other manuscripts of this group, the Winchester
acanthus is radically transformed to look like the
abstract Ringerike pattern.

Toward the middle of the eleventh century
there was a considerable change in the Winchester School style, the forms becoming more static
and solid, a clear step toward the Romanesque
style.

Anglo-Saxon manuscripts were sent to the
Continent as gifts, many to Normandy, some to

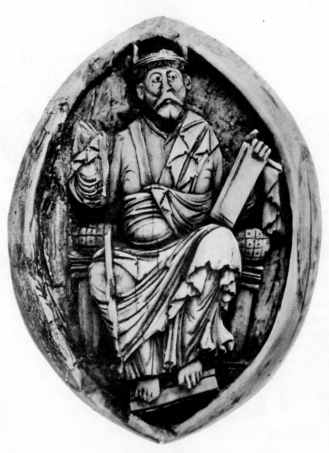

191. *Christ in Majesty.*
Walrus tusk, height 3 3/4". Early 11th century.
Victoria and Albert Museum, London

inks rather than by painting. This technique was
already in use in the tenth century, and it continued until well into the thirteenth.

A group of Winchester School manuscripts
stands apart because of the numerous elements of
decoration which are of Viking origin, being
related to or inspired by the Ringerike style
(see page 202). One of this group is a collection

Fleury and even further afield. It is known, for instance, that Judith, countess of Flanders and wife of Tostig, earl of Northumbria, gave two manuscripts, made for her between 1050 and 1065, to the abbey of Weingarten (colorplate 33). English painters were called to execute manuscripts in the abbey of St-Bertin, where a famous scriptorium that employed a modified Winchester School style was at work under Abbot Odbert (c. 986–1007), himself a painter. Anglo-Saxon influences were also to be found in Normandy, in the scriptoria at Jumièges, Mont-St-Michel, and elsewhere.

The Winchester School style was not restricted to painting. There are a number of works in metal, ivory (fig. 191), and stone in which all the features of the manuscript style are present.

But it would be a mistake to think of the Winchester School as the only form of art in tenth- and eleventh-century England. The Viking population of the country was considerable, and it retained links with its former Scandinavian homeland.

I have already referred several times to the Vikings and their raids on England, Scotland, Ireland, Germany, and France. They even made sporadic attacks on Spain, Provence, and Tuscany. These early activities as pirates were followed by Viking settlements, first in the British Isles and later in Normandy. The Vikings' hunger for land, combined with their superb seamanship, led them to discover and then found settlements in Iceland (860) and Greenland (c. 980), and even to the chance discovery of America. Not all Viking activities were destructive, since, for example, they established trading towns in Russia and maintained commercial links with the Arabs and the Greeks, as well as with the more distant parts of Asia.

Until the Scandinavians accepted Christianity (the Danes in 965, the Norwegians and Swedes in the course of the eleventh century), their buildings were exclusively of timber, and their art was confined to the ornamentation of weapons, jewelry, and even objects of everyday use. Knowledge of Scandinavian art during the pagan period is based chiefly on burials in tombs, the most famous and richest being the Oseberg ship-burial of the first half of the ninth century, excavated in Oslo Fjord. The ship and the objects it contained—a cart, sledges, beds, and many other items—are of great beauty and technical excellence (figs. 192–94). Clearly, the pirates who were so skilled with their weapons were no less skilled with their tools.

The wooden objects in the ship, as well as the ship's prow, are covered with carvings of an extraordinary complexity that can be matched only by the complexity in early Hiberno-Saxon manuscripts. From the earliest times Viking art was confined to animal motifs, and this predilection found full expression in the Oseberg ship-burial. Within a restricted range of motifs, the Viking artists were able to express a feeling of almost tormented agitation by using different animal forms, in different combinations, in different actions, and in different degrees of relief. Some of the sculptures are flat, others round and soft. On some objects the animal motifs are large, their structures easily comprehended in spite of their being creatures of the imagination, unrelated to any particular species. In others the forms are ambiguous, and confusingly entangled. The animals overlap, grip each other, extend their limbs, necks, tails, and wings like the suckered tentacles of an octopus. They not only overlap and grip, they often interpenetrate one another and form knots with their own bodies or the bodies of their neighbors.

The reliefs on the processional cart include some obscure narrative scenes, foreign to Scandinavian art and perhaps derived from models looted by the Vikings in their raids.

The Oseberg ship-burial was connected with a high-born and rich woman, but there is no reason to think that the objects it contained were unique. Similar works of art were found in the nearby Gokstad ship-burial, and it is probable

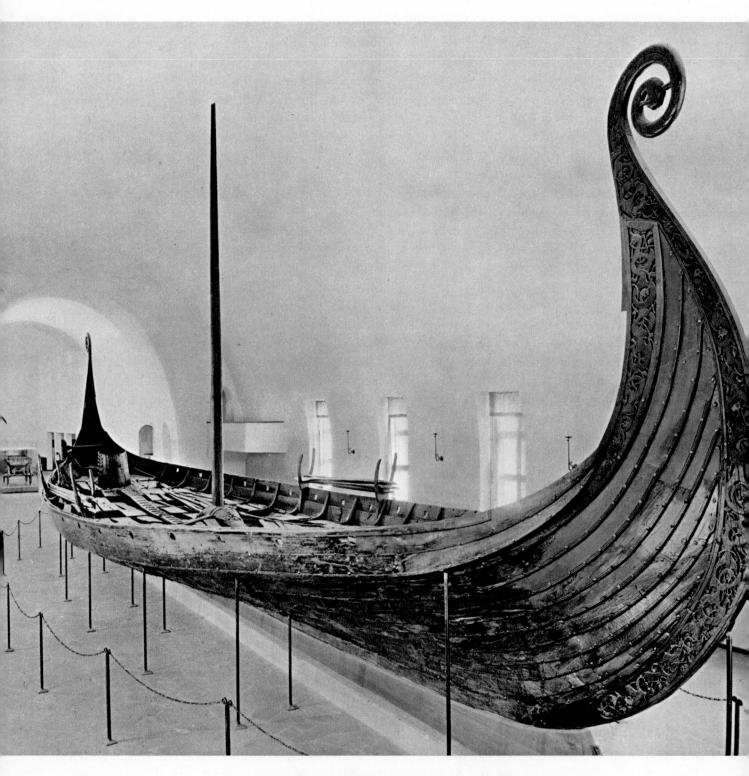

192, 193, 194. Oseberg Ship-burial. 1st half 9th century.
The Viking Ship Museum, Oslo
(*above*) Oseberg Ship. Wood, length c. 65′
(*opposite, above*) Wooden Cart with Animal Reliefs
(*opposite, below*) *Animal Head*. Carved wooden post

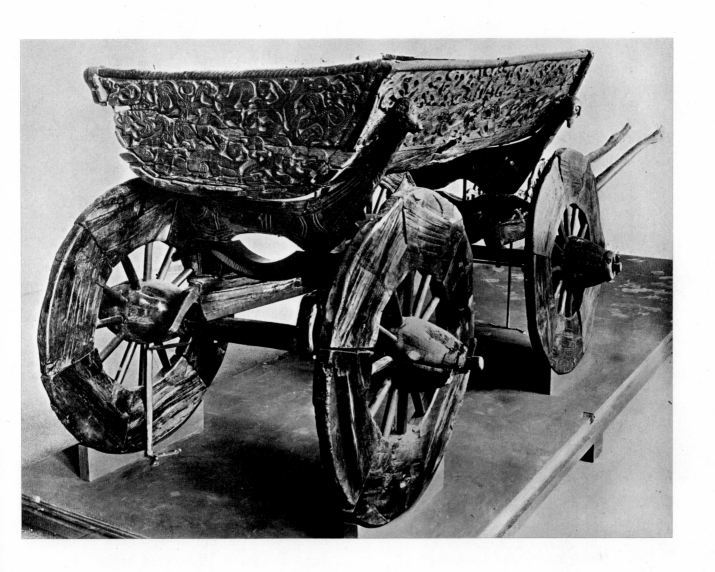

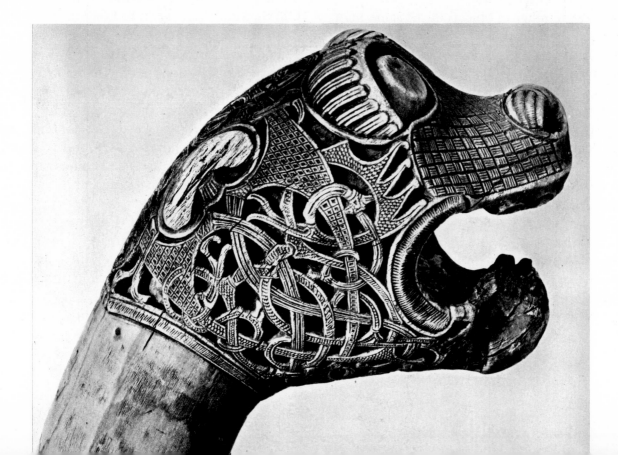

195. *Crucifixion.* Jelling Stone.
Height over 5'. Before 985.
Jelling, East Jutland (Denmark)

that a great number of objects of the same high artistic quality did not end in burials, but were eventually discarded and destroyed.

The stone sculpture which survives on memorial stones on the Baltic island of Gotland, with scenes from Scandinavian mythology, belongs to a different class, for stone sculpture was not native to Scandinavia. But shortly after Denmark was converted to Christianity, King Harald Bluetooth (d. 985) erected a stone at Jelling, in Jutland, in memory of his heathen parents (fig. 195). This granite boulder is carved with a strange *Crucifixion*, without a cross, and with Christ entangled in ribbon-like bands; on the other side is the Scandinavian Great Beast struggling with a snake. This is what is called the Jelling style, a type of decoration which the

Vikings took with them to Britain. During the second half of the tenth century the Jelling style evolved into the more exaggerated Mammen style. The Great Beast motif proved to be far more popular than the *Crucifixion*, and was used over and over again throughout Scandinavia.

The evolution of the Jelling and Mammen styles led, toward the end of the tenth century, to a modification known as the Ringerike style. In all previous manifestations of Viking art the animal motif was the dominant factor, with an abstract ribbon interlace as the sole decorative addition. The new Ringerike style introduced something into Viking art that was entirely foreign, and can only be explained by the contact of Viking settlers with the Winchester School style, namely, foliage. The usual Ringerike composition consists of the Great Beast and the snake entangled in the irrationally twining stalks of a nondescript plant having thin voluted terminals. These are derivatives of the acanthus of the Winchester School style.

The gilt-bronze weather vane from Heggen, in Norway (fig. 196), is a good example of the Ringerike style, full of vigor and dynamic design. Similar in the use of animal and plant motifs is the tomb-slab found in the cemetery of Old St. Paul's Cathedral in London (fig. 197). It is a Christian tomb from the reign of King Knut, a good illustration of the existence in England of an artistic tradition very different from the Winchester School style. England in the eleventh century was half-Scandinavian, and so was Ireland; the Ringerike style, applied with great mastery to church vessels and reliquaries, to stone sculpture, and even to manuscripts, continued to be popular in Ireland until the twelfth century.

After the adoption of Christianity by the Vikings, burial objects were no longer put in graves, and our knowledge of their art in the period following their conversion thus depends on a different kind of material, chiefly of a religious character. The tomb-slab in London il-

196. Weather Vane (front). Gilt bronze, c. 10 × 14".
Late 10th century. Heggen (Norway)

197. Tomb-slab. Width 24". Early 11th century.
Museum of London

198. *Saint* (one of a series).
Wooden wall panel from Flatatunga; 9 × 7″. 11th century.
National Museum of Iceland, Reykjavik.

lustrates the adaptation of an essentially pagan art to Christian use. Even more striking are wooden panels from Flatatunga, in Iceland (fig. 198), on which are engraved Ringerike foliage and nimbed figures.

By the middle of the eleventh century, the last of the native Viking styles was evolved, the Urnes. One of the favorite motifs of this style is a thin, ribbon-like creature, forming elegant, fluid curves; another is a snakelike monster with one foreleg, and a second leg taking the place of a tail-end. An essential part of Urnes design is a thin ropelike element, interlacing with the animals and terminating in a small leaf or head. The monument which gave the name to this style is the Norwegian stave church at Urnes, where a number of wooden sculptures, such as doors and door frames (fig. 199), have been reused from an earlier building of the third quarter of the elev-

enth century.

In elegance and technical mastery, the Urnes sculpture can be compared to objects from the Oseberg ship-burial and to the animal interlaces of the Lindisfarne Gospels (see fig. 96). Such comparisons are historically meaningless, yet the similarity between the works is real and must be due to the northern taste for dynamic, abstract design, based only vaguely on animal forms. The Urnes church sculpture is a pagan art applied to a Christian building. But this art was doomed to extinction. The introduction of stone building into Scandinavia, and with it architectural sculpture and painting of Mediterranean inspiration, put an end to the Urnes style. It was employed sporadically during the twelfth century in Scandinavia and in the British Isles, and its echoes last for centuries in Scandinavian folk art.

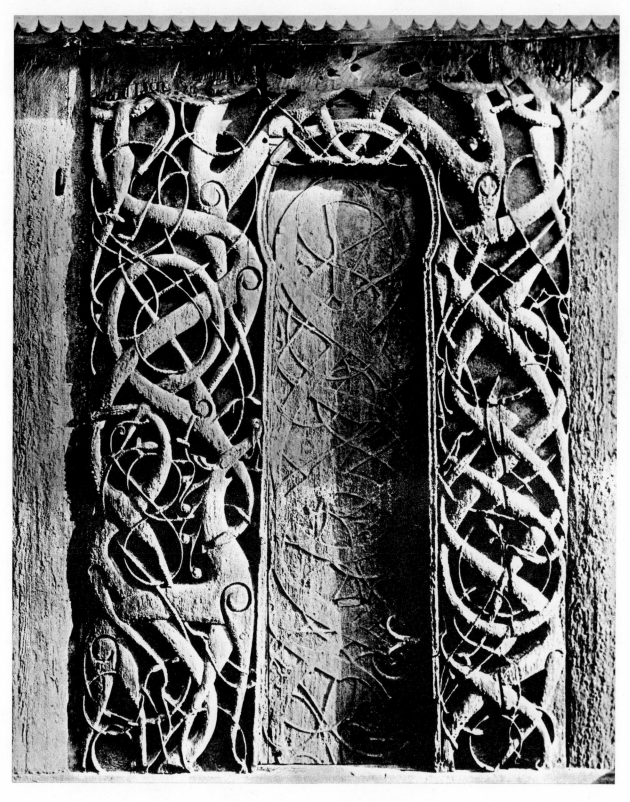

199. Carved frame, north doorway.
Wood. 3rd quarter 11th century.
Stave church, Urnes (Norway)

Romanesque Art

In July 1054, the papal legates from Rome excommunicated the patriarch of Constantinople in the cathedral of Hagia Sophia. By this act the ever-widening rift between the Byzantine and Roman Churches ended in a final breach. Thus, in religious matters, most of the Christian world could be divided into those who owed allegiance to the patriarch of Constantinople—including not only Byzantium but Russia, Bulgaria, and Serbia—and those who recognized the pope as the head of the Church. By the eleventh century the Roman Church had enormously extended its sphere of influence through the conversion of central Europe and the Scandinavian north, and by the new conquests at the expense of the Muslims in Spain, Sicily, and the Holy Land.

Romanesque art developed during the eleventh century, matured in the first half of the twelfth, and gave way—rapidly in some regions, more slowly in others—to the Gothic style in the course of the twelfth and thirteenth centuries. Originating in the countries of western Europe, Romanesque spread north and east with the expansion of the Roman Church; only in a few isolated cases, in Serbia and in Russia, did it penetrate the territories joined by religious links to Constantinople. Thus it was the first medieval style which can be termed truly European, for it could be found from the Atlantic to the Vistula, from Sicily to Iceland, and almost to the Arctic Circle in Norway. Romanesque art was born in a Europe that was gaining in strength and confidence, for now, no longer harrassed by barbarian invasions, Europe was, on the contrary, on the offensive. The Norman conquest of southern Italy in the course of the eleventh century removed the last Byzantine possessions there, and more important, it freed Sicily from Arab rule and made of the island a place where the various civilizations mixed

freely and fruitfully. The Christian states in northern Spain, only recently plundered by the armies of Al-Manzor in the tenth century, not only recovered quickly but went on the offensive themselves, and the *Reconquista*, the holy war to free the territories lost in 711, made rapid progress: by 1085 Toledo was captured; by 1236, Cordoba, and soon afterward Valencia and Seville. The Moors were no longer a danger and were permitted to remain in Granada until it too was taken in 1492, the year Columbus sailed from Spain on his momentous voyage. The wars of the reconquest were a crusade in which other countries than the Spanish kingdoms were involved, a fact not without influence on artistic matters.

The crusades to the Holy Land were another sign of Europe's new, expansive, confident, and aggressive mood. The travel of many thousands of persons across Byzantine lands and the intimate contact they had over many decades, through the kingdom of Jerusalem, with Islam and with other cultures and arts, was of great importance for the development of Romanesque art.

Romanesque art was predominantly, though of course not exclusively, religious, and it expressed the deeply religious, if often superstitious, character of society at the time. During the period the authority and prestige of the Church increased enormously. The papacy, ineffective and often corrupt, underwent a similar reform to that carried out in the monasteries earlier on. The election of the popes, which had formerly been at the mercy of the emperors, the nobility, and even the Roman mob, was now entrusted to the college of cardinals. Bishops, abbots, and the lesser clergy had frequently, in the past, been appointed by kings, barons, and other patrons of churches, with the result that few were suitable for their offices and most were merely pawns in the hands of unscrupulous laymen. In the famous ordinance of Pope Gregory VII (1073–85) this system was forbidden under threat of

excommunication. But the feudal nobility and, above all, the emperors had a vested interest in the old system, and the struggle which followed, known as the Investiture Contest, plunged the Holy Roman Empire into a series of wars with the popes until a temporary compromise was reached in 1122 by the Treaty of Worms. The problem of the supremacy of spiritual over temporal power was at the root of the contest, and continued to dominate the relations between the Church and most of the European states; it exploded in a series of wars between Emperor Frederick Barbarossa (1152–90) and the popes, ending in the humiliation of the emperor. The final triumph of the papacy came under Pope Innocent III (1198–1216), when Rome emerged as a spiritual and political power of great magnitude.

The continued involvement of the Empire in Italian affairs had, as will be seen, a profound influence in the artistic field. Politically, the drain on energies and resources for what were, in actuality, foreign wars had a disastrous effect on the future of the Empire, for Germany remained split into rival duchies while France and England developed into strong, unified states. Moreover, the rivalry between the emperors and the popes divided Germany and Italy into feuding factions—the Welfs and Hohenstaufen in Germany, and their Italian equivalents, the Guelphs and the Ghibellines—that were to dominate the future of those countries for a long time to come.

Italy was prevented during the Romanesque period from developing into a unified state, and had to wait until the nineteenth century to achieve it. Only the Italian south saw the meteoric rise of a strong feudal state, under the brilliant Norman dynasty. Lack of central power in the rest of Italy gave its towns an opportunity to acquire more and more autonomy. The visible sign of the growing importance of the towns was the formation of the Lombard League, whose municipal army inflicted a decisive defeat on

Frederick Barbarossa at Legnano, in 1176.

Romanesque art flourished in cathedrals, monasteries, and smaller churches, of which very many thousands still survive in their entirety or in part. Economic expansion and the growth of population made possible and necessary the building of a vast number of churches on new sites, or the rebuilding of old foundations. With the development of the feudal nobility, there was no lack of pious patrons to give large sums of money and generous endowments for the building of churches. Piety was not their only motive. A penance for serious misdeeds was another. A further motive was the desire to have a church in which prayers would be said regularly for the well-being and the souls of the founder and his family. In the past, churches had been built by kings, princes, and the powerful clergy; now these were joined by many lesser, more humble people who, if unable to erect a church themselves, could at least donate money for one or contribute an ornament.

Monasteries expanded in number and in the variety of their Rules, though the Benedictines remained numerous and influential. The Cluniacs were the most powerful until the early twelfth century, when their influence declined in the face of the new Cistercian Order. The Cluniac Order well reflected the hierarchy of feudal society: the abbot of Cluny was like a king, the supreme autocratic ruler of the whole organization. Its associated monasteries were not abbeys (with the exception of the few old foundations which joined the Cluniacs as abbeys) but priories, and they were under strict obedience to the mother house of Cluny. The Cluniac Order was an aristocratic institution which devoted much time to an elaborate liturgy; it is therefore not surprising that Cluniac churches were among the most elaborate of Romanesque buildings.

The Cluniacs came into being as a result of dissatisfaction with the Benedictine Rule as practiced at the turn of the ninth century; likewise the Cistercians, the Carthusians, and many

of the other Orders founded during the eleventh and twelfth centuries owed their origin to disapproval of the rich and worldly Benedictines and Cluniacs. Cistercian simplicity and austerity, supported by uncompromising and fanatical leaders such as St. Bernard, was a reaction against the prevailing monastic life, and Cistercian artistic works paved the way for early Gothic architecture. The emergence of the new military Orders in the Holy Land kept the crusading spirit alive, and helped to disseminate artistic forms from the East throughout Europe.

Romanesque art evolved, during the eleventh century, almost simultaneously out of existing styles in the countries of Western Europe—Germany, Italy, Spain, and, to a lesser degree, England—but the most promising experiments were undoubtedly carried out in France, and it was also in France that some of the most significant masterpieces were created during the next century. Of course, it is somewhat misleading, while discussing the eleventh and twelfth centuries, to talk in terms of nationalities and national boundaries, especially in regard to France. The French branch of the Carolingian dynasty was replaced by the Capetian, in 987, but for the next hundred years or more, France was still a conglomeration of independent or semi-independent duchies and counties, with the king's power restricted to the royal domain around Paris and Orléans. But in the feudal system the prestige of a king, anointed with the holy oil and thus credited with being endowed by God with special powers, was very great. Supported by the Church, the Capetian kings asserted their authority over their fiefs, some of whose territories were far larger than the kings'. By the time of Louis VI the Fat (1108–37) France had emerged as a powerful kingdom.

The Norman conquest of England, in 1066, created a difficult problem and many dangers for the French kingdom, for the dukes of Normandy were now also the kings of England. The danger became even more alarming when Aquitaine and England were united under Henry II

Plantagenet and the English king ruled over territories from the border of Scotland to the Pyrenees. This was an artificial creation which did not survive for long, but in artistic matters it was of great importance, especially to England.

The final triumph of France as the leading kingdom of Europe was the victory of Philip Augustus over Emperor Otto IV in 1214, at Bouvines in Flanders.

A. Early Romanesque Art in France and Spain

The division of France, during the eleventh century, into several more or less independent units is well reflected in the artistic forms that differ so greatly from region to region.

In the territories adjoining the Empire, the influence of Ottonian art was felt very strongly. The churches at Montier-en-Der and at Vignory, on the upper Marne River (the first consecrated in 998 and rebuilt about 1040, the other dating from about 1050), both have Ottonian elements in their structures and decoration. In Champagne, the ancient abbey of St-Remi at Rheims was rebuilt toward the middle of the century and also has some Ottonian details. The stucco capitals of high quality, some historiated, have close parallels in Ottonian art.

Curiously, the region of Paris had few monuments of Romanesque art, as if it were an artistic backwater during this period. Only the abbey of St-Germain-des-Prés, in Paris, stands out as a more ambitious building. A series of capitals from there, in date about 1050, is now in the Musée de Cluny in Paris, one with an expressive *Christ in Majesty;* these are the only important sculptures of the period from the royal domain.

One of the most inventive regions in the field of Romanesque architecture was the valley of the Loire, in the counties of Anjou, Poitou, and Blois. The brigand counts, such as the notorious Fulk Nerra, count of Anjou (987–1040), were as pious as they were ferocious, and covered their lands with magnificent abbeys, cathedrals, and, not least, numerous castles (Fulk alone is known to have built thirteen of these).

It was in this region that the east end of a church, in the form of an ambulatory with radiating chapels, was perfected. First used in the cathedral at Clermont-Ferrand (946), the idea was further developed in the cathedral at Orléans (before 1016) and, a little later, in the church of St-Aignan in the same town. The future success of the ambulatory system was assured when it was used, between 1003 and 1014, at St-Martin at Tours (fig. 200), then the most important Pilgrimage church in France, containing the relics of St. Martin, the founder of the abbey. It was in this venerable house that Alcuin had been abbot and initiated there the famous Carolingian scriptorium. Of this great church, today only a ruined tower of the transept survives; it dates from the middle of the eleventh century, when the church was vaulted to replace the original timber roof.

200. Plan of Abbey Church, St-Martin, Tours. c. 1050 (reconstruction after K. J. Conant)

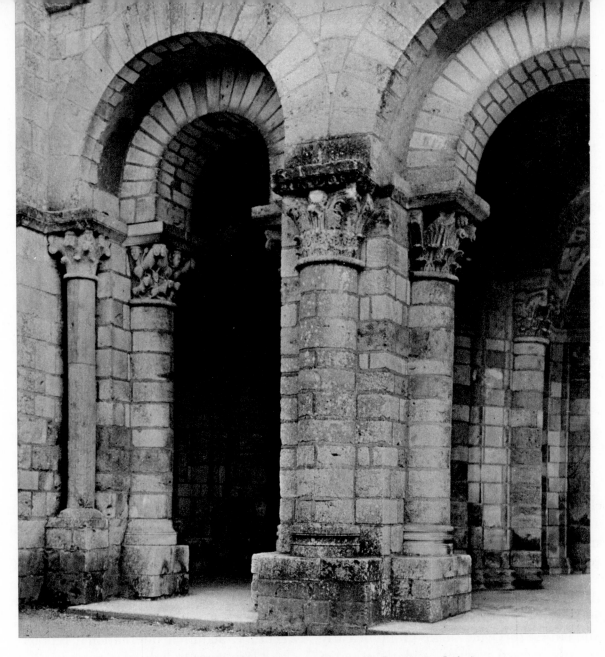

201, 202. Tower-Porch, Abbey Church, Fleury (St-Benoît-sur-Loire). c. 1050.
(*above*) Exterior from northwest.
(*below*) *Flight into Egypt*, capital in tower-porch, ground floor

St-Martin had another feature which was to become important, namely, a transept having aisles with galleries along all three walls. This arrangement was first used in the cathedral at Orléans, to be repeated in all so-called Pilgrimage churches and, curiously, in some cathedral-abbeys in England. All the early Romanesque churches of the Loire Valley use compound piers as the means of support, piers to which are attached shafts with carved capitals. The abbey of Fleury (now St-Benoît-sur-Loire; fig. 201) was another famous pilgrimage center in the region, having the relics of St. Benedict which the monks of Fleury claimed to have rescued from Montecassino when that abbey was destroyed by the Lombards. The church is entered through a tower-porch, with arcades on three sides and four compound piers that support the interior vaulting. Above the porch is a chapel of similar design. This structure of unknown date (but close to 1050) is celebrated for its carved capitals (fig. 202). Some of these imitate the Corinthian form very successfully, others incorporate into the Corinthian capital figural motifs, and a large number are devoted to religious subjects based on the Gospels. They form the largest surviving single group of early Romanesque carved capitals, and they had a considerable influence on the development of sculpture, not only in the region, but also further afield (León in Spain, and Normandy). Works by the same group of sculptors survive in the tower of St-Hilaire at Poitiers and at Cormery. The sculpture of St-Benoît cannot be called graceful, since the forms are somewhat gauche and the figures doll-like. But this sculpture has a naive strength and expresses a simple but deep faith. What is important above all is that the sculpture and the capital to which it is applied are beautifully harmonized and complementary to each other. The future development of the best Romanesque sculpture went along this path of close unity with the architectural member to which it is applied.

PILGRIMAGES AND PILGRIMAGE CHURCHES

Nothing illustrates more eloquently the international character of Romanesque art than the so-called Pilgrimage churches. St-Martin was an early example, but they are not confined to the Loire Valley or even to France; the most celebrated example, in fact, is found near the Atlantic coast of northwestern Spain, at Santiago de Compostela.

Santiago owed its fame to one of those pious beliefs which turned legend into reality, an attitude so popular in the Middle Ages. No rational person can believe that a boat without sail or rudder bore unaided to Spain the beheaded body of St. James the Greater, the apostle who had witnessed Christ's Transfiguration and the Agony in the Garden; the boat was shipwrecked, and after many picturesque and miraculous events, the apostle was buried at Compostela. But the legend started an astonishing cult, and Santiago became, in the eyes of the Christian world, the champion of those fighting against the Moors, and the patron saint of Spain. The church housing his tomb became a place of pilgrimage which, during the eleventh century, acquired international repute.

Pilgrimages to holy places, especially to those connected with the life of Christ on earth, were already made in Early Christian times. In the eighth century a practice developed in Ireland that soon spread throughout Europe, of imposing a pilgrimage as a penance for sins. The greater the sin, the more distant and perilous a journey was required. By the eleventh century the practice of penitential and purely devotional pilgrimages was widespread, well organized, and protected by Church and civil legislation. Hostels were built along the routes frequented by pilgrims, roads were repaired and bridges built. Monasteries and secular clergy were great supporters of the pilgrimages, and along the routes churches sprang up to help the pilgrims and to benefit from their generosity, for

the pilgrims stopped on their way at famous shrines to pray and to make their offerings. The most popular pilgrimages throughout the Middle Ages were those to the Holy Land and to Rome, and, from the eleventh century onward, Santiago became equally important. The success of the *Reconquista* added to the attraction of Santiago, for was not St. James himself the *Matamoros*, the Moor-slayer? It was believed that he appeared miraculously on a white horse and in armor at the victorious battle of Ramiro I at Clavijo. The *chansons de geste*, and particularly the *Song of Roland*, with which the pilgrims were entertained on their journey, must have increased greatly the pilgrims' attraction to Santiago and fired their imagination with stories of heroic deeds: the story of Roland was especially appreciated, for it describes Charlemagne's expedition to Spain to fight the Moors, and the heroic death of Roland in the battle of Roncesvalles (Roncevaux) in the Pyrenees. On the spot where the battle took place (in reality, Charlemagne's rearguard was slain by the Basques, not the Moors) a hostel was provided for pilgrims. Even today, reading the *Song of Roland* at this place is a moving experience!

The pilgrims traveled to Santiago by various routes, depending on their place of origin. One most frequently used started at Paris, continuing through Tours, Poitiers, and Bordeaux; also popular was the route from Vézelay, through Limoges; a third was from Le Puy, through Conques and Moissac; a fourth from Arles, through St-Gilles and Toulouse. The first three crossed the Pyrenees and passed through Roncesvalles, the fourth joined the others at Puente la Reina; from then onward there was only one road, through Burgos and León to Santiago.

The well-known *Pilgrim's Guide*, written by a priest from Parthenay-le-Vieux in Poitou (included in a book called *Jacobus* which, it was recently argued, was a schoolbook used for teaching Latin and music), describes all four routes and the major shrines along them, and ends with a description of the cathedral of Santiago as it was at about 1130.

The spacious abbey church of St-Martin at Tours was designed to accommodate a large congregation of monks and pilgrims. The abbey of St-Martial at Limoges, founded by Louis the Pious, became Cluniac in 1063 and was rebuilt in a form similar to that used at St-Martin. Tours was on the first road to Santiago, Limoges on the second.

On the third road was the celebrated abbey at Conques (fig. 203), with its relics of Ste. Foy enclosed in a tenth-century gold statue-reliquary which attracted many pilgrims (see colorplate 30); the church had been rebuilt in the course of the eleventh century but was not completed until about 1140. It is located in a beautiful valley and, although considerably smaller than the other Pilgrimage churches, has a similar plan and elevation. It is lavishly decorated with sculpture, and part of the Romanesque cloister is still preserved. The unfortunate addition of western towers in the last century rather spoils the original appearance.

The fourth and southernmost road, used by pilgrims from Italy and Provence, went through Toulouse, with the shrine of St. Sernin in the collegiate church (figs. 204, 205); the Cluniacs took possession of St-Sernin, but only briefly, in the 1080s. The church was rebuilt during the last quarter of the eleventh century, although work on this large brick-and-stone building went on for about fifty years. In its plan it is another version of St-Martin, both churches having double aisles to the nave, and single aisles with galleries on all three sides of the transept arms. The chevet of St-Sernin preserves well the original apsidal chapels, grouped around the ambulatory and the east walls of the transept.

Like St-Sernin, the cathedral of Santiago (fig. 206) was not monastic, but it has the same features as the monastic Pilgrimage churches, for these were ideally suited to accommodate large numbers of the faithful, allowing vast crowds of

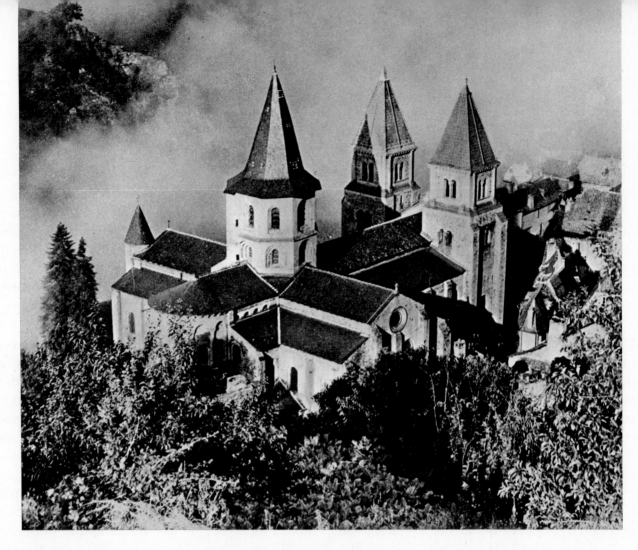

203. Exterior from northeast,
Abbey Church of Ste-Foy, Conques. 11th century

pilgrims to circulate around the building, along the aisles, and past the shrine displayed by the altar. All these churches have, or had, large transepts with a tower over the crossing, and their sanctuaries had two bays, ending in an apse beyond. In all cases the aisles with galleries continue around the transepts and the apse, thus forming an ambulatory from which radiate apsidal chapels, five in all except Conques, which has only three. There are four more apsidal chapels for altars in the transept, though in Conques and Limoges the number is reduced to two. All the aisles are groin-vaulted, and the naves have tunnel vaults with transverse arches which rest on shafts with carved capitals. These shafts go the whole height of the building, dividing the church into clearly demarcated bays. The shafts are attached to the front of the piers of the ground arcades and the galleries, and there

204, 205. Plan and exterior from southeast,
Collegiate Church of St-Sernin, Toulouse.
Last quarter 11th century

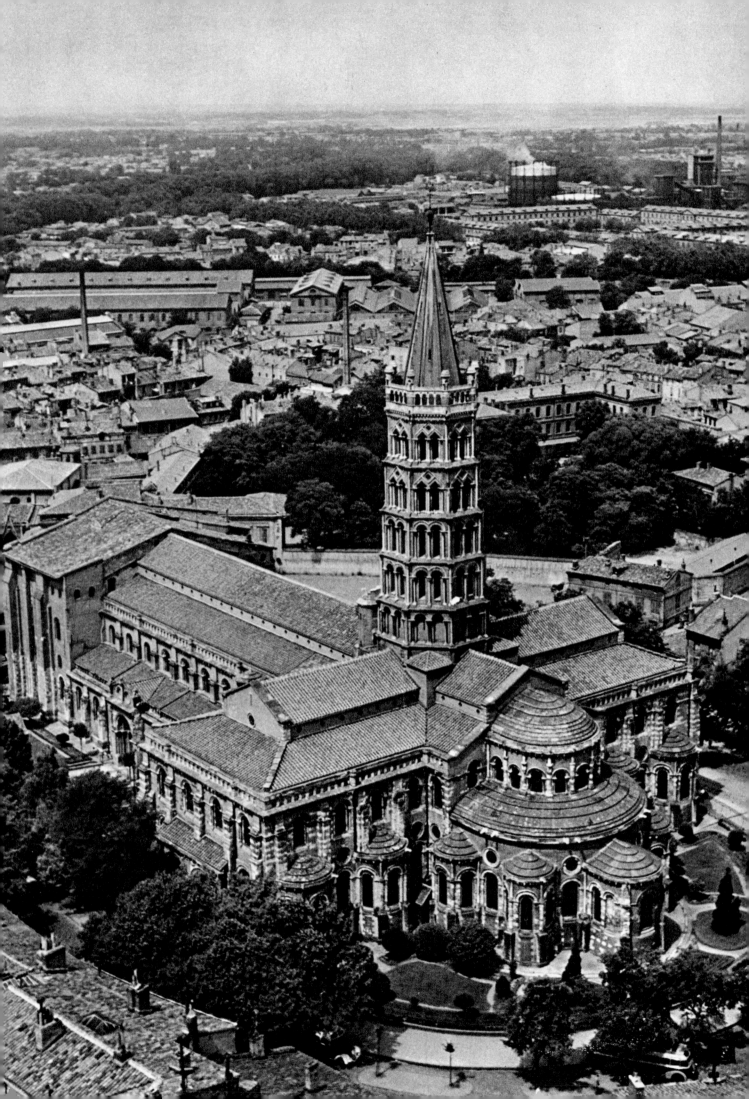

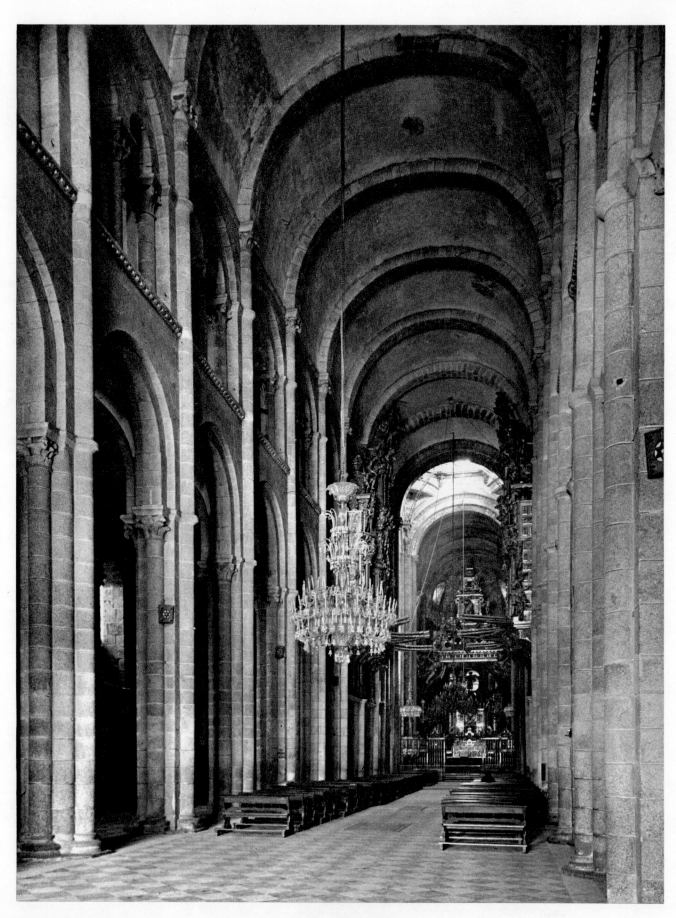

206. Interior toward east,
Cathedral, Santiago de Compostela. 1078–1120.

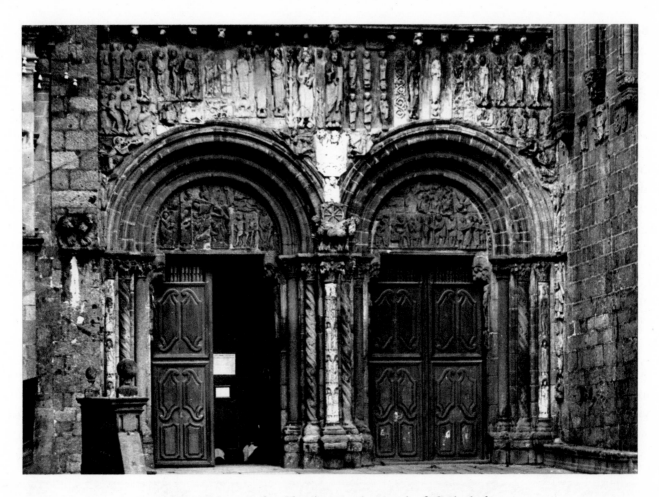

207. *Puerta de las Platerías*, south portal of Cathedral,
Santiago de Compostela. Completed 1103, with later additions

are smaller shafts on the other sides of the piers, providing rich, plastic forms. There is no clerestory; light filters through from the windows in the aisle and gallery walls, so that the interior is dim and cool, a real advantage during the hot summer.

The rebuilding of the cathedral of Santiago was started in 1078 and interrupted ten years later, when the easternmost part of the church had been finished. Work was resumed in 1093, when Diego Gelmíres became administrator of the see, and later bishop (1100). It is interesting that one chapel of the ambulatory was dedicated to Ste. Foy of Conques, and consecrated in 1102, and that the capitals in that part of the church are stylistically related to sculpture at Conques and in Auvergne generally. Obviously the connections

between Santiago and Conques were close, to judge from the facts of the dedication of the Ste. Foy chapel and the employment at Santiago of a sculptor from Auvergne. The transepts of the cathedral were ready by 1112, and the whole church finished in the 1120s.

Like all of the Pilgrimage churches (except Conques), each transept arm was entered by a twin portal, an arrangement dictated by purely technical considerations but having important aesthetic consequences. The transept aisles made it structurally necessary to have a pier in the center of each transept end, which would have obstructed a broad central entrance. To avoid this awkward inside pier, particularly inconvenient for processions, twin portals were made, separated by a thick outer pier (fig. 207). Finally

218

the two doorways were incorporated under a single arch enclosing a tympanum, and the pier was transformed into a trumeau. This later solution was not devised for technical reasons but for the sake of an imposing composition, and, above all, to make room for the large tympanum which this design required. This method of constructing grand doorways continued throughout the Middle Ages.

SCULPTURE

At Santiago the two transept façades, with their twin doorways, were decorated with sculpture of great richness. It is generally agreed that much of the sculpture was due to another French sculptor, this time from Toulouse.

Many French art historians of an older generation claimed a special place for Toulouse in the revival of Romanesque sculpture. Their claims

were somewhat exaggerated, but Toulouse in particular, and Languedoc in general, did indeed play a leading role in reviving architectural sculpture as a major art form, after many centuries of neglect. It is, of course, not true to say that the practice of architectural sculpture had gone out of use after the fall of the Roman Empire, although sculpture, and particularly figural sculpture, had less importance in the decoration of buildings during the early centuries of the Christian era than it did in classical times. But architectural sculpture had been practiced in Visigothic and Asturian Spain, in Anglo-Saxon England, on the Continent during the Carolingian and Ottonian periods, in Armenia, and at various times in Byzantium. It was natural that sculpture became an expendable luxury during the perilous century after the disintegration of the Carolingian Empire,

208. *Christ in Majesty, and Six Apostles.*
Marble lintel, height c. 2′. 1019–20. St-Génis-des-Fontaines

when peripatetic monks were hard-pressed to save their lives and the movable objects from their churches as well. In Ottonian churches, architectural sculpture was restricted to capitals, though fragments of large figures preserved from St. Pantaleon at Cologne, originally in niches on the façade, indicate that some attempts were made to incorporate sculpture into an architectural design.

In First Romanesque churches, sculpture played a very secondary role except in a small region of the eastern Pyrenees: in French Roussillon and in Catalonia, the area which formed the Spanish March in Carolingian times. Here, in a number of abbeys, experiments in the use of sculpture were made: at S. Pedro de Roda, dedicated in 1022, are found exquisite capitals, clearly influenced by Islamic art; at St-Génis-des-Fontaines there is a lintel with Christ in Majesty and six apostles (fig. 208), dated by an inscription to 1019–20; at St-André-de-Sorède is another lintel, a little later, with a similar composition, and a window frame with the symbols of the Evangelists, the seraphim, and angels blowing horns—taking frame and lintel together, this is the first *Last Judgment,* however abridged, in sculpture. Finally, on the façade at Arles-sur-Tech there is a cross within which is a Christ in Majesty and the symbols of the Evangelists; this cross is set in a field between a plain lintel and an arch, making it an early form of a tympanum. All these sculptures are of marble, and clearly the works of one and the same workshop. Also, a number of marble altar slabs made in the Pyrenees and exported over a wide area are related to this group. Apart from the Islamic decorative motifs present in these sculptures, the chief influence on the figure style was from Ottonian ivories.*

Not only was this Pyrenean workshop impor-

tant for its serious attempt to decorate doorways and windows with sculpture at this early date, but it also seems to have had some influence on the Toulousan workshop which was entrusted, in the last quarter of the eleventh century, with carving the capitals and the twin portals of the transepts at St-Sernin. The portals of the south transept, known as *Porte des Comtes,* have carved capitals with the parable of Lazarus and the Rich Man used in antithesis, and on the spandrels there were originally three niches that contained reliefs of St. Saturninus (St. Sernin, the patron saint) and two other saints of unknown identity. Such spandrel niches with figures were part of the decoration of St. Pantaleon at Cologne some eighty years earlier and could well have provided the source for St-Sernin, in view of the other German connections in Toulousan art.

The next sculptural workshop at St-Sernin was headed by a certain Bernardus Gilduinus, who was responsible for some capitals of the interior, for seven marble reliefs, and for the main altar, related to the earlier altars made by the Pyrenean workshop but more elaborate. This altar was consecrated in 1096 by Pope Urban II, in the presence of fifteen French and Spanish bishops. The participation of the Spanish bishops was not without significance, for it seems certain that a sculptor from the team of Gilduinus, if not the master himself, joined the sculptors working on the transept portals and the façade of the cathedral of Santiago. This was truly a close collaboration between the major Pilgrimage churches.

The seven marble slabs of Gilduinus (figs. 209, 210), now on the ambulatory piers, were originally, in all probability, part of a screen that separated the choir reserved for the canons from the rest of the church. They are the first truly monumental works of French Romanesque sculpture. It has been shown* that Gilduinus copied

* H. Schnitzler, "Eine ottonische Reliquienburse," *Mouseion: Studien aus Kunst und Geschichte für Otto H. Förster,* Cologne, 1960, pp. 200–202.

* M. Durliat, "L'atelier de Bernard Gilduin à Saint-Sernin de Toulouse," *Anuario de Estudios Medievales,* I, Barcelona, 1964, pp. 521–29.

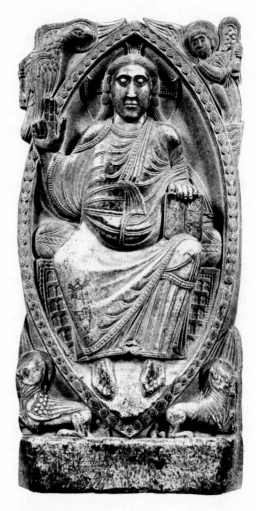

209, 210. GILDUINUS. Marble reliefs in ambulatory,
Collegiate Church of St-Sernin, Toulouse. c. 1100.
(*left*) *Apostle in Niche.* Height c. 72''.
(*right*) *Christ in Majesty.* Height 49 1/2''

some motifs on his altar from a Carolingian ivory, and it is equally probable that, for his large panels, he used either ivories or metalwork as models. The panel with *Christ in Majesty*, especially, makes the impression of an enlarged, embossed metal object studded with precious stones. In some of his other works, however, there are clear signs that Gilduinus was influenced by Roman sculpture. A similar interest in Roman works, with their high relief and well-modeled human figures, is shown by other contemporary sculptors, especially those who

were working in the cathedral at Jaca, in Aragon, where astonishing nude figures are carved on capitals (fig. 211), evidently inspired by classical putti.

Closely connected with the early work of Gilduinus' team in Toulouse is the sculpture of the cloister of the Cluniac abbey of Moissac, and the capitals from another Cluniac abbey, La Daurade, at Toulouse (these now in the local museum; fig. 212), both from the end of the eleventh century. The capitals present a wonderful richness of motifs, religious, fabulous, and deco-

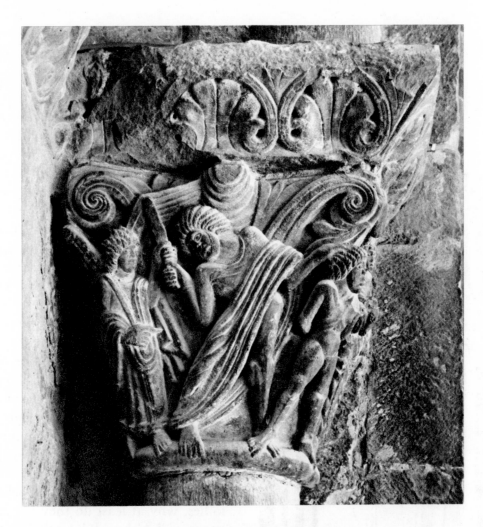

211. *Sacrifice of Isaac*. Capital of south portal. c. 1100.
Cathedral, Jaca (Spain)

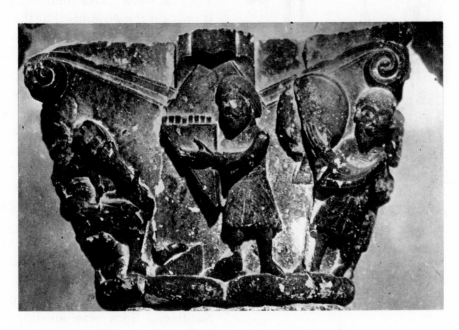

212. Capital with *David and Musicians*. From cloister of La Daurade Abbey.
End of 11th century. Musée des Augustins, Toulouse

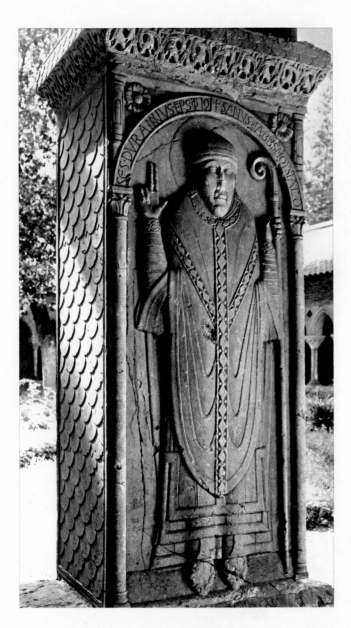

213. *St. Durandus.*
Marble relief on cloister pier; height c. 6'. c. 1100.
Abbey Church of St-Pierre, Moissac

rative. It was this kind of lavish sculpture in Cluniac houses which shocked the austere Cistercian, St. Bernard, and prompted him to complain: "But in the cloister, under the eyes of the brethren who read there, what profit is there in those ridiculous monsters, in that marvelous and deformed comeliness, that comely deformity? To what purpose are those unclean apes, those fierce lions, those monstrous centaurs, those half-men, those striped tigers, those fighting knights, those hunters winding their horns? Many bodies are there seen under one head, or again, many heads to a single body. Here is a four-footed beast with a serpent's tail; there, a fish with a beast's head. Here again the forepart of a horse trails half a goat behind it, or a horned beast bears the hinder quarters of a horse. In short, so many and so marvelous are the varieties of divers shapes on every hand, that we are more tempted to read in the marble than in our books, and to spend the whole day in wondering at these things rather than in meditating the law of God. For God's sake, if men are not ashamed of these follies, why at least do they not shrink from the expense?" Although intended as a criticism, this description of Romanesque cloisters, written in 1127, acknowledges their beauty and condemns it only on the grounds that the monks are tempted to gaze at them rather than read pious books.

In the cloister of Moissac Abbey, on the piers, are marble reliefs of the apostles, related in style to the screen panels in St. Sernin. In addition there is a superb panel with St. Durandus (fig. 213), bishop of Toulouse and abbot of Moissac, shown in splendid ecclesiastical vestments, giving a blessing. The folds are curiously formed by two parallel, crisp edges, a variant of what is known as "plate" drapery. It cannot be an accident that a similar drapery is seen in the panels (also on cloister piers; fig. 214) in the even more beautiful, two-storied cloister of the far-off abbey of S. Domingo de Silos, south of Burgos.

Although not on the main pilgrimage road to Santiago, Silos was an important pilgrimage

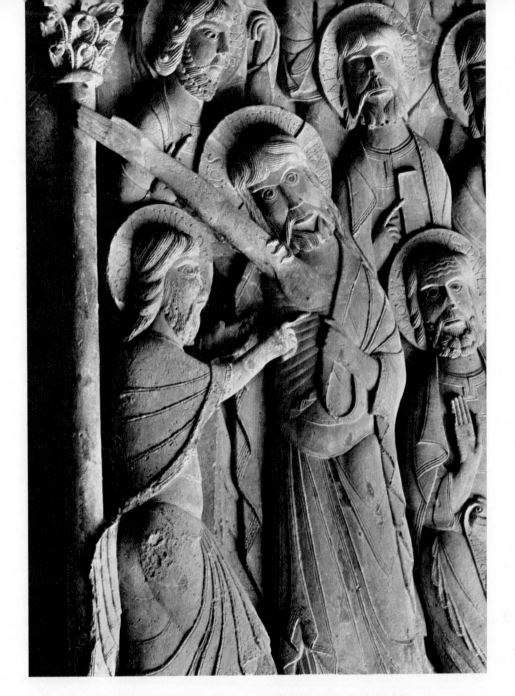

214. *Doubting Thomas* (detail). Marble relief on cloister pier.
End of 11th century. Santo Domingo de Silos (Spain)

place in its own right, housing the relics of the local St. Dominic. Much heated argument has been devoted to the date of the Silos cloister, French scholars suggesting a date toward the middle of the twelfth century, the American and Spanish, just before 1100. This last date seems much more likely. The panels at Silos are narrative scenes from the Gospels, carved with great precision, with smooth surfaces, sharp-edged folds, and expressionless faces, all alike. They clearly represent a similar stage in the development of Romanesque sculpture as the cloister reliefs at Moissac. What, moreover, speaks in favor of an early date for the oldest part of the Silos cloister are the capitals (fig. 215), which were, in all probability, the work of Muslim artists, or at least inspired by such Arab works as the ivory caskets produced at Cordoba and widely used in Christian countries. It is unlikely that these capitals were made in the later Roman-

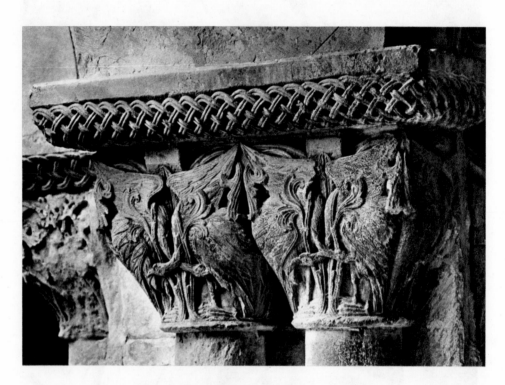

215. Double Capital with Fantastic Birds.
End of 11th century. East side of cloister,
S. Domingo de Silos (Spain)

esque period, when capitals based on the Corinthian type were used everywhere in Spain. The Silos and Moissac cloisters are examples of the cross-fertilization of Romanesque art—of influences over long distances, and the exchange of artists. This was truly the art of the pilgrimage roads, the art which makes nonsense of nationalities and frontiers. Perhaps it was not without significance that King Alfonso's mistress at that time, later his second wife, was an Arab woman, Zaida; she was given to the king by her father, the ruler of Seville, together with a rich dowry of nine castles. It would not be surprising if she had Arab artists in her retinue, and undoubtedly she brought with her numerous Arab works of art.

It has already been said that a sculptor from Conques was at work at Santiago, and that he was joined, in the first years of the twelfth century, by Gilduinus of Toulouse or one of his best pupils (see page 219). The two styles, one from Auvergne, the other from Toulouse, were present at Santiago simultaneously and appear mixed in the *Puerta de las Platerías,* the twin portals of the south transept. Unfortunately these doorways were rearranged at various dates, and they now include reliefs from the north transept and the west front. One of the most extraordinary reliefs is incorporated in the left tympanum (fig. 216); it shows a woman holding a skull on her lap. The *Pilgrim's Guide* singles out this relief for description, stating that the woman holds the head of her seducer, decapitated by her husband, which he ordered her to embrace twice a day. "Oh, what a terrible and admirable punishment of the adulterous woman, which should be told to all!" However improbable this interpretation, nobody has yet been able to solve the true meaning of the relief. Stylistically, it is undoubtedly the work of a Toulousan sculptor.

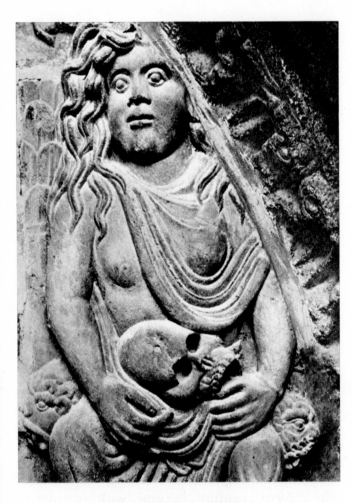

216. *Woman with Skull.*
Left tympanum, *Puerta de las Platerías*. Early 12th century.
Cathedral, Santiago de Compostela

Meanwhile, in Toulouse, the nave of St-Sernin was being completed and the south door carved shortly before 1118. This doorway, known as the *Porte Miégeville* (fig. 217), is in the mature Gilduinus style, practically undistinguishable from that of the *Puerta de las Platerías*; as if to emphasize the connection with Santiago, the figure on the left spandrel of the *Porte Miégeville* is the patron saint of Santiago, St. James. The *Porte Miégeville* is a fully developed Romanesque portal, deeply recessed, with a tympanum, lintel, supporting consoles, capitals, spandrel

figures, and a corbel table on the top. In comparison with the earliest works of the Gilduinus workshop, the relief is more voluminous, the tubular folds rhythmically arranged.

The influence of Toulouse-Santiago sculpture is to be found in a great many churches on both sides of the Pyrenees, for instance, in the collegiate church of S. Isidoro at León.

León's importance is closely linked with the *Reconquista,* for in the tenth century it became the capital of the kingdom of Asturias in place of Oviedo, after the territories along the Duero River had been taken from the Arabs; the old capital, separated by a range of high mountains from this newly conquered area, proved to be inconvenient. León's artistic importance began during the reign of Ferdinand I (1037–65), who united the kingdom of León (formerly Asturias) with that of Castile. Ferdinand and his wife Doña Sancha started to build the church of S. Isidoro to house the relics, brought from Seville, of St. Isidore, the seventh-century archbishop of Seville. The church, which was only completed in 1149, incorporated two portals in the Toulouse-Santiago style (fig. 218), and has also an eleventh-century mausoleum, the *Panteón de los Reyes,* influenced by the tower-porch of St-Benoît-sur-Loire, with an early series of historiated capitals and well-preserved wall paintings dating from the third quarter of the twelfth century (see colorplate 37). The patronage of Ferdinand and Doña Sancha included wonderful objects in ivory—the cross of 1063 (now in Madrid), the reliquary of 1059 with ivory reliefs—and, above all, the gilt-silver shrine of St. Isidore of 1063 with embossed Genesis scenes, influenced by the Hildesheim doors (fig. 219; see fig. 174). The presence of German artists in Spain at this period is well attested by, for instance, the names of Master Engelram and his son Redolfo (Rudolf) on the shrine of St. Millán de la Cogolla.

Cluny's influence in Spain started in the first half of the eleventh century, when a number of

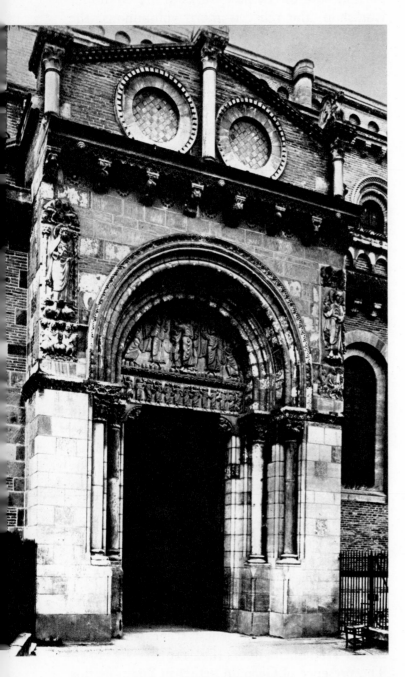

217. *Porte Miégeville* (south portal),
Collegiate Church of St-Sernin,
Toulouse. Before 1118

monasteries were placed under the authority of Cluny (for example, the Aragonese monastery of S. Juan de la Peña, in 1025). It was partly for this reason that the old Mozarabic liturgy was abandoned in favor of the Roman rite. The links with the Order were further strengthened during the reign of Alfonso VI (1072–1109), for he married Constance, daughter of the duke of Burgundy and also niece of St. Hugh, abbot of Cluny. It was principally during this time that close artistic connections were established between Spain and France, and also among Spain, the Empire, and Italy.

B. Romanesque Art in Burgundy

The artistic prominence of the duchy of Burgundy was closely linked with the two monastic Orders which had originated there, the Cluniac and the Cistercian.

CLUNY

The tenth-century church of Cluny, known to us as Cluny II, which was the inspiration for endless buildings throughout the West in the course of the eleventh century, became, with time, insufficient to accommodate the increased number of monks. When St. Hugh became abbot in 1049 there were about seventy monks in the abbey, but by the time of his death in 1109 the number had grown to about three hundred. Work on a new church, known as Cluny III (figs. 220–23), started in 1088 with funds provided by Alfonso VI of Spain, and the church was dedicated by Pope Innocent II in 1130. It was the largest church of Western Christianity until St. Peter's in Rome was rebuilt four hundred years later, and it is a tragedy that this colossal and beautiful church was demolished in the wake of the French Revolution; only small vestiges of it survive, notably the southwest transept.

The nave with double aisles, the double transepts, and the choir with an ambulatory (as in the Pilgrimage churches) were all of huge pro-

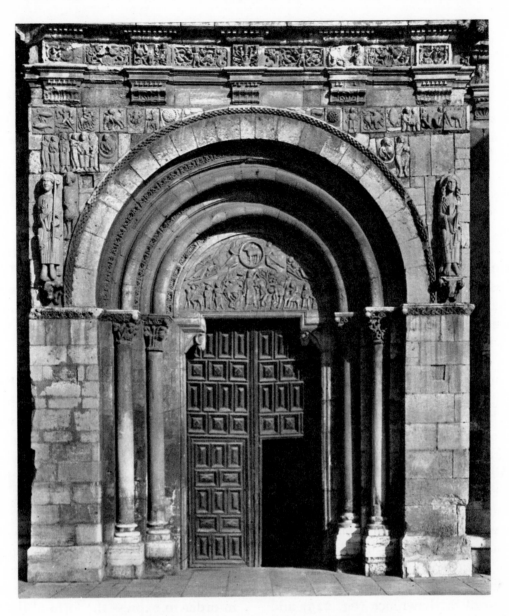

218. *Portál del Cordero* (south side of main portal),
Collegiate Church of S. Isidoro, León. Completed 1149

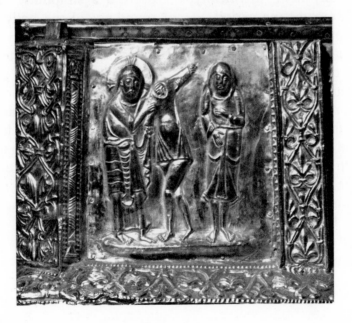

219. *God the Father Clothing
Adam and Eve.*
Panel on side of Shrine of
St. Isidore.
Silver, partly gilded. 1063.
Treasury, Collegiate Church
of S. Isidoro, León

portions and vaulted throughout. The nave arcades had pointed arches; the tall pilasters of the compound piers were fluted in the classical manner. This last feature, derived from Roman buildings, was to be a favorite form in Burgundy, and the pointed arch likewise. Externally, viewed from the east, the church appeared as a cliff of masonry, with a string of apses attached to the choir and transepts, and a multitude of towers over two crossings and the transepts; a pair of towers also flanked the entrance to the narthex at the west end. The enormous complex of monastic buildings, including an infirmary chapel the size of a large church, was to the south.

The interior was covered with wall paintings culminating in a huge *Christ in Majesty* in the main apse. The loss of these paintings is a misfortune for they must have been superb, judging from the quality of the paintings that survive at Berzé-la-Ville, a short distance from Cluny and a favorite retreat of Abbot Hugh. It is believed that the Berzé paintings are by the same painters who worked in the great abbey, and this is plausible. In the apse at Berzé there is a magnificent *Christ in Majesty* with Apostles (colorplate 33; fig. 224) and, in the flanking niches, scenes of the martyrdom of St. Lawrence (fig. 225) and from the life of St. Blaise. In addition, there are numerous saints. The Berzé paintings are among the most subtle, technically and artistically, which remain from the Romanesque period.

At this time few wall paintings were done in true fresco, that is to say, painted on fresh plaster prepared for only one day's work. In the majority of cases the technique was of *fresco secco,* in which the plaster was prepared for the entire work, the area needed for one day being remoistened to enable the paint to adhere. At Berzé the colors are rich and warm, yet only eight different colors were employed. They were never mixed, but placed in layers, often translucent. The contours were filled with a flat color and modeling then achieved by shading, first in dark tones, with highlights added last. In subtle-

ty, the crosshatching seen at Berzé has been compared with Albrecht Dürer's work.* The style that resulted is agitated, a quality further emphasized by the elongated, angular figures gesticulating and expressing violent emotions.

Much has been written about the Berzé paintings, and it is universally agreed that they contain many Byzantine elements, transmitted, in all probability, by way of Italy. From the once rich library of Cluny few manuscripts survive, but in two manuscripts which date from the early years of the twelfth century, the date of the Berzé paintings, there are clearly Byzantine elements combined with Ottonian. These manuscripts (the Cluny Lectionary in Paris; fig. 226; and the Ildefonsus *De Virginitate* in Parma) display a form of drapery which is very similar to that in the Berzé paintings and has been termed "panel" drapery. This drapery style is a convention which appeared at roughly the same time, about 1100, in many centers in the West, its purpose being to give more volume to the human figure by means of the garment which covers it. The ancient Greeks had been masters of the technique by which the draperies appear transparent, clinging to certain areas of the human body in order to express the form of the body and its movement; Byzantine artists were the heirs of classical art in this respect, but they gradually evolved a simplified method of expressing the roundness of the body by purely linear means, gathering the drapery into veinlike folds. This formula was transmitted to the West in the late eleventh century and gave rise to endless variations on the Byzantine theme.

One of the earliest and most striking examples north of the Alps is found in the work of the Saxon goldsmith, Roger of Helmarshausen, who made two portable altars, one for Bishop Henry of Paderborn (1084–1127), the other for the abbey of Abdinghof (fig. 227). Roger is thought to

* O. Demus, *Romanesque Mural Painting,* New York, 1970, p. 64.

220. Model of Abbey Church, ▶ Cluny III, from east. 1088–1130. Musée Ochier, Cluny

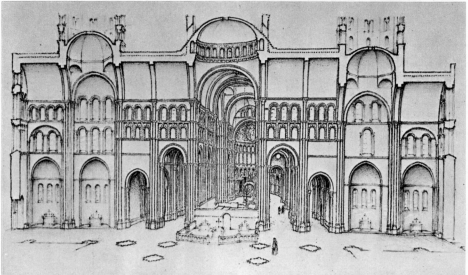

221a, 221b. Abbey Church, Cluny III. 1088–1130.
(*above*) Transverse section of nave
and west elevation of great transept.
(*below*) Transverse section of great transept
(drawings by K. J. Conant)

222. Interior toward east,
Abbey Church, Cluny III. 1088–1130
(18th-century drawing)

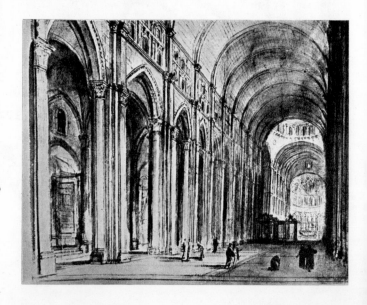

223. Exterior of southwest transept,
Abbey Church, Cluny III. 1088–1130

be identical with Theophilus, the author of *De diversis artibus,* a monk who wished to remain anonymous and signed his work with that fictitious name. This celebrated treatise of about 1100 gives instruction on the various techniques in painting, glasswork, and metalwork; it is an invaluable source of information on the methods employed by craftsmen in the Early Romanesque period. Theophilus had an intimate knowledge of several techniques and did not write separately for painters, goldsmiths, and other craftsmen, and it can be assumed that he was addressing men who did not specialize in one craft only, but were expected to work in many.

Modern writers often make the mistake of believing that there was the same specialization during the early Middle Ages that existed later. But even during the Renaissance many artists worked in painting, sculpture, bronze-casting, and even in architecture, not from their particular genius but according to the traditional practice. I have already stressed this point in previous chapters — that an illuminator could be also an ivory carver, or a stucco sculptor a painter. It is, therefore, even more understandable that close stylistic connections occur among different media.

Roger's style is similar in many ways to that

224. *Christ in Majesty, with Apostles.* Apse fresco. Early 12th century.
Upper Chapel, Priory, Berzé-la-Ville (see colorplate 34)

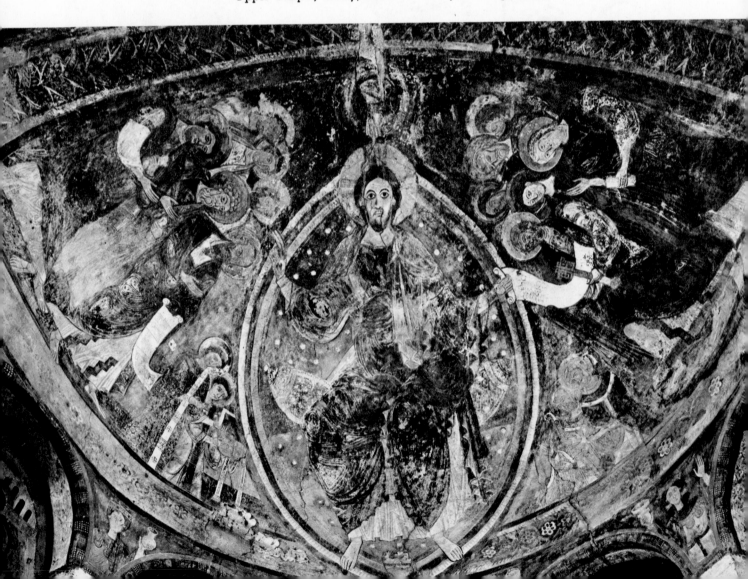

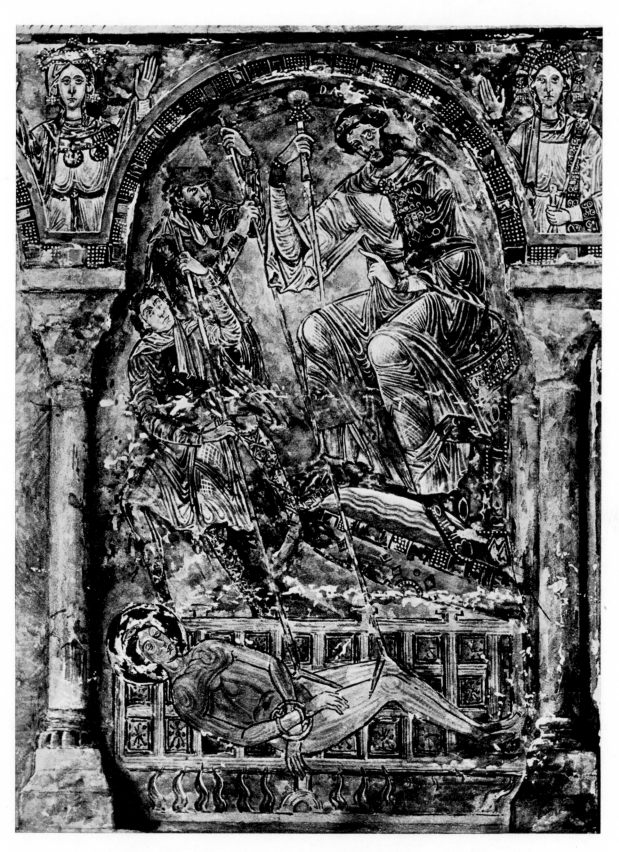

225. *Martyrdom of St. Lawrence*. Wall fresco. Early 12th century.
Upper Chapel, Priory, Berzé-la-Ville

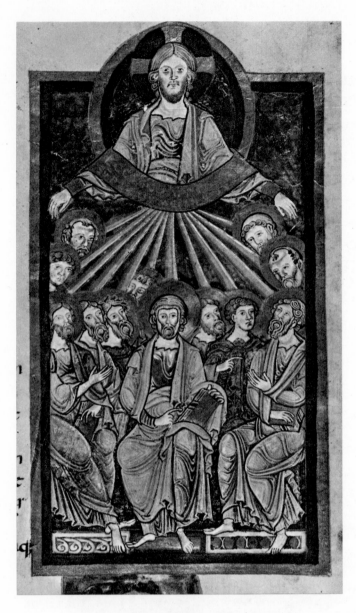

226. *Pentecost.* Cluny Lectionary.
Illumination 9 × 5″. Early 12th century.
Bibliothèque Nationale
(Ms. nouv. acq. lat. 2246, fol. 79v), Paris

prominently used. The Berzé paintings do not belong to this particular convention; there the drapery "panels" are often enclosed by several, almost parallel lines of folds, hence the term "multilinear" style. Another frequent form of "panel" drapery is that known as the "clinging curvilinear."

But let us return to the great church at Cluny. In spite of the destruction of most of the abbey, eight large free-standing capitals from its ambulatory have miraculously survived, though some are seriously damaged. As can be expected in a church of Cluny's importance, these capitals are of a very fine quality and great iconographical sophistication. On them are represented the Virtues, the serenity of the monastic life, and Paradise,** and they were flanked by engaged capitals with the *Fall of Man* and the *Sacrifice of Isaac*. One capital is a marvelous imitation of an antique Corinthian type; another shows the personifications of Justice, Faith, Hope, and Charity, and yet another the Rivers of Paradise (fig. 228); two capitals illustrate eight modes of music, and on another there are four personifications, of Spring (fig. 229), Summer, and two of Prudence. Finally, there are two capitals difficult to identify, with scenes depicting apiculture on one of them. The high quality of these carvings make many scholars doubt whether these capitals could have been ready by about 1095, when the ambulatory was built. The folds used in the lively and dainty figures are of the "plate" form, as if they were made of overlapping plates of armor with sharp, metallic edges. A very similar treatment is found in Early Romanesque art in Germany, such as the reliefs in the abbey of

of the Cluny manuscripts and the Berzé wall paintings. He also articulates the human figure by a network of clinging folds of the "panel" type, but in his case it has a form that has been termed "nested V-folds"* from the frequent repetition of the enclosed field—a "panel" in which V-shaped folds, one within the other, are

* E. B. Garrison, *Studies in the History of Mediaeval Italian Painting*, vol. 3, Florence, 1958, pp. 200–210.
** K. J. Conant, *Carolingian and Romanesque Architecture: 800 to 1200* (Pelican History of Art), Harmondsworth, 1959, p. 117. *Idem, Cluny: les églises et la maison du chef d'ordre*, Cambridge, Mass. (The Mediaeval Academy of America; printed at Macon), 1968, p. 87.

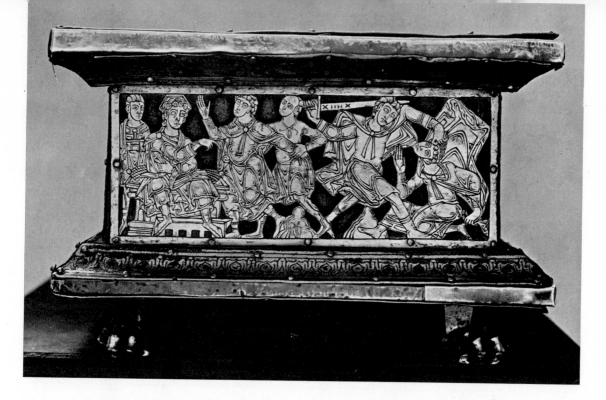

227. ROGER OF HELMARSHAUSEN. *Martyrdom of St. Paul.* Portable altar from Abdinghof Abbey. Silver, copper, and bronze, gilded, over wood; height 4 1/2". c. 1100. Franciscan Church, Paderborn

Werden, dating to between 1050 and 1059; it can be proved that such works must have been known in Burgundy, since the tympanum with *Christ in Majesty* in the Cluniac priory at Charlieu (fig. 230), dedicated in 1094, is stylistically very close to the reliefs at Werden. The connection between Charlieu and Cluny was most intimate, for it has been claimed that "the façade at Charlieu was designed by one of the architects who worked on the new abbey church begun in 1088 at Cluny."* The Charlieu tympanum is not so high in quality as the Cluny capitals, but it indicates a possible German source for both workshops. At Charlieu, the "nested V-folds" are timidly employed, while at Cluny it is the "multilinear" style in its early stages.

Of the west portal at Cluny only a few fragments survive, but the general design is known from old drawings. It was a majestic entrance, flanked by four columns and surmounted by a

large tympanum on which was *Christ in Majesty* with angels and the symbols of the Evangelists. Carved around the arches were angels and the Elders of the Apocalypse, while in the spandrels were four apostles, including St. Peter (this work is preserved in the Rhode Island School of Design, Providence; fig. 231). The whole was framed by fluted pilasters and a corbel table. The portal was made between 1107 and 1115, that is to say roughly contemporary with the *Porte Miége-ville* of St-Sernin at Toulouse, with which it has some similarities of design, such as the spandrel sculpture.

As far as the architecture is concerned, Cluny had no competitors, only imitators. It was a different thing with architectural sculpture, for Cluny was only the splendid beginning of a brilliant development. The sculptors trained in the great workshop of the abbey dispersed about 1120, and produced a series of masterpieces which make Burgundy one of the most important centers of Romanesque sculpture.

The two places where the style initiated at Cluny was further developed were Autun and

* K. J. Conant, *Carolingian and Romanesque Architecture: 800 to 1200* (Pelican History of Art), Harmondsworth, 1959, p. 114.

236

228, 229. Capitals from ambulatory, Abbey Church, Cluny III. c. 1095.
(above) Rivers of Paradise. (below) Spring.
Height of each c. 34″. Musée Ochier, Cluny

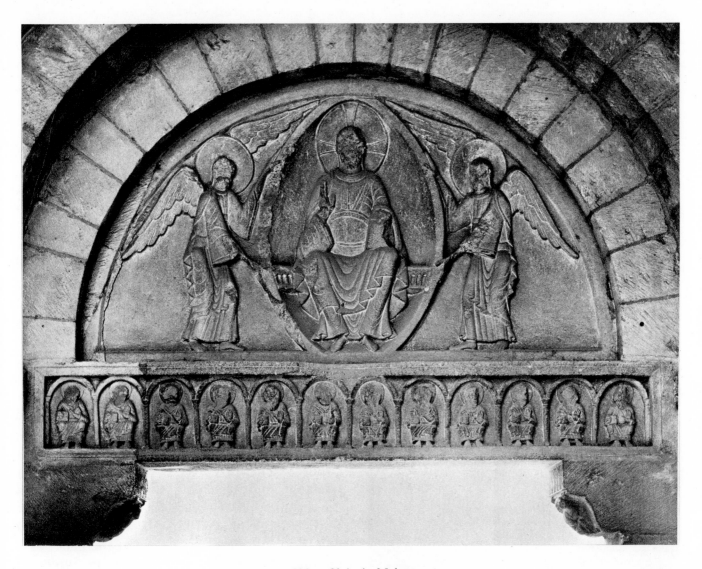

230. *Christ in Majesty.*
Tympanum and lintel, inner portal of narthex.
Dedicated 1094. Abbey Church, Charlieu

Vézelay. Autun Cathedral was built on a new site, adjoining the ducal castle and next to the old cathedral, which remained standing for some centuries. The reason for two cathedrals standing side by side is obscure. The cathedral was an important pilgrimage place, claiming to have the relics of St. Lazarus, whom Christ resurrected at Bethany. The bishop and the canons of the old cathedral embarked on the new building about 1120, with the generous support of Duke Hugh II of Burgundy; there was a consecration in 1130 and the translation of the relics in 1146.

The Cluniac abbey at Vézelay (it left the Order in 1137) was dedicated to the sister of St.

Lazarus, Mary Magdalen, and was also a Pilgrimage church of great importance. The church was rebuilt between 1096 and 1104; it was repaired after a fire in 1120, and enlarged and dedicated in 1132.

GISLEBERTUS AND THE VÉZELAY MASTER

One of the great masters of Romanesque sculpture, a certain Gislebertus, worked in both these places. At Vézelay only a few remnants of his work survive, for about the year 1125 he was evidently induced to take over the decoration at Autun, where he worked for some ten years. It is not known how many assistants helped him

231. *St. Peter.* From spandrel of west portal,
Abbey Church, Cluny III. Height 28 1/2″. 1107–15.
Museum of Art, Rhode Island School of Design,
Providence

at Autun, but the sculpture there is so homo-
geneous that it seems they were used only for
secondary jobs. Gislebertus started with the capi-
tals of the pilasters in the apse and, with very few
exceptions, he carried out the work on dozens
of capitals throughout the church, ending with
the gigantic tympanum of the west doorway. In
fact, there were two major entrances to the
church, each with a tympanum supported by a
trumeau, but that in the north transept no

longer exists. Among the fragments from this
north doorway is the beautiful *Eve* from the
lintel, now in the local museum (fig. 232). She
is in a horizontal position, and was facing Adam.
The *Eve* of Autun, a large-size nude, is a work
that proves, beyond any doubt, that Gislebertus
was trained in the Cluny workshop.

The capitals of the interior show that Gisle-
bertus was capable of expressing whatever mood
the subject required, lyrical, pensive, pathetic,
or terrifying. The capitals include Biblical and
allegorical subjects and a great many purely
decorative motifs. Some capitals are grouped in
a significant way, their subjects complementing
one another; for instance, the two capitals with
the death of Cain (who killed his brother in
anger) and the suicide of Judas (who betrayed
Christ out of greed for money; fig. 233) are close
to one with the triumphs of Patience over Anger
and of Generosity over Greed. There are many
details whose meaning was perfectly obvious
to a contemporary onlooker, such as the belt on
which Judas hanged himself, a belt with a disk
which would have been worn at the back: as it
happens, such belts are known from numerous
other representations, and signify either the
strength or the evil character of the wearer.

The great west doorway is of colossal size; its
tympanum (fig. 234) measures twenty-one feet at
its base and is fourteen inches thick. For easier
transport and handling, twenty-nine separate
pieces of stone were used for the tympanum, and
two for the lintel; at the join, the lintel is sup-
ported by a trumeau (now a nineteenth-century
replacement). In the eighteenth century the
tympanum was despised as a product of the "age
of superstition"; it was covered with plaster, and
at the same time the sculpture on one of the
archivolts was destroyed. The subject of the tym-
panum is the Last Judgment, with the Resur-
rection of the Dead on the lintel, the Elders of
the Apocalypse on the inner arch (destroyed),
the Signs of the Zodiac and Labors of the
Months on the outer arch; St. Lazarus and his

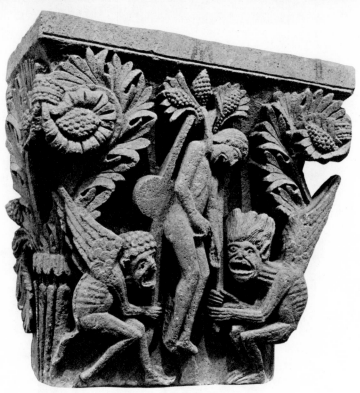

232, 233. GISLEBERTUS.
Sculptures from Cathedral, Autun. c. 1125.
(*above*) *Eve*. Lintel of north portal
(right half). 27 1/2 × 51".
Musée Rolin, Autun.
(*below*) Capital with
Suicide of Judas.
Musée Lapidaire, Autun

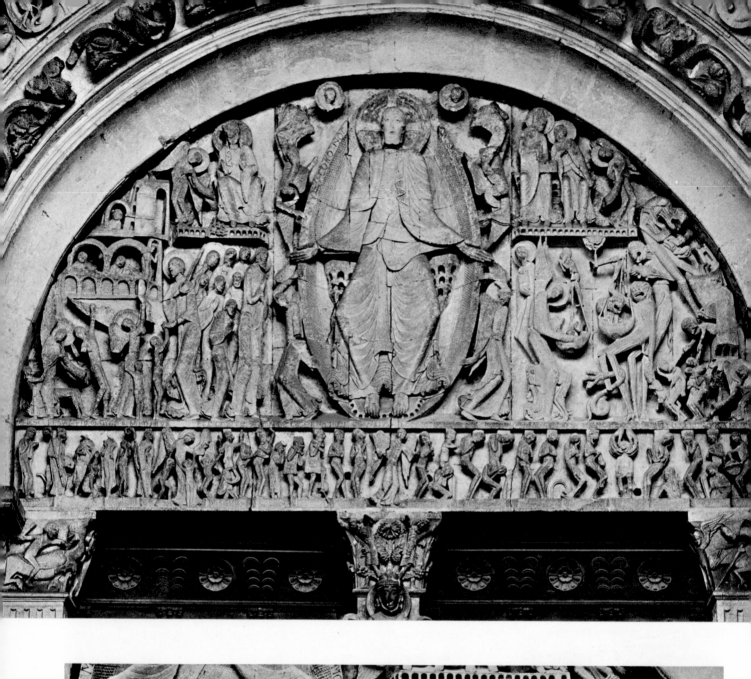

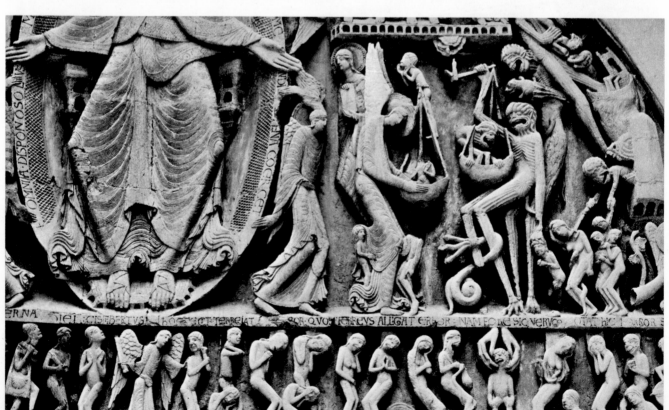

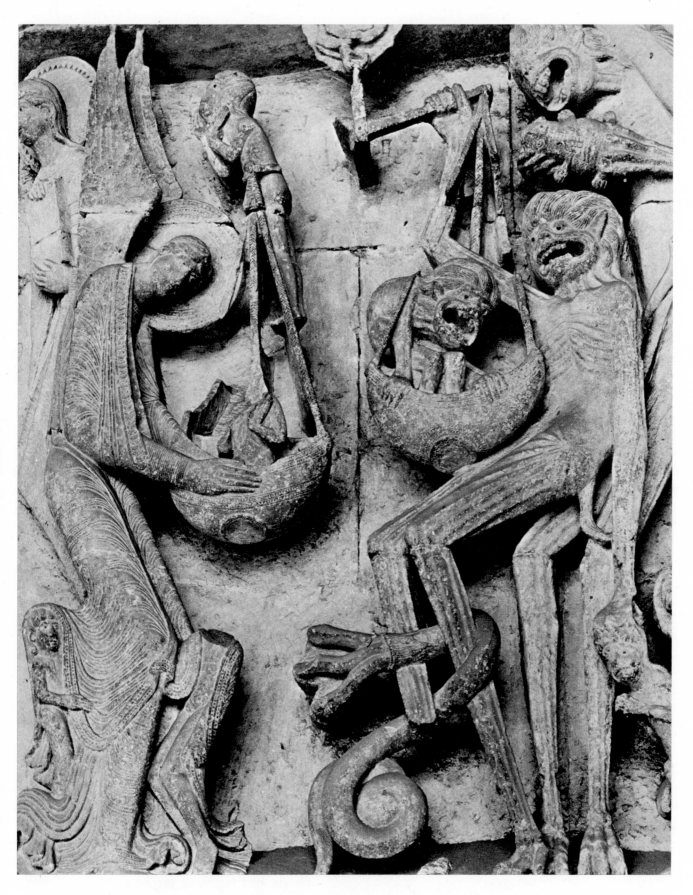

234, 235, 236. GISLEBERTUS. Tympanum and lintel, west portal,
Cathedral, Autun. c. 1125–35. (*opposite, above*) *Last Judgment.* 11′4″ × 21′.
(*opposite, below*) *Damned Souls,* portion of *Last Judgment.*
(*above*) *Psychostasis* (*Weighing of Souls*), portion of *Last Judgment*

sisters Mary Magdalen and Martha on the trumeau were replaced by Viollet-le-Duc.

The composition is dominated by the central figure of Christ with outstretched hands, enthroned within a mandorla supported by four angels. Under His feet is the signature of the artist: GISLEBERTUS M(AGISTER?) HOC FECIT. This and other signatures, which are not infrequent during this period, indicate the pride of the artist in his work and his wish to preserve knowledge of his authorship for posterity. This very human trait, perhaps even vanity, illustrates the changing climate of the period, now a more humane one, in which the individual begins to matter. Here, the craftsman has begun to think of himself as an artist.

Gislebertus' crowded composition is orderly, easy to comprehend even without the inscriptions. The upper zone is heaven, containing the Virgin Mary, Enoch, and Elijah, all of whom were taken bodily to heaven. On Christ's left are the damned in hell and the *Psychostasis,* the weighing of souls (figs. 235, 236), on His right the elect are led to heaven by St. Peter and an angel. On the lintel below hell are the resurrected destined for hell and chased there by an angel; below heaven is a procession of the resurrected about to be rewarded, including ecclesiastics and pilgrims. The relief of the figures is high, some practically detached from the background. Although carved in the workshop on so many separate pieces of stone, the carvings fit together very well. But however bold technically, it is the extraordinary expressiveness of the whole that makes this work so outstanding. This vision of the Last Judgment conveys both the horror of the punishment and the serenity of the reward. The giant Christ is awe-inspiring and the figures of the apostles on His right are taller than the others, as if through their nearness to God. Their anatomy is, to say the least, peculiar, their elongation anatomically absurd, yet the distortion is clearly deliberate, to convey the notion that they are no longer earthly beings.

Gislebertus must have been trained at Cluny, for many features of his art can only be explained by making this assumption. It was there, in the workshop of the sculptor who carved the eight ambulatory capitals, that he learned the use of "plate" drapery, but he used it in a very different way, combining it with the "multilinear" style (see page 234). For this reason his method is related, yet different, from that used at Cluny and in the Berzé paintings.

After Gislebertus left Vézelay for Autun, a new team of sculptors arrived at Vézelay about 1120, or a little later, to carve some new capitals for the nave and the newly built narthex. The most important task was to provide three doorways leading from the narthex to the nave, and these were presumably ready by 1132. Gislebertus' work had probably been intended for these doorways, but it was installed on the main façade where it has now been largely replaced by the work of Viollet-le-Duc.

The three portals in the narthex are very well preserved and, like the work at Autun, rank among the most important of the Romanesque period. The lateral doorways are small, but each encloses a tympanum divided into two registers; the south tympanum contains scenes of the Virgin and the Infant Christ (fig. 237), the north one *Christ's Appearance at Emmaus* and the *Ascension.* In both of these the stylistic connection with the ambulatory capitals at Cluny is very strong. But it is the central doorway that is of the greatest importance and artistic merit (fig. 238). Compared with Cluny and Autun, the Vézelay doorway is far more complex, foreshadowing the developments which were shortly to revolutionize the sculpture at St-Denis and Chartres, and throughout Europe. The innovation in the design of this doorway is the inclusion of large figures on the sides of the portal, a pair on each side; the sculptured area is now very much extended, covering not only the huge tympanum, with its enclosing arches, and the lintel and trumeau, but the door jambs as well.

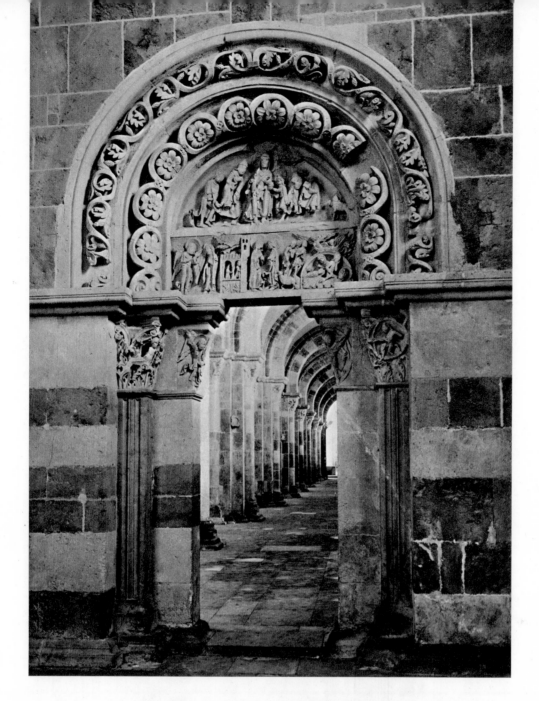

237. South portal in narthex; on tympanum,
Scenes of the Virgin and Infant Christ. 1120–32.
Abbey Church of Ste-Madeleine, Vézelay

The tympanum shows Christ in a mandorla, and from His hands emerge rays which descend on the heads of the apostles, seated on either side (figs. 239, 240). This, then, is the *Commission of the Apostles*, although it has also been suggested* that it is streams of blood, not rays, that link Christ with the apostles, and that the meaning intended was the Redemption of the World through the Blood of Christ. In the eight compartments around this central scene, and on the lintel, there are strange groups of exotic and monstrous people to whom the words of the Gospels are to be carried for their physical and spiritual healing—lepers, cripples, the blind, and the inhabitants of far-off lands, such as the heathen sacrificing a bull, pygmies so small that they mount horses with ladders, Scythians with

* J. Evans, *Cluniac Art of the Romanesque Period*, Cambridge, England, 1950, p. 70

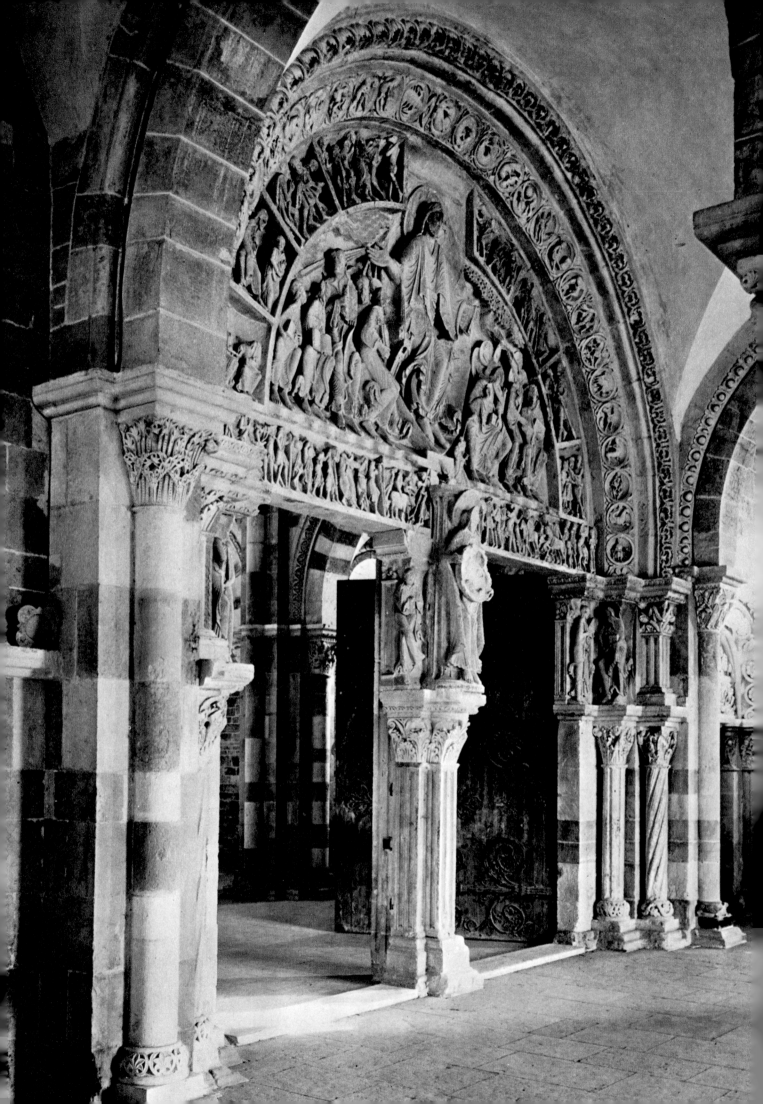

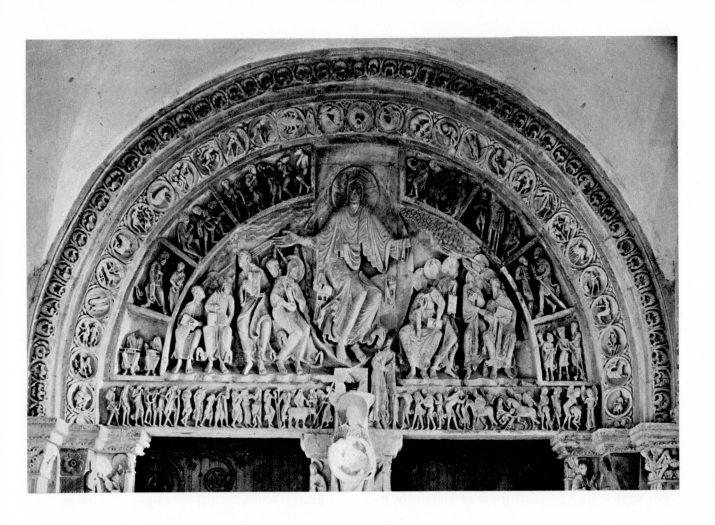

238, 239, 240. Abbey Church of Ste-Madeleine, Vézelay. 1120–32.
(*opposite*) Interior of narthex toward central portal.
(*above*) Tympanum and lintel, *Commission of the Apostles*.
(*below*) *Christ*, portion of *Commission of the Apostles*

246

monstrous ears, and many others. On the trumeau is St. John the Baptist, and on the jambs four apostles, including St. Peter. As at Autun, medallions with the Signs of the Zodiac and the Labors of the Months crown the whole design.

The style of the sculpture of this doorway is sufficiently related to the work at Cluny and Autun to assume that the sculptor originated from the Cluny workshop,* but it is, at the same time, a highly individual, dynamic style which gives evidence that there was yet another great Burgundian artist at work, who unfortunately did not record his name. In contrast to Gislebertus, this artist uses agitated poses and gestures, and the folds express tension and movement by sudden changes of direction, by violent and cascading forms, and by circular patterns. This is the "multilinear" style run riot. The style of this great master is very close to the Berzé paintings, the pose of Christ and especially His proportions bringing to mind those of Decius in the *Martyrdom of St. Lawrence* (see fig. 225).

Just as the architecture in Burgundy after Cluny III reflects the great church without ever surpassing it, so the sculpture of Burgundy draws its inspiration from, and is influenced by, the three major monuments, Cluny, Autun, and Vézelay—without, however, reaching their heights. In the second half of the century an independent, dynamic style made an appearance (fig. 241), linked with developments outside Burgundy, especially in the Rhone Valley. This style, mannered and agitated, existed side by side with proto-Gothic forms brought from the region of Paris, and the acceptance of the new style marked the end of Romanesque art in Burgundy.

CÎTEAUX

But while Cluniac-inspired art was still dominating the scene in Burgundy, a new Order was

born there, the Cistercian, which had a profound influence on the arts, both positively and negatively. The so-called White Monks wished to live in poverty and simplicity, and their Rule was based on the original ideals of the Benedictine Rule. The Order was founded in 1098 and confirmed by Pope Calixtus. Under its second abbot, who was an Englishman, Stephen Harding (1109–34), the original headquarters at Cîteaux was joined by a number of "daughters" —La Ferté (1113), Pontigny (1114), Clairvaux, and Morimond (1115)—all in Burgundy; by the end of the century there were over five hundred houses in all the countries of Europe. The prodigious success of the Order was due in great measure to St. Bernard, who joined the Cistercians in 1113 and was the abbot of Clairvaux for twenty-eight years, from its foundation until his death in 1153.

The White Monks were forbidden by their statutes to have any painting, sculpture, decoration, or precious metals in their churches. St. Bernard violently opposed lavishness in liturgy and decoration, and his famous passage against decorated cloisters has already been quoted (see page 222). Cistercian churches were also to be without stone towers.

The austerity of the Order demanded that churches be built in remote places, where the monks and lay brothers could work in the fields and workshops, far from human settlements. The sites of Cistercian abbeys are usually enchanting, often on a river or a stream. The churches were built with great technical skill and are of an astonishingly uniform character. They differ in size and the number of chapels, but by and large they were all built to one master plan.

Fontenay Abbey in Burgundy (figs. 242, 243), erected between 1139 and 1147, is the best preserved of the early Cistercian buildings. It is a cruciform building with a rectangular sanctuary, and rectangular chapels on the east side of the transept. The pointed arcades of the nave are

* F. Salet, *La Madeleine de Vézelay*, Melun, 1948, pp. 150 ff.

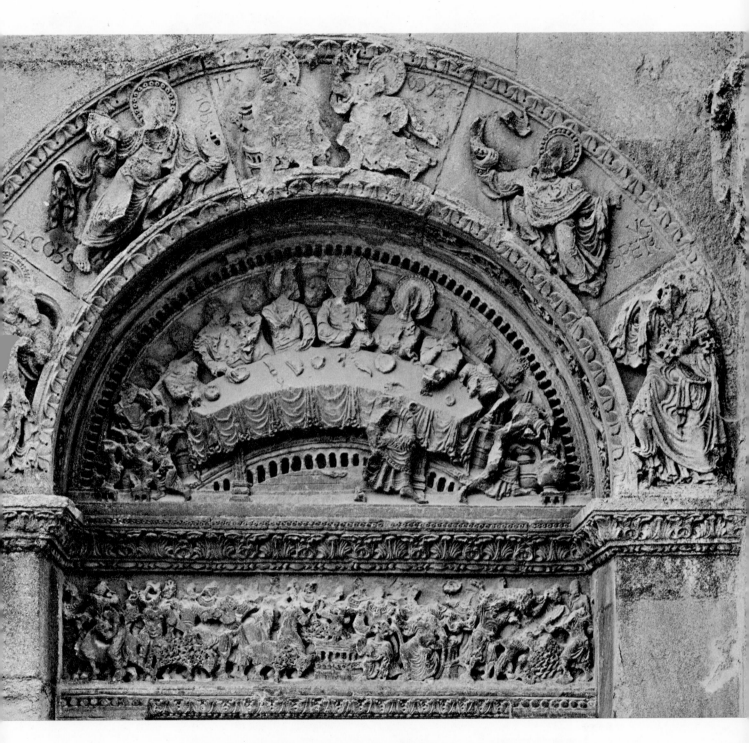

241. *Last Supper* (tympanum); *Transfiguration* (archivolt).
Portal on north side of narthex.
Mid 12th century. Priory Church, Charlieu

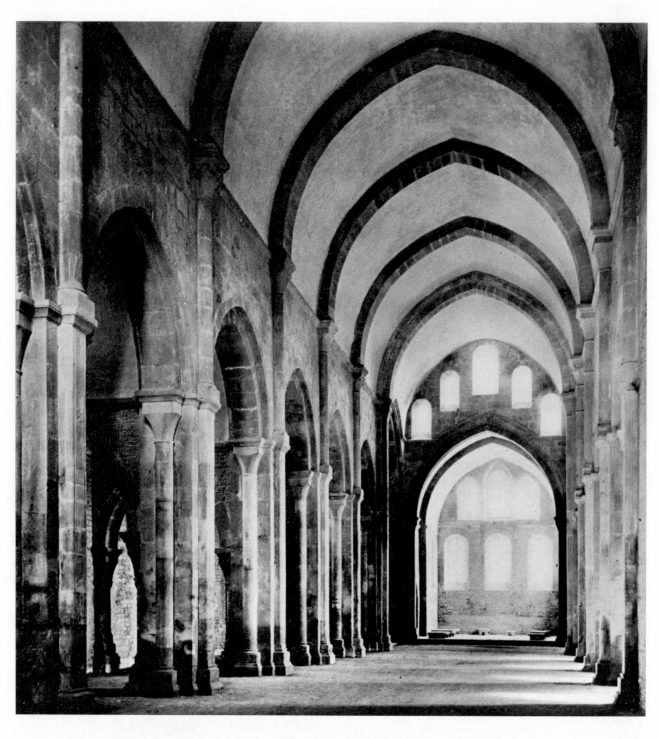

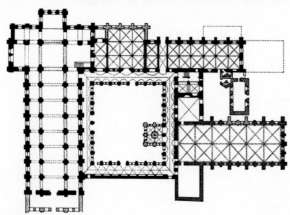

242, 243. Plan and interior toward east,
Abbey Church, Fontenay. 1139–47

without moldings and there is no clerestory above; light comes from the numerous windows in the east and west walls and in the crossing. The nave is covered by a pointed tunnel vault, with transverse arches that rest on shafts with plain capitals. The aisles also have pointed tunnel vaults, but they are placed across the axis of the church. Externally, the church is as plain as an Early Christian basilica.

The monastic buildings are equally rectangular and well built. There is a considerable use of

244. *Monks Felling Tree.*
Initial Q in St. Gregory's *Moralia in Job.*
Cîteaux. c. 1111. Bibliothèque Municipale
(Ms. 170, fol. 75v), Dijon

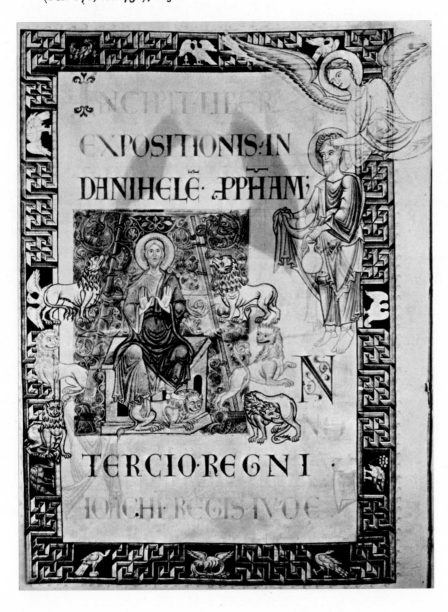

245. Page with
Daniel in the Lions' Den
(upper right: *Habbakuk Carried
by an Angel*). Saint Jerome's
Explanatio in Prophetas.
Cîteaux. 17 3/4 × 12 1/2". c. 1130.
Bibliothèque Municipale
(Ms. 132, fol. 2v), Dijon

250

rib vaulting, but this was not exploited to the full by the Cistercians.

Cistercian buildings from Portugal to Poland and from Italy to the British Isles are all of the same austere character, though in some regions local building methods and materials were used (such as brick in Lombardy and Germany).

Cistercian hostility to the arts did not apply to book illumination during the abbacy of Stephen Harding, nor even until the middle of the twelfth century. It has been convincingly argued* that the earliest manuscripts decorated at Cîteaux were strongly influenced by English decorative initials, which is not surprising in view of Harding's early connections. Also, some of the early Cistercian manuscripts display a rare sense of humor in depicting monks in their daily menial occupations (fig. 244). But in the second quarter of the century a different, more austere and serious mood entered the Cîteaux scriptorium, and the predominant influence became Byzantine. In one manuscript the Virgin Mary is inscribed with the Greek title Theotokos, and Greek or Italo-Byzantine models had obviously become available in the abbey library. The changed character of Cistercian illumination is well illustrated by St. Jerome's *Explanatio in Prophetas,* with its delicate paintings full of reminiscences of Byzantine art. In *Daniel in the Lions' Den* (fig. 245), the hieratic figure of the principal hero is of a quality and beauty that permits comparison with the great tympana at Autun and Vézelay.

C. Romanesque Art in Central and South Italy

Like France, and for similar reasons, Italy presents a very complex regional development in all the arts. Lack of political unity and of strong central power encouraged a regional rather than a countrywide development.

* C. R. Dodwell, *Painting in Europe: 800 to 1200* (Pelican History of Art), Harmondsworth, 1971, p. 91.

ROME

Rome took little or no part in the architectural experiments which originated in Lombardy, and its only contribution was the erection of over thirty brick campanili during the eleventh and twelfth centuries, probably as much to provide a refuge for church treasures in time of danger as to house church bells. And such moments of danger were frequent: during the Investiture Contest, Henry IV captured Rome in 1083, and the following year it was sacked by the Normans, who left a large part of it in ruins.

The greatest contribution of Rome was in the field of wall painting. The frescoes in the lower church of S. Clemente (colorplate 35), dating from the late eleventh century, depict the lives and miracles of St. Clement and St. Alexis in an elegant and delicate style which brings to mind miniature painting. The somewhat later wall paintings in the church at Castel Sant'Elia and the two churches at Tuscania, in the neighborhood of Rome, show strong Byzantine influences, which probably came from Montecassino. It was also in Rome that the production was initiated of huge ceremonial Bibles with paintings, the practice spreading northward to Umbria and Tuscany and even beyond the Alps. No large Bibles had been illuminated since Carolingian times, and the fashion initiated at the papal court may have been influenced by Carolingian Bibles, especially those from the School of Tours, though the style of the Roman Bibles, too, was markedly Byzantine in flavor.

The Romanesque style of the mosaics in Rome is strangely inhibited by Early Christian traditions. This is particularly striking in the apse mosaic in S. Clemente (before 1128; fig. 246), where, unusually, it is the *Crucifixion* which is the center of the composition. The symbolism of the twelve doves (for the apostles), the *Agnus Dei* among sheep, and stags drinking from the Four Rivers of Paradise is taken from Early Christian sources, as are the scrolls of foliage with birds, some very naturalistic, which are derived from

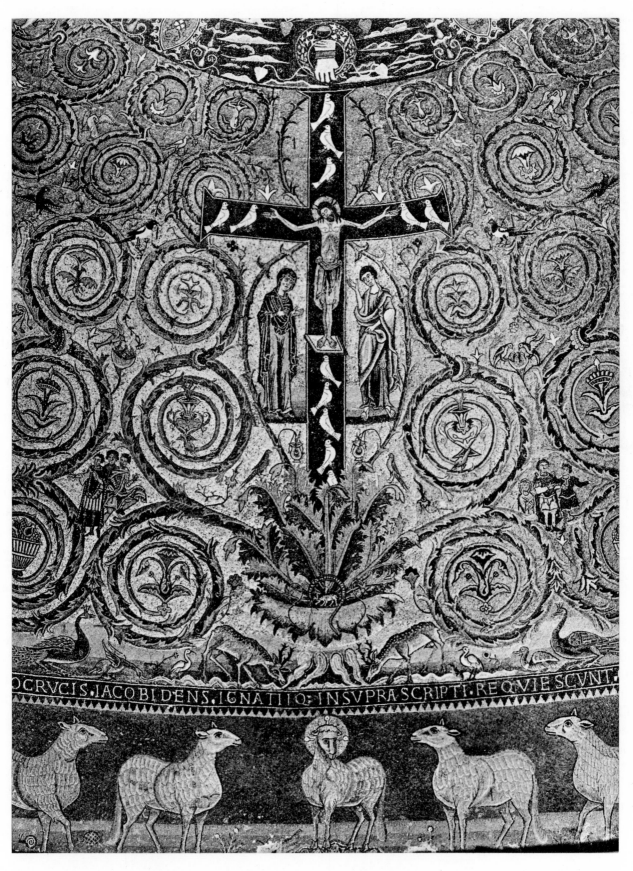

246. *Crucifixion*. Portion of apse mosaic. Before 1128.
Upper Church, S. Clemente, Rome

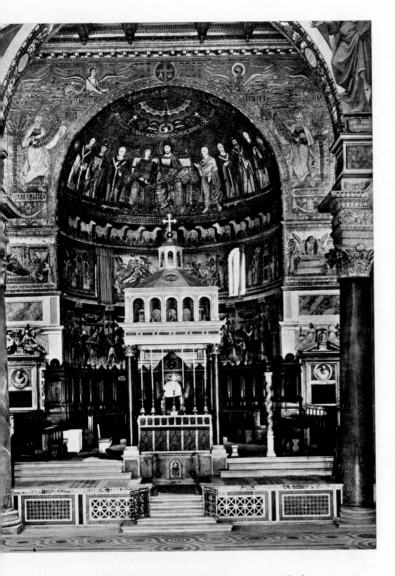

247. Apse with mosaic *Triumph of the Virgin*,
S. Maria in Trastevere, Rome. 1130–43

the mosaics in S. Costanza (see fig. 16). There is a
subtle juxtaposition of the serpent below the
cross, symbolizing the Fall of Man, and the
Crucifixion itself, the act of Redemption.

The apse of S. Maria in Trastevere was pro-
vided with a new mosaic (fig. 247), paid for by
Pope Innocent II (1130–43), who is shown hold-
ing a model of the church. The main subject is
the Triumph of the Virgin, an iconographic in-
novation reflecting the growing cult, in the West,
of the Virgin Mary. Saint Bernard and the

Cistercians in general were great champions of
her cult, and all their churches were dedicated
to Mary. Pope Innocent knew St. Bernard well,
and it was due to St. Bernard's support that he
was recognized as the true pope, against the
claims of the antipope Anacletus II. The *Triumph
of the Virgin* in S. Maria in Trastevere could
have been inspired by an ancient icon the
church possessed, dating from the early eighth
century and still extant. It represents the Virgin
wearing a crown, and is a replica of an even older
Maria Regina, the sixth-century wall painting
in S. Maria Antiqua, also in Rome (see fig. 79).
The *Triumph of the Virgin* is a further develop-
ment of that subject, showing Mary wearing a
crown and seated beside Christ, His hand em-
bracing her. The inscriptions accompanying the
scene, taken from the *Song of Songs*, suggest that
the representation had more than one meaning
and that the Virgin appears here not only as
Christ's mother, but also as an allegory of the
Church. The style of the mosaic is appropriately
hieratic and sumptuous.

Side by side with the revival of the mosaic
technique in twelfth-century Rome another
technique, known as *Cosmati* work, flourished
there also and lasted well into the next century.
Cosmati, combining marble inlay and mosaic,
was applied to church furniture, such as pulpits,
ciboria, thrones, and candlesticks, and even to
architecture, on portals, pavements (fig. 248),
and the twisted columns of cloisters. Similar ge-
ometric inlays were practiced during that period
in Sicily and Campania, where they show a
marked Islamic influence. But the origin of this
technique on Italian soil was probably at Mon-
tecassino, and it was also due to that center that
the art of mosaic was revived in Rome.

MONTECASSINO

The abbey of Montecassino, the cradle of West-
ern monasticism, has had more than its share of
disasters, having been destroyed by the Lom-
bards about 581, by the Arabs in 883, and by an

earthquake in 1349; in World War II it was again reduced to a heap of rubble, to be rebuilt once more. During the eleventh century the abbey had regained its former importance and fame, and was held in great esteem not only in the West, but also in Byzantium, receiving annual emoluments from the Eastern emperors. The Holy Roman emperors were also benefactors of the abbey, and Henry II even paid a visit

248. Epistolary Pulpit (detail).
Marble inlay. 1153–81. Cathedral, Salerno

there. The success of the Normans in southern Italy was viewed with alarm at Montecassino, for the abbey itself and most of its properties were in the threatened territories; two successive abbots were Germans, Richerus and Frederick of Lorraine, who supported the anti-Norman policy of the papacy and the Empire. In 1058, with the election of a new abbot, Desiderius, this policy was reversed, and the abbey established friendly relations with the Normans. It was Desiderius who brought about the alliance between Rome and the Normans, thus gaining Norman gratitude and benefactions. It is a measure of Desiderius' diplomatic skill that, while supporting the Normans who deprived Byzantium of their last possessions in Italy, he remained on excellent terms with Constantinople. Desiderius succeeded Gregory VII in 1086 as Pope Victor III, having ruled the abbey for nearly thirty years; during this time Montecassino became not only a seat of learning, but also an artistic center of great importance.

Desiderius started rebuilding the abbey church in 1066, and Leo of Ostia, the chronicler of the abbey who witnessed the events, described the church in great detail. He says that Desiderius bought in Rome huge quantities of columns, bases, and colored marbles for the new structure. The church had a similar form to that of Old St. Peter's in Rome, including a large atrium (see fig. 9). "Meanwhile he sent envoys to Constantinople to hire artists who were experts in the art of laying mosaics and pavements," writes Leo, and then relates that Desiderius decided to train a number of young monks in these arts, so that the knowledge of these long-neglected techniques might not be lost. In addition, the monks were trained in the arts which employ gold, silver, bronze, iron, glass, ivory, wood, stucco, and stone.

The church was dedicated by the pope in 1071, but there was still much to be done to beautify the building. Once again Desiderius sent to Constantinople for a golden antependium

254

decorated with gems and enamels, on which were scenes from the New Testament and "almost all the miracles of St. Benedict," and for a screen barrier in bronze, a beam of bronze with fifty candlesticks, thirty-six hanging lamps, and many other items. Leo of Ostia describes in detail the splendid furniture of bronze, silver, and gold. He mentions round and square icons, some made in Constantinople, others painted in the Greek manner by the monks. The bronze doors that had been made in Constantinople for the old church were transferred to the new one, although they were now too short.

The abbey church, as rebuilt and furnished by Desiderius, had considerable importance for the future development of the arts not only in Campania, but throughout the West. Although the architectural forms of the church were, on the whole, conservative, it is believed* that it was here, in the porch and the atrium, that the first pointed arches were employed in any Western building. This oriental feature could have been transmitted from Montecassino to Cluny (see fig. 223), and the visit of St. Hugh of Cluny to Montecassino in 1083 could have provided an opportunity for this. The use of the pointed arch at Cluny III started a chain of developments that eventually led to Gothic architecture.

Of the Byzantine mosaics at Montecassino, not a trace survives. There are, however, remnants of mosaics in the cathedral at Salerno, built about 1080 by Robert Guiscard, the new Norman ruler, and Archbishop Alfanus on the model of Montecassino. Alfanus had been a monk at Montecassino and a friend of Desiderius, and he probably obtained the services of mosaicists from there. The Salerno apse mosaics date to about 1085, and, as shown recently,** the draperies

exhibit unmistakable signs of late Comnenian art. But in many other respects they try to imitate Early Christian art. It seems clear that what Desiderius wanted from Byzantium was technical expertise, but his aim in using mosaics was to re-create Early Christian art. It is the same aim which made him build the abbey church of Montecassino on the model of a great Early Christian basilica. From this point of view the S. Clemente mosaics in Rome, too, fall into place in this deliberate revival of the venerable art forms of the Early Christian past, and must be seen as a later stage of the development initiated by Desiderius. It goes without saying that the Greek mosaicists at Montecassino must have used the figure style then current in Constantinople, and that the influence of this style contributed to the wave of Byzantine influences in the West, so widespread at the end of the eleventh century.

The most striking early result of these Byzantine influences is seen in the wall paintings of S. Angelo in Formis, near Capua, a church belonging to Montecassino and rebuilt by Desiderius, who is represented in the apse with a model of the church (fig. 249), below the enthroned Christ. On the walls of the nave are scenes from the Old and New Testaments (fig. 250), painted in the Romanesque style and strongly influenced by Greek conventions of drapery design. The scenes are arranged in consecutive order, however, not in the selective groupings that were the custom in Byzantium (see page 147). Several artists took part in this extensive work, so there are slight differences among the various groups of scenes, but the whole was painted in one operation and must have been completed by about 1085.

This date is confirmed by the closely related paintings in a manuscript produced at Montecassino in the 1070s (now in the Vatican), illustrating the lives of St. Benedict and his companion, St. Maurus. Under Desiderius' rule, Montecassino produced a number of important

* K. J. Conant, *Carolingian and Romanesque Architecture: 800 to 1200* (Pelican History of Art), Harmondsworth, 1959, p. 223
** E. Kitzinger, "The First Mosaic Decoration of Salerno Cathedral," *Jahrbuch der österreichischen Byzantinistik*, 21, 1972, pp. 149–62.

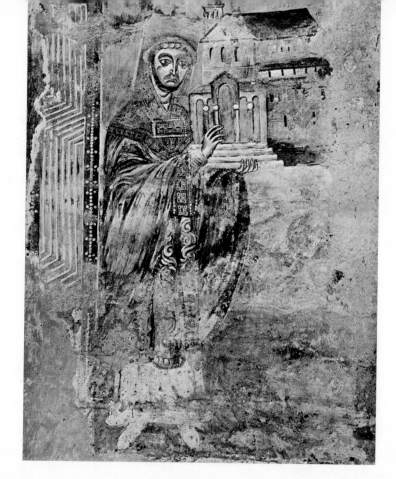

249, 250. Wall paintings, S. Angelo in Formis (near Capua). c. 1085.
(*above*) *Desiderius Offering the Church* (in apse).
(*below*) *Cain and Abel; Noah* (in nave)

251. *Adam and Eve*. Exultet Roll.
Height of figures c. 5 1/4″. c. 1060.
British Library (Add. ms. 30337), London

illuminated manuscripts, including three Exultet Rolls (fig. 251), a peculiarity of southern Italy, that contained the text for the blessing of the Paschal candle on Holy Saturday, read by the deacon from the pulpit; the pictures were placed upside-down in relation to the text, so that the congregation could see them in the right position as the roll manuscript was slipped over the balustrade of the pulpit.

SOUTHERN ITALY

Montecassino was a meeting place for Western and Byzantine art, and the same can be said of the whole of southern Italy. Apulia and Calabria were part of the Byzantine Empire for many centuries, and had a large Greek-speaking population. The Byzantine and the Latin rites existed side by side and both Basilian and Benedictine

monasticism flourished. The Lombard principalities of Benevento, Capua, and Salerno, as well as the city-states at Naples, Gaeta, and Amalfi, were all meeting places of various civilizations, not least the Muslim, for the maritime cities were trading with the whole Arab world.

The Norman conquest of southern Italy brought all these territories under one rule and transformed what was, in effect, an artistic backwater into a vital and creative territory that was to shine throughout the twelfth century and be the model and envy of the rest of Europe.

Norman mercenaries found the feuding southern Italian principalities an easy prey, and by 1030 they were already in possession of Aversa. But it was the arrival, in 1047, of Robert Guiscard that was to start the systematic conquest. In 1053 the papal army with its German allies

was defeated; in 1058 Capua was taken; and in 1061 the conquest of Sicily was begun with the capture of Messina. The last Byzantine city on Italian soil, Bari, fell to the Normans in 1071, and the conquest of Sicily was completed in 1091. Robert received papal recognition as duke of Apulia and Calabria in 1059, and his nephew Roger II as king of Sicily in 1130. Under Roger, all the Norman possessions were united, and he passed to his successors William I (1154–66) and William II (1166–89) a prosperous and powerful kingdom. In 1194 it was conquered by Emperor Henry VI, and was to shine again under the formidable rule of Frederick II Hohenstaufen.

The Norman conquest is reflected in an outburst of building activities in their new possessions. The abbey at Venosa, built by Robert Guiscard as the mausoleum for himself and his family, and the cathedral at Aversa are both remarkable for their French plans, having an ambulatory with radiating chapels. But undoubtedly the most important church in Apulia was that of S. Nicola at Bari (figs. 252, 253),

built to house the relics of St. Nicholas brought from Myra in Asia Minor in 1087, soon after Bari became Norman. Started almost at once by Abbot Elia on the arrival of the precious relics, which were to make the place a famous pilgrimage center, S. Nicola was finished early in the twelfth century, though additions were made later and the final consecration took place in 1197. This is the first church in Apulia with a three-storied elevation, a form that must be attributed to transalpine influence. Other peculiar features of S. Nicola are external open galleries above the aisles, and a rectangular wall which encloses the three-apse eastern end of the building. San Nicola was imitated in a number of Apulian churches, among these the cathedral at Trani, the rival of S. Nicola as a pilgrimage place since it housed the relics of St. Nicholas the Pilgrim, whose cult was an obvious attempt to divert pilgrims from that of St. Nicholas of Bari. Thus, along the coast of Apulia, in addition to the very ancient pilgrimage place of St. Michael at Monte S. Angelo on Mount Gargano,

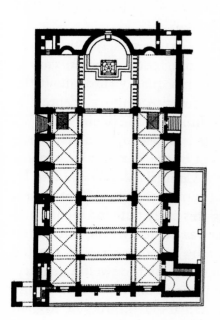

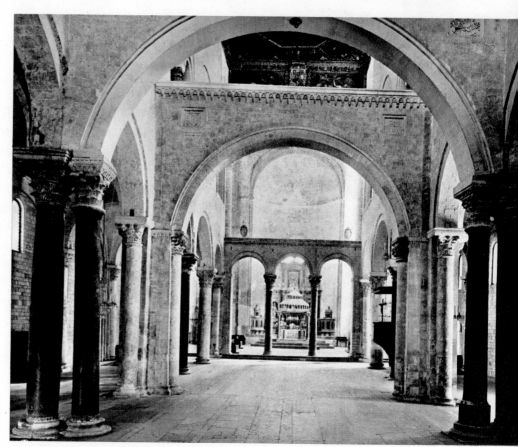

252, 253. Plan and interior toward east, S. Nicola, Bari. Late 11th century

258

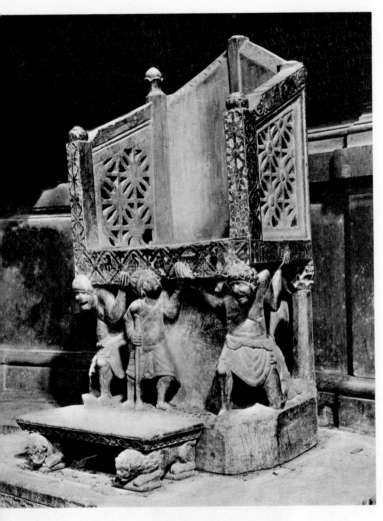

254. Throne of Archbishop Elia. Marble. c. 1098.
San Nicola, Bari

two others began to attract the devotions of pilgrims, though Trani never attained the fame of the cave of St. Michael or the shrine of St. Nicholas of Myra, the patron saint of sailors and children.

Apulia was receptive to architectural forms not only from France, but also from Pisa, for the cathedral at Troia (c. 1093–1127) is a close derivative of Pisa Cathedral and started a whole series of local variants. The traditional local forms, of Greek origin, continued to be employed

also, resulting in a series of domed churches, such as the cathedral at Canosa.

Many churches in Bari were destroyed in 1156 by William I, as punishment for a revolt against him. The cathedral of Bari was one of the victims; when rebuilt, S. Nicola was used as the model, but its lavish Late Romanesque decoration distinguishes it from S. Nicola, where decorative sculpture was used more sparingly.

In the field of sculpture, southern Italy presents a very different picture than the rest of Italy. Because of the close connections with Byzantium, decorative sculpture of a high quality was practiced in south Italy throughout the tenth and eleventh centuries. The best examples of this sculpture, mainly chancel screens, survive in Campania (Sorrento Museum, Capua Museum, Cimitile, and Naples). In Apulia, a remarkable series of pulpits and bishop's thrones was produced between the 1040s and the end of the century; the pulpits are decorated with elegant foliage and eagles, while the thrones rest on animal supports (lions at Monte S. Angelo and Siponto; elephants at Canosa; lions and human figures in S. Nicola, Bari).

It is clear from this extensive series that there were several workshops specializing in carved church furniture of high quality throughout the second half of the eleventh century. Especially noteworthy is the throne in S. Nicola (fig. 254) which was made, it is believed, by Archbishop Elia (formerly abbot of the Benedictine monastery at Bari) for the Council convoked at Bari by Pope Urban II, in 1098. Scholars are not unanimous in accepting this early date for the throne; some agree that it was made by Elia, but a little later (he died in 1105); and some even put the date into the second half of the twelfth century. The throne is important for its figures in the round that show a marked imprint of Roman art. Apart from the throne, however, Bari is far more important for the presence of the sculptor Ursus (who carved the throne in the cathedral of Canosa about 1080), employed there not for

making church furniture, but for the architectural enrichment of S. Nicola. The work of this sculptor can be easily identified in the east window of the church, where columns are supported by elephants, as at Canosa, and in the north portal of about 1105, the first in existence where lions are used to support free-standing columns (fig. 255). This motif was to become almost universally accepted in Italy, and it is not uncommon in other countries as well. The same north doorway of S. Nicola has an archivolt carved with an episode from the legend of King Arthur; it is believed that the subject was brought to Apulia by the Norman crusaders under Duke Robert of Normandy, who spent the winter of 1096–97 in Apulia. Among these crusaders was Odo, bishop of Bayeux, who commissioned the famous Bayeux Tapestry, with which the Arthurian relief at Bari has many common features. As will be seen later in this chapter, a similar relief is found on a side doorway of Modena Cathedral (see page 270).

Unfortunately, the great Norman abbeys in Calabria were destroyed in the earthquake of 1783, so that little is known of Romanesque art there.

With the exception of a few features which can be attributed to Norman importations from beyond the Alps, the buildings in southern Italy and their decoration are of local inspiration and craftsmanship.

SICILY

The same also applies, with certain modifications, to eleventh-century Sicily, where Norman power was established toward the end of the century, and their artistic patronage did not begin until the twelfth. The brilliance of Sicilian artistic life during the Norman period has already been briefly mentioned in connection with the Byzantine mosaics there (see page 151). The policy of tolerance toward both Greeks and Muslims, pursued by all successive Norman rulers, produced an almost exotic mixture of forms belong-

255. URSUS. North portal,
called Lion Door. c. 1105.
San Nicola, Bari

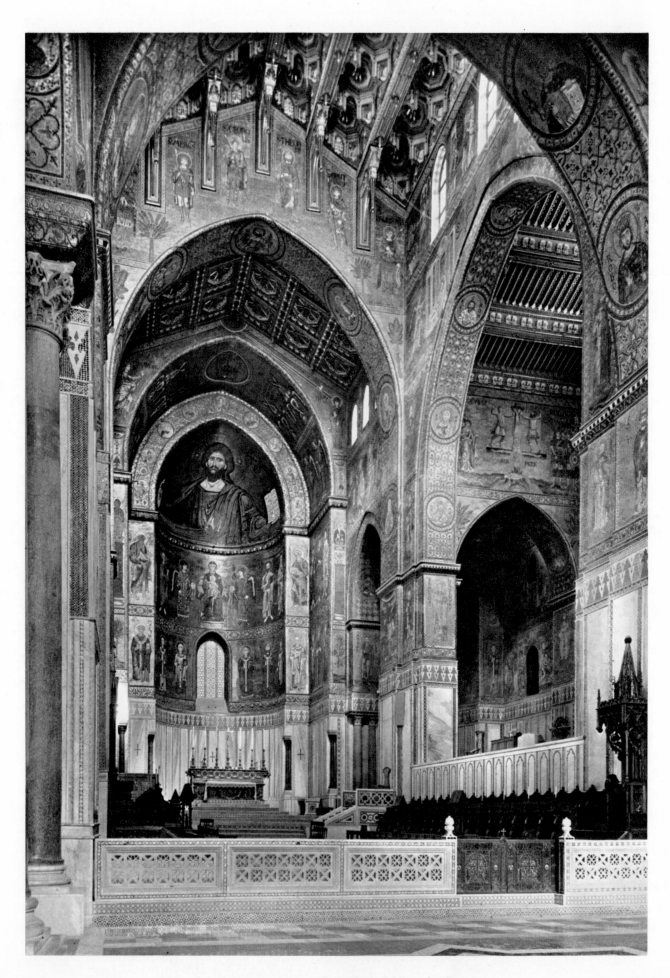

256. Interior toward east, Cathedral, Monreale. Begun 1174

ing to three different civilizations. Under royal patronage or with the benevolent approval of the kings, not only Latin churches but also Greek ones were built, as well as mosques. The church of Martorana in Palermo was, for instance, built in 1143 by Admiral George of Antioch and dedicated to the Theotokos; it is a Byzantine church with Byzantine mosaics, although its tower, added later, was inspired by the turrets of the cathedral at Laon. The domed churches of S. Giovanni degli Eremiti (1148) and S. Cataldo (1161), both in Palermo, are Greek but have many Islamic constructional details. Secular

buildings in Palermo are particularly Islamic in character and reflect the Norman adoption of many customs from the pleasure-loving Arabs.

To the same class of Arab-inspired buildings, though outside Sicily, belongs the tomb of Robert Guiscard's son, Bohemund, prince of Antioch (died 1111), adjoining the cathedral at Canosa. Not only is the form of the building Islamic, but its bronze doors are also decorated with Islamic designs.

The large Sicilian cathedrals are, however, Romanesque basilicas (fig. 256), and their cloisters are also Romanesque. Some have western

257. West façade, Cathedral, Cefalù. 1131

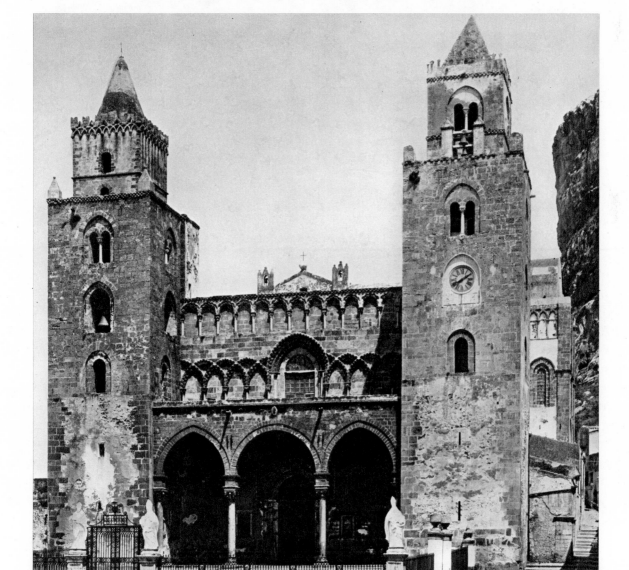

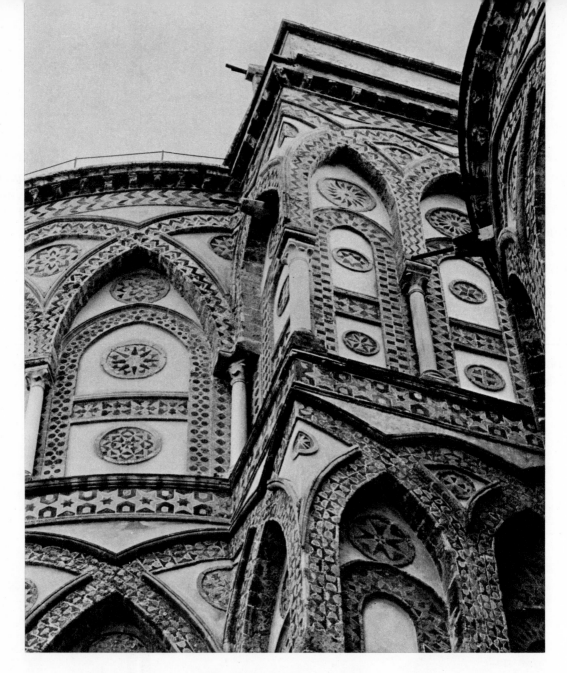

258. Exterior of apse (detail),
Cathedral, Monreale. 1174–82

towers (Cefalù, fig. 257; Monreale, Troina). The lavish use of pointed arches was the result of Islamic influence and this may also account for the use of intersecting arches and the chevron ornament, although these last two are sometimes thought to be an importation from Normandy or England. The early intersecting arches, as at Cefalù (1131), are undoubtedly very Anglo-Norman in character, but those on the exterior of Monreale Cathedral, with their inlay designs (fig. 258), including the chevron, are strikingly Islamic. A similar use of Islamic decoration in cloisters or on the exterior of buildings is found, under Sicilian influence, on the mainland, at Amalfi, Salerno, Ravello, and many other places.

Except in the cloisters of Cefalù and Monreale, comparatively little Romanesque sculpture was used in those buildings. On the other hand, a brilliant school developed in Campania in the second half of the twelfth century, probably based at Salerno; it specialized in the making of rich pulpits (see fig. 248) as well as other church furniture.

D. *Romanesque Art in North Italy*

The political and geographical conditions of Italy to the north of Rome account for the formation of Romanesque schools, each with fairly distinct features, in Lombardy, Tuscany, Emilia, and Venice.

VENICE

The merchant republic of Venice and the coastal strips to the east and south of it, because of their past association and their continuing commercial contacts with Byzantium, were a meeting place of artistic traditions from East and West. Such churches as S. Fosca on the island of Torcello, or St. Mark's in Venice, are buildings based on Byzantine models, the latter on the church of the Holy Apostles in Constantinople. Started in 1063, St. Mark's was consecrated in 1073, but the decoration of the interior was carried on for much longer, with much enlarging and enriching after the loot was brought from Constantinople in 1204. St. Mark's is essentially a Middle Byzantine building based on a Justinianic prototype, but its structure is Western and many technical solutions are due to Italian workmanship.

A similar observation can be made about Venetian mosaics. The earliest at Torcello and St. Mark's (end of the eleventh century) are purely Byzantine, but the late twelfth-century work in the five main cupolas of St. Mark's shows a considerable departure from Middle Byzantine principles in its iconography and in the application of mosaics to a domed church. Also very unlike contemporary Byzantine mosaics are those in the domes of the narthex of St. Mark's, started about 1220 and not finished until the end of the century. They show Genesis scenes from the Creation to the life of Moses (fig. 259), based on an early Byzantine cycle similar to that in the Cotton Genesis (see page 66). The Genesis mosaics in the earliest of the six cupolas are arranged in three concentric zones, each scene separated from the next in an abrupt and awkward manner and each obviously corresponding to a single picture on one page of the manuscript model. In the subsequent domes the division into three zones was abandoned, and in one dome a Romanesque motif was introduced based on the rose window.

From earliest times St. Mark's was a repository for sculpture, built into its exterior and interior. Many panels were brought from Byzantium but there are also numerous local imitations, executed with great skill. Venice, with its predilection for Byzantine rather than Romanesque art, has few works of sculpture that can be termed Romanesque. The great archivolts over the doorways of St. Mark's (fig. 260), dating from the thirteenth century, are Late Romanesque in spite of their date, but they cannot be explained by any indigenous development and must be due to an outstanding team of sculptors, possibly from Parma.

LOMBARDY

Of all the Italian schools of Romanesque art, the most influential was that of Lombardy. As could be expected in a region that had already experimented with problems of vaulting in the late ninth century, these continued to be a constant preoccupation of Lombard builders. Unfortunately the earthquake of 1117 brought down many churches, particularly their vaultings, and much of the evidence has perished. Nonetheless, there are grounds for believing that experiments were made during the eleventh century in reinforcing the groin vaults with diagonal arches, thus producing an early form of rib vaulting. The abbey church at Sannazzaro Sesia, north of Milan, is believed to be the earliest example surviving (c. 1040); even if the date of its construction was somewhat later, considerable progress in the field of vaulting must be assumed, for the entire interior of S. Ambrogio in Milan (figs. 261, 262) was covered with rib vaulting, presumably soon after 1117. This

259, 260. St. Mark's, Venice.

(*above*) *Creation Scenes.* Dome mosaic in narthex, south portal. c. 1220.

(*right*) Exterior from west. 13th century

important church was built of brick like most buildings in Lombardy, stone being used for certain structural features and for sculpture; it was served by monks and canons, and originally had two separate cloisters. The church is preceded by a narthex with an open gallery above and a large atrium. Two towers flank the west bays of the nave; the southern or Monk's Tower is a plain structure of the tenth century, but the tall northern or Canon's Tower was partially built by 1123 and finished later in the century. The Canon's Tower is a good example of a Romanesque campanile which, like the church and the atrium, used First Romanesque Lombard arches as the principal means of decoration.

The interior of S. Ambrogio (fig. 263) is highly sophisticated in the carefully worked-out relationship among all the parts. The nave is divided into square bays covered with domed-up rib vaulting. The ribs are heavy and unmolded. The aisles and the triforium gallery above them are groin-vaulted, resting on slender intermediate supports.

The façade of S. Ambrogio, with its huge gable over the nave and aisles, became an extremely popular form in northern Italy, the heaviness often relieved by a stepped, arcaded gallery following the form of the gable. The Romanesque churches at Pavia have such galleries (fig. 264).

Very different from these "typical" churches are some which clearly reflect the close connections between Lombardy and Germany. For instance, the stone church of S. Abbondio at Como, dedicated in 1095, has two towers that flank the choir in the Ottonian manner. Inside, huge columns with cubic capitals support a wooden ceiling, and only the sanctuary is ribvaulted.

The sculptural decoration of Romanesque

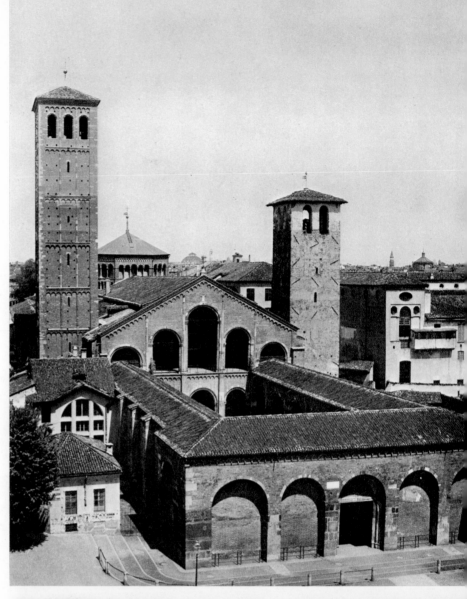

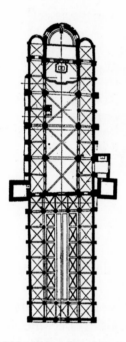

261, 262, 263. Sant'Ambrogio, Milan.
(*above, right*) Exterior from west. 10th–13th century.
(*above*) Plan.
(*below, right*) Interior from west. Vaulted after 1117

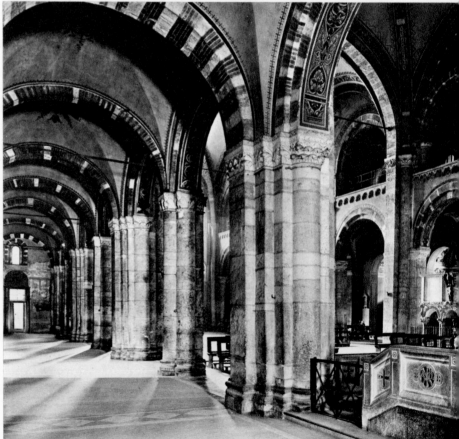

churches in Lombardy was profuse and distinctive, and is known by the name of the *corrente comasca*. When applied to capitals it is used almost like a continuous frieze, spreading from capital to capital and invading their abaci; it often even covers columns and bases. Lombard portals are easily recognizable by their alternation of round and square profiles, seen in both archivolts and door jambs; such portals are covered with sculpture, but the tympana are usually plain. The motifs used by the sculptors are on the whole restricted to interlaces and foliage, sometimes intermingling with animals, birds, and occasional figure subjects. Sant' Ambrogio in Milan has good examples of this type of decorative sculpture, and the churches of Pavia, especially S. Michele, are celebrated for the profusion of sculptural enrichment. The façade of S. Michele is decorated with numerous horizontal strips of sculpture without frames, bringing to mind such Armenian churches as Agthamar (see fig. 152). The connection might be

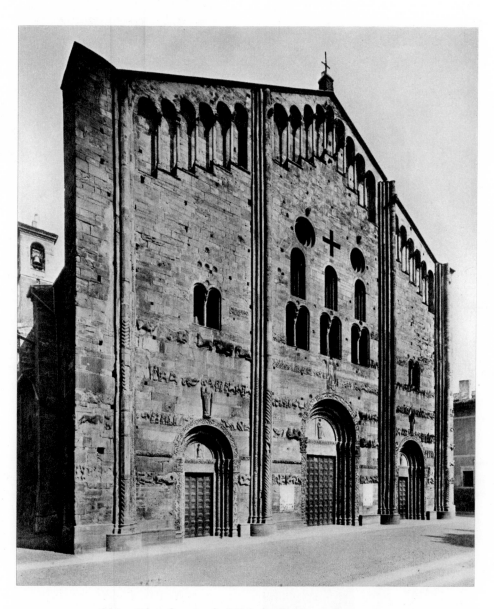

264. West façade, S. Michele, Pavia. 12th century

real, for there was an influx of Armenians to the West, and especially to Italy, when their homeland was annexed by the Eastern Empire in 1046 and soon afterward overrun by the Turks.

The *corrente comasca* was, at least in part, derived from eighth- and ninth-century Lombard sculpture (see fig. 78), of which there must have been numerous examples then in existence, since reliefs survive even today throughout Italy. No school of Romanesque sculpture was more influential. In Italy the style spread south as far as Montefiascone, near Rome, and it had an effect even in Apulia. But its most spectacular influence, presumably through migrant Lom-

266. WILIGELMO. *Prophets in Niches.* Door jambs, west façade. Before 1120. Cathedral, Modena

265. Exterior from west, Cathedral, Modena. 1099–1120

267, 268. WILIGELMO.
Friezes on west façade, Cathedral, Modena. Height c. 36″. Before 1120.
(*above*) *Creation of Adam; Creation of Eve; Temptation* (above northwest
portal). (*below*) *Expulsion of Adam and Eve from Paradise*
(at left of main portal)

bard craftsmen, was in Germany, and it was felt as far north as England and Sweden, and as far east as Hungary, Poland, and even Russia.

One decorative feature of churches which originated in Lombardy and spread widely in Italy and beyond the Alps was the open arcaded gallery around the outside of the apse, replacing the Lombard arches of the First Romanesque. The earliest Lombard example is at S. Giacomo at Como (c. 1095), and soon afterward it was used in Emilia, at Modena.

EMILIA AND THE SCULPTOR WILIGELMO

Modena Cathedral was started in 1099; by 1106 the crypt was ready, and the church must have been nearly complete by about 1120 (fig. 265). Some rebuilding took place in the last quarter of the century, ending with a consecration in 1184. Modena, together with a group of other Emilian churches, differs considerably from the designs prevalent in Lombardy, for it has a three-storied elevation (ground arcade, triforium, and clerestory); it is very likely that Modena, in this respect, imitated S. Nicola at Bari. Also derived from S. Nicola is the doorway with archivolt reliefs depicting the Arthurian legend: it is placed in precisely the same position on the north side of the church, and the columns, as at Bari, are resting on lions.

We know the names of the architect and the chief sculptor who worked at Modena: Lanfranco and Wiligelmo. Wiligelmo's name appears in a boastful inscription which reads, in translation: "Among sculptors, your work shines forth, Wiligelmo. How greatly you are worthy of honors." The sculptor was truly an outstanding artist and all his works bear the imprint of a great and inventive talent. His west doorway, for instance, uses, in addition to the "inhabited scrolls" of classical derivation and the atlas figures, a series of prophets in small niches, one above the other, on door jambs (fig. 266). This method was later employed at St-Denis Abbey,

in obvious reference to Wiligelmo. The most important and unusual of Wiligelmo's works is the frieze which runs across the façade in four sections (fig. 267, 268). These were originally placed low on the façade. It has recently been claimed that the frieze was originally part of the choir screen and was moved onto the façade later in the century, but this has been conclusively disproved.* The scenes of the frieze are from Genesis, carved in a monumental, if heavy style. Wiligelmo obviously studied Roman reliefs, and he could have traveled to Bari and even to France; but for all his indebtedness to the sculpture of antiquity and to Romanesque sculpture elsewhere, he was an artistic personality of undoubted and unique genius. The idea of a frieze with narrative subjects was, of course, classical, and Wiligelmo no doubt knew Roman triumphal arches with such friezes. Purely decorative friezes had been employed in Byzantium, and, during the early Middle Ages, in Visigothic Spain, in England, and in some Carolingian churches; narrow friezes with decorative motifs and an occasional narrative scene made their appearance in some early Romanesque buildings in the Loire Valley and in Provence. But Wiligelmo's is the first frieze of considerable size that is devoted exclusively to Biblical subjects.

Wiligelmo trained a group of pupils at Modena who were entrusted with a great deal of work in the cathedral itself. They carried his style to other places, notably Cremona Cathedral, where fragments survive of a frieze similar to that at Modena.

Not all of Wiligelmo's collaborators adopted his style, however. A sculptor who carved the south doorway of Modena Cathedral, known as the *Portale dei Principi,* with the story of S. Geminiano on its lintel, used small, doll-like figures in

* A. Quintavalle, *La Cattedrale di Modena,* Modena, 1964, vol. I, pp. 184–201; R. Salvini, *Il Duomo di Modena,* Modena, 1966, pp. 72–77; E. Fernie, "Notes on the Sculpture of Modena Cathedral," *Arte Lombarda,* 1969, pp. 88–93.

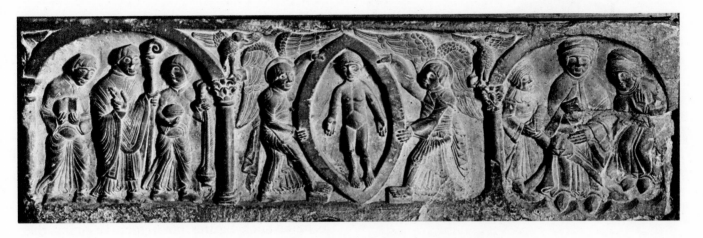

269. Sarcophagus of Doña Sancha (front). Early 12th century.
Originally in convent of S. Cruz de la Serós;
now in Monastério de la Benedictinas, Jaca

crowded scenes which show only an occasional detail taken from the style of Wiligelmo. Curiously enough, a similar style is found not only in nearby Nonantola, but also in far-off Aragon—on capitals at Jaca Cathedral (see fig. 210), and on a celebrated sarcophagus probably for Doña Sancha (fig. 269), a daughter of Ramiro I of Aragon (now in the Benedictine monastery at Jaca), as well as at a few other places in the region. As we have already seen, artists frequently moved over great distances in this period, and this accounts for the rapid spread of artistic styles and ideas.

NICCOLÒ

Another sculptor of considerable talent was Nicholaus, or Niccolò; he had an enormous influence on sculpture in northern Italy from Piedmont to the Adriatic, and his style was also well known in Germany.

His earliest work is found in the picturesque abbey built on a high mountain top near Turin, Sagra di S. Michele, where he signed his name on the Zodiac Portal. His sculpture shows a mixture of classical elements with others derived from the Gilduinus workshop in Toulouse. As the two first decades of the twelfth century were

dominated in Emilia by the style of Wiligelmo, so the succeeding period, from 1120 to 1150 or even longer, is strongly influenced by the style of Niccolò, whose activities can be studied in the portals of the cathedrals of Piacenza (1120–30), Ferrara (1135; fig. 270), Verona (c. 1139; fig. 271), and that of S. Zeno at Verona (c. 1138). With the exception of his work at Piacenza, which must be assigned to Niccolò on the basis of the style, the portals are signed by the sculptor in a boastful way. Needless to say, Niccolò must have employed a number of assistants, for not all his work is stylistically homogeneous.

Niccolò's great contribution to Italian sculpture was the use of certain French elements in the portal design; these he combined with other elements which, thanks to Wiligelmo, had become current in Italy. Thus a large carved tympànum is found in most of his portals, whereas Italian tympana had previously been plain or at best painted. He must have seen the *Porte Miégeville* in Toulouse (see fig. 216), for he uses spandrel sculpture in practically all his portals. From Wiligelmo and his team at Modena, Niccolò derived the small-scale jamb sculpture within rectangular fields or in niches. But he was no mere copyist; he combined the French and Ital-

270. NICCOLÒ. Main portal with jamb figures of Prophets in niches, and *Annunciation*. 1135. Cathedral, Ferrara

ian motifs in an original way and added a number of features of his own invention.

The west doorway of Verona Cathedral is a good example of Niccolò's work at its grandest. A deeply recessed, very large doorway has a tympanum with the *Annunciation to the Shepherds* and the *Adoration of the Magi*, and a lintel with figured medallions that presumably symbolize Faith, Hope, and Charity, the theological Virtues. The door jambs supporting the lintel are very classical in their simple moldings.

The recessed orders are eight in number and alternately squared and round, a feature obvi-

ously Lombard in derivation. The round orders, arches as well as shafts, are richly decorated with geometric patterns, while the squared jambs have flat little panels and niches based on Wiligelmo's example at Modena. In addition, and this is a novelty, on these jambs are carved nearly lifesize figures that project from them. At Modena, Wiligelmo had already carved figures of prophets in small niches on square jambs, an idea that was further developed by his followers at Modena and Cremona. What Niccolò did was to make such figures far bigger, bringing them out of niches and placing them, in some cases, on the angles of the jamb, not on the flat surfaces. Niccolò had already used such figures at Ferrara, in 1135, and possibly in earlier work which does not survive. The importance of Niccolò's portal design will be realized later on, when discussing the emergence of column-figures at St-Denis at roughly the same time, the late 1130s (see page 364). A number of Italian features suggests that the sculptors there knew about Niccolò's portal designs.

At Ferrara these jamb figures represent four prophets and the Virgin Mary and Archangel Gabriel, the latter two forming an *Annunciation* group separated by the door-opening. At Verona Cathedral ten of the jamb figures are prophets, while the two largest, outer figures are knights, believed to represent Roland and Oliver, heroes of the *chanson de geste*. The identification is plausible, for epic poems were popular in Italy, and Roland and his companion are represented, for instance, on the pavement of the cathedral at Otranto. The reliefs with Arthurian subjects at Bari and Modena are further testimony that illustrations of heroic legends were quite happily used in the decoration of churches.

In front of the Verona Cathedral doorway is a deep arched porch supported by free-standing columns resting on griffins. This is a further development of the idea initiated in S. Nicola at Bari and taken up by Wiligelmo at Modena. But Niccolò's porch is far more impressive by its

271. NICCOLÒ. West portal and porch, ▶
Cathedral, Verona. c. 1139

274

size and elaboration, and the sculpture is applied to its external face and to the soffit of the arch as well. In the spandrels are St. John the Evangelist and St. John the Baptist, the latter pointing to the Lamb in the apex of the arch. The idea of filling spandrels with figures was first used at Cluny (see page 235) and then on the *Porte Miégeville* of St-Sernin at Toulouse; in view of other evidence it is most likely that Niccolò derived this motif from Toulouse rather than from Cluny.

It is generally believed that Niccolò was in Toulouse sometime before 1120. This is very likely indeed. But it is difficult to imagine that a successful and very busy sculptor, responsible for a series of major works executed between 1120 and 1140 and also for a team of collaborators, made another trip to Toulouse between 1130 and 1135 and was influenced once again by what he saw there—yet this second trip is usually suggested to explain the style of Niccolò's jamb sculptures. Their soft, gentle, elegant modeling, the crossed legs, the occasional use of a fluted nimbus—all these features make Niccolò's work fairly similar to the apostles from the chapter house of the cathedral of St-Étienne at Toulouse (now in the museum; see fig. 287). Since, however, these apostles do not seem to have evolved from the previous styles in Toulouse, a more likely explanation for them is that their author knew and admired the work of Niccolò. And he would not have been the only sculptor to learn something from Niccolò, as is demonstrated by very numerous derivatives in Italy and beyond the Alps.

Niccolò, on the evidence of surviving monuments, anticipated the development of the French Gothic portal with column-figures. It is believed that the earliest column-figures were those at St-Denis (1137–40). However, it is significant that true column-figures, in a style derived from Niccolò's, were on a portal added to S. Vitale at Ravenna (now in the local museum), and others in the cathedral at Ancona. Could it

be that they imitate a Niccolò portal that is no longer in existence?

TUSCANY

Romanesque art in Tuscany forms a distinctive group that has considerable local variations at Pisa, Lucca, and Florence.

The common building material was stone with marble facing on both exterior and interior, frequently in two or three colors. San Miniato al Monte, finished in 1062 (though the façade is of twelfth-century date), is the best-preserved example in Florence. However, the most important Romanesque building in Tuscany is the cathedral complex at Pisa (figs. 272–74), a gigantic project reflecting the aspirations and the new wealth of the republic-city, one of the most powerful maritime centers of Italy at that time.

The huge cross-transept basilica at Pisa, with double aisles and galleries extending from the west to the sanctuary, has most unusual transept arms: each has an aisle along the eastern wall and toward the nave, and an apse at each end wall, so that they look like two complete churches adjoining the main church at right angles. The dome covers the crossing, but otherwise the church has a timber ceiling over nave and galleries, and only the aisles have groin vaults. Externally, also, the church is unusual for its continuous decorative arcades across the lower story and pilasters in the upper; it is sometimes suggested that the arcading is of Armenian origin (for instance, the cathedral at Ani, 989–1001). The building was started in 1063 by a certain Busketos, obviously a Greek name, and consecrated in 1118, but the church was subsequently enlarged westward by Rainaldus. To the west stands the baptistery, begun in 1153, and to the east the cylindrical belfry, the Leaning Tower, started in 1174; both were finished considerably later.

The façade of Pisa Cathedral, with its horizontal galleries, so different from those in Lombardy, was imitated frequently and not only in

272, 273, 274. Cathedral complex, Pisa. Begun 1063.
(*above*) View from southwest. (*below, left*) Plan of cathedral complex.
(*below, right*) BUSKETOS. Plan of Cathedral

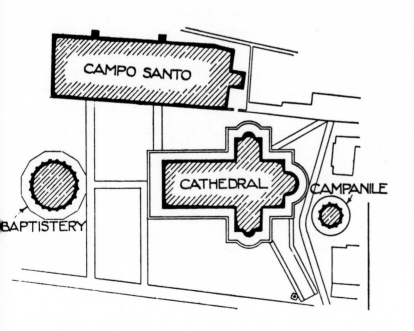

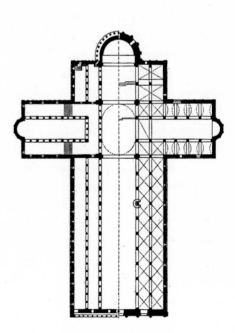

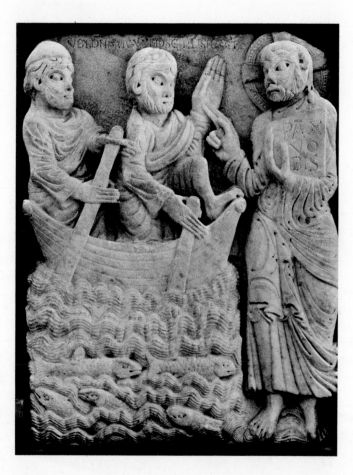

275. MASTER OF CABESTANY. *Calling of Peter and Andrew.*
Formerly portion of tympanum. S. Pedro de Roda.
Height 32″. Mid 12th century.
Museo Marés, Barcelona

Tuscany. The decoration of Tuscan buildings relies as much on marble inlays as on sculpture, and in both media there are two very strong sources of inspiration, classical and Islamic. Good quality figural sculpture was rare in Tuscany before the middle of the twelfth century. At an unknown date, but probably toward 1150, a curious artistic personality known under the conventional name of the Master of Cabestany seems to have worked in Tuscany; his style of carving is so personal, so unique, that there is never any difficulty in recognizing his works (fig. 275) though they are found scattered in Catalonia, Navarre, Roussillon, and

Languedoc. In Tuscany only two works survive, a capital in S. Antimo Abbey near Siena (a church with an ambulatory of a French type), and a colonnette covered with narrative scenes at S. Giovanni at Sugana, near Florence. The sculptor used the drill a great deal for effect, in the late Roman manner, and his indebtedness to classical sculpture is profound. His manner of carving asymmetrical faces, long hands, deeply undercut folds, and bulging eyes is expressive, and the mood of his scenes reflective, almost melancholy. Was he a native of Tuscany? Was he trained in this region, so full of classical sarcophagi and other Roman sculpture? Present views* favor a Catalan origin for the sculptor, but the matter is far from settled. The fact remains that the "Master of Cabestany" exercised a far greater influence in Tuscany than in Languedoc or Catalonia, and it must be assumed that he worked there extensively though only these two sculptures survive.

Tuscan sculptors of the second half of the twelfth century evolved a style that is often called Proto-Renaissance, because it is so strongly indebted to classical ideals of naturalism in the treatment of forms. In animal sculpture, especially in the lions which were so popular as supports for architectural members, the naturalism in rendering the muscles and the ferocious heads is so thoroughly Roman that, at times, it is difficult to distinguish between a Roman original and a Tuscan imitation. And in the figure style—the bulky proportions, the heavy draperies deeply undercut, the grouping of crowded scenes—the debt that the sculptors of this period owed to Roman sarcophagi is altogether self-evident.

* M. Durliat, "Le Maître de Cabestany," *La sculpture romane en Roussillon*, vol. 4, Perpignan, 1954; *idem*, "Du nouveau sur le maître de Cabestany," *Bulletin monumental*, 129, pp. 193-98; L. Pressouyre, "Une nouvelle oeuvre du 'Maître de Cabestany' en Toscane," *Bulletin de la Société Nationale des Antiquaires de France*, 1971, pp. 30-55.

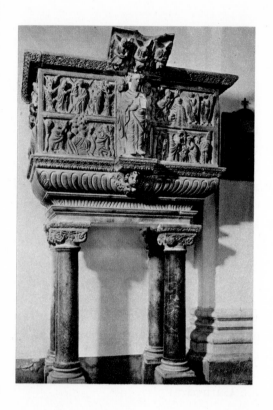

276. (*left*) GUGLIELMO. Pulpit with Scenes of the Life of Christ.
Originally in Cathedral, Pisa. 1159–62.
Cathedral, Cagliari (Sardinia)

277. (*below*) BIDUINO. Lintel with Scenes of the Passion
and Resurrection of Christ. 1180.
San Cassiano a Settimo (near Pisa)

278. (*bottom*) BIDUINO. Lintel with Scenes of
the Life of St. Nicholas of Bari.
Late 12th century. Church of the Saviour, Lucca

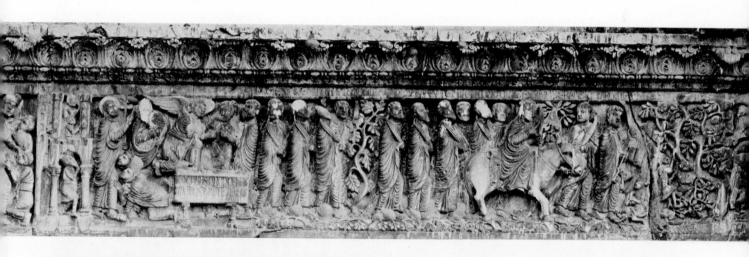

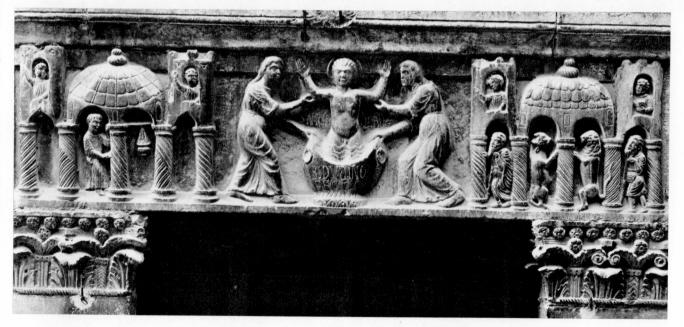

The material used is exclusively marble from the Carrara quarries. Several sculptors are known by name; there is, for instance, a certain Guglielmo who carved, between 1159 and 1162, a marble pulpit for Pisa Cathedral (fig. 276) which established a form that was followed by his more famous successors, Nicola Pisano and Nicola's son Giovanni. In fact, the pulpit of Guglielmo was replaced by Giovanni's; Guglielmo's was shipped to Sardinia, where it still survives in Cagliari Cathedral.

In spite of repeated claims by scholars that Guglielmo learned his art in Provence, the matter can be argued to the contrary, that Provence sculpture was deeply indebted to Tuscany.

Among the followers of Guglielmo the most important was Biduino, who signed a lintel at S. Cassiano a Settimo (fig. 277), near Pisa, and gave the date of 1180. He also signed two other lintels in Lucca (fig. 278), for the enmity between Pisa and Lucca did not prevent an intimate artistic relationship between these and the other city-states in Tuscany.

At the close of the twelfth century a strong Byzantine element found its way into Pisan artistic production, demonstrated by the exterior sculpture on the baptistery. The bronze doors for the cathedral were made by a certain Bonannus, who also made, in 1186, a second version of them for Monreale Cathedral.

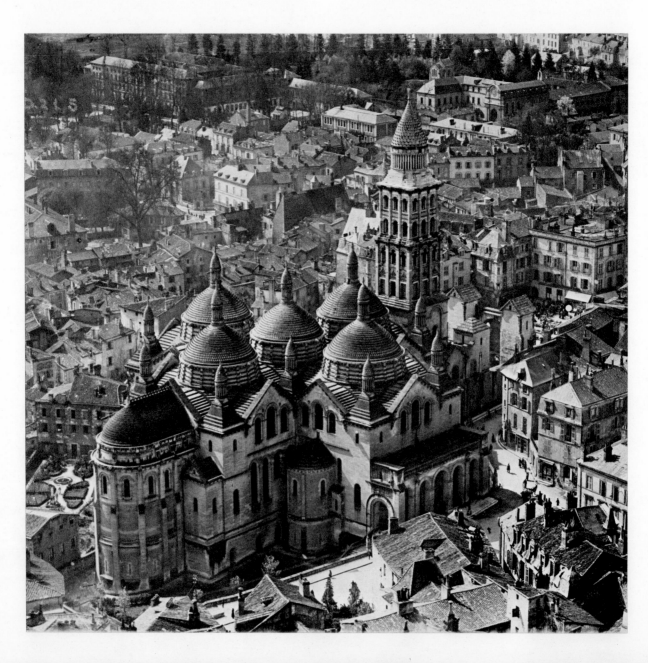

E. Later Romanesque Art in Southwest and West France.

The brilliant artistic life which radiated from Toulouse during the last quarter of the eleventh century and the first of the twelfth did not end with the completion of the collegiate church of St-Sernin. For a time, however, the center of artistic activity moved further north to Moissac Abbey, the cloister of which was, as will be remembered, a Toulousan work of about 1100 (see page 222).

LANGUEDOC

The new abbey church of Moissac was built during the abbacy of Roger (1115–31). Architecturally, the building originally belonged to a group of domed churches, of which seventy-seven examples are now known to have been built in western France, between the Loire and Garonne rivers. The inspiration for these churches obviously came from the East and it is thought that their closest parallels are on Cyprus. William IX, duke of Aquitaine, could well have been influential in introducing this type of church into his dominions, for he joined the First Crusade in 1100, and soon afterward the domed churches made their appearance—first at Périgueux in the cathedral of St-Etienne, where four domes in one straight row were used. The most elaborate was also at Périgueux, St-Front (c. 1120), with its five domes above the Greek-cross church (figs. 279, 280). The domes are lit by windows and rest on pierced wall piers, and in this case the model seems to have been St. Mark's in Venice.

The abbey of Moissac is entered through a western tower, a two-storied structure having the earliest known rib vaulting built entirely on pointed arches. But it is the south doorway, within a shallow porch leading through the tower to the church, that is of prime importance, one of the greatest works of Romanesque art (figs. 281–83). It consists of a huge slightly pointed tympa-

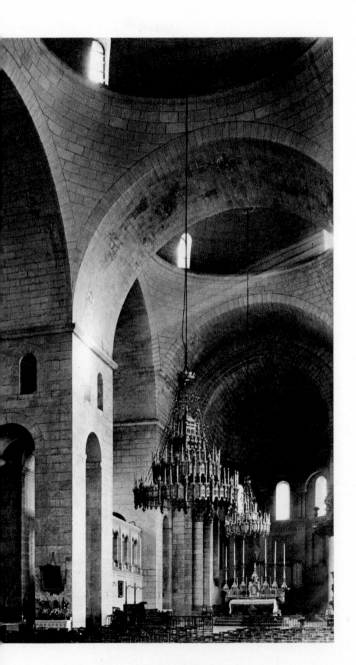

279, 280. St-Front, Périgueux. c. 1120.
◀ (*opposite*) Exterior from northeast.
(*above*) Interior toward east

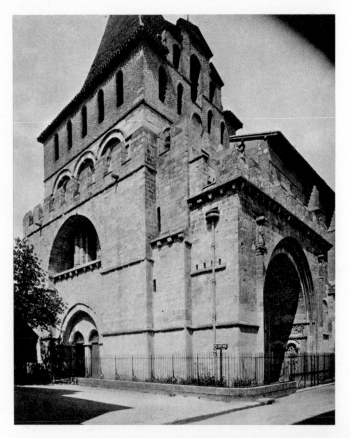

num representing the apocalyptic vision of the Second Coming, based on the illuminations of Beatus' Commentary on the Apocalypse. Basically, the theme is similar to that on the doorway at Cluny, but here it is arranged quite differently: the Twenty-four Elders are not on the archivolt, as at Cluny, but are arranged in three rows, five on either side of Christ and fourteen below Him. The central composition consists of Christ giving the blessing, the four symbols of the Evangelists, and two assisting angels. The lintel and the arches around the tympanum are carved with decorative motifs of great beauty and precision, repeated many times. As will be seen, this is a derivative of a method of decorating arches on façades in Saintonge (see fig. 292) and in Poitou. The lintel, flanked by two beasts, is carved with sunk rosettes joined together by clasps or monstrous heads, and on its under surface is an

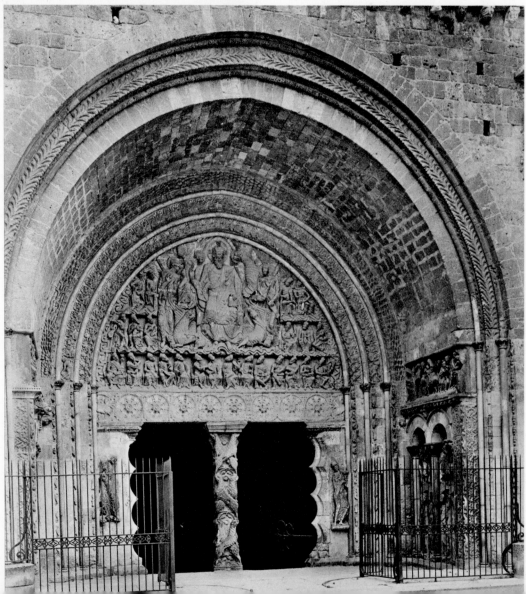

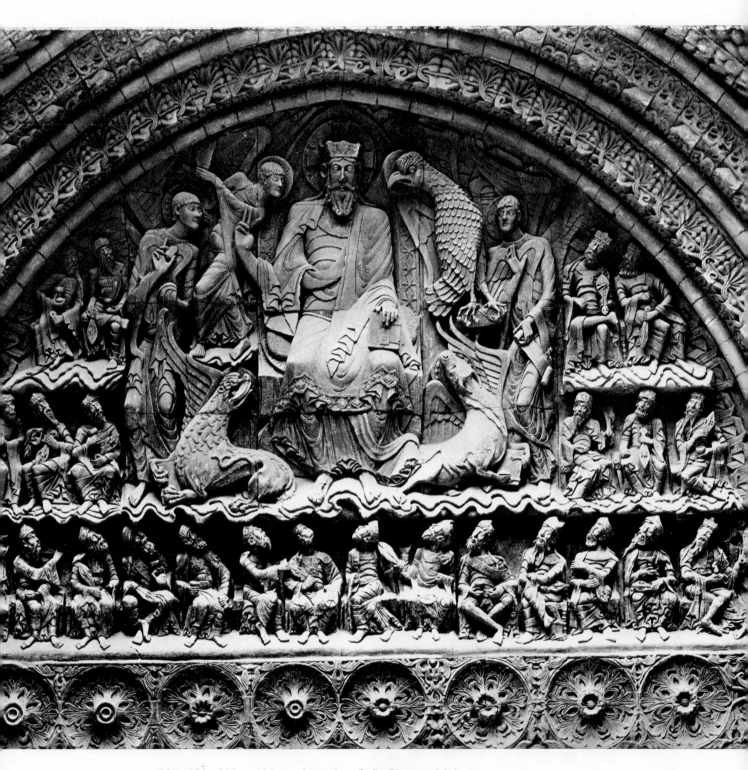

281, 282, 283. Abbey Church of St-Pierre, Moissac. 1125–30.
(*opposite, above*) Exterior of west tower.
(*opposite, below*) South porch.
(*above*) *Apocalyptic Vision of the Second Coming of Christ.*
Tympanum, south porch

acanthus scroll and the chrism, copied from Visigothic reliefs of the fifth century, of which very numerous examples are still extant in the Gallic territories held by the Visigoths until 507. A lintel almost identical to that at Moissac, preserved in the museum at Cahors,* suggests that it was part of a doorway, now missing, by the same sculptor.

The contrast between the small figures of the Elders, all gazing at Christ with an excitement expressed by their agitated poses, and the dominant Christ in Majesty in the center serves to show that the central group is a dramatic vision. The figures are carved in high relief, parts of their bodies being completely detached from the background. This high relief, as well as the method of carving on many pieces of stone joined skillfully together, brings to mind the great Burgundian tympana at Cluny, Autun, and Vézelay. The style of the Moissac tympanum is far more crisp, precise, and calligraphic than any in Burgundy, although it uses extensively the "plate" drapery that is so characteristic of the Cluny capitals. The evident love with which the sculptor carved the crowns, the haloes, and the embroidered borders and collars of the robes indicates that perhaps he was a goldsmith as well as a stone sculptor.

The tympanum rests on cusped jambs, with attached colonnettes that follow the cusped forms; this unstructural, purely decorative device is of Islamic inspiration. The trumeau supporting the tympanum echoes the cusped shape of the jambs (figs. 284, 285), but partly obscures it with sculptured lions and lionesses, ingeniously placed in pairs that stand on each other's back, and with two figures on the sides, probably St. Paul and Jeremiah. It will be remembered that

* J. B. Ward-Perkins, "The Sculpture of Visigothic France," *Archaeologia*, 87, 1938, p. 102, note 2. He rightly rejects Meyer Schapiro's view ("The Romanesque Sculpture of Moissac," *Art Bulletin*, 13, 1931, pp. 493 ff.) that the Moissac lintel is an Early Christian monument, reused in the twelfth century.

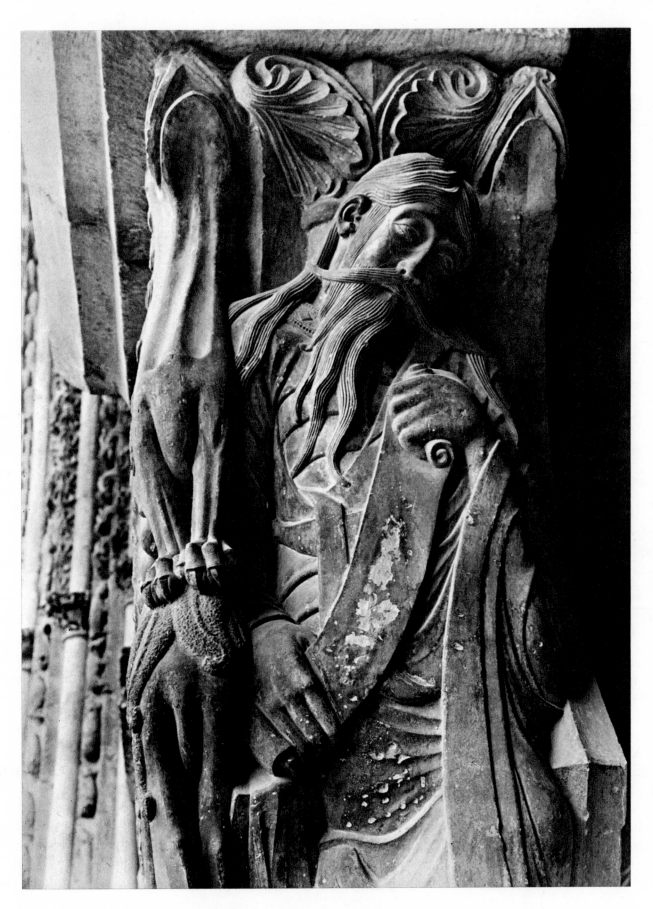

284, 285. Sculpture on trumeau, south porch,
Abbey Church of St-Pierre, Moissac. 1125–30.
(*opposite*) *Prophet Jeremiah; Lions and Lionesses.*
(*above*) *Prophet Jeremiah* (on east face)

284

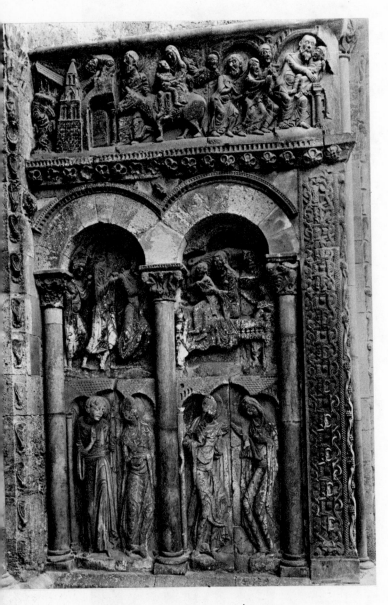

286. Scenes of the Life of the Virgin
and Infancy of Christ. East wall, south porch.
1125–30. Abbey Church of St-Pierre, Moissac

at Autun, soon after 1125, a trumeau was provided for the north doorway, and for the central one about 1130; both have perished, though we know that the central one had three figures attached to it. At Vézelay, again about 1130, a trumeau with John the Baptist supports the central tympanum. The Moissac trumeau undoubtedly surpasses it in extraordinary beauty.

The elongated figures are so placed on the cusped background that the structure of their bodies—the hips, the knees—follows the cusps. There can surely be no closer unity between an architectural form and its sculpture. The elongation of the figures, especially of their limbs, is most unnatural, and yet, in their setting, they look harmonious and beautiful. The head of Jeremiah, with its exaggerated moustache and hair, is expressive of gentleness and humility.

Reliefs of St. Peter and Isaiah on the jambs, at the same level as the trumeau figures, are by a less able sculptor. These reliefs are in roughly the same position as the two pairs of apostles flanking the central doorway at Vézelay (see fig. 238).

In spite of the probability that the Moissac doorway and those in Burgundy are very close in date—that is, they were all (except Cluny) carved between 1125 and 1130—the conventional date given to Moissac is about 1115, in my view an untenable proposition. Both sides of the shallow porch containing the Moissac doorway have other sculptures, enclosed by arcades (fig. 286). This work is often thought to be later than the tympanum, but in some of the reliefs the hand of the master of the tympanum is easily recognizable, and the whole scheme must have been executed in one campaign lasting certainly no more than five years.

The hand of the chief master can again be recognized in reliefs from the portal, now partly destroyed, of the abbey church at Souillac, also domed. One of the master's pupils must have executed the tympanum with the Last Judgment at nearby Beaulieu.

The origin of this second Moissac workshop (the first being the workshop of the cloister; see page 222) is obscure. The presence of Islamic motifs, the iconography derived from Beatus, the decoration of the arches related to the Western French school—all these suggest that the chief sculptor was trained in Languedoc (Toulouse?) rather than in any other part of France. But that he knew Burgundy, there can be no doubt. The

idea of a colossal tympanum supported by a trumeau, and especially the drapery conventions, are unthinkable without Burgundian inspiration.

The style of the Moissac master is found again in some of the twelve figures of apostles which were originally in the chapter house of the cathedral of St-Etienne at Toulouse (now in the local museum; fig. 287). These figures are carved in pairs, except for four singles. In the past it was believed that they formed part of a doorway, placed on either side in recessed orders and thus anticipating the column-figures of St-Denis. However, it has recently been demonstrated* that the figures were placed inside the chapter house, the pairs supporting transverse arches and the single ones at the four corners of the room. Above the figures were capitals, some historiated, most of which still survive.

Stylistically, the chapter-house figures fall into two groups, one related to the portal of Moissac, the other less angular, more solemn, and softer in the modeling of the round forms. The sculptor responsible for the second group was obviously the head of the workshop, for he signed two single figures in this soft style with the name Gilabertus (not to be confused with Gislebertus of Autun). One signature takes a boastful form, reminiscent of the signatures of Wiligelmo and Niccolò: VIR NON INCERTUS ME CELAVIT GILABERTUS. But there are other things as well which make the work of Gilabertus comparable to that of Niccolò: both use fluted haloes and, more important, both carve their figures diagonally at the angle of a block of stone; although both are also fond of showing figures with crossed legs, this convention became so widely used that it cannot be taken as a particularly important point of similarity.

The date of the Toulouse apostles is not

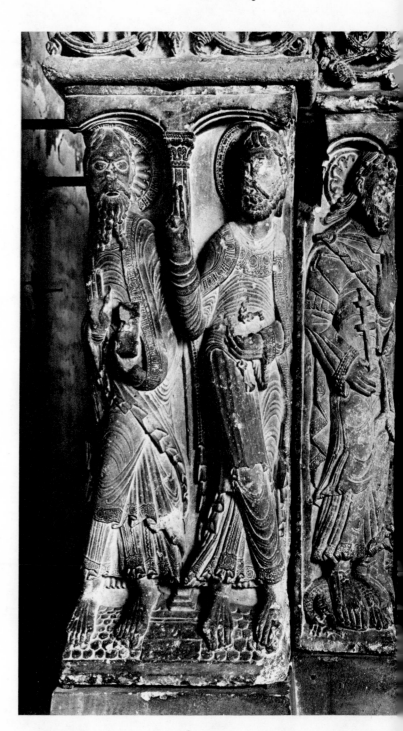

287. GILABERTUS. *Apostles Paul (?), Peter, and Philip.* From portal of chapter house, Cathedral of St-Etienne, Toulouse; height c. 45″. c. 1130.
Musée des Augustins, Toulouse

* L. Seidel, "A Romantic Forgery: the Romanesque 'Portal' of Saint-Etienne in Toulouse," *Art Bulletin,* 50, 1968, pp. 33–42.

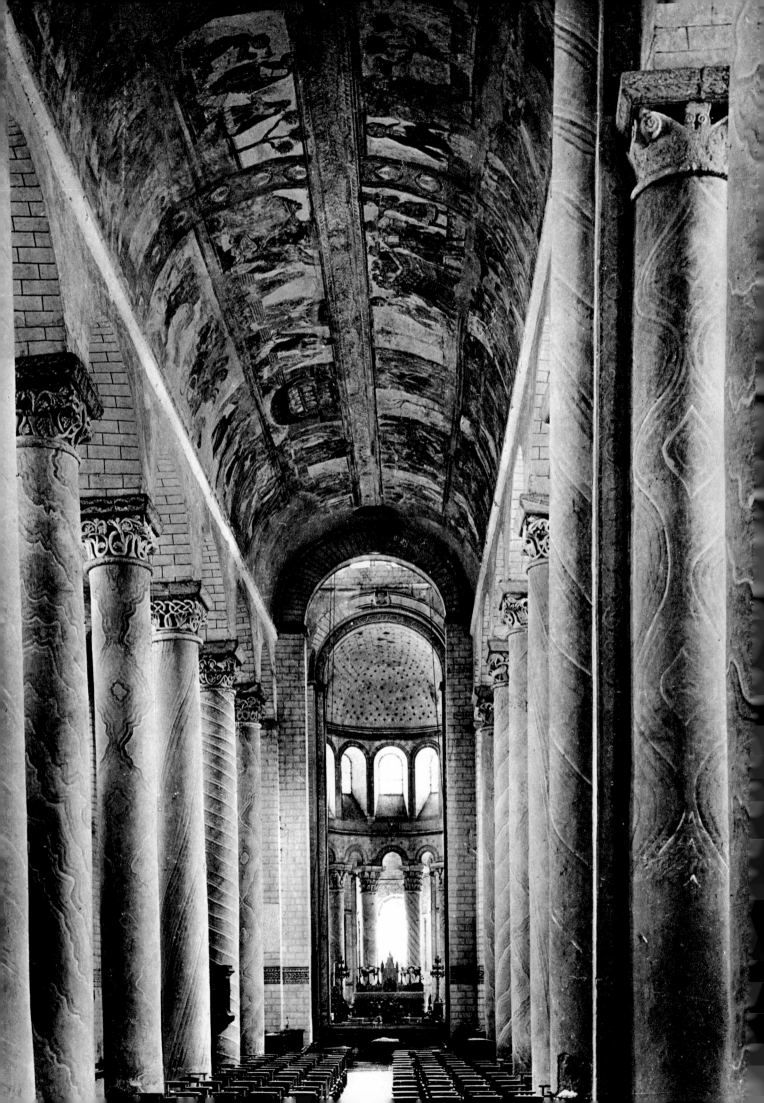

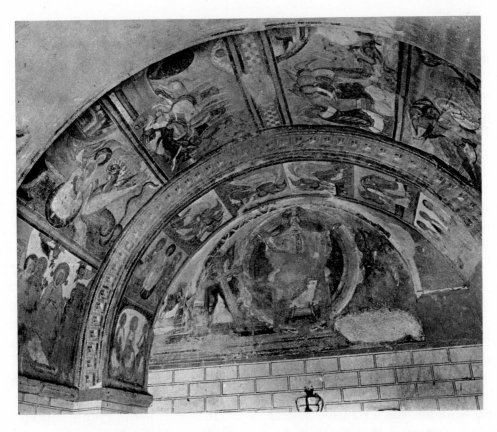

288, 289. Abbey Church, St-Savin-sur-Gartempe. c. 1100.
(*opposite*) Interior toward east. (*above*) Wall paintings in narthex:
Christ in Majesty (tympanum); *Apocalypse* (barrel vault)

known, but it is generally assumed that it must be prior to 1137, the date when the work started on St-Denis, for Gilabertus' style was one of the formative influences there. If they were carved sometime between 1130 and 1135, this would place them within the period of Niccolò's career just before he started his work at Ferrara (see page 271). Much more study is required to establish what, if any, was the relationship between the art of Gilabertus and that of his Italian contemporary.

AQUITAINE AND THE WEST OF FRANCE

To the north of Languedoc, in the territories which were ruled by the dukes of Aquitaine from their capital at Poitiers and extending north to the county of Anjou, the twelfth century witnessed a blossoming of all branches of Roman-

esque art. In no other region of Europe is there such a concentration of Romanesque churches. Many are admittedly only small and parochial, but all are richly decorated with sculpture and some still preserve their original wall paintings and stained-glass windows. The manuscripts, too, especially those produced at Limoges, are among the most sumptuous of the period and it was also at Limoges that the production of enamels was initiated, which developed into an industry of European reputation.

For a short period Aquitaine was united with the French crown, when Eleanor, who succeeded to the ducal title on the death of her father William X, married Louis VII of France in 1137. The marriage, negotiated by Abbot Suger of St-Denis, had, as will be seen later, a considerable influence on the artistic development in the royal

domain. Their subsequent divorce, in 1152, was soon followed by the marriage of Eleanor to Henry II Plantagenet, who became the king of England in 1154; in this way, Aquitaine was part of a large empire until Eleanor died in 1204. The artistic consequences of this union were more important for England than for Aquitaine.

The soft but durable limestone found in the western part of the region encouraged elaborate forms of masonry and sculpture. The domed churches mentioned above were only one of the church types in use. The "hall church," that is, one having nave and aisles of the same or nearly the same height, made an early appearance at Lesterps Abbey (c. 1070). Many churches have ambulatories with radiating chapels, which is not surprising in view of the early use of this form at Limoges and Tours.

Another frequent feature is the tunnel vault that rests directly on tall columns, as at St-Savin-sur-Gartempe (fig. 288). Such vaulting was particularly suitable for extensive mural paintings, and it is fortunate that those at St-Savin have survived. They illustrate Old Testament scenes, from the Creation to the story of Moses. The paintings in the crypt are devoted to the martyrdoms of St. Savin and St. Cyprian; there are two other groups of paintings in the narthex (colorplate 36; fig. 289) and in the chapel above it, the former with scenes from the Apocalypse, the latter with Christ's Passion.

All these paintings were executed by one team of painters, and within a short space of time while the scaffolding of the masons was available to them, that is, very soon after 1100. Although contemporary with the Burgundian wall paintings at Berzé they are very different, quite unaffected by Italo-Byzantine influences (see colorplate 34). It is believed that the iconography at St-Savin has some connections with Anglo-Norman or even earlier Anglo-Saxon sources.

But let us return to the buildings. Whatever the design of the church, whether it is a domed building or a church with a single nave or with a nave and aisles, the façades of most twelfth-century churches between the Loire and Garonne rivers seem to be quite unrelated to their interiors. They are screen-façades, usually taller than the roof and wider than the church itself. For instance, the Abbaye-aux-Dames at Saintes has a façade divided into three bays, suggesting a tripartite division of the interior, but in fact the façade hides a single nave with domes. Such screen-façades, of which there are several types, are lavishly decorated with sculpture which presents some similarity to the sculpture in Lombardy; in both instances the sculpture is predominantly decorative and often applied without much concern for the architectural background, and the rich decorative effects override architectural propriety. It will be seen that even before 1154, when England became united with Aquitaine, the screen-façade as well as decorative sculpture of the type used in Western France were both imitated in England.

In some of the grand churches, such as Angoulême Cathedral or Notre-Dame-la-Grande at Poitiers (figs. 290, 291), there are extensive iconographic sculptural programs. At Angoulême (before 1130), unfortunately disastrously restored in the last century, the apocalyptic vision of the Second Coming is illustrated in reliefs placed all over the façade; at Poitiers the spandrels of the ground story have scenes based on a mystery play (including an early representation of the *Tree of Jesse*), arranged almost like a frieze. There are other, real friezes, as at St-Jouin-de-Marne and Montmorillon, where the influence from Modena could have played some part. An interesting peculiarity of these decorative schemes is the absence of a tympanum over doorways; when tympana are used, as at Angoulême, they are placed not over doorways but in blind niches flanking a doorway. Such niches, as well as the doorways themselves, the windows, and the rows of arcading, are decorated by a method which is characteristic of the School of the West of France. Each voussoir of an arch

290. West façade,
Cathedral, Angoulême.
Before 1130

291. West façade,
Notre Dame-la-Grande,
Poitiers.
2nd quarter 12th century

290

(and an arch may have, in some cases, as many as fifty voussoirs) is carved with a single motif, placed radially, and frequently repeated on every stone with little or no change. At Poitiers it is a seated dog that is repeated some thirty times around one niche. At Aulnay-de-Saintonge the Twenty-four Elders are more than doubled (fig. 292). This attitude toward iconography seems to have been dictated by a sheer delight in carving

292. Portion of archivolts,
portal of south transept,
St-Pierre, Aulnay-de-Saintonge. c. 1130

small, repetitive forms for the sake of decoration, often at the expense of correctness in the subject matter.

The influence of this method of carving was very widespread, and even when it was abandoned in the west of France, it continued to be practiced, not only in England, but also in Normandy and Spain. In Spain radiating voussoirs were still popular in the last quarter of the twelfth century, as may be seen in the west portal of Santiago Cathedral, the *Pórtico de la Glória*, of 1188 (see fig. 391).

Radiating voussoirs had two drawbacks. One was the amount of work involved in shaping and carving separately a very large number of stones to form each arch; secondly, the width of the arch limited the size of the motifs applied to the archivolt. By about 1130 there was an obvious desire to use larger figure sculpture on arches, especially those of doorways. At about that time arches started to be made in much larger segments, and figures were carved on them not radially, but along the curve of the arch. By carving figures across two or more segments their size was increased considerably, by three-, four-, or fivefold. The subjects frequently carved were the Virtues and Vices, the Wise and Foolish Virgins, and, at the apex, angels supporting medallions of Christ and the Lamb, as shown on Notre-Dame-de-la-Couldre, at Parthenay (fig. 293). It will be seen that this method and these subjects were employed by Suger at St-Denis, and thus passed into Gothic portal sculpture. The change in the manner of applying sculpture to arches must have occurred sometime between 1130 and 1135, and, like the radial method, this new invention was widely imitated in Spain, though the size of the figures there was never as large as in Western France, the sculptors merely changing the axis of the figures placed on the voussoirs.

The change of design brought about a change in style, and the sculptors seemed to turn to the painting which emanated from the scriptoria at

293. Portion of archivolts, west portal,
Notre-Dame-de-le-Couldre,
Parthenay-le-Vieux.
1130–35

enamels were made toward the middle of the century, such as the shrine of St. Domingo at Silos (now in the Burgos museum; fig. 295), and the style and technical details of these enamels are very similar to the Limoges works. The close relationship between the two groups of enamels cannot be doubted, and in the early stages this was probably because the work was done by itinerant craftsmen. But the Spanish enamels disappear toward the end of the twelfth century, while those made at Limoges increase in number and continue to be mass-produced throughout the best part of the next century. The enamels of

Limoges, especially the dynamic style represented by the Sacramentary of St. Etienne, from the beginning of the twelfth century. This style had a long local history and was also found in stained-glass painting, as in the *Ascension* panel of about 1145 in the cathedral of Le Mans (fig. 294). A comparison of the elongated and agitated figures of the apostles in this panel with the angels on the doorway at Parthenay illustrates vividly their similarity of style and also its common source.

Limoges was a center not only of manuscript painting but also of enameling; the beginning of this production, however, which eventually led to exporting Limoges works as far afield as Scandinavia, Poland, and even Mt. Sinai, does not seem to have been earlier than about 1170. It is true that about the middle of the century a magnificent and large enamel plaque was made for the tomb of Geoffrey of Anjou, the father of the future king of England, Henry II, but this seems to be an isolated work. It is in Spain, in Castile, that extremely accomplished champlevé

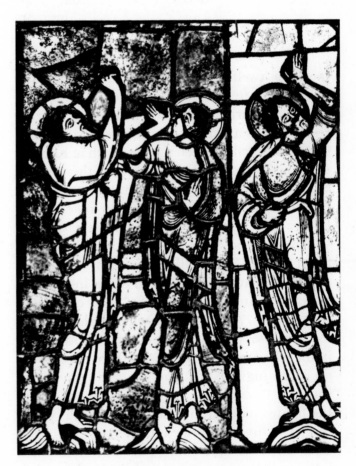

294. *Ascension of Christ* (portion).
Stained-glass window. c. 1145.
Cathedral, Le Mans

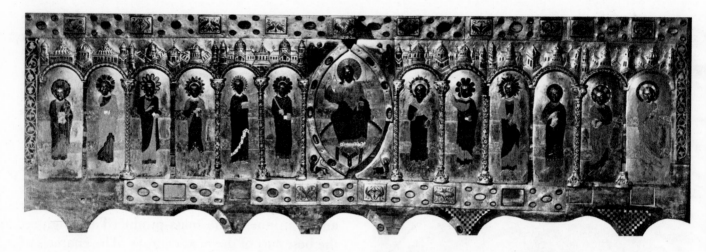

295. *Christ in Majesty, with Apostles.*
Shrine (antependium?) of S. Domingo de Silos.
Gilded copper with enamel; 2' 9 1/2" × 7' 8 1/2". 2nd half 12th century.
Museo Arqueologico, Burgos

the later twelfth century, like the architecture and sculpture of the late eleventh and early twelfth centuries in France and Spain, were a result of that artistic cooperation across political frontiers which characterizes so much of Romanesque art. The peculiar technique of these enamels, in which the figures are in flat enamel but the heads are frequently in bronze relief, seems to be a faint echo of Ottonian bronze-casting, in which the relief increases toward the head of a figure (compare the Hildesheim doors; fig. 173), a method that was imitated in Spain in the later eleventh century (Shrine of St. Isidore at León; see fig. 219). A technique similar to these enamels was also used in large-scale sculpture, for in the Cámara Santa at Oviedo there is a *Crucifixion* consisting of Christ and the two thieves, the three heads carved in high relief and the rest of the figures painted in fresco on the wall.

The *Christ in Majesty* and the apostles of the Silos shrine of St. Domingo are in a style which has parallels in painting, both in Spain and in France. The *Majesty* in the Panteón de Los Reyes at León (colorplate 37), with its exaggerated sweep of drapery below the blessing hand and

the vertical, stiff folds along the limbs, recalls the Silos *Christ*.

F. Romanesque Art in Normandy

The duchy of Normandy, which evolved in 911 from an agreement between the French king Charles the Simple and the Vikings, became in a little more than a century one of the most dynamic forces in Europe. The foundation of the Norman state in southern Italy (see page 257), the Norman participation in the Spanish *Reconquista* (they were prominent in the capture of Barbastro, in 1064), and their conquest of England in 1066 were all visible signs of their expansive spirit. Under able and vigorous dukes, the Vikings not only became Christians but also merged with the local Gallic population, adopting their language and feudal customs. Monastic reform, supported by Duke Richard II the Good, was initiated in 1002 by the Cluniac abbot of St-Bénigne at Dijon, with the reorganization of Fécamp Abbey on the Channel. Soon afterward a

large number of monasteries were reformed or newly established (such as Bernay, founded by Judith, wife of Duke Richard). Duke Robert I continued his father's policy in supporting the Cluniac reform, and himself founded the abbey of Cerisy-la-Forêt and a nunnery at Montivilliers, and endowed a number of older foundations, among which the most prominent were Mont-St-Michel, St-Ouen at Rouen, Jumièges, and St-Wandrille. The barons followed his example and the number of monasteries multiplied rapidly. In 1065, during the reign of William the Conqueror, Normandy had twenty-one monasteries for men, of which eight were under his patronage. Duke William and his wife, Matilda of Flanders, founded two new monasteries at Caen, one for men, dedicated to St. Stephen (Abbaye-aux-Hommes), and the other to the Trinity, for women (Abbaye-aux-Dames). During this time, the abbey of Bec became a celebrated center of piety and learning under its Italian prior, Lanfranc of Pavia, the future archbishop of Canterbury.

It is not surprising that in this atmosphere of religious zeal and of wide contacts with the rest of Europe, Norman architecture of the eleventh century became one of the most impressive and inventive of Romanesque styles. Following the example of Bernay Abbey, built from 1017 to about 1050, the plan of Cluny II became most popular for large Norman churches; the ambulatory plan, too, was not unknown (Jumièges, and Rouen Cathedral). Externally Norman churches are dominated by the crossing tower and, in larger buildings, also by two western towers. The derivation of the western block, such as that at Jumièges Abbey (1037–67; fig. 296), is from Carolingian buildings. At Jumièges the porch projects westward beyond the towers, but at St-Etienne, Caen (1064–77; fig. 297), the two towers rise from a huge square block divided by heavy buttresses into three units. The influence of such Norman façades on Gothic architecture was decisive.

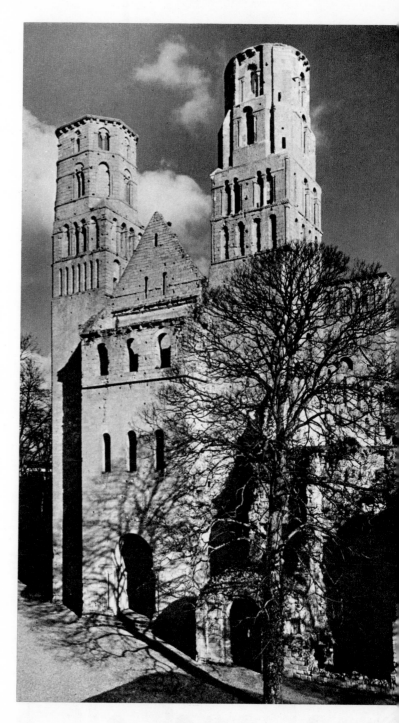

296. West façade, Abbey Church, Jumièges. 1037–67

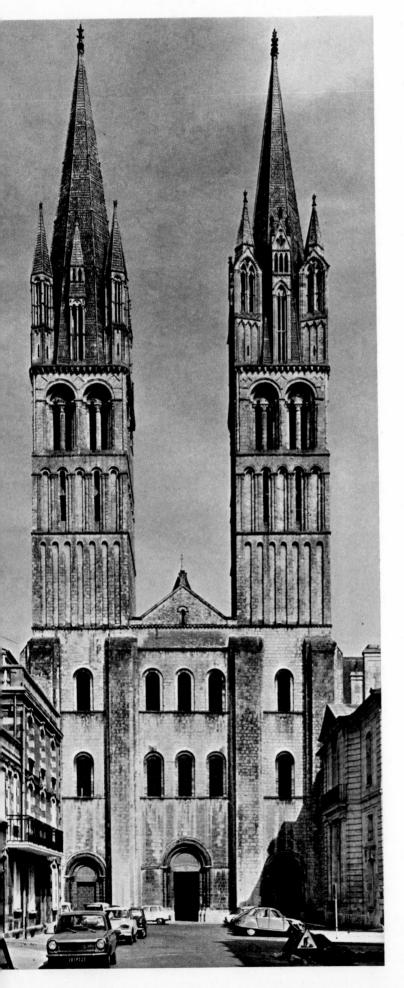

These early Norman buildings had groin-vaulted aisles, but the naves were covered with timber ceilings; most of them received rib vaulting in the twelfth century.

As originally designed, the elevations of these churches were three-storied and the supports were either compound piers alternating with columns (as at Jumièges; fig. 298), or a continuous succession of compound piers (as at St-Etienne, Caen; figs. 299, 300). At the clerestory level at St-Etienne there is a continuous passage within the wall; it gives access to the clerestory windows and allows circulation around the building, presumably for maintenance. But this passage necessitated a very thick wall which, in turn, required very thick piers below to support it. The tribunes and the main galleries have a complex and sophisticated system of moldings and shafts, and each bay was clearly indicated by a semicolumn running up the whole height of the interior. The clarity of the design, the massiveness, and the beautiful masonry are the principal characteristics of this architecture.

The sculptural decoration of early Norman churches, at Bernay for instance, is of considerable interest, showing stylistic connections with Burgundy (no doubt through William of Volpiano) and, later, about 1070, with the Loire Valley (as at Bayeux Cathedral). But after the middle of the eleventh century the sculptural enrichment becomes more limited; in the majority of cases it was confined to simplified Corinthian capitals, and to geometric patterns applied to arches, string-courses, doorways, and even tympana.

The Norman conquest of England, in 1066, brought a great opportunity for Norman artistic expansion there. Of course, the Normans were not strangers to England, for the Channel was no barrier to contacts. During the reign of King Edward the Confessor (1042–66) artistic influences from Normandy had been encouraged through the king's policy of appointing Normans to English bishoprics. Edward's mother was

297. West façade, St-Etienne (Abbaye-aux-Hommes), Caen. 1064–77

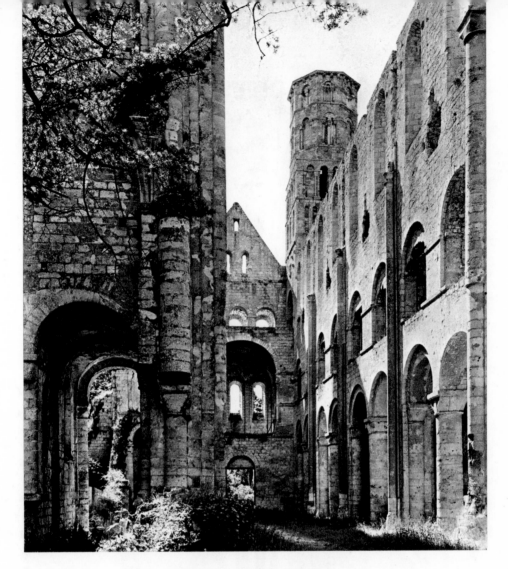

298. Interior toward west,
Abbey Church, Jumièges.
1037–67

Norman, and he spent his youth in Normandy. It is no wonder, therefore, that his beloved Westminster Abbey, in London, was rebuilt on the model of Jumièges, and that Romanesque art in its Norman form was beginning to make an impact on English art. But it will be remembered that artistic influences traveled in both directions, that, for instance, Norman manuscript painting was deeply indebted to the Winchester School (see page 196). In this way the path to artistic cooperation was prepared even before political union took place.

The celebrated Bayeux Tapestry (in fact, it is an embroidery: colorplate 38; fig. 301) was the fruit of Anglo-Norman collaboration. It is generally agreed that this epic, illustrating the events leading to the Conquest and the victory of the Normans, was commissioned between 1070 and 1080 by Bishop Odo of Bayeux, half-brother of William the Conqueror. It is ironic that this document of Norman triumph and English humiliation was executed, in all probability, by English needlewomen in Kent, where Odo held his principal possessions. Artistically the Bayeux Tapestry is a typical example of the Anglo-Norman style, in which the English Winchester School forms became, under Norman influence, entirely Romanesque.

To establish their rule, the Normans covered the country with a network of castles. Consisting

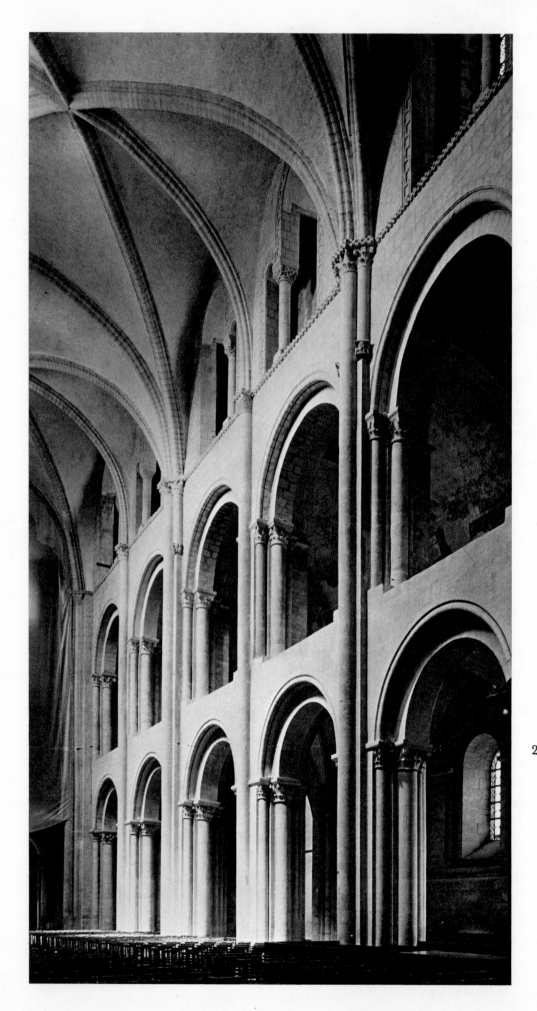

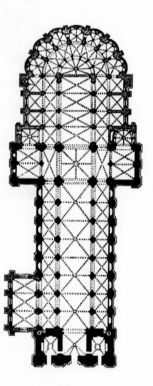

299, 300. Interior from southeas
and plan, St-Etienne
(Abbaye-aux-Hommes), Caen.
1064–77

Colorplate 32. *The Second Coming of Christ.*
Benedictional of St. Ethelwold. 11 1/2 × 8 1/2″. 971–84.
British Library (Ms. Add. 49598, fol. 9v), London

Colorplate 33. *Crucifixion*. Weingarten Gospels.
11 5/8 × 7 1/2″. 1050–65.
Pierpont Morgan Library (Ms. 709, fol. 1v), New York

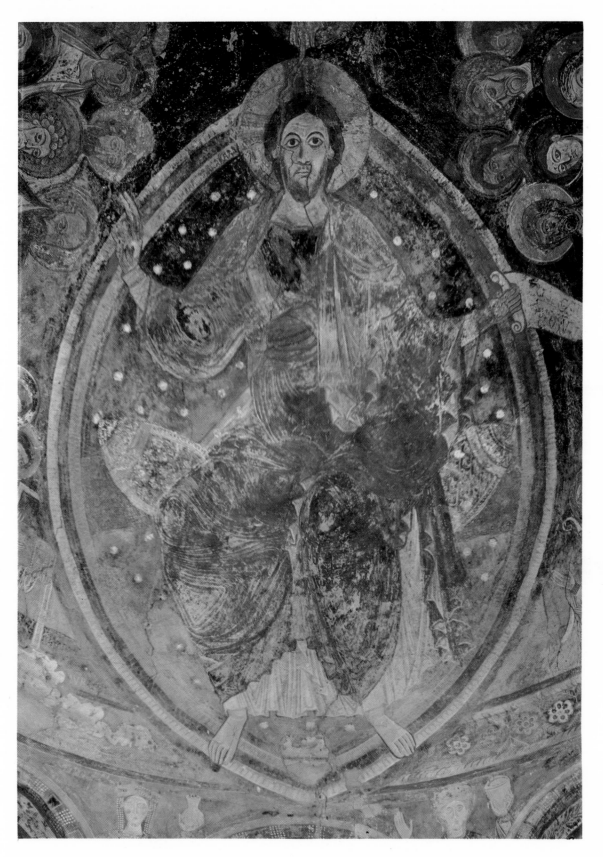

Colorplate 34. *Christ in Majesty*. Apse fresco (center portion).
Early 12th century. Upper Chapel, Priory, Berzé-la-Ville

Colorplate 35. *St. Clement Celebrating Mass.*
Fresco in narthex of lower church. Late 11th century.
San Clemente, Rome

Colorplate 36. ▶
Plague of Locusts (above);
The Apocalyptic Woman (below).
Wall painting on barrel vault of narthex. c. 1100.
Abbey Church, St-Savin-sur-Gartempe

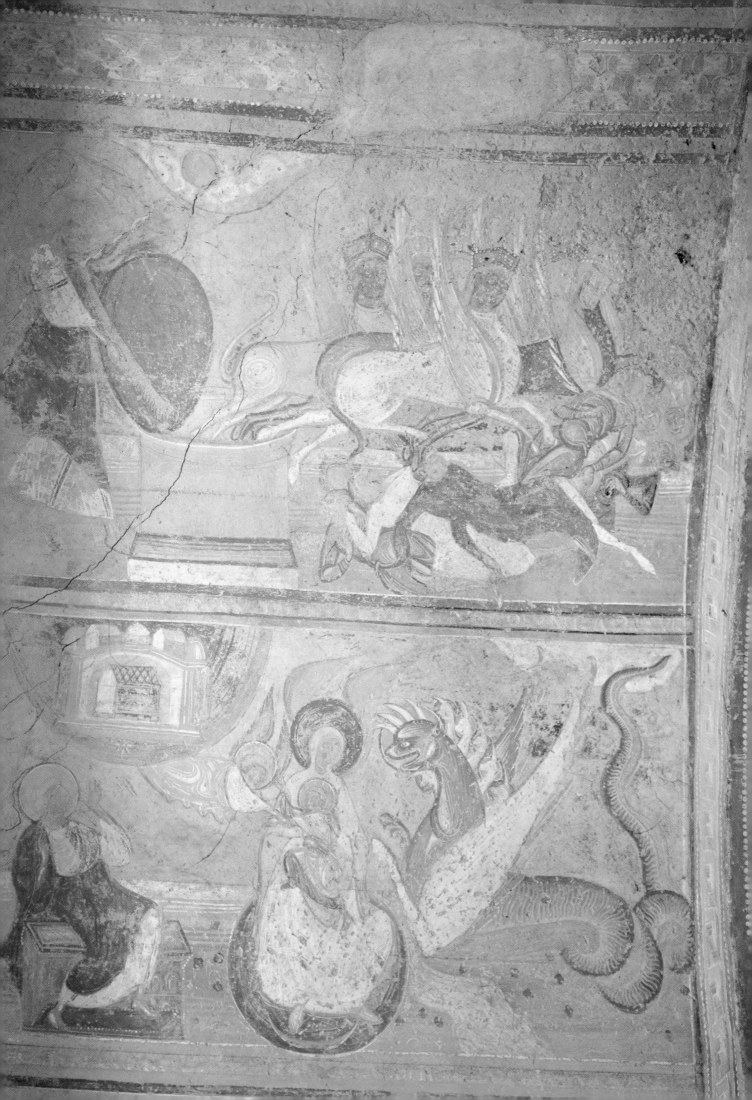

◀ Colorplate 37. *Christ in Majesty.* Ceiling painting. 1157–88.
 Panteón de los Reyes, Leon

Colorplate 38. *Battle of Hastings:*
Norman Invaders Crossing Channel. Bayeux Tapestry.
Wool embroidery on linen; height c. 20″. 1070–80.
Musée de Peinture, Ancien Evêché, Bayeux

Colorplate 39. Exterior from south,
Castle (Keep), Colchester. Late 11th century

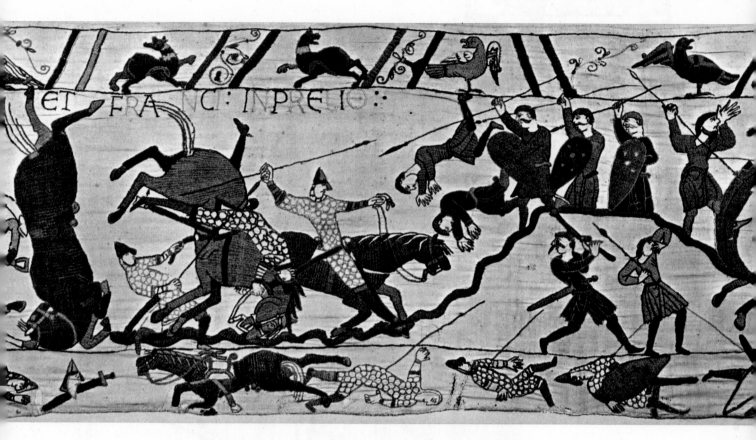

301. Battle of Hastings: Normans Repulsed in Battle.
Bayeux Tapestry. Wool embroidery on linen; height c. 20″
(entire length 229′ 8″). 1070–80.
Musée de Peinture, Ancien Evêché, Bayeux
(see colorplate 38)

of earthworks and timber constructions, such castles were merely buildings of utility. But they were gradually replaced by more permanent stone structures; although most of them survive as ruins, they still impress with their engineering skill and often austere beauty. Particularly fine were the so-called keeps, tower-like fortresses on artificial or natural mounds. These provided living quarters for the lord and a prison in the basement; in case of siege, the keep was the dominant stronghold in the system of adjoining defenses. Two keeps built by William the Conqueror survive, one at Colchester (colorplate 39; fig. 302) and the other in London. This last is a

particularly massive, well-built stone fortress, incorporating a large, three-aisled chapel. The Normans did not have only one blueprint for all their castles; each was different, partly dictated by the terrain. Square keeps gave way, in time, to polygonal and round forms. The splayed plinths found in some twelfth-century keeps (Conisborough) provided greater structural stability and assured an easier defense. Only the crusaders' castles (see fig. 332) surpass these Norman structures in size and technical inventiveness.

By the time of the Conquest, the reforming zeal of the tenth-century English Church had spent itself; the far-reaching reforms in Church

302. Plan of Castle (Keep), Colchester. Late 11th century (see colorplate 39)

organization and the blossoming of monastic life and intellectual activities that took place after 1066 were entirely due to the influx of Norman and other Continental ecclesiastics. Two successive archbishops of Canterbury, Lanfranc and Anselm, both Italian by birth but Norman in their loyalties, were scholars of European reputation who set the course for the extraordinary revival of intellectual life which led England out of its insular isolation.

The reorganization of the English Church brought about building activities on a truly gigantic scale. Anglo-Saxon cathedrals and

303. Interior from southeast, Cathedral, Gloucester. Begun 1087

304. West façade, Cathedral, Lincoln. Begun 1072

monasteries were torn down and replaced by large Romanesque buildings, in most cases of the type that evolved first in Normandy: the churches were characterized by the three-apse or ambulatory plan, with a large, often aisled transept and crossing tower, a nave of three stories, and a façade that frequently included two towers. But Normandy was not the only source for their designs: the first Cluniac priory in England, founded at Lewes by William de Warenne, the friend and follower of William the Conqueror, was enlarged in the twelfth century and given the double-transept plan of the Burgundian mother house. Also Canterbury Cathedral, when enlarged toward the end of the eleventh century, received a second transept, and the practice was taken up in many Gothic cathedrals.

Also unparalleled in Normandy is a group of

churches in the west of England, including Gloucester Cathedral (fig. 303) and the abbeys at Tewkesbury and Pershore, that are characterized by gigantic, massive nave columns and, at Tewkesbury and Pershore, four-storied elevations. In some buildings the use of transept towers (Exeter and Old Sarum) suggests inspiration from the Holy Roman Empire. The strange niches at the corners of the façade of Lincoln Cathedral (fig. 304) have been ascribed to the influence of St. Mark's in Venice. Other churches followed similar designs, notably Bury St. Edmunds and Tewkesbury, where one gigantic niche dominates the façade. On the whole, however, the façade which became the most popular in the course of the twelfth century was the screen-façade, transmitted to England from Aquitaine.

After their initial and almost feverish building

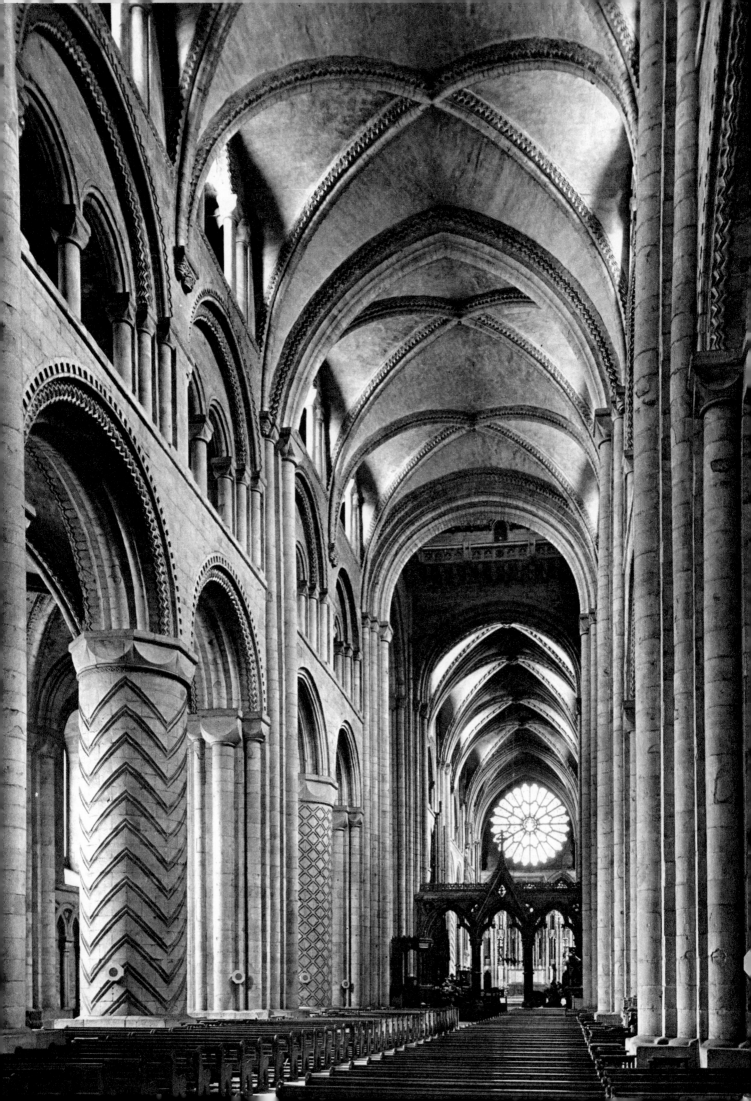

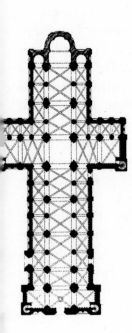

305, 306, 307.
Cathedral, Durham. 1093–1133.
(*opposite*) Interior toward east.
(*above*) Rib vaults in south
triforium of choir.
(*left*) Plan

activity subsided and the Norman rulers be-
came more settled, they ceased to regard ver-
nacular Anglo-Saxon architecture with their
former contempt. There began a gradual infil-
tration of local features into Norman Roman-
esque. The square east end had been the normal
termination of pre-Conquest churches, and
before the Cistercians introduced this feature
into their buildings in Burgundy, dictated by
reasons of simplicity, it had already been used
at Southwell Minster and Romsey Abbey (both
c. 1120), an obvious revival of a pre-Conquest
practice.

The cathedral of Durham, a building vaulted
throughout with ribs and supported on the al-
ternating system of cylindrical and compound
piers, was started in 1093 and consecrated in

308. *Foot-soldier Assaulting Castle.* Capital
(two sides) from Westminster Hall. c. 1090.
Jewel Tower, Westminster, London
(Crown Copyright Reserved)

1133, and is quite rightly considered the high
point in the development of Romanesque archi-
tecture (figs. 305–7). It is a worthy successor to
Jumièges Abbey, with which it shares the alter-
nating system of supports, and yet it has several
features, including the rib vaulting, that were
evolved not in Normandy but in England. Some
of its ornamental features were also absent in
contemporary Normandy, as, for instance, the
chevron.

But the next phase in the development of rib
vaulting took place in Normandy about 1130,
when the two ducal abbeys at Caen were vaulted,
the Trinity (Abbaye-aux-Dames) with a quadri-
partite ribbed vault over two bays and a support-
ing arch across the intermediate piers, and at
St-Etienne (Abbaye-aux-Hommes) a sexpartite
vault (see figs. 299, 300) which later played
an important role in the evolution of Gothic
architecture.

The Normans succeeded in conquering only
small parts of Wales, but Norman architecture
became, in the twelfth century, the standard
form for large churches there. Similarly Scotland
retained its political independence, but artis-
tically it became an Anglo-Norman province.
Only Ireland followed a more independent de-
velopment in artistic matters, although the situa-
tion changed there also after the conquest of the
island by Henry II; Ireland gradually aban-
doned its own highly original art in favor of
Romanesque and, later, Gothic forms, trans-
planted from the west and northwest of England.

In the earliest Anglo-Norman churches sculp-
tural decoration consisted mainly of carved capi-
tals, many obviously made near the quarries of
Caen and imported ready-made, others executed
in England by Norman craftsmen. In compari-
son with the sophisticated Anglo-Saxon sculp-
ture these works were modest and often crude,
but they were an integral part of the architec-
ture, a Romanesque innovation practically un-
known in pre-Conquest England.

In manuscript painting, also, the Norman
contribution was modest but significant. Often
using selected elements of Anglo-Saxon decora-
tion, such as the acanthus, Norman painters
evolved a highly original form of initial, known

as the inhabited initial, in which figures, occasionally of a religious character, are submerged in riotous, complex scrolls. In a number of instances there is a very close interdependence between these initials and contemporary Norman sculpture on capitals.

The reorganization of English monasteries after 1066, and the massive influx of Norman monks, produced a dramatic change in manuscript painting in England. Narrative religious painting ceased to exist almost overnight, and this iconophobic attitude continued for some fifty years. Instead, the Norman inhabited initial was introduced and, as in Normandy, it also affected the decoration of carved capitals. In one important respect, however, there was a fundamental difference between the types of capital used in Normandy and in England: the Corinthian type, with angle volutes, was the only form employed in Normandy at the time of the Conquest; it made its appearance in England, too, but by far the most popular English type was the cubic capital, adopted from Flanders or Germany.

The striking absence of narrative art in Normandy and England during the early Romanesque period applies only to religious art. Secular narrative followed an independent development and tradition, so well illustrated by the Bayeux Tapestry (see colorplate 38; fig. 301).

It is tempting to see in the Bayeux Tapestry a tradition which the Normans inherited from their Viking ancestors, and the Anglo-Saxons from the Viking settlers in England. Woven strips of cloth depicting epic stories were found in the ninth-century Oseberg ship-burial, and there is documentary evidence of their use in tenth-century England. On the other hand, secular hangings seem to have existed in other parts of Europe; this is suggested by indirect evidence such as the imitation of a hanging textile painted on the walls of Aquileia Cathedral, depicting scenes from what appears to be a Crusader romance.

The Bayeux Tapestry is not the only example of narrative art in eleventh-century England. If churches of the period lack religious narrative sculpture, in secular buildings narrative sculpture and, no doubt, painting were employed. There are capitals depicting hunting scenes in the crypt of the castle chapel at Durham and on a doorway of the castle at Norwich, but the most extensive series of capitals with secular scenes survives from Westminster Hall (fig. 308), erected about 1090 near Westminster Abbey by William II. They include illustrations of fables, and there is also one scene, closely related to those on the Bayeux Tapestry, which represents an assault on a castle by a foot-soldier with an axe—strongly suggesting that he is English, not Norman. The few capitals from Westminster Hall are chance survivals from this enormous building, and it is permissible to suggest that if we had more of them we would find here an extensive epic, perhaps a Bayeux Tapestry in stone.

The turning point in the history of narrative religious art in England came in the second and third decades of the twelfth century. The reasons for this renaissance are not yet clear but the facts are indisputable, and they apply to both sculpture and painting. Before that period the arts in England had been predominantly Norman-inspired; after that the arts in England began increasingly to part company from those in Normandy. England became by far the more inventive and influential partner, and Normandy was drawn more closely into the orbit of French art, though frequently borrowing ideas from England. What had been, until then, Norman art in England, became Anglo-Norman; the non-Norman elements, rare in the eleventh century, grew in importance in the course of the twelfth.

The artistic sources of this English art were varied: partly local, of pre-Conquest date, but predominantly Continental—Ottonian, Lombard, Italo-Byzantine, Byzantine, and French. Of the pre-Conquest styles the most striking was

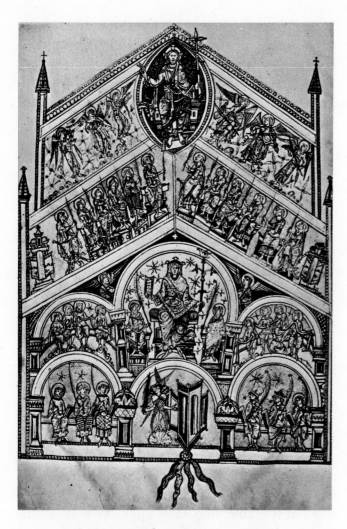

309. *City of God.* St. Augustine's
De Civitate Dei. Page 13 3/4 × 9 7/8". c. 1120.
Biblioteca Medicea-Laurenziana
(Ms. Laur. Plut. XII, 17, fol. 2v), Florence

vived in the twelfth century was of Viking inspiration, but it affected only sculpture. There are very numerous works in England which display the Urnes style (see page 204), sometimes put into the service of religious art but, in most cases, used merely as a decorative enrichment.

The best-preserved works of the twelfth century in England (saved from the artistic depredations of the Reformation) are illuminated manuscripts. They rank among the masterpieces of all Romanesque art. It is enough to mention a few. Among the Psalters, the earliest is that illuminated soon after 1120 at St. Albans, now in Hildesheim (fig. 311). It has been demonstrated that the style of this book is indebted both to Italy and to Ottonian Germany.* It is interesting to see that Ottonian inspiration contributed to the revival of religious narrative subjects in contemporary sculpture also, as may be seen in the panels from the screen at Chichester Cathedral (fig. 312). Italian elements in English sculpture were even more extensive, but here the inspiration came predominantly from Lombardy, reinforcing the native Anglo-Norman love for rich interlace and grotesque subjects. The three doorways of Ely Cathedral (c. 1135) are perhaps the most striking evidence of the influence of the *corrente comasca* in England (see page 267), while a frieze across the façade of Lincoln Cathedral (c. 1150) is an English version of Wiligelmo's frieze at Modena (see page 270). But by far the most widely adopted type of decoration was the West French method of applying small-scale, repetitive motifs to individual voussoirs in the radial manner. This type of sculpture appeared in England in the 1130s in Herefordshire, the first regional school of sculpture in England. After 1154, when England was united with the Continental possessions of Henry II, this method spread throughout the country.

the revival of the Anglo-Saxon drawing technique, clearly connected with the Winchester School style but now tamed by Romanesque conventions. The illuminations in *De Civitate Dei* of St. Augustine (fig. 309), produced at Canterbury about 1120, are a good example of this technique and style; in sculpture, at about the same time, there are capitals carved with motifs based on the Anglo-Saxon Winchester acanthus (Canterbury Cathedral, fig. 310; Romsey Abbey, c. 1130; and many others).

The second pre-Conquest style that was re-

* O. Pächt, C. R. Dodwell, and F. Wormald, *The St. Albans Psalter,* London, 1960, pp. 115-25.

310. *Musical Animals*:
(*above*) Capital in crypt, 1120,
Canterbury Cathedral;
(*below*) Manuscript initial,
Canterbury School, early 12th century,
British Library
(Ms. Cotton Claudius E.v, fol. 49), London

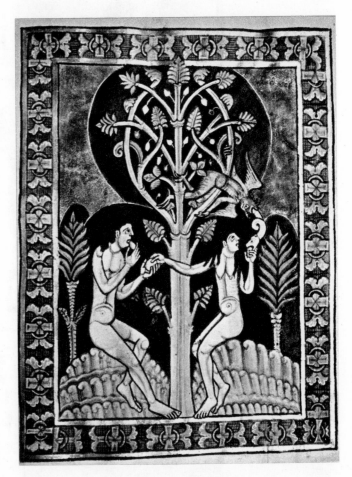

311. *The Fall of Man*. Albani Psalter.
10 7/8 × 7 1/4″. After 1120.
Library of St. Godehard (fol. 9r), Hildesheim

The St. Albans Psalter, mentioned above, was
soon followed by a series of illuminated Psalters
and Bibles. These last are large in size and in-
spired, no doubt, by the giant Bibles which were
so popular in Italy in the twelfth century (see
page 250). One of the earliest is the Bible from
Bury St. Edmunds Abbey (colorplate 40), il-
luminated between 1130 and 1140 by a secular
artist, Hugo, whose style displays a strong Byz-
antine element, especially in the device of the
so-called damp-fold drapery. He was active dur-
ing the abbacy of Anselm, who was an Italian

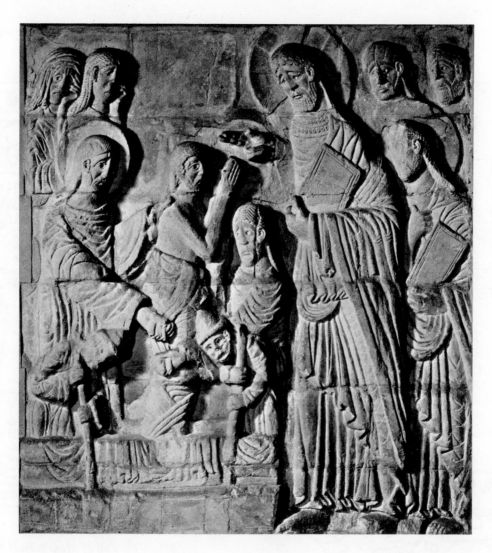

312. *Raising of Lazarus.*
Stone relief in south aisle of choir; height c. 44″. 2nd quarter 12th century.
Cathedral, Chichester

from the Italo-Greek monastery of S. Saba in Rome; this may account in part for the style of this manuscript. It is known from documents that Hugo was a metalworker and sculptor as well as a painter, and it is probably through him that a style analogous to that of the Bury Bible is found not only in painting, but also in sculpture (colorplate 41).

Out of this Byzantine-inspired art there had emerged, by the middle of the twelfth century, a style of painting and enameling in which "damp-fold" drapery became not a means of modeling the human form, but a convention in itself, a dynamic pattern.

There was an underlying tendency in English Romanesque art, whatever the influences, to use small forms, intricate patterns, and complicated designs. These tendencies, which were present in Hiberno-Saxon art, were operating with almost the same force in the twelfth century. For this reason Romanesque art in England was seldom monumental but, rather, decorative and ornamental.

G. German Romanesque Art

The artistic supremacy of Germany during the Ottonian period meant that Germany contribut-

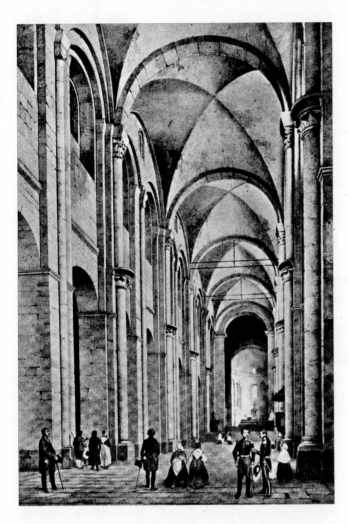

313. Interior after vaulting, Cathedral, Speyer.
Late 11th-century rebuilding
(lithograph made before 19th-century restoration)

ed a valuable stimulus to the creation of Romanesque art. During the late eleventh and twelfth centuries German architecture became, despite considerable building activity, rather conservative and backward-looking; the attachment to ancient Carolingian traditions proved to be so strong that, in spite of Cluniac influences through Hirsau and the constant influx of stimuli from Lombardy, German Romanesque buildings remain distinctive and traditional. In the large churches, the Carolingian two-apse

plan still persisted, as well as the crossing tower and the circular staircase towers. The Lombard arches, which originated in the First Romanesque buildings, were popular throughout the twelfth century, long after they went out of fashion in the rest of the West. The arcaded gallery round the apse was adopted soon after it made its appearance in Lombardy and, with it, the Lombard *corrente comasca* sculpture.

The rebuilding of the imperial cathedral of Speyer, toward the end of the eleventh century, resulted in the vaulting of the nave with groined and domed vaults over the double bays (fig. 313); this form was repeated at Mainz, another imperial cathedral, begun by Henry IV but not finished until well into the twelfth century. The abbey of Maria Laach (figs. 314, 315), founded in 1093, has similar vaulting, in this case over single bays. These early and technically courageous experiments in vaulting large churches were not followed up, however, and the initiative for further advance passed to the Anglo-Norman school and then to the Ile-de-France.

Except for the Hirsau group of monastic churches, which were reformed by Cluny and underwent widespread influence from Cluny II, German Romanesque architecture shows little awareness of the developments that were taking place in France or England. This applies even to Alsace, where the proximity of France would be expected to have exercised some influence; but the Alsatian churches (e.g., Murbach Abbey; fig. 316), both in structure and decoration, belong entirely within the German development. Its closest outside contacts were with Italy, especially Lombardy. External galleries (as at Speyer; see fig. 163) were only one of the features from Lombardy enthusiastically adopted in German buildings. However, the use of Italian details did little to alter the indigenous character of German Romanesque churches, especially large cathedrals and abbeys. In many ways, the abbey of Maria Laach is a characteristic example of a twelfth-century Rhineland church,

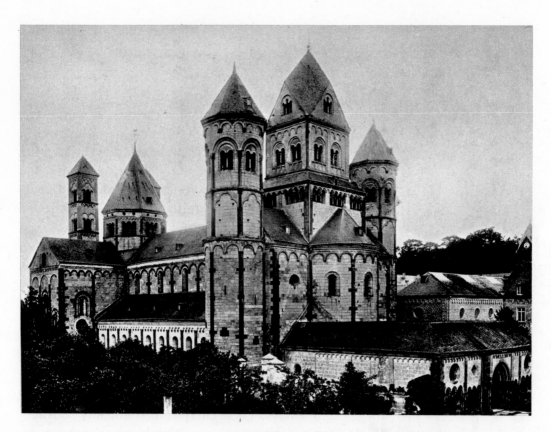
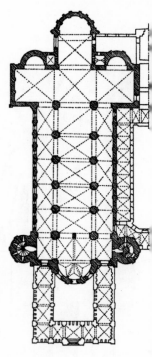

314, 315. Exterior from northwest and plan,
Abbey Church, Maria Laach. Founded 1093

having two apses, two transepts, and six towers. It is an impressive, homogeneous structure built between 1113 and 1156; the atrium, still in practically the same style, was added in the early thirteenth century.

A group apart are the churches having a trefoil eastern termination. Churches of that form made their appearance in Early Christian times (see page 42), and were revived in Lombardy in the eleventh century. But it was in Germany that they became particularly popular, starting with the Ottonian building of St. Maria im Kapitol in Cologne (dedicated in 1065) and followed by such late Romanesque churches as Great St. Martin, Holy Apostles (both in Cologne; fig. 317), and a string of other churches in the Lower Rhineland region.

In the field of architectural decoration, the Lombard type of rich sculpture of a purely ornamental character was dominant. As in the earlier periods in Germany, works of sculpture of the highest quality were not of stone, or found on doorways or capitals as in France, Spain, or Italy, but were on church furnishings, such as screens (often in stucco), lecterns, baptismal fonts, retables, tombs, and many other objects. It is true that, following the Ottonian tradition, carved reliefs with figures were occasionally used on the exterior of churches (for example, at St. Emmeram, Regensburg, c. 1070), but these were rather exceptional. In sculpture as in architecture, contact with French Romanesque was practically nonexistent, and the inspiration came chiefly from Ottonian art and from Italy, at first from the Lombard school and later from the art of Niccolò.

In its painting, metalwork, and ivory carving German Romanesque was the true heir to the Ottonian period, and produced some notable masterpieces. And as windows in Romanesque buildings became larger, stained glass gradually assumed a role comparable to that of wall paintings; in addition, its colors had the advantage of far greater durability. But the part played by

stained glass can only be guessed, since so few examples are left to us. The celebrated glass surviving in Augsburg Cathedral dates from the first half of the twelfth century (fig. 318), and it provides a striking contrast to contemporary glass in France. The figures in German glass are far more monumental and hieratic; standing immobile with large gazing eyes, they are like sacred icons. In France, the stained glass depicts lively scenes, full of movement and emotion.

The ravages of time and the misguided efforts of nineteenth-century restorers have reduced German wall painting to a comparatively small number of examples; in these the impact of Byzantine art is dominant, transmitted by way of Italy (Venice and Sicily) and by direct contact with Constantinople. Of the various regional centers of painting, that of the Lower Rhineland and Westphalia is distinguished by a soft, flowing style of great beauty (e.g., Schwarzrheindorf, fig. 319; Brauweiler); it is assumed that this style originated in Cologne. The surviving Romanesque paintings in Denmark (including southern Sweden, at that time part of Denmark) seem to be related stylistically to the paintings in Lower Saxony, of which those at Idensen near Hanover are the most important. The influence of Bavarian painting, of which Regensburg was the chief center, was wide, extending even to Slavic lands, as is testified by the wall paintings in Znojmo in Moravia, dated 1134. The recently discovered paintings in the abbey church at Lambach, in Upper Austria (fig. 320), date from the late eleventh century and are the earliest and most important example of the Salzburg school of Romanesque painting, strongly influenced by the Byzantine art of Venice.

Luckily, the number of illuminated manuscripts of the period that survive from German scriptoria is large, and several particularly notable centers of production can be distinguished. These correspond fairly closely with the centers of wall painting, thus supporting the view of

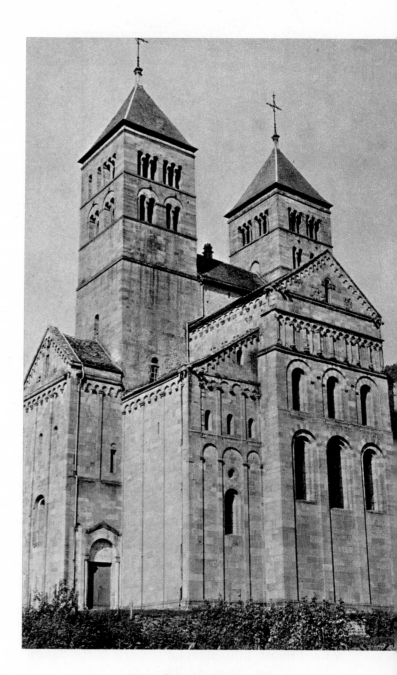

316. Exterior from southeast,
Abbey Church, Murbach. 12th century

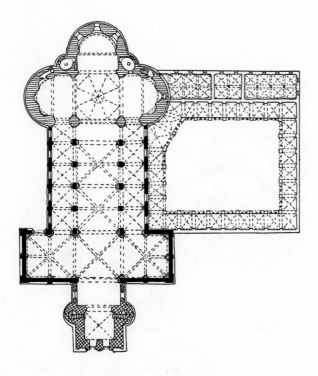

317. Plan of Church of the Holy Apostles,
Cologne. c. 1190

the close relationship between these media, in many cases practiced by the same artists. It is not surprising, for instance, to find parallels between wall paintings and manuscripts that were produced in Salzburg, Regensburg, or Cologne. Another important center of illumination was Saxony, where all the arts flourished under the rule and patronage of Duke Henry the Lion (1129–95). His marriage in 1168 to Matilda, daughter of Henry II Plantagenet, accounts for some English influences on the arts of the Saxon province, but the early Romanesque style there was dominated by the activity of a great artist, Roger of Helmarshausen, who has already been mentioned in discussing the wall paintings at Berzé-la-Ville in Burgundy (see pages 228–32). A style similar to Roger's is also found in manuscripts produced at Helmarshausen, although Roger is best known as a goldsmith (see fig. 226).

The technical mastery of his works is compatible with the belief that Roger can be identified with Theophilus, who compiled the technical manual *De diversis artibus*. Roger's style was based on Byzantine, or Italo-Byzantine, sources transformed into a purely Romanesque idiom; it is a flat style and the shapes are arbitrary, relying on dynamic patterns of lines that form characteristic "nested V-folds." He was the first of the great artists of the Romanesque period whose influence was widely felt, not only in metalwork but in other media as well. It must be assumed that Roger was also working in these materials and techniques which he knew so well, as is testified by his written work.

Mosan Art Contemporary with Roger was another great artist, Rainer of Huy, active at Liège in the Mosan region (the name derived from the Meuse River). There are good reasons to think that between 1107 and 1118 he made a bronze font for the church of Notre-Dame-aux-Fonts (now in St-Barthélemy) at Liège (figs. 321, 322). In contrast to Roger's linear, dynamic style, Rainer's style is soft, almost lyrical in mood. The figures are three-dimensional and well proportioned, their draperies are strikingly classical; particularly classical is the pose and treatment of one of the figures seen from the back. The font is composed of a cylindrical bowl covered with scenes of baptism, and this rests on ten (originally twelve) oxen, cast in the round. The idea was derived from the description of the "molten sea" in the Temple of Solomon, cast in bronze by Hiram of Tyre, which "stood upon twelve oxen" (I Kings 7, 23–25). Rainer's font at Liège is as unusual in its form as in its "un-Romanesque" style. It is generally agreed that its classicism was not inspired directly from classical art but rather several times removed, by way of Carolingian and Ottonian art. A group of ivories, the so-called small-figure ivories made in Liège in the eleventh century (fig. 323), are thought to have been particularly influential in transmitting into the twelfth century the

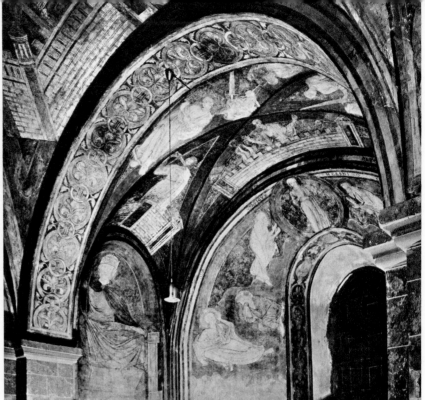

319. Wall paintings in Lower Church (south arm).
Window wall, *Transfiguration of Christ*;
ceiling, *Tribulations of Israel*.
Consecrated 1151. Sankt Clemens, Schwarzheindorf (near Bonn)

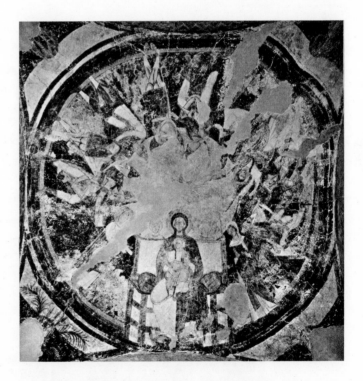

320. *Journey of the Magi; Adoration of the Magi.*
Ceiling painting in central bay, west choir.
Late 11th century. Abbey Church, Lambach

Prophet Daniel. Stained-glass window in nave;
7' 6 1/2'' × 1' 9 5/8''. 12th century.
Cathedral, Augsburg

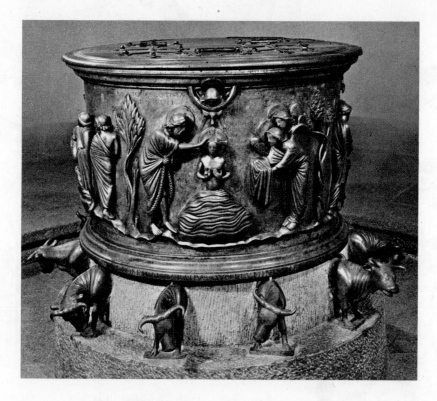

321, 322. RAINER OF HUY. Baptismal Font.
Bronze; height 23 5/8, diameter 31 1/2″. 1107–18.
Saint Barthélemy (originally for Notre-Dame-des-Fonts), Liège (Lüttich)

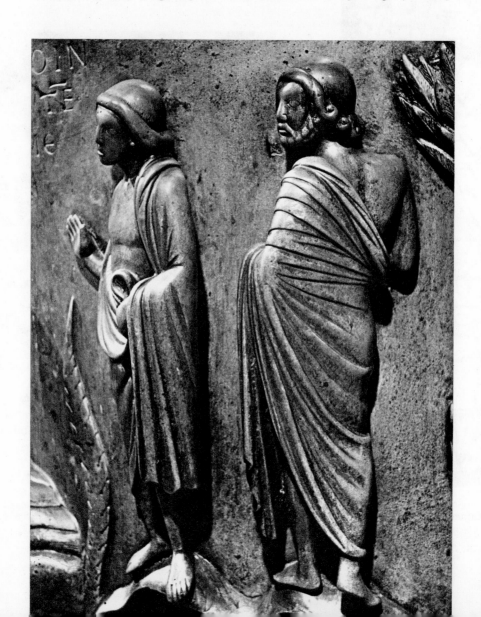

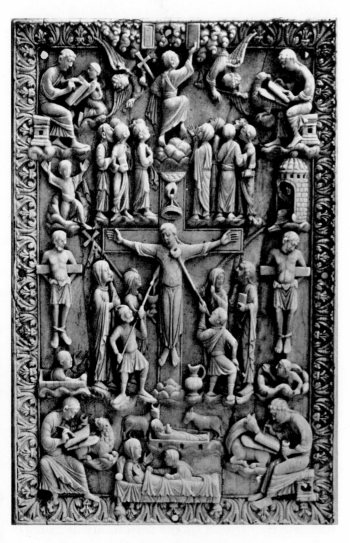

323. *Crucifixion.*
Small-figure ivory panel; 6 3/4 × 4 1/4″. c. 1050.
Musées Royaux, Brussels

became one of the most inventive and influential in Europe, but it stood somewhat apart from the mainstream of Romanesque development, which was dominated by arbitrary forms. Mosan art favored a more naturalistic, if idealized, attitude to the human figure, having more in common with Byzantine than Romanesque art. This is very noticeable in the illuminations found in the Averbode Evangelistary (fig. 325), from the mid-twelfth century, and also in the two-volume

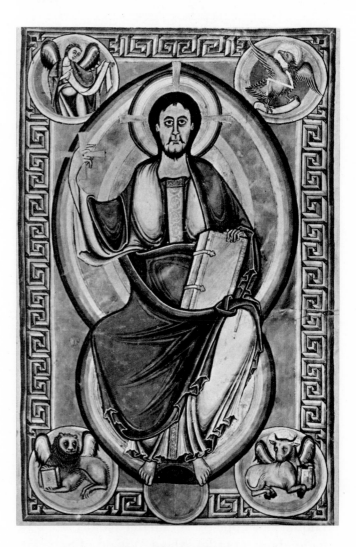

324. *Christ in Majesty.*
Stavelot Bible. 22 5/8 × 14 5/8″. 1097.
British Library (Ms. Add. 28107, fol. 136r), London

classical forms inherited from Carolingian art.

A certain number of Italo-Byzantine elements were already present in early Romanesque illuminations of the Mosan region. The Stavelot Bible is one instance, completed in 1097 and decorated with historiated initials and one full-page picture of *Christ in Majesty* (fig. 324), a monumental representation of penetrating if severe power and beauty.

After such auspicious beginnings, Mosan art

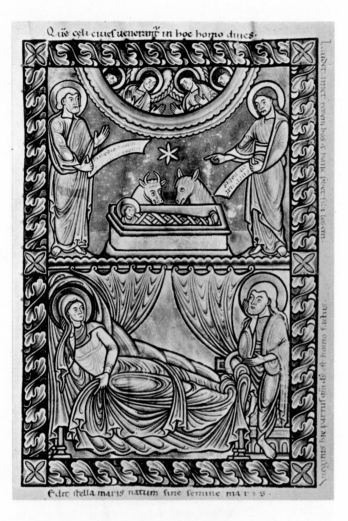

Q̃ ue celi cuief uenerãt in boc bomo dutes.

Ede ftella maris natum fine femine maris.

325. *Nativity*. Averbode Evangelistary.
Mid 12th century.
University Library (Cod. 363, fol. 17r),
Liège (Lüttich)

The reputation of Mosan metalworkers in Europe was very high, and it is not surprising that Abbot Suger of St-Denis employed a number of these craftsmen. It has been argued* that the twelve enameled panels scattered in collections on both sides of the Atlantic originally formed part of the base of Suger's great crucifix. Among the famous goldsmiths of the Mosan region, documents mention one Godefroid of Huy (or de Claire), to whom various surviving objects have hopefully been attributed, but without any certainty. One of these is the superb base of the cross from St-Bertin Abbey (in the museum at St-Omer).

Sumptuous shrines, retables, reliquaries, and a host of other objects survive in great number, made by Mosan goldsmiths, and they testify to their technical skill and their artistic, as well as iconographic, inventiveness. Such works were not only made for local patrons and churches; Suger's statement illustrates that artists also traveled to execute important commissions. The region of the Lower Rhineland was strongly influenced by Mosan art, and the shrine of St. Heribert at Deutz (across the Rhine from Cologne) is the work of Mosan artists. Metalwork in Cologne during the first half of the twelfth century was dominated by the personality of Eilbertus, an artist who employed a linear, sketchy style, but subsequently this was abandoned in favor of the soft and classicizing forms of Mosan inspiration. Among the Cologne works which show Mosan influence are the reliquaries in the form of a miniature church on a Greek-cross plan (fig. 326) dominated by a ribbed dome and made of gilt bronze, decorated with enamels, ivory figures, and reliefs.

Floreffe Bible (in the British Library); in these the figures are well proportioned and solid and their draperies are logically arranged, falling in soft, rounded curves. Mosan metalwork shows a similar development, for instance in the shrine of St. Hadelinus at Visé, as reshaped in the second quarter of the twelfth century, or the head reliquary of Pope St. Alexander (colorplate 42), made about 1145 for Abbot Wibald of Stavelot. This last includes champlevé enameling, a technical innovation of Mosan artists.

* P. Lasko, *Ars Sacra: 800 to 1200* (Pelican History of Art), Harmondsworth, 1972, pp. 188–91.

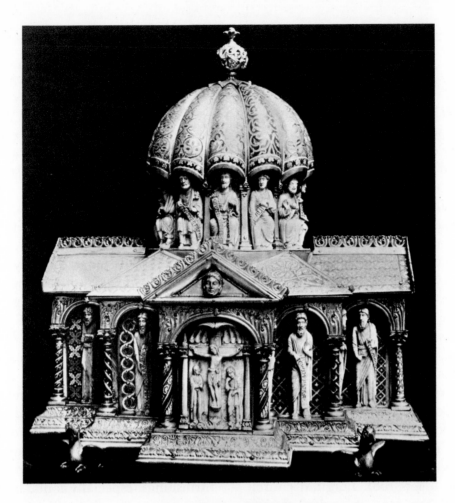

326. Domed Reliquary.
Gilt bronze, with ivory and enamel; height 21 1/2".
Late 12th century.
Victoria and Albert Museum, London

H. Romanesque Art in Scandinavia and Central Europe

In spite of early missionary activities, Christianity was not adopted in the Scandinavian countries until the end of the first and the beginning of the present millennium. As mentioned above (see page 202), Harald Bluetooth (d. 985), who set up the Jelling Stone, converted Denmark to Christianity, and his grandson, Knut the Great (1016–35), who ruled over England as well as over Denmark, established close ecclesiastical and cultural links between these countries, with important artistic results. The conversion of Norway was slow and at times harsh and bloody; in .the process, it produced the first national saint, King Olaf II (killed in 1030 in the battle of Stiklestad), whose shrine was at Nidaros

(now Trondheim). Here, too, the contacts with England were very strong. Nidaros was raised to an archbishopric in 1152, with jurisdiction over Iceland, Greenland, the Orkney Islands, and other Norwegian possessions. In Sweden, paganism continued to be a living force in many parts of the country until the end of the eleventh century, and in more remote districts it survived even longer.

While Norway extended her conquest and settlements west to the remote Atlantic islands, Sweden's contacts were with the East. Commercial ties with Russia dated back to Viking times and continued throughout the twelfth century, and it was during this period that Sweden annexed Finland.

The traditional building material in all the Scandinavian countries was timber, and the

324

majority of the early churches were built in this material, more specifically in pine wood. In Denmark and Sweden these timber churches were soon replaced by more durable stone buildings, but in Norway timber churches continued to be built even after the art of stone building had been introduced by foreign clergy and monastic Orders. It has recently been estimated that some twelve hundred timber churches were erected in Norway between the eleventh and sixteenth centuries; ninety-five of these were still in existence in the early nineteenth century, but now only thirty-two survive. These churches, known as mast or stave churches, rest on stone foundations that support the chassis of ground sills; from these rise the columns and braces, crowned by the roof. The wall plates also rest on sills, and carry a lower roof which encircles the central structure. To the east, there is a rectangular chancel, and the whole is flanked by an open gallery with a low roof. Borgund church (fig. 327), one of the most beautiful timber churches anywhere, was probably erected about 1150, but enlarged and embellished in the last quarter of that century by the addition of an apse having a separate circular roof, and by picturesque gables terminating in dragons' heads. The tradition of carving the portals had been initiated at Urnes (see fig. 199), but the Urnes carving was entirely inspired by the Viking animal style while all the other carved portals, the dating of which is still a matter of dispute (though a great many are of the twelfth century), show a delightful mixture of Romanesque motifs and those still looking back to pre-Christian animal styles (fig. 328).

Stone architecture of the eleventh century in Scandinavia was frequently of Anglo-Saxon inspiration, but by the twelfth century its sources were more complex and varied. In Norway Anglo-Norman forms predominated; in Denmark, because of the proximity of German lands, the connections were with north German buildings. But the most important Danish building

was the cathedral at Lund (now in southern Sweden; fig. 329). About 1103 Lund was made an archbishopric; soon afterward the old church, based on Anglo-Saxon models, was replaced by a splendid cathedral with a crypt under its entire transept and east end. It was built by *Donatus architectus*, presumably an Italian, who must have worked in the Rhineland before coming to Lund, for its design and the style of its decoration are closely linked not only with Lombard but also with imperial buildings, especially the cathedral at Speyer (see fig. 163). Lund was built between about 1120 and 1145, and became the model for a number of more modest buildings (Dalby, Vä); but above all, it introduced into Scandinavian countries the Lombard-type sculpture, the *corrente comasca*. This style often mixed quite happily with traditional Scandinavian forms, and the resulting style of decoration, whether architectural or applied to church furnishings, especially fonts, is full of vigor and exuberance.

Another importation from Lombardy was brick architecture, which appeared in Denmark in about 1160 (e.g., Ringsted Abbey, consecrated 1170; Sorö Abbey, begun 1162). Among the brick buildings, one of the most original is the fortress church at Kalundborg, which combines the Greek-cross plan with an elevation dominated by five towers. A group apart are the round churches, especially numerous on the island of Bornholm.

A large number of surviving wall paintings, notably in Denmark, belong to the Western artistic tradition, with strong elements of Byzantine origin. But a few wall paintings on the island of Gotland, a prosperous trading center between the West and the East, display a style dependent on the school of Novgorod in Russia.

327. Exterior of Stave Church, ▶ Borgund (Norway). c. 1150

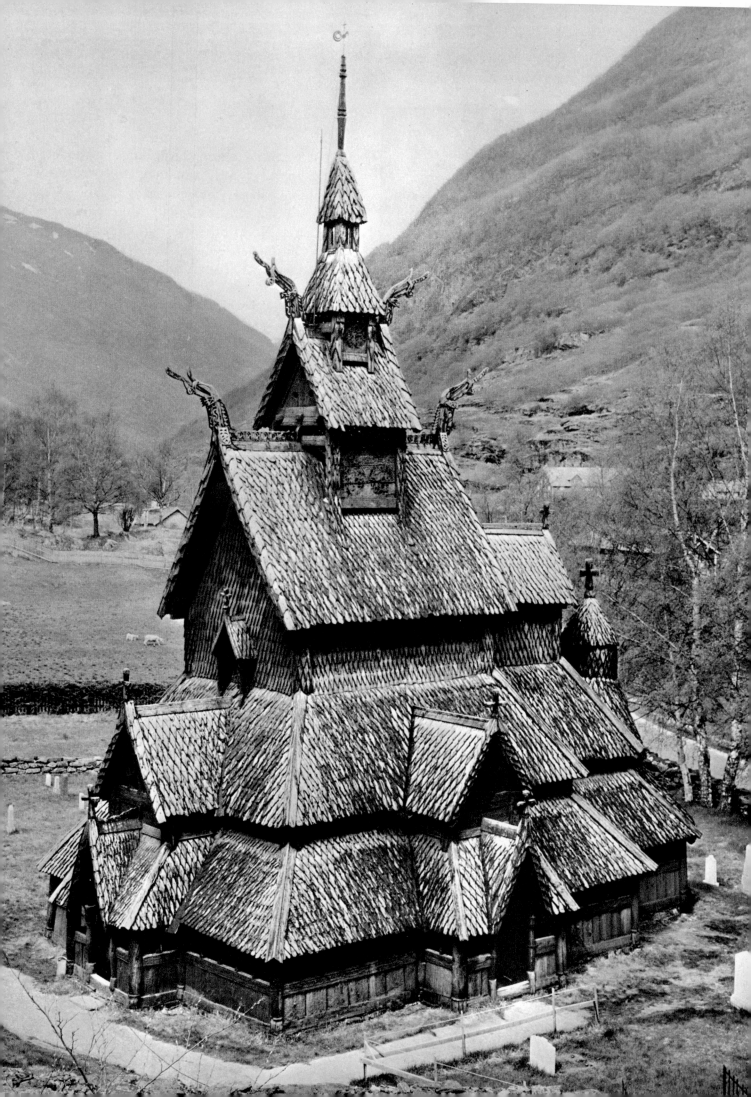

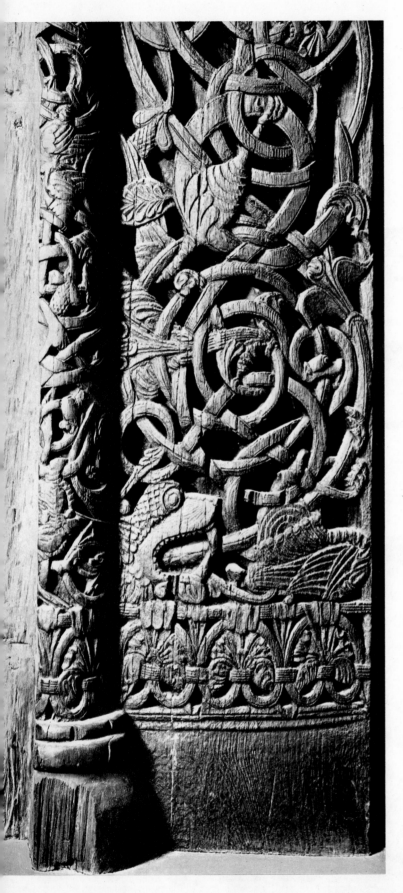

The wealth of church furnishings in wood and metal in all three Scandinavian countries is truly astonishing, and includes an altogether unique series of bronze-gilt altar frontals in Denmark. Most of these are inspired by English artistic forms; in view of the destruction of so much medieval art in England during the Reformation and later, the study of the Scandinavian derivatives of lost English models becomes invaluable for the understanding of Romanesque art in England.

Pre-Romanesque and Romanesque art spread to Central Europe at about the same time as to Scandinavia. By the tenth century all traces of the early Slav liturgy, introduced from Byzantium to Moravia and Bohemia, had disappeared, and allegiance to Rome was firmly established. Bohemia belonged to the ecclesiastical province of Mainz, but the new state of Poland freed itself from dependence on German church organization and had its own archbishop; Hungary, for so long the scourge of western Europe, became Christian and also had an independent archbishop.

Bohemia's political and ecclesiastical links with the Empire brought about close artistic links as well, especially with her neighbors Austria and Bavaria. In Poland and Hungary, however, other elements were at play, although artistic influences from the Empire were always present. In twelfth-century Poland, in addition to strong Mosan qualities in metalwork and manuscript painting, the most notable influences were from northern Italy, especially Lombard sculptural decoration. With the advent of the Cistercians from Burgundy, French architectural forms also made a strong impact on both Poland and Hungary. Italian influence was even more pronounced in Hungary than in Poland, no

328. Carved door jamb (detail), from west portal, Church at Ål, Buskerud (Norway), Wood, 1150–75. Universitetets Oldsaksamling, Oslo

329. Exterior from northeast, Cathedral,
Lund (Sweden). c. 1120–45

330. Exterior, Church of the Virgin,
Studenica (Yugoslavia). Late 12th century

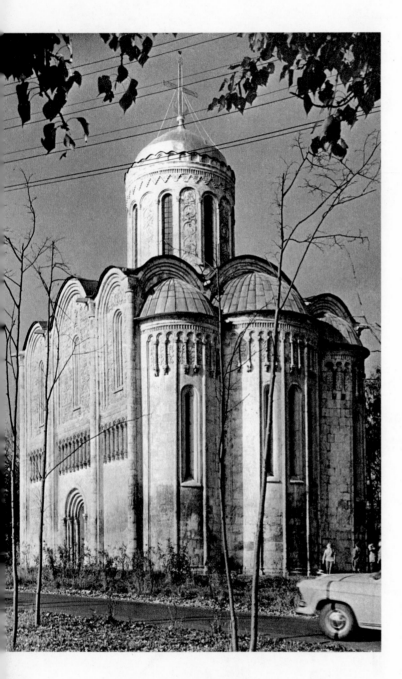

331. Exterior from east,
Cathedral of St. Dimitri, Vladimir
(U.S.S.R.). 1194–97

doubt because the Hungarian crown, by 1102, had extended its rule to the Adriatic coast by its union with Croatia (Dalmatia). Serbia became a satellite of Hungary during this time, and was influenced by artistic forms from Dalmatia; strange hybrid monuments survive, such as the church of the Virgin at Studenica (late twelfth century; fig. 330), which combine Middle Byzantine architecture with Romanesque decorative features and sculpture.

Romanesque influences reached even to Russia, no doubt through trade and dynastic marriages. As in Serbia, the decorative features of buildings and their sculpture are at times an obvious emulation of Western forms, while the architectural designs are Byzantine. The most striking examples of this mixture—the church at Pokrov-on-the-Nerl (c. 1165), the cathedral of St. Dimitri at Vladimir (1194–97; fig. 331), and the cathedral of St. George at Yuryev-Polski (c. 1234)—all present similarities with equally richly decorated buildings in Hungary and Austria on the one hand, and in Armenia on the other.

I. Romanesque Art in the Crusading Kingdom

The capture of Jerusalem by the crusaders on July 15th, 1099, was an event having not only great political importance, but also a considerable effect on the art of the twelfth century. Contacts between the West and the East which had previously existed through trade, pilgrimages, and other means were now revolutionized: large numbers of settlers from the West now lived in the East, and were in constant touch with the cultures of the local and neighboring peoples who belonged to many religions and traditions. At no time before the First Crusade had so many westerners visited Constantinople, and come to know intimately the buildings and works of art in Syria, in Palestine, and even in places which they were never to conquer but

frequently visited on various missions, such as Cairo, Aleppo, and Damascus. Although the Latins were almost permanently at war with their Muslim neighbors, they adopted many Islamic customs and possessed many Islamic artistic products. From their Armenian allies in Little Armenia, the Latins must have learned something about their art (see page 156). Above all, they were surrounded by ancient and venerable structures commemorating Christ's life and Passion, and these they restored and embellished.

The survival of the crusading states depended on their military power; the Latins, who were many times outnumbered by their enemies, relied on the fortresses they had conquered or had newly built. These castles provided safety for the settlers, and also for the neighboring population in time of war. From such castles, placed strategically along the main roads and river fords, the unreliable local population could be kept under control.

Western European castles were unsophisticated in comparison with Byzantine military architecture, and the crusaders quickly learned new methods of building in which the exploitation of the rocky sites played an important part. One of the most ingenious is the castle of Saone (Sahyūn), inland from Latakia, built on a large rocky spur projecting from a hill and made safe by two artificial ditches.

Most castles of the Crusading Kingdom were, at one time or another, manned by one of the

333. Krak des Chevaliers, from southwest (Syria). 12th century

332. Plan of Krak des Chevaliers

330

two military Orders established there, the Knights Templar or the Templars, and the Knights of St. John or the Hospitalers. Founded to care for the sick and, especially, the pilgrims, and to defend the holy places, these Orders became highly disciplined and immensely wealthy military organizations with establishments all over Europe. Their churches were often of a circular or polygonal form, in distant imitation of the Holy Sepulcher at Jerusalem. However it was in the field of castle building that the Orders became supreme masters, and of all their castles the most famous one, still well preserved, is Krak des Chevaliers (figs. 332, 333) in the vicinity of Tripoli, now in western Syria. The Arab fortress which stood there was captured in 1099

334. Plan of Church of the Holy Sepulcher, Jerusalem, showing 12th-century additions

by Raymond de St-Gilles; it was enlarged on numerous occasions, most drastically after the earthquake in 1170. Its position on a high hill, and its two powerful enceintes with square and circular towers, made it invulnerable; no wonder Saladin thought it wise in 1188 to bypass this fortress rather than attack it, and the castle did not surrender until 1271, on the defenders' receiving a safe conduct from Sultan Baybars I.

The crusaders imposed Latin organization on the Church in all the conquered territories and they converted to Latin use all the important churches they seized. They restored and often enlarged major Christian shrines. The church of the Holy Sepulcher at Jerusalem (fig. 334; see fig. 12) was given to the Augustinian Canons and the building was enlarged toward the east by adding a choir, with ambulatory and radiating chapels, and a transept with twin portals (fig. 335), this last detail bringing to mind Santiago and St-Sernin. Many of the newly built crusading churches were of the three-aisled basilican type, terminating with three apses enclosed by square masonry. Pointed barrel vaults were very popular for the naves, and pointed arches for numerous architectural features. Instances of a dome on pendentives over the crossing are also found, most notably at the Holy Sepulcher.

The decoration of the crusading churches expressed the lavish tastes of the Latins who settled in the East and tried to emulate the Byzantines. No wonder, therefore, that in more important churches mosaics were employed alongside wall paintings, as in the cathedral at Bethlehem where the mosaics were executed by a painter, Basilius. Sculptural decoration of churches was also practiced on a lavish scale. After the fall of the Crusading Kingdom many churches were converted into mosques and much of the figural sculpture destroyed; wall paintings and mosaics had more chance of surviving, being merely covered with whitewash. Among the best-known works of sculpture that we have are the two lintels above the twin portals leading to the south

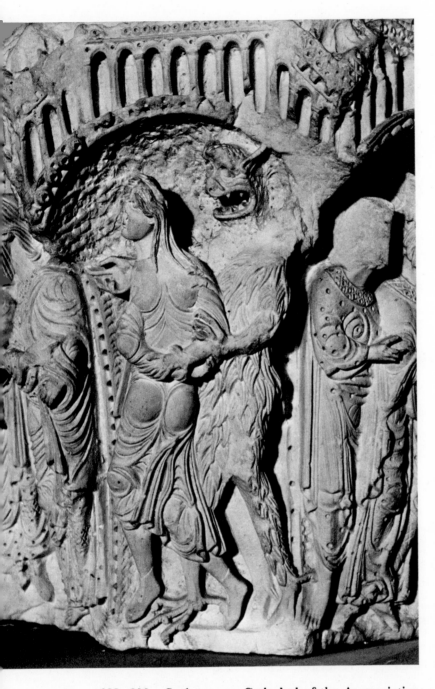

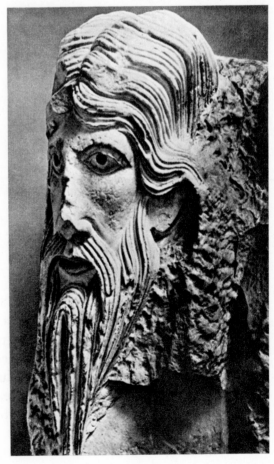

335, 336. Sculpture on Cathedral of the Annunciation,
Nazareth. c. 1160.
(*above*) Capital with *Woman and Devil*.
(*right*) *Head of a Prophet*, detail of lintel

332

337. Exterior from southwest,
Templars' Church of La Vera Cruz, Segovia. 1208

transept of the church of the Holy Sepulcher. One has graceful scrolls, the other has scenes from the life of Christ. It has recently been argued that the artist of the latter lintel was trained in Tuscany, and that he was profoundly influenced by Early Christian sarcophagi. Of far greater artistic merit are the capitals and fragmentary reliefs from the church of the Annunciation at Nazareth (fig. 336), carved by a French sculptor whose artistic affiliations are with the Rhone Valley, and with the remarkable capitals at Plaimpied in Berry.

Among the manuscript paintings produced in the scriptorium in Jerusalem, working under court patronage, the most celebrated is the Psalter of Melisende, queen of Jerusalem, made between 1131 and 1143 (colorplate 43), which combines Western, chiefly English, with Greek

elements. One painter was named Basilius, perhaps the same who worked at Bethlehem Cathedral. The manuscript is between ivory covers of great beauty, carved with scenes from the life of David. After Jerusalem was captured from the crusaders by Saladin in 1187, a new center of painting came into being in Acre and continued until the fateful year 1291, when Acre too was lost to Christendom.

The crusaders and pilgrims were the agents for the transmission to the West of Byzantine, Islamic, and many other artistic forms; the art sponsored in the East by the settlers, although rather eclectic, also made some impact on Western Europe. It is undeniable, for instance, that the appearance of domed churches in Aquitaine, or of chevron ornament in England and Normandy, coincided with the return of the first crusaders. The pointed arch was known in the West before the First Crusade, but an increased familiarity with this feature in the East no doubt encouraged its use in some Romanesque buildings. Imitations of that most venerated church of Christendom, the Holy Sepulcher, were much more frequent after Jerusalem had become easily accessible to westerners, and the military Orders were especially fond of building circular or polygonal churches. For instance, the Templars' church in Segovia, La Vera Cruz, built in 1208 (fig. 337), although polygonal and thus reminiscent of the Dome of the Rock in Jerusalem (which the Templars converted from a mosque into their own church), has a tomb chamber inside, to symbolize the rotunda of the Holy Sepulcher. But it is in castle building that the impact of the East was most profound, and the outstanding example of this is Château Gaillard (fig. 338), built by Richard Coeur-de-Lion on his return from the Third Crusade and obviously inspired by Krak des Chevaliers.

338. Air view of Château Gaillard, Les Andelys (near Rouen). 1196–97

XI

Late Byzantine Art

The year 1204 was one of the most shameful in the history of Christianity. The Fourth Crusade, launched at Venice in 1202 with the noble aim of helping the remnants of the Latin Kingdom in Egypt, turned into the "Crusade against the Christians" and led to the conquest of Constantinople. For three days and nights the drunken soldiers looted, burned, smashed, raped, and slaughtered. The glorious and proud city, the center of civilization and the only real barrier against the westward expansion of Islam, lay stripped of her treasures and rendered powerless. Many of the Byzantine works of art that today embellish Venice were taken there as loot in 1204. The Byzantine Empire was not yet entirely destroyed, however; centers of resistance were set up at Trebizond on the eastern coast of the Black Sea, at Epirus in Greece, and at Nicaea across the Bosphorus. The empire of Trebizond survived until it was conquered by the Turks in

1461; that of Nicaea succeeded in regaining Constantinople from the Latins in 1261. The Paleologue dynasty, which achieved this victory, witnessed the last revival of Byzantine culture before the final blow came in 1453, when Constantinople fell to the Ottoman Turks.

In spite of the disaster, artistic activities in Constantinople did not come to a sudden end in 1204: numerous works still testify to this. Latins as well as Greeks were now patrons, producing an interesting influx of Western iconographic themes into local art. The best and most numerous works surviving from this period are illuminations, made in Constantinople as well as in provincial centers.

Byzantine buildings of the last stages of the Empire show a considerable variety of types, mostly variants on old themes, in which great stress was laid on multi-colored materials and decorative details. Occasionally, as in Mistra,

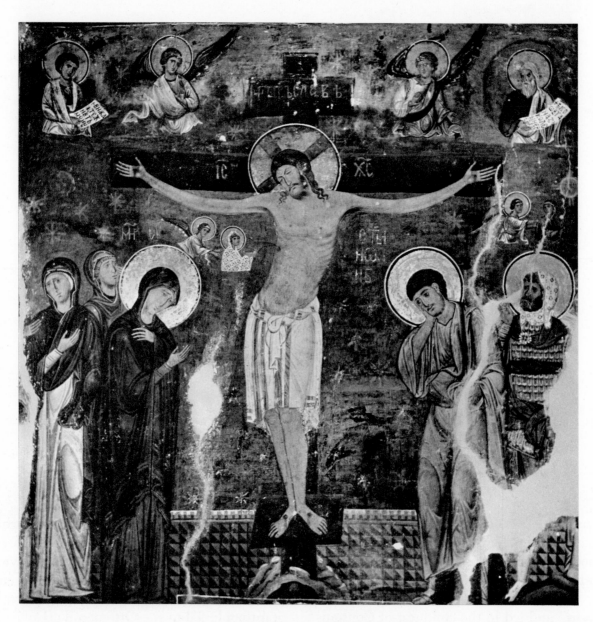

339. *Crucifixion*. Wall painting. 1208–9.
Church of the Virgin, Studenica

Western influences are perceptible; these are also quite strong in Serbia.

But it is in wall paintings and mosaics that the last blossoming of Greek art can best be seen. A great many examples survive not in Constantinople, but in Bulgaria and Serbia, where many metropolitan artists presumably took refuge during the Latin occupation of the capital. The wall paintings at Studenica (1208–9; fig. 339) in Serbia show a stylistic change in comparison with the agitated style of the late twelfth century, and a new monumentality of the forms. Throughout the thirteenth century there seems to have been a development toward greater stress on heavy voluminous masses, placed not against flat neutral backgrounds but within concave architectural frames, or in landscapes which give the idea of space—artificial hills and strips

of ground disappearing behind each other to suggest, in a very elementary way, spatial depth.

In the mosaic representing the Deësis in Hagia Sophia (fig. 340), in Constantinople, dating from the end of the thirteenth century, the background is flat, but the figures are three-dimensional, with subtle modeling of the faces and bodies. But it is in the mosaics and the frescoes of the church Kariye Djami, also in the capital, that the new style can best be studied. This small. church was decorated during the second decade of the fourteenth century, and has been cleaned and restored in recent years. The mosaics in the two vestibules are due to a high court official, Theodore Metochites, who is shown in ceremonial dress holding a model of the church. The walls and cupolas are covered by a series of small scenes of exquisite quality and liveliness (fig. 341), and in all of them the interest in spatial illusionism can be observed. Thus, in its last glory Byzantine art once again turned to its early period for inspiration, as if nostalgically seeking encouragement from the great epoch for the uncertain future.

Apart from the mosaics on walls of buildings, miniature mosaics were also made; these were used as icons, and must have been exceedingly expensive. They were made of tiny cubes of gold, silver, and colors, and pressed into wax on wooden boards. As portable objects, they were particularly suitable as gifts, and several must have reached the West during medieval times. One of these is a diptych with the Twelve Feasts (fig. 342), which was given to the baptistery of S. Giovanni in Florence in 1344 by a Venetian woman, who had obviously acquired it in Constantinople.

It is through works like these—enamels, ivories, painted icons—and, above all, through the journeys by Western artists to Byzantine territories, and in the opposite direction by Greek artists, that knowledge of Paleologan art was transmitted to Italy; it contributed to the revolutionary changes in Italian painting, which

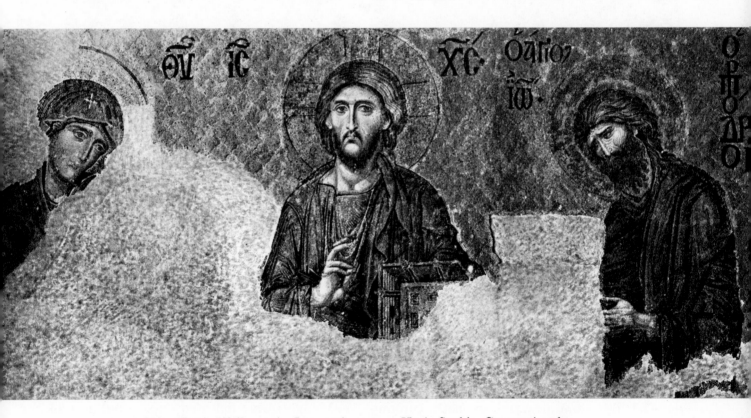

340. *Deësis*. Wall mosaic. Late 13th century. Hagia Sophia, Constantinople

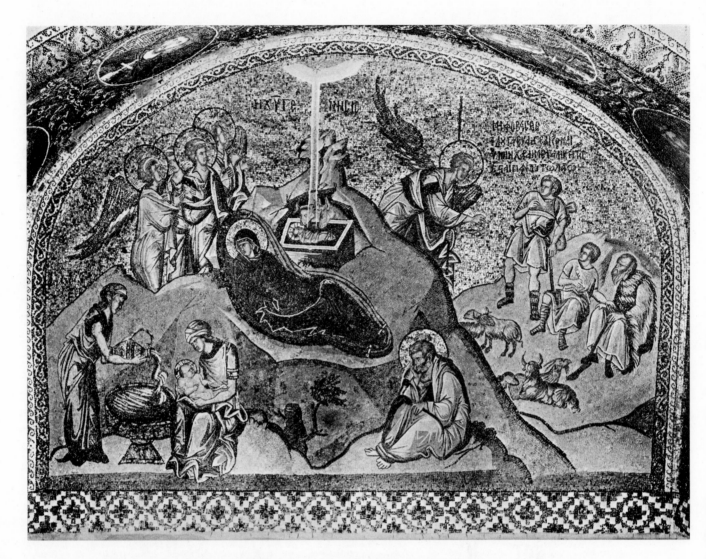

341. *Nativity*. Mosaic in parekklesion (2nd vestibule), first bay. 1310–20.
Kariye Djami (Church of the Saviour, Chora), Constantinople

eventually went much further than anything attempted by Byzantine artists. The *maniera greca* in Italian painting was a Western echo of Paleologan painting, striving toward a style less bound by medieval restrictions.

Outside Constantinople, Mistra in the Peloponnese was an important center of the arts and of intellectual life. Founded by a Frank in 1246, it joined in the artistic development of the metropolis and flourished as a center of painting throughout the fourteenth century. Another center of late Byzantine art was the monastic commu-

nity on Mount Athos which, because of Turkish toleration after the fall of the Empire, continued as a lively Byzantine artistic center for some time after 1453.

Byzantine art flourished not only in the Balkans but, as has already been mentioned, in Russia as well. With the subjugation of the early state by the Mongols in the thirteenth century (1240), the only centers that remained free were the regions of Novgorod, Vladimir-Suzdal, and Pskov. At the end of the fourteenth century the Mongols were defeated (1380), but it took an-

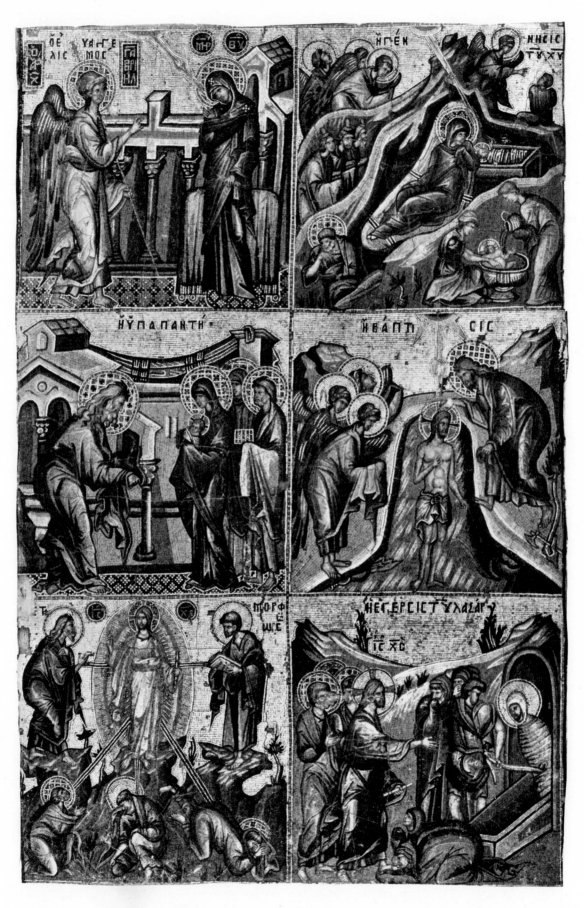

342. Diptych of the Twelve Feasts (left leaf). Mosaic, 10 5/8 × 7 1/2".
12th century. Museo del Opera del Duomo, Florence

other hundred years for Russia to become truly free of foreign oppression. Many Greek artists were working in these northern regions, among them Theophanes the Greek. The first Russian artist of great individuality was a monk, Andrei Rublev (late fourteenth to early fifteenth century), working in Moscow and its neighborhood, who absorbed many features of Theophanes' art. He painted frescoes and icons, including the famous icon of the *Trinity* in the Tretyakov Gallery in Moscow, dating from about 1411 (colorplate 44). It shows three angels personifying Christ, God the Father, and the Holy Ghost. In spite of his marked individual characteristics, Rublev's art is inconceivable without the Paleologan revival in Constantinople.

With the fall of Constantinople, Russia assumed the leadership of Orthodox Christianity; gradually a national style of icon painting developed, somewhat distinct from late Byzantine art in its iconography, color scheme, and rigid, linear style. This art continued into the nineteenth century; in Russian architecture, Byzantine traditions were replaced at a much earlier date by western Renaissance and later forms.

XII

Gothic Art

A. Early and High Gothic Architecture

The twelfth century witnessed the emergence of a strong French monarchy, which was gradually to eclipse the Holy Roman Empire in power and influence. While the capital, Paris, was of no great artistic significance during the Romanesque period, after the middle of the twelfth century it became a center of great inventiveness and prestige. The Ile-de-France, which comprised the royal territories around Paris, and the adjoining provinces took the leadership of Europe in artistic matters. The turning point in the history of medieval architecture was the rebuilding of the Carolingian royal abbey at St-Denis, then a short distance north of Paris, now an industrial suburb (figs. 343–45; see also fig. 107). The work was carried out under the auspices of its renowned abbot, Suger, who ruled it from 1122 to 1151 and left an account of

his administration of the abbey. Suger was a friend of King Louis VI, a counsellor of Louis VII, and regent during the latter king's absence on the Second Crusade, in 1146.

The initial work consisted of adding a monumental, two-towered façade, linked to the old nave by a three-aisled narthex. (The three doorways of the façade were as important for the history of sculpture as the design of the west front was in the subsequent development of architecture; these doorways are discussed on pages 364–65.) Work on the west front was started about 1135, and it was solemnly consecrated in 1140. The following four years were devoted to the building of a new choir, consecrated in 1144. The old nave was not replaced until the middle of the thirteenth century.

The essential difference between a Romanesque and a Gothic building lies in the massive, thick walls of the former and the light, thin

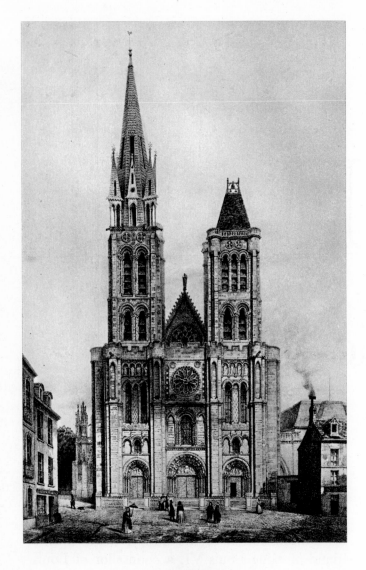

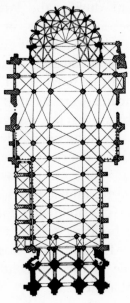

structure of the latter. The stability of a Romanesque church, with its heavy vaults, depended on walls thick enough to take the various pressures and stresses. The designer of the choir of St-Denis, and his Gothic successors, reduced the weight of vaults by using pointed arches and ribs; these are more stable than semicircular ones, and can span bays of various shapes. The cells between the ribs were filled with light masonry. The weight of the vault could be supported by slender piers or columns, and the size of the windows, of necessity always small in Romanesque buildings, was now enormously increased, allowing for stained glass to be used on an unprecedented scale. In its plan, the choir of St-Denis followed the ambulatory type with radiating chapels, but the chapels were no longer isolated units, as in earlier buildings; the walls between chapels were now dispensed with, and the impression is of one unified space, articulated by two rows of supporting columns arranged in two semicircles. The semidarkness of a Romanesque interior is replaced by a spacious, open structure, filled with multi-colored light. It has frequently been remarked* that Suger was profoundly influenced by neo-Platonic ideas, especially those of an anonymous Syrian of the late fifth century whom the monks of St-Denis confused with Dionysius the Areopagite (who had been converted by St. Paul), and further confused with the patron saint of the abbey, St. Denis, first bishop of Paris and martyr. Suger was particularly impressed by the mystic role of light as presented by Dionysius the Pseudo-Areopagite, according to whom "Every creature, visible or invisible, is a light brought into being by the Father of the lights." There seems to be a connection between the design of Suger's choir and the "orgy of neo-Platonic light metaphysics" in his writings. Suger loved symbolism

* Abbot Suger, *On the Abbey Church of St. Denis and Its Art Treasures* (E. Panofsky, ed. and tr.), Princeton, 1946, pp. 18–24.

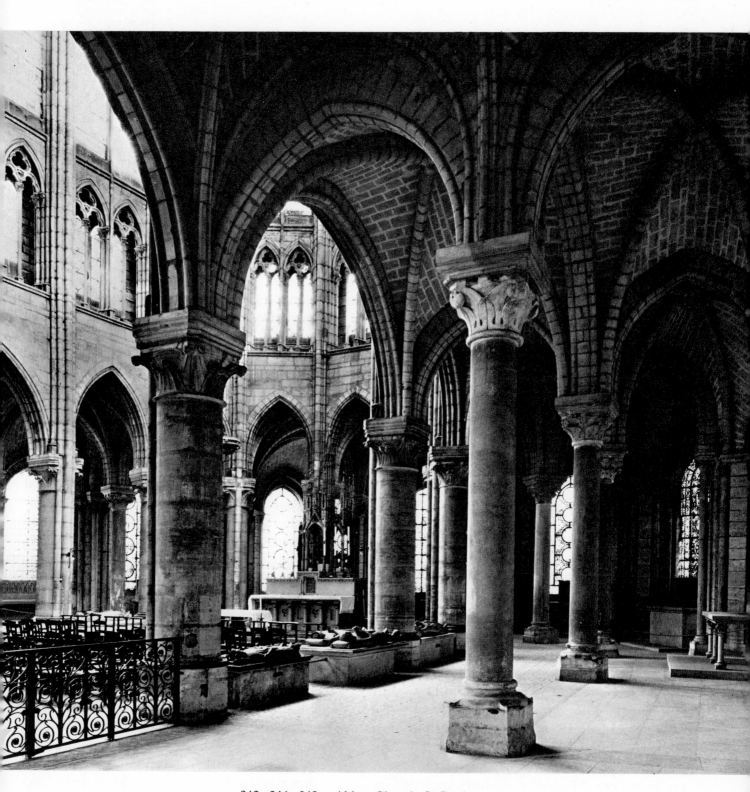

343, 344, 345. Abbey Church, St-Denis.
(*opposite, above*) West façade. 1135–40.
(*opposite, below*) Plan. (*above*) Interior of ambulatory. 1140–44

344

in all its forms, and tells us that the twelve columns around the choir symbolize the twelve apostles, and the columns of the ambulatory the twelve minor prophets. A similar symbolism in architectural design is found in numerous other churches, and was embodied in a compendium on liturgy with mystical interpretation by the thirteenth-century writer, Durandus.

Although Suger undoubtedly had considerable influence on all the works carried out at St-Denis, the actual design and supervision was the work of an architect of great inventiveness. The master-builders of Romanesque churches were professional men, who gained their expert knowledge by empirical methods on actual building sites. The builders of Gothic cathedrals differed from their predecessors only in the use of more sophisticated methods. The architects' drawings became far more complex; although few of them have survived, each building required detailed measured plans and elevations drawn on parchment, board, or even plaster. The designs were made with the use of a module, or standard unit, which varied from place to place and required some knowledge of geometry. The status as well as the pay of the master-builder increased as time went on, but little is known of these matters during the early Gothic period.

St-Denis was a monastic church, but most of the subsequent great buildings in the new style were urban cathedrals. The great age of monasticism was gradually passing, though it was to be revitalized in the thirteenth century by the emergence of the friars. The artistic initiative had, by now, passed into the hands of the towns; these, in the more settled conditions of the twelfth century, developed in size and prosperity.

Laon Cathedral (1165–1205; figs. 346–48) is a good example of a cathedral built in the early Gothic style, with the exception of the choir, replaced later. Many of its features are based on Romanesque buildings in northern France, Flanders, and Normandy; the nave, for instance, has a four-storied elevation like Tournai Cathe-

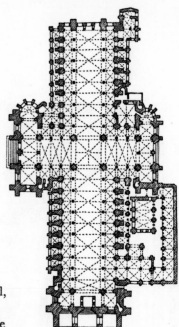

346, 347. Cathedral, Laon. 1165–1205. Plan and West façade

dral, and sexpartite rib vaulting (six ribs over two bays) like St-Etienne at Caen. The horizontality implied in a four-storied elevation is here avoided by the generous use of vertical shafts, grouped in threes and fives, that link the ribs with the supporting columns of the ground arcade. The capitals, which received individual attention in so many Romanesque buildings, are now much more uniform: they are of the crocket type, evolved from an extreme simplification of the Corinthian capital. Like Tournai Cathedral and many other German Romanesque churches, Laon was intended to be crowned by numerous towers, seven in fact, of which five were actually built.

Gothic churches with four-storied elevations include the cathedrals at Arras and Valenciennes, now destroyed, and the cathedral at Noyon (fig. 349). This last is a fine example of an early Gothic building which, in common with a few other churches, is built on a trefoil plan, that is, its transept terminates in apses toward the south and north. This arrangement was clearly derivative from the now-perished Romanesque church of St-Lucien at Beauvais. Transepts of this type were, however, rather exceptional; the general tendency of Gothic builders (other than in England) was to give the interior greater spatial unity by shortening the transepts. In the cathedral of Notre-Dame in Paris, begun in 1163

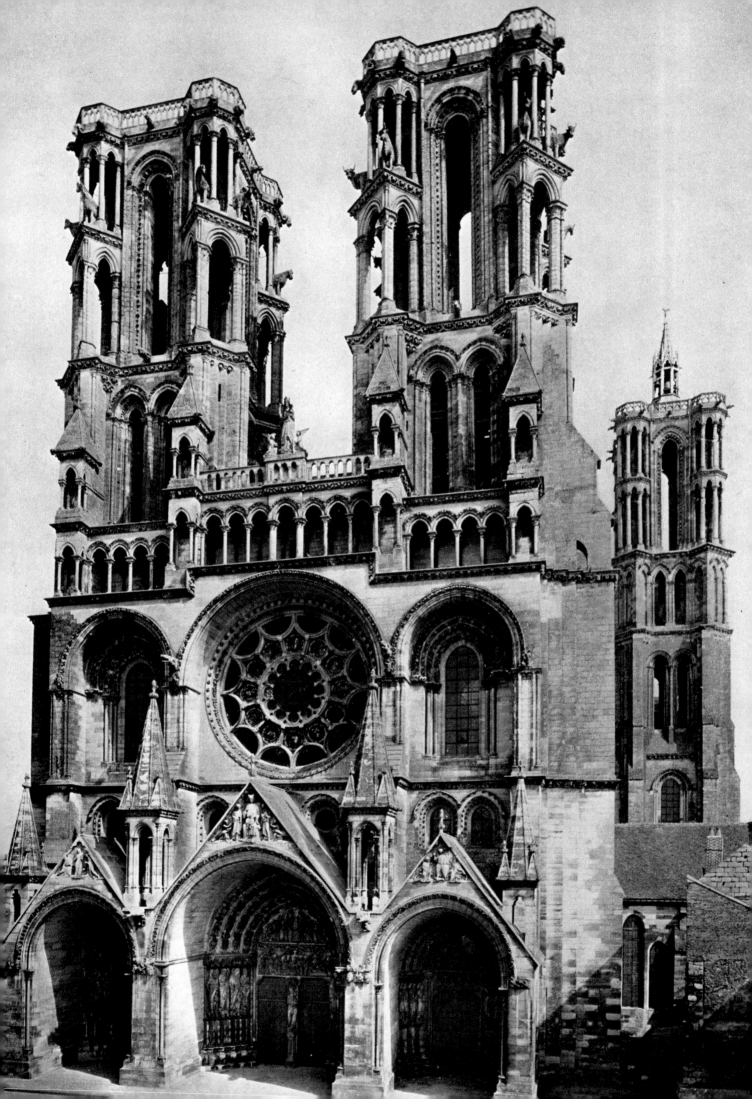

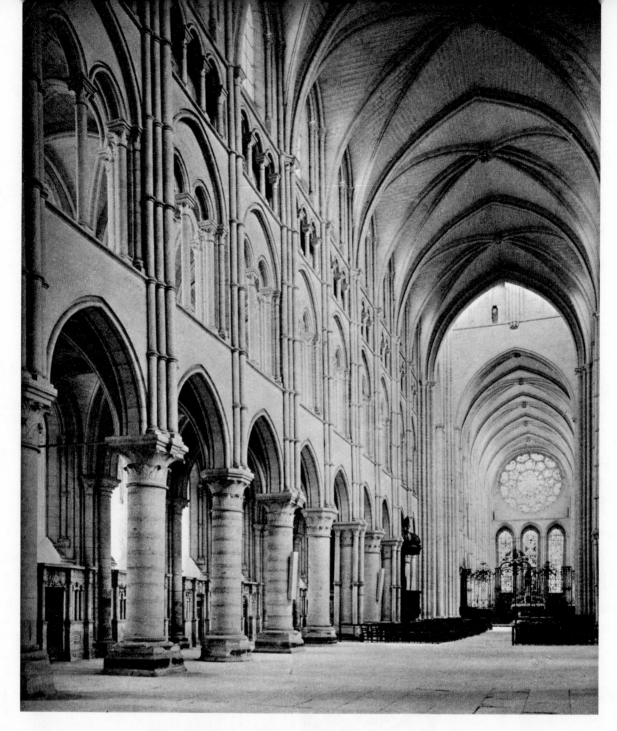

348. Interior toward east, Cathedral, Laon. 1165–1205

(figs. 350, 351), the transepts do not project be-
yond the aisle walls. This church was conceived
as a building worthy of the capital city, and
in having double aisles it is a conscious successor
of Old St. Peter's in Rome and of Cluny Abbey
(see figs. 10, 222). The nave, finished by 1196, is
of the same width as the choir; the two are

separated by the transept, which is almost half-
way between the east and west ends. The build-
ing has a great unity and balance of its parts.
The interior elevation is a modification of that
first used at Laon; originally, it followed a four-
storied design, but instead of a triforium, it
had circular windows below the clerestory. The

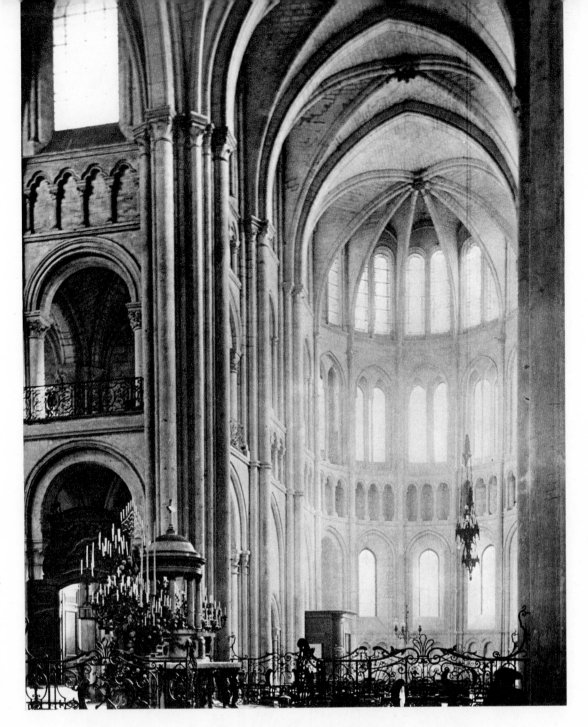

349. South transept with apse, Cathedral, Noyon. 1150–70

twin arcades of the gallery at Laon are replaced in Paris by triple arcades with slender colonnettes. The whole design is more elegant, and all the forms more delicate.

Future development in early Gothic went toward greater height for the ground arcades and the clerestory windows, and the elimination of the gallery. The triforium was now squeezed between them. The building in which this design was first adopted was Chartres Cathedral, as rebuilt after a fire in 1194 (colorplate 45; fig. 352). With this structure the Gothic style entered a new phase, High Gothic. The rebuilding of Rheims and Amiens cathedrals offered marvel-

348

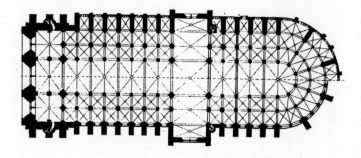

350, 351. Cathedral of Notre-Dame, Paris. Begun 1163.
Plan and Interior from southwest

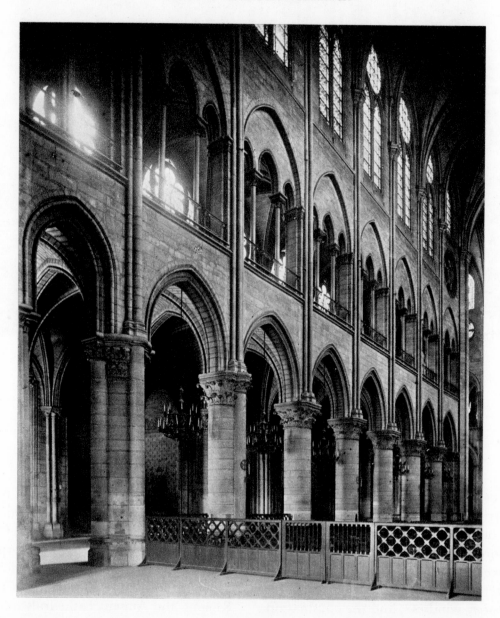

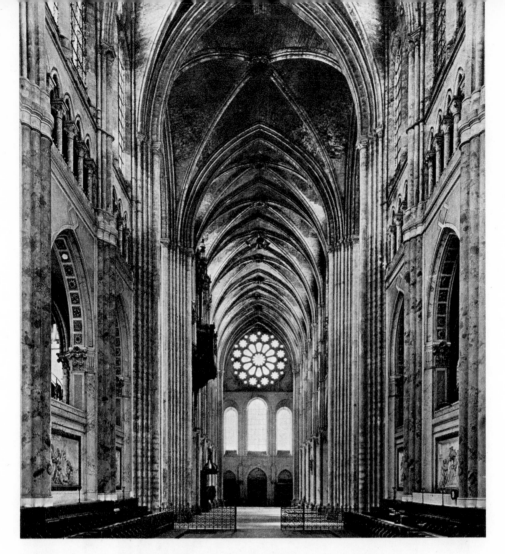

352. Interior toward west, Cathedral, Chartres.
After 1194 (see colorplate 45)

ous opportunities for further development and modification of this design. The important role of windows in High Gothic was recognized by the builders of Rheims, the first to employ bar tracery (colorplate 46), the delicate stone divisions within the windows, which achieved a prodigious complexity as time went on.

Not all High Gothic buildings followed the design of Chartres. Bourges Cathedral is an extreme example of an independent development (figs. 353, 354). Started in 1195, it combines the double-aisle plan of Notre-Dame in Paris with an exceedingly unusual elevation consisting of a very tall ground arcade which dominates the interior at the expense of even the clerestory, here reduced to a comparatively insignificant size. Interior unity is achieved by the total omis-

sion of transepts and the "integration of volumes into a pyramid-like construction."* Externally also, the building is marvelously unified; its choir and nave appear as one, surrounded by a forest of flying buttresses steeply linking the main vessel of the church with the heavy buttresses placed along the outer walls of the aisles. The flying buttress, probably already used at Notre-Dame, was a feature of some Romanesque buildings (e.g., Durham; see fig. 306), but hidden under the aisle roofs; Gothic builders brought them out into the open where they played their part in a bold design, in which structural necessity is made into a thing of beauty.

* R. Branner, *La cathédrale de Bourges et sa place dans l'architecture gothique*, Paris–Bourges, 1962, p. 191.

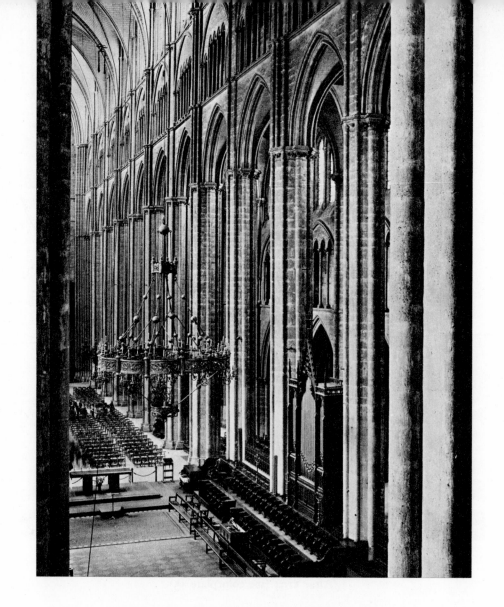

353, 354. Cathedral, Bourges. Begun 1195.
(*above*) Interior from southwest. (*below*) Exterior from southwest

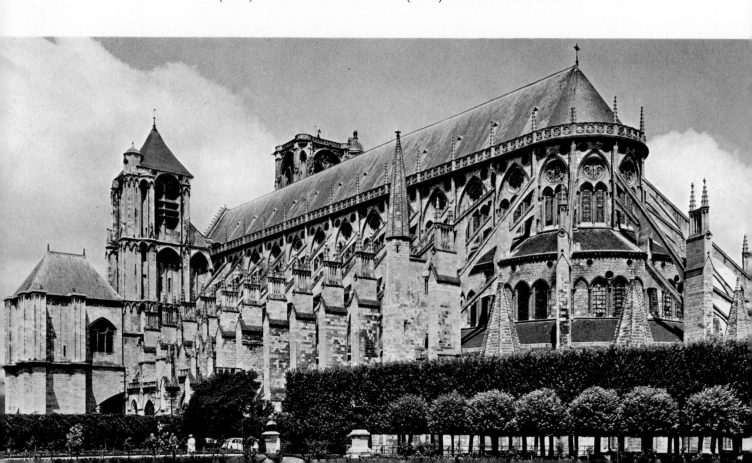

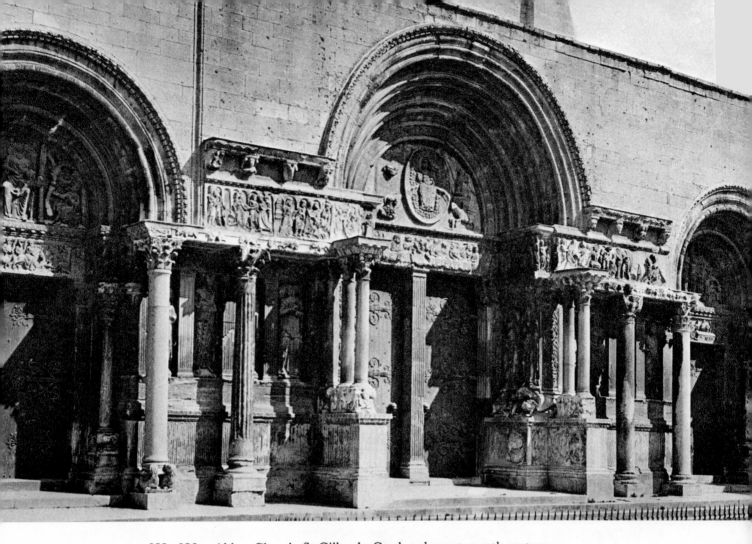

355, 356. Abbey Church, St-Gilles-du-Gard. 3rd quarter 12th century.
(above) Façade.
(below) St. John and St. James, on north jamb of central portal

The new Gothic architecture did not have an immediate impact outside northern France, or at least did not lead to an abrupt ending of the Romanesque style. Frequently, some Gothic decorative features were incorporated into what was still a Romanesque structure, but a great many unashamedly Romanesque churches were also being built at the time when the great Gothic cathedrals were already changing the face of northern French towns. For instance, the emergence of the Romanesque school of Provence, with such striking buildings as St-Gilles-du-Gard (figs. 355, 356) and St-Trophime at Arles and their distinctive sculptural decoration, falls within the third quarter of the twelfth century. In those buildings, often described as proto-Renaissance, the inspiration came from imperial

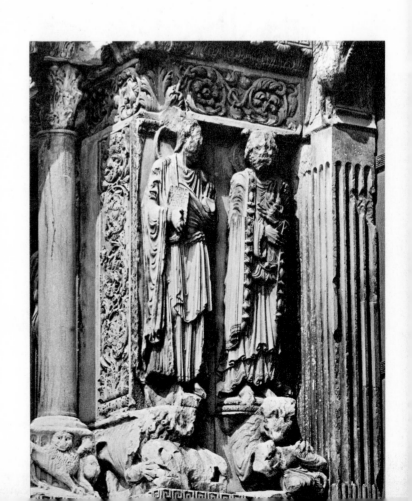

Roman works, not from innovations of Suger's builders and sculptors. When, as in Poitiers Cathedral, rebuilt in 1162, the forms are Gothic, their use is adapted to local traditions and the resulting building is of the hall type, with aisles almost as high as the nave, thus eliminating not only the gallery but the clerestory as well.

In England, Romanesque building went on throughout the twelfth century, but some Gothic features were brought in from France by Cistercian builders. The first fully Gothic structure was the choir of Canterbury Cathedral (colorplate 47; fig. 357), rebuilt after a fire of 1174 by a French architect, William of Sens, and his successor, William the Englishman. Although a very up-to-date building by northern French standards, the design incorporates some concessions to contemporary English taste, for instance, the clerestory passage. The proliferation of black shafts and colonnettes set a fashion for many English Gothic buildings (e.g., Lincoln and Salisbury cathedrals; figs. 358, 359). English Gothic interiors are lower than French ones; there is far less stress on verticality, and the English delighted above all in using multiple moldings on arches, within arcades, and on piers, and in clustering numerous shafts together. They also developed much more complex rib-vaulting designs than the French, those in St. Hugh's choir at Lincoln Cathedral being particularly

357. WILLIAM OF SENS. Interior of Choir, Cathedral, Canterbury. After 1174

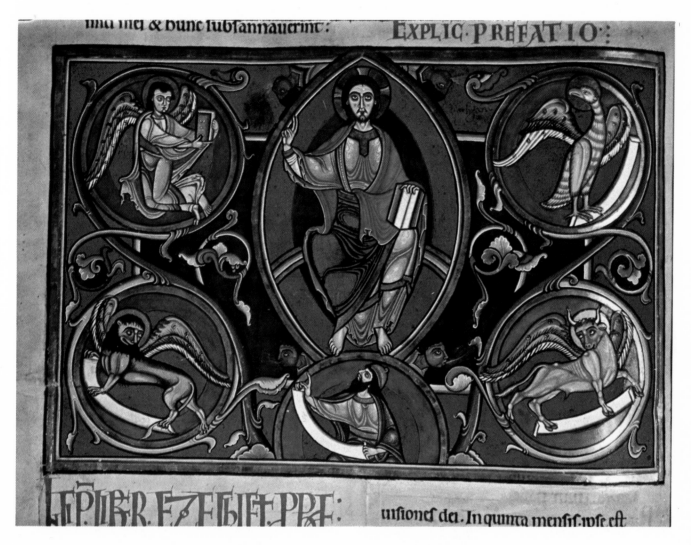

Colorplate 40. MASTER HUGO. *Christ in Majesty.*
Bury Bible, from Abbey of Bury St. Edmunds.
Page 19 7/8 × 14″. 1130–40.
Library of Corpus Christi College (Ms. 2, fol. 281v), Cambridge
(courtesy the Master and Fellows of Corpus Christi College,
Cambridge, England)

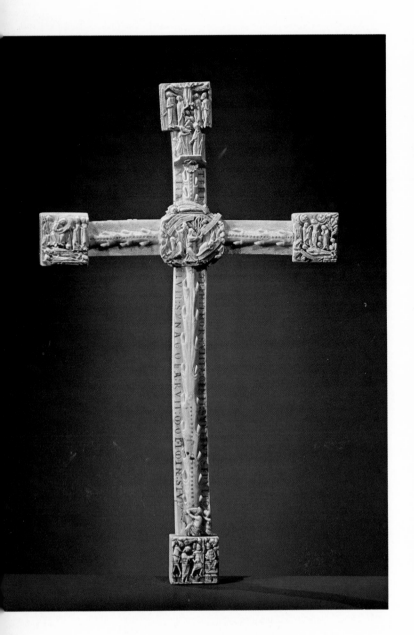

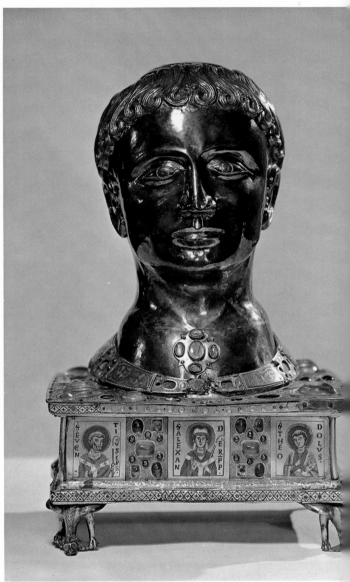

Colorplate 41. Altar Cross (front),
from Abbey of Bury St. Edmunds.
Walrus ivory, height 22 3/4". c. 1140.
The Metropolitan Museum of Art,
The Cloisters Collection
(Purchase, 1963), New York

Colorplate 42.
Head Reliquary of Pope St. Alexander.
Head: silver, partially gilt;
base: gold with enamel and
precious stones; height 17 1/4". 1145.
Musées Royaux, Brussels

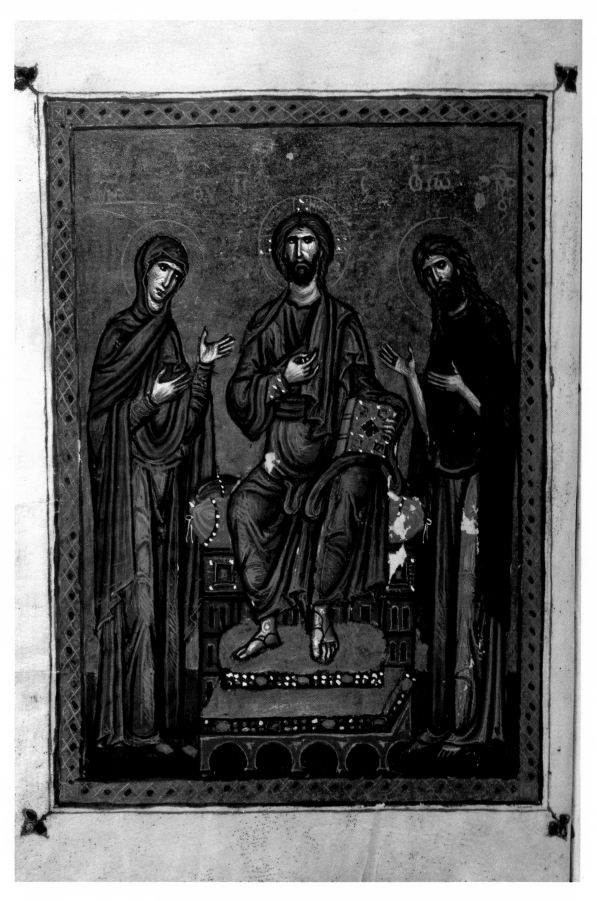

Colorplate 43. *Deësis*. Psalter of Queen Melisende.
Illumination 5 5/8 × 4 1/8''. 1131–43.
British Library (Ms. Egerton 1139, fol. 12v), London

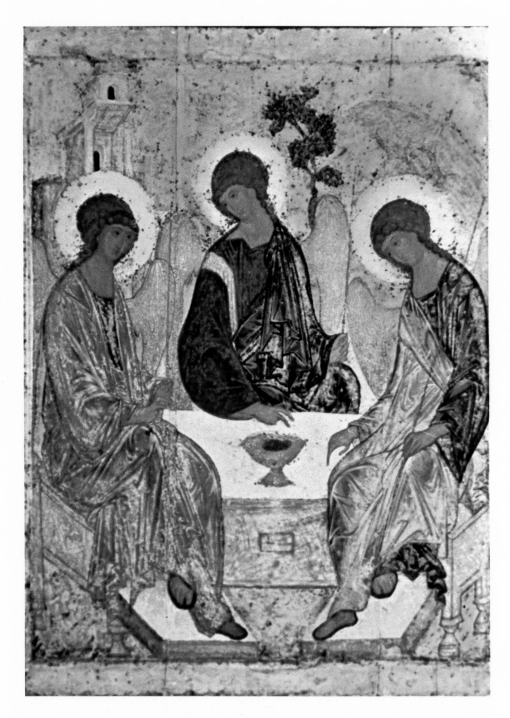

Colorplate 44. ANDREI RUBLEV. *The Trinity*.
Panel, 55 1/2 × 44 1/2″. c. 1410–20.
Tretyakov Gallery, Moscow

Colorplate 45. ▶
Interior toward east, Cathedral,
Chartres. After 1194

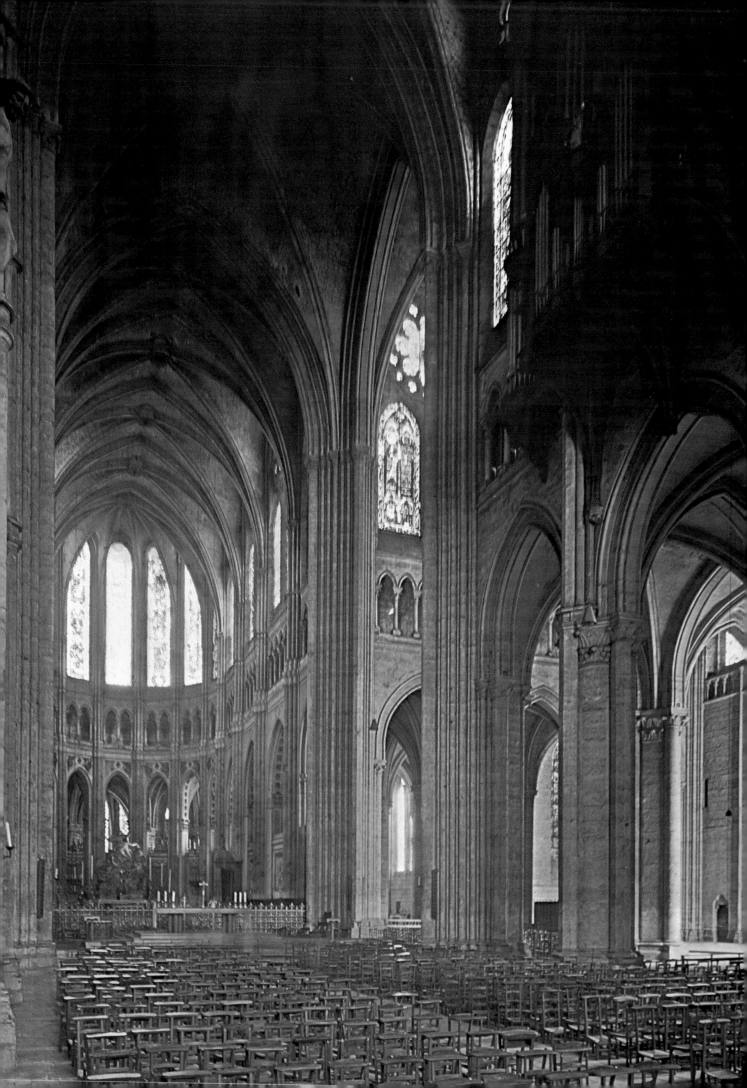

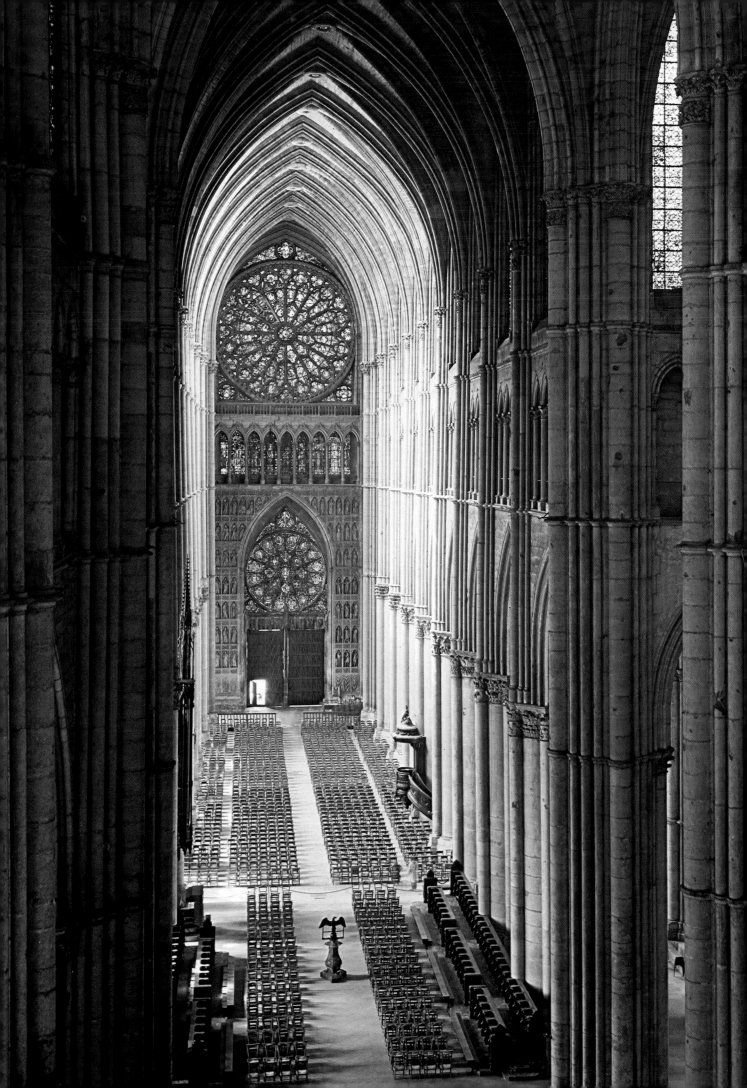

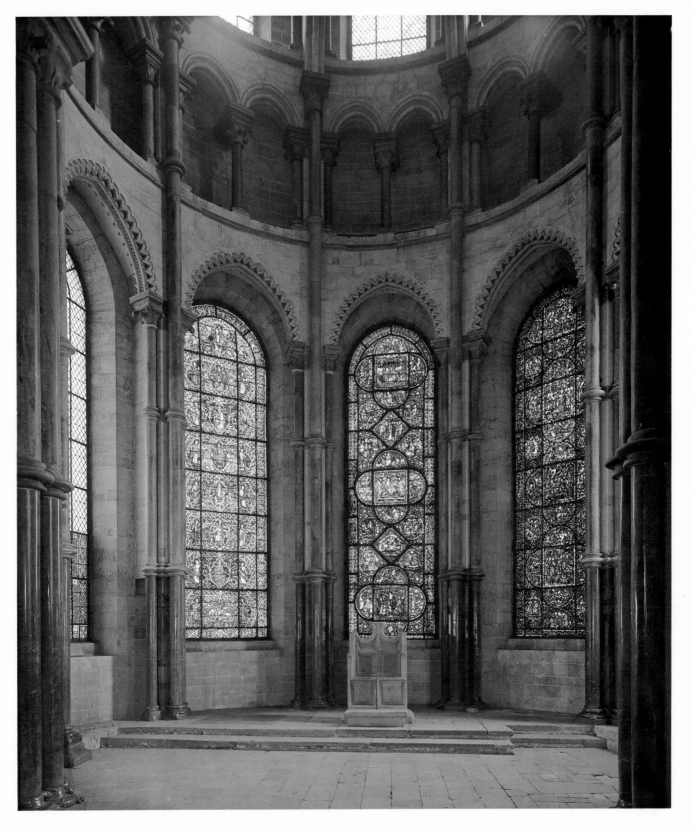

Colorplate 47. WILLIAM THE ENGLISHMAN.
Interior of Corona, Cathedral, Canterbury. 1175–84

◀ Colorplate 46. Interior toward west, Cathedral,
Rheims. Before 1240

Colorplate 48.
Initial V with
Christ and Apostles,
Book of Zephaniah.
Winchester Bible.
Initial 4 5/8 × 4 1/2".
1170–80.
Cathedral Library
(fol. 209), Winchester
(courtesy the
Dean and Chapter,
Winchester)

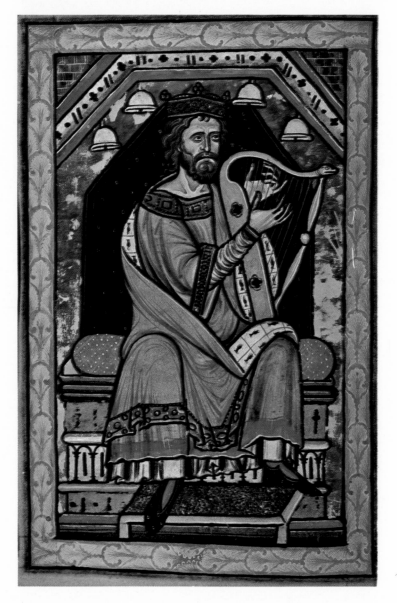

Colorplate 49.
David Harping.
Psalter of Westminster Abb
Illumination 6 1/2 × 4"
Late 12th century.
British Library
(Ms. Roy. 2 A. xxii, fol. 14
London

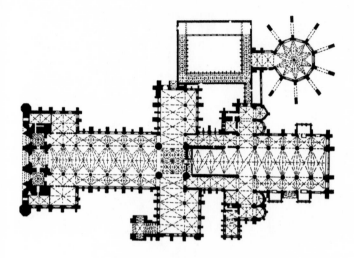

358. Plan of Cathedral, Lincoln.
Late 12th century

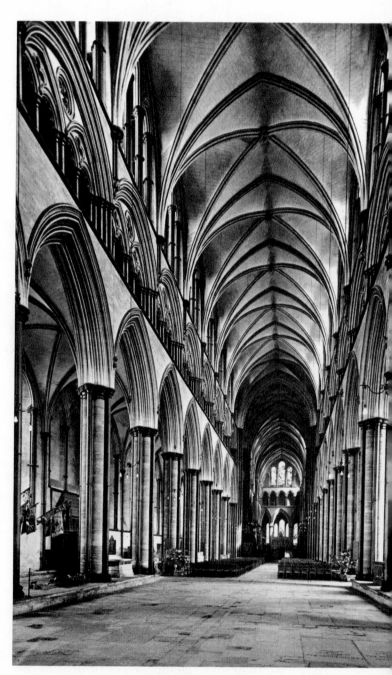

359. Interior toward east, Cathedral, Salisbury.
2nd quarter 13th century

famous for their asymmetrical patterns. But the English version of Gothic differs most strikingly from the French in the treatment of the façade (fig. 360). Admittedly most French cathedrals were started on such an ambitious scale that few were ever finished as intended; it was invariably the west façade, with its two colossal towers, that was left unfinished, and few towers were crowned with high spires, as planned. Thus French façades, as at Paris and Rheims (see figs. 414, 419), look more squat than was originally intended, though most Gothic cathedrals were designed to have two-towered façades rising powerfully to a great height. In contrast, the façades of English cathedrals, such as Wells, Salisbury, and Lichfield, were spread horizontally beyond the lateral walls of the naves, giving the impression of colossal screens.

In Germany, the resistance to northern French Gothic forms was very strong until the rebuilding of Cologne Cathedral in 1248. Gothic churches built before that event, such as the collegiate church at Limburg-on-the-Lahn (before 1220; fig. 361), retain the heaviness of structure which is still Romanesque. In Spain, also, the real impact of the Gothic style was not real-

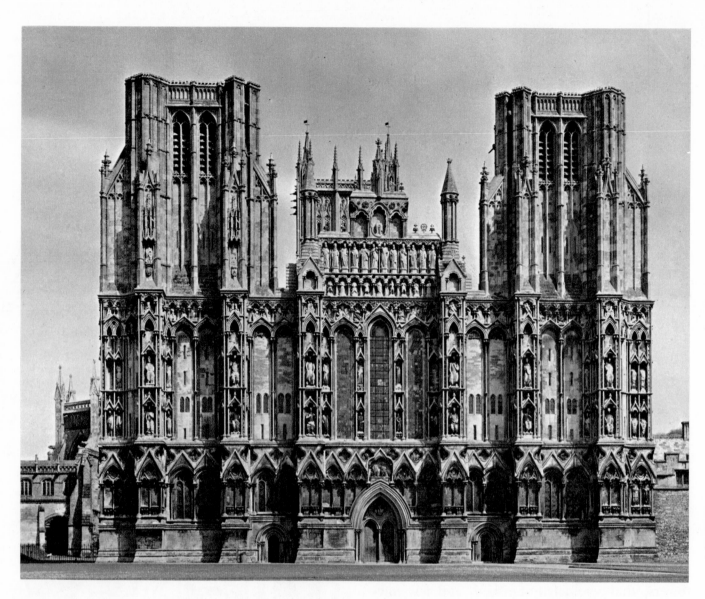

360. West façade, Cathedral, Wells.
Begun after 1186

ized until the thirteenth century with the build-
ing of the cathedrals at Burgos and Toledo, the
latter originally modeled on Bourges Cathedral.
The most striking resistance to the Gothic style
was displayed, however, by Italian patrons and
builders. Were it not for such Cistercian abbeys
as Fossanova (fig. 362), one could hardly speak
of "Gothic" architecture in thirteenth-century
Italy. Romanesque elements continued to be
used with obstinate persistency. It is no wonder
that the term "Gothic" was coined in Italy as an
expression of contempt for barbaric art, though
admittedly in a later age and to describe me-
dieval architecture as a whole.

B. "Transitional" Style in Sculpture, Metalwork, and Painting

Unlike Gothic architecture, which emerged in
the 1140s, Gothic sculpture was the creation of
the thirteenth century. It can be argued that the
sculpture that decorates a Gothic building and is
contemporary with it must be Gothic. Many
writers take this view, and to them the sculpture
of St-Denis Abbey is therefore early Gothic in
style. However, this is a simplification, and dif-
ficult to reconcile with the evidence of the mon-
uments themselves. The sculpture of St-Denis

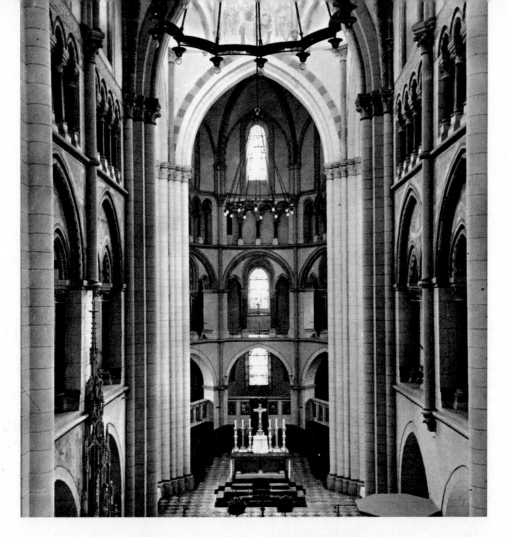

361. Interior of choir (after restoration),
Collegiate Church of St. George, Limburg-on-the-Lahn. Before 1220

362. Interior toward east, Abbey Church, Fossanova. Consecrated 1208

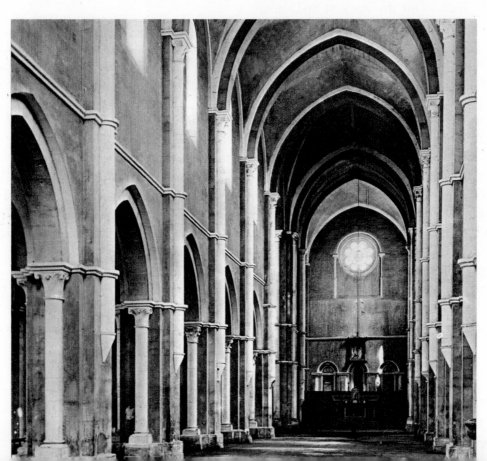

is still deeply rooted in Romanesque sources, iconographic and stylistic. Its novel features are the general arrangement of the three portals of Suger's façade and especially the column-figures, which were originally one of the most striking elements of the whole. But column-figures were not invented at St-Denis, although their source is obscure (see page 272) because of the destruction of so many monuments and the uncertainty about the exact dates of so many relevant sculptures. In any case, many sculptural works later than St-Denis, such as at Laon or Sens, and, in the thirteenth century, at Rheims, have as little in common with Gothic sculpture as they do with Romanesque. In other words, the sculpture which flourished in the second half of the twelfth and the first quarter of the thirteenth centuries is distinctive, neither Romanesque nor Gothic; it is sculpture in a style which has, as yet, no name but is generally known as "Transitional," "Early Gothic," or the "Style Around the Year 1200." This unsatisfactory terminology applies not only to sculpture, but also to painting, metalwork, glass painting, ivory carving, and other media.

Suger tells us that he gathered the best craftsmen from many regions for the work at St-Denis, and his statement is borne out by the fusion of many elements, stylistic and decorative, which can still be seen in the much-mutilated and over-restored west front of the abbey. The archivolts over the three doorways are of the type developed in Western France; one tympanum was in mosaic, a technique which suggests Italian craftsmanship, but it has been destroyed. There are numerous Italian elements: figures on door jambs or placed in little niches, atlas figures supporting columns, and several others. The trumeau which originally supported the tympanum of the central doorway corresponds to those previously employed in Burgundy and Languedoc. Stylistically the sculpture owes much to the Toulousan workshops of about 1130, most notably to the chapter-house figures

363. Column-figures on jamb of central portal, west façade. 1135–40. Abbey Church, St-Denis (drawings by Montfaucon, before 1729; Bibliothèque Nationale, Paris)

of the cathedral there. The column-figures at St-Denis, which are known only from drawings that were subsequently engraved (fig. 363; three heads in the Walters Art Gallery, Baltimore, and the Fogg Art Museum, Cambridge, are said to be from these figures, but the claim is not generally accepted), were nearly lifesize and attached at their back to portal columns, eight flanking the central doorway and six for each lateral doorway. The use of figures on such a scale in doorways was to be decisive for the future course of European sculpture, and it gave birth to the

gigantic "royal" portals of the next two hundred years or more. The St-Denis figures perished during the French Revolution, because it was believed they represented the ancient dynasties of French kings and queens. In fact, they were the Old Testament precursors of Christ.

The decorative scheme of St-Denis was further developed at Chartres between 1145 and 1155 (colorplate 54; figs. 364–66). The triple portals placed between the two west towers had

originally been intended for a slightly wider space, and were trimmed down. Nevertheless, they possess an unmatched unity in their design. At St-Denis the three portals were separated from each other; at Chartres they are brought closely together and the decoration spreads from one to the other. There is also a close iconographic unity among the three: the lateral tympana depict the beginning and the end of Christ's life on earth, on the right His infancy and on the left

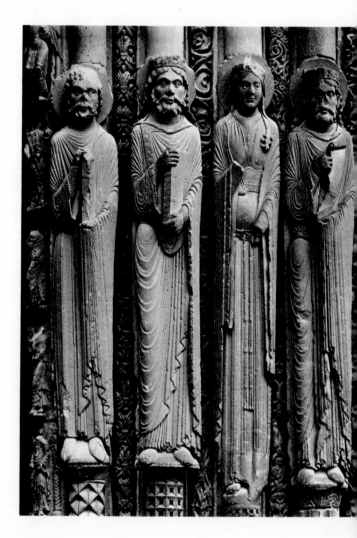

364, 365. *Ancestors of Christ.* Central portal, west façade,
Cathedral, Chartres. 1145–55.
(*left*) Column-figures on left jamb.
(*right*) Column-figures on right jamb

366

the Ascension; in the center tympanum is His Second Coming. Of the original twenty-four column-figures nineteen survive, but the visitor to Chartres will find that more and more of them have been removed because of the danger of decay, and are to be replaced by copies. The archivolts and the capitals are carved with scenes from the life of Christ, and ancillary subjects of great subtlety.

The style of Chartres is less homogeneous than

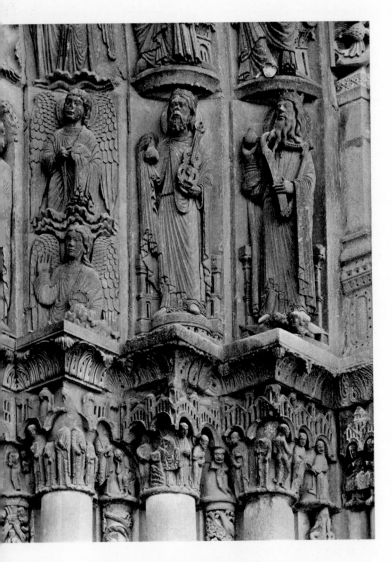

366. Archivolts and capitals,
right jamb of central portal, west façade. 1145-55.
Cathedral, Chartres

its iconography, and it is generally accepted that the whole work was executed by several sculptors working under a head sculptor, who carved much of the central doorway. His style is truly monumental and austere; most striking are his elongated column-figures, which stress the verticality of the columns to which they are attached. This master uses either gently curving folds or vertical pleated folds, bold yet delicate. The figures are motionless, hieratic, and full of grave spiritual life. Their feet point downward as if the figures were not standing on the socles, but were suspended in midair. One of the assistants of this great sculptor carved some of the figures of the right portal; he is known as the Etampes Master, for he had previously carved the portal of Notre-Dame at Etampes.

The impact of Chartres was immediate and its west front was imitated in a string of monuments, though on a reduced scale (e.g., at Le Mans, Angers, Dijon). But after Suger brought Mosan goldsmiths to work at St-Denis (see page 322), Mosan influences also began to play their part in stone sculpture. The monument which displays this clearly is the west portal of Senlis Cathedral; the date of this portal is assumed to be about 1170, and it has suffered from mutilation and restoration (all heads of column-figures are modern). On its tympanum is depicted the Coronation of the Virgin (fig. 367), a new subject for French tympana and one that was to be increasingly popular. The appearance of this subject in art was stimulated by the cult of the Virgin, which, under Byzantine influence, blossomed in the West during the twelfth century. Saint Bernard was a great supporter of this cult, and it will be remembered that all Cistercian churches were dedicated to the Virgin. Prior to Senlis the Coronation theme occurs in Rome (see fig. 246), but the oldest known representation is found in England on a damaged capital from Reading Abbey (c. 1130). At Senlis the crowned and enthroned Virgin is being blessed by Christ, and on the lintel are two scenes, at the left the

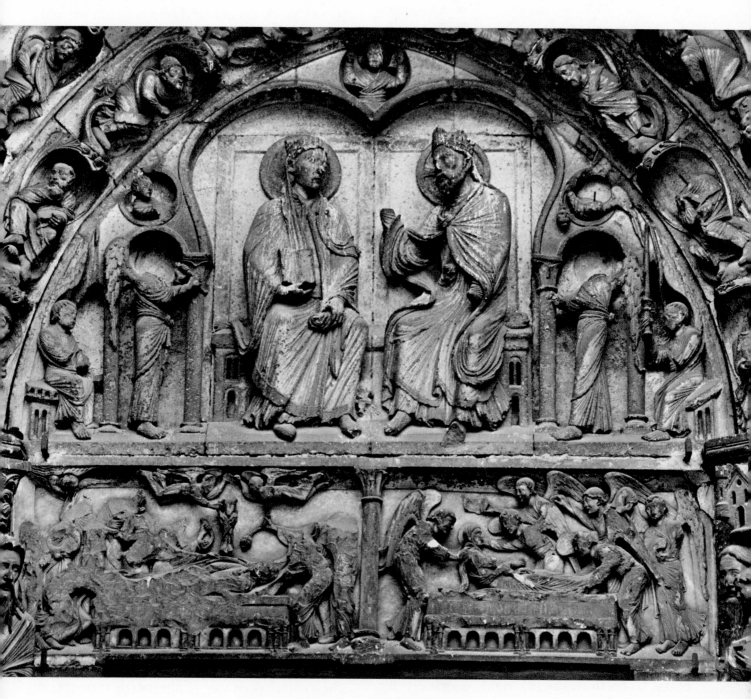

367. *Coronation of the Virgin* (tympanum);
Death and Resurrection of the Virgin (lintel).
West façade. c. 1170. Cathedral, Senlis

368. *Virgin Enthroned. Porte romane,*
right portal of north transept. c. 1180.
Cathedral, Rheims

Death of the Virgin, and at the right the Assumption of the Virgin, accompanied by a flight of angels. The style of this charming portal is profoundly influenced by Mosan ivories and metalwork, as is suggested by the gentle facial expressions and the rounded forms of the draperies, which bring to mind the Liège font (see fig. 322) and the cross from St-Bertin.

Senlis was succeeded by a great number of sculptural works in which Mosan influences are undisputed, including the north transept portal at St-Denis and the two twelfth-century doorways at Mantes. A similar style was also used in the decoration at Sens and of the cloisters at Châlons-sur-Marne, and on the so-called *Porte romane* of the cathedral at Rheims ("Romanesque portal"; north transept, right doorway; fig. 368), the sculpture originally decorating a tomb. The demand for portals such as were being carved in these great cathedrals in northern France was rapidly spreading to other regions; it

has been suggested* that the west doorways of Sens Cathedral were due to sculptors who had previously worked at Mantes, and that the north portal at St-Benoît-sur-Loire also shows a dependence on Mantes, through Sens.

The culmination of this development, which led from St-Denis and Chartres to Senlis and Sens, was the west front of Laon Cathedral (see figs. 347, 385); this was provided, at the very end of the twelfth century, with three portals under projecting porches. Unfortunately, much of this sculpture fell victim to the iconoclasts of the French Revolution and to subsequent restorations. The program at Laon included two portals devoted to the Virgin, center and left, and the one at right to the Last Judgment (this last of c. 1160); it extended to the gables of the porches and the archivolts of the two windows that flank the rose window. High above, protruding from the angles of the two towers, are sixteen oxen, which local tradition claims were used to carry building materials needed for the construction of the cathedral. The Laon sculptors left two other works, the now-fragmentary remains of the abbey church at Braisne and a wonderfully preserved Coronation portal of the north transept at Chartres.

The cathedral of Chartres was consumed by fire in 1194; the crypt survived, and the west towers with the portals between them. These were incorporated into the new design (colorplate 54). As if to compensate for keeping the west front of the old church, an ambitious program was made for the two transept entrances (figs. 369-71); both transepts have three doorways each, under elaborate porches that themselves contain much sculpture. Such a vast quantity of work took over thirty years to complete, roughly from 1205 to 1240. The earliest is the central doorway of the north transept, devoted to the Coronation of the Virgin and follow-

* W. Sauerländer, *Gothic Sculpture in France: 1140–1270*, New York, 1972, pp. 418–19, 422.

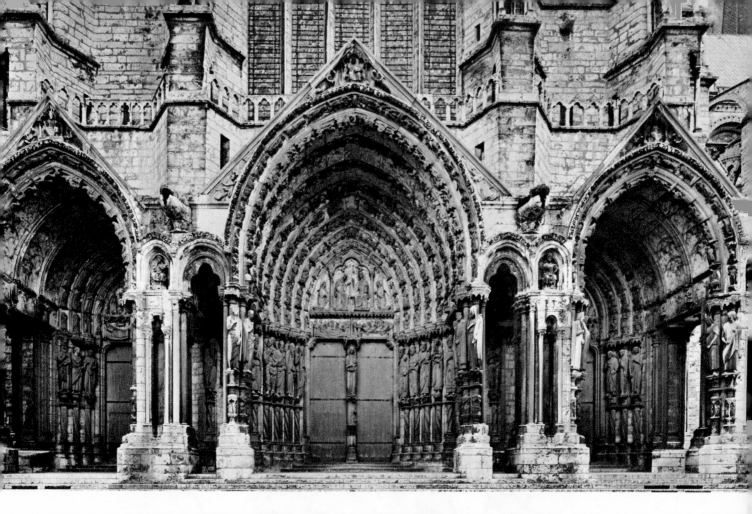

369, 370. (*above*) Portal of north transept, Cathedral, Chartres. After 1205.
(*below*) Central portal of north transept with *Coronation of the Virgin* (tympanum),
Death and Resurrection of the Virgin (lintel)

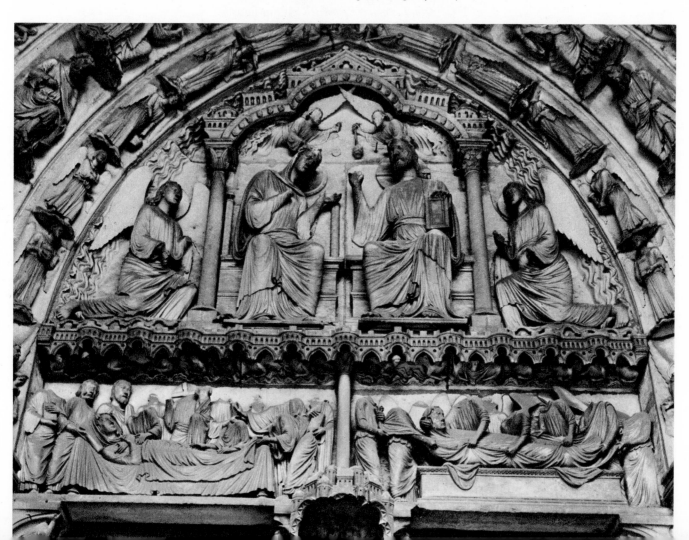

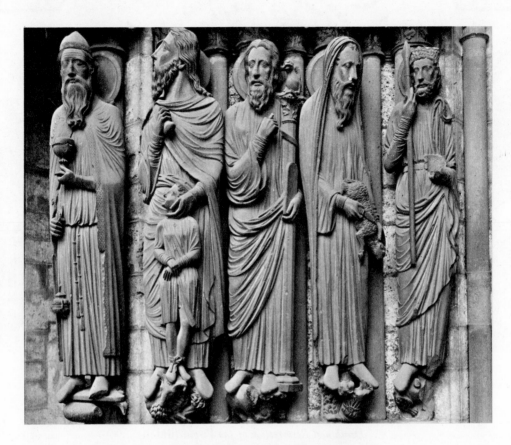

371. *Old Testament Prophets*. Column-figures,
left jamb of central portal, north transept.
Before 1205. Cathedral, Chartres

ing the composition of Laon and Senlis; below the tympanum level are column-figures of Old Testament persons selected to symbolize Christ's sacrificial death, and on the trumeau is St. Anne, mother of the Virgin, whose relics were given to Chartres in 1204. The corresponding portal of the south transept is devoted to the Last Judgment and is in a similar soft, gentle style, the figures naturalistic yet idealized, their robes covered with multiple, deeply grooved folds. In comparison with the static, elongated figures of the west portals, carved some sixty years earlier, a great change has taken place in the treatment of the human figure; it is now more natural in its proportions and gestures, and in the way it

stands firmly on the socle. The figures are no longer isolated supernatural beings, but more earthly and alive. This development went further, step by step, as lateral portals were added to both transepts, and as other statues and reliefs were carved to decorate the porches protecting them.

The large workshop assembled at Chartres helped to spread the style to distant places, either by its local sculptors' later travels or by the inspiration it provided to sculptors who came from other regions. The twin portal of the south transept of Strasbourg Cathedral, a city then in the Empire, has on its two tympana the Death and the Coronation of the Virgin, and column-

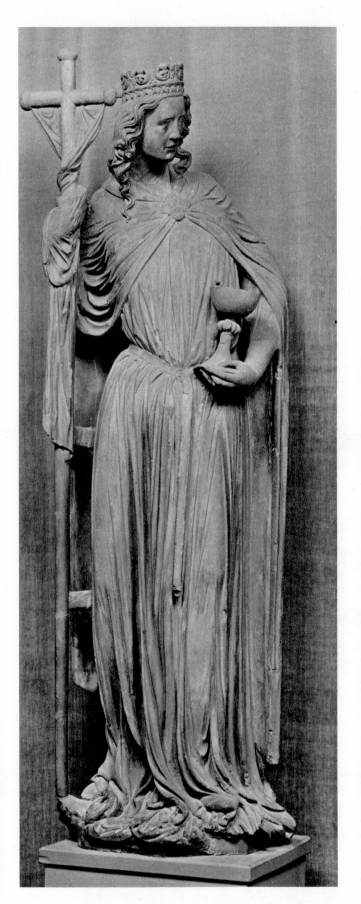

372, 373. *Ecclesia* and *Synagoga*.
Column-figures formerly at left and right of portal, south transept,
Cathedral, Strasbourg. Height of each c. 6′ 5″.
Musée de l'Oeuvre, Strasbourg

figures representing Ecclesia and Synagoga at either side, carved about 1230 (figs. 372, 373); these are close to the style of Chartres, yet they contain elements of overemphasis and almost neurotic drama which seem to characterize many masterpieces of German art. There are also close stylistic links with Chartres in the west portals of Notre-Dame at Paris (fig. 374), about 1200 to 1220, though only in the earliest works; and also in the early sculpture at Rheims Cathedral, undertaken soon after fire destroyed the previous church in 1210.

Some of the sculpture at Rheims of about 1230 exhibits, in the most extreme form, the soft, classicizing style which was present in Mosan art throughout the twelfth century and made its appearance about 1170 in French monumental sculpture. Already at Chartres, about 1205, some folds were chiseled with troughs, as in antique sculpture, and this method was used in an almost obsessive way by the Master of the Antique Figures at Rheims in, for instance, the group of the Visitation (fig. 375). With this stylistic development the "Transitional" period (or, according to another point of view, "Early Gothic") had ended, for in the meantime the true High Gothic style in sculpture had come into being in the workshops of Notre-

374. Archivolts, lintel, and tympanum with *Coronation of the Virgin*.
Left portal of west façade. 1200–1220.
Cathedral of Notre-Dame, Paris

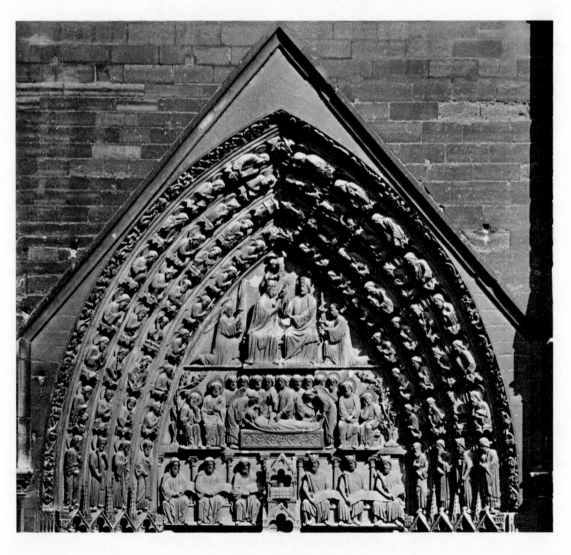

Dame at Paris, at Amiens, and at Rheims Cathedral itself.

The classical trend of which the Rheims sculpture is the extreme example was not confined only to monumental sculpture. The greatest exponent of this style was the Mosan goldsmith, Nicholas of Verdun.

NICHOLAS OF VERDUN

In common with his Mosan predecessors, Nicholas of Verdun shows more than a superficial knowledge of Byzantine art in his understanding of the three-dimensional human figure and of the drapery, which is no longer merely a pattern, but has weight, and is used logically to emphasize the form and structure of the figure it covers. But in addition Nicholas' art shows an unmistakable familiarity with antique sculpture. It is an unresolved question whether he had made a journey to Constantinople, where he could have studied both Byzantine art and antique statues, at some time before 1181, when he executed a pulpit (later made into an altarpiece; figs. 376, 377), covered with enamel plaques, for the abbey of Klosterneuburg near Vienna. Forty-five plaques of champlevé enamel form a comprehensive typological program in which events from the New Testament are paralleled by those from the Old. In this, presumably, early work of Nicholas the Romanesque convention of abstract patterns is still present, but there is an undoubted naturalism in the treatment of the draperies. As on certain fourth-century B.C. statues, the draperies are composed of numerous parallel folds in the so-called *Muldenstil*, or style of trough-shaped folds.

The only other documented work by Nicholas is the much-restored shrine of 1205 in Tournai Cathedral. Another work attributed to him on stylistic grounds, and dating from about 1190, is the huge Shrine of the Three Kings (fig. 378) in Cologne Cathedral, decorated with three-dimensional figures in the *repoussé* technique. Here the individuality of the artist is demonstrated even

375. MASTER OF THE ANTIQUE FIGURES. *Visitation.* Column-figures, central portal of west façade. c. 1230. Cathedral, Rheims

376, 377. Nicholas of Verdun. Plaques of Klosterneuburg Altarpiece.
Gold with enamel. 1181. Chapel of St. Leopold,
Augustinian Convent, Klosterneuburg. (*above*) *Moses Crossing the Red Sea*
(on center section). Height of portion shown, c. 11 1/2''.
(*below*) *Christ as Ruler of the World* (on right wing). 5 1/2 × 4 1/2''

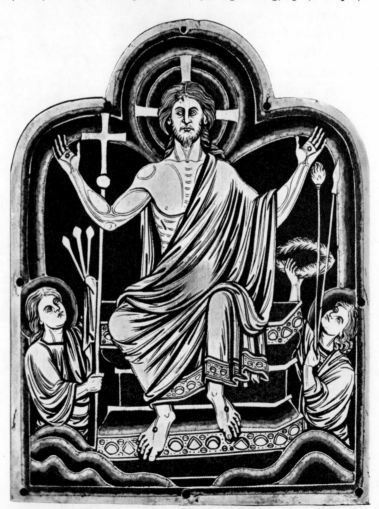

more strongly, for not only are the draperies expressive and dynamic but the faces are also individual rather than stereotyped, and full of power.

Similar influences to those which helped to form the style of Nicholas of Verdun can be detected in media other than metalwork, and in regions outside the Meuse Valley and the Rhineland, most notably in England.

MANUSCRIPTS

In manuscript painting the most important surviving example of the "Transitional" style in England is the Winchester Bible (colorplate 48; fig. 379), illuminated between 1170 and 1180 by a group of artists, some of whom were well versed in Byzantine or Siculo-Byzantine art. It has been demonstrated that at least one of these artists executed the wall paintings of the convent chapter house at Sigena in Aragon (now in Barcelona; fig. 380). The classicizing style of these works was not confined to Winchester only, for the Psalter made for Westminster Abbey toward the end of the twelfth century (colorplate 49) illustrates equally well the impact of Byzantine art on the painter of this outstanding manuscript.

In English sculpture, a related style is found in the small-scale carvings of the Lady Chapel at Glastonbury (c. 1185), or on the highly original ivory crozier (fig. 381), carved with scenes from the life of St. Nicholas, in the Victoria and Albert Museum, London. The wonderful series of stained-glass windows installed in the newly rebuilt choir of Canterbury Cathedral (fig. 382) is particularly interesting; they combine the "Transitional" style and the occasional use of *Muldenstil* folds with elongated figures and dynamic poses and gestures, these an inheritance from the Anglo-Saxon tradition of the Winchester School (see page 196).

In France the "Transitional" style is well illustrated in a number of manuscripts made at St-Bertin, St-Amand, Anchin, and other monas-

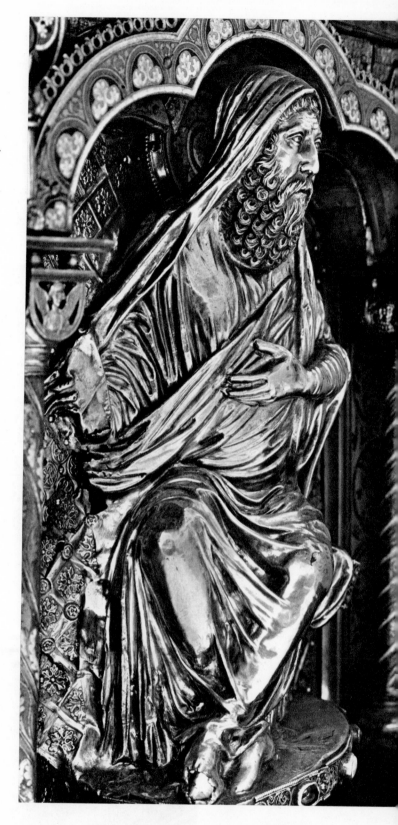

378. NICHOLAS OF VERDUN (workshop). *Prophet Joel*, from Shrine of Three Kings. Silver and bronze, gilded; enamel, filigree, and precious stones; height of portion shown c. 13". c. 1190. Cathedral Treasury, Cologne

376

379.
Master of the
Morgan Leaf.
Scenes from the Life of Da
Page of a Bible;
22 5/8 × 15 1/4″.
Winchester,
3rd quarter 12th centu
Pierpont Morgan Libr
(M. 619, v), New Yo

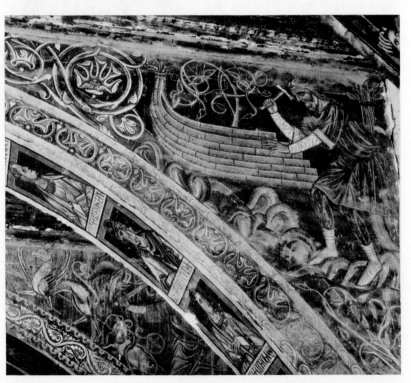

380.
Noah Building the Ark.
Wall painting
from chapter house,
Convent, Sigena
(now destroyed). c. 123
Museo de Arte de
Cataluña, Barcelona

381. Crozier with Scenes from the
Life of St. Nicholas. Ivory, height 4 1/8".
h century. Victoria and Albert Museum, London

382. *Mathusalah.*
Stained-glass window, southwest transept. c. 1178.
Cathedral, Canterbury

383. *Scenes from the Life of David.* Souvigny Bible. 22 × 15 3/8".
Late 12th century. Bibliothèque Municipale (Ms. 1, fol. 93r), Moulins

tic centers in the North. The close artistic contacts between England and France at that time can be seen in the numerous examples of books sent across the Channel, such as those which Herbert Bosham, St. Thomas à Becket's secretary, sent from Pontigny to Canterbury. On the other hand, the Manerius Bible (Paris, Bibl. Ste-Geneviève Mss. 8 to 10) was executed in France by an Englishman from Canterbury. The Souvigny Bible (fig. 383) of the late twelfth century shows a fair knowledge of Byzantine naturalism, but at the same time it reveals

with what naivety this knowledge was used.

To a different artistic class and style belongs the celebrated Ingeborg Psalter (fig. 384) painted about 1200 for Danish-born Queen Ingeborg, wife of King Philip Augustus of France. This is not, as might be expected, a Parisian book, but a work very closely associated with the style of Nicholas of Verdun and his "trough-fold" draperies. It is through this and other similar works that the "Transitional" style of Nicholas became available as a source of inspiration in the French royal domain, and exercised so

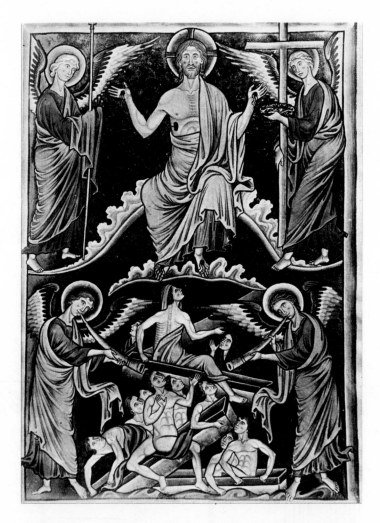

384. *Last Judgment*. Ingeborg Psalter. 12 × 8″. c. 1200.
Musée Condé (Ms. 1695, fol. 33r), Chantilly

profound an influence on monumental sculpture.

There is nothing surprising in the stylistic relationships which existed at that time among different media, for many craftsmen continued to be, as during the Romanesque period (see page 232), masters of many trades. A precious proof of this exists in the form of a book (figs. 385, 386) compiled about 1220–1235 by Villard de Honnecourt, an architect of Picardy, who recorded details of buildings, such as Rheims, Laon, Cambrai, and Lausanne, as well as sculptures and designs for church furniture; there are also numerous figural subjects, some drawn from existing works of art, others of his own invention. He was interested not only in buildings, but also in recording for the use of a mason's lodge, which he clearly headed, a variety of things he thought useful to architects. The figure style Villard employed was a very close imitation of the *Muldenstil* of Nicholas of Verdun, and this he must have absorbed in his youth, presumably by studying original works of the Mosan artist. Villard tells us that he made a journey to Hungary, probably in connection with some commis-

385, 386. VILLARD DE HONNECOURT. Two pages of Sketchbook.
Each page 9 1/4 × 6″. Bibliothèque Nationale (Ms. 19093), Paris.
(*left*) *Tower of Laon Cathedral* (fol. 10r).
(*right*) *Christ in Majesty* (fol. 16v)

sion, and such journeys must have contributed
to the spread of Mosan and French artistic
ideas throughout Europe.

As we pointed out before, England adopted
Gothic architecture rather earlier than did
Germany or Spain, and there is evidence that, in
painting also, Paris provided a frequent source
of inspiration; there are numerous parallels
between French and English books produced in

the second quarter of the thirteenth century. In
both countries, the soft flowing style continued
to be used until the middle of the century, and
one of the latest English exponents of it was the
monk of St. Albans, Matthew Paris, the historian
and artist (fig. 387).

GERMANY, SPAIN, ITALY

In Germany, the "Transitional" style took on

various forms. Apart from the Mosan region and the Rhineland, dominated by the art of Nicholas of Verdun, there was also a strong Byzantine influence evident in book illumination (for instance, the Berthold Missal given to Weingarten Abbey, c. 1216, now Pierpont Morgan Library Ms. F10). In addition, there was a dynamic and angular style known as the *Zackenstil*, which affected painting—the ceiling of St. Michael's, Hildesheim (fig. 388; see fig. 159)—and sculpture—the tomb of Henry the Lion and his wife Matilda, in Brunswick Cathedral (c. 1230). Among English manuscripts of about 1250, the Evesham Psalter (fig. 389) exhibits somewhat similar agitated folds, and may be considered as a rare example of German influence at that time in England.

A technique which had flourished in Germany since Carolingian times was stucco sculpture, and there are two fine examples of this in the "Transitional" style: the choir screens at St. Michael's, Hildesheim (c. 1190), and at the Liebfrauenkirche, Halberstadt (c. 1200). The later screen made of stone in Bamberg Cathedral (fig. 390), executed in an agitated style of great power and originality, stands at a turning point, after

387. MATTHEW PARIS. *Virgin and Child,* in *Historia Anglorum.* Tinted drawing; 14 × 9 3/8″. 1259. British Library (Ms. Roy. 14 C. vii, fol. 6r), London

388. *Virgin as Blossom on Tree of Jesse,* and other figures. Ceiling painting on wood; central section c. 9 1/2 × 10′. c. 1230. St. Michael, Hildesheim

389. *Crucifixion.* Evesham Psalter.
12 3/8 × 8″. c. 1250.
British Library (Ms. Add. 44874, fol. 6r), London

which the new Gothic style from France became a decisive formative force.

The most celebrated work of Spanish sculpture of this period of transition is the triple west doorway of Santiago de Compostela, known as the *Pórtico de la Glória* (fig. 391). It is signed by a certain Mateo and dated 1188. This huge complex consists not only of three doorways with column-figures (the central portal having a tympanum and a trumeau), but also of figures placed on the walls of the narthex. Strangely enough, the sources of Mateo's art are not directly from the Ile-de-France but, at second hand, through Burgundy.

In Italy the impact of French developments in the "Transitional" period is hardly noticeable. The artist who alone deserves to be mentioned in this context is Benedetto Antelami, active in Parma, where he signed a relief of the *Deposition* in 1178 (fig. 392), in the cathedral, and then carved the three doorways of the baptistery (fig. 393), one signed and dated 1196. The design of the doorways is Italian, not French, and there are no column-figures, but the iconography shows French influences. Some of the high-relief figures inside are attributed to him (colorplate 50). Although, like so much Italian sculpture, the inspiration is from antique models, there are some details, especially in the modeling of the heads, which betray Antelami's familiarity with French sculpture.

STAINED GLASS

It has previously been pointed out that Gothic architecture, with its huge windows, provided great opportunities for development of stained glass and in this field, as in others, Suger of St-Denis gave the lead. He wrote ". . . we caused to be painted, by the exquisite hands of many masters from different regions, a splendid variety of new windows, both below and above; from that first one which begins [the series] with the *Tree of Jesse* in the chevet of the church to that which is installed above the principal door in the

390. *Disputing Prophets.* Choir screen, north side. c. 1230.
Cathedral, Bamberg

church's entrance." Much of this glass has perished, but from what survives it is clear that Suger's windows were as important in that field as were his portals and choir in the development of sculpture and architecture.

Romanesque windows were characterized by compositions with large figures. Now the figures had become smaller, more delicate, and less monumental, and they are placed within the frames of medallions or quatrefoils. The colors become more varied and the iconography more complex. Chartres had followed the example of Suger at St-Denis in sculpture; such was now the case with stained glass, and we find the *Tree of Jesse*, made about 1150 for one of the lancet windows in the west façade, to be a clear imitation of St-Denis. Stylistically, the windows of St-Denis and Chartres are still Romanesque, with some classicizing elements of Mosan inspiration. The beautiful glass in the cathedral at Châlons-sur-Marne (c. 1155; fig. 394) is entirely Mosan in style and iconography. The "Transitional" style in glass painting presents many similarities with manuscript illumination and even sculpture, and it disappeared during the second quarter of the thirteenth century, when the true Gothic forms of figures, such as those evolved in the sculpture of Paris, Rheims, and Amiens, had be-

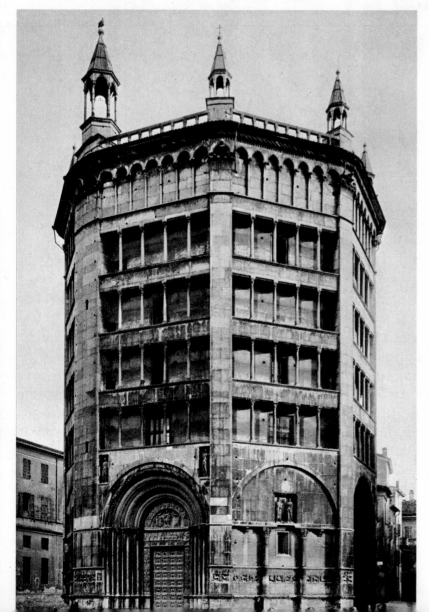

391. (*opposite*) MASTER MATEO. Central portal of *Pórtico de la Glória*, west façade, Cathedral, Santiago de Compostela. 1188

392. (*above*) BENEDETTO ANTELAMI. *Deposition*. Marble. 1178. Cathedral, Parma

393. Exterior of Baptistery, Parma. Doorways by BENEDETTO ANTELAMI, c. 1196

394. *Finding the Relics of St. Stephen.*
Stained-glass window (portion). c. 1155.
Cathedral of St. Stephen, Châlons-sur-Marne

come universally accepted (see page 397). Ste-Chapelle has been called a church built around its glass (colorplate 52), and it is certainly true that the desire to have more and more stained glass influenced the course of architectural development. It was also at this time that stained glass made its impact on manuscript illumination, as in the case of the Psalter of Blanche of Castile, about 1235, where the pages, covered with narrative roundels, unmistakably imitate contemporary windows.

Ste-Chapelle and its glass were due to royal patronage. But the majority of glass in big cathedrals, such as at Chartres or Bourges (figs. 395, 396), was paid for by guilds and other corporate bodies, and thus frequently connected with the appropriate patron saints. In spite of the vivid colors, the small compositions of this type of

395. *Good Samaritan.*
Stained-glass window in ambulatory.
Mid 13th century.
Cathedral, Bourges

396. *Good Samaritan* (lower portion).
Stained-glass window in ambulatory. Mid 13th century.
Cathedral, Bourges

glass required a great number of lead frames and thus created badly lit interiors. It was obviously in order to allow in more light, so that the sculptural details and the numerous church fittings could be seen in more favorable conditions, that, toward the end of the thirteenth century, the multi-colored glass was frequently replaced by *grisaille* glass in light colors, using geometric or foliage patterns in keeping with the decorative qualities of the architecture of the period.

C. *Rayonnant Architecture*

The years of the reign of Louis IX (1226–70), known as St. Louis after his canonization in

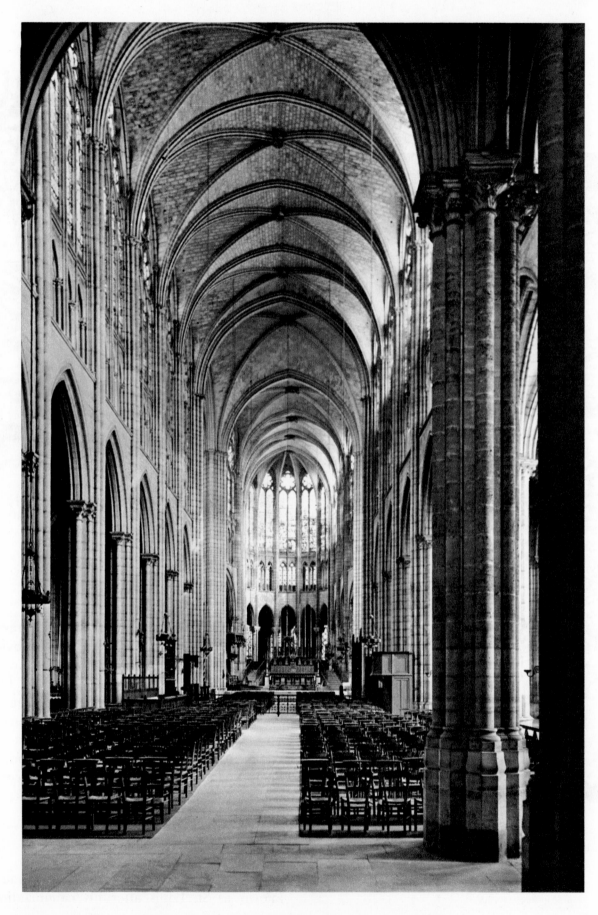

397. Interior toward east, Abbey Church, St-Denis.
Begun 1231

1297, saw an increase in the prestige of the French monarchy, a corresponding gradual decline in that of the Empire, and a weakening of the papacy, exhausted by its struggle with Frederick II Hohenstaufen. Constantinople, Cordoba, and Rome had been leading cities in the past; now it was Paris, envied and emulated, which became the political and cultural center of Europe. The second quarter of the thirteenth century saw the completion of a number of great cathedrals in cities not far from Paris, among them Chartres, Amiens, and Rheims. In Paris itself, Notre-Dame was completed and work was started on reshaping its transepts. At St-Denis, the old nave linking Suger's east and west ends was pulled down, and replaced by a new structure (fig. 397). The king himself sponsored numerous works, the most influential of which was the Ste-Chapelle in Paris (colorplate 52; fig. 398), built between 1243 and 1248 within the precincts of the royal palace to house the relics of Christ's crown of thorns which Louis had purchased from Constantinople. This two-storied building exhibits, in an admirable way, the development of Gothic architecture toward lightness and verticality, and the decorative effect of the window traceries. Ste-Chapelle is a space enclosed by stained glass, and the tracery patterns of the windows are repeated in relief along the low walls. This method of extending the tracery patterns, which became more and more elaborate and daring in their designs, to wall surfaces within and without buildings, is what characterizes this *rayonnant* stage in the development of Gothic art. The term is derived from the radiating patterns in rose windows, one of the most characteristic features of thirteenth-century cathedrals. The Ste-Chapelle is frequently compared to the style of metal reliquaries, and there is little doubt that metalwork had a considerable influence on architectural decoration.

The Parisian court style spread rapidly throughout France, and one of the most striking

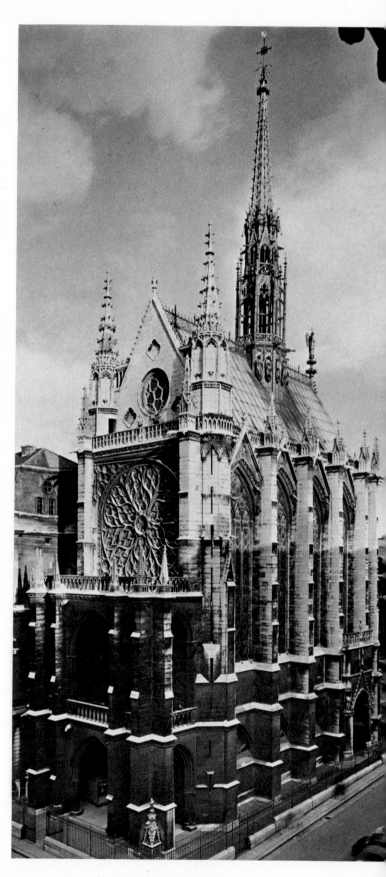

398. Exterior from southwest, Ste-Chapelle, Paris.
1243–48 (see colorplate 52)

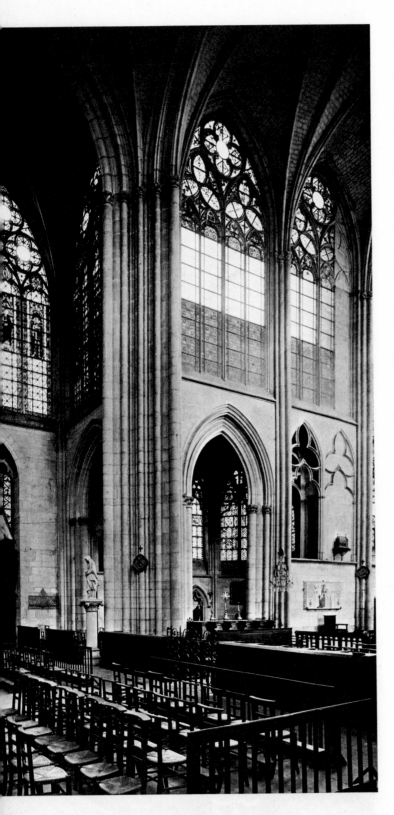

399. Interior of crossing toward northeast,
St-Urbain, Troyes. Begun 1262

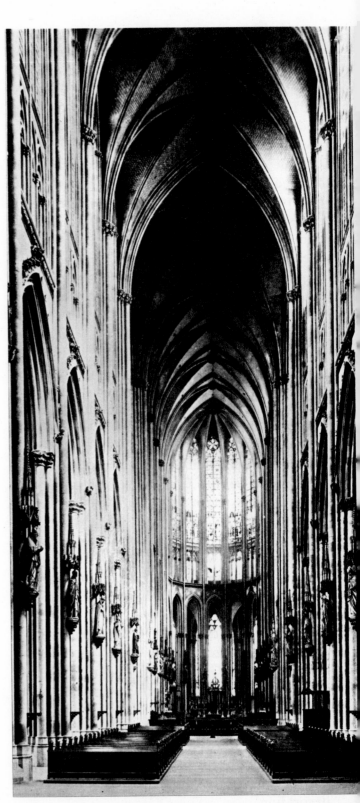

400. Interior toward east, Cathedral, Cologne.
Begun 1248

examples of it is the church of St-Urbain at Troyes, started in 1262 (fig. 399). Gradually this style became repetitive, and during the fourteenth century there are few buildings in France as memorable as those built during the previous century.

The cathedral which, as originally planned in 1247, was to surpass in size and height all other churches, was at Beauvais. However, in 1284, the choir vaults fell from a height of 158 feet, and the church was rebuilt on a more modest scale. Its immediate imitator was Cologne Cathedral (fig. 400), started in 1248, and the most French church on German soil. The vast scale of this daring church made the progress of building slow; the choir was dedicated only in 1322, and in 1559 work on the nave and the façade was suspended, to be completed only after 1824. Another *rayonnant* building in Germany was the façade of Strasbourg Cathedral, begun in 1277 (figs. 401–3). On the west front, the use of free-standing traceries that enclose the masonry like a gigantic cage illustrates the decorative character of the style. The original drawings for this work still survive, and thus we know that the original intention was to erect two open-work towers with spires. In fact, a similar design was executed at Freiburg-im-Breisgau (fig. 404), but with a single spire, built in the fourteenth century.

In England, French architectural ideas were emulated first by Henry III in his rebuilding of Westminster Abbey, started in 1245. The design also includes many traditionally English features, such as the tribune gallery; nevertheless the abbey, with its choir and the huge rose windows in both transepts (fig. 405), is "the least un-French" of English Gothic buildings. The rebuilding of St. Paul's Cathedral in London followed, from 1258 onward, and the design (known from pictorial sources prior to 1666, when the medieval church perished in the fire of London), included many French features. This London or court style spread to Lincoln Cathe-

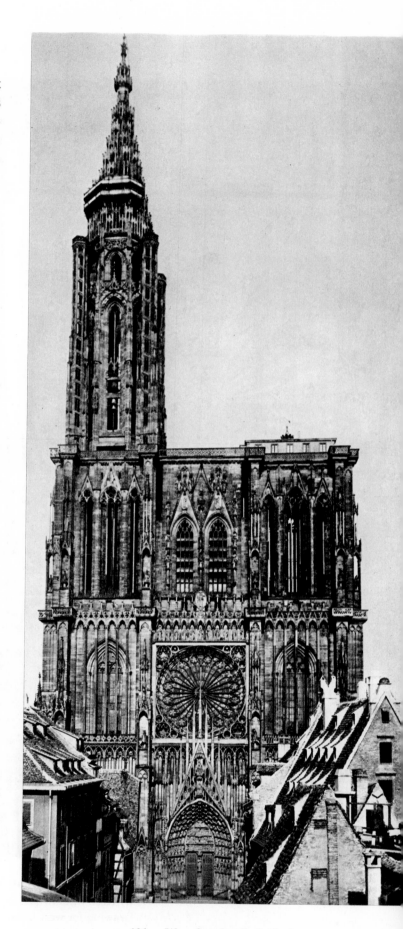

401. West façade, Cathedral, Strasbourg. Begun 1277

402, 403. West façade, Cathedral, Strasbourg. Begun 1277.
(*left*) Rose window and Apostles Gallery.
(*right*) Drawing for west façade (portion). c. 1385.
Musée de l'Oeuvre, Strasbourg

404. Interior of spire,
Minster, Freiburg. Begun 1275

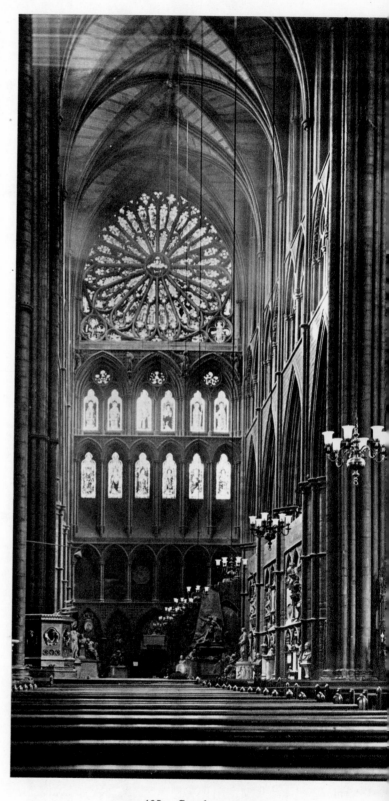

405. South transept,
Westminster Abbey, London.
Begun 1245

dral; in the Angel Choir (fig. 406), started in
1256, were repeated many decorative elements
inspired by Westminster.

D. Towns and Castles

In 1229, Emperor Frederick II Hohenstaufen
secured Jerusalem for the Christians, but it was
not held for long, and in 1244 it was again lost,
this time finally. But Louis IX of France, at that
time seriously ill, vowed to set out on a Crusade
if he recovered. Three years were spent in prep-
arations for this expedition, though it ended,
like so many others, in disaster. To ensure the
successful departure of the huge army, the har-

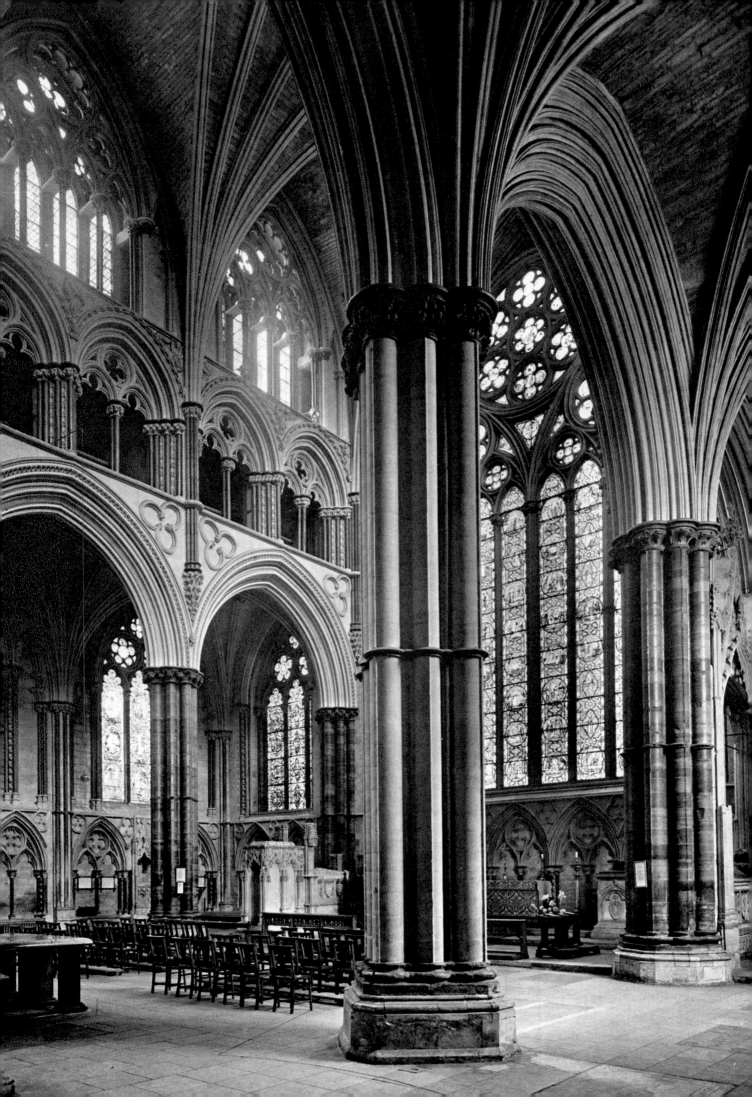

bor and town of Aigues-Mortes, in Provence, were rebuilt (figs. 407, 408); it was also from Aigues-Mortes that Louis embarked in 1270 on his last Crusade, which ended with his death in Tunis. What characterizes this "new town," still wonderfully preserved, is the regular plan of the streets, like a chequerboard, enclosed by rectangular ramparts with huge round towers at the corners, and numerous gates defended by rectangular or circular towers. This large enterprise is a precious example of a town built practically anew in the thirteenth century, and was not finished until the next reign, that of Philip the Bold (1270–1285). In most cases, towns grew in a more haphazard fashion, or upward and outward as the population increased. The prosperity of the towns and their complex organization and government led to the erection of public buildings on a scale unknown since Roman times. Town halls, guild houses, and many other public buildings started to compete in their splendor with churches. Italy and Flanders preserve particularly large numbers of such public buildings.

In its symmetry and regularity, Aigues-

407, 408. Aigues-Mortes. 1245–48.
(*top*) Air view from east.
(*above*) Ramparts, south side

◀406. Angel Choir from southwest, Cathedral, Lincoln. Begun 1256

409. Air view, Castle, Harlech. 1286–90

410. Exterior from east, Castel del Monte. c. 1240

411. *Head of Zeus*, from Porta Capuana.
Marble, height c. 31″. c. 1233.
Museo Campano, Capua

Mortes was clearly reviving the Roman method, and was echoed in many smaller undertakings. In castle building, also, symmetry became the basis of design, whether in the majestic castles of Wales, such as at Harlech (fig. 409), built between 1286 and 1290, or in Frederick II's castles in southern Italy, of which Castel del Monte is the best preserved (fig. 410). Built about 1240 on an octagonal plan with eight octagonal towers, it proclaims its dependence on France in numerous architectural details, but also on Rome in its spectacular classical portico. It is well known that Frederick's patronage in sculpture also led to striking imitations of the antique, the statues and busts which decorated

the gateway at Capua (1233; fig. 411) are representations of the emperor and his officials in Roman dress, and are carved in a style which is based on a very profound knowledge of late antique portraiture.

E. Gothic Sculpture of the Thirteenth Century

The work which proceeded on the façade of Notre-Dame in Paris between about 1200 and the 1220s includes two styles, one looking back to the classicizing trend of the late twelfth century and another which was truly Gothic (figs. 412, 413). Nineteenth-century restoration and the replacement of many sculptures (especially the column-figures) make it difficult fully to appreciate today this important decorative scheme, involving three doorways. In St. Anne's portal, on the south side, parts of an earlier doorway were incorporated. Of the remaining two doorways, the central one is devoted to the Last Judgment, and that on the north to the Coronation of the Virgin. In both, the tympana are divided into three registers having roughly the same importance. Iconographically, the portals are very inventive, and the north portal especially has many novel subjects (see fig. 374). But it is the style of the sculpture that is quite new; the draperies are not soft and curving, as on the plinths, but more solid, and they are either straight or have angular, clear-cut forms. However, it has recently been suggested that two figures in the central tympanum, that of Christ and of the angel with the nails of the Crucifixion, are more advanced in style, perhaps inserted toward the middle of the century.* The style of Notre-Dame was further developed, and probably by the same workshop, in the triple portals of the façade of Amiens Cathedral, dating to between 1225 and 1235 (figs. 414, 415). As at

* A. Erlande-Brandenburg, "Les remaniements du portail central à Notre-Dame de Paris," *Bulletin monumental*, 129, 1971, pp. 241–48.

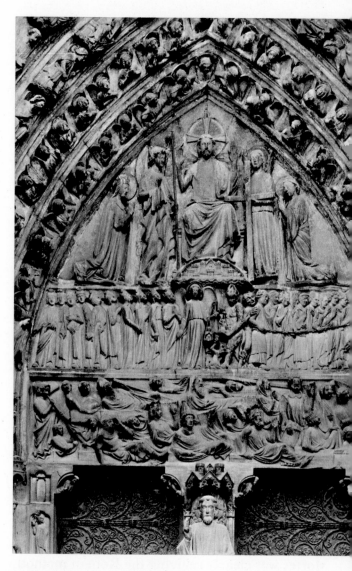

412, 413. (*left*) West façade, Cathedral of Notre-Dame, Paris. 1200–1220.
(*right*) *Last Judgment*. Tympanum of central portal
(center section of lintel restored). 1225–30

Laon, earlier, they are sheltered by huge porches, and the decoration extends from the tympana to the walls of the porches by way of the archivolts (eight over the central doorway) and, below, the column-figures. The entire plinth of the façade is covered with two rows of quatrefoils containing allegorical reliefs relating to the column-figures above. This enormous program involved a large workshop and not all the sculptures are of the highest quality.

In the meantime, the Gothic style developed a stage further in the Parisian court workshop, which provided the figures of Apostles inside the Ste-Chapelle, standing on socles between the windows (1240s; fig. 416). The break with earlier traditions is here strikingly demonstrated by masses of crinkled, agitated folds which entirely conceal the bodies. The faces, though idealized, are expressive and energetic.

Some of the sculpture of Rheims Cathedral has

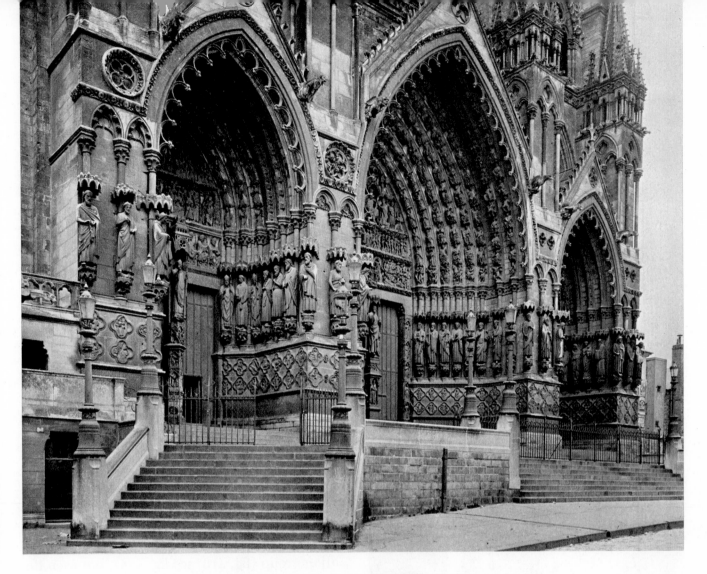

414, 415. (*above*) Porch of west façade, Cathedral, Amiens. 1225-35.
(*below*) *Virtues and Vices* (*Courage and Cowardice;*
Patience and Impatience), quatrefoils on plinth below column-figures

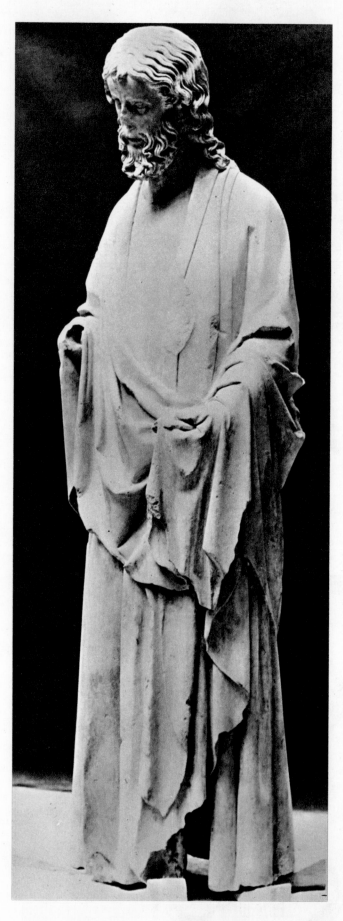

416. *Apostle*, formerly in interior of Ste-Chapelle.
Before 1248. Musée de Cluny, Paris
(see colorplate 52)

already been mentioned (see page 372), but the entire program included large reliefs and statues on the exterior of the choir and transepts, as well as the west portals and the transept portals (fig. 417); this vast work required many decades to complete, and consequently, although it was started in 1211, went on for about fifty years. As a result, the Rheims sculpture, unlike that of Amiens, is not homogeneous, and many statues no longer occupy the places for which they were originally designed. Tympana above the portals are dispensed with at Rheims, and replaced by windows; these are now surmounted by carved groups in the framing gables above. There are two tympana carved on the buttresses flanking the west portals, however, thus extending the sculptural program and giving the impression of five doorways. The portal statues, carved at different times and by different sculptors, now stand side by side, providing considerable contrast of styles. The classicizing Visitation group stands, for instance, next to the Gothic Annunciation group (fig. 418; see fig. 375), but even this last pair was not carved simultaneously: the Virgin is a work by one of the Amiens sculptors, about 1230, while the Angel is some twenty years later. The Angel is by a Rheims sculptor, who frequently gathered angular draperies together, providing rich surface contrasts of light and shade, and who invariably represented faces as smiling. This joyful artist is called the Joseph Master in art-historical literature. A similar, almost lyrical mood is found in the sculpture on the south transept façade of Notre-Dame in Paris (c. 1250), and in the celebrated *Vierge dorée* (the figure was originally gilded) on the trumeau of the south transept of Amiens Cathedral (variously dated between 1240 and 1260; fig. 419).

Elaborate theological programs in stone, involving a large number of sculptors, led gradually to the division of work, to specialization, and not infrequently to something approaching mass-production, with the inevitable lowering of standards. But in big centers and on major sites,

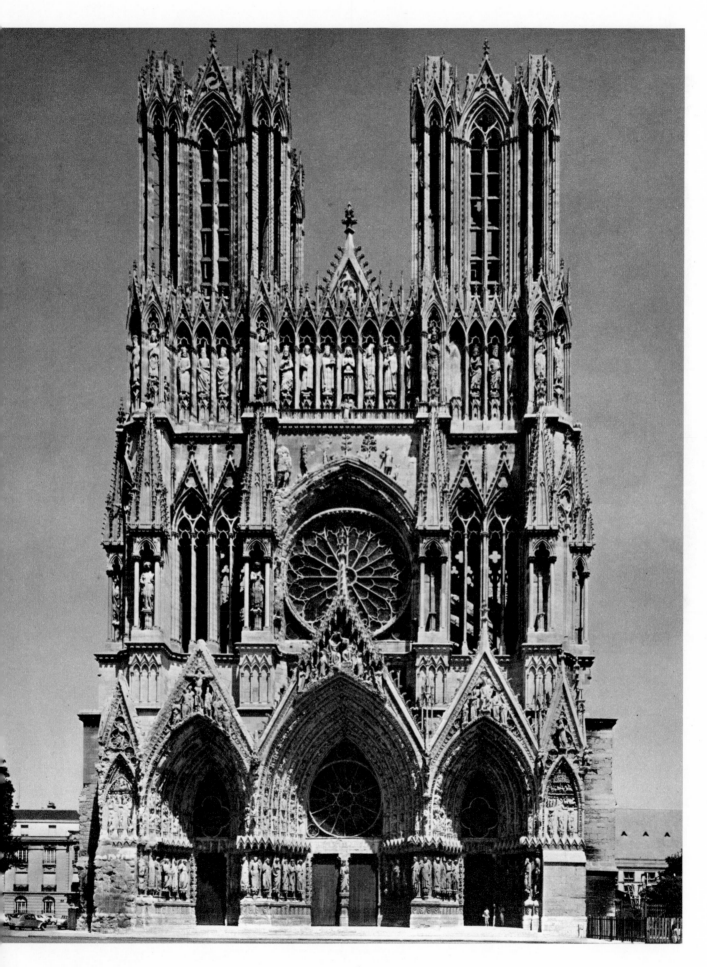

417. West façade, Cathedral, Rheims. 1211–60

images in stone and wood continued to provide interiors with veritable *lapidaria*.

The spread of the "opus francigenum" in architecture and sculpture must surely have been furthered by the foreigners who returned home from the large number of workshops which existed in France during this period. It is, for instance, quite clear that a Bamberg sculptor had previous-

418. *Annunciation*. Column-figures, central portal, west façade. Virgin, c. 1230; Angel, c. 1250. Cathedral, Rheims

419. *Vierge dorée*. Trumeau, portal of south transept. 1240–60. Cathedral, Amiens

the quality and variety remained high throughout. It should not be overlooked that much effort and expense was devoted to the architectural sculpture decorating the interiors; at Rheims, the entire west wall below the rose window is carved with figures in niches and surrounded by naturalistic foliage, and many capitals are covered with delightful genre scenes and with botanically identifiable plants (fig. 420; see color-plate 46). The screens, fonts, retables, and cult

420. *Vintage.* Capital of nave arcade.
Before 1240. Cathedral, Rheims

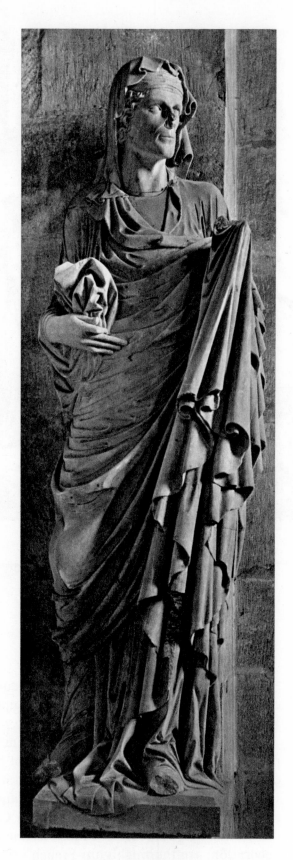

421. *St. Elizabeth.*
Column-figure on pillar in St. George's Choir.
Height 6′ 2″. c. 1230–40.
Cathedral, Bamberg

ly been employed at Rheims and brought home with him the classicizing style (fig. 421; see fig. 375). The sculptor of statues on the west front at Strasbourg was also influenced by Rheims, this time not by the classicizing style but by that of the Joseph Master (fig. 422), making almost grotesque what was already mannered in France by the overemphasis of the expressions and gestures.

The most original and successful German Gothic sculpture is that of the west choir of Naumburg Cathedral (c. 1240). Here, placed against the walls between the windows of the interior, like the apostles of the Ste-Chapelle, are the long-dead benefactors of the see, singly or in pairs, their individual characters portrayed with great sensitivity (colorplate 51). But it is the screen at the entrance to this choir that is a work of singular, touching anguish and expressiveness. On it is a Crucifixion with Mary and

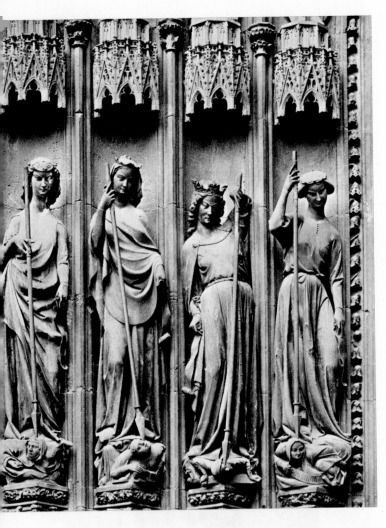

422. *Virtues Trampling Vices.*
Column-figures on left portal, west façade. c. 1275.
Cathedral, Strasbourg

423. *Crucifixion*, at entrance to choir. c.1240.
Cathedral, Naumburg

St. John, a work that is the equal, though so different, of the best work in contemporary France (figs. 423, 424).

In England, the "royal portals" of France had practically no impact. The north transept portal of Westminster Abbey (the principal entrance in the thirteenth century; since replaced) and the related south transept portal of Lincoln Cathedral, although both using French elements of decoration, are thoroughly un-French in apply-

ing them. Instead of solid rows of column-figures, the statues were placed at different heights and at some distance from the entrance, and the stress was not on a comprehensive iconography but on the playful use of decorative devices. Nevertheless, the Gothic style was well established in sculpture by about 1250, both at Westminster (the spandrels in the abbey transepts, and the entrance to the chapter house; fig. 425), and in the later sculpture at Wells Cathedral,

preceded a similar stylistic change in painting. In fact, it is the architecture and sculpture of the *rayonnant* period that was the basis for this change, as can be seen in the Psalter of St. Louis (colorplate 53), executed for King Louis IX shortly after 1250. This lavish book, which contains seventy-eight full-page pictures from the Old Testament, is executed with utmost liveliness, elegance in the poses and gestures, and elongated proportions for the figures. The scenes are set against neutral gold backgrounds and are surmounted by architectural canopies,

424. *St. John the Evangelist,* at entrance to choir. c. 1240. Cathedral, Naumburg

Lincoln following soon after. The naturalistic "botanical" sculpture of Rheims had its early followers in England and culminated in the superb work at Southwell Minster, about 1295.

F. The Court Style in France and England

The emergence of the true Gothic style in sculpture in **Paris**, **Amiens**, and **Rheims** slightly

425. *Angel of Annunciation,* at entrance to chapter house. Height c. 6'. Mid 13th century. Westminster Abbey, London

426. MAÎTRE HONORÉ.
Anointing of David (above);
David and Goliath (below).
Breviary of Philip the Fair. 7 7/8 × 4 7/8″. c. 1296.
Bibliothèque Nationale (Ms. lat. 1023, fol. 7v),
Paris

imitating actual details of the Ste-Chapelle (see colorplate 52). This refined blending of figural and architectural forms, brings to mind sculpture on portals and inside churches, and there is little doubt that it was inspired by them. Several related books, made for the use of Ste-Chapelle and the royal family, illustrate the various stages of this court style, which was undoubtedly due to St. Louis' own taste and patronage.

These books were painted by secular, professional illuminators, who lived in Paris, in adjoining streets, and there is a certain amount of documentary information about their activities and earnings. One such painter was Maître Honoré, first mentioned in 1288, who was commissioned by King Philip the Fair to make a Breviary, for which a payment was made in 1296 (fig. 426). A group of manuscripts ascribed to the master show a development away from decorative architectural accessories; and while the figures continue to be graceful and mannered, they are given more substantial volume, chiefly by the heavy folds of their drapery, modeled by subtle use of light and shade. These are the hints of Italian influences on French painting. In the next generation, most notably in Jean Pucelle, they were to lead to an interest in pictorial space, a concept which heralded the end of old, medieval traditions.

The dominance of Paris as an artistic center during the lifetime of St. Louis and his immediate successors is well reflected in English painting. Unfortunately, the wall paintings in Westminster Palace, dating from the 1260s and 1270s, perished during the nineteenth century and are known only from imperfect copies. But in manuscript painting the close connections with Paris are very clear, as seen in the Apocalypse (known as the Douce Apocalypse; fig. 427) painted for Henry III's son Edward and Edward's wife Eleanor of Castile, before his accession to the throne as Edward I in 1272. The treatment of the figures, with their small heads and elongated bodies, resembles the French court style, and the heavy draperies are also unmistakably Parisian, though more linear than those used by Maître Honoré. As in English sculpture, in painting also the English frequently transformed their French models by the more angular treatment of the folds and by exaggerated poses and even expressions. This is certainly the case in the Oscott Psalter of about 1270 (fig. 428).

There survives in Westminster Abbey a much

427. *St. John on Patmos*. Douce Apocalypse.
12 1/4 × 8 5/8″. Before 1272. Bodleian Library
(Ms. Douce 180, fol. lr), Oxford

428. *David Harping. Oscott Psalter.*
Illumination 7 7/8 × 4 3/8″. c. 1270.
British Library (Ms. Add. 50000, fol. 15v), London

damaged retable from the end of the thirteenth century; it is a panel painting of great refinement in which the French court style is reinterpreted in accordance with the English taste for exaggerated forms, elongated and slim, and for lavish decoration by means of inserted glass, stones, and imitation cameos made of gesso. But the most particularly English feature are the *drôleries* which began, during the thirteenth century, to invade the margins of books. At first restrained, they increased in importance and variety as time went on. In them, medieval humor found a wonderful outlet, and they provide a mine of precious information about, among other matters, contemporary costumes, customs, musical instruments, social behavior, and eccentricities. Such marginalia were also used to decorate religious books—for instance, the Psalter of Alfonso (King Edward's son, d. 1284; fig. 429), and the Queen Mary Psalter of about 1310 (fig. 430). In this last manuscript there are large

pictures in architectural frames; below is the text, starting with a historiated initial; and further below, on the lower margin, is a tinted drawing of a grotesque subject. *Drôleries* were employed in France by Maître Honoré and Pucelle (see fig. 473), probably under English influence, but the first ones were timid in comparison with the English practice.

The provenance of the Queen Mary Psalter is not known, but it is related to a number of

429. *Drôlerie*. Psalter of Alfonso. 1284.
British Library (Ms. Add. 24686, fol. 17v),
London

430. Page with main illumination,
historiated initial, text, and *drôlerie*.
Queen Mary Psalter. 7 × 4 1/2". c. 1310.
British Library (Ms. Roy. 2B. vii, fol. 168v),
London

present in the works of Honoré and Pucelle, were transmitted to England. By the second quarter of the fourteenth century, however, it must be assumed that there were direct artistic influences from Italy. The *Crucifixion* scene in the Gorleston Psalter (fig. 431) is proof that its author knew something of the art of Duccio (see fig. 470). From then on Italian inspiration in English art was on the increase, to be grad-

books associated with East Anglia. These books were mainly commissioned by lay patrons, but it is uncertain where the center of their production was. It should be remembered that East Anglia was very prosperous at that time, thanks to the export of wool in large quantities to the Continent. Manuscripts of this group, such as the Peterborough Psalter (colorplate 55), are characterized by pages richly framed with *drôleries*. The Peterborough Psalter was thought worthy of a king and a pope, as it belonged for a time to Pope John XXII and then was purchased, in 1328, by Philip VI of France.

The influence of the French court style in England meant that some Italianate elements, also

papal inventory lists 113 items in the possession of the Vatican.

Among the works commissioned by St. Louis about 1260, a group of tombs holds an important place. Some of these tombs were made for the early French kings buried at St-Denis; others were for members of Louis' family, buried at Royaumont Abbey near Paris, the king's favorite foundation (these tombs are now also installed

431. *Crucifixion*. Gorleston Psalter.
Illumination 10 1/8 × 6 3/4". 2nd quarter 14th century.
British Library (Ms. Add. 49622, fol. 7r),
London

ually superseded by that from the Netherlands.

English craftsmen of the thirteenth and fourteenth centuries were supreme in the field of embroidery (fig. 432). Known as *opus anglicanum*, this work was used predominantly for ecclesiastical vestments, and is characterized by complicated figure subjects within architectural frames, executed in bright silks combined with gold. These embroideries are related stylistically to illuminated manuscripts. The fame of English embroideries was widespread, and in 1295 a

432. Chasuble (back) with *Trinity* (above),
Adoration of the Magi (center),
and *Annunciation* (below).
Red velvet embroidered with metal and silk
threads in *opus anglicanum*.
1st third 14th century.
Metropolitan Museum (Fletcher Fund, 1927),
New York

at St-Denis). The tomb of Dagobert I (fig. 433), who died in 639, was crowned by a canopy, and this form became increasingly popular. Equally influential was the tomb of the king's son, Louis de France (d. 1260; fig. 434), which has an arcade around the tomb-chest consisting of figures in high relief showing the funeral procession. This type was made famous later by Claus Sluter's tomb of Philip the Bold. The effigies on thirteenth-century tombs were idealized, with no attempt at portraiture, and the true portrait was the achievement of the next century. The first hints at portraiture, though still tempered by a stylized treatment of the hair and eyes, are to be found on the early fourteenth-century tomb of Philip IV the Fair (d. 1314).

433. Cenotaph of Dagobert I (d. 638).
Commissioned by Louis IX, 1263–64. Abbey Church, St-Denis
(destroyed; engraving by Montfaucon, 1729)

434. Tomb of Louis de France (d. 1260).
Commissioned by Louis IX, 1263–64. Abbey Church, St-Denis

XIII

Later Gothic Art

ENGLAND AND FRANCE

The sumptuous surface decoration of Westminster Abbey was symptomatic of things to come in the development of English Gothic and, later, of European Gothic architecture. In England the phase between about 1280 and 1375 is termed the Decorated style, during which English buildings evolved exuberant forms which anticipate the late Gothic in Germany and France. At Exeter Cathedral (1280–1350; fig. 435) and in the eastern parts of Wells Cathedral (started in 1285) the decorative effect of every detail is emphasized, the moldings are multiplied, and the ribs of the vaulting project boldly from the vault surfaces and their numbers increase. At Wells there are eleven ribs springing from each bay boundary, producing the impression of an overwhelming richness in the linear forms and an ambiguous play of light and shade. At Bristol—St. Mary Redcliffe, and the Augustinian monastery that is now Bristol Cathedral—ingenious vaulting solutions were devised, and at Wells four so-called strainer arches were inserted between the crossing piers in 1338 (fig. 436) dictated by the demands of stability but contributing an element which is at once highly decorative and somewhat ambiguous. One of the most daring works of the fourteenth century is the crossing tower of Ely Cathedral (fig. 437), rebuilt between 1323 and 1330 on an octagonal plan in deliberate contrast to the rectangular Romanesque transept and nave and to the early Gothic choir. The stone octagon supports a timber roof and an octagonal lantern which seems to be suspended in mid-air.

The same tendency toward effects of surprise and richness is found in a series of English cano-

435. Interior toward east,
Cathedral, Exeter.
1280–1350

pied tombs, in which sculptural and architectural elements complement each other. Initiated in France, canopied tombs are evidence of the widespread influence of French tomb sculpture (see page 410). One of the earliest of the English tombs of this type was for Edmund Crouchback (fig. 438), earl of Lancaster and the youngest son of Henry III, who died in 1296 and whose tomb in Westminster Abbey adjoins two others of a similar type. Even richer and more complex is the canopied tomb of Edward II (d. 1327) in Gloucester Cathedral. All these tombs are works of sculpture set in a very rich architectural setting; similarly, all possible surfaces of a building become covered with lavish decorative sculpture, making use in unexpected ways of the effects of motion—three-dimensional ogee arches, so-called nodding arches, interpenetrating moldings, and buttresses or gables set at acute angles to the wall surfaces. The window traceries are increasingly complex in their design (fig. 439), and at times carved with figures on the inner faces, as at Dorchester Abbey.

One feature of the French *rayonnant* style was the extension of window traceries to cover adjacent wall surfaces, for no other than decorative reasons. This device was used as early as 1248 in the cathedral at Clermont-Ferrand; and as already mentioned (see page 391), this led to an eccentric development at Strasbourg Cathedral, where such traceries become detached from the wall and appear to be enclosing it like a cage. Under the inspiration of this French method English architects developed it into a highly original version of late Gothic style, known as the Perpendicular style. It originated in London, but the best examples that now survive are found elsewhere. The early Romanesque choir of Gloucester Cathedral was reshaped in the 1330s into a striking illustration of the new style (fig. 440). The east wall is replaced by a huge window, its traceries equally stressing vertical and horizontal elements. The Romanesque side walls are covered with thin, crisp traceries.

436. Arches of crossing, Cathedral, Wells. 1338

437. Interior of crossing-tower, Cathedral, Ely. 1323–30

The vaulting now consists of a network of short so-called *liernes,* or subordinate ribs, that form numerous cells between the main ribs, and the decorative effect is further increased by placing carved bosses at the points where the ribs join.

The inventiveness of English builders in devising ever more complex vaults is further demonstrated by the invention of fan vaulting, using conelike forms. First appearing before 1377 in the cloister of Gloucester Cathedral (fig. 441), it was perfected during the fifteenth century and used in a number of late Gothic royal buildings, at Windsor, in Westminster Abbey (Chapel of Henry VII, begun 1503; colorplate 56), and in King's College Chapel at Cambridge (fig. 442).

No greater contrast can be drawn than between this lavishness and the austerity of the buildings connected with the new Orders of

438. Tomb of Edmund Crouchback,
Earl of Lancaster. c. 1300. Westminster Abbey, London

440. Interior of choir toward east, ▶
Cathedral, Gloucester. Rebuilt c. 1330

439. Rose window, southwest transept,
Cathedral, Lincoln. 1325–50

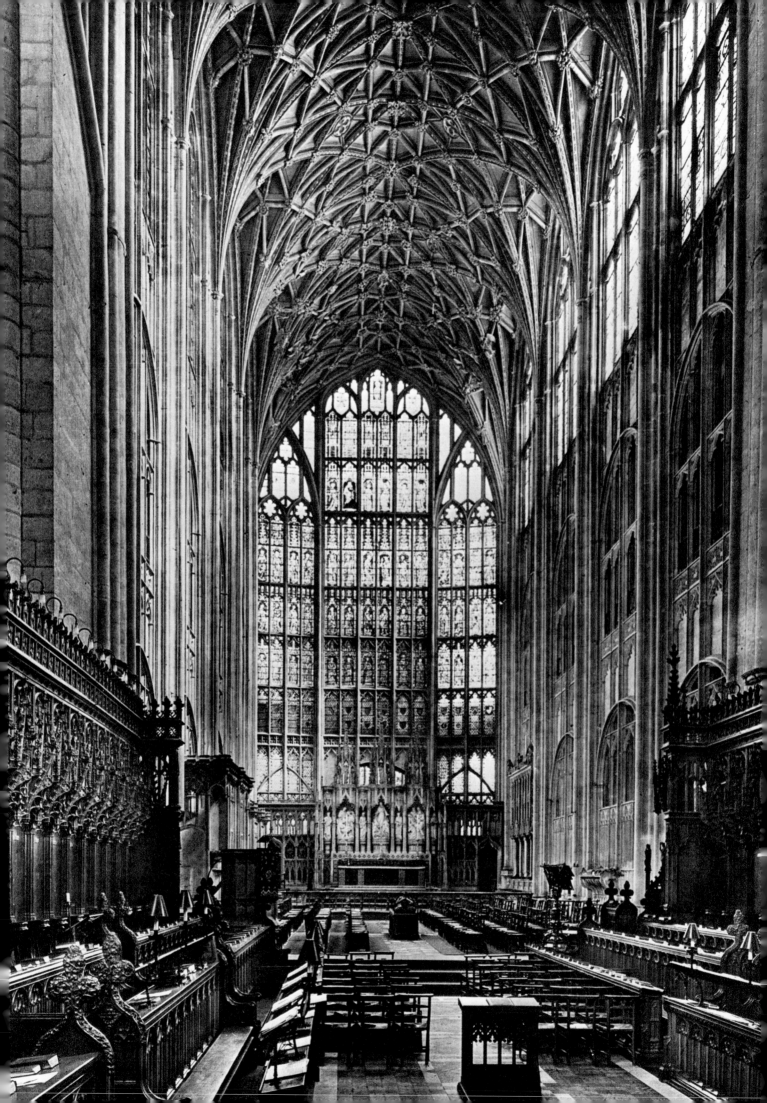

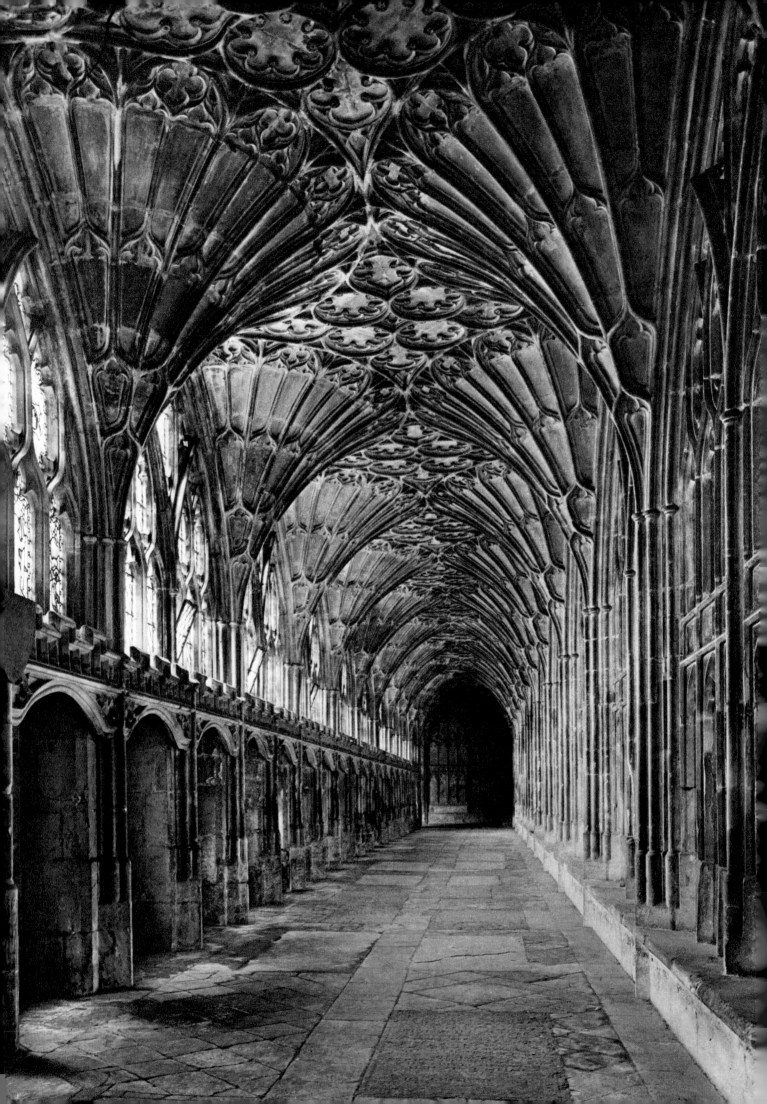

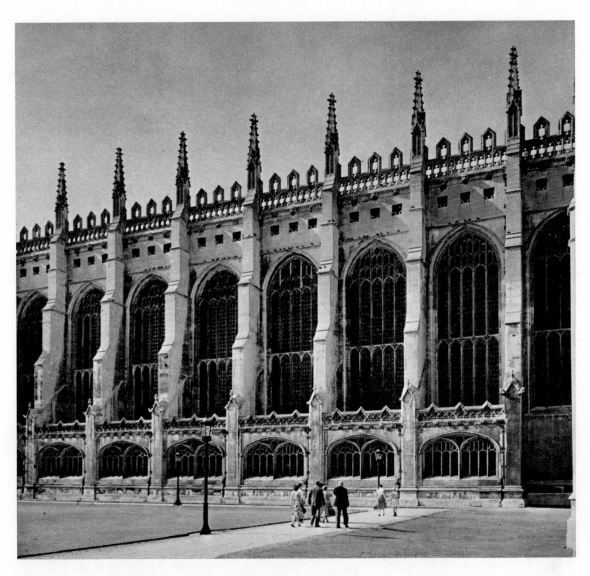

442. Exterior from south, Chapel,
King's College, Cambridge (England). 1446–1515

◀ 441. South cloister, Cathedral, Gloucester. Before 1377

mendicant friars which were founded in the thirteenth century: the Franciscans in 1209 and the Dominicans in 1216. The strict discipline of poverty precluded the friars from carrying out extravagant building programs, at least at first. Since their main goal was to teach through preaching, their churches were designed for large congregations and were devoid of lavish ornament. San Francesco at Assisi (1228–53; figs. 443, 444) cannot be termed typical because it is a two-story church, but the upper structure set a pattern for unified, aisle-less buildings, so suitable for the preaching of sermons. Not all the Italian churches built for friars were of this type: some were aisled (S. Croce, Florence; fig. 445), some were vaulted (S. Maria Novella, Florence), and others had trussed or flat ceilings. But all of them are roomy, and offer the congregation an unimpaired view of the altar and the pulpit. As the mendicant Orders spread

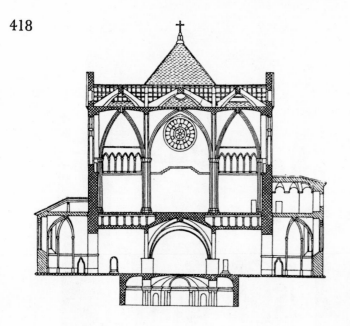

rapidly throughout Europe, similar designs were followed, or new types were attempted which had the same aim, namely, that of providing large assembly halls. In France, for instance, a two-naved church was built at Toulouse by the Dominicans (fig. 446), and its austerity is reflected in the aisle-less cathedral at Albi (begun 1282; fig. 447); the exterior of this remarkable building brings to mind a fortress rather than a church. In Germany, the type of church favored by the mendicant Orders was the *Hallenkirche*, or hall church, having aisles of the same height as the nave. This type was adopted throughout

443, 444.
San Francesco, Assisi. 1228–53.
(*above*) Transverse section.
(*below*) Interior of Upper Church toward apse (west)

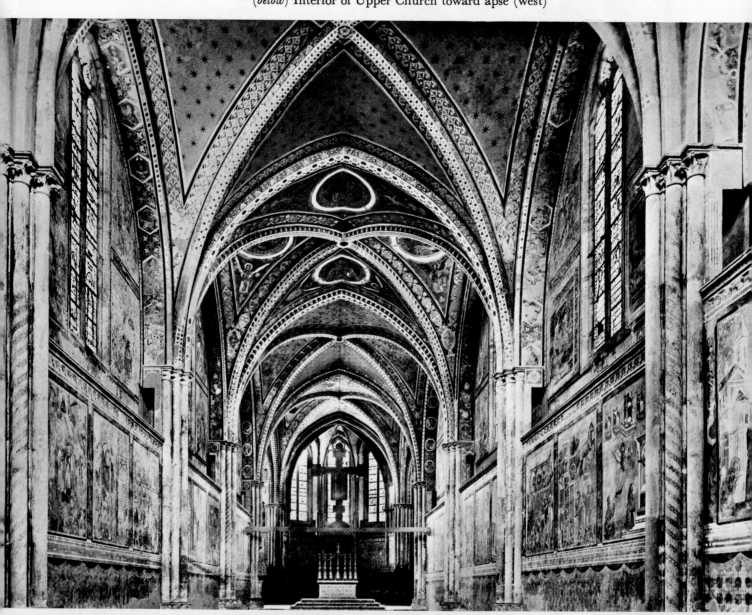

445. Interior toward east,
S. Croce, Florence. Begun 1294

tinguished family of German master-masons (fig. 449). Parler died in 1399, without completing the building. Numerous features of Parler's building are ultimately of English inspiration, and it is not improbable that he had some first-hand knowledge of English churches. But the Decorated style also exercised some influence on the architecture of the Teutonic Order in their territories on the Baltic, and these English

446. Interior toward east,
Jacobin Church, Toulouse. 1230–92

central and eastern Europe, and not only for the use of the friars: one of the most elegant is the hall choir added to St. Lorenz at Nuremberg (1439; fig. 448), with very high piers supporting vaults of which the ribs form intricate patterns that are clearly inspired from England.

During the second half of the fourteenth century the most creative artistic center in the Empire was Prague, the seat of the imperial court of Emperor Charles IV (1346–78). The cathedral at Prague, started under the emperor's patronage, was first designed by a French architect, but on his death in 1353, the work was taken over by Peter Parler, a member of a dis-

447. Exterior from east, Cathedral, Albi. Begun 1282

features were, in turn, taken up in Silesia and Bohemia. So Parler's design for Prague Cathedral is not entirely unexpected. In the sculpture which decorates the building, however, especially the busts in the triforium of the choir by Parler (fig. 450), representing members of the royal family and a self-portrait, there is a broad, monumental treatment of forms and a naturalism which were not present in the English sculpture of the period.

Among the artists employed by Charles IV were several Italians, whose activities in Prague profoundly affected the development of the arts north of the Alps (see page 446). Similarly, Parisian art of the second half of the fourteenth century was increasingly indebted to Italian influences, coming either directly or by way of Avignon, where successive popes made their headquarters between 1309 and 1378.

Not surprisingly, English art could not remain unaffected by these developments, and Italianate elements are clearly distinguishable in the wall paintings at Westminster (St. Stephen's Chapel, and in the Abbey). With the marriage of Richard II in 1382 to Anne of Bohemia, daughter of Charles IV, artistic contacts were established between London and Prague. The bronze gilt effigies of the royal couple in Westminster Abbey were made in 1397, three years after Anne's death but still during Richard's lifetime (fig. 451). They are undoubtedly unflattering portraits. It is known that death masks were being made during the fourteenth century, and sculptors used these to make faithful reproductions of the features of the deceased. This was the case, for instance, with the bronze effigy of Bishop Wolfhart von Roth (d. 1302; fig. 452) in Augsburg Cathedral; the ascetic face, with skin sagging and eyeballs protruding, is a striking portrait of a dead person.

This interest in an exact portrayal of the dead coincides with the great popularity, particularly in Germany, of images in painting and sculpture depicting the Passion of Christ. It was during the

448. Interior of choir,
St. Lorenz, Nuremberg. Begun 1439

fourteenth century that new iconographic representations of the suffering or dead Christ made their appearance, stimulated by the mystical writers of the period. One such new iconographic subject was the *Pietà*, the Virgin Mary holding on her knees the dead body of Christ (fig. 453). The Crucifixion, always a popular subject, now took a new form, in which the agony and ugliness of death was shown with exaggerated

449. Interior from southwest, Cathedral, Prague.
2nd half 14th century

450. PETER PARLER. *Portrait of Charles IV,*
bust in triforium of apse. Width of base c. 19″. 1353–78.
Cathedral, Prague

vividness (fig. 454). As in tomb portraiture, death masks could provide a model, so the Crucifixions were based on well-observed features distorted by pain; there was also an obsessive interest in representing Christ's wounds with blood pouring from them. These morbid tendencies received further stimulus from that great disaster which engulfed the whole of Europe between 1347 and 1350, namely, the Black Death. The plague reduced the population of Europe by about one third, and had far-reaching economic and social consequences. The Hundred Years War added to the turmoil and the economic exhaustion of the two adversaries, England and France. The Great Schism of 1378 to 1417 divided the Church into opposing factions led by two, at times even three concurrent popes. It was a period of unrest, of insurrection among peasants and workmen; a time of doubt, of the questioning of centuries-old beliefs and institutions. The end of the Middle Ages was in sight.

451. Tomb of Richard II and Anne of Bohemia.
Gilt bronze. 1397. Westminster Abbey, London

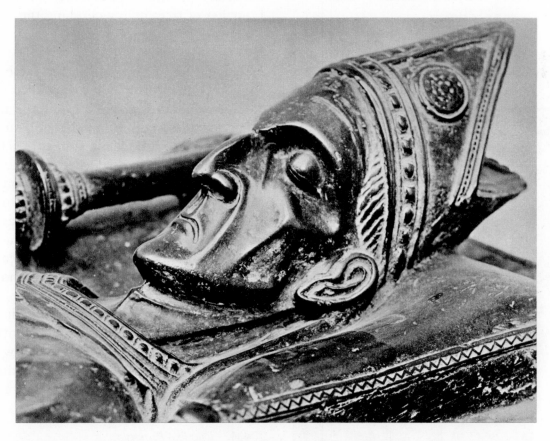

452. Tomb of Wolfhart von Roth (detail).
Bronze. c. 1302. Cathedral, Augsburg

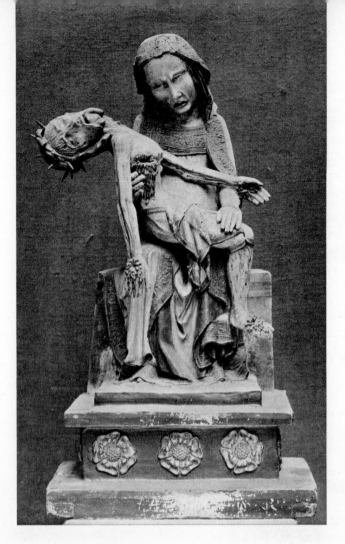

453. *Pietà*. Wood, painted; height 34 1/2".
Early 14th century. Landesmuseum, Bonn

The fourteenth and fifteenth centuries saw the transformation of the earlier stages of French Gothic forms into local architectural styles of high originality in various regions of Europe, most notably in England, Germany, and Spain. Meanwhile in France the last form of Gothic, known as *flamboyant*, made its appearance. Taking its name from the flickering of flames, the style relies on the undulating movement of forms applied to wall surfaces, to spires, and, above all, to porches (fig. 455). There is a particular abundance of *flamboyant* churches in the north of France, from Brittany to Flanders, and this concentration reinforces the belief that this style developed under the influence of the Decorated style in England. For all their differences of detail, the various national styles of Gothic architecture reflect the same technical virtuosity put to the service of an ever-increasing richness of picturesque forms, a far cry from the rational and sober Gothic of the thirteenth century. Whether of stone or brick, the forms defy the material, at times pretending to be twisted branches of trees or ivy climbing the walls.

ITALY

Italy alone had little or no part in these pursuits. French Gothic forms never took deep root, and Romanesque and, above all, antique traditions remained a constant stimulus there. In Giovanni Pisano's façade of Siena Cathedral (1285–95) Gothic elements are used side by side with those derived from Tuscan Romanesque and provide a background for large agitated statues. (For Giovanni's pulpit sculpture, see page 438.) The slightly later cathedral at Orvieto was still essentially Romanesque, with the façade by a Sienese master, Lorenzo Maitani, who worked there between 1310 and 1330 (figs. 456–58). Two drawings for this façade survive; the first, which was never executed, draws substantially on French ideas, but the second, which with some modifications was carried out, abandons the verticality of the previous design and reverts to

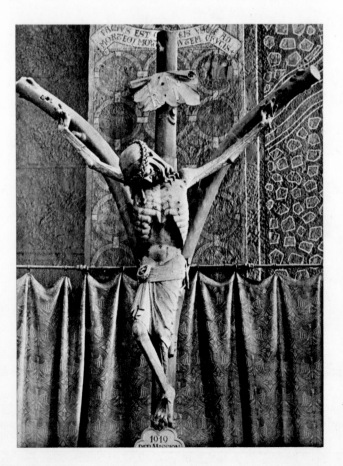

454. *Crucifix (Pestkreuz)*.
Wood, painted; height 57". 1304.
Schnütgen Museum, Cologne

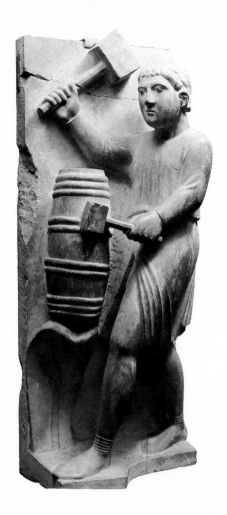

Colorplate 50.
BENEDETTO ANTELAMI. *August: A Cooper Prepares Wine-cask.*
Late 12th century. Baptistery, Parma

Colorplate 51.
Ekkehard and Uta.
c. 1240. Choir,
Cathedral, Naumburg

Colorplate 53. *Gideon's Army Surprises the Midianites.*
Psalter of St. Louis. Illumination 4 3/4 × 3 5/8''. After 1253.
Bibliothèque Nationale (Ms. lat. 10525, fol. 52r), Paris

◀ Colorplate 52. Interior of upper chapel toward east,
Ste-Chapelle, Paris. 1243–48

Colorplate 54.
West portal
(*Porte Royale*),
Cathedral, Chartres.
1145–55

Colorplate 55. Page with Initial D, and Psalms 109 and 110.
Peterborough Psalter. 11 3/4 × 7 5/8″. c. 1300.
Bibliothèque Royale Albert 1ᵉʳ (Ms. 9961, fol. 74r), Brussels (copyright)

Colorplate 56. ▶
Interior toward east, Chapel of Henry VII,
Westminster Abbey, London. 1503–19

Colorplate 57. NICOLA PISANO.
Pulpit. 1259. Baptistery, Pisa

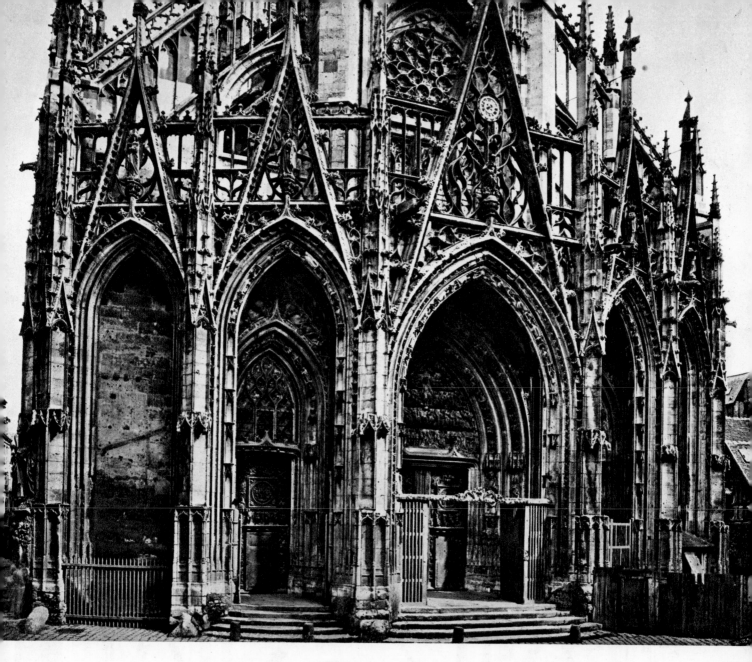

455. West façade, St-Maclou, Rouen. Begun 1434

the traditional Italian layout in which only secondary details are Gothic. The sculpture of the façade is remarkable in quality, but it is worth mentioning that the design of the central portal is almost Romanesque, save for the group of the Virgin and Child with attendant angels, placed in front of the tympanum, which reflects the Parisian style of nearly a hundred years earlier; the reliefs on the wall surface between the doorways follow not the Gothic but the Romanesque practice.

From such evidence it must be concluded that Italian architects and sculptors, though they knew about Gothic art north of the Alps, were prepared to adopt from it only minor features, and remained faithful to their local traditions. Their knowledge was not restricted to French Gothic, for at times there are indications of direct contact with Germany. The projected façade of the Baptistery of Siena Cathedral, for instance, preserved in a parchment drawing of about 1382, included statues of the Annunciation, the Virgin and Archangel Gabriel set behind a balustrade on either side of the base of the gable; this

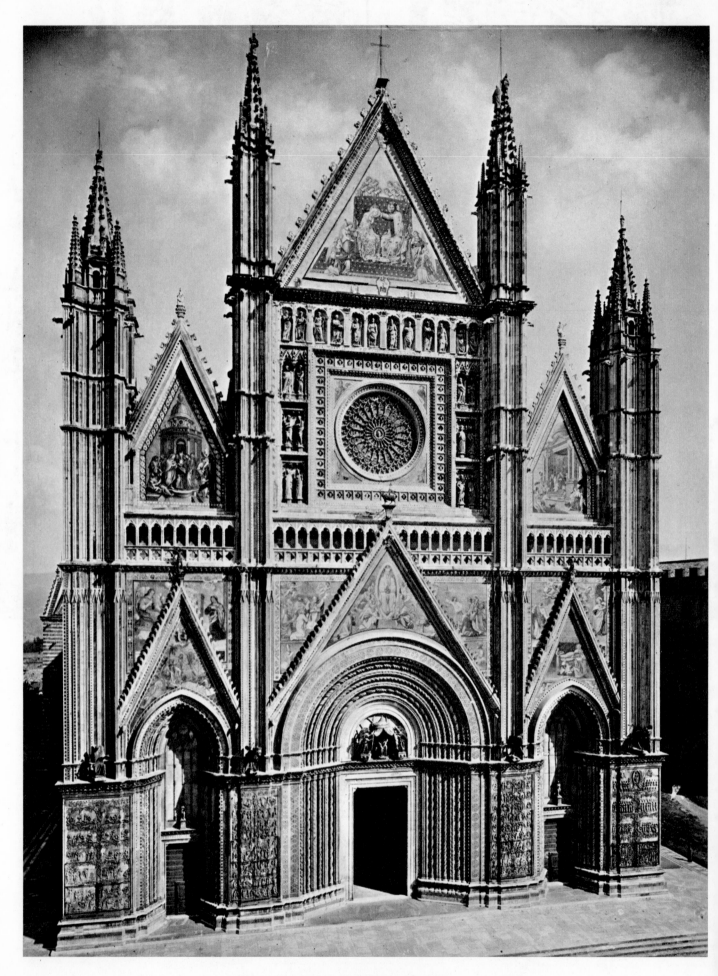

456. West façade, Cathedral, Orvieto. c. 1310

457, 458. LORENZO MAITANI. Sculptures on west façade,
Cathedral, Orvieto. 1310–30.
(*above*) *Madonna and Angels,* in lunette above central portal.
(*below*) *Creation Scenes,* on north pier

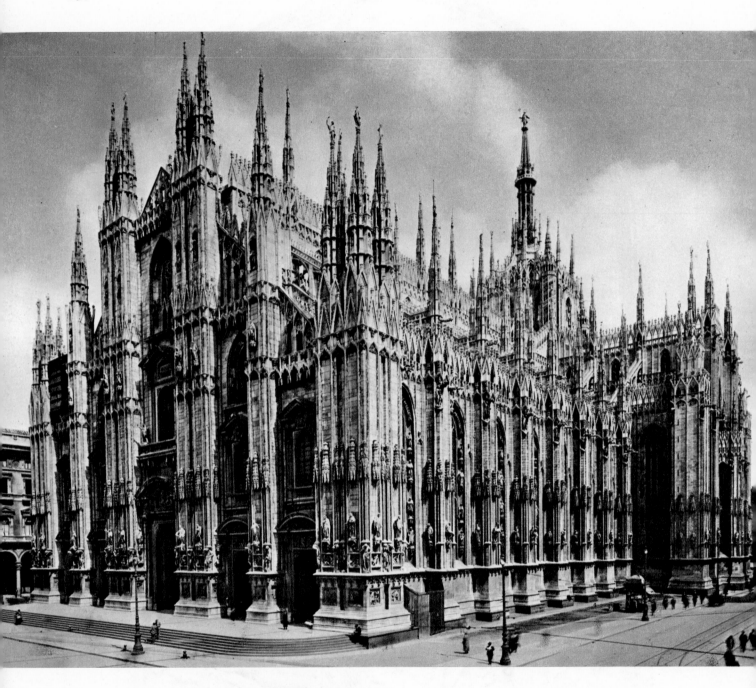

459, 460. Cathedral, Milan. Begun 1387.
Exterior from southwest, and Plan

arrangement aims at a spatial illusion reminiscent of that at the Marienkirche of Mühlhausen, in Thuringia (c. 1370), where busts of the emperor Charles IV and his wife seem to lean over the balustrade of the south transept as if to greet the people. A similar stagelike device was used, under German influence, on the south portal of the façade of Exeter Cathedral, the two half-length figures presumably representing Richard II and Anne of Bohemia. The best-known example of this Gothic illusionism, though of a later date (1442–53), is found in the sculptural decoration of the house of Jacques Coeur at Bourges.

However, an Italian building that is unquestionably Gothic is Milan Cathedral, started in 1387 and built amid the frequent dismissal of architects, some coming from France or Germany, and interminable discussions about problems of stability, proportion, and the beauty of the church (figs. 459, 460). In plan and elevation it derives distantly from Bourges Cathedral (see fig. 354). Externally, though much of the detail is now nineteenth-century restoration, it is the most *rayonnant* building in Italy, its flat surfaces not filled with mosaics, as in so many other Italian churches, but with tracery paneling and a wealth of Gothic decorative detail.

The cooperation of northern and Italian artists on this vast project around the year 1400 was, in a sense, symbolic of the trend in Gothic art which is known under the somewhat misleading term of International Gothic. At that time the courtly art at Paris, Prague, London, Milan, and many other centers shared certain common characteristics. In painting and in sculpture, the almost sentimental, mannered elegance of pose and gesture of the figures was northern, the solidity of the figure structure was Italian.

For Italian Gothic has a twofold aspect: on the one hand, it is a local or regional variant of "opus francigenum," more conservative and subject to persistent local traditions, including the antique; on the other hand, it is also the

dawn of the Renaissance era through the great innovations of such artist as Giotto and Duccio. The latter aspect cannot be fully explored in this volume but will at least be hinted at.

Italian Gothic sculpture starts with Nicola Pisano (active 1259–78), who combined the use of the northern Gothic drapery style with a realism, especially in the treatment of heads, that is based not so much on observation of live models as on antique sculpture (fig. 461). Documents

461. NICOLA PISANO. *Personification of Strength,*
on Pulpit. Height 22″. 1259.
Baptistery, Pisa (see colorplate 57)

462. Nicola Pisano. *The Damned,* portion of *Last Judgment,* on Pulpit.
Panel 33 1/2 × 38 1/4". 1265–68.
Cathedral, Siena

refer to him as a native of Apulia, and thus it is often assumed that he was trained in southern Italy in the atmosphere of rigid classicism of the sculpture employed for propaganda purposes by Emperor Frederick II (1220–50). But as late as the second half of the twelfth century a remarkable group of pulpits were carved in southern Italy, as at Salerno, for instance (see fig. 247), displaying some elements of classicism which could have inspired young Nicola. But for his own pulpit (1259–60; colorplate 57) in the Baptistery of Pisa Cathedral he goes far beyond these earlier models in his ability to handle crowded groups in his reliefs, giving them an illusion of depth and space. In his other pulpit, in Siena Cathedral (1265–68; fig. 462), the northern influence increased. This applies also to the sculpture of his son Giovanni: the marble pulpit in Pisa Cathedral (1302–10; fig. 463) and for the cathedral and baptistery at Siena.

For all his debt to antique models Nicola's drapery, with its angular folds, is unthinkable without a knowledge of French Gothic sculpture; this is even more true of the drapery style of

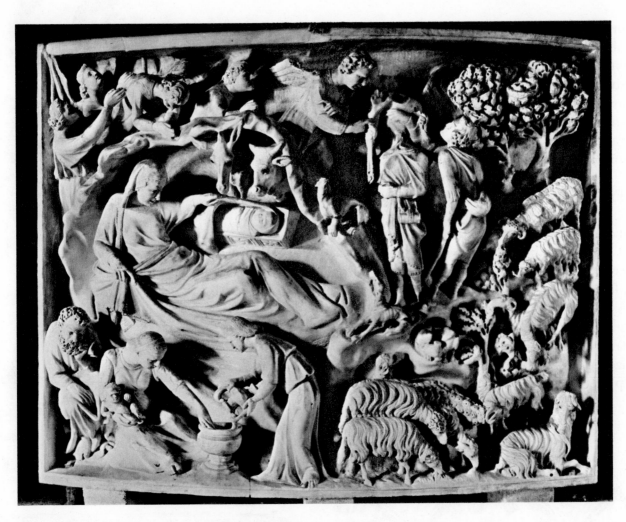

463. GIOVANNI PISANO. *Nativity,* on Pulpit.
34 3/8 × 43″. 1302–10.
Cathedral, Pisa

his son Giovanni. If, however, the style of the Joseph Master at Rheims provides a probable source for Nicola's draperies, Giovanni's more dramatic, agitated treatment of the human figure suggests influences from Germany; the sculpture at Strasbourg provides a somewhat parallel development. It is unfortunately not known whether either of the Pisani crossed the Alps and saw Gothic sculpture at first hand, but it is more likely that they were influenced by the movable objects made of metal, wood, or ivory which circulated throughout Europe. The major

center of production of such objects was Paris, and from the middle of the thirteenth century onward this center excelled especially in ivory carving. It was through ivory diptychs, triptychs, and devotional figures, made in Paris for local use and for export, that the elegant Parisian Gothic style became widely known and French fashions were transmitted to all the countries of Europe (fig. 464).

The art of Nicola and Giovanni set the development of Tuscan sculpture on a new course. Arnolfo di Cambio, the pupil of Nicola, exercised

a profound influence on sculpture, especially tomb sculpture, in Rome, where he was employed during the last quarter of the thirteenth century. Roman sculpture was at that time still dominated by mediocre *Cosmati* work; the first effigies appeared about 1270 under French inspiration, and it is significant that the earliest among these, as well as the most outstanding, is the tomb of the French pope Clement IV in S. Francesco at Viterbo. Arnolfo's monumental style introduced the new Gothic idiom into what had been hitherto a rather conservative output, and Italian tomb sculpture owes to him its subsequent rapid development into a highly original art form (fig. 465).

As remarked above (see page 424), the façade of Orvieto Cathedral, with its extensive sculptural decoration, was also due to a Tuscan, Lorenzo Maitani. And at the Angevin court in Naples the exponent of Gothic sculpture was

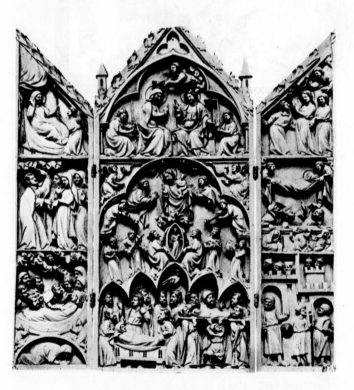

464. Ivory Triptych. 14th century.
Bibliothèque, Amiens

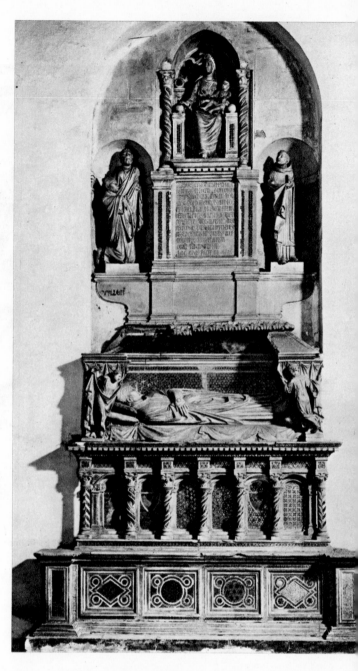

465. ARNOLFO DI CAMBIO. Tomb of Cardinal de Braye.
Height c. 19'. After 1282.
San Domenico, Orvieto

Tino da Camaino (d. 1337), born and trained in Tuscany.

These developments in Italian sculpture, while demonstrating some stylistic links with northern Gothic, followed, like Italian architecture, a rather independent course. There are no "royal portals" in Italy, few column-figures or

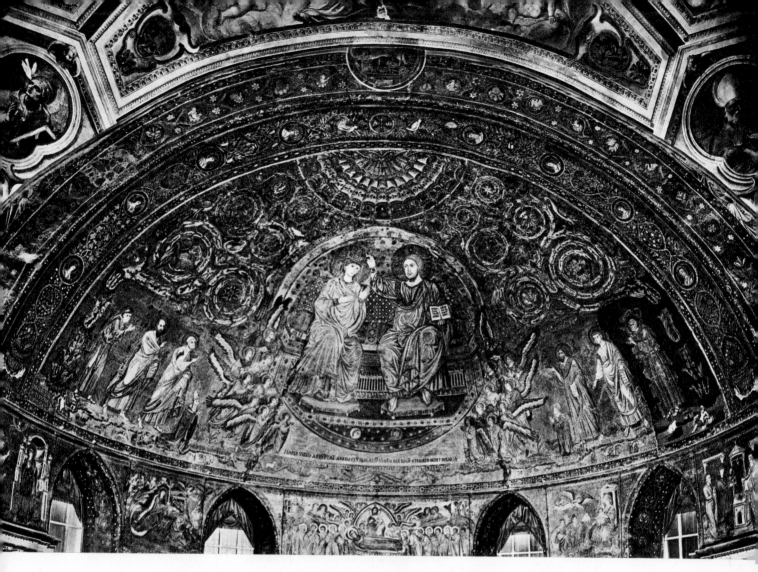

466. JACOPO TORRITI. *Coronation of the Virgin.* Apse mosaic. c. 1295.
Santa Maria Maggiore, Rome

tympana. Church furnishings, especially pulpits and tombs, and statues in niches on church façades were the chief vehicle for sculptural work. The role of painting, mosaic, and multicolored marble was as important as sculpture in the decoration of church façades.

The reduction of wall surface in favor of large windows in the *rayonnant* churches had profoundly influenced the history of painting north of the Alps. Mural painting lost much of the importance it had had during the Romanesque period, and large schemes of decoration in this medium were usually found only in secular buildings. In Italy the architectural changes during the thirteenth and fourteenth centuries were less

radical than in the north, and large wall surfaces continued to be decorated in the traditional manner with mosaics and wall paintings; the Romanesque style maintained its existence throughout the greater part of the thirteenth century (e.g., frescoes in the church of the SS. Quattro Coronati, Rome, 1246). Measured against this conservatism, the changes in Italian painting which took place in the last quarter of the thirteenth century are very significant and foreshadow the revolutionary developments of the next century.

In the surviving works of Cimabue, Jacopo Torriti (fig. 466), and Pietro Cavallini (fig. 467; see fig. 247), and in the earliest frescoes by the

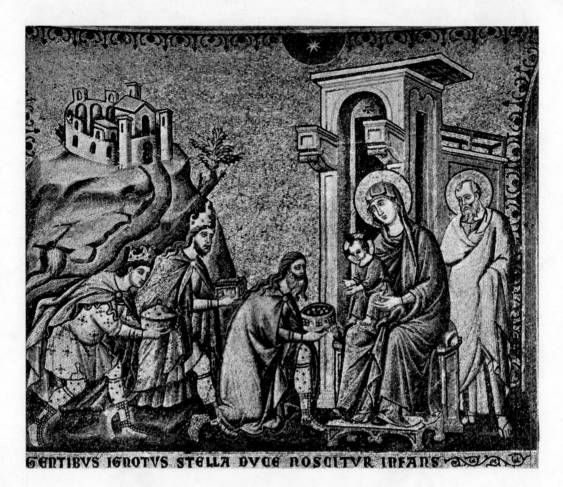

GENTIBVS IGNOTVS STELLA DVCE NOSCITVR INFANS

467. PIETRO CAVALLINI. *Adoration of the Magi.*
Mosaic frieze below apse mosaic. 1291.
Santa Maria in Trastevere, Rome

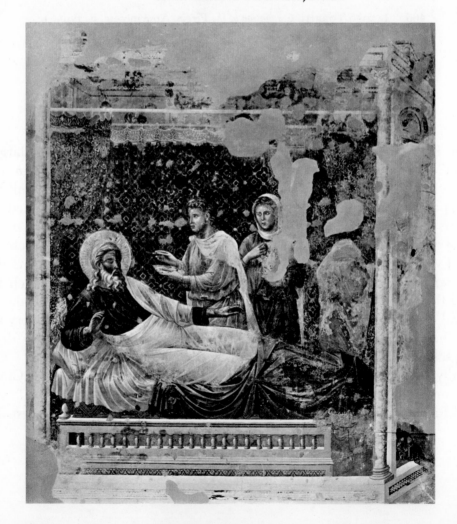

468. THE ISAAC MASTE[R]
Isaac Rejects Esau.
Fresco. 1290s (?).
Upper Church,
S. Francesco, Assisi

so-called Isaac Master in the upper church of S. Francesco at Assisi (fig. 468), the link with Byzantine traditions is clearly discernible. But there is also a striving toward a solidity in the figures and a more convincing spatial relationship among them—and, in the work of Cavallini, toward a more logical use of light and shade.

As mentioned above (see page 336), Byzantine painters from the thirteenth century on turned their attention to problems of spatial perspective. Even if their solutions were far from com-

pletely successful, there can be little doubt that Italian painters of the generation preceding Giotto were aware of this development and took it up with great enthusiasm, thus preparing the way for the achievements of Italian painting of the fourteenth century, and especially the work of Giotto himself. When the papal court settled in Avignon, in 1309, Rome declined as an artistic center but it was earlier Roman painting, of the generation of Cavallini, and the sculpture of Arnolfo di Cambio that inspired Giotto's

469. GIOTTO. *Vision of Joachim.*
Fresco, 6′ 6″ × 6′. After 1305. Arena Chapel, Padua

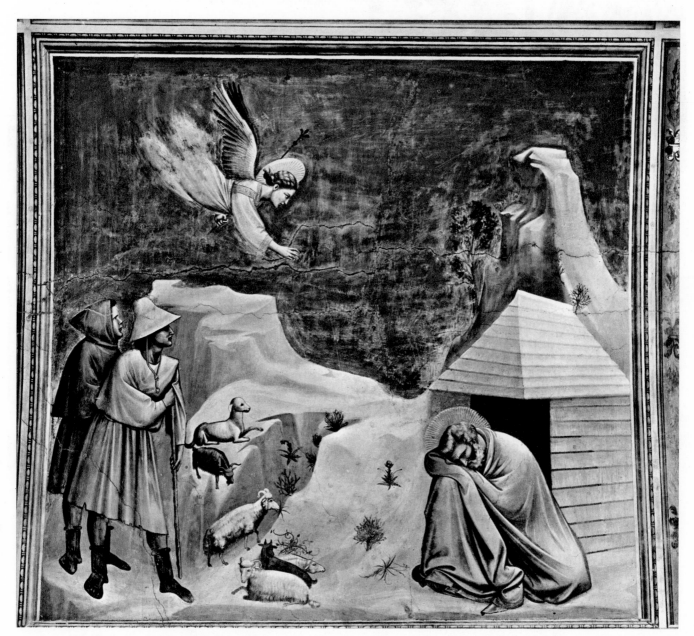

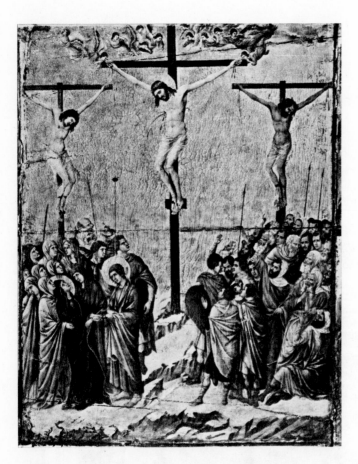

470. DUCCIO. *Crucifixion. Maestà* Altarpiece (back).
Panel, 40 1/8 × 29 7/8". 1308–11.
Museo dell'Opera del Duomo, Siena

of Cavallini; the figures themselves, however, are slight, agitated, and elegant, and Duccio's use of ornamental devices and the absence of monumentality in his works make his art more comparable to Gothic miniature painting north of the Alps than to any contemporary paintings in Italy. Another Sienese painter, Simone Martini, who worked a great deal outside Siena, notably in Naples, Assisi, and Avignon, where he died in 1344, was a master of both fresco technique and panel painting. These last vary from large altarpieces to miniature panels. The courtly, elegant aspect of some of his works (fig. 471) brings to mind northern Gothic paintings, especially

471. SIMONE MARTINI. *St. Louis of Toulouse Crowning Robert of Anjou, King of Naples.*
Panel, 78 3/4 × 54 1/4". 1317.
Museo di Capodimonte, Naples

interest in problems of spatial relationships, monumentality, and naturalism, and like his Roman predecessors, Giotto worked chiefly in fresco and mosaic. Although he also used Gothic V-folds and Gothic decorative details, he went far beyond the limited aims of the northern Gothic painters, both in his formal means and in the expressive qualities of his figures (fig. 469).

The main centers for the development of panel painting in the thirteenth century were the Tuscan towns of Siena, Pisa, Lucca, and Florence. The Sienese artist Duccio, like Cavallini, his contemporary in Rome, left the traditional, half-Byzantine conventions of the period behind (fig. 470). His modeling of figures, particularly by his logical use of sources of light, recalls the style

472. AMBROGIO LORENZETTI. *Good Government in the Country*. Fresco. 1338–39.
Sala della Pace, Palazzo Pubblico, Siena

those in Paris. The brothers Pietro and Ambrogio Lorenzetti of Siena were also altarpiece and fresco painters, both influenced by the monumentality of Giotto; Ambrogio's panoramic Tuscan landscapes and townscapes in his frescoes of *Good and Bad Government in the City and Country* (fig. 472) reflect a growing interest in nature that was to transform art of all kinds in the near future.

The novel ideas developed by Italian painters of the last quarter of the thirteenth century and the first half of the fourteenth made some impact on Gothic painting in France and elsewhere, but only in superficial ways. Occasionally a more substantial Italian influence can be detected, as in the work of the royal Parisian illuminator Jean Pucelle, who, it can be assumed, made a journey to Italy and saw the works of his contemporary, Duccio. Pucelle's Book of Hours of Queen Jeanne d'Evreux, illuminated between 1325 and 1328 (fig. 473), shows a considerable interest in placing figures in three-dimensional

473. JEAN PUCELLE. *Annunciation.* The Hours of Jeanne d'Evreux.
Grisaille and colors; page 3 1/2 × 2 1/2''. 1325–28.
The Metropolitan Museum of Art,
The Cloisters Collection (Purchase, 1954), New York

settings, a matter that was being so extensively experimented with in Italy.

From the fourteenth century onward, although Paris maintained its prestige in artistic matters and Parisian influences can be observed throughout Europe, Italian artistic ideas played an ever-increasing role in northern painting. This is particularly well illustrated in the decoration of the chapels in Karlštejn, the castle of Emperor Charles IV not far from Prague, where Italian as well as Bohemian painters were employed. These last included a certain Master Theodoric, an artist of great individuality and expressive power, whose realistic figures in the chapel of the Holy Cross (c. 1365; fig. 474) differ strikingly from the elegant, Sienese-influenced style prevalent at that time in Bohemia. In another chapel, dedicated to the Virgin, contemporary episodes are depicted that relate to the relics which the emperor had received in 1356 from the future king Charles V of France and, in turn, gave to the chapel: in one episode (fig. 475) the emperor is placing on the altar a metal reliquary containing the relics. There is an attempt at portraiture in these paintings, and the figures are shown in plausible interiors. More astonishingly, below these wall paintings there is a zone of illusionistic architecture, for its own sake.

The Bohemian court school under Charles IV was obviously in contact not only with Italian art, but also, through dynastic links, with the

course of art in Paris, where similar trends existed during the reigns of King John II the Good (1350–64), and King Charles V (1364–80). From these French developments it may be seen that, toward the end of the fourteenth century, the courtly style known as International Gothic became the fashion across western Europe, and even found a footing in northern Italy. As far as Italy was concerned, this was the swan song of the Gothic style. North of the Alps it took another hundred years or more until the Renaissance style finally triumphed.

474. MASTER THEODORIC. *St. Matthew.* Panel, 44 × 37″. c. 1360–65. National Gallery, Prague (from Chapel of the Holy Cross, Karlštejn

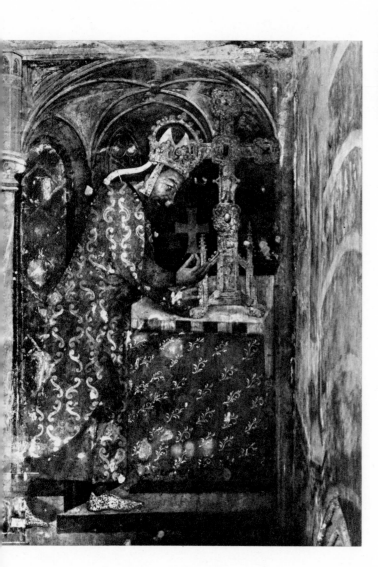

475. *Emperor Charles IV.* Wall painting. 1357–58. Chapel of the Virgin, Karlštejn

CHRONOLOGICAL
CHART

LIST OF ABBREVIATIONS

TITLES AND OFFICES

abs	abbess
abt	abbot
archbp	archbishop
BE	Byzantine Emperor
bp	bishop
emp.	emperor
empr.	empress
gov.	governor
HRE	Holy Roman Emperor
RE	Roman Emperor

POLITICAL AND GEOGRAPHIC TERMS

Arag.	Aragonese
Arm.	Armenian
Bohem.	Bohemian
Burg.	Burgundian
Byz.	Byzantine
Carol.	Carolingian
Dan.	Danish
Eg.	Egyptian
Eng.	English
Fr.	French
Frank.	Frankish
Ger.	German
Gr.	Greek
Hib.-Sax.	Hiberno-Saxon
It.	Italian
Lomb.	Lombard
Merov.	Merovingian
Mil.	Milanese
Mos.	Mosan
Norm.	Norman
Norw.	Norwegian
Ostrog.	Ostrogothic
Otton.	Ottonian
Rus.	Russian
Sax.	Saxon
Sic.	Sicilian
Sp.	Spanish
Visig.	Visigothic

ART TERMS

arch. (*pl.* archs.)	architect
min. ptr.	miniature painter
ms.	manuscript
ptr. (*pl.* ptrs.)	painter
sc. (*pl.* scs.)	sculptor
sm.	smith (*as in* goldsmith)
wkr.	worker (*as in* enamelworker)

Glossary

The figure numbers added to certain entries are intended to be illustrative only, and are not to be taken as exhaustive.

ABACUS (pl. ABACI). The uppermost part of a capital, usually a thin slab on which the architrave rests (figs. 29, 63).

ABBEY. The religious body of monks or nuns governed by an abbot or an abbess, respectively; also, the buildings used by it (figs. 108, 109).

AGNUS DEI. Latin for Lamb of God, a name applied to Jesus by St. John the Baptist. Thus, a figure of a lamb as an emblem of Christ (figs. 15, 74, 218). Also, a prayer in the MASS or a musical setting of the same.

AL-MANZOR. Ibn Amer' Moham, 914–1002, also called Al-Mansur, Almazor. He began as a lawyer in Cordoba but rose rapidly to power, becoming regent for the young caliph. He reconquered territory from the Christians in northern Spain and for a time restored Muslim power in that area.

ALTAR FRONTAL. See ANTEPENDIUM.

AMBULATORY. In a BASILICAN church, the passage around the APSE allowing circulation behind the high altar (figs. 200, 205, 220, 345); in a BAPTISTERY or a church with a centralized plan, the passageway around the central space (figs. 13, 29).

ANTEPENDIUM. The hanging or frontal of an altar, often richly decorated (figs. 105, 173).

APOCALYPSE (adj. APOCALYPTIC). The Book of Revelation, the last book of the New Testament, traditionally attributed to St. John the Evangelist.

APSE. A vaulted semicircular or polygonal niche normally at the east end of a church facing the nave (figs. 33, 34, 52); occasionally at end of TRANSEPT (figs. 274, 349).

ARCADE. A series of arches with their supports (figs. 14, 37, 185). When placed against a wall and used primarily as decoration, it is called a blind arcade (figs. 188, 257, 264, 272, 304).

ARCHANGEL. The eighth highest of the nine orders of angels. Three archangels are named: Michael, Gabriel, and Raphael (figs. 80, 173).

ARCHBISHOP. A bishop of the highest rank having jurisdiction over an archbishopric or archdiocese, an ecclesiastical province which includes several SEES of ordinary bishops. In the Eastern Church the title Patriarch is used instead of Archbishop.

ARCHIVOLT. One of a series of moldings applied to an arch, often decorated with sculpture (figs. 237, 241, 255, 292).

ARCOSOLIA. The burial chambers of the CATACOMBS.

ARIANISM. Christian doctrine named after its founder, Arius, a presbyter in Alexandria (c. 256–336). This doctrine rejected the accepted view of the Trinity and held that Christ was not the eternal Son of God nor of the same substance. The Arians were excommunicated and the doctrine declared heretical at the Council of Nicaea in 325, but it continued to be held by Teutonic tribes in western Europe (Lombards, Visigoths, etc.).

ASHLAR. Masonrywork of carefully squared stones, requiring a minimum of mortar (figs. 35, 84).

ATLAS (pl. ATLANTES). Male sculptured figures used instead of supporting columns (fig. 254). (Corresponding female figures are called caryatids.)

ATRIUM. The open forecourt of a church, usually ARCADED (figs. 9, 261).

AUGUSTINIAN CANONS, also called Canons Regular of St. Augustine. Priests following the Rule of St. Augustine, based on his teaching and less detailed than that of St. Benedict. The Order rose to importance in the 11th century. Monastic in certain observances, they differ in being priests and in undertaking apostolic works.

AULA REGIA. Latin for "royal hall" (figs. 7, 102).

BALDACHIN. From the Italian *baldacchino*. A free-standing canopy over an altar, throne, or tomb (figs. 253, 433, 438).

BAPTISTERY. A structure for baptismal rites; may be part of a church or a separate building (figs. 28, 36, 272).

BARBARIC. As opposed to classical. Here used to refer to the migratory tribes which invaded the Roman Empire from the 3rd century on.

BAR TRACERY. Thin molded strips of stone which form geometric patterns; used in windows, on walls, or as free-standing decoration (figs. 402, 439, 455).

BARREL VAULT. A half-cylindrical masonry roof, straight or curved. Also called a tunnel vault (figs. 16, 206, 223).

BASILIAN. The monastic RULE established by St. Basil (c. 330–79), still surviving in the Orthodox Church.

BASILICA. From the Greek word *basilikos* meaning royal. Originally a Roman assembly hall (see fig. 7). In Early Christian and medieval architecture, a longitudinal church consisting of a nave, two or four aisles, and an APSE at one end of the nave (figs. 31, 203). The nave is lit by windows in the CLERESTORY.

BEATUS OF LIÉBANA (c. 730–98). A Spanish theologian and geographer, author of the *Commentary on the Apocalypse* (c. 776), to which was attached one of the earliest maps of the Christian world. His *Commentary* was frequently copied and illuminated (colorplate 31).

BENEDICTINE. The monastic RULE founded by St. Benedict of Nursia (c. 480–547/50) at Subiaco, near Rome; then (c. 525) established at Montecassino.

BENEDICTIONAL. A book for the bishop's use containing a series of blessings for the MASS.

BLIND ARCADE. See ARCADE.

BOSS. An ornamental knoblike projection placed at the intersection of RIBS or GROINS (figs. 400, 435).

BREVIARY. A book for the Divine Office; the counterpart of the MISSAL: contains the necessary material for celebrating the daily devotions (Psalms, hymns, etc.).

BYZANTINE, BYZANTIUM. Refers either to the Greek city of Byzantium on the shores of the Bosphorus (called Constantinople after Constantine moved the seat of imperial government there in 330, and subsequently by its Turkish name, Istanbul, after the city fell to the Turks in 1453), or to the Byzantine Empire (4th–15th centuries), its culture, art, etc.

CAMPANILE (pl. CAMPANILI, CAMPANILES). From the Latin word *campana* meaning bell. A bell tower, frequently separate from the church (figs. 33, 179, 261, 272).

CANON. A clergyman serving in a CATHEDRAL or a COLLEGIATE CHURCH.

CAPELLA PALATINA. Latin for PALACE CHAPEL.

CAROLINGIAN. The historical epoch named after its founder Charlemagne (Carolus Magnus, Charles the Great; 768–814), which marked an attempt to revive late classical Christian civilization. It continued under Charlemagne's successors through much of the 9th century.

CARPET PAGES. Pages in Northumbrian manuscripts completely covered by decoration with a cross motif in the center (figs. 95, 96).

CARTHUSIAN. The monastic RULE founded by St. Bruno (c. 1030–1101) at Chartreuse near Grenoble in 1084.

CATACOMBS. Subterranean burial places, consisting of galleries with recesses for tombs and sometimes small rooms for memorial services. See ARCOSOLIA (figs. 2, 15).

CATECHUMEN. A neophyte under instruction in the elements of Christianity, but not yet baptized.

CATHEDRA. The bishop's throne in a CATHEDRAL, usually in the APSE, behind the altar (colorplate 9; fig. 254).

CATHEDRAL. The church containing the bishop's CATHEDRA; the principal church of a DIOCESE.

CHAMPLEVÉ. See ENAMEL.

CHANCEL. The part of the church reserved for the clergy, generally the eastern portion including the choir and altar area.

CHANCEL SCREEN. A screen between the CHANCEL or choir and the nave, which separates the clergy and the congregation; it is frequently decorated (figs. 253, 423).

CHANSONS DE GESTE. French for "songs of deeds." Frequently centered on themes of war with Charlemagne as a favorite hero (see ROLAND, SONG OF), these epic poems originated in the 11th century and were sung by troubadours along the Pilgrimage roads to Santiago de Compostela.

CHARLEMAGNE. See CAROLINGIAN.

CHERUBIM. The second highest of the nine orders of angels (fig. 190).

CHEVET. The eastern end of a church or CATHEDRAL including the APSE, AMBULATORY, and radiating chapels.

CHEVRON. A V-shaped mark or zig-zag pattern used as a decorative element, especially in Romanesque architecture (fig. 305).

CHOIR SCREEN. See CHANCEL SCREEN.

CHRIST IN MAJESTY. A representation of the enthroned Christ, usually with the symbols of the four EVANGELISTS (colorplates 40, 48; figs. 90, 210, 283).

CIBORIUM (pl. CIBORIA). The BALDACHIN on columns constructed over the altar (fig. 169); also a container for keeping the HOST.

CIRE-PERDUE PROCESS. French for "lost wax." A method of bronze casting in which the molten metal displaces the wax in a clay mold (figs. 174, 321).

CISTERCIAN. A reformed BENEDICTINE RULE founded in 1098 by St. Robert of Molesme at Cîteaux in Burgundy, in eastern France (figs. 242, 362).

CLERESTORY. The upper nave wall of a BASILICA with its row of windows above the roof of the adjoining aisle (figs. 26, 32, 351), or a similar wall in the TRANSEPT.

CLOISONNÉ. See ENAMEL.

CLUNIAC. A reformed BENEDICTINE RULE founded in 910 by William I the Pious at the monastery of Cluny in Burgundy, in eastern France (figs. 183, 220).

CODEX (pl. CODICES). A manuscript in book form with parchment pages bound between protective covers.

COLLECTS. Short prayers said or sung before the EPISTLE at MASS and having reference to the feast, etc., of the day.

COLLEGIATE CHURCH. A church which has a chapter or college of CANONS, but not a bishop's SEE.

COLUMN-FIGURE. A statue attached to a column. The term is most frequently used in reference to the JAMB sculptures of Romanesque and Gothic portals (colorplate 48; figs. 287, 363, 364, 422).

COMNENE DYNASTY. The Byzantine dynasty that ruled from 1081–1185.

CONSTANTINOPLE. See BYZANTIUM.

COPTS. The Christianized descendants of the ancient Egyptians. The Coptic Church followed the MONOPHYSITE doctrine.

CORBEL. A projecting stone used as a support of some element in a building. A series of such stones below the eaves is called a corbel table (figs. 182, 314, 331).

CORRENTE COMASCA. The profuse and distinctive sculptural decoration first appearing on early Romanesque churches in Lombardy, employing motifs of interlace, foliage, animals, birds, and some figures(fig. 264).

COSMATI WORK. A technique of combining marble inlay and mosaic, used on church furniture, columns, portals, pavements, etc., and practiced in Rome and its neighborhood during the 12th–13th centuries. The term is derived from the names Cosma and Cosmato, frequently found among marble workers in Rome at that time.

COUNCILS. See OECUMENICAL COUNCILS.

CROZIER. The staff carried by a bishop or abbot symbolizing his role as a shepherd of Christ's flock (fig. 381).

CRYPT. A vaulted, underground chamber used for burial, as in the CATACOMBS; in a church, a vaulted chamber usually beneath the raised CHANCEL and APSE, housing one or more tombs or a chapel (figs. 88, 161).

CUSP. A pointed projection where two curves meet (figs. 59, 284).

DEACON. A cleric or layman who assists a priest or minister. In the Roman Catholic Church the cleric serving as deacon ranks second after the priest.

DEËSIS. A representation of Christ enthroned between the Virgin Mary and St. John the Baptist who act as intercessors for mankind (colorplate 43; fig. 340).

DIACONICON. In Early Christian and Byzantine churches, a chamber to the south of the sanctuary in charge of the DEACONS, where vessels, vestments, and books needed for services were kept (fig. 8). See also PROTHESIS.

DIOCESE. The territory under the jurisdiction of a bishop, with the churches under his pastoral care.

DIPTYCH. A pair of hinged wood, ivory, or metal plaques, the interior surfaces painted, carved, or covered with mosaic or with wax for writing (figs. 25, 342). Multiple diptychs have plaques composed of five interlocking panels (fig. 73).

458

DOME ON PENDENTIVES. See PENDENTIVE.

DOMED-UP RIB VAULT. See RIB VAULT.

DOMINICAN. A mendicant preaching Order founded at Toulouse in 1206–16 by St. Dominic from Castile (Dominic Guzmán, 1170?–c. 1221).

DOMUS ECCLESIAE. Latin for "house church" (fig. 1).

DRÔLERIES. French word for "jests." Marginal decorations in Gothic manuscripts, frequently humorous in character (figs. 429, 430, 473).

ENAMEL. Colored glass in powder form, thermally fused to a metal ground.

 Champlevé. French word meaning "raised ground." A method whereby the areas to be filled with enamel are dug from the metal with a cutting tool (colorplate 16).

 Cloisonné. French word for "partition." A method whereby the surface to be decorated is divided into compartments with strips of metal; the compartments are then filled with enamel and the whole piece is fired (colorplates 22, 28; fig. 376).

ENCEINTE. In a castle, a surrounding wall for fortification, or the space enclosed by such a wall (figs. 332, 333).

EN ÉCHELON. A steplike arrangement of chapels in the east end of a church.

ENTABLATURE. The superstructure carried by columns or piers, generally consisting of the architrave, frieze, and cornice (figs. 27, 38, 121).

EPISTLES. The twenty-one books of the New Testament written as, or in the form of, letters to individuals or churches. Fourteen are ascribed to St. Paul; the other authors are named in the respective titles.

EUCHARIST. Originally the thanksgiving offering to Christ before a meal; the SACRAMENT of the Last Supper reenacted during the MASS, in which the bread (HOST) and wine are consecrated and distributed.

EVANGELIARY. A liturgical book containing selections (PERICOPES) from the GOSPELS to be read during the MASS. It went out of use and was replaced by the SACRAMENTARY.

EVANGELISTS, and SYMBOLS OF THE EVANGELISTS. The authors of the four GOSPELS, Matthew, Mark, Luke, and John; frequently identified by their respective symbols: the angel, the lion, the ox, and the eagle (colorplates 21, 29, 37; fig. 128).

EXARCHATE. A province of the BYZANTINE Empire, ruled by an exarch or provincial governor.

FRANCISCAN. A mendicant Order founded in 1209 at Assisi by St. Francis of Assisi (Giovanni di Bernardone, 1182?–1226) (fig. 444).

FRANKS, FRANKISH. Germanic tribes who conquered Gaul about 500 A.D. Clovis established the first Frankish or Merovingian empire; it was ultimately supplanted by the CAROLINGIAN empire.

FRESCO. A painting on wet plaster (buon fresco, true fresco), the pigment suspended in water so that the plaster absorbs the colors (figs. 469, 472). In FRESCO SECCO the painting is done on dry plaster, the portion needed for one day's work being remoistened to enable pigment to adhere to the surface (colorplates 17, 36; fig. 225).

FRIAR. A member of one of the mendicant Orders such as the DOMINICAN or the FRANCISCAN.

GARGOYLE. A waterspout carved with a grotesque monster.

GESSO. A plaster-based material spread upon a surface in preparation for painting or gilding.

GOOD SHEPHERD. An allegorical figure of Christ represented with a lamb on his shoulders; derived from the Greek statue-type of Hermes Kriophoros but with specific Christian references, since Christ called Himself the "Good Shepherd" (colorplate 5; figs. 2, 5).

GOSPELS. The first four books of the New Testament, which recount the life of Christ and are traditionally ascribed to Matthew, Mark, Luke, and John.

GREEK CROSS. A cross with arms of equal length.

GRISAILLE. Stained-glass painting using light colors in geometric patterns; also any monochromatic painting in shades of gray (fig. 473).

GROINS. The intersection of two BARREL VAULTS at right angles which produces arcs or groins dividing the resulting vault into four triangular segments (fig. 313).

HALLENKIRCHE. German for "hall church." A church having aisles the same or nearly the same height as the nave (figs. 446, 448).

HETOIMASIA. The throne prepared for the second coming of Christ, foretold in the Book of Revelation (fig. 146).

HISTORIATED CAPITALS. In sculpture, capitals carved with narrative subjects (figs. 86, 202, 211).

HISTORIATED INITIALS. In manuscripts, initials containing narrative scenes (colorplates 49, 55; fig. 132).

HOHENSTAUFEN. The German dynasty which ruled the Holy Roman Empire from 1138 to 1254. The most important emperors of this dynasty were Frederick I Barbarossa and Frederick II.

HOMILY. A discourse or sermon.

HOST. From the Latin hostia, meaning a sacrificial victim. The consecrated wafer offered during the MASS, symbolizing the body of Christ.

HUNS. An Asiatic people who devastated Europe during the fourth and fifth centuries.

ICON. A venerated image of Christ, the Virgin Mary, or a saint, usually a panel painting (colorplate 44).

ICONOCLASM. A movement launched in 726 by the BYZANTINE emperor Leo III forbidding the use of images in the churches; ICON worship was fully reinstated in 843.

IMPOST BLOCK. A plain or decorated block placed between the capital of a column and the arches or vaults it supports (figs. 53, 59).

INHABITED INITIAL. In manuscripts, a form of initial in which figures are integrated into a complex scroll design (figs. 244, 245, 310b).

INVESTITURE CONTEST. The violent dispute concerning Church and State, and the issue of lay versus canonical election of bishops; it broke out between Pope Gregory VII and Emperor Henry IV in 1075 and lasted until the Treaty of Worms, 1122.

ISTANBUL. See BYZANTIUM.

JAMBS. The sides of a doorway or window; often splayed to accommodate decoration, especially figural sculpture (figs. 266, 271, 414). See COLUMN-FIGURE.

JULIAN THE APOSTATE. Flavius Claudius Julianus, the nephew of Constantine, born in Constantinople about 332. An avowed pagan himself, he instituted a brief restoration of paganism when he became emperor in 361. He died in 363.

KATHOLIKON. The chief church of a BYZANTINE monastery (figs. 139, 140).

KUFIC SCRIPT. An angular written form of the Arabic alphabet used in especially fine copies of the Koran, and, outside of Islam, frequently as pure ornament (fig. 138).

LADY CHAPEL. A chapel attached to a large church and dedicated to the Virgin Mary; it is usually larger and of more importance than the other chapels.

LANCET WINDOW. A high, narrow window without tracery and pointed at the top (colorplate 45; fig. 318).

LAPIDARIUM (pl. LAPIDARIA). From the Latin *lapidarius* meaning relating to stone. Collection of carvings and inscriptions in stone.

LATIN CROSS. A cross with one long and three short arms.

LATINS; LATIN KINGDOM OF JERUSALEM. Feudal state created by the leaders of the First Crusade in 1099. Also, Latin Empire of Constantinople, founded 1204 by the leaders of the Fourth Crusade.

LECTERN. A bookstand in a church from which various lessons and services are read or chanted; it may be decorated with sculpture, frequently an eagle.

LECTIONARY. A liturgical book containing extracts or PERICOPES from the GOSPELS, organized according to the church calendar.

LIBER PONTIFICALIS. The Papal Book; the official collection of biographies of the popes, from St. Peter to Pope Steven V (d. 891).

LIBRI CAROLINI. Treatise composed by Charlemagne's counsellors, perhaps Alcuin or Theodulf, attacking the decisions of the Seventh OECUMENICAL COUNCIL (Nicaea, 787) to restore the veneration of ICONS.

LIERNE. A short subordinate RIB that runs from one main rib of a vault to another (fig. 440).

LINTEL. The horizontal architectural member supporting the weight above a door or window, occasionally formed of a single slab (figs. 208, 230, 232, 234, 277).

LITURGY. The public services and rites of worship of the Church.

LOGGIA. An ARCADED gallery built into or projecting from a building, particularly overlooking a court (fig. 113).

LOMBARD ARCHES. A form of external decoration consisting of narrow pilasters carried up to the eaves and joined together by small blind ARCADES (figs. 179, 186, 265, 314).

LOMBARDS OR LONGOBARDS. A Teutonic tribe that invaded Italy in 568 and established a kingdom with its capital in Pavia (thence the name of the northern province, Lombardy, and of several dukedoms, e.g., at Benevento and Spoleto).

MACEDONIAN RENAISSANCE. Term used for the art produced in Byzantium between 867 and 1056, when emperors of the Macedonian dynasty ruled the Eastern Empire.

MANDORLA. An almond-shaped halo of glory used around the figures of God, Christ, the Virgin Mary, or other figure (colorplates 32, 34; figs. 165, 229, 269).

MARIA REGINA. A representation of the Virgin Mary as queen of heaven (fig. 79).

MARQUETRY. Inlaid work done with thin pieces of variously colored wood or other materials, such as ivory, mother-of-pearl, etc.

MARTYRIUM (pl. MARTYRIA). A commemorative structure erected over the tomb of a martyr (figs. 11, 12).

MASS. The EUCHARISTIC rite of the Latin Church, to perpetuate the sacrifice of Christ on the cross, plus readings from one GOSPEL and one EPISTLE, and the LITURGY of prayers and ceremonies.

MAUSOLEUM (pl. MAUSOLEA). A monumental tomb (figs. 13, 30, 35); its name is derived from the magnificent tomb of Mausolus erected by Artemisia, his wife and sister, at Halicarnassus in the mid-4th century B.C.

MAYOR. Governing minister of a region in the FRANKISH kingdom.

MEROVINGIAN. Refers to FRANKISH dynasty.

MILLEFIORI. Italian for "thousand flowers." A kind of ornamental glass made by fusing together a number of glass rods of different sizes and colors and cutting the mass into sections (colorplates 12, 13).

MINSTER. A monastery church, in England often a CATHEDRAL.

MISSAL. A book used by a priest, containing the text and ceremonial instructions for the celebration of the MASS throughout the year.

MOLDING. Architectural member either projecting from the surface of a building or recessed, whose purpose is purely ornamental (fig. 40).

MONOPHYSISM. The doctrine of the unique, divine nature of Christ; though condemned as heretical by the Council of Chalcedon in 451, it was adopted by the churches of Syria, Egypt, Armenia, and Georgia. The Catholic view is that Christ had both a divine and a human nature.

MOZARABS. The Christian heirs of the VISIGOTHS in Spain living under Arab domination.

MULDENSTIL. A convention for representing the contours of drapery by using trough-shaped folds (figs. 376, 377).

MULTIPLE DIPTYCH. See DIPTYCH.

NAOS. Greek word for the main body of a temple; in a Byzantine church, the sanctuary where the LITURGY was performed (fig. 139).

NARTHEX. The transverse vestibule of a church preceding the nave (figs. 238, 260).

NEO-PLATONISM. A school of late Greek philosophy which grew up mainly in Alexandria in the 3rd century A.D. under the leadership of Plotinus.

NEREID. A classical sea nymph attendant on Neptune, often represented as a maiden with a fish tail (fig. 70).

NIELLO. Process of decorating metal with incised designs filled with a black alloy of sulphur (colorplate 16; figs. 196, 227).

NORMANS. Norsemen or VIKINGS who conquered Normandy in France in the 10th century and settled there; in the following century they conquered England (colorplate 38; fig. 301), established a state in southern Italy, and participated in the Spanish RECONQUISTA.

OECUMENICAL COUNCILS. Theoretically, councils to which the pope summons the bishops of the world to decide various doctrinal matters, the decisions taken being binding on the whole Church after confirmation by the pope. Actually the first eight, held in Nicaea, Constantinople, Ephesus, and Chalcedon from the 4th through 9th century, were convened by the emperors.

OPUS ANGLICANUM. The embroidery work for vestments produced in England in the 13th–14th centuries (fig. 432).

OPUS FRANCIGENUM. The term used by the 12th-century chronicler Burchard von Hall to describe the new Gothic architecture of Paris and northern France.

OPUS RETICULATUM. A form of Roman masonry using lozenge-shaped stones to create a net design.

ORANT. A figure with hands raised in an attitude of prayer (colorplate 24).

ORATORY. A chapel or separate structure for the meditation and prayer of a small group of people (fig. 106).

ORDER, MONASTIC. See RULE.

OSTROGOTHS. Goths of the East, a Teutonic tribe which

settled in Italy under Theodoric in 493 and was practically annihilated by the BYZANTINE army in 553.

OTTONIAN. The historical epoch named after the 10th century German dynasty which included Henry I, Otto I, II, and III, and Henry II.

PALACE CHAPEL. A chapel built within the precinct of a royal palace (figs. 103, 398).

PALEOLOGENE DYNASTY. The last BYZANTINE dynasty, which ruled from 1261 to 1453.

PALLIUM. In the Catholic Church, a woolen vestment worn over the shoulders by the pope and conferred by him upon ARCHBISHOPS as a symbol of authority.

PANAGHIA. See THEOTOKOS.

PANTOCRATOR. A representation of Christ as ruler of the world (fig. 150).

PARISH CHURCH. A church subordinate to the CATHEDRAL.

PASSION OF CHRIST. The last week of Christ's life on earth from the time of His entry into Jerusalem (Palm Sunday) to His crucifixion (Good Friday) (fig. 131).

PATRIARCH. See ARCHBISHOP.

PENDENTIVE. A concave triangular area of masonry which enables a dome to be supported over an angular area. Four pendentives are needed if the base is square, more if it is polygonal (colorplates 3, 4; fig. 280).

PENTECOST. The "Descent of the Holy Ghost upon the Apostles" according to Acts 2:1–4, marking the beginning of the apostles' mission to the world (figs. 146, 226).

PERICOPE. A selected extract or passage from the GOSPELS for use in church services.

PIER. A vertical mass of masonry which serves as a support; a square or round pillar (fig. 156). When combined with projecting pilasters, shafts, or columns, it is called a compound pier (colorplate 46; figs. 201, 298).

PILGRIM'S GUIDE. A guide written about 1130 by a priest from Poitou describing the four routes to Santiago de Compostela, the major shrines along the way, and the Cathedral of Santiago itself.

PISCINA. From the Latin word meaning "fishpond." In the early Church, a pool for baptism (fig. 28); subsequently, an aperture in the wall near an altar with a shelf for cruets and a drain for the disposal of water, etc., used in sacred ceremonies.

PLINTH. The projecting block at the base of a column or wall; it is sometimes decorated (figs. 20, 355).

PORPHYROGENITUS. A child "born in the purple" (Greek porphyra). The room in the Great Palace of the Byzantine Emperors in Constantinople which was reserved for the confinement of the ruling empress was decorated with porphyry, a dark purple-red stone.

PORTICUS. One of a series of rectangular annexes adjoining the nave and used primarily for burials. They were a feature of early Anglo-Saxon churches.

PRIORY. A monastic body presided over by a prior or prioress, usually dependent on an ABBEY.

PROTHESIS. A chamber north of the sanctuary in Early Christian and Byzantine churches used for the safekeeping of the EUCHARIST (fig. 8). See also DIACONICON.

PSYCHOSTASIS. The weighing of souls in the Last Judgment (fig. 236).

PUTTO (pl. PUTTI). A small nude boy, often winged, frequently used decoratively in painting, sculpture, and architectural ornamentation (figs. 16, 64).

QUATREFOIL. A leaflike design having four lobes, used in ground plans of buildings or as an ornamental element

in painting and sculpture (fig. 415).

RECONQUISTA. The holy war in Spain from the 11th–13th century, to regain Christian territories lost to the Arabs in 711, and in the 10th century to AL-MANZOR.

RELICS. The material remains of saints, or the objects associated with them, venerated by the faithful and kept in reliquaries (colorplates 30, 42; fig. 326).

RENOVATIO. From the Latin word for renewal. In general, a rebirth or revival of the political, cultural, and especially the artistic aims of an earlier glorified era; associated mainly with the Carolingian, Ottonian, and Middle Byzantine periods.

REPOUSSÉ. A technique of raising a design in relief on metal by hammering the reverse side (figs. 219, 378).

RETABLE. The elaborate wood, stone, or metal framework behind an altar, usually decorated with sculpture or painting.

RIBS. Projecting arches that carry a vault (figs. 299, 357).

RIB VAULT. A vault supported by a framework of ribs or arches, either semicircular (domed-up; fig. 263) or pointed (figs. 299, 397).

ROLAND, SONG OF. An eleventh-century epic poem about the conflict between Christendom and paganism, centering around Charlemagne's expedition to Spain to fight the Moors and his disastrous retreat, in which the rearguard under Roland was slain. It was one of the most popular CHANSONS DE GESTE.

ROLL. A scroll with a written text, originally of papyrus, later of parchment (figs. 144, 251). It was largely superseded by the CODEX.

ROTULUS (pl. ROTULI). Latin word for scroll or ROLL.

RULE. The laws or regulations established by the founder of a religious Order for observance by its members. The most famous was that of St. Benedict for the BENEDICTINE monks. See also BASILIAN, CARTHUSIAN, CISTERCIAN, CLUNIAC, DOMINICAN, FRANCISCAN.

SACRAMENTARY. A liturgical book containing the COLLECTS and prayers recited by the celebrant at MASS.

SACRAMENTS. The seven religious ceremonies in the Christian rites (Roman Catholic and Eastern Churches): baptism, confirmation, the EUCHARIST, penance, ordination, matrimony, and extreme unction.

SALIAN DYNASTY. The 11th-century German dynasty which included emperors Conrad II, Henry III, IV, and V.

SARCOPHAGUS (pl. SARCOPHAGI). A large stone or marble coffin, frequently decorated (figs. 6, 22, 89, 269).

SCRIPTORIUM (pl. SCRIPTORIA). The area in a monastery reserved for writing and decorating manuscripts.

SEE. In ecclesiastic terms, the local seat from which the bishop exercises his authority, or the office itself—the position of being bishop of a particular DIOCESE.

SERAPHIM. The highest of the nine orders of angels (fig. 78).

SICULO-BYZANTINE. BYZANTINE art in Sicily (Latin, Siculum).

SOFFIT. The inner face of an arch, lintel, or cornice (fig. 271).

SONG OF ROLAND. See ROLAND.

SPANDREL. The triangular space separating the exterior curve of one arch from that of its neighbor, or the space between the exterior curve of an arch and an adjoining perpendicular form (figs. 19, 217).

SQUINCH. The CORBELED arch or niche placed across the corners of a square bay for supporting a dome (fig. 181).

STAVE or MAST CHURCH. A type of Norwegian timber

church built on a stone foundation (fig. 327).

STELE (pl. STELAE). A slab or pillar of stone used as a gravestone, and generally carved with commemorative reliefs or inscriptions (figs. 195, 197).

STRING-COURSE. A horizontal molding along the wall of a building (fig. 290).

STUCCO. A form of fine plaster decoration chiefly for interior use (colorplate 8; figs. 116, 169).

SYMBOLS OF THE EVANGELISTS. See EVANGELISTS.

SYNOD. An ecclesiastical council, often national, provincial, or diocesan rather than OECUMENICAL.

TERRACOTTA. Italian for "baked earth." It is used for building, and for sculpture and pottery.

TEUTONIC KNIGHTS. A military Order composed of German knights, priests, and brothers, originating in Acre in 1189, to care for the sick and to combat enemies of Christianity. In the 13th century its center was moved to Europe, to convert pagan Prussia.

THEOTOKOS. From the Greek word meaning "Mother of God"; the Virgin Mary was proclaimed *Theotokos* at the Council of Ephesus (fig. 431).

TRANSEPT. The transverse unit of a BASILICAN church, usually between the nave and the apse. Some German and English churches have two transepts of different widths (fig. 358).

TREFOIL. A trilobed form in a ground plan (fig. 41), or used as ornamentation (fig. 406).

TRIBUNE. An ARCADED gallery above the aisles and open to the nave.

TRIFORIUM. The space between the aisle vaults and the aisle roof. At first the triforium had openings toward the nave; later the term became applied to any passage or gallery occupying that position (figs. 306, 347).

TRIPTYCH. Three hinged wood, ivory, or metal plaques, the interior surfaces painted or carved. The outer leaves are narrower, and may be folded over the center panel (figs. 148, 464).

TRITON. One of a classical race of sea gods represented as having the body of a man and the tail of a fish, and carrying a conch shell (colorplate 2).

TRIUMPHAL ARCH. An arch commemorating a military victory, first used in ancient Rome (fig. 18); in a Christian church, the transverse wall with a large arched opening which separates the CHANCEL and the APSE from the main body of the church (fig. 50).

TROMPE L'OEIL. From the French, meaning literally "to fool the eye"; a term used to designate illusionistic decorations that appear to be an extension of real space.

TRUMEAU. The central post of a portal, often decorated with sculpture, supporting a TYMPANUM (figs. 238, 282).

TUNNEL VAULT. See BARREL VAULT.

TYMPANUM. The area between the lintel and the arch of a medieval portal (fig. 230).

VANDALS. A Teutonic tribe whose destructive raids are commemorated in the term vandalism. They sacked Rome in 455 and established a province in North Africa, which was eventually overthrown by the BYZANTINE army.

VAULTS. See GROINS, RIBS, BARREL VAULTS, etc.

VELLUM. A fine-grained animal skin or parchment prepared for writing or illumination, or as a book binding.

VESTRY. See DIACONICON.

VICTORY. A female deity of the ancient Romans, usually represented as winged and holding a laurel wreath, a palm branch, or other symbolic object (figs. 73, 77).

VIKINGS. A people of Scandinavian origin who became pirates, attacking much of northern Europe from the 8th–11th century (figs. 192, 193). They settled in the British Isles and in France (see NORMANS).

VIOLLET-LE-DUC. The architect and restorer of Romanesque and Gothic buildings in France (1814–1879), and the author of the *Dictionnaire raisonné de l'architecture française du XIe au XVIe siècle* (10 vols., Paris, 1854–68).

VISIGOTHS. Goths of the West, a people of Teutonic origin who, after sacking Rome in 410, settled in southern Gaul; they then controlled the Iberian Peninsula until the Arab conquest in 711.

VOUSSOIR. A wedge-shaped block used in constructing an arch; the central one is the keystone (figs. 18, 292).

VULGATE. The Latin translation of the Bible made by St. Jerome in the fourth century.

WESTWORK. The towered west end of certain CAROLINGIAN churches (figs. 110, 158), with an entrance on the lower level and a chapel above, which opened by ARCADES toward the nave. This feature survived in Germany until the twelfth century (fig. 314).

ZACKENSTIL. A name given to a phase of late Romanesque art in Germany characterized by a zig-zag pattern of drapery (fig. 388).

Bibliography

1. General

ADHÉMAR, JEAN, *Influences antiques dans l'art du moyen-âge français*, London, 1939

ANTHONY, EDGAR W., *A History of Mosaics*, Boston, 1935

AUBERT, MARCEL, *L'architecture cistercienne en France* (2nd ed.), 2 vols., Paris, 1947

_____, *Romanesque Cathedrals and Abbeys of France*, New York, 1966

_____, *La sculpture française au moyen âge*, Paris, 1947

_____, *Le vitrail en France*, Paris, 1946

BALTRUŠAITIS, JURGIS, *Le moyen âge fantastique*, Paris, 1955

BAUM, JULIUS, and SCHMIDT-GLASSNER, HELGA, *German Cathedrals*, London, 1956

BECKWITH, JOHN, *Ivory Carvings in Early Medieval England*, London, 1972

BEVAN, BERNARD, *A History of Spanish Architecture*, London, 1938 (reprinted 1974)

BONY, JEAN, and HÜRLIMANN, MARTIN, *French Cathedrals*, London, 1951

BROOKE, CHRISTOPHER, *The Structure of Medieval Society*, London, 1971

BROWN, R. ALLEN, *English Castles*, London, 1962

CHAMOT, MARY, *English Mediaeval Enamels*, London, 1930

CONANT, KENNETH JOHN, *Carolingian and Romanesque Architecture: 800 to 1200* (Pelican History of Art), Harmondsworth, 1959

DODWELL, C. R., *Painting in Europe: 800 to 1200* (Pelican History of Art), Harmondsworth, 1971

DUCHESNE, L., *Le Liber Pontificalis*, 3 vols., Paris, 1881–92 (reprinted 1957)

EGBERT, VIRGINIA WYLIE, *The Mediaeval Artist at Work*, Princeton, 1967

ESCHAPASSE, MAURICE, *L'architecture bénédictine en Europe*, Paris, 1963

EVANS, JOAN (ed.), *The Flowering of the Middle Ages*, New York, 1966

FILLITZ, HERMANN (ed.), *Das Mittelalter I* (Propyläen Kunstgeschichte, vol. 5), Berlin, 1969

GALL, ERNST, *Cathedrals and Abbey Churches of the Rhine*, New York, 1963

GAUTHIER, MARIE-MADELEINE, *Émaux limousins des XIIe, XIIIe et XIVe siècles*, Paris, 1950

_____, *Émaux du moyen âge*, Fribourg, 1970

GOLDSCHMIDT, ADOLPH, *Die deutschen Bronzetüren des frühen Mittelalters*, Marburg, 1926

GRODECKI, LOUIS, *Ivoires français*, Paris, 1947

_____, *Les vitraux des églises de France*, Paris, 1948

_____, *Vitraux de France du XIe au XVIe siècle*, Paris, 1953

GUDIOL, JOSÉ, *The Arts of Spain*, London, 1964

HAHN, HANNO, *Die frühe Kirchenbaukunst der Zisterzienser*, Berlin, 1957

HARVEY, JOHN H., *The Cathedrals of Spain*, London, 1957

_____, *The Master Builders: Architecture in the Middle Ages*, New York, 1972

HOLT, ELIZABETH GILMORE, *A Documentary History of Art. I: The Middle Ages and the Renaissance*, Garden City, N.Y., 1957

Ivory Carvings in Early Medieval England, 700–1200 (exhibition catalogue), Victoria and Albert Museum, London, 1974

KATZENELLENBOGEN, ADOLF, *Allegories of the Virtues and Vices in Mediaeval Art*, New York, 1939 (paper reprint 1964)

KIDSON, PETER, *The Medieval World*, New York, 1967

_____, MURRAY, P., and THOMPSON, P., *A History of English Architecture*, London, 1965

LASKO, PETER, *Ars Sacra: 800–1200* (Pelican History of Art), Harmondsworth, 1972

LASTEYRIE, R. DE, *Études sur la sculpture française au moyen âge*, Monuments Piot, VIII, 1902.

LAVEDAN, PIERRE, *French Architecture*, Harmondsworth, 1956

LEJEUNE, RITA, and STIENNON, JACQUES, *The Legend of Roland*, London, 1971

LONGHURST, MARGARET H., *English Ivories*, London, 1926

MARTINDALE, ANDREW, *The Rise of the Artist*, London, 1972

MOREY, CHARLES RUFUS, *Lost Mosaics and Frescoes of Rome of the Mediaeval Period*, Princeton, 1915

_____, *Mediaeval Art*, New York, 1942

MYNORS, ROGER A. B., *Durham Cathedral Manuscripts*, Oxford, 1939

OAKESHOTT, WALTER, *Classical Inspiration in Medieval Art*, London, 1959

_____, *The Mosaics of Rome from the Third to the Fourteenth Centuries*, London, 1967

PALOL, PEDRO DE, and HIRMER, MAX, *Early Medieval Art in Spain*, New York, 1967

PANOFSKY, ERWIN, *Die deutsche Plastik des 11. bis 13. Jahrhunderts*, Munich, 1924

_____, *Renaissance and Renascences in Western Art*, Stockholm, 1960

_____, *Tomb Sculpture*, New York, 1964

PEVSNER, NIKOLAUS, *An Outline of European Architecture* (7th ed.), Harmondsworth, 1974

PORCHER, JEAN, *Medieval French Miniatures*, New York, 1960

PORTER, ARTHUR KINGSLEY, *Lombard Architecture*, 4 vols., New Haven, 1915–17

_____, *Medieval Architecture, Its Origins and Development*, 2 vols., New Haven, 1912

POST, CHANDLER RATHFON, *A History of Spanish Painting*, 12 vols., Cambridge, Mass., 1930–58

PRIOR, EDWARD S., and GARDNER, ARTHUR, *An Account of Medieval Figure-Sculpture in England*, Cambridge, England, 1912

Rhin-Meuse, Art et Civilisation, 800–1400 (exhibition catalogue), Cologne-Brussels, 1972

RICKERT, MARGARET, *Painting in Britain: The Middle Ages* (Pelican History of Art; 2nd ed.), Harmondsworth, 1965

SALMI, MARIO, *Italian Miniatures*, New York, 1957

SALVINI, ROBERTO, *Medieval Sculpture*, Greenwich, Conn., 1969

SAXL, FRITZ, and WITTKOWER, RUDOLF, *British Art and the Mediterranean*, Oxford, 1947

SCHELLER, R. W., *A Survey of Medieval Model Books*, Haarlem, 1963

SIMSON, OTTO G. VON., *Das Mittelalter II* (Propyläen Kunstgeschichte, vol. 6), Berlin, 1972

SOUTHERN, R. W., *The Making of the Middle Ages.*, London, 1953

STEINGRÄBER, ERICH, *Antique Jewelry, Its History in Europe from 500 to 1900*, London, 1957

STOLL, ROBERT, *Architecture and Sculpture in Early Britain: Celtic, Saxon, Norman*, London, 1966

STONE, LAWRENCE, *Sculpture in Britain in the Middle Ages* (Pelican History of Art), Harmondsworth, 1955

TARALON, JEAN (ed.), *Treasures of the Churches of France*, New York, 1966

TOESCA, PIETRO, *Storia dell'arte italiana*, 3 vols., Turin, 1927–51

TRISTRAM, ERNEST W., *English Medieval Wall Painting*, 3 vols., Oxford, 1944, 1950, 1955

TUULSE, ARMIN, *Castles of the Western World*, London, 1958

VENTURI, ADOLFO, *Storia dell'arte italiana*, 11 vols., Milan, 1901–40

VOLBACH, WOLFGANG FRITZ, and LAFONTAINE-DOSOGNE, JACQUELINE, *Byzanz und der christliche Osten* (Propyläen Kunstgeschichte, vol. 3), Berlin, 1968

WATSON, A., *The Early Iconography of the Tree of Jesse*, Oxford, 1934

WEBB, GEOFFREY, *Architecture in Britain: The Middle Ages* (Pelican History of Art), Harmondsworth, 1956

WEBBER JONES, LESLIE, and MOREY, CHARLES RUFUS, *The Miniatures of the Manuscripts of Terence*, Princeton, 1931

WEBSTER, J. CARSON, *The Labours of the Months*, Evanston–Chicago, 1938

WEITZMANN, KURT, *Ancient Book Illumination*, Cambridge, Mass., 1959

_____, *Illustrations in Roll and Codex*, Princeton, 1947

WENTZEL, HANS, *Meisterwerke der Glasmalerei*, Berlin, 1951

WILPERT, JOSEF, *Die römischen Mosaiken und Malereien der kirchlichen Bauten vom IV. bis XIII. Jahrhundert* (3rd ed.), 4 vols., Freiburg-im-Breisgau, 1924

2. Early Christian & Byzantine Art

AINALOV, DIMITRII V., *The Hellenistic Origins of Byzantine Art*, New Brunswick, N. J., 1961

L'art copte (exhibition catalogue), Paris, 1964

BECKWITH, JOHN, *The Art of Constantinople: An Introduction to Byzantine Art*, London, 1961

_____, *Coptic Sculpture, 300–1300*, London, 1963

_____, *Early Christian and Byzantine Art* (Pelican History of Art), Harmondsworth, 1970

BUTLER, ALFRED, *The Ancient Coptic Churches of Egypt*, Oxford, 1884

BUTLER, HOWARD C., *Early Churches in Syria*, Princeton, 1929

Byzantine Art–An European Art (exhibition catalogue), Athens, 1964

DALTON, ORMONDE MADDOCK, *Byzantine Art and Archaeology*, Oxford, 1911 (reprinted 1965)

_____, *East Christian Art*, Oxford, 1925

DELBRÜCK, RICHARD, *Die Consulardiptychen und verwandte Denkmäler*, 2 vols., Berlin–Leipzig, 1926–29

DEMUS, OTTO, *Byzantine Art and the West*, New York, 1970

_____, *Byzantine Mosaic Decoration: Aspects of Monumental Art in Byzantium*, Boston, 1950

DER NERSESSIAN, SIRARPIE, *The Armenians*, London, 1969

Early Christian and Byzantine Art (exhibition catalogue), Walters Art Gallery, Baltimore, 1947

FILOW, BOGDAN D., *Early Bulgarian Art*, Berne, 1919

GOLDSCHMIDT, ADOLPH, and WEITZMANN, KURT, *Die byzantinischen Elfenbeinskulpturen*, 2 vols., Berlin, 1930–34

GRABAR, ANDRÉ, *The Beginnings of Christian Art, 200–395*, London, 1967

_____, *Byzantine Painting*, Geneva, 1953

_____, "La décoration architecturale de l'églises de la Vierge à Saint-Luc en Phocide et les débuts des influences islamiques," *Comptes rendus de l'Académie des inscriptions et belle-lettres*, Jan.–Mar., 1971

_____, *The Golden Age of Justinian, from the Death of Theodosius to the Rise of Islam*, New York, 1967

_____, *Martyrium. Recherches sur le culte des reliques et l'art chrétien antique*, 3 vols., Paris, 1943–46

_____, *Sculptures byzantines de Constantinople* (IVe–Xe siècle), Paris, 1963

HAUSSIG, HANS W., *A History of Byzantine Civilization*, London, 1971

Illuminated Greek Manuscripts from Armenian Collections (exhibition catalogue), The Art Museum, Princeton University, 1973

KAUTZSCH, R., *Kapitellstudien*, Berlin, 1936

KONDAKOV, NIKODIM P., *The Russian Icon*, Oxford, 1927

KRAUTHEIMER, RICHARD, *Early Christian and Byzantine Architecture* (Pelican History of Art), Harmondsworth, 1965

LANG, DAVID MARSHALL, *The Georgians*, London, 1966

LAWRENCE, MARION, *The Sarcophagi of Ravenna* (College Art Association Monographs), New York, 1945

MACLAGAN, MICHAEL, *The City of Constantinople*, London, 1968

MÂLE, ÉMILE, *The Early Churches of Rome*, London, 1960

MOREY, CHARLES RUFUS, *Early Christian Art* (2nd ed.), Princeton, 1953

NATANSON, JOSEPH, *Early Christian Ivories*, London, 1953

PEIRCE, HAYFORD, and TYLER, ROYALL, *Byzantine Art*, London, 1926

RICE, DAVID TALBOT, *Art of the Byzantine Era*, New York, 1963

_____, *The Beginnings of Christian Art*, New York, 1957

_____, *Russian Icons*, London, 1959

VAN DER MEER, FREDERICK, and MOHRMANN, CHRISTINE, *Atlas of the Early Christian World*, New York, 1958

VOLBACH, WOLFGANG FRITZ, *Early Christian Art*, New York, 1961

_____, *Elfenbeinarbeiten der Spätantike und des frühen Mittelalters* (2nd ed.), Mainz, 1952

WEITZMANN, KURT, "Prolegomena to a Study of the Cyprus Plates," *Metropolitan Museum of Art Journal*, 3, 1970

_____, and others, *A Treasury of Icons: Sixth to Seventeenth Centuries*, New York, 1967

WILPERT, JOSEF, *Le pitture delle catacombe romane*, Rome, 1903

_____, *I sarcofagi cristiani antichi*, 5 vols., Vatican City, 1929–36

WORMALD, FRANCIS, *The Miniatures in the Gospels of Saint*

Augustine (Corpus Christi, Cambridge, Ms. 286), Cambridge, England, 1954

3. Pre-Romanesque Art
(The Dark Ages, Carolingian, Ottonian, etc.)

ÅBERG, NILS, *The Occident and the Orient in the Art of the Seventh Century*, 3 vols., Stockholm, 1943–47

Atti della Pontificia Accademia Romana di Archeologia: Memorie, ser. 3, X: *La cattedra lignea di S. Pietro in Vaticano*, Vatican City, 1971

BECKWITH, JOHN, *Early Medieval Art*, New York, 1964

BEUTLER, C., *Bildwerke zwischen Antike und Mittelalter*, Düsseldorf, 1964

BOECKLER, ALBERT, *Abendländische Miniaturen bis zum Ausgang der romanisches Zeit*, Berlin–Leipzig, 1930

BOINET, AMÉDÉE, *La miniature carolingienne*, Paris, 1913

BRAUNFELS, WOLFGANG, and SCHNITZLER, HERMANN (eds.), *Karl der Grosse. III: Karolingische Kunst*, Düsseldorf, 1965

BROWN, G. BALDWIN, *The Arts in Early England*, 7 vols., London, 1903–37

BRUCE-MITFORD, R. L. S., "The Reception by the Anglo-Saxons of Mediterranean Art following their Conversion from Ireland and Rome," *Settimane di studio del Centro italiano di studi sull'alto medioevo*, Spoleto, 1967

BULLOUGH, D. A., *The Age of Charlemagne*, New York, 1966

CLAPHAM, ALFRED W., *English Romanesque Architecture before the Conquest*, Oxford, 1930 (reprinted 1964)

DE WALD, ERNEST T., *Illustrations of the Utrecht Psalter*, Princeton, 1933

_____, *The Stuttgart Psalter*, Princeton, 1930

DODWELL, C. R., and TURNER, D. H., *Reichenau Reconsidered: A Reassessment of the Place of Reichenau in Ottonian Art* (Warburg Institute Surveys, II), London, 1965

FOCILLON, HENRI, *L'an mil*, Paris, 1952

FOOTE, P. G., and WILSON, D. M., *Viking Achievement* (2nd ed.), London, 1973

GOLDSCHMIDT, ADOLPH, *Die Elfenbeinskulpturen aus der Zeit der karolingischen und sächsischen Kaiser*, 4 vols., Berlin, 1914–26

_____, *German Illumination*, Florence, 1928

GÓMEZ MORENO, MANUEL, *Iglesias mozárabes*, 2 vols., Madrid, 1919

GRABAR, ANDRÉ, and NORDENFALK, CARL, *Early Medieval Painting*, Geneva, 1957

GRODECKI, LOUIS, *L'architecture ottonienne*, Paris, 1958

_____, MÜTHERICH, F., TARALON, J., and WORMALD, F., *Le siècle de l'an mil*, Paris, 1973

HASELOFF, ARTHUR E. G., *Pre-Romanesque Sculpture in Italy*, New York, 1931

HENDERSON, GEORGE, *Early Medieval*, Harmondsworth, 1972

HENRY, FRANÇOISE, *Irish Art during the Viking Invasions (A.D. 800–1200)*, Ithaca, N.Y., 1967

_____, *Irish Art in the Early Christian Period to A.D. 800*, Ithaca, N.Y., 1967

HINKS, ROGER, *Carolingian Art*, London, 1935 (reprinted 1962)

HOLMQVIST, WILHELM, *Germanic Art during the First Millennium A.D.*, Stockholm, 1955

HUBERT, JEAN, *L'art pré-roman*, Paris, 1938

_____, PORCHER, J., and VOLBACH, W. F., *Carolingian Art*, London, 1970

_____, _____, and _____, *Europe of the Invasions*, New York, 1969

JANTZEN, HANS, *Ottonische Kunst* (2nd ed.), Hamburg, 1959

Karl der Grosse (exhibition catalogue), Aachen, 1965

KENDRICK, THOMAS D., *Anglo-Saxon Art to A.D. 900*, London, 1938

_____, *Late Saxon and Viking Art*, London, 1949

KING, GEORGIANNA GODDARD, *Pre-Romanesque Churches of Spain* (Bryn Mawr Monographs), New York, 1924

KITZINGER, ERNST, *Early Medieval Art in the British Museum*, Bloomington, Ind., 1964

KOEHLER, WILHELM, *Die Karolingischen Miniaturen. I: Die Schule von Tours*, 3 vols., Berlin, 1930–33

_____, *Die Karolingischen Miniaturen. II: Die Hofschule Karls des Grossen*, 2 vols., Berlin, 1958

KRAUTHEIMER, RICHARD, "The Carolingian Revival of Early Christian Architecture," *Art Bulletin*, XXIV, 1942, pp. 1–31

LASKO, PETER, *The Kingdom of the Franks: North-West Europe Before Charlemagne*, London, 1971

NEUSS, WILHELM, *Die Apokalypse des Hl. Johannes in der altspanischen und altchristlichen Bibelillustration*, 2 vols., Münster, 1931

PAOR, M. and L. DE, *Early Christian Ireland*, London, 1964

RICE, DAVID TALBOT (ed.), *The Dark Ages* (3rd ed.), London, 1969

ROSS, MARVIN C., *Arts of the Migration Period in the Walters Art Gallery*, Baltimore, 1961

SCHNITZLER, HERMANN, "Eine ottonische Reliquienburse," *Mouseion: Studien aus Kunst und Geschichte für Otto H. Förster*, Cologne, 1960, pp. 200–202

SCHRAMM, P. E., and MÜTHERICH, FLORENTINE, *Denkmäler der deutschen Könige und Kaiser*, Munich, 1962

STRZYGOWSKI, JOSEF, *Early Church Art in Northern Europe*, London, 1928

SWARZENSKI, GEORG, *Die Regensburger Buchmalerei des X. und XI. Jahrhunderts*, Leipzig, 1901

TAYLOR, HAROLD McC. and JOAN, *Anglo-Saxon Architecture*, 2 vols., Cambridge, England, 1965

TSCHAN, FRANCIS J., *Saint Bernward of Hildesheim*, 3 vols., South Bend, Ind., 1942–52

WARD-PERKINS, JOHN B., "The Sculpture of Visigothic France," *Archaeologia*, 87, 1938, p. 102

WEITZMANN, KURT, *The Fresco Cycle of S. Maria di Castelseprio*, Princeton, 1951

WESENBERG, RUDOLF, *Bernwardische Plastik*, Berlin, 1955

WILSON, DAVID M., *The Anglo-Saxons*, London, 1960

_____, and KLINDT-JENSEN, O., *Viking Art*, London, 1966

WORMALD, FRANCIS, *English Drawings of the Tenth and Eleventh Centuries*, London, 1952

ZIMMERMANN, E. HEINRICH, *Vorkarolingische Miniaturen*, Berlin, 1916

4. Romanesque Art

ALEXANDER, J. J. A., *Norman Illumination at Mont Saint-Michel, 966–1100*, New York, 1970

ANFRAY, MARCEL, *L'architecture normande*, Paris, 1939

ANKER, PETER (Vol. I), and ANDERSSON, ARON (Vol. II), *The Art of Scandinavia*, 2 vols., New York, 1970

ANTHONY, EDGAR W., *Romanesque Frescoes*, Princeton, 1951

El arte románico (exhibition catalogue), Barcelona–Santiago de Compostela, 1961

AUBERT, MARCEL, *L'art roman en France*, Paris, 1961

AVERY, MYRTILLA, *The Exultet Rolls of South Italy*, 2 vols., Princeton, 1936

BAUM, JULIUS, *Romanesque Architecture in France* (2nd ed.), London, 1928

BEENKEN, HERMANN, *Romanische Skulptur in Deutschland*, Leipzig, 1924

BERTAUX, E., *L'art dans l'Italie méridionale*, Paris, 1904

BLINDHEIM, MARTIN, *Norwegian Romanesque Decorative Sculpture, 1090–1210*, London, 1965

BLOCH, HERBERT, "Monte Cassino, Byzantium and the West in the Earlier Middle Ages," *Dumbarton Oaks Papers*, No. 3, 1946, pp. 165–224

BOASE, THOMAS S. R., *English Art, 1100–1216*, Oxford, 1953

BORG, ALAN, *Architectural Sculpture in Romanesque Provence*, Oxford, 1972

BROOKE, CHRISTOPHER, *The Monastic World, 1000–1300*, London, 1974

_____, *The Twelfth Century Renaissance*, London, 1969

CLAPHAM, ALFRED W., *Romanesque Architecture in Western Europe*, Oxford, 1936

CONANT, KENNETH JOHN, *Cluny: les églises et la maison du chef d'ordre*, Cambridge, Mass. (The Mediaeval Academy of America; printed at Mâcon), 1968

_____, *The Early Architectural History of the Cathedral of Santiago de Compostela*, Cambridge, Mass., 1926

CRIGHTON, GEORGE H., *Romanesque Sculpture in Italy*, London, 1954

CROSBY, SUMNER McK., *The Apostle Bas-Relief at Saint-Denis*, New Haven–London, 1972

CROZET, RENÉ, *L'art roman en Berry*, Paris, 1932

_____, *L'art roman en Poitou*, Paris, 1948

_____, *L'art roman en Saintonge*, Paris, 1971

DECKER, HANS, *Romanesque Art in Italy*, New York, 1959

DEMUS, OTTO, *The Mosaics of Norman Sicily*, London, 1950

_____, *Romanesque Mural Painting*, New York, 1970

DESCHAMPS, PAUL, *French Sculpture of the Romanesque Period*, Florence–Paris, 1930

_____, and THIBOUT, MARC, *La peinture murale in France*, Paris, 1951

DODWELL, C. R., *The Canterbury School of Illumination*, Cambridge, England, 1954

_____, *The Great Lambeth Bible*, London, 1959

_____ (ed.), *Theophilus De Diversibus Artibus*, London, 1961

DOMINGUEZ BORDONA, J., *La miniatura española*, I, Florence–Barcelona, 1930

DURLIAT, M., "L'atelier de Bernard Gilduin à Saint-Sernin de Toulouse," *Anuario de Estudios Medievales*, I, Barcelona, 1964

_____, "Le Maître de Cabestany," *La sculpture romane en Roussillon*, IV, Perpignan, 1954

_____, "Du nouveau sur le maître de Cabestany," *Bulletin monumental*, 129, 1971, pp. 193–98

EVANS, JOAN, *Cluniac Art of the Romanesque Period*, Cambridge, England, 1950

_____, *The Romanesque Architecture of the Order of Cluny*, Cambridge, England, 1938

FERNIE, E., "Notes on the Sculpture of Modena Cathedral," *Arte Lombarda*, 1969, pp. 88–93

FOCILLON, HENRI, *L'art des sculpteurs romans*, Paris, 1931

_____, *The Art of the West in the Middle Ages*. I: *Romanesque Art*, London, 1963

FORSYTH, ILENE H., *The Throne of Wisdom: Wood Sculptures of the Madonna in Romanesque France*, Princeton, 1972

FRANCOVICH, GEZA DE, *Benedetto Antelami, architetto e scultore, e l'arte del suo tempo*, 2 vols., Milan, 1952

_____, "La corrente comasca nella scultura romanica europea," *Rivista del R. Istituto de Archeologia e Storia dell'Arte*, V, 1935–36; VI, 1937–38

GAILLARD, GEORGES, *Les débuts de la sculpture romane espagnole*, Paris, 1938

_____, *La sculpture romane espagnole*, Paris, 1946

GÁL, L., *L'architecture religieuse en Hongrie du XIe au XIIIe siècle*, Paris, 1929

GANTNER, JOSEPH, and POBÉ, MARCEL, *Romanesque Art in France*, London, 1956

GARRISON, EDWARD B., *Italian Romanesque Panel Painting: An Illustrated Index*, Florence, 1949

_____, *Studies in the History of Mediaeval Italian Painting*, 4 vols., Florence, 1953–62

GÓMEZ MORENO, MANUEL, *El arte románico español*, Madrid, 1934

GRABAR, ANDRÉ, and NORDENFALK, CARL, *Romanesque Painting from the Eleventh to the Thirteenth Century*, New York, 1958

GRIVOT, DENIS, and ZARNECKI, GEORGE, *Gislebertus, Sculptor of Autun*, New York, 1961

HASKINS, CHARLES HOMER, *The Renaissance of the Twelfth Century*, Cambridge, Mass., 1927

HILDBURGH, W. L., *Medieval Spanish Enamels*, Oxford, 1936

HUTTON, EDWARD, *The Cosmati*, London, 1950

JULLIAN, RENÉ, *L'éveil de la sculpture italienne. La sculpture romane dans l'Italie du nord*, Paris, 1945

KITZINGER, ERNST, "The Byzantine Contribution to Western Art of the Twelfth and Thirteenth Centuries," *Dumbarton Oaks Papers*, No. 20, 1966, pp. 27–47

_____, "The First Mosaic Decoration of Salerno Cathedral," *Jahrbuch der österreichischen Byzantinistik*, 21, 1972, pp. 149–62

KUHN, CHARLES L., *Romanesque Mural Painting of Catalonia*, Cambridge, Mass., 1930

LASTEYRIE, R. DE, *L'architecture religieuse en France à l'époque romane* (2nd ed.), Paris, 1929

LAURENT, M., *L'architecture et la sculpture en Belgique*, Paris–Brussels, 1928

MÂLE, ÉMILE, *L'art religieux du XIIe siècle en France* (5th ed.), Paris, 1947

MAŠIN, JIŘI, *Romanesque Mural Painting in Bohemia and Moravia*, Prague, 1954

Medieval Art from Private Collections (exhibition catalogue), The Metropolitan Museum of Art, New York, 1968

MILLAR, ERIC G., *English Illuminated Manuscripts from the Tenth to the Thirteenth Centuries*, Paris–Brussels, 1926

NAESGAARD, OLE, *Saint-Jacques de Compostelle et les débuts de la grande sculpture vers 1100*, Aarhus, 1962

OAKESHOTT, WALTER, *The Artists of the Winchester Bible*, London, 1945

_____, *Sigena: Romanesque Paintings in Spain and the Winchester Bible Artists*, London, 1972

OURSEL, C., *Miniatures cisterciennes (1109–1134)*, Dijon, 1960

PÄCHT, OTTO, *The Rise of Pictorial Narrative in Twelfth-Century England*, Oxford, 1962

_____, DODWELL, C. R., and WORMALD, F., *The St. Albans Psalter*, London, 1960

PORTER, ARTHUR KINGSLEY, *Romanesque Sculpture of the Pilgrimage Roads*, 10 vols., Boston, 1923

_____, *Spanish Romanesque Sculpture*, 2 vols., New York–Florence, 1928

PRESSOUYRE, L., "Une nouvelle oeuvre du 'Maitre de Cabestany' en Toscane," *Bulletin de la Société Nationale des Antiquaires de France*, 1971, pp. 30–55

PUIG Y CADAFALCH, JOSÉ, *Le premier art roman*, Paris, 1928

QUINTAVALLE, ARTURO CARLO, *La Cattedrale di Modena*, Modena, 1964

——, *Wiligelmo e la sua scuola*, Florence, 1967

READ, HERBERT, *English Stained Glass*, London, 1926

REY, RAYMOND, *L'art des cloîtres romans*, Toulouse, n.d.

RICCI, CORRADO, *Romanesque Architecture in Italy*, London, 1925

Romanische Kunst in Oesterreich (exhibition catalogue), Krems, 1964

ROOSVAL, JOHNNY A. E., *Swedish Art*, Princeton, 1932

SALET, FRANCIS, *La Madeleine de Vézelay*, Melun, 1948

SALMI, MARIO, *Romanesque Sculpture in Tuscany*, Florence, 1928

SALVINI, ROBERTO, *Il Duomo di Modena*, Modena, 1966

——, *Wiligelmo e le origini della scultura romanica*, Milan, 1956

SAXL, FRITZ, and SWARZENSKI, HANNS (ed.), *English Sculptures of the Twelfth Century*, London, 1954

SCHAPIRO, MEYER, *The Parma Ildefonsus: A Romanesque Illuminated Manuscript from Cluny and Related Works* (College Art Association Monographs), New York, 1964

SCHER, K., *The Renaissance of the Twelfth Century* (exhibition catalogue), Providence, R.I., 1969

SEIDEL, LINDA, "A Romantic Forgery: the Romanesque 'Portal' of Saint-Etienne in Toulouse," *Art Bulletin*, 50, 1968, pp. 33–42

SWARZENSKI, GEORG, *Die Salzburger Malerei von den ersten Anfängen bis zur Blütezeit des romanischen Stils*, 2 vols., Leipzig, 1908–13

SWARZENSKI, HANNS, *The Berthold Missal*, New York, 1943

——, *Monuments of Romanesque Art* (2nd ed.), Chicago, 1974

TURNER, D. H., *Romanesque Illustrated Manuscripts*, London (British Museum), 1966

VIELLIARD, JEANNE (ed.), *Le guide du Pèlerin de Saint-Jacques de Compostelle* (2nd ed.), Mâcon, 1960

VÖGE, WILHELM, *Die Anfänge des monumentalen Stiles im Mittelalter*, Strassburg, 1894

WHITEHILL, WALTER M., *Spanish Romanesque Architecture of the Eleventh Century* (2nd ed.), Oxford, 1965

ZARNECKI, GEORGE, *English Romanesque Lead Sculpture*, London, 1957

——, *English Romanesque Sculpture, 1066–1140*, London, 1951

——, *Later English Romanesque Sculpture, 1140–1210*, London, 1953

——, *Romanesque Art*, New York, 1972

5. Art of the Crusading Kingdom

BARASCH, MOSHE, *Crusader Figural Sculpture in the Holy Land*, New Brunswick, N.J., 1971

BOASE, THOMAS S. R., "The Arts in the Latin Kingdom of Jerusalem," *Journal of the Warburg Institute*, II, 1938–39, pp. 1–21

——, *Castles and Churches of the Crusading Kingdom*, New York, 1967

BUCHTHAL, HUGO, *Miniature Painting in the Latin Kingdom of Jerusalem*, Oxford, 1937

DESCHAMPS, PAUL, *Le Crac des Chevaliers*, Paris, 1934

ENLART, CAMILLE, *Les monuments des Croisés dans le royaume de Jérusalem*, Paris, 1925–28

SMAIL, R. C., *The Crusaders in Syria and the Holy Land*, London, 1974

6. Gothic:

A. GENERAL

Art and the Courts: France and England from 1259 to 1328 (exhibition catalogue), 2 vols., Ottawa, 1972

BRIEGER, PETER, *English Art, 1216–1307*, Oxford, 1957

Cathédrales (exhibition catalogue), Musée du Louvre, Paris, 1962

EVANS, JOAN, *Art in Medieval France*, Oxford, 1948

——, *English Art, 1307–1461*, Oxford, 1949

FOCILLON, HENRI, *The Art of the West in the Middle Ages. II: Gothic Art*, London, 1963

FRANKL, PAUL, *The Gothic: Literary Sources and Interpretations Through Eight Centuries*, Princeton, 1960

HAHNLOSER, HANS R., *Villard de Honnecourt*, Vienna, 1935

HARVEY, JOHN H., *Gothic England: A Survey of National Culture, 1300–1550* (2nd ed.), London, 1948

HENDERSON, GEORGE, *Gothic, Style and Civilization*, Harmondsworth, 1967

HUIZINGA, JOHAN, *The Waning of the Middle Ages*, New York, 1954

JACKSON, THOMAS G., *Gothic Architecture in France, England and Italy*, Cambridge, England, 1915

LAMBERT, ÉLIE, *L'art gothique en Espagne aux XIIe et XIIIe siècles*, Paris, 1931

MÂLE, ÉMILE, *L'art religieux en France au XIIIe siècle* (9th ed.), Paris, 1958

——, *L'art religieux de la fin du moyen-âge*, Paris, 1908

——, *The Gothic Image*, New York, 1958

MARTINDALE, ANDREW, *Gothic Art*, New York, 1967

NOLTHENIUS, HÉLÈNE, *Duecento: The Late Middle Ages in Italy*, New York, 1969

PANOFSKY, ERWIN (ed. and tr.), *Abbot Suger: On the Abbey Church of St.-Denis and Its Art Treasures*, Princeton, 1946

WHITE, JOHN, *Art and Architecture in Italy: 1250–1400* (Pelican History of Art), Harmondsworth, 1966

B. ARCHITECTURE

AUBERT, MARCEL, *Notre-Dame de Paris*, Paris, 1920

BONY, JEAN, "The Resistance to Chartres in Early Thirteenth-Century Architecture," *Journal of the British Archaeological Association*, 3rd ser., 20–21, 1957–58, pp. 35–52

BRANNER, ROBERT, *Burgundian Gothic Architecture*, London, 1960

——, *La cathédrale de Bourges et sa place dans l'architecture gothique*, Paris–Bourges, 1962

——, *Chartres Cathedral*, New York, 1969

——, *St. Louis and the Court Style in Gothic Architecture*, London, 1965

CROSBY, SUMNER McK., *The Abbey of Saint-Denis (475–1122)*, New Haven, 1942

——, *L'abbaye royale de Saint-Denis*, Paris, 1953

DIMIER, M.-A. (ed.), *L'art cistercien hors de France*, Paris, 1971

EYDOUX, HENRY-PAUL, *L'architecture des églises cisterciennes d'Allemagne*, Paris, 1952

FRANKL, PAUL, *Gothic Architecture* (Pelican History of Art), Harmondsworth, 1962

GRODECKI, LOUIS, *Sainte-Chapelle*, Paris, n.d.

HARVEY, JOHN H., *Early Mediaeval Architects: A Biographical Dictionary down to 1550*, London, 1954

_____, *The Gothic World, 1100–1600: A Survey of Architecture and Art*, New York–Evanston, 1969

JANTZEN, HANS, *High Gothic: The Classic Cathedrals of Chartres, Reims, Amiens*, New York, 1962

LASTEYRIE, R. DE, *L'architecture religieuse en France à l'époque gothique* (2nd ed.), 2 vols., Paris, 1929

LONGHI, L. F. DE, *L'architettura delle chiese cisterciensi italiane*, Milan, 1958

PANOFSKY, ERWIN, *Gothic Architecture and Scholasticism*, New York, 1967

SIMSON, OTTO G. VON, *The Gothic Cathedral: Origins of Gothic Architecture and the Medieval Concept of Order* (2nd ed.), New York, 1962

C. SCULPTURE

ANDERSSON, ARON, *English Influence in Norwegian and Swedish Figure Sculpture in Wood, 1220–70*, Stockholm, 1949

AUBERT, MARCEL, *French Sculpture at the Beginning of the Gothic Period*, Florence–Paris, 1929

BEHLING, LOTTLISA, *Die Pflanzenwelt der mittelalterlichen Kathedralen*, Cologne–Graz, 1964

BLINDHEIM, MARTIN, *Main Trends of East Norwegian Wooden Figure Sculpture in the Second Half of the XIIIth Century*, Oslo, 1952

CRICHTON, GEORGE H. and ELSIE P., *Nicola Pisano and the Revival of Sculpture in Italy*, Cambridge, England, 1938

ERLANDE-BRANDENBURG, A., "Les remaniements du portail central à Notre-Dame de Paris," *Bulletin Monumental*, 129, 1971

HUNT, JOHN, *Irish Medieval Figure Sculpture, 1200–1600*, 2 vols., Dublin–London, 1974

KATZENELLENBOGEN, ADOLF, *The Sculptural Programs of Chartres Cathedral*, Baltimore, 1959

KIDSON, PETER, *Sculpture at Chartres*, New York, 1959

KOECHLIN, RAYMOND, *Les ivoires gothiques français*, 2 vols., Paris, 1924

LAPEYRE, A., *Des façades occidentales de Saint-Denis et de Chartres aux portails de Laon*, Paris, 1960

NATANSON, JOSEPH, *Gothic Ivories of the 13th and 14th Centuries*, London, 1951

PEVSNER, NIKOLAUS, *The Leaves of Southwell*, Harmondsworth, 1945

POPE-HENNESSY, JOHN, *Italian Gothic Sculpture* (2nd ed.), London, 1972

SAUERLÄNDER, WILLIBALD, *Gothic Sculpture in France: 1140–1270*, New York, 1972

_____, *Von Sens bis Strassburg*, Berlin, 1966

STODDARD, WHITNEY S., *The West Portals of Saint-Denis and Chartres*, Cambridge, Mass., 1952

D. PAINTING

ANTAL, FREDERICK, *Florentine Painting and Its Social Background*, London, 1948

BORSOOK, EVE, *The Mural Painters of Tuscany*, London, 1960

CARLI, ENZO, *Sienese Painting*, Greenwich, Conn., 1956

DEUCHLER, FLORENS, *Der Ingeborgpsalter*, Berlin, 1967

DUPONT, JACQUES, and GNUDI, CESARE, *Gothic Painting*, Geneva, 1954

DVORAKOVA, V., and others, *Gothic Mural Painting in Bohemia and Moravia, 1300–1378*, London, 1964

LEMOISNE, PAUL A., *Gothic Painting in France*, Florence–Paris, 1931 (reprinted New York, 1973)

MATEJČEK, ANTONIN, and PEŠINA, JAROSLAV, *Czech Gothic Painting, 1350–1450*, Prague, 1950

MATHER, FRANK JEWETT, *The Isaac Master*, Princeton, 1932

MEISS, MILLARD, *Giotto and Assisi*, New York, 1960

_____, *Painting in Florence and Siena after the Black Death*, Princeton, 1951

MILLAR, ERIC G., *English Illuminated Manuscripts of the XIVth and XVth Centuries*, Paris–Brussels, 1928

_____, *The Parisian Miniaturist Honoré*, London, 1959

MORAND, KATHLEEN, *Jean Pucelle*, Oxford, 1962

PANOFSKY, ERWIN, *Early Netherlandish Painting: Its Origin and Character*, 2 vols., Cambridge, Mass., 1953

RACKHAM, BERNARD, *The Ancient Glass of Canterbury Cathedral*, London, 1949

ROWLEY, GEORGE, *Ambrogio Lorenzetti*, 2 vols., Princeton, 1958

SMART, ALISTAIR, *The Assisi Problem and the Art of Giotto*, Oxford, 1971

STERLING, CHARLES, *Les peintres du moyen âge*, Paris, 1941

TINTORI, LEONETTO, and BORSOOK, EVE, *Giotto: The Peruzzi Chapel*, New York, 1965

_____, and MEISS, MILLARD, *The Life of St. Francis of Assisi*, New York, 1962

WEIGELT, CURT H., *Sienese Painting of the Trecento*, New York, 1930

E. EMBROIDERY AND GLASS

CHRISTIE, A. G. I., *English Mediaeval Embroidery*, Oxford, 1938

MARCHINI, G., *Italian Stained Glass Windows*, New York, 1957

Opus Anglicanum: English Medieval Embroidery (exhibition catalogue), Victoria and Albert Museum, London, 1963

Index

Page numbers are in roman type. Figure numbers of black-and-white illustrations are in *italics*. Colorplates are specifically so designated. Names of artists and architects are in CAPITALS. Titles of works are in *italics*.

PHOTOGRAPHIC CREDITS

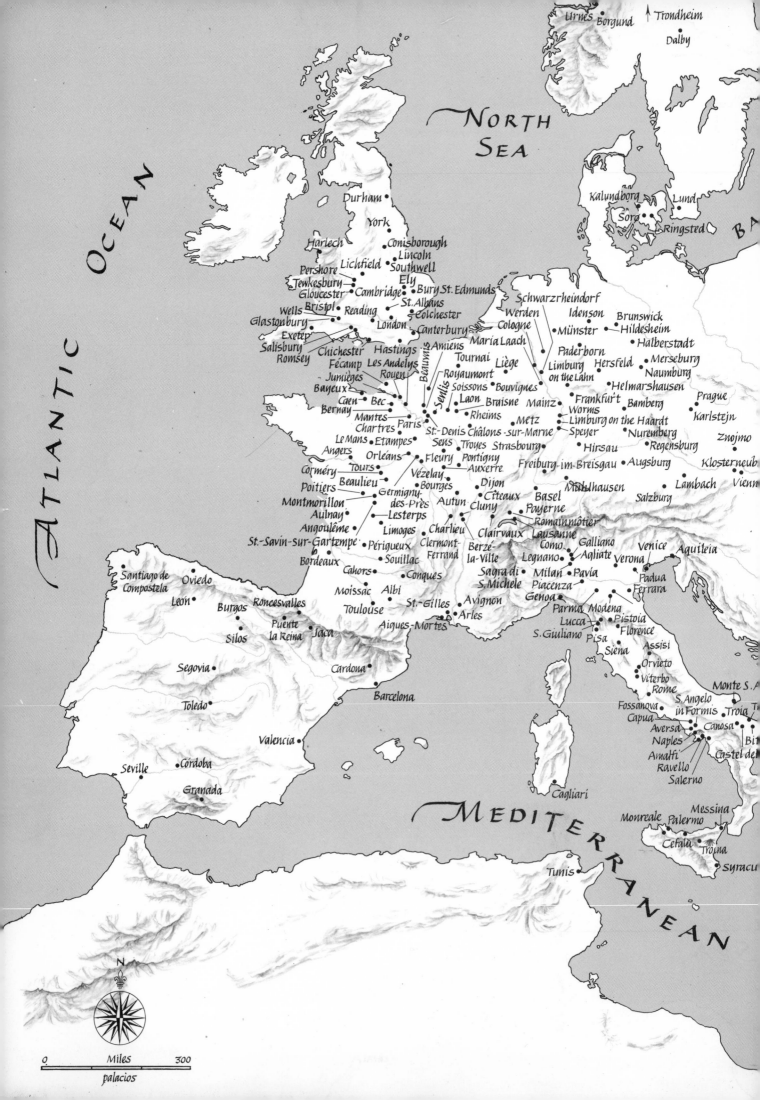

ATLANTIC OCEAN

NORTH SEA

MEDITERRANEAN

BA...

Trondheim
Urnes • Borgund
Dalby

Kalundborg Lund
Sora
Ringsted

Durham
York
Harlech • Conisborough
Lichfield • Lincoln
Pershore • Southwell
Tewkesbury • Ely
Gloucester • Cambridge • Bury St. Edmunds
Wells • Bristol • Reading • St. Albans
Glastonbury • London • Colchester
Exeter • Canterbury
Salisbury • Chichester • Hastings
Romsey • Fécamp • Les Andelys
Jumièges • Rouen
Bayeux
Caen • Bec
Bernay
Mantes
Chartres • Paris
Le Mans • Etampes
Angers
Orléans
Cormery • Tours
Poitiers • Beaulieu
Montmorillon • Germigny-des-Prés
Aulnay • Lesterps
Angoulême • Limoges
St.-Savin-sur-Gartempe • Périgueux • Souillac
Bordeaux
Cahors
Moissac • Albi
Toulouse
Aigues-Mortes

Schwarzrheindorf
Werden • Idenson • Brunswick
Cologne • Münster • Hildesheim
Maria Laach • Paderborn • Halberstadt
Beauvais • Amiens • Liège • Hersfeld • Merseburg
Tournai • Limburg on the Lahn • Naumburg
Royaumont • Bouvignes • Helmarshausen
Soissons • Mainz • Frankfurt • Bamberg • Prague
Senlis • Laon • Braisne • Worms • Karlstejn
Rheims • Metz • Limburg on the Haardt • Znojmo
St.-Denis • Châlons-sur-Marne • Speyer • Nuremberg
Sens • Troyes • Strasbourg • Hirsau • Regensburg • Klosterneub...
Fleury • Pontigny • Freiburg-im-Breisgau • Augsburg • Vienn...
Vézelay • Auxerre • Lambach
Bourges • Dijon • Mühlhausen • Salzburg
Autun • Cîteaux • Basel
Cluny • Payerne
Charlieu • Romainmôtier • Como • Galliano • Venice • Aquileia
Clairvaux • Lausanne • Legnano • Agliate • Verona
Clermont-Ferrand • Berze-la-Ville • Milan • Pavia • Padua
Sagra di S. Michele • Piacenza • Ferrara
Conques • Avignon • Genoa
St.-Gilles • Arles • Parma • Modena
Lucca • Pistoia
S. Giuliano • Pisa • Florence • Assisi
Siena • Orvieto
Viterbo • Rome
Monte S. A...
Fossanova • S. Angelo in Formis • Troia
Capua • Canosa
Aversa • Bi...
Naples • Castel de...
Amalfi
Ravello • Salerno
Monreale • Messina
Palermo
Cefalù • Troina
Syracu...
Cagliari
Tunis

Santiago de Compostela
Oviedo
León
Burgos • Roncesvalles
Puente la Reina • Jaca
Silos
Segovia
Toledo
Cardona
Barcelona
Valencia
Seville • Córdoba
Granada

N

0 Miles 300
palacios